Edited by Sylva Dobalová ar

# Archduke Ferdinand II of Austria

ÖSTERREICHISCHE AKADEMIE DER WISSENSCHAFTEN
PHILOSOPHISCH-HISTORISCHE KLASSE
SITZUNGSBERICHTE, 909. BAND

VERÖFFENTLICHUNGEN ZUR KUNSTGESCHICHTE 21
HERAUSGEGEBEN VON HERBERT KARNER

Edited by Sylva Dobalová and Jaroslava Hausenblasová

# Archduke Ferdinand II of Austria:
## A Second-Born Son
## in Renaissance Europe

AUSTRIAN
ACADEMY
OF SCIENCES
PRESS

Accepted by the publication committee of the Division of Humanities and Social Sciences
of the Austrian Academy of Sciences:

Michael Alram, Bert G. Fragner, Andre Gingrich, Hermann Hunger, Sigrid Jalkotzy-Deger,
Renate Pillinger, Franz Rainer, Oliver Jens Schmitt, Danuta Shanzer, Peter Wiesinger,
Waldemar Zacharasiewicz

This book is the result of the research funded by the Czech Science Foundation as
the project no. 17–25383S, "Archduke Ferdinand II of Tyrol (1529–1595)
and his cultural patronage between Prague and Innsbruck".
The recipient of the project was the Institute of Art History, Czech Academy of Sciences.

Photographic credit for the cover illustration:
Francesco Terzio, Archduke Ferdinand II, after 1557, detail, Vienna, Kunsthistorisches Museum,
inv. no. GG 7971, © KHM-Museumsverband

This publication was subject to international and anonymous peer review.
Peer review is an essential part of the Austrian Academy of Sciences Press evaluation process.
Before any book can be accepted for publication, it is assessed by international specialists and ultimately
must be approved by the Austrian Academy of Sciences Publication Committee.

The paper used in this publication is DIN EN ISO 9706 certified and meets the requirements
for permanent archiving of written cultural property.

# Contents

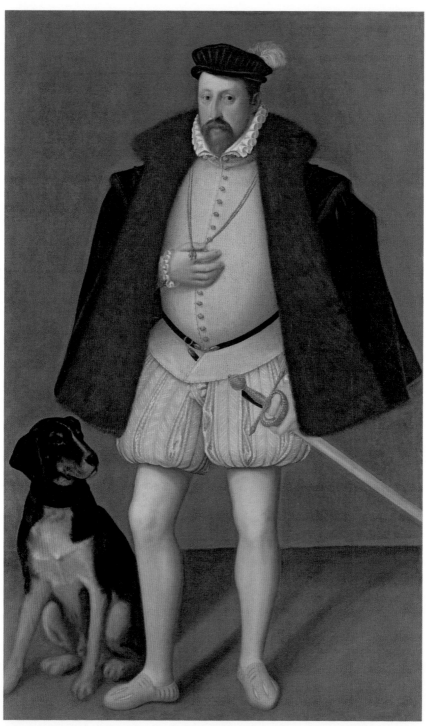

Archduke Ferdinand II, c. 1570 (Vienna, Kunsthistorisches Museum, Picture Gallery, inv. no. GG 4388)

# Introduction

Archduke Ferdinand II of Austria, also called Ferdinand II of Tyrol, was born into the House of Habsburg in 1529 (d.1595) and became famous during his lifetime not only as a politician and ruler, but even more so as a fervent collector of armour, creator of a world-famous *Kunst- und Wunderkammer*, an organiser of splendid festivities with luxurious costumes, and finally as the owner of a huge library. He was an educated man interested in the natural sciences, and also a dilettante architect who designed the unique Star Summer Palace in Prague, which still stands today. Paradoxically however, in the present time he is mainly remembered for his secret morganatic marriage to a beautiful burgher, Philippine Welser.

Ferdinand II was the second son of Emperor Ferdinand I of the House of Habsburg (1503–1564). His position as the second-born son was highly significant in determining Ferdinand's fate and ambitions. His unclear dynastic and economic position within the Habsburg family, as well as rivalry with his older brother Emperor Maximilian II (1527–1576), and later with Emperor Rudolf II (1552–1612), influenced his politics and subsequently also his cultural strategy. At the beginning Ferdinand II's adult life, both his political and cultural interests were concentrated within the Bohemian lands, especially Prague, where he served for 20 years in the office of Governor of the Lands of the Bohemian Crown. Later this focus shifted to the Tyrol (in particular Innsbruck and Ambras) where Ferdinand reigned from 1564 to his death. With his personal contacts and artistic commissions, however, he contributed significantly to the interconnections between the Lands of the Bohemian Crown, Tyrol, and the Austrian countries, as well as with the other economic and cultural centres of Western and Southern Europe.

At the end of the 19th century, Archduke Ferdinand II was a relatively famous personage. At the Austrian castle of Ambras in Innsbruck, Tyrol, a permanent exhibition devoted to his person and legacy was opened in 1880 by Wendelin Boeheim and Albert Ilg, curators of the museum there. These researchers also devoted themselves to studying the history of the castle itself. In the 1880s, a two-volume monograph on Ferdinand II was also written by Tyrolean historian Josef Hirn, and this remains the only detailed publication to this day.[1]

The interest shown in Archduke Ferdinand II by the Austrians was echoed during the last third of the 19th century in Bohemia, where an effort arose to save the unique Star Summer Palace in Prague, a building connected precisely with the archduke's name.[2] The subsequent decrease in academic interest for historical research into Arch-

---

1  Josef Hirn, *Erzherzog Ferdinand II. von Tirol. Geschichte seiner Regierung und seiner Länder*, 2 vols. (Innsbruck, 1885–1888); Albert Ilg and Wendelin Boeheim, *Das k. k. Schloss Ambras in Tirol. Beschreibung des Gebäudes und der Sammlungen* (Vienna, 1882).

2  Important sources on this summer residence have been published by David von Schönherr, 'Ezherzog Ferdinand von Tirol als Architect', *Repertorium für Kunstwissenschaft* 1 (1876), pp. 28–44.

duke Ferdinand II's life and work might be explained by the fact that as the second-born son of Ferdinand I, he did not become king or emperor. In terms of European political history, he remained a man in the background. The importance of his twenty years' residence in Prague was eclipsed by his nephew Rudolf II (1552–1612), whose activity in the Bohemian metropolis produced a second golden age: the first is recognised as the era of the city's blossoming under Charles IV (1316–1378).[3] Similarly, Tyrol, which stabilised and experienced an economic boom thanks to the arrival of Archduke Ferdinand II, still lived rather with the legacy of Ferdinand's great-grandfather, Emperor Maximilian I (1459–1519), founder of the modern Habsburg monarchy "on which the Sun did not set". Ferdinand could hardly compete with the legendary Maximilian I, who devoted the majority of his attention to Innsbruck specifically, as his seat.[4] By contrast, the archduke built upon Maximilian's legacy, protecting and developing it.[5]

The existing publications (exhibition catalogues, journal studies and so on) have been exclusively devoted to certain aspects of Archduke Ferdinand II's legacy, most particularly his activities as a collector of art and curiosities.[6] Such scholarship has naturally dealt with him mostly in connection with the ongoing research at Ambras castle, which was transferred to the ownership of the Austrian Republic at the beginning of the 20th century, and in 1950 came under the administration of the Kunsthistorisches Museum in Vienna. Some valuable, but nonetheless very specialised publications were issued upon the opening of the new installations at Ambras during the 1970s, under the direction of Elizabeth Scheicher.[7] In 1974, the *Kunst- und Wunderkammer* was opened as a permanent public exhibition, followed by the Habsburg portrait gallery, and finally the armoury or *Rüstkammer*. The above-mentioned sections of the Ambras collections have received exhaustive scholarly attention in a large body of published works.[8] Archduke Ferdinand II has also been given great attention

---

3    Thomas DaCosta Kaufmann, *The School of Prague: Painting at the Court of Rudolf II* (Chicago, 1988).

4    Larry Silver, *Marketing Maximilian: The Visual Ideology of A Holy Roman Emperor* (Princeton, 2008), p. ix; Hermann Wiesflecker, *Maximilian I. Die Fundamente des habsburgischen Weltreiches* (Vienna, 1992).

5    *Werke für die Ewigkeit. Kaiser Maximilian I. und Erzherzog Ferdinand II.*, ed. by Wilfried Seipel, exh. cat. (Innsbruck, 2002).

6    First emphasized by Julius von Schlosser, *Die Kunst- und Wunderkammern der Spätrenaissance. Ein Beitrag zur Geschichte des Sammelwesens* (Leipzig, 1908).

7    Elisabeth Scheicher, Ortwin Gamber, Kurt Wegerer and Alfred Auer, *Die Kunstkammer*, Führer durch das Kunsthistorisches Museum, 24 (Innsbruck, 1977); Elisabeth Scheicher, Ortwin Gamber and Alfred Auer, *Die Kunstkammer*, Führer durch das Kunsthistorisches Museum, 30 (Vienna, 1981); Elisabeth Scheicher, Ortwin Gamber and Alfred Auer, *Die Rüstkammern auf Schloß Ambras* (Vienna, 1981).

8    For example, Laurin Luchner, *Denkmal eines Renaissancefürsten: Versuch einer Rekonstruktion des Ambraser Museums von 1583* (Vienna, 1958); Günther Heinz and Karl Schütz, *Porträtgalerie zur Geschichte Österreichs von 1400 bis 1800* (Vienna, 1976).

in the wider context of Tyrolean history, and his construction works have been ana-
lysed as a part of the greater inventory of Innsbruck's monuments.[9]

A relatively stereotypical image of Archduke Ferdinand II took root in Czech his-
toriography at the beginning of the 20th century. His appointment to the post of
Bohemian vicegerent was one of a number of measures used by Ferdinand I, as King
of Bohemia, to punish the estates that had denied the crown their obedience in 1547
and failed to support the crown in the battles against the Schmalkaldic League. Ferdi-
nand II's task was to execute the Habsburg anti-Reformation religious policies
throughout the Lands of the Bohemian Crown in the sovereign's absence.[10] Neverthe-
less, his role was also understood to be administrative and economic,[11] and his suc-
cesses in defending crown lands against the Turks were also highlighted in scholarship
at the turn of the 20th century.[12] In the decades after World War II, and the installation
of the Communist regime in the new Czechoslovakia, historical research on the rulers
from the House of Habsburg was generally not supported. For this reason, one of the
first targeted studies was a text by Jaroslav Pánek, who in the 1980s pointed out the
Habsburg ruler's political and cultural ambitions during his residence in the Bohemian
lands; his well-founded study on Archduke Ferdinand II emerged in 1993.[13]

It was only with the international exhibition "Rudolf II and Prague" (1997), prepa-
rations for which began in Prague right after the so-called Velvet Revolution in 1989,
that the significance of Archduke Ferdinand II as a person was emphasised in terms of
his role in preparing the way for the ambitious cultural programme of Rudolf II in
Prague.[14] The catalogue and conference proceedings from this exhibition also played
an important part in disseminating this new perspective. The analysis presented by
Petr Vorel followed fundamental sources for the history of Archduke Ferdinand II's

---

9    E.g. Josef Riedmann, *Geschichte Tirols* (Vienna, 1982); Rudolf Palme, 'Frühe Neuzeit. 1490–1665', in
     *Geschichte des Landes Tirol*, II, *Die Zeit von 1490 bis 1848*, ed. by Josef Fontana et al. (Bozen, Inns-
     bruck and Vienna, 1986); Elisabeth Scheicher, 'Schloß Ambras', in *Die Kunstdenkmäler der Stadt
     Innsbruck: Die Hofbauten*, ed. by Johanna Felmayer, Österreichische Kunsttopographie, 47 (Vienna,
     1986), pp. 509–623; Ricarda and Karl Oettinger, 'Hofburg', in ibidem, pp. 55–208; Johanna Felmayer,
     'Silberne Kapelle', in ibidem, pp. 427–448; Johanna Felmayer, 'Ruhelust', in ibidem, pp. 626–639.

10   Ferdinand Hrejsa, *Česká konfese, její vznik, podstata a dějiny* (Prague, 1912); Rudolf Říčan, *Dějiny
     Jednoty bratrské* (Prague, 1957); Jan Smolík, 'Jan Augusta na Křivoklátě', *Středočeský sborník
     historický* 8 (1973), pp. 167–180.

11   Václav Pešák, *Dějiny Královské české komory od roku 1527. Část I.: Začátky organizace české komory
     za Ferdinanda I.* (Prague, 1930); Miloslav Wolf, 'Boj o solný monopol v Čechách v XVI. a na počátku
     XVII. století', *Český časopis historický* 39 (1933), pp. 297–326, 505–536.

12   František Kameníček, 'Výprava arciknížete Ferdinanda na pomoc obleženému od Turků Sigetu roku
     1556', *Sborník historický* 4 (1886), pp. 321–331; Idem, 'Účastenství Moravanů při válkách tureckých
     od r. 1526 do r. 1568', *Sborník historický* 3 (1885), pp. 15–29, 65–77, 157–175, 193–206, 271–284.

13   Jaroslav Pánek, *Stavovská opozice a její zápas s Habsburky 1547–1577 (K politické krizi feudální třídy
     v předbělohorském českém státě)* (Prague, 1982); Idem, 'Der Adel im Turnierbuch Erzherzog
     Ferdinands II. von Tirol. Ein Beitrag zur Geschichte des Hoflebens und der Hofkultur in der Zeit
     seiner Statthalterschaft in Böhmen', *Folia Historica Bohemica* 16 (1993), pp. 77–96.

14   *Rudolf II and Prague: the Court and the City*, ed. by Eliška Fučíková et al. (London, 1997);
     *Rudolf II, Prague and the Word. Papers from the International Conference, 2–7 September 1997*, ed.
     by Lubomír Konečný, Beket Bukovinská and Ivan Muchka (Prague, 1998).

court in Prague.[15] The studies by Václav Bůžek, which later formed the basis for a monograph, followed the relations between the archduke, his court, and the Bohemian aristocracy, and summarised the most important episodes of his rule in the Bohemian lands and Tyrol. These texts were outstanding in terms of their broad social and cultural-historical scope.[16]

The exhibition "Rudolf II and Prague" instigated the establishment of the Research Centre for Arts and Culture in the Age of Rudolf II at the Institute of Art History of the Czech Academy of Sciences. To this day the Research Centre provides a platform for connecting many Czech and foreign experts in the cultural history of the 16th and first half of the 17th century. The continuity of our "Ferdinandian" research within the long-term activities of the Centre is proven by the number of publications prepared here: a two-volume monograph created under the guidance of Ivo Purš on the library of Archduke Ferdinand II (2015),[17] and the monograph on the Star Summer Palace written by Ivan P. Muchka, Ivo Purš, Sylva Dobalová and Jaroslava Hausenblasová (English version 2018).[18] Of course, it is therefore perfectly logical that the book which you now hold in your hands was also created at the Research Centre for Arts and Culture in the Age of Rudolf II.

The publication presented here is one of the results of the grant project of the Czech Science Foundation: "Archduke Ferdinand II of Tyrol (1529–1595) and his cultural patronage between Prague and Innsbruck", no. 17-2538S (2017–19). The Institute of Art History of the CAS received this grant, allowing the large group of researchers to collaborate under the guidance of Sylva Dobalová. The core of the team further comprised Jaroslava Hausenblasová and Petr Uličný. Other employees of the Institute of Art History also participated, namely Ivan Muchka, Beket Bukovinská and Ivo Purš. This team was expanded by our young colleague Markéta Ježková and several external specialists (Eliška Fučíková, Blanka Kubíková, Jan Baťa, Annemarie Jordan Gschwend, Stanislav Hrbatý and Marta Vaculínová).

The year 2017 was significant for our research, because it marked the 450th anniversary of Archduke Ferdinand II's effective relocation of his court from Prague to Innsbruck. Veronika Sandbichler, director of Ambras Castle Innsbruck, was the initiator and chief organiser of the exhibition "Ferdinand II. – 450 Jahre Tiroler Landesfürst", which opened first at Ambras in 2017, and then in winter 2017/2018 was also shown in Prague.[19] This exhibition provided the impetus for intensive international collabora-

15 Petr Vorel, Místodržitelský dvůr arciknížete Ferdinanda Habsburského v Praze roku 1551 ve světle účetní dokumentace, *Folia Historica Bohemica* 21 (2006), pp. 7–66.

16 Václav Bůžek, *Ferdinand von Tirol zwischen Prag und Innsbruck. Der Adel aus den böhmischen Ländern auf dem Weg zu den Höfen der ersten Habsburger* (Vienna, Cologne and Weimar, 2009).

17 *Knihovna arcivévody Ferdinanda II. Tyrolského*, 2 vols., ed. by Ivo Purš and Hedvika Kuchařová (Prague, 2015). The book contains more than 100 pages of German summaries and a list of books in Ferdinand II's library, along with their identification in Austrian libraries.

18 Ivan Muchka, Ivo Purš, Sylva Dobalová and Jaroslava Hausenblasová, *The Star: Archduke Ferdinand II of Austria and His Summer Palace in Prague* (Prague 2018) (in Czech, 2014).

19 *Ferdinand II. 450 Jahre Tiroler Landesfürst. Jubiläumsausstellung*, ed. by Sabine Haag and Veronika Sandbichler, exh. cat. (Innsbruck and Vienna, 2017) (also in an English version, which is quoted here

tion culminating in the international conference "Archduke Ferdinand between Prague and Innsbruck" (Prague, 2018), which was financially supported by the above-mentioned grant from the CSF and also aided in terms of both funding and organisation by the National Gallery in Prague.[20] The conference participants enjoyed an unforgettable experience, discussing the exhibits and exchanging their academic knowledge and opinions in a unique setting of Wallenstein Riding Hall.

Foreign scholars were also called upon to contribute to this book. First and foremost, our Austrian colleagues from Ambras in Innsbruck collaborated with us on this project – director Veronika Sandbichler, and the curators of the exhibitions there dedicated to Archduke Ferdinand II, Thomas Kuster and Katharine Seidl. This team, all of whom were of such great assistance during our research, even managed to bring together younger researchers still working on their doctoral dissertations, and here we present the work of two such doctorands, Elisabeth Reitter and Eva Lenhart Putzgruber. This group was finally joined by our long-term co-workers Joseph Patrouch and Václav Bůžek. Without their collaboration, this volume could not have hoped to thoroughly cover all the important aspects, with such a geographically diverse material, or to provide this field of research with so many new findings.

The catalogues produced for the above-mentioned exhibitions could be listed among those publications that provide a certain amount of 'competition' for the present volume. However, the format of an exhibition catalogue limits articles in terms of length and the number of references to the sources and literature, and often provides only very brief catalogue entries. For this reason, we consider the present volume to be both unique and academically valuable. Otherwise, there is one academic monograph in the form of a dissertation by Madelon Simons that deals directly with this topic. Simons, a Dutch scholar, had already cooperated with the Research Centre for Arts and Culture in the Age of Rudolf II during the above-mentioned Rudolfine exhibitions. However, her work, entitled *'Een Theatrum van Representatie?' Aartshertog Ferdinand van Oostenrijk, stadhouder in Praag tussen 1547–1567* (University of Amsterdam, 2009) was exclusively devoted to the Prague residence of Archduke Ferdinand II, and this approach is different to that of our publication.

The present volume could be better categorised alongside studies such as Dagmar Eichberger's *Leben mit Kunst. Wirken durch Kunst. Sammelwesen und Hofkunst*

---

in this volume: *Ferdinand II. 450 Years Sovereign Ruler of Tyrol. Jubilee Exhibition*, ed. by Sabine Haag and Veronika Sandbichler, exh. cat. [Innsbruck 2017]); *Arcivévoda Ferdinand II. Habsburský. Renesanční vladař a mecenáš mezi Prahou a Innsbruckem / Ferdinand II. Erzherzog von Österreich aus dem Hause Habsburg. Renaissance-Herrscher und Mäzen zwischen Prag und Innsbruck*, ed. by Blanka Kubíková, Jaroslava Hausenblasová and Sylva Dobalová (Prague, 2017). The German version of a catalogue from Prague does not have pictures and it is intended as a supplement to the Czech version.

20 Two papers were published as: Michaela Pejčochová, '*Ain Indianisch tuech, darauf Indianische heuser gemalt.* Revisiting the Chinese Paintings in the Kunstkammer of Archduke Ferdinand II at Ambras Castle', *Studia Rudolphina* 19 (2019), pp. 34–49; Frederik Pacala, 'Georgius Handschius and Music: Notes on the Role of Music in the Life of the Humanist Scholar ', *Hudební věda* 2 (2019), pp. 293–317.

*unter Margarete von Österreich, Regentin der Niederlande* (Turnhout, 2002), Robert
J. W. Evans' *Rudolf II and his word: a study in an intellectual history* (London, 1997),
or the work of a group of scholars guided by Friedrich Edelmayer and Alfred Kohler
(eds.), *Kaiser Maximilian II.: Kultur und Politik im 16. Jahrhundert* (Vienna and
Munich, 1992). If we compare research on the Habsburgs with research into the lives
of non-aristocratic patrons and collectors, the concept of our book would for example
correspond to the anthology of articles devoted to the Welser family edited by Mark
Häberlein and Johannes Burkhardt: *Die Welser. Neue Forschungen zur Geschichte und
Kultur des oberdeutsches Handelshauses* (Berlin 2002). Recently a two-volume mono-
graph was published by Dirk Jansen on Jacopo Strada[21]: this work deals with the per-
son and life of the famous antiquarian and architect, who was of course also a contem-
porary of Archduke Ferdinand II (Ferdinand also tried to employ Strada). As in our
publication, Jansen introduces the antiquarian's historical personage and life at the
Habsburg courts in terms of several specialised fields, wherein the main role is played
by Renaissance culture as a whole.

This book aims to present Archduke Ferdinand II in the role of a creator, investor,
and inventor in the context of formative processes within Central European culture,
and this is a role that has not yet been the subject of systematic research. Our research
team faced a series of desiderata from the beginning of their work on this project. One
particular problem was presented by the fragmentary nature of the existing research.
This fragmentation resulted in the first instance from the fact that the necessary sources
are mainly dispersed among the archives in Prague, Vienna and Innsbruck, and are
therefore difficult to access for a unique scholar. Moreover, many of the sources cited
in the earlier literature (for example, those used by Josef Hirn in his monograph or
those published in the form of regesta in the *Jahrbuch der kunsthistorischen Sammlun-
gen des Allerhöchsten Kaiserhauses*), had to be sought again because their signatures
had been changed in the intervening years. Only then could the information in them
be verified, supplemented, and re-interpreted. The second cause of this fragmentary
state of research is simply that Czech and Austrian scholars worked completely sepa-
rately for a long time, until the beginning of the 1990s.

Because of this situation, it has not yet been possible to sufficiently demonstrate
one fact that forms a very important premise for our research. We know that the arch-
duke built up the basis of his later court in Prague, and not only began to accumulate
his emerging collections, but also gathered artists and humanists around himself.
However, when he moved to Innsbruck after 20 years in Prague, he certainly did not
go there alone, forsaking all his former activities and connections. From that point on,
his activities between the seats of Innsbruck and Prague remained tied, not only by his
personal experience, acquired during the first half of his life in Bohemia and later
applied to his duties in Innsbruck, or by the objects that he brought to Tyrol. The two
seats were now also connected by the people of Archduke Ferdinand II's court, and his

---

21  Dirk J. Jansen, *Jacopo Strada and Cultural Patronage at the Imperial Court. The Antique as Inno-
vation*, 2 vols. (Leiden and Boston, 2019).

favoured artists. In Tyrol, he also took advantage of the relationships he had established in Bohemia. His residence in Innsbruck became renowned for its busy social life, and was visited by Bohemian and also foreign aristocrats and diplomats traveling between Central Europe and Italy. Thanks to the dynastic policies of the House of Habsburg, the archduke was also engaged in the networks of political communication that spread throughout Europe at this time, including Portugal and Spain. He managed to utilise these networks to further the interests of the Habsburg dynasty, but also to serve his own needs. The present volume aims to capture and communicate these extremely important relationships.

Our research also aims to contribute to the evaluation of Habsburg rule in the Bohemian lands, which, despite intensive research over the past thirty years, has not yet completely lost its national tint. The role of the first Habsburgs, who ruled on the Bohemian throne in 1526–1619, is of primary concern, as its perception in Czech scholarship is still generally inconsistent. In terms of the Habsburgs' internal policies, Czech historians usually regard all of the ruling house's efforts towards centralisation as detrimental to the unique rights of the Bohemian estates. The connected anti-Reformation measures are likewise seen in a similar light in Czech scholarship. However, in terms of the Habsburg cultural contributions, there is a tendency towards the opposite view. The Habsburg sovereigns of the 16th century are perceived as the main bearers of Renaissance culture into Central Europe. The administrative-political networks they created during the formation of the Danube monarchy were simultaneously socio-cultural networks. Working in a targeted manner from the individual centres of their seats and strengthened by a dynastic sense of family, these rulers managed to fundamentally shape the administrative networks not only in Bohemia, but also between Bohemia and Austria. Their activities in the fields of construction, collection, and patronage were an expression of the dynasty's need for representation. Despite this, it has not been sufficiently proven that these were not merely isolated activities, but rather components in a long-term plan. The research gathered and presented in this volume supports the latter hypothesis.

From the perspective of art history, it is possible to appreciate the increasing number of articles, monographs, and volumes devoted to the dynamics behind the coexistence of Gothic and Renaissance forms in mid-16th century Central Europe, with Bohemia at its 'heart'.[22] Austria was nevertheless a significant component of Central Europe, which consequently increased the significance of alpine Tyrol, an area that today spreads across the territory of both Austria and Italy. From our point of view, the pioneering monograph by Jan Białostocki *The Art of the Renaissance in Eastern Europe: Hungary, Bohemia, Poland* (Ithaca NY, 1976) is flawed in its geographical delimitation: it gives insufficient attention to relations between Prague and the Habsburg territories, which were crucial for Bohemia from the middle of the 16th century on. It is also necessary to add that whereas the art and culture of so-called East Central

---

22    For an overview see chapters about the art of the Early Modern period in: *Art in the Czech Lands 800–2000*, ed. by Taťána Petrasová and Rostislav Švácha (Řevnice and Prague, 2017), pp. 343–441.

Europe has attracted specialised international attention, research on Renaissance art within the territory of modern-day Austria has remained primarily within the scope of local scholarship.[23] The Austrian lands were always mainly considered to be an important transit area, through which Italian artistic, architectural, and artisanal models flowed into the transalpine lands. South Tyrolean Trento was an especially important centre for the development of Italian culture in this region.[24] In terms of the Renaissance within the territory of Bohemia and Austria, broader international attention has only really been paid to certain use of art connected precisely with the Habsburg dynasty and its representation. The publication presented here falls within the same spectrum of academic research, in that it takes courtly art as its subject, but nevertheless includes articles that overlap and examine the lives of court artists, workshop management, competition and collaboration of artists and scholars of different nations.

The period defined in this volume, particularly the years of active engagement of Archduke Ferdinand II, is seen as a particular watershed between the Renaissance and the Baroque within the mosaic of 16th century Central European art history. It is a stage which lacks so-called 'great names' – those artists whose production became a measure of quality and unified the activities of the individual courts and interests of the patrons. This phenomenon, for example, can be observed in a maintenance of the legacy of Albrecht Dürer during the first half of the 16th century. Although many names have been preserved in the sources, we are unable to identify these names with any specific works of art. On the other hand, the authorship of the most important works of art from this period and region is most often unclear. Instead, the period studied here is usually thematised by certain topics and the problematic 'circles' of discussion arising from them. These include the aforementioned phenomenon of court patronage and collecting.[25] Other topics used to raise questions about the shifting dynamics that influenced the arts during this period include: the view of the centre of

23   See e.g. the very few references to Austria in Thomas DaCosta Kaufmann's works, *Court, Cloister & City: The Art and Culture of Central Europe 1450–1800* (Chicago, 1995); research of the GWZO centre in Leipzig is focused on "East Central Europe", and has published numerous books and proceedings more focused on historical research, nevertheless the centre is also planning an encyclopaedic publication *Handbuch zur Geschichte der Kunst in Ostmitteleuropa* (the first and so far only published volume from 2017 is dedicated to Romanesque art).

24   One volume specifically concentrated on the Tyrolian Renaissance is *Kunst in Tirol*, I: *Von der Anfangen bis zum Renaissance*, ed. by Paul Naredi-Rainer and Lukas Madersbacher (Innsbruck, 2007). Extraordinary recent publications devoted to the Austrian Renaissance include: *Geschichte der Bildenden Kunst in Österreich*, III: *Spätmittelalter und Renaissance*, ed. by Arthur Rosenauer (Vienna, 2003), and the projects of the ÖAW on Hofburg under the guidance of Herbert Karner; Austrian and Bohemian researchers were also working together under the ESF programme *Palatium*.

25   Schlosser 1908; Elisabeth Scheicher, The Collection of Archduke Ferdinand II at Ambras: its purpose, composition and evolution, in *Origins of Museum: The cabinet of curiosities in sixteenth- and seventeenth-century Europe*, ed. by O. R. Impey and Arthur MacGregor (Oxford, 1985), pp. 29–38 (with a bibliography); Veronika Sandbichler, '"souil schönen, kostlichen und verwunderlichen zeügs, das ainer vil monat zu schaffen hette, alles recht zu besichtigen vnd zu contemplieren": die Kunst- und Wunderkammer Erzherzog Ferdinands II. auf Schloss Ambras', in *Das Haus Habsburg und die Welt der fürstlichen Kunstkammern in 16. und 17. Jahreshundert*, ed. by Sabine Haag, Franz Kirchweger and Paulus Rainer, Schriften des Kunsthistorischen Museums 15 (Vienna, 2015), pp. 167–193.

culture (Italy) versus the periphery (transalpine lands) as a methodological perspective on the process of the adaptation of the Italian Renaissance; the contrasting of Italian and German art (welsch versus deutsch); the preference for sculpture versus painting; the Reformation and its influence on sacral art; the consequences of the Council of Trent; the growing role of graphic art and book-printing; ephemeral architecture and symbolic communication; the relationship between the court and the urban milieu, and especially that of court artists and the guild organisations. This list is not exhaustive – we could name many other relevant areas,[26] and a comprehensive list of recommended literature could be added to each of the above-mentioned topics. In this volume, we have gathered a wealth of scholarship providing insight into the fascinating process that shaped the educated cultural atmosphere that Archduke Ferdinand II deliberately created: his court was a real phenomenon that touched on all the topics outlined above to a certain degree. Despite that, it is clear that in practice, some areas of the archduke's interest were much more significant than others, and it is precisely these areas that this volume aims to draw greater attention to.

The selection of the themes dealt with in this volume was not primarily influenced by any methodological theory. Nevertheless, the main mode of scholarship can be described as 'comparison', because the articles presented here not only compare Archduke Ferdinand II's activities in two different regions, i.e. in the Bohemian lands and in Tyrol, but also compare the range of his activities during particular, individual periods of his life. This comparison is based, in all cases, on a profound knowledge of the archival sources, both written and material.

Taken as a whole, the volume forms a consistent testimony; the majority of the articles were conceived to provide a holistic view and facilitate the reader's orientation in the broader context of the outlined topics. However, the book also includes several micro-studies or 'case studies' that we considered to be very beneficial. It was not possible to avoid overlapping themes between certain texts, however, where there is overlap, there is also always contrast in terms of perspective on a given issue. Most important to note is that to fully benefit from the volume's holistic approach to the problems outlined earlier in this introduction, the book should be read as a whole.

Recently, there has been a decline in the claim that research in Central European art is only published in Slavic languages.[27] Nonetheless, in the deeply Anglophone milieu of international academic research, not even German can compete as a 'universal' language, and for this reason we have chosen English as the language for this publication.

---

26  E.g. Marina Dmitrieva sees the phenomenon of "the ideal city", artistic patronage (under Ferdinand II of Tyrol), triumphal gates, and sgrafitto as transmittors of the Italian influence; see Marina Dmitrieva, *Italien in Sarmatien: Studien zum Kulturtransfer im östlichen Europa in der Zeit der Renaissance* (Stuttgart, 2008).

27  Larry Silver, 'The State of Research in Nothern European Art of the Renaisance Era', *Art Bulletin* 68:4 (1986), pp. 518–535; Larry Silver, 'Arts and Minds? Scholarship on Early Modern Art History' (Nothern Europe) *Renaisance Quarterly* 59:2 (2006), pp. 351–373; Thomas DaCosta Kaufmann, *Art and Architecture in Central Europe. An Annotaded Bibliography* (Marburg, 2003); Milena Bartlová, 'Renaissance and Reformation in Czech Art History. Issuses of period and Interperatation', *Umění/ Art* 59 (2011), pp. 2–19.

The book features the biography of Archduke Ferdinand II, which was written by Jaroslava Hausenblasová. This piece summarises the important periods of Ferdinand's personal life. These undoubtedly included his youth and common upbringing with his older brother Maximilian, who was destined to inherit their father's throne, and the as-yet unexplained circumstances of his secret wedding in Bohemia to the burgher Philippine Welser, as well as his later dynastic marriage with his own niece, Anna Caterina (Juliana) Gonzaga. It also focuses on his role as the representative of his father Ferdinand I in the Bohemian lands, and finally his activity as the ruler of Tyrol.

The first collection of articles in this volume has been entitled Dynasty, Court, and Court Festivities. This opening chapter deals particularly with questions surrounding the archduke's life in Prague, without ignoring his residence in Tyrol. The crucial theme outlined here is the question of how Archduke Ferdinand II became financially, politically, and culturally independent of his father King Ferdinand I, namely in terms of the process of forming his own court, the creation of his collections, and his practice of organising and financing festivities celebrating the political successes of the Habsburgs. The text by Jaroslava Hausenblasová concerns precisely the question of the formation of the court, which included both the archduke's own smaller personal household, as well as a wider circle of courtiers, intellectuals, artists, and artisans, ensuring the cultural and artistic life of the court. The issue of the status of Archduke Ferdinand II's court artists is very revealing, as the artists resident at the Prague court were, with some exceptions, actually employed by King Ferdinand I, and not by the archduke himself.

In another article, Markéta Ježková presents evidence of two trips to the Netherlands undertaken by the archduke just before his arrival in Prague. Until now, almost nothing was known of these journeys. Ježková therefore broaches the fundamental question of how these visits to the court of the governess in the Spanish Netherlands Mary of Hungary could have influenced the archduke's approach to collecting art and curiosities, and whether it was in fact here that he gained his inspiration for organising celebrations at his own court, many of which he probably helped arrange himself.[28]

If Archduke Ferdinand II received new impulses in the Netherlands for organising celebrations, tournaments, and so on, he also needed a certain basis for organising his own festivities and hunts in the Bohemian lands. However, the Habsburgs were not surrounded by a permanent group of artists and artisans in Prague whose services they could simply use at any time. The archduke therefore had to begin organising everything from scratch. The problems he faced from 1547 on, as he tried to create a crucial collection of arms and armour for his own needs in the entirely new milieu of Prague, is described in the text by Stanislav Hrbatý. This piece answers the long-standing absence of research into the initial formation of the pre-eminent Ambras armoury, in

---

28    Cf. his own theatrical play *Speculum vitae humanae*, published by Jacob Minor (ed.), *Speculum vitae humanae – Ein Drama von Erzherzog Ferdinand von Tirol, 1584. Nebst einer Einleitung in das Drama des 16. Jahrhunderts* (Halle an der Saale, 1889).

Prague.[29] The study by Hrbatý also provides new evidence regarding specifics of the transfer of the collection from Prague to Innsbruck in 1567.

Hunting was an essential part of the archduke's self-presentation, and was also his personal passion. In his text, Václav Bůžek analyses the diaries of Ferdinand II with regard to his hunting practices. However, he also asks to what extent the hunt was a dangerous entertainment and how should we understand the role hunting played in the allegorical and symbolic communication typical in Renaissance society.

Although festivities are counted among the ephemeral arts, in the case of Archduke Ferdinand II's achievements, a great deal of unique visual documentation has been preserved, especially from his time in Tyrol (in Innsbruck, the wedding of the archduke's chamberlain Kolowrat in 1580, and of course his own second wedding to Anna Caterina Gonzaga in 1582).[30] From the period in Prague, records of tournaments for knights and several descriptions of the ceremonial entry of the newly crowned Emperor Ferdinand I into Prague in 1558 have been preserved. Detailed analyses of this theme have already been published, in particular by Veronika Sandbichler.[31] For this reason, festivities are not the subject of a separate, targeted article within this volume, but rather appear throughout all the texts in the first chapter, as well as in some articles included in later chapters. Jan Baťa purposefully devotes himself to the musical component of these festivities, for which only a few records have been preserved. This is in contrast with the scrolls containing detailed costume processions and textual descriptions. For this reason, Baťa attempts to reconstruct the music based on comparison with music known from similar Renaissance ceremonies held at other European courts. The text by Joseph F. Patrouch, which concludes the first section of the volume, could be thematised via his closing motto "No man stood alone in Renaissance Europe". It draws attention to the familial relationships between the Habsburgs and the family's marital policies, with a special focus on the powerful women who played an important role in the life of Archduke Ferdinand II around the key transitory year of 1567.

The second chapter of the volume is devoted to the theme of Architecture. The archduke was an educated dilettante in the art of architecture, and he could therefore theoretically have had a fundamental influence on the shaping of Prague Castle. Moreover, Ferdinand I delegated the main supervision of the castle's construction to him – although the archduke still had to consult with his father on all building issues. The existing research tends to conclude that with a single exception – The Star Summer

---

29   See most recently Thomas Kuster, 'Die Plattnerei in Prag and in Innsbruck zur Zeit Erzherzog Ferdinands II. (1529–1595)', in *Turnier. 1000 Jahre Ritterspiele*, ed. by Stefan Krause and Matthias Pfaffenbichler (Vienna, 2018), pp. 217–221.

30   Elisabeth Scheicher, 'Ein Fest am Hofe Erzherzog Ferdinands II.', *Jahrbuch der Kunsthistorischen Museums in Wien* 77 (1981), pp. 119–154; Veronika Sandbichler, 'Der Hochzeitkodex Erzherzog Ferdinands II.', *Jahrbuch der Kunsthistorischen Museums in Wien* 6/7 (2004/2005), pp. 47–89.

31   *Wir sind Helden. Habsburgische Feste in der Renaissance*, ed. by Wilfried Seipl, exh. cat. (Vienna, 2005); Veronika Sandbichler, 'Er hatte es zum Vergnügen Seiner Majestät veranstaltet': höfische Feste und Turniere Erzherzog Ferdinands II. in Böhmen', *Studia Rudolphina* 9 (2009), pp. 7–21.

Palace – Archduke Ferdinand II did not receive many chances to implement his opinions. The question of whether or not some of the archduke's more 'advanced' ideas were therefore lost is presented by Petr Uličný. These advanced ideas can be observed in the archduke's sense for Italianizing architecture and its decoration, discussed by Uličný against the background of an overview of Prague Castle's development. Uličný's text follows the special contrast that characterised the Habsburg attitude towards construction works: on the one hand, the mid-16th century Habsburgs supported a very pragmatic approach to construction in terms of their own dwellings and offices. However, they also devoted extraordinary attention and financial means to representative summer residences. The author provides an interesting evaluation of Archduke Ferdinand II's contribution to the Royal Summer Palace at Prague Castle.

The complicated situation emerging from the organisation of construction works, and the problematic relations between the Italian and German builders are both examined in another article, which provides a detailed study of the life of a court artist at Prague Castle: in this case the builder, Hans Tirol. Eliška Fučíková has created an exceptionally illustrative depiction of this problematic employee, and the way in which he sought to earn his livelihood.

Ivan Muchka's article discusses the building activities of Archduke Ferdinand II in Tyrol, especially the effort he devoted to rebuilding numerous hunting lodges around Innsbruck. Ferdinand's main seat – the wooden palace "Ruhelust", built next to the Hofburg residence – also comes into question here. Muchka asks what the proper functions of all these buildings were, and proposes answers based on his consultation of the archduke's 1596 estate inventory.

The third collection of articles in the volume is devoted to the fine arts. The initial article by Sylva Dobalová thematises the seeming paradox that painting was not a priority for the Habsburgs during this developmental phase of Central European Renaissance art. Their interest was rather concentrated on the three-dimensional arts and reliefs, which the Habsburg rulers used to decorate their buildings (in Prague the Royal Summer Palace and the Star Summer Palace), as well as on bronze objects: fountains, for example. The monumental project of establishing the memorial of Emperor Maximilian I in Innsbruck fell to his grandson Ferdinand I, but was finally assumed by Archduke Ferdinand II during his rule in Tyrol. In executing this highly demanding project, the archduke demonstrated his good organisational abilities in the face of the complicated coordination of many specialised artists, and the long time-period over which various elements of the work were completed. This essay also demonstrates how drawing as a medium had a special position in the communication between patron and his artists.

In contrast with the preceding article, Blanka Kubíková's text concentrates on portraiture: portraits of living and possibly even deceased ancestors and heroes can certainly be considered the dominant form of painting commissioned by the Habsburgs. During his residence in Prague (but also Innsbruck) Archduke Ferdinand II commissioned many portraits; these comprised both paintings of himself, and cycles depicting important personages and his Habsburg ancestors (in the form of graphic art, paint-

ings, and murals). Kubíková demonstrates how the archduke's plans were shaped within the Bohemian milieu and focuses on how they were subsequently implemented and realised at his Innsbruck residence and at Ambras castle. Elisabeth Reitter's contribution concerning Archduke Ferdinand II's court artists and artisans in Tyrol supplements the texts by Jaroslava Hausenblasová and Eliška Fučíková. Only when he became an independent ruler, no longer financially dependent upon his father, could the archduke employ artists based on his own preferences. Reitter raises many specific questions, for example the archduke's methods for seeking out artists, where these artists came from, and whether trouble-free collaboration between artists of diverse nationalities was truly a reality (as presented by Hirn), or if in fact the Italian artists really received the most prestigious commissions. Reitter's research also demonstrates that many masters did not have any interest in becoming 'court artists', but would rather simply give priority to the archduke whenever he commissioned something from them.

At the court of Archduke Ferdinand II, science and scholarly literature represented an important cultural component, a fact particularly well evidenced by the famous inventory of his library deposited at Ambras. The comprehensive text by Ivo Purš explains the reasons behind Ferdinand's preference as a patron for individual fields, and also maps the activities of the humanists and scientists within his court circle. Several interesting questions arise here: to what degree did these people reflect the archduke's own interests? To what extent were the printed and manuscript texts actually related to his material collections? Finally, did Archduke Ferdinand II also support the spread of the Catholic faith by literary means? The study by Lucie Storchová presents the physician Georg Handsch, one of the most important scholars at the archduke's court, from a completely unconventional point of view. Storchová examines a collection of Handsch's poetry, and looks at the way this occasional poet wrote and disseminated his work in order to expand his group of potential patrons and friends. In a similar way, Marta Vaculínová focuses on "the poetizing physician [Dichterartz]" Laurentius Span, who wanted to attain a permanent position at Archduke Ferdinand II's court. His poem celebrating the Star Summer Palace (*Ferdinandopyrgum*, 1555) was not, however, financially supported by the archduke. Vaculínová clarifies the reasons for this, and discusses the strategies that motivated Span and other humanists to dedicate their manuscripts to the archduke as their ruler. Katharina Seidl presents humanism in a close relation to objects from the *Kunstkammer* that were associated with novelties in the area of botanical discoveries, as well as exotic plants and crops. Archduke Ferdinand II supported the study and furthering of botanical knowledge, especially in connection with medicine and healing, as is demonstrated by his employment of Pietro Andrea Mattioli in Prague, as well as in Innsbruck.

The final chapter of this volume is devoted to Archduke Ferdinand II's *Kunst- und Wunderkammer*, which is generally considered one of the most famous landmarks in the history of Central European culture. Of course, no volume dedicated to issues of collecting art and curiosities can afford to ignore Ferdinand II's collection. Here, Veronika Sandbichler's article summarises the basic facts known about the *Kunst- und*

*Wunderkammer* at Ambras, and highlights the unique aspects which set it apart from the collections held by other European courts. The other texts in this section, all produced by specialists on the subject, build on this initial article. These texts elaborate upon selected questions that have not yet been dealt with in the existing scholarship. Annemarie J. Gschwend utilises recently discovered archival materials to reveal how exotic objects and animals were transferred to the collection from overseas, having been especially sought and acquired for the archduke by the agents Anthonio Meyting and Hans Khevenhüller working in Spain. Eva Lenhart devotes herself to the specific technique used in the production of small glass objects (so-called 'lampworking'), which the archduke successfully imported from Venice to Innsbruck.

After the death of Archduke Ferdinand II in 1595, his property was immediately sealed and placed under guard at the order of his uncle, Emperor Rudolf II. However, the estate inventory (a manuscript deposited in the ÖNB) was created only a year later, and this became the fundamental instrument for all research into the archduke's collections, including for example the library and the armoury, as well as the *Kunstkammer* and art collections. Thomas Kuster analyses the little-known second version of the inventory (in the holdings of the Kunsthistorisches Museum Wien), explaining the circumstances of its creation and summarising the new information that this version of the inventory contains. Kuster's article therefore raises the question that concerns the final contribution to this chapter of the volume: Rudolf II naturally sought to acquire some items from Archduke Ferdinand II's collection for his own holdings, even though he was not the in fact rightful heir. In her contribution, Beket Bukovinská examines selected items from Rudolf's collections, especially the so-called exotica, and basing her investigations on the inventories of the holdings in Innsbruck and Prague reaches some surprising conclusions about their journey through the Habsburg collections.

It is clear from the content outlined above that this volume broaches some general, but also many specific questions. The answers to these questions are summarised in the closing chapter, which concludes with a retrospective overview of Archduke Ferdinand II's life and his activities in the role of patron and collector. The amount of archival material available has provided us with the opportunity to determine his aims quite accurately. Were these aims consistent, and did he manage to achieve them? Did the archduke actively shape his cultural milieu, and apart from creating the collections that made him famous, which other areas of cultural activity did he prefer? Or were his choices opportunistic, based on those possibilities most easily accessible to him? Does this then imply that he may have regarded his artistic achievements outside of the *Kunstkammer* and the armoury as mere 'accessories'? Were his activities 'original', the result of his own personal interest and impetus, or did these activities simply represent the fruit of the famous 'Habsburg upbringing'? Can we really prove that Archduke Ferdinand II began to gather his collections during his residency in Prague as vicegerent? How did his lifestyle in Prague and in Innsbruck differ? Did he manage to harmonise his obligations as a ruler with his known tendency towards a life of pleasures and entertainments? And most particularly, what were the motivations behind his

actions and decisions? In the conclusion, we finally come to the phenomenon of the "second-born son" indicated in the volume's title. It is our belief that Archduke Ferdinand II's position as a second son, and hence second in the line of succession following his father, the King and later Emperor Ferdinand I, and indeed second in line for any of the other European thrones that may have been accessible to him, influenced his representational strategy. The effort to prove himself in competition, especially against his brother Maximilian II, who as the first-born was destined to inherit their father's throne, was a stimulating factor that guided Ferdinand's hand in his selection of architects, artists, and artisans, as well as scientists and humanists, and in his awarding of ambitious commissions. Archduke Ferdinand II's desire to be seen and to legitimise his political aims and dynastic plans gradually gave birth to a number of projects, through which the archduke did indeed acquire fame throughout Europe, even during his own lifetime.

Sylva Dobalová and Jaroslava Hausenblasová

For the editorial help on this book, special thanks go to Markéta Ježková (Bibliography) and Marta Vaculínová. We are also most grateful to Beket Bukovinská, Thomas Kuster, Blanka Kubíková, Ivan Muchka and other colleagues for sharing their expertise on various questions, and to Kunsthistorisches Museum in Vienna for their generosity in composing the pictorial accompaniment of the book. We owe a particular debt of gratitude to Maya Jaeck Woodgate, a conscientious and tireless English language editor, and to all translators of texts collected in this book.

Jaroslava Hausenblasová

# The life of Archduke Ferdinand II: Between ambitions and reality

Having viewed the spectacular and renowned cenotaph of Emperor Maximilian I and climbed up the steps to the *Silberne Kapelle* (Silver Chapel), the visitor to the *Hofkirche* (Court Church) in Innsbruck will almost certainly be captivated by two Renaissance tombstones placed in niches in eastern wall. The first one, which is freely accessible and simply decorated, is that of Philippine Welser (d. 1580), the first wife of Archduke Ferdinand II of Austria. The second one, situated near the altar and separated from public space by a richly decorated grille, is the tombstone of the archduke himself (d.1595). (Fig. 1) Created in the years 1588–1596, this tombstone provides valuable evidence of a well-executed posthumous artistic presentation of the ruler of Tyrol, although its concept and iconography raise a great number of questions.[1] These ques-

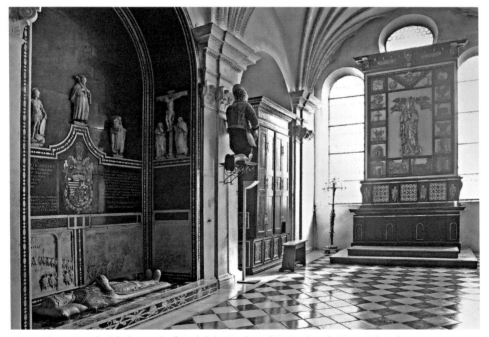

Fig. 1. Silver Chapel with the tomb of Archduke Ferdinand II, Innsbruck, Court Church

1    Erich Egg, *Die Hofkirche in Innsbruck. Das Grabdenkmal Kaiser Maximilians I. und die Silberne Kapelle* (Innsbruck, Vienna and Munich, 1974), pp. 88–94; *Die Kunstdenkmäler der Stadt Innsbruck. Die Hofbauten*, ed. by Johanna Felmayer, Österreichische Kunsttopographie, 47 (Vienna, 1986), pp. 433–437.

tions primarily relate to the four marble reliefs that depict important moments of the archduke's life and accomplishments, clearly intended to guarantee his place in posterity, and in the memory of his successors. The reliefs feature three battlefield scenes: the Battle of Mühlberg (1547), the Battle of Szigeth (1556), and the Battle of Esztergom (1566),[2] as well as another scene in which the archduke assumes rule over the Lands of the Bohemian crown from his father in 1547. It is well known that Alexander Colin, the tombstone's sculptor, factored the wishes of Archduke Ferdinand II into his design; therefore, the reliefs may be regarded as a selection of those deeds that the archduke considered most significant and important in his life. Nevertheless, when studying the archduke's multidimensional life and observing the key moments and influences that affected him, we must begin to consider whether he truly earned his place in European history on the basis of these particular deeds – in other words, we ought to contemplate what it is that we actually appreciate about the personage of Archduke Ferdinand II, his life, and his work.

Archduke Ferdinand II was born in Linz, Upper Austria, on 14 June 1529, a year that indisputably belonged to the most turbulent period of his father Ferdinand I's rule (b.1503, d.1564). The life and fates of Ferdinand I had already proven somewhat volatile and uncertain. As the second-born son of Philip the Fair and Joanna of Castile, Ferdinand I struggled for the greater part of his life to assert his opinions and policies despite the disapproval of his older brother Emperor Charles V. It was not until 1521/22 that agreements concluded by the two siblings paved the way for Ferdinand I to become the ruler of the Austrian lands and acquire further territory under the inheritance from Emperor Maximilian I. Following his marriage to Princess Anna of Bohemia and Hungary in 1521, Ferdinand I managed to establish his own dynasty.[3] (Fig. 2) The Turkish aggression which resulted in the death of Anna's childless brother Louis II, King of Bohemia and Hungary, in the Battle of Mohács in 1526 was paradoxically instrumental in Ferdinand I's succession to the two thrones.[4] However, in

---

2    The site of the battle remains unclear; it could have been Székesfehérvár.

3    For the childhood and youth of Ferdinand I, and his role in the dynastic plans of his grandfathers, Ferdinand of Aragon and Emperor Maximilian I, see Hermann Wiesflecker, *Kaiser Maximilian I. Das Reich, Österreich und Europa an der Wende zur Neuzeit*, 4 (Vienna and Munich, 1981), pp. 181–204; 218–220; Alphons Lhotsky, *Das Zeitalter des Hauses Österreich. Die ersten Jahre der Regierung Ferdinands I. in Österreich (1520–1527)* (Vienna, 1971); Alfred Kohler, *Ferdinand I. Fürst, König und Kaiser* (Munich, 2003), pp. 35–59.

4    Although the Bohemian estates did not recognise the hereditary claims of Princess Anna, and Ferdinand I had to stand for the election, he won and was crowned as the King of Bohemia at Prague Castle on 24 February 1527 – see Oskar Gluth, 'Die Wahl Ferdinands I. zum König von Böhmen 1526', *Mittheilungen des Vereines für die Geschichte der Deutschen in Böhmen* 15 (1876–1877), pp. 198–302; Jaroslav Pánek, 'Königswahl oder Königsaufnahme? Thronwechsel im Königreich Böhmen an der Schwelle zur Neuzeit', in *Der frühmoderne Staat in Ostzentraleuropa*, 2, ed. by Wolfgang E. J. Weber, Documenta Augustana 3 (Augsburg, 2000), pp. 37–52. His accession to the Hungarian throne was more complicated. Part of the Hungarian estates elected John Zápolya, who was also supported by the Turkish sultan, as the king in November (10 to 11 of November) 1526, while the second part elected Ferdinand I on 16 December. However, the Ferdinand I and Queen Anna had to wait for the coronation until November next year (3 November 1527 in Székesfehérvár) because of the war – Kohler 2003, pp. 165–172; Thomas Winkelbauer, *Österreichische Geschichte*

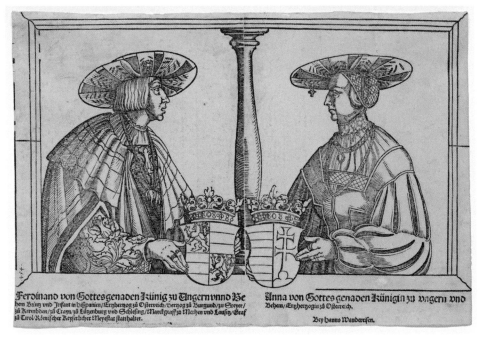

Fig. 2. Unknown engraver after Erhard Schön, King Ferdinand I. and Queen Anna of Bohemia and Hungary, around 1528 (Universität Erlangen-Nürnberg, Graphic Collection, no. AH 512)

the same year Ferdinand I, as the sovereign of the emerging Central European monarchy, also became a target for the Turkish army led by Sultan Suleiman the Magnificent. This brief sketch shows how Archduke Ferdinand II's father had already had to deal with his own fate as a second-born son and find his place in the European power arena.

On the 10th of April 1529, the Ottoman army led by the sultan set out from Constantinople to support John Zápolya, the Hungarian counter-candidate to Ferdinand I for the Hungarian throne. Suleiman conquered Buda, and arrived in front of the gates of Vienna on the 27th of September 1529. Ferdinand I did not participate in the defence of his Austrian residence. Relying on his commanders, he directed the defence of Vienna from nearby Linz and later from Prague, the capital of the Kingdom of Bohemia; he left Linz for Prague on the 30th of September.[5] Furthermore, he ordered that his family – his wife Anna, their three older children Elisabeth, Maximilian, and Anna, and the three-month-old Ferdinand – be relocated to safety in Passau along with his

1522–1699. Ständefreiheit und Fürstenmacht. Länder und Untertanen des Hauses Habsburg im konfessionellen Zeitalter, I (Vienna, 2003), pp. 123–134; Géza Pálffy, The Kingdom of Hungary and the Habsburg Monarchy in the Sixteenth Century (Boulder and Wayne, 2009), pp. 23–33.

5    On the siege of Vienna 1529 see: Leopold Kupelwieser, Die Kämpfe Österreichs mit den Osmanen 1526 bis 1537 (Vienna, 1898), esp. pp. 23–60; Wien 1529. Die ersten Türkenbelagerung. Textband 62. Sonderaustellung des Historischen Museums der Stadt Wien (Vienna 1979).

sister Mary of Hungary, the widow of King Louis II.[6] Although Vienna remained unconquered, and the Turks withdrew as early as the 14th of October, the Queen Anna and the children did not return to the Austrian lands until the end of the year. Only three years later the Turks attacked the Austrian lands again, and the queen was once again sent to Passau. On this occasion, King Ferdinand I decided to face the Turks in person, and awaited their army along with his brother Emperor Charles V near Vienna. The large joint Habsburg army was, among other things, one reason for the Ottomans' decision to abandon their campaign to conquer Vienna and withdraw. Most likely it was the emperor who decided not to take advantage of this situation and disperse the smaller Turkish army during their retreat. Military historians have been puzzled by this decision ever since, as it may have represented a missed opportunity to permanently eliminate the Turkish threat.[7]

In 1532, immediately before the imminent military clash, King Ferdinand I formalised his will and testament in Linz.[8] It was the first legally binding statement of the hereditary rights of his two eldest sons, Archduke Maximilian (later Emperor Maximilian II) and Archduke Ferdinand II, and their possible assumption of their father's rule in the case of his death. (Fig. 3) At that time, when the king had only two sons who were still underage, and when his lands faced constant threats, it seemed advantageous to divide the lands between the two heirs and make Charles V their guardian in case of his death. The king constituted an interim government comprising a board of officials whose task would be to administer his lands until his sons reached majority. While the young Archduke Maximilian II was to rule over the two kingdoms of Bohemia and Hungary, including the relevant neighbouring countries and the Duchy of Württemberg, Archduke Ferdinand II was assigned to rule over his father's lands in Upper and Lower Austria, along with Styria, Carinthia, Carniola, and Tyrol.[9] Ferdinand I's testament remembered his daughters as well; there were five of them[10] at that point, and they would become the heiresses of all the domains in the case of the death of the two sons and Queen Anna.[11] Over time, King Ferdinand I modified his will in response to the changing political and family situation. In 1543, three years after Queen Anna gave birth to another son, Karl (b.1540, d.1590), he published a new will[12] that still gave his eldest son Maximilian to rule over the two kingdoms of Bohemia and Hungary. However, unlike the 1532 testament, the Austrian lands were not assigned to Archduke

---

6    On the stay of the family in Passau and the perception of the Turkish threat by the Habsburg family see Jaroslava Hausenblasová, 'Reflexe událostí První rakousko-turecké války v soukromé korespondenci Ferdinanda I., Anny Jagellonské a Marie Habsburské', *Historie – Otázky – Problémy* 6:2 (2014), pp. 125–137.

7    Josef Janáček, *České dějiny. Doba předbělohorská 1526–1547*, I/2 (Prague, 1984), pp. 103–107; Kohler 2003, p. 217.

8    Haus-, Hof- und Staatsarchiv, Vienna (hereafter HHStA), Familienurkunden, inv. no. 1213/1,2: 1532, 17 September, Linz, original, parchment, fol. 1–12v.

9    HHStA, Familienkunden, inv. no. 1213/1,2, fol. 5r.

10   In 1531, their daughter Maria was born in Prague.

11   The testament did not specify the hereditary rights for daughters.

12   HHStA, Familienurkunden, inv. no. 1255/1.

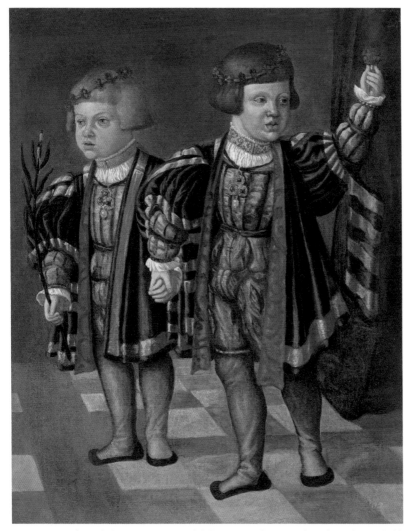

Fig. 3. Copy after Jakob Seisenegger, Archdukes Maximilian II and Ferdinand II as children, after 1534 (Vienna, Kunsthistorisches Museum, Picture Gallery, inv. no. GG 3492)

Ferdinand II as the second son. Instead, he was to rule over them in partnership with his elder brother. The administration was based on governors' offices, referred to as 'regiments'. It is possible that the negotiations of Ferdinand I and Emperor Charles V about the matrimonial connection of the two families, which culminated in an agreement at the Diet of Worms in 1545 (further discussed below), instigated these changes. Ferdinand I's eldest and second sons were regarded as heads of the family who were responsible for their younger siblings. Upon reaching the age of majority, Karl was also to be invited to rule in the Austrian Lands. The archdukes Maximilian and Ferdinand II were obliged to ensure dowries for their sisters, who were now nine in total. An amendment to the testament dated 1547 modified the hereditary claims on account

of Queen Anna's death on the 27th of January 1547.[13] Nevertheless, the conclusive statement of succession in Ferdinand I's domains appeared in the last will and testament of the king, dated 1554 (discussed further below).

Although Ferdinand I's testaments clearly stipulated his sons' hereditary hierarchy, the king and the queen treated them all equally in terms upbringing and education. This egalitarian attitude may have been further influenced by the frail health of Archduke Maximilian, who had been frequently ill since childhood and was therefore less certain to reach adulthood. However, it is certain that the royal couple planned a monarchical career for their second-born son as well as their first-born son, and he had to be well-prepared. The court where the children stayed together was situated in Innsbruck, a rather distant city that provided safety from the Turkish threat but nonetheless welcomed eminent representatives of the cultural world to provide the children with the fundamentals of education, and later to introduce them to the desired knowledge base for a future monarch (see my article 'The Court of Archduke Ferdinand II' in this volume). The educational principles employed in the children's upbringing were not only evident in the instructions for their tutors and teachers, but also in the further regulations supervised by their parents. From today's perspective, the Central European Habsburg court appears to have exercised very modern opinions and practices that prioritised a healthy lifestyle: this was probably influenced by the new renaissance schools of thought. One of the principles highlighted was that the children should spend sufficient time outdoors, which the large Innsbruck court garden could provide.[14] Great attention was further paid to alimentation – the parents preferred a moderate diet and strictly observed the practice of fasting.[15] Beginning in 1538, the archdukes Maximilian and Ferdinand were brought up apart from the growing number of other children. The instructions issued by the king in 1538 reveals his effort to bring up the future monarchs in compliance with humanistic principles, influenced by historical-theoretical treatises,[16] and including discipline and emphasis on the fulfilment of assigned tasks. Strict planning and regularity characterised the daily routine of the young archdukes. The system of control and possible punishments stipulated by

---

13   HHStA, Familienurkunden, inv. no. 1284.

14   This becomes apparent from Veit of Thurn's letter to King Ferdinand I from the 4th of May 1546 – see HHStA, Familienakten, sign. 53/3, fol. 8–9.

15   These principles are found not only in the 1538 instructions of King Ferdinand I (see article on The Court of Archduke Ferdinand II by the author in this volume), but also later in the instructions dealing with the operation at the Innsbruck court and the unmarried daughters of Ferdinand I issued by the king in 1561 – Tiroler Landesarchiv, Innsbruck (hereafter TLA), Ferdinandea, sign. Pos. 54, cart. 49, see further Victor Bibl, *Maximilian II. Der rätselhafte Kaiser. Ein Zeitbild* (Hellerau bei Dresden, 1929), p. 29; Jaroslava Hausenblasová, 'Dvůr habsburských arcivévodkyň a jeho reforma v roce 1563', *Paginae Historiae* 27:1 (2019), pp. 91–103.

16   Mainly the treatise of Erasmus von Rotterdam, *Institutio principis Christiani*, ed. and transl. by Gertraud Christian, Erasmus von Rotterdam Ausgewählte Schriften, 5 (Darmstadt, 1995) or the book of Juan Luis Vives, *Introductio ad veram sapientiam* (1524) – see Dietrich Briesemaister, 'Vives in deutschen Übersetzungen (16.–18. Jahrhundert)', in *Juan Luis Vives. Sein Werk und seine Bedeutung für Spanien und Deutschland*, ed. by Christoph Strosetzki (Frankfurt am Main 1995), pp. 231–246 (235).

Ferdinand I's instructions leads the contemporary observer to consider what the consequences of such an upbringing might have been. The question arises of whether the resistance towards their father, which was differently yet clearly expressed by both of the archdukes, was caused by Ferdinand I's excessive disciplinary requirements for his sons at a young age. Here we might recall the future Emperor Maximilian II's openly expressed fondness towards the teaching of Martin Luther[17] and Archduke Ferdinand II's secret morganatic marriage with the *Bürgerin* (female burgher) Philippine Welser (this is further discussed below).

The two archdukes stayed in Innsbruck intermittently until 1543, when they began to learn about politics and diplomacy. Ferdinand I took his sons on several journeys during which they could see the important cities of the empire and participate in the Imperial Diets. He did so during the period when the armed conflict over Milan and the Kingdom of Naples between Emperor Charles V and King Francis I of France was re-escalating, and the religious conflict in the empire between the Catholic emperor and the military alliance of Protestant princes called the Schmalkaldic League had intensified. The two archdukes could observe the political situation at the Imperial Diet in Speyer (1544)[18] and Worms (1545).[19] Although the young archdukes only played passive roles and were always part of their father or uncle Charles V's entourages, their presence was still important in that it declared the actual and future power of the Catholic House of Habsburg, and their resolve to struggle for its interests. Moreover, the alliance between the Spanish and Austrian lineages of the Habsburgs was established during the Imperial Diet in Worms. Archduke Maximilian II, the future heir of the Central European domain, was appointed to marry his cousin, the emperor's daughter Maria.[20] From that time, visiting foreign countries would become the lifelong destiny of the two brothers, although their paths separated in 1544 based on Ferdinand I and Charles V's plans and agreements. While Archduke Ferdinand II accompanied his aunt Mary of Hungary, governess of the Netherlands, from Speyer to her residence in Brussels,[21] Archduke Maximilian II joined Emperor Charles V in the successful military campaign against France. The brothers met again in Cambrai in September 1544 to

---

17  In particular adhering to Confesio Augustana – Theodor Josef Scherg, *Ueber die Religiöse Entwicklung Kaiser Maximilians II. bis zu seiner Wahl zum römischen Könige (1527–1562)* (Würzburg, 1903); Victor Bibl, *Zur Frage der religiösen Haltung Kaiser Maximilians II.* (Vienna, 1917); Paula Sutter-Fichtner, *Emperor Maximilian II* (New Haven and London, 2001), pp. 32–49.

18  *Deutsche Reichstagsakten. Jüngere Reihe. Deutsche Reichstagsakten unter Kaiser Karl V.*, XV: *Der Speyrer Reichstag von 1544*, 4 vols., ed. by Erwein Eltz (Göttingen, 2001), esp. pp. 773–776, 781, 1780–1782.

19  *Deutsche Reichstagsakten. Jüngere Reihe. Deutsche Reichstagsakten unter Kaiser Karl V.*, XVI: *Der Reichstag zu Worms 1545*, 2 vols., ed. by Rosemarie Aulinger (Munich, 2003), pp. 574, 704, 731, 1462–1464, 1468, 1470, 1517; see also Robert Holtzmann, *Kaiser Maximilian II. bis zu seiner Thronsteigung (1527–1564). Ein Beitrag zur Geschichte des Überganges von den Reformation zur Gegenreformation* (Berlin, 1903), p. 42.

20  Holtzmann 1903, p. 45.

21  Holtzmann 1903, p. 37; Josef Hirn, *Erzherzog Ferdinand II. von Tirol. Geschichte seiner Regierung und seiner Länder*, 2 vols. (Innsbruck, 1885–1888), I, p. 11, states erroneously that Archduke Ferdinand II also participated in the military campaign against the French king.

celebrate the ceasefire and the peace agreement at Crépy-en-Laonnois.[22] The archdukes spent the winter ceasefire together. At the court of Mary of Hungary they not only attended crucial diplomatic negotiations but also experienced the rich and well-known local cultural and social life, and this undoubtedly affected both of them. Visiting Brussels, Ghent, and Mechelen, the archdukes spent seven months in the Netherlands, from the 1st of October 1544 until the 29th of April 1545. The Imperial Diet in Regensburg in 1546, where the weddings of Ferdinand I's two daughters took place, was a majestic political and social event attended by the entire Habsburg family. Archduchess Anna married Albrecht V, Duke of Bavaria of the Wittelsbach family, and Archduchess Maria married Duke Wilhelm of Cleves. The two marriages ensured alliances with other significant families in Europe.[23] That year, the disputes between the Schmalkaldic League of Protestant princes and the emperor escalated into an armed conflict in which the League was defeated at the Battle of Mühlberg on 24 April 1547.[24] It was probably the first battle attended by Archduke Ferdinand II. Even there the two archdukes were passive onlookers: their active participation in the battle has not been recorded. Nonetheless, the impressions from the battle, in which Johann Friedrich I, Elector of Saxony, was defeated and taken captive, were so intense, and its importance for European political history so decisive that it is hardly surprising that Archduke Ferdinand II had the battle immortalised on his tombstone. After all, the archduke was also present at the negotiations to resolve the religious dispute at Augsburg in 1555.[25]

The Kingdom of Bohemia was most affected by the defeat of the Protestant elector at the Battle of Mühlberg; the Bohemian estates had taken advantage of Ferdinand I's perceived weakness and revolted against him as allies of Johann Friedrich I of Saxony. This revolt began with the refusal to send military assistance to King Ferdinand I when he set out to support his brother Emperor Charles V in the war for Saxony. However, it soon escalated into an ultimatum demanding various changes to the conditions of Ferdinand I's rule. The estates were dissatisfied with the suppression of their rights and privileges and in this way their passive resistance soon developed into a military conflict. After the Battle of Mühlberg, the king returned to Bohemia with Archduke Ferdinand II, successfully besieged Prague, and punished the rebels with imprisonment, torture, executions, and confiscations of property. (Fig. 4)

Since the king had to physically leave the Bohemian lands in the autumn of 1547, he left his son Archduke Ferdinand II there to play the roles of both governor and informer. Although literary and scholarly sources often state that the king appointed

---

22  In the Treaty of Crépy (1544), King Francis renounced his claim to the Kingdom of Naples and the fief claim to Flanders and Artois, and made an oral pledge to help against the Protestants.

23  *Deutsche Reichstagsakten. Jüngere Reihe. Deutsche Reichstagsakten unter Kaiser Karl V.*, XVII: *Der Reichstag zu Regensburg 1546*, ed. by Rosemarie Aulinger (Munich, 2005), pp. 53–54, 387; Holtzmann 1903, pp. 45–48.

24  Holtzmann 1903, pp. 47–48, 55.

25  *Deutsche Reichstagsakten. Jüngere Reihe. Deutsche Reichstagsakten unter Kaiser Karl V.*, XX: *Der Reichstag zu Augsburg 1555*, 4 vols., ed. by Rosemarie Aulinger, Erwein H. Eltz and Ursula Machoczek (Munich, 2009), p. 386.

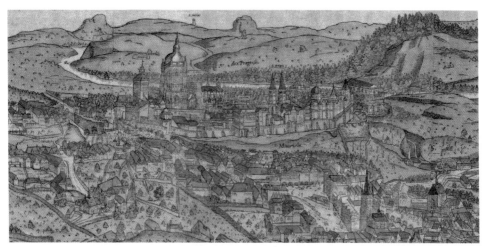

Fig. 4. Jan Kozel and Michael Peterle, Prospect of Prague, detail with Prague Castle, 1562, photolithographic reproduction from 1904 (The City of Prague Museum, inv. no. HP 2003_0042)

the archduke governor of the Bohemian Lands the same year, this is inaccurate. There is no extant evidence to confirm this appointment. The formal investiture of Archduke Ferdinand II was only carried out after Ferdinand I's death, when Maximilian II assumed rule as Holy Roman Emperor. In 1564, Maximilian II officially authorised his younger brother to perform the function of governor in Bohemia. The relief above Archduke Ferdinand II's tombstone in Innsbruck that depicts the handover of a sceptre as the symbol of reign over the Bohemian lands therefore does not correspond strictly to reality and rather appears to be a symbolic depiction of the undeniable fact that the archduke served as the de facto administrator and governor from 1547 on, and that he highly appreciated this important political and social function.[26]

The archduke became accustomed to his new role very quickly. His careful education and the theoretical fundamentals he had acquired during his travels around Europe, together with his innate intelligence and organisational skills, made him an excellent candidate capable of fulfilling the new task assigned to him. In the beginning, his powers were rather limited and he consulted his father about every the issue and possible solution. Over time he gained the necessary overview concerning the situation in the Lands of the Bohemian Crown and the king gave him more leeway in making decisions which affected nearly all areas of the region's administration. Yet the

---

26　To learn more about the beginnings of Archduke Ferdinand II in the role of governor see Ivan Prokop Muchka, Ivo Purš, Sylva Dobalová and Jaroslava Hausenblasová, *The Star. Archduke Ferdinand II of Austria and His Summer Palace in Prague* (Prague, 2017), p. 24; Jaroslava Hausenblasová, 'Erzherzog Ferdinand II. – Verweser und Statthalter der Länder der böhmischen Krone', in *Arcivévoda Ferdinand II. Habsburský. Renesanční vladař a mecenáš mezi Prahou a Innsbruckem / Ferdinand II. Erzherzog von Österreich aus dem Hause Habsburg. Renaissance-Herrscher und Mäzen zwischen Prag und Innsbruck*, ed. by Blanka Kubíková, Jaroslava Hausenblasová and Sylva Dobalová, exh. cat. (Prague, 2017), pp. 13–16 (13–14).

sovereign always had the final say. The archduke was mostly in charge of economic issues such as the supervision of tax collection, mining of precious metals, quality of coin mintage and the minting reform, customs duties, import of salt, and other tasks that – as quickly became evident – were very close to his heart.

Archduke Ferdinand II further deputised for his father in the judiciary, especially arbitrating mutual disputes between nobles or the Bohemian estates, and in complex constitutional issues such as border disputes affecting the Lands of the Bohemian Crown. Moreover, he supervised the publication of the renewed *Landesordnung* (Land Ordinance) of the Kingdom of Bohemia. He soon understood the complexity of domestic policy not only in the Kingdom of Bohemia but also in the neighbouring countries and strictly observed his father's ruling strategy. This became most evident at *Landtagen* (State Diets), the summoning and organisation of which fell within the scope of the archduke's authority from the 1550s on, and which he sometimes even chaired on behalf of his father.[27] Nevertheless, the archduke was rather unsuccessful in convincing the estates to permit higher taxes, mainly collected for the wars against the Turks but also for the repairs of Prague Castle and other necessary expenses.[28] He further observed his father's instructions during the negotiations with royal and land officials, from whom both father and son required absolute obedience and loyalty.

In terms of religious politics, the archduke acted as the sovereign's representative, functioning as the absent king's 'right hand' in the Bohemian Lands as they endeavoured to hinder the spreading reformation in the region and to strengthen the Catholic Church, which had been weak in the area since the Hussite era. Not only did the archduke inform the king about the religious situation in the country in detail, but also often outstripped Ferdinand I in the fervour of his persecution of religious dissenters. Archduke Ferdinand II was mainly concerned with the Unity of the Brethren, whose activity was banned by the 1547 royal mandate on account of their participation in the uprising.[29] In the spring of 1548 the archduke was instrumental in the arrest of the Brethren's bishop Jan Augusta, who was imprisoned until 1564.[30] In compliance with the re-Catholisation ideas of his father, the archduke supported the newly-emerging Society of Jesus (1558); Ferdinand I had given the Jesuits the former Dominican Monastery of Saint Clement in the Old Town of Prague to use as their base. Moreover, both the archduke and his father promoted Catholic noblemen to influential positions within the administrative offices of the Kingdom of Bohemia. They achieved a supreme

---

27    In 1553 he directed the Bohemian Diet in Prague and in 1554 presided over the Diet in Wrocław.

28    The negotiations of the Bohemian Diet during the governance of Archduke Ferdinand are documented in the edition *Die böhmischen Landtagsverhandlungen und Landtagsbeschlüsse vom Jahre 1526 an bis auf die Neuzeit, herausgegeben vom königlich böhmischen Landesarchive*, II, 1546–1557 (Prague, 1880), III, 1558–1573 (Prague, 1884).

29    Janáček 1984, pp. 328–332.

30    Archduke's contribution to the persecution of the Unity of Brethren and the arrest of John Augusta is described by *Die Gefangenschaft des Johann Augusta, Bischofs der böhmischen Brüder 1548 bis 1564 und seines Diakonen Jakob Bilek von Bilek selbst beschrieben*, ed. by Joseph Theodor Müller (Leipzig, 1895) and *Historie pravdivá Jana Augusty a Jakuba Bílka*, ed. by Mirek Čejka (Středokluky, 2018), esp. pp. 29–30, 53–56.

victory as early as 1554 when three members of prominent Catholic families, Jan Popel the Younger of Lobkowicz, Jan Popel the Elder of Lobkowicz, and Jáchym of Hradec, became the members of the royal council and added their support to the sovereign's Counter-Reformation policies.[31]

The reliability and willingness to fulfil his father's wishes also facilitated Archduke Ferdinand II's role as a diplomat and politician. The king and from 1558 Holy Roman Emperor Ferdinand I authorised his son to undertake important foreign missions which often necessitated Archduke Ferdinand's II absence from the Bohemian lands. Similar to his experiences during the 1540s, he was once more called to participate in the Imperial Diets, namely in Augsburg in 1550–1551 and in 1555, although always in his father's company. In 1549, he was assigned a significant individual task: he accompanied his sister Catherine to join her bridegroom Francesco III Gonzaga in Mantua.[32] In 1561, Ferdinand returned to Mantua, this time leading the entourage of Archduchess Eleanor to her wedding with Guglielmo, the Duke of Mantua.[33] The richness and cultural diversity of the court in Mantua undoubtedly affected Archduke Ferdinand II's personal tastes and avocations, as had his previous sojourn at the Flemish court of Mary of Hungary.

In 1556, an opportunity opened for the then nearly thirty-year-old archduke to win recognition as a warrior, when he led an army carrying supplies to the defenders of Szigetvár Fortress in Hungary. Even though he most likely did not actively participate in the battle against the Turks near the fortress, his merits were nonetheless appreciated. Emperor Charles V awarded him the Order of the Golden Fleece for bravery. It appears that the awarding of this highly regarded Habsburg decoration (rather than military heroism) lie behind the depiction of this part of the archduke's history on the marble relief over his tombstone in the court church at Innsbruck. The archduke also valued his own personal participation in his second and last military campaign in Hungary in 1566, although historical records show that it was in reality a fiasco. Emperor Maximilian II led the campaign this time; however, the brothers strongly disagreed about battle strategy. In October the same year, Archduke Ferdinand II actually left the battlefield regardless of his elder brother's appeal to his honour. As it turns out, the archduke did not earn a reputation as a valiant military commander in the eyes of his contemporaries, but this meant there was even more reason to find a more favourable interpretation with which to immortalise these events for future generations.[34]

---

31  *Jednání a dopisy konsistoře katolické i utrakvistické*, ed. by Klement Borový, I (Prague, 1868), pp. 332–336; Ferdinand Hrejsa, *Česká konfese, její vznik, podstata a dějiny* (Prague, 1912), pp. 7–8; Jaroslav Pánek, *Stavovská opozice a její zápas s Habsburky 1547–1577. K politické krizi feudální třídy v předbělohorském českém státě* (Prague, 1982), pp. 61–62, 84.

32  Hirn 1888, p. 20; Václav Bůžek, *Ferdinand von Tirol zwischen Prag und Innsbruck. Der Adel aus den böhmischen Ländern auf dem Weg zu den Höfen der ersten Habsburger* (Vienna, Cologne and Weimar, 2009), pp. 84–85.

33  Bůžek 2009, pp. 258–259.

34  Sutter-Fichtner 2001, pp. 130–131. Emperor Maximilian II interpreted the disinclination of his brother to fight in Hungary and return to Bohemia under the false pretext of illness as a consequence of rumours about the infidelity of Archduke Ferdinand II's wife Philippine Welser during his absence.

The period of the archduke's sojourn in the Bohemian lands also produced quite a few disappointments that affected his future as a statesman. As a second-born son, he was not guaranteed a ruling position; therefore, he had to depend upon the political and diplomatic skilfulness of his father in seeking to marry his second son to one of the available heiresses to a European throne. Ferdinand I had to compete with his brother Emperor Charles V in this matter, since both brothers shared similar ambitions. In keeping with his universalistic aim to take control over Europe and other territories, Emperor Charles V pushed forward his son Philip II. The family's varied interests clashed during the negotiations over the hand of Mary Tudor, Queen of England, and in this case the imperial side eventually won: in 1554 Philip II married Mary and became the King of England. After Mary's death in 1558, history repeated itself and the cousins Philip II (now King of Spain) and Archduke Ferdinand II competed to marry the newly crowned Elizabeth I (b.1533, d.1603), the daughter of King Henry VIII of England and his second wife Anne Boleyn. The negotiations took place in Brussels, where the archduke travelled in 1555, but in this case not only the archduke, but also the emperor and Philip II, who also attended, were unsuccessful. Speculations have also appeared that suggest the archduke applied to the emperor for the position of imperial vicar in Italy.[35]

The period during which the archduke served as governor of the Lands of the Bohemian Crown and during which his personal life became independent of his father's control was not only crucial in the formation of his political opinions: it also attests to the clearly defined Catholic beliefs he had held from childhood on, and formed the priorities he set in his personal life. Archduke Ferdinand II dedicated his free time to his avocations, which included hunting, tournaments, banquets, and other social events in the company of his courtiers as well as Bohemian nobles. It is clear that due to his extensive early education, he had little difficulty communicating in Czech with the latter group.

Having been inspired by his father, other members of the House of Habsburg, and his brothers-in-law, Archduke Ferdinand II began to compile his first art collections at his Prague residence. His art patronage, as well as his commissions to builders, artists, scientists, and artisans, further reveal a motivation that might be credited to his rivalry with his older brother Maximilian II, who returned from Spain to Vienna in 1551 to implement his own extensive architectural and artistic projects.[36] As evidenced by historical sources, the archduke tried to imitate and later even outstrip his brother's activities. This partially concerned Archduke Ferdinand II's largest project in Bohemia, the Hvězda or Star Summer Palace, built in 1555 near the royal residence in Prague. (Fig. 5) Through this structure the archduke endeavoured to manifest his high position as governor of the Lands of the Bohemian Crown – unlike his older brother who was 'just' an

35    Heinrich Lutz, *Christianitas afflicta. Europa, das Reich und die päpstliche Politik im Niedergang der Hegemonie Kaiser Karls V. (1522–1556)* (Göttingen, 1964), pp. 204–208.

36    Sutter-Fichtner 2001, pp. 92–104; *Die Wiener Hofburg 1521–1705. Baugeschichte, Funktion und Etablierung als Kaiserresidenz*, ed. by Herbert Karner (Vienna, 2014), pp. 294–305.

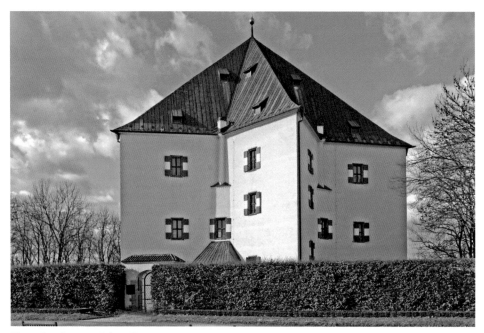

Fig. 5. Star Summer Palace, Prague

uncrowned pretender to both thrones in the 1550s – and gain the necessary background for his fulfilling his avocations.[37] The Star Summer Palace is also unique in that almost no other European ruler could boast an architectural structure built after his own design.

Archduke Ferdinand II also used his organisational skills, education, and creativity to organise grandiose events representing the House of Habsburg on his father's orders, primarily the triumphal entry of Ferdinand I into Prague on the 8th of November 1558, shortly after his imperial coronation in Frankfurt,[38] and the welcoming ceremony for Maximilian II who arrived in Prague for his coronation as King of Bohemia on the 7th of September 1562.[39]

---

37  The project of the Royal Summer Palace constructed at Prague Castle at the command of Ferdinand I undoubtedly motivated this structure. Nevertheless, Archduke Ferdinand II sought inspiration for many details from his father, as was the case of the planned fountain from the studio of the Nuremberg goldsmith Wenzel Jamnitzer in collaboration with Jacopo Strada – see Jaroslava Hausenblasová, 'Building development of Hvězda – written sources and their interpretation', in Muchka / Purš / Dobalová / Hausenblasová 2017, pp. 49–64 (56–58).

38  Jan Bažant, 'Pompa in honorem Ferdinandi 1558', in *Druhý život antického mýtu*, ed. by Jana Nechutová (Brno, 2004), pp. 195–205; Václav Bůžek, 'Symboly rituálu. Slavnostní vjezd Ferdinanda I. do Prahy 8. listopadu 1558', in *Ve znamení zemí Koruny české. Sborník k šedesátým narozeninám prof. PhDr. Lenky Bobkové*, ed. by Luděk Březina, Jana Konvičná and Jan Zdichynec (Prague, 2006), pp. 112–128.

39  Jaroslava Hausenblasová, 'Die Krönung Maximilians II. zum böhmischen König 1562 in Prag und ihre langjährigen Vorbereitungen', in *Festvorbereitung. Die Planung höfischer Feste in Mitteleuropa 1500–1900,* ed. by Gerhard Ammerer, Ingonda Hannesschläger, Milan Hlavačka and Martin Holý, forthcoming.

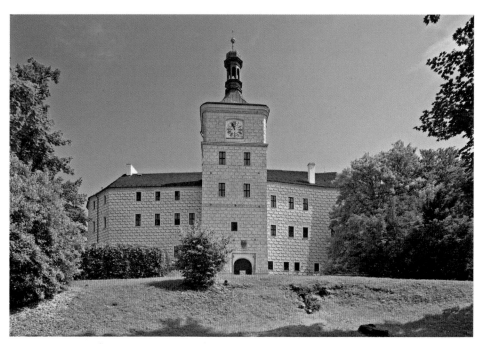

Fig. 6. Březnice Castle

Despite his privileges and responsibilities, the persisting uncertainty concerning Archduke Ferdinand II's immediate future (he did not know how long he would stay in the Bohemian lands), insufficient funds, and the ongoing failure of marital plans were the most likely causes for his feelings of frustration and the endeavour to find satisfaction in an alternative marital solution. In the early 1550s, the archduke met the charming and educated Philippine Welser, from the Welser burgher family, during one of his frequent visits to Březnice Castle south of Prague. (Fig. 6) The Březnice domain was owned by Kateřina of Lokšany, the widow of the royal official Jiří of Lokšany, who was Philippine's aunt and often invited her to stay. The archduke married Philippine Welser secretly there in 1557. (Figs. 7, 8) The marriage produced several children, and two sons survived into adulthood: Andreas (b.1558, d.1600) and Karl (b.1560, d.1618). However, the marriage also caused many problems. The morganatic marriage complicated the archduke's future career as a sovereign. Although Ferdinand I recognised the marriage as legitimate and over the following years settled the legal and property issues of Philippine and her children, he stipulated that the sons resulting from this marriage would be excluded from the Habsburg succession. Moreover, Philippine was not allowed to present herself as the legitimate spouse of the archduke.[40]

---

40   Sigrid-Maria Größing, *Die Heilkunst der Philippine Welser. Außenseiterin im Hause Habsburg* (Augsburg, 1998); Gunter Bakay, *Philippine Welser. Eine geheimnisvole Frau und ihre Zeit* (Innsbruck and Vienna, 2016).

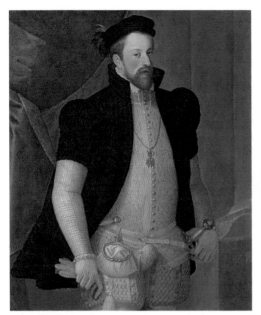

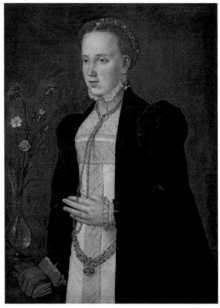

Fig. 7. Francesco Terzio, Archduke Ferdinand II, after 1557 (Vienna, Kunsthistorisches Museum, Picture Gallery, inv. no. GG 7971)

Fig. 8. South German painter, Philippine Welser, around 1557 (Vienna, Kunsthistorisches Museum, Picture Gallery, inv. no. GG 8012)

The last will and testament of Emperor Ferdinand I in 1554 had brought further changes to the inheritance of his three sons. Based on this third testament, Archduke Maximilian (II) was designated as the ruler of the kingdoms of Hungary and Bohemia, and was responsible for the protection of these domains against the Turks. He was also obliged to pay an annual allowance of ten thousand guilders to his two brothers from the income of the two kingdoms. Moreover, he was also given rule over both Lower and Upper Austria. Archduke Ferdinand II was allotted Tyrol, Swabia, Alsace, Sundgau, Burgau, and certain other domains. The youngest son, Karl, was to rule over Styria, Carinthia, Carniola, Gorizia, and Trieste. Ferdinand I also bore in mind the division of further income. This included rent from the Kingdom of Naples and valuable movables, but it should be noted that Ferdinand I also distributed the responsibility for payment of various substantial debts amongst his heirs. In the testament, Ferdinand I exhorted his sons to maintain their unity and bonds, and appealed to them to care for their unmarried sisters. One of the last paragraphs included an earnest plea to the sons to retain their Catholic faith. The testament became effective upon Ferdinand I's death, on the 25th of July 1564.[41]

The negotiations over Emperor Ferdinand I's testament were protracted and although Maximilian II was now the new King of Bohemia and Holy Roman Emperor,

---

41    HHStA, Familienurkunden, inv. no. 1319; *Kaiser Ferdinand I. 1503–1564. Das Werden der Habsburgermonarchie*, ed. by Wilfried Seipel (Vienna, 2003), cat. no XI/21, pp. 563–565; Kohler 2003, pp. 299–303; Exh. Cat. Prague 2017, cat. no. III/1, pp. 178–179.

he preferred that his younger brother, who had proven an efficient governor, stay in office a little longer. For this reason, Archduke Ferdinand II did not actually leave Bohemia (along with his family, court, and collections) until as late as 1567, terminating his nearly twenty-year sojourn. His reluctance to leave Prague and the Bohemian nobility after such a long residency (despite his enthusiasm for his new position as sovereign in Tyrol) is evidenced by his frequent returns and his efforts to maintain intense business, political, social, and cultural contacts with the Bohemian nobility for the rest of his life.[42]

The last stage of Archduke Ferdinand II's life, which saw the fulfilment of his life-long endeavour to become a sovereign ruler, remains surprisingly neglected in the scholarship as regards the archduke's economic and political contribution to the development of Tyrol. (Fig. 9) Historians still primarily focus on the period of the most illustrious ruler over this domain, Emperor Maximilian I, whose achievements seem to have outshone those of his great-grandson. Even today, scholars must rely on the two-volume monograph by Josef Hirn (1885, 1888) to draw a general picture concerning Archduke Ferdinand II's strategies as a ruler. Rich in facts, yet obsolete in methodology, this work celebrates the archduke rather than providing us with an objective evaluation of his personality.[43]

It is certain that the new Tyrolean ruler could use the precious experience he had gained as the representative of his father, and later of his brother, in the Bohemian lands. This experience was mainly focused on economic concerns: the continuous decline of copper and silver mining despite the ruler's best efforts played a negative role in the economic situation of Tyrol.[44] On the other hand, handicrafts and transit trade from South Tyrol over Brenner and Innsbruck, and into Central and Western Europe experienced a permanent boom. The support and maintenance of trade routes were essential to the domain's programme of economic stability, and this was one of Archduke Ferdinand II's priorities.[45] The sources reveal that the archduke still faced financial problems despite his economic independence because of the increasing expenses of his court, his costly social life, frequent travels, and expenditure on representation.[46]

At the political level, the internal development of Tyrol under Archduke Ferdinand II may be judged as stable. The changes in the tax collection handled by the Tyrolean estates contributed to the reduction of social tension in the country, which

---

42   His sojourns in Prague and other places were documented in the years 1569–1571, 1574, 1581, 1585, and 1588 – see Bůžek 2009, pp. 279–303.

43   Hirn 1888, pp. 505–519.

44   Hirn 1885, pp. 539–597; Rudolf Palme, 'Frühe Neuzeit. 1490–1665', in *Geschichte des Landes Tirol*, II, *Die Zeit von 1490 bis 1848*, ed. by Josef Fontana et al. (Bozen, Innsbruck and Vienna, 1986), pp. 120–125.

45   Palme 1986, pp. 125–133; Rober Büchner, 'Soziale Dimensionen einer Alpenstraße im 16. Jahrhundert. Die Arlbergsäumer auf ihrem Weg durch das Stanzertal', in *Annali dell'Istituto storico italo-germanico in Trento*, 31 (2005), pp. 31–85 (38).

46   Hirn 1888, pp. 466–594; Heinz Noflatscher, 'Erzherzog Ferdinand II als Tiroler Landesfürst', in Exh. Cat. Prague 2017, pp. 17–19 (18).

Fig. 9. Matthäus Merian, View of the Hofburg in Innsbruck, detail from an Oenipons. Inspruckh, in: Martin Zeiller, Topographia Provinciarum Austriacarum [...], Franckfurt 1677 (Prague, National Library of the Czech Republic, sign. 65 C 001092)

was not affected by any great social unrest. The estates appreciated the presence of Archduke Ferdinand II's court after a long absence of any resident ruler, and were open to his financial requirements as presented at the diets, and the estates did not oppose the archduke's undertaking of a moderate programme of re-Catholisation.[47] This programme focused on the elimination of banned churches, especially the Anabaptists. Just as in Prague, the archduke supported the Society of Jesus in Innsbruck, which had been invited there by his father in 1562. Together with his sisters Magdalena and Helena, Archduke Ferdinand II invited the Jesuits to Hall (1569) where they established a gymnasium.[48] The archduke was favourably disposed to the other religious orders, primarily the Capuchins.[49] The archduke's limited engagement in foreign wars, restricted 'solely' to the support of Hungary and Croatia against the continuous Turkish expansion, as specified in his father's testament, certainly also contributed to internal stability.[50] However, his father's wish to observe the cohesiveness of the Habsburg family did not prevent the Archduke from competing with his nephews, Ernst and Maximilian, to try to win the vacant Polish throne twice, in 1575 and 1587.[51]

47  Jürgen Bücking, *Frühabsolutismus und Kirchenreform in Tirol (1565–1665). Ein Beitrag zum Ringen zwischen ‚Staat‘ und ‚Kirche‘ in der frühen Neuzeit* (Wiesbaden, 1972), pp. 23–99; Palme 1986, esp. pp. 104–108; Bernhard Groß, *Gegenreformation und Geheimprotestantismus unter besonderer Berücksichtigung des Landes Tirol unter dem Einfluss der jesuitischen, franziskanischen und kapuzinischen Gegenreformation zur Zeit Erzherzog Ferdinand II.* (unpublished Ph. thesis, Universität Wien 1994).

48  *F. Schweygers Chronik der Stadt Hall 1303–1572*, ed. by David Schönherr (Innsbruck, 1867), p. 146.

49  Hirn 1885, pp. 227–262; Konrad Fischnaler, *Innsbrucker Chronik mit Bildschmuck nach alten Originalen und Rekonstruktions-Zeichnungen*, II (Innsbruck, 1930), p. 39.

50  Hirn 1885, pp. 288–309.

51  Hirn 1888, pp. 249–288; Oswald Bauer, *Zeitungen vor der Zeitung. Die Fuggerzeitungen (1568–1605) und das frühmoderne Nachrichtensystem* (Berlin, 2011), pp. 207–253.

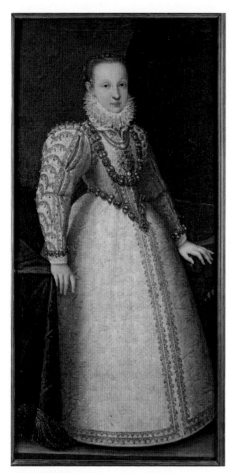

Fig. 10. North Italian painter, Anna Caterina
Gonzaga, before 1582 (Vienna, Kunsthistorisches
Museum, Picture Gallery, inv. no. 3167)

The rule over Tyrol paved the way for Archduke Ferdinand II to implement many of his ideas about the ideal Renaissance monarch's interests and activities. He paid great attention not only to the development of education and culture in the country he reigned,[52] but he also worked constantly on his self-education. In addition to scholarship and administration of the domains entrusted to him, the many contacts he had maintained with Bohemian aristocrats contributed to the rich social life of his new court.[53] The reconstruction and completion of the Innsbruck residence, as well as the nearby Ambras Castle, had already been initiated prior to the archduke's arrival in Tyrol, and these works created ideal conditions for the monarchical family and its guests once they settled there. Tyrol was a relatively tranquil country without major complications, and this relatively peaceful situation enabled Ferdinand II to pursue his greatest passion – the expansion of his collections. The aging ruler also appears to have found real satisfaction in his own creative activity, as evidenced, for example, by his glass workshop experiments and his authorship of a theatre play.[54]

In 1580, when Philippine Welser died, a glimmer of hope emerged that the archduke would have male descendants eligible for the Habsburg succession. In his search for a new wife, he chose his niece Anna Caterina Gonzaga, 37 years his junior, whom

52   Hirn 1888, pp. 322–370 primarily mentions his merits in terms of the development of education, education and science; Palme 1986, pp. 135–141.

53   Bůžek 2009, esp. pp. 241–278.

54   Jacob Minor, *Speculum vitae humanae. Ein Drama von Erzherzog Ferdinand II. von Tirol 1584. Nebst einer Einleitung in das Drama des XVI. Jahrhunderts herausgegeben* (Halle a. S., 1886). The marriage with Anna Caterina Gonzaga in 1582 most likely contributed to the origin of the comedy celebrating a life in marriage. See also Christina Mürner, 'Wie nannte man behinderte Menschen im 16. Jahrhundert? Dokumentation am Beispiel einer von Erzherzog Ferdinand II, von Tirol verfassten Komödie', in *Das Bildnis eines behinderten Mannes. Bildkultur der Behinderung vom 16. bis ins 21. Jahrhundert*, ed. by Petra Flieger and Volker Schönwise (Neu-Ulm, 2007), pp. 168–170.

he married in 1582.[55] (Fig. 10) Contrary to his expectations, only daughters resulted from this marriage. One of these daughters, Anna of Tyrol (1585–1618), became the wife of the future Emperor Matthias in 1611. She and her husband were crowned Emperor and Empress in 1612. Later she was also crowned Queen of the Hungary (1613) and Queen of Bohemia (1616). After Archduke Ferdinand II's death in 1595, Archduchess Anna Caterina continued the re-Catholication policy of her husband. The Tyrolean domain passed back to the Habsburg family (at first Matthias was appointed governor there temporarily and since 1602 archduke Maximilian III).[56] Karl of Burgau, the youngest son of Ferdinand II and Philippine Welser, received Ambras Castle.

The life of Archduke Ferdinand II coincided with a fairly turbulent period of European history, and as such it abounded with action and events, but also, on the more personal level, with the archduke's loves, passions, and of course the fulfilment of the duties given to him. As such, the life of Archduke Ferdinand II may be best characterised in the lines of the motto that decorates his portrait in *Imagines Gentis*: DUM SUMMAE INVIGILANT ALTISSIMA PECTORA LAUDI ASPERA NON TERRENT CURA LABORQ IUVANT: as long as those personalities in the highest positions are animated by the intention of achieving the greatest fame, great worries or hardship shall generate no fear, but shall be overcome with joy.[57] But the question remains open as to how exactly we should evaluate the archduke's activities in the Bohemian lands and in Tyrol, and more than that, his role in the greater history of Europe.

---

55　Hirn 1888, pp. 449–466; *Philippine Welser & Anna Caterina Gonzaga, die Gemahlinnen Erzherzog Ferdinands II.*, ed. by Alfred Auer, exh. cat. (Innsbruck, 1998).

56　Albert Jäger, 'Beiträge zur Geschichte der Verhandlungen über die erbfällig gewordene gefürstete Grafschaft Tirol nach dem Tode des Erzherzogs Ferdinand von 1595 – 1597', *Archiv für österreichische Geschichte* 50 (1873), pp. 103–212; Palme 1986, pp. 153–154.

57　Exh. Cat. Prague 2017, cat. no. VI/2c, p. 307 and cat. no. VI, pp. 115–116.

# Dynasty, Court and its Festivities

Jaroslava Hausenblasová

# The court of Archduke Ferdinand II: Its organisation, function and financing

It would be a mistake to evaluate the significance of Archduke Ferdinand II solely on the basis of his opinions, actions, or the extensive legacy that he left behind. To fill in the details of the general picture it is important to try to approach this figure through the people who surrounded him and shaped his ideological world via the wide spectrum of their possible influence.[1]

As was the case for all members of the ruling European families in the early modern age, the courts of the Habsburgs and their wider court circles were subject to relatively exact rules.[2] At the beginning of the 16th century it was the founder of the Danube Monarchy, Ferdinand I (1503–1564), who gradually defined the basic form and function of these rules and thus predetermined the direction taken in the development of the sovereign court as an entity in Central Europe right up to the 20th century. The Habsburg court was itself the result of the influence of many different European models, and in turn influenced the formation of the political, administrative, social and cultural circles of the other European rulers and important noble families.[3]

The system created by Ferdinand I was relatively complicated and included not only the hierarchically structured court of the monarch, but also the household of his wife Anna and the smaller individual courts of their children. These of course also included the court of their second son, Archduke Ferdinand II. Even though the group of sources that could inform us about the form, size and composition of the archduke's court is far from complete, we are able, on the basis of research results, to define the individual stages of its development, its structure, size and composition, and to show how the circle of people it comprised influenced the formation of the archduke's personality. No less interesting, however, is discovering how the archduke himself was able to intervene in his court's development, and finally how his financial capacities influenced the forming of the court and its wider cultural circle, and possibly also his activities as a benefactor and patron. In conclusion we can thus, at least in part, answer the question of what part Archduke Ferdinand II and his court played in the political-

---

1   This was successfully attempted in the case of the Emperor Rudolf II by Robert J. W. Evans, *Rudolf II and his World. A study in intellectual History 1576–1612* (Oxford, 1973).

2   For a definition if the concept of "court", "Hofstaat" and the wider court circle – see Jaroslava Hausenblasová, *Der Hof Kaiser Rudolfs II. Eine Edition der Hofstaatsverzeichnisse 1576–1612*, Fontes historiae artium, IX (Prague, 2002), pp. 52–56.

3   Jaroslava Hausenblasová, 'Ein modifiziertes Vorbild oder ein eigenes Modell? Der Aufbau des Hofes Ferdinands I. in Mitteleuropa in der ersten Hälfte des 16. Jahrhunderts', in *Vorbild, Austausch, Konkurrenz. Höfe und Residenzen in der gegenseitigen Wahrnehmung*, ed. by Werner Paravicini and Jörg Wettlaufer, Residenzenforschung, 23 (Ostfildern, 2010), pp. 363–390.

administrative system of the Central European Habsburgs, and evaluate what the
archduke's social and cultural role in 16th century Europe may have been.

The development and formation of Archduke Ferdinand II's court can be roughly
divided into three main periods that simultaneously correspond to the basic stages in
his life, defined by clear milestones. These include his childhood and adolescence
(1529–1547), the period spent as the governor of the Lands of the Bohemian Crown
(1547–1567), and finally the period spent governing the Tyrol (1567–1595). These indi-
vidual periods differ not only in terms of fundamental systematic changes to the court
apparatus, but also – as we shall see later – in terms of the extent of the relevant surviv-
ing written sources. Today most of these sources are held in three archives. In the
Haus-, Hof- und Staatsarchiv in Vienna in particular there are lists of the archduke's
court dating from his childhood and youth, as well as the instructions for his officials
from his father, Ferdinand I, and also correspondence and important documents relat-
ing to the life of the archduke himself. Some important documents remained in Prague
after the archduke's departure, and these are held today in the National Archives in
Prague. These sources also contain plenty of documentary material, accounts, and cor-
respondence, which not only shed light on the activities of the archduke as the admin-
istrator of the Lands of the Bohemian Crown, but also on the composition and financ-
ing of his court, and the members of his court circle. The most important source of
information about the form, organisation and financing of the archduke's court is the
Tiroler Landesarchiv in Innsbruck, which holds the greater part of the office registry
that the archduke brought with him from Prague and that continued to accrue here
right up to the end of his life in 1595.

### Childhood and adolescence (1529–1547)

The rapidly rising number of children born to Ferdinand I and Anna Jagiellon a caused
the king to issue an important document in the very year of his son Ferdinand II's
birth, 1529. In this document he stipulated the rules concerning how the joint court of
the archdukes Maximilian and Ferdinand, and the archduchesses Elisabeth and Anna
in Innsbruck should appear and function.[4] The king stipulated the court's composition
and size, and determined the duties and also the salaries of the individual members of
the court, which consisted of around 50 people. At its head was the *Obersthofmeister*
(lord high steward),[5] who supervised the running of the court and especially the cooks,
gatekeepers (door guards) and the court chaplain. The *Hofmeisterin* (female steward),
Bianca of Thurn was responsible for the noble chambermaids and nursemaids who
looked after the royal children, and also the maidservants (e.g. the laundrywoman,
cook, the *Heizerin* (literally, heating woman) and the *Kuewarterin* (dairymaid). For
the entertainment of the children there were also a male and female dwarf and a *Vogel-
warter* (aviary keeper).

---

4    Haus-, Hof- und Staatsarchiv, Vienna (hereafter HHStA), OMeA SR, cart. 181/7, 1529, 1 November,
     Krems: "Jung König und Königin Stadt".
5    His name is not given in the attached court list.

Five years later in 1533, the king issued a detailed instruction for the children's *Obersthofmeister* (lord high steward) Veit of Thurn and the other courtiers.[6] In it he laid down the main principles according to which the children were to be raised in the praise of God, respect for their parents, and reassurance of the lands and people ruled by their father, who they might perhaps one day also govern.[7] Their preparation for this role was to include, among other things, learning the Hungarian, Czech and Italian languages, especially through conversation and play with pages from noble families of the individual countries. Archduke Maximilian was to read for two hours every day, and Archduke Ferdinand (then only four years old) was allowed to merely attend lessons occasionally, as he wished.[8] On Sundays and holy days the children devoted themselves to reading the Gospels. King Ferdinand I had advanced ideas about education for the age – in the case of misdemeanours or failure to fulfil school tasks he wished the children to be first reprimanded and only then, if words had not been effective, could corporal punishment be used.[9]

We find more specific information about the members of the court from two documents dated around 1536.[10] According to these, the main posts in the court of the royal children were occupied by members of important Austrian noble families. Among these were, in particular, the aforementioned Veit of Thurn as the *Obersthofmeister* (lord high steward) and a whole range of sons of the nobility serving as pages (Pötting, Salm, Polheim, Fels, Zelking, Puchheim and others). Evidently, from as early as 1530 the children had their own personal physician, Georg Tannstetter, professor and former rector of the University of Vienna, known for his writings in the spheres of mathematics, astronomy and physics, who is also recorded in this court list.[11] Their *preceptor* (tutor) was the humanist poet and historiographer Kaspar Ursinus Velius.[12] A dance teacher, Bernhard Tämerlin, is also documented.[13]

6 HHStA, OMeA SR, cart. 73/1, 1533, 27 January, Innsbruck, fol. 68r–72v: "Instruktion König Ferdinands für den Hofmeister seiner Kinder in Innsbruck".

7 HHStA, OMeA SR, cart. 73/1, 1533, fol. 68r: "...Der Romischen kunigelichen maiestat etc. unsers allergenedigisten herrn bedencken, wie derselben liebsten kinder dem Allmechtigen zu lob und eere irer kunigelichen Mt. und derselben gemahel zu wolgefallen und landen und leuten zu hohen trost und nutz in Irer jugent in Gots forcht tugentlichen und adennlichen kunigelichen sitten auferzogen werden sollen...".

8 HHStA, OMeA SR, cart. 73/1, 1533, fol. 71r.

9 HHStA, OMeA SR, cart. 73/1, 1533, fol. 71r,v.

10 HHStA, OMeA SR, cart. 181/8, 1536, 28 August, p.l.: "Küniglicher Kinder Statt"; HHStA, OMeA SR, cart. 181/9, 1536 (?): "Kunigclicher kinnder stat sambt der verodenten rete neben gestelten ratslegen und gutbedunkhen". Both documents arose as an expression of the effort to reduce the financial costs of the operation of the court.

11 HHStA, OMeA SR, cart. 181/9, fol. 3v; see Franz Graf-Stuhlhofer, *Humanismus zwischen Hof und Universität. Georg Tannstetter (Collimitius) und sein wissenschaftliches Umfeld im Wien des frühen 16. Jahrhunderts*, Schriftenreihe des Universitätsarchivs, Universität Wien, 8 (Vienna, 1996), p. 80.

12 HHStA, OMeA SR, cart. 181/9, fol. 4r.

13 HHStA, OMeA SR, cart. 181/9, fol. 11r. See Josef Hirn, *Erzherzog Ferdinand II. von Tirol. Geschichte seiner Regierung und seiner Länder*, I (Innsbruck, 1885), pp. 6–7; Robert Holtzmann, *Kaiser Maximilian II. bis zu seinen Thronsteigung (1527–1564). Ein Beitrag zur Geschichte des Überganges von den Reformation zur Gegenreformation* (Berlin, 1903), pp. 21–22.

We also find the names of humanist scholars in the vicinity of the archdukes and
archduchesses in a further court list from 1538, when there were already more than 60
people serving the six children.[14] Among them was the personal physician Paulus
Ricius,[15] professor of philosophy at the University of Padua, a translator of Hebrew
and author of the manuscript *De Cælesti Agricultura*. The king appointed Wolfgang
Schiefer (Severus),[16] a humanist and graduate of Wittenberg University who belonged
to the circle of Erasmus of Rotterdam to the post of preceptor to his children. How-
ever, as soon as the king heard of Schiefer's personal relations with Martin Luther and
Phillip Melanchton, he had to leave the court.[17] The children were surrounded by 34
pages in all, mainly from Austrian families, but there were also two Czech noblemen
amongst them.[18]

In the same year, 1538, the king established a new joint court for his sons the arch-
dukes Maximilian and Ferdinand, with separate staffing and finance from the court of
the other children. The chief reason for this was the fact that, according to the customs
of the time, both the eldest and second-eldest sons had to be considered as possible
future rulers. In case the eldest son should die early (Ferdinand I's eldest son Archduke
Maximilian was frequently ill in his youth), the second son would automatically take
his place in the line of succession. The upbringing and educational process preparing
them for a ruling role would therefore take place for both of them simultaneously. In
the same year, Ferdinand I also issued very detailed instructions for the members of his
sons' court.[19] He appointed the Czech nobleman Ladislav Berka of Dubá as *Ober-
sthofmeister* (lord high steward) heading the court.[20] He, together with the *Oberst-
kämmerer* (lord chamberlain) Johann Gaudenz of Madrutz,[21] were to oversee the
safety of the two young archdukes, their health and their proper upbringing. The
king's previous bad experiences with the Lutheran preceptor Schiefer were strongly
reflected in the text of the instruction. The effort to restrict his sons' contact with Ref-
ormation teaching runs like a scarlet thread throughout the text. The obligation to
preserve „unserm alten wahren heilig christlich glauben und religion"[22] is mentioned
for practically all the members of the court and at the same time it is emphasised that

---

14  HHStA, OMeA SR, cart. 181/11a, b, after 10. 4. 1538, s.l.: "Statt der Kü. Kinder etc. sechs hietz zu
    Innsbruck".
15  HHStA, OMeA SR, cart. 181/11b, fol. 3r.
16  HHStA, OMeA SR, cart. 181/11b, fol. 3r.
17  Holtzmann 1903, pp. 18–19; Theodor Joseph Scherg, *Ueber die Religiöse Entwicklung Kaiser Maxi-
    milians II. bis zu seiner Wahl zum römischen Könige (1527–1562)* (Würzburg, 1903), p. 5; Paula Sutter
    Fichtner, *Emperor Maximilian II* (New Haven, 2001), pp. 9–10.
18  HHStA, OMeA SR, cart. 181/11b, fol. 4v: "Wilhelm herr zu Sternberg, seines alters 14 jahr, ain
    Behem"; "Zwelßge Paußer, ain Behaim, seines alters 16 jahr".
19  HHStA, OMeA SR cart. 181/12, 1538, 13 October, Linz: "Instruktion König Ferdinands I. für den
    Hofstaat der Erzherzoge Maximilian und Ferdinand", fol. 1–21.
20  HHStA, OMeA SR cart. 181/12, fol. 1r–4v.
21  HHStA, OMeA SR cart. 181/12, fol. 4v–8v.
22  The obligation to preserve "our old, true, sacred Christian faith and religion". HHStA, OMeA SR
    cart. 181/12, fol. 1r.

the training of the archdukes should be aimed at strengthening their virtues as future rulers of the *Haus Österreich* (Austrian House). From these instructions we can form an idea of the daily regime that Maximilian and Ferdinand had to adhere to. In the morning they rose between 6 and 7 o'clock, and after morning ablutions they went to mass and then received a small bowl of soup. Until 10 o'clock there were lessons and only after this was breakfast served. Lessons also continued in the afternoon from one until half past two. After this the boys were given a small snack (usually fruit), around four they had supper and before bed they could have more bread and something to drink. They lay down to sleep around eight o'clock.[23] The chamberlain was never allowed to leave them unattended, even at night. Their rooms were guarded by a door-keeper. The chamberlain also had to report every disobedience on the part of the two young archdukes directly to the king.[24] The system of education was also strictly organised. At the wish of Ferdinand I the educational programme for his sons was to run along two lines. Maximilian and Ferdinand had lessons with the preceptor in Latin and German, reading and writing. They also participated, however, in joint lessons with the pages, with whom they were not permitted to talk in German, but rather only in Latin, Czech or another foreign language. On Saturday they read the Gospels.[25]

The departure from Innsbruck in 1543 and the subsequent separation of the two archdukes (see chapter The Life of Archduke Ferdinand II: Between Ambitions and Reality), each to his own fate, also called for changes at their respective courts. From 1544 on the two brothers had their own entourages. Archduke Ferdinand II set out for the Netherlands with an entourage of more than 40 persons.[26] In comparison with the earlier situation, when noblemen from the Austrian Lands prevailed at he and his brother's court, the archduke was now surrounded by a varied international circle. At the head of the court was the Spanish nobleman Ludwig Tobar of Enzesfeld,[27] the post of preceptor was held by Jan Horák of Milešovka, a Czech humanist (also called Hasenberg), known for his anti-Lutheran writings.[28] Among the nobility serving the archduke at table during his travels there were also the Czech noblemen Vratislav of Pernštejn and Jan Popel of Lobkowicz, as well as representatives of Austrian and Tyrolean noble families.[29]

In the years 1529–1547, then, it was King Ferdinand I who determined the selection of persons with whom not only Archduke Ferdinand II, but all of his children

---

23  HHStA, OMeA SR, cart. 181/12, fol. 3v, 7v.

24  HHStA, OMeA SR, cart. 181/12, fol. 5v.

25  HHStA, OMeA SR, cart. 181/12, fol. 10r–11v.

26  HHStA, OMeA SR, cart. 181/20: 1544, 31 May, Speyr: "Erzherzog Ferdinanden Stat".

27  Christopher F. Laferl, *Die Kultur der Spanier in Österreich unter Ferdinand I. 1522–1564* (Vienna, Cologne and Weimar, 1997), pp. 69, 275; Václav Bůžek, *Ferdinand von Tirol zwischen Prag und Innsbruck. Der Adel aus den böhmischen Ländern auf dem Weg zu den Höfen der ersten Habsburger* (Vienna, 2009), pp. 89–90.

28  *Rukověť humanistického básnictví v Čechách a na Moravě*, II, ed. by Josef Hejnic and Jan Martínek (Prague, 1966), p. 333.

29  HHStA, OMeA SR, cart. 181/20, fol. 3r, v.

came into contact. The king also defined the duties of the courtiers and paid for the running of the entire court, doing so from the incomes of two different chambers. During the period of both sons' residence in Innsbruck the burden of the general operation of the court was borne mainly by the *Oberösterreichische Kammer* (Upper Austrian Chamber). However, as soon as the archdukes Maximilian and Ferdinand left the Tyrolean residence, the king covered their court expenses from the treasury of the *Hofkammer* (Court Chamber). The *Hofzahlamtsbücher* (court accounting books) document the large sums that the king devoted to equipping his sons. In 1543, when both archdukes resided at the Imperial Diet in Nuremberg, their father bought fabrics and other luxury items for them, such as bottles and knives for use at table.[30] In the following year, in preparation for further travel, more fabrics were purchased for both archdukes in Speyer and in Prague. These comprised various types of velvet, atlas silk, taffeta, woollen cloth and linen, all in varying colours. The need for proper representation also called for new clothing for the members of their court, such as liveried servants (lackeys) and stablemen.[31] The king had silks and other fabrics embroidered with gold and silver. These could not be purchased in nearby towns of the realm, so they were brought from Florence in 1546.[32] Ferdinand I often resolved the high costs of his sons' luxurious outfitting (which exceeded the capacities of the royal treasury) by borrowing, especially from the Fugger family in Augsburg.[33]

From 1545 on, we find accounting records of expenditure on the personal equipment of Archduke Ferdinand II, and on the operation of his own independent court.[34] In just one year his father's Court Chamber paid out the sum of 4,500 *Gulden* to cover the cost of the archduke's journey to the Netherlands,[35] as well as paying the sum of 190 *Gulden* to a Nuremberg armourer for armour (a *Küriss* or *Kyriss*, namely a curass) for the archduke's planned military campaign alongside the Emperor Charles V and

---

30    Finanz- und Hofkammerarchiv, Vienna (hereafter FHKA), Hofzahlamtsbuch (hereafter HZAB), 1543, fol. 70v–71r: "Jacoben Hofman, burger und goldschmied zu Nurnberg, zu zwaien flaschen fur die jungen erzherzogen zu Österreich, Maximilian und Ferdinandten gehörige 8 markh [...] und zu zwaien credenzmessern 1 markh 1 latt 2 pfennig [...] Id est 147 gld. 60 kr. 1 d."

31    FHKA, HZAB, 1544, fol. 43r–47r.

32    FHKA, HZAB, 1546, fol. 78v–81v.

33    See, for instance, the record in FHKA, HZAB, 1544, fol. 42r, according to which there was paid out on the 28th September 1544 from the Fuggers for the court of Archduke Ferdinand II in the Netherlands 2,000 *Gulden*; further amounts to the total value of 18,543 *Gulden* in the course of 1545 for the maintenance of the courts of both archdukes – see FHKA, HZAB, 1545, fol. 36r–37r, 38v, 40v, 41v; in the course of 1546 for the court of Archduke Ferdinand II. a total of 9,300 *Gulden* – FHKA, HZAB 1546, fol. 66r,v.

34    FHKA, HZAB, 1546: fol. 77v: "Marcus Anthonius Spinolla, Rom. Ku. Mt. etc. diener und dieser zeit erzherzog Ferdinanden verwallter des stallmaister ambts zu wolgedachts erzherzog Ferdinanden stall notdufften als zueberziehung sätl und zuerichtung etlicher gezeug durch die Anthionori [?] vermug bevelch und quittung zu Regensburg den 26. Juni, geben und uberantwurt 19 ¼ wiener elln gueten schwarzen samat von zwaien harn per 3 gld. 15 kr. angeschlagen, das in gelt bringt benedtlichen 62 gld. 33 kr. 3 d. Id est ... 62 gld. 33 kr."

35    FHKA, HZAB, 1545, fol. 38r.

King Ferdinand I.[36] Large amounts were paid out in the name of appropriate family representation in 1546, when the whole family came together in Regensburg with a large retinue on the occasion of the joint wedding of the archduchesses Anna and Maria. Of the sum total 45,732 *Gulden* spent on maintaining the courts of the children of the royal family in 1546, more than 45,000 were spent on Archduke Maximilian and Archduke Ferdinand. The ordering and purchasing of signet rings for the two archdukes is of particular interest among the numerous items in the court accounting books.[37]

## In the role of Governor of the Lands of the Czech Crown (1547–1567)[38]

The year 1547 marked a fundamental turning-point in the life and political career of Archduke Ferdinand II. The uprising of the Czech estates, political tension in the land, and the death of Queen Anne (27th January 1547) were King Ferdinand I's chief reasons for leaving his second-born son in Prague and entrusting him with the role of governor. Consolidating the situation in the Bohemian Lands would be a demanding task: the archduke's thorough education and upbringing in the company of leading humanist scholars, his knowledge of languages (including Czech), and the political and diplomatic experience he had gained at the Imperial Diets and during his stay in the Netherlands, as well as his participation in the military campaigns of Emperor Charles V and King Ferdinand I all served to develop and enhance the skills and knowledge he would need to navigate that task. The execution of the organisationally and politically difficult office of governor, the growing social standing connected with both this office and the further diplomatic and military tasks that his father and later his brother Maximilian II would entrust to him: all of these factors were also fundamentally reflected in the development of Archduke Ferdinand II's court. The circle of people by whom he was surrounded and whose services he used can be divided into three groups:

### a) The *Hofstaat* (Court)

For his personal requirements, namely service, protection, handling of personal correspondence, entertainment and other tasks essential to the life of a Renaissance cavalier, the archduke continued to utilise his own court, the structure and functions of which reveal a continuous development from the earlier incarnations of his personal and shared court. At the beginning of this period court members continued to be

---

36   FHKA, HZAB, 1545, fol. 38v–39r.
37   FHKA, HZAB, 1546, fol. 72v–73r: "Jacoben Khuen von Bellasy, ritter, Ro. Khu. Mai. etc. rat und beder Irer Khuniglichen Maiestat etc. gelibten sune erzherzogen Maxmilian und Ferdinandn zu Osterreich etc. camer zubezalung zwaier pedtschadt ring, so fur bed ir Fr. Dt. gemacht worden, geben und uberantwurt zu Prag an 24. November […] Id est … 33 gld. 35 kr. 3 d."
38   Since the 14th century, the lands of the Bohemian Crown were formed by the Kingdom of Bohemia, Moravian Margraviate, Lower and Upper Lusatia, and the Silesian principalities.

appointed by the king (from 1558 Emperor Ferdinand I), but later the archduke had the main say not only in the selection of his court, but also in the organisation of its running. As early as the 1550s the archduke was issuing detailed instructions for his court officials directly, however only a few of these have been preserved.[39] Unfortunately, no lists for the period 1547–1566 have been found that contain exact information on the structure of the court, its personnel, and any possible changes that may have taken place in it. This lack of sources is in itself evidence that the former system of organisation and firm control on the part of the archduke's father had ceased to hold up. Our impressions of how the archduke's court functioned at this time are therefore extremely fragmentary, and the blank areas can only be filled in with great difficulty on the basis of a number of partial sources scattered today across many different European archives and libraries.

A particularly important source of information for us is found in the book of accounts dated 1551, i.e. from the period of the archduke's initial activity in his new role of governor.[40] This book was compiled by the archduke's chief accountant Leonard Gienngerer and records the financial and material incomes and outgoings of the court in the appropriate year.[41] On the basis of the data from this book we can reconstruct, at least approximately, the appearance of the court. The source mentions a total of 145 courtiers and other employees of the court, who were (or rather should have been) paid regularly.[42] At their head there stood, as in 1544, the *Obersthofmeister* (lord

---

39    Tiroler Landesarchiv, Innsbruck (hereafter TLA), Ferdinandea, cart. 50, unfolioed. It contains an undated instruction for the *Obersthofmeister* (lord high steward) Franz of Thurn, an instruction for the *Kuchenschreiber* (kitchen scribe) 1559, an instruction for the *Oberstkämmerer* (lord chamberlain) Alois Lodron (1559) and the main text of an instruction for the *Obersthofmarschall* (supreme marshal) (1560).

40    Prague, National Archives (hereafter NA), Komorní knihy, sign. KK 1898, 147ff. This source was analysed in detail by Petr Vorel, 'Místodržitelský dvůr arciknížete Ferdinanda Habsburského v Praze roku 1551 ve světle úřední dokumentace', *Folia Historica Bohemica* 21 (2005), pp. 7–66. Cf. also *Arcivévoda Ferdinand II. Habsburský. Renesanční vladař a mecenáš mezi Prahou a Innsbruckem / Ferdinand II. Erzherzog von Österreich aus dem Hause Habsburg. Renaissance-Herrscher und Mäzen zwischen Prag und Innsbruck*, ed. by Blanka Kubíková, Jaroslava Hausenblasová and Sylva Dobalová, exh. cat. (Prague, 2017), cat. no. II/10, p. 102 and II/10, pp. 58–59. The internal organisation of the book corresponds to the accounts books of the Viennese Court Treasury, the so-called *Hofzahlamtsbücher*, today deposited in Vienna, Finanz- und Hofkammerarchiv, recording the financial management of the ruler's court. First of all there is the column of incomes, after this follows an overview of expenditure, which is divided into fourteen thematic groups. Within the individual columns there are records kept mainly in chronological order, and at the end of the pages the total expenditures are listed. Finally, at the end of each month the monthly total is noted. The accuracy of the calculations was confirmed by the lord high steward Ludwig Tobar with his signature. The total sum of the incomes (47,539 *Gulden*) consist of two sources: 12,278 *Gulden* from the Court Chamber of Ferdinand I and 32,777 *Gulden* from the Royal Bohemian Chamber.

41    Respectively from 1 December 1550 to 31 December 1551. About the production of the book – see Vorel 2005, pp. 8–15.

42    It is necessary to realise that the source only contains data on those people to whom a certain financial sum was paid or whose names were linked with the operating costs of the court. Those who did not receive any salary or remuneration in 1551 are not mentioned in the book. Irregularity in the payment of courtiers and the amassing of arrearswere a standard phenomena across Europe, not only in the courts of the Habsburgs.

high steward) Ludwig Tobar of Enzesfeld,[43] endowed with extensive authorities. Not only did he oversee the operation of the entire court, but he also controlled the observance of the court rules and the entire accounting agenda. After his death in 1553 he was replaced by Franz Count of Thurn, son of the above-mentioned Veit of Thurn.[44] The second most important 'official' was the *Oberstkämmerer* (lord chamberlain) Jakub Khuen of Belasy,[45] guardian of the archduke's personal property and responsible for maintaining his privacy. Khuen, his immediate successor Zbyněk Berka of Dubá[46] and, from 1559 on, Alois of Lodron were also in charge of the staff of the (personal) chamber of the archduke, staffed by three or four chamberlains, two chamber servants, a wardrobe master, a *Leibbarbier* (personal barber), a stoker, a chamber *fourrier* (also *fourier* or *furýr*: the special valet responsible for locating and securing lodgings and catering when the court was travelling), personal tailor, trouser-maker, bootmaker, laundress and doorkeeper.[47] We find no mention of a personal physician in the accounts book from 1551, but other sources confirm that this position was already held in 1549 by Andrea Gallo, a native of Trent[48] and author of books about the plague.[49] The archduke's correspondence was handled by his secretary, who was often privy to both personal and political matters.[50] Financial matters were handled by the accountant and court controller. The judicial agenda for members of the court was executed by the *Obersthofmarschall* (supreme marshal).[51] Because one of Archduke Ferdinand II's greatest pleasures was hunting, the stables were also an important part of the court, cared for by the *Oberststallmeister* (grand master of the horse) and his assistants. In 1551 this post was by Alois of Lodron,[52] and later by Andreas Teufel.[53]

---

43 Vorel 2005, p. 23.

44 Bůžek 2009, p. 96. On the genealogy of the family: https://www.geni.com/people/Franz-von-Thurn/4732226587920070463 (searched 7.3.2021).

45 Vorel 2005, p. 23.

46 Bůžek 2009, p. 96.

47 TLA, Ferdinandea, cart. 50: 1559, 1 June, Prague: "Instruction auf Graven Aloisen zu Lodron, obristen camerer etc", draft, Prague, unfolioed.

48 This physician came with Archduke Ferdinand II from the Innsbruck residence, where he was the personal physician to all of the children of King Ferdinand I – see TLA, O.Ö. Raitbuch, 1548, fol. 84v and others.

49 See the article by Lucie Storchová in this volume.

50 According to the accounting book of 1551 this post was held by Adam Schenkh – see Vorel 2005, p. 23. However, he was evidently soon replaced by Osvald Schönfeld – see Petr Vorel (ed.), *Česká a moravská aristokracie v polovině 16. století. Edice register bratří z Pernštejna z let 1550–1551* (Pardubice, 1997), p. 230 (no. 406). From 1560 there is evidence that the post of secretary was held by Hans Habersack, author of the description of all three coronations of Maximilan II (1562, 1563). Originally he worked as a scribe in the chancellory of the Royal Bohemian Chamber and evidently even then showed his worth in the handling of "important and confidential" matters that the archduke entrusted to him – see *Die Krönungen Maximilians II. zum König von Böhmen, Römischen König und König von Ungarn (1562/63) nach der Beschreibung des Hans Habersack, ediert nach CVP 7890*, ed. by Friedrich Edemayer et al. (Vienna, 1990), pp. 39–42.

51 TLA, Ferdinandea, cart. 50, unfoliated, 1560, 19 November, Pürglitz (Křivoklát), preserved incomplete.

52 Vorel 2005, p. 23.

53 Ibidem, p. 23.

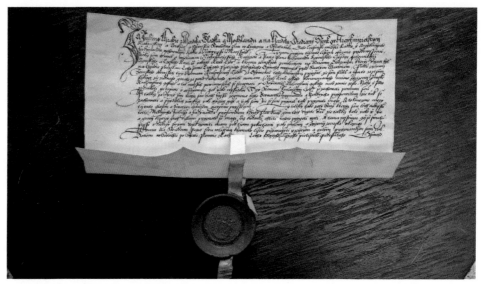

Fig. 1. Right to purchase land of Julius of Hardegg (Prague, National Archives of the Czech Republic)

Their duties included not only the care of the horses, but also the maintenance of hunting equipment, and the management of hounds and birds, as well as the requisite equipment for possible military expeditions. At this time there were also salaried craftsmen employed in the archduke's stables: a blacksmith, armourer, body armourer, and tailor. To ensure the smooth running of the young Habsburg's rich social life, care was also required in the selection of the staff for the kitchen, the cellars and serving at table – namely the *Mundschenk* (waiter), *Vorschneider* (carver) and *Truchsessen* (food bearers). From the accounts book of 1551 we also have information concerning the trumpeters, whose playing usually acted as a signal, important not only at festivities but also in the usual daily ceremonies, and also concerning other musicians and singers, whose performances were part of religious ceremonies, banquets, and other festivities organised by the archduke (cf. the contribution by Jan Bat'a in this volume). There was also a large personal bodyguard (around 34 men), whose task was the protection of the archduke himself. As in the preceding period, the archduke's court was also a place for the training of young noblemen, who undertook this training as pages. A dwarf was in charge of their entertainment.[54]

In the years 1547–1567 then, the court of Archduke Ferdinand II was organised in a similar manner to the court of King Ferdinand I, the only difference being that here there were none of the bureaucratic and government offices that the monarch used in the administration of his realm. The structure of the courts of the king's other offspring was similar. The court of the archduke was, in comparison with his father's

---

54   Vorel 2005, p. 26.

court, also smaller in numbers.[55] We can only assume that the court increased in size during the residence of Archduke Ferdinand II in the Bohemian Lands, but there is no documentation to support this. Many members of the court also accompanied the archduke on his frequent travels.[56]

The king continued to try and place politically and religiously reliable people at his son's court. Many of the courtiers who surrounded the archduke during his governorship in the Bohemian Lands were also formerly, or even simultaneously, active in the service of King Ferdinand I. Among the persons who were part of both court structures were, for instance, the above-mentioned personal physician Andrea Gallo, the secretary Osvald of Schönfeld and the *Oberststallmeister* (grand master of the horse) Andreas Teufel of Enzersdorf. Many of these people were from noble families with an established tradition of serving at court, such as Jakub Khuen of Belasy, Alois of Lodron, Franz of Thurn and others.

After 1547, just as in the earlier years, the court of Archduke Ferdinand II was varied in terms of both nationality and social status. Apart from representatives of the Austrian, Tyrolean and Spanish aristocracy, who held the leading positions at the archduke's court, there was also a gradually increasing employment of persons belonging to the ancient Czech nobility. Among them were, for instance, the *Oberstkämmerer* (lord chamberlain) Ladislav Berka of Dubá, the commander of the personal guard Mikuláš Vrchota of Janovice,[57] the *Mundschenk* (personal waiter) Kryštof Vachtl of Pantenov, *Truchsas* (seneschal) Václav Posadovský of Posadov,[58] *Kämmerer* (chamberlain) Ladislav of Šternberk and others.[59] Later other members of noble Czech families entered the wider court circle, but they did not hold any decisive positions. The archduke's court attracted them not only because of the potential career opportunities it presented, but also because of its rich social life.[60]

Many of the nobles who came to the Bohemian Lands together with Archduke Ferdinand II gradually settled there. Some of them married Czech noblewomen[61] and a number of them managed to acquire the *incolat* (sometimes also *inkolat*), meaning they were accepted as inhabitants of the Kingdom of Bohemia. After they had, as it was termed, avowed themselves to the land and issued a declaration to this effect con-

---

55  The number of court members at the court of Emperor Ferdinand I is estimated to have been, at the end of his reign, more than 500 people – HHStA, OMeA SR, cart. 183/45, after 1563 December: "Hofstaat Kaiser Ferdinands I.", fol. 1–39; Hausenblasová 2002, p. 61.

56  In this volume, see chapter 'The life of Archduke Ferdinand II: Between ambitions and reality'.

57  Vorel 2005, p. 33.

58  Vorel 2005, p. 37; Bůžek 2009, pp. 94–97.

59  Vorel 2005, esp. p. 96, note 261.

60  Among the members of the aristocracy active in the court circle of Archduke Ferdinand II, the families of Berka of Dubá, Donín, Gutnštejn, Lobkowicz, Lokšany, Šternberk and Thurn were particularly well-represented, and the knightly families were represented by Černín of Chudenice, Kaplíř of Sulevice, Miřkovský of Tropčice, Pětipeský of Chýše, Vřesovec of Vřesovice and others – Václav Bůžek, 'Ferdinand II. Tyrolský a česká šlechta (K otázce integračních procesů v habsburské monarchii)', *Český časopis historický* 98 (2000), pp. 261–291; Bůžek 2009, pp. 88–97, 241–278.

61  Bůžek 2009, p. 93.

firmed by their personal signature, they were entitled to purchase property here. The first to acquire this privilege was Ludwig Tobar in 1553.[62] He was followed by more of the archduke's courtiers, who immediately took advantage of their newly acquired rights to purchase houses and estates. Among them were Andreas Teufel of Enzersdorf,[63] Julius of Hardegg (Fig. 1),[64] Andrea Gallo of Gallis,[65] Martin Maminger of Lok,[66] Jan Velingar of Fehynek,[67] and Franz of Thurn and Kříž,[68] whose *incolat* to the land have been preserved up to the present day in the National Archives in Prague.

Prague Castle was the traditional royal residence of the kings of Bohemia, and during the years 1547–1567 it also served as the temporary seat of the archduke as governor. Thus in its vicinity there was a considerable change in the composition of the population during the course of the 16th century. The neighbourhood was filled with houses and palaces belonging to the Czech nobility, the most splendid of which belonged to the lords of Švamberk, Rožmberk and Pernštejn. As early as the first half of the sixteenth century, some of these houses had already been purchased by courtiers of King Ferdinand I. After 1547 some of these courtiers sold their houses to the newly-arrived servants of Archduke Ferdinand II. One of these, for example, was the vice-chancellor and privy councillor of Ferdinand I, Dr. Georg Gienger. His house later passed into the ownership of Archduke Ferdinand II's *Oberstkämmerer* (lord chamberlain), Alois of Lodron.[69] At the beginning of the 1560s the above-mentioned Franz of Thurn,[70] Andrea Gallo[71] and also the personal chef Hans Piger,[72] already had houses in Prague Castle or its vicinity. However, only some of the archduke's courtiers man-

---

62    NA, Reversy k zemi (Commitments to the Land, hereafter RevZ), inv. no. 12: 11 March 1553: "Ludwig of Tobar (von Dubar), Freeman from Enzefeld, courtier of Archduke Ferdinand, avows himself to the land", original, parchment, seal appended.

63    NA, RevZ, inv. no. 20: 18 January 1558: "Andreas Tejvl (Teufel) and at Encesdorf, supreme equerry of Archduke Ferdinand, avows himself to the land". Original, parchment, seal appended.

64    NA, RevZ, inv. no. 21: 26 November 1558: "Julius Count of Hardek…, counsellor of His Imperial Grace and supreme marshal, counsellor of Archduke Ferdinand, avows himself to the land". Original, parchment, seal appended.

65    NA, RevZ, inv. no. 22: 3 December 1558: "Andrea Gallus of Gallis, life physician of His Imperial Grace and Archduke Ferdinand, life physician of Emperor Ferdinand and Archduke Ferdinand, avows himself to the land". Original, parchment, seal appended.

66    NA, RevZ, inv. no. 27: 17 October 1561: "Martin Maminger of Lok, supreme kitchen master of Archduke Ferdinand, avows himself to the land". Original, parchment, seal appended.

67    NA, RevZ, inv. no. 32: 25 November 1561: "counsellor of His Imperial Grace and Archduke Ferdinand, doctor of both laws, avows himself to the land". Original, parchment, seal appended.

68    NA, RevZ, inv. no. 33: 25 November 1561: "Franz Count and Freeman of Thurn (Turn) and at Kříž, supreme hereditary chief steward of Kraňsky Principality, counsellor of His Imperial Grace…, supreme steward of Archduke Ferdinand, avows himself to the land". Original, parchment, seal appended.

69    The Archives of the Prague Castle (hereafter APH), ČDKM, inv. no. 172. Jaroslava Hausenblasová, 'Prag in der Regierungszeit Ferdinands I. Die Stellung der Stadt im System des höfischen Residenznetzwerks', *Historie – Otázky – Problémy* 7:2 (2015), pp. 9–28 (24).

70    NA, Kopialbuch, inv. no. 78, fol. 128.

71    NA, Kopialbuch, inv. no. 54, fol. 242v.

72    TLA, Ferdinandea, cart. 10, 1561, unfoliated.

Fig. 2. Tombstone of Ludwig Tobar, Prague, St. Vitus Cathedral

aged to acquire property within the castle. The remainder had to be satisfied with the area below it. For example, Dr. Johann Wellinger, counsellor of appelate court, and later vice-chancellor of the Tyrol, owned a house in the Lesser Town and sold it on his departure for the Tyrol to Osvald of Schönfeld, the archduke's secretary and later vice-

chancellor of the Kingdom of Bohemia.[73] The archduke's personal tailor Hans Kachel also owned a house in the Lesser Town of Prague.[74]

Some of the courtiers also found their final resting place in Prague. Among them were the Austrian nobleman Hans Gregor of Herberstein (d. 1548), the archduke's table waiter, the above-mentioned Ludwig Tobar (d. 1553) and the apothecary Claudius Trippet (d. 1560): the three men's gravestones are still preserved today in St. Vitus Cathedral in Prague Castle.[75] (Fig. 2)

## b) Offices of the Kingdom of Bohemia

Even though Archduke Ferdinand II often left the Bohemian Lands, usually on the orders of his father, his permanent residence was at Prague Castle.[76] Here he devoted himself to his duties as governor, in function of which he depended on the working system of the offices of the Kingdom of Bohemia and the other lands of the Bohemian Crown. The Czech and later also Austrian nobility that the king appointed to these offices thus became, in the years 1547–1567, part of not only the political, but also the social and cultural circle of the archduke. Among the high officials of the Kingdom of Bohemia who were close to Ferdinand I and his representatives, in both their political and religious opinions, were the *Oberstburggraf* (supreme burgrave) Jan the Younger Popel of Lobkowicz, the *Obersthofmeister* (lord high steward) of the Kingdom of Bohemia Jan the Elder Popel of Lobkowicz and the *Oberstkanzler* (supreme chan-

Fig. 3. Master of the Lords of Rožmberk, Jáchym of Hradec, 1561–1565 (Prague, The Lobkowicz Collections, inv. no. LR 4763)

73   TLA, Ferdinandea, cart. 8, fol. 20 (Ferd. 395/20), 1567, 2 April. About Osvald Schönfeld see note 50.
74   TLA, Ferdinandea, cart. 10, after 1560, unfoliated.
75   *Umělecké památky Prahy. Pražský hrad a Hradčany*, ed. by Pavel Vlček (Prague, 2000), pp. 102–103.
76   In this volume, see the chapter 'The life of Archduke Ferdinand II: Between ambitions and reality'.

cellor) Jáchym of Hradec.[77] (Fig. 3) In practical matters and in the sphere of the economic administration of the Kingdom of Bohemia the archduke depended chiefly on officials from the ranks of the lower nobility. An important place among these was held by Volf Vřesovec of Vřesovice, a member of the old Czech nobility who, in recognition of his loyalty to the monarch during the 1547 uprising, acquired the position of *Oberstlandschreiber* (supreme scribe) of the Kingdom of Bohemia and in 1562 became the Bohemian *Kammerpräsident* (president of the Royal Bohemian Chamber). He was assisted in the acquisition of this position by Archduke Ferdinand II, who also made use of his services outside the official framework. From the sources we learn that Vřesovec acquired monies required by the archduke for his social and patronage activities, and when the archduke was not present Vřesovec also supervised the construction and financing of the Star (Hvězda) Summer Palace.[78]

Other men who would also soon become part of the political and social circle were the *Berghauptmann* (supreme sheriff of underground mining) of the Kingdom of Bohemia Kryštof Gendorf of Gendorf (1497–1563), originally from Carinthia,[79] the *Kammerrat* (counsellor) of the Royal Bohemian Chamber Florian Griespek of Gries-

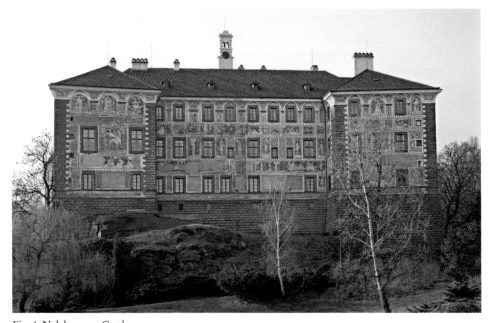

Fig. 4. Nelahozeves Castle

77   Bůžek 2009, p. 114.

78   Jaroslava Hausenblasová, 'Porträtmedaille des Wolf von Vresowitz', in Exh. Cat. Prague 2017, p. 98, cat. no. II/6 and pp. 57–58, cat. no. II/6; Ivan P. Muchka, Ivo Purš, Sylva Dobalová and Jaroslava Hausenblasová, *The Star. Archduke Ferdinand II of Austria and His Summer Palace in Prague* (Prague, 2017), pp. 51–52.

79   For more detailed information about his life and activity as a patron see Jiří Louda, *Kryštof Gendorf* (Vrchlabí, 2015).

pach, originally from the Tyrol,[80] and the *Schlosshauptmann* (sheriff) of Prague Castle Jiří Gerstorf of Gerstorf (from 1558 on), who came from Lusatia.[81] These officials had also demonstrated their loyalty to the monarch in 1547, which not only helped their successful further careers, but also led to their acquiring numerous property assets. Advantageous purchases of property, which included estates, manors and houses in Prague, and the subsequent costly building alterations undertaken at these sites also guaranteed Gendorf and Griespek their place among the particularly important Renaissance patrons of the middle of the 16th century. (Fig. 4) All of these officials were paid a regular salary funded by the Royal Bohemian Chamber.

### c) The wider court circle: builders, artists, scientists, court suppliers, correspondents

Archduke Ferdinand II had already had ample opportunity to be inspired by the rich cultural life at the Habsburg and other European Renaissance courts during his childhood in the Tyrol, his visits to Vienna, and during his later travels around the empire, the Low Countries and Italy. His governorship in Bohemia was also an important stimulus for his own patronage activities: here, one of his duties included supervising the reconstruction of Prague Castle, already started in the 1530s by his father Ferdinand I. Archduke Ferdinand II's responsibility for the proper running of the building works was confirmed in the *Bauordnung* (building regulations) issued by the king. We find a precise definition of the archduke's authority, for instance, in one such building regulation from 1557, which stipulated that no construction or reconstruction could begin without his knowledge and also that he personally should consider all the plans or proposed models of buildings.[82] He also had the same authority in the so-called chamber estates (estates belonging to the king in the Kingdom of Bohemia), where there were also alterations underway to various castles (especially at Poděbrady, Brandýs nad Labem, and Lysá nad Labem).[83]

The archduke had to respect the system of organisation and commission as stipulated by the monarch, but at the same time, from the very beginning of his residence, he created his own court's cultural circle and systems. Soon this included not only the *Baumeister* working in the Prague royal residence or in the chamber estates, but also the stonemasons, stucco artisans, masons, painters, craftsmen and other persons who worked for the king but were also gradually beginning to receive their orders from the archduke. For Archduke Ferdinand II, cultural sponsorship very soon became not only a personal pleasure, but also an expression of the need to represent his office and his social standing. In the creation of his socio-cultural networks, the archduke also utilised his newly acquired connections to the Czech nobility, Prague University and

---

80   Roma Griessenbeck von Griessenbach, *Florian Griespek von Griespach in Geschichte und Gegenwart* (Regenstauf, 2014), pp. 30–55; Exh. Cat. Prague 2017, p. 96, cat. no. II/5a-c and p. 57, cat. no. II/5a-c.

81   Gerstorf z Gerstorfu, in *Ottův slovník naučný*, X (Prague, 1896), pp. 82–84 (83).

82   NA, Stará manipulace (hereafter SM), S 21/3, cart. 2090: 1557, 1 April, unfolioed.

83   Muchka / Purš / Dobalová / Hausenblasová 2017, pp. 29–31.

the humanist circle active around it. He also widened his contacts to include the surrounding European countries, making use of wide-branching family connections.[84] The relationships between artists, scholars and the archduke were mainly based on occasional commissions and therefore also on intermittent payments. The majority of these persons were not, then, members of his *Hofstaat* (official court), but only of a wider court circle loosely connected to the archduke. The activities of this wider circle were not subject to any precise rules, and its composition was completely at the archduke's discretion, since his father King Ferdinand I did not interfere in it. There were however exceptions amongst the artists or scholars belonging to the cultural circle of the archduke. For instance, the painter Francesco Terzio, creator of several of the archduke's portraits, is listed in sources as "Hofmaler des Erzherzogs Ferdinands"[85] or "Hofdiener des Erzherzogs Ferdinands"[86] and we can therefore assume that he was a salaried member of the *Hofstaat*. However, as we do not have any complete list of the court from the years 1547–1566 at our disposal, we still cannot state this with absolute certainty. In the same way we do not know when the important scientists and humanists Georg Handsch[87] and Pietro Andrea Mattioli (author of a herbarium, medical writings and also of a description of the ceremonial arrival of Emperor Ferdinand I in Prague in 1558)[88] actually served as personal physicians to the

---

84  See the article by Joseph Patrouch in this volume.

85  For the year 1554 Terzio is listed in the *Hofzahlamtsbuch* of the Court Chamber as "erzherzogen Ferdinandt maller", see Wendel Boeheim, 'Urkunden und Regesten aus der k.k. Hofbibliothek', *Jahrbuch der kusthistorischen Sammlungen des Allerhöchsten Kaiserhauses* (hereafter as JKSAK), 7 (1888), pp. XCI–CCCXIII, reg. 4910 on p. CXIV, whereas in 1556 he is already described as "des Erzherzogs Ferdinand Hofmaler", see Boeheim 1888, p. CXV, reg. 4922. We also find him under this title in accounting sources in 1561 (Hans von Voltelini, 'Urkunden und Regesten aus dem K. und K. Haus-, Hof- und Staats-Archiv in Wien', *JKSAK* 11 [1890], pp. I–LXXXIII (LXXVII), reg. 6523), 1562 (David von Schönherr, 'Urkunden und Regesten aus dem k.k. Stadhalterei-Archiv in Innsbruck', *JKSAK* 11 [1890], pp. LXXXIV–CCXLI, p. CCX, reg. 7639), 1565 (David von Schönherr, 'Urkunden und Regesten aus dem k.k. Stadhalterei-Archiv in Innsbruck. Fortsetzung', *JKSAK* 14 [1893], pp. LXXI–CCXIII, p. LXXVI, reg. 9795 and p. LXXXVI, reg. 9826), 1568 (Schönherr 1893, reg. 10118 on p. CXII and 10128 on p. CXII).

86  Karl Friedrich von Frank, *Standeserhebungen und Gnadenakte für das Deutsche Reich [...]*, V (Schloss Senftenegg, 1974), p. 98, where it is recorded as of 1 October 1565 (Vienna), that "Tertiis, Franz de, Hofdiener des Erzeherzogs Ferdinand", received a noble title and the coat of arms he had already received in 1561 was enhanced.

87  Cf. articles by Lucie Storchová and Marta Vaculínová in this book

88  For a herbal and medical writings see articles by Ivo Purš and Katharina Seidl in this volume; Pietro Andrea Mattioli, *Le solenni pompe, i superbi, et gloriosi apparati, i trionfi, i fuochi,... fatti alia venuta dell'invictissimo imperadore Ferdinando primo, dal serenissimo suo figliulo l'archiduca Ferdinando, nella cittá di Praga l'ottavo giorno di novembre* (Prague, 1558). He was raised in 1561 by Emperor Ferdinand I to the rank of knight and in 1562 he was awarded the title of imperial counsellor – Karl Friedrich von Frank, *Standeserhebungen und Gnadenakte für das Deutsche Reich [...]*, III (Schloss Senftenegg, 1972), p. 202. Mattioli's career and works, including his stay in Bohemia, was described by Miroslava Hejnová, *Pietro Andrea Mattioli 1501–1578, u příležitosti 500. výročí narození / in occasione del V centenario della nascita* (Prague, 2001); for a Mattioli's descriptions of an architecture see Guido Carrai, Pietro Andrea Mattioli: architettura ed effimero alla corte imperiale alla fine del XVI secolo, in *Humanitas latina in Bohemis*, ed. by Giorgio Cadorini and Jiří Špička (Kolín and Treviso, 2007), pp. 169–194 (173).

*Simens, vt corpus, depingi poſſet, imago*
*Vna Dioſcoridis, Matthioliá foret.*

*Georg: Handſchius.*

Fig. 5. Pietro Andrea Mattioli, in Pietro Andrea Mattioli,
New Kreuterbuch, Prague 1563 (Prague, National Library
of the Czech Republic, sign. 16 A 50)

archduke.[89] We find both Handsch and Mattioli in the court lists for the first time around 1567.[90] (Fig. 5)

The reason why neither artists nor scholars were usually a fixed part of the court during Archduke Ferdinand II's residence in Bohemia, and were dependent on occasional commissions or support in the publication of works, was simply that archduke's financial capacities were limited. His personal requirements, the maintenance of the court, commissions for art and building works, and the beginnings of his art collections were all financed from several sources, discussed below.

Even after 1547 the king covered the costs of the operation of Archduke Ferdinand II's court from the budget of his *Hofkammer* (own court chamber), but as opposed to the preceding period, only to a limited extent. In the years 1547–1554 the *Hofzahlamtsbücher* (court accounting books) record the payment of considerable sums for the running of the archduke's court. Later Ferdinand I paid his son what was known as a *deputat* (appanage) and also paid some of his exceptional outgoings, usually clothing, materials and representational requirements on the official tours and visits he entrusted to his son. The accounting books from the years 1554 to 1562 provide us with information about the level of the *deputat*, and especially the purposes for which the archduke expended it.[91] Ferdinand I was evidently convinced to establish this kind of regular payment to his son by the catastrophic situation that occurred in 1554, when the outstanding sum that the archduke owed to his court servants and craftsmen for their salaries, as well as for various purchases, totalled 32,491 *Gulden* and 20 crowns. From this year onwards the

89   See the contributions from Ivo Purš, Lucie Storchová and Marta Vaculínová in this volume.
90   TLA, Ferdinandea, cart. 57 (see note 102).
91   TLA, Handschrift, inv. no. 1357, 1554–1562: "Verzeichnis dessen, was Kaiser Ferdinand I. an jähr-
      lichem Deputat und anderen Summen gegeben hat", fol. 1–29.

monarch allocated to his son 20,000 *Gulden* annually, sometimes even more. In the years 1556–1557 the archduke used these funds to pay for, among other things, his great building project – the Star Summer Palace.[92] In 1557 Ferdinand I allowed his son an exceptional sum for his armoury[93] and in 1558 further compensated him, in the form of *deputat* (appanage), for the archduke's expenses in preparing and organising the ceremonial welcoming of his father to Prague as the freshly crowned Emperor.[94] Up until roughly 1556, though, Ferdinand I had paid for at least some of the exceptional expenses accrued by Archduke Ferdinand II.

Goods ordered by the archduke from Innsbruck to be sent to his court in Prague were also partly covered from 1547/48 by the Upper Austrian Chamber,[95] but the greatest part of the costs of maintaining the governor's court lay on the shoulders of the Royal Bohemian Chamber in Prague and also on the Czech estates, which paid them from the *posudné* (*Biergeld*, the so-called barrel tax), i.e. the tax on beer, wine and spirits.[96] If we consider the fact that expenditure on the courts of the numerous children of Ferdinand I was continuously rising, whereas the monarch's incomes did not increase to any fundamental extent, the question finally arises of whether it was the obligation of the Czech estates to cover the costs of the monarch's court (if he was resident in the country) or that of his representative, that motivated Ferdinand I to make Prague his son's residence from 1547. In his testament Ferdinand I even stipulated that after his death the Royal Bohemian Chamber was to continue to pay the Archdukes Ferdinand and Karl an annuity of 10,000 *Schock* (threescore) of *Meissen Groschen* until the end of their lives. In 1575 the Czech estates were still complaining to Bohemian Diet about this excessive burden.[97]

---

92   TLA, Handschrift, no. 1357, fol. 1v: "[1556] Mehr ist Irer Fr. Dr. etc. zu erpauung des Neuen tiergarten von einem alten ausstandt ettlicher verkauften dorfer, so graf Wolf Schlickh von Irer Mt. etc. gekauft bewilligt worden 2300 taller … 2683 fl.", Ibidem, fol. 2r: "[1557] Mehr haben Ir Mt. etc. Ir Dr. etc. zuerpauung des Neuen Tiergarten 25.000 taler gnedigist bewiligt … 29.166 fl. 40 kr."; Ibidem: "So ist im ersten anfanng[en] des gebeu am Neuen Tiergarten durch den rentmaister herrn Hansen Spiegl vierhundert und drey taler aindlif groschen vier pfening clain bezalt und die neben andern zum empfang ins pfeningmaister ambt kommen thuen … 470 fl. 23 kr. 3 d."

93   TLA, Handschrift, no. 1357, fol. 2r: "[1557] Mehr so haben die Röm. Khay Mt. Irer Fr. Dr. etc. zu huelf derselben rustcammer und verbrachten raiß nach Regenspurg allergenedigist achczehen tausent taler richtig zu machen bewilligt … 21.000 fl."

94   TLA, Handschrift, no. 1357, fol. 2v: "[1558] In ernenten 58tn jar haben Ir Rö. Khay. Mt. etc. Irer Fr. etc. von wegen uncosten des gehalltenen triumps und graf Anndre Schlicken aufgeloffenen schaden halben drey tausend vierhundert ain und dreissig taler acht und funfzig kreuzer bewilligt … 4.003 fl. 48 kr. 2 d."

95   We have information about the sending of southern fruit ("welsche frucht"), delicacies, fish and other requirements from Tyrol to Prague not only in the ledgers books of the Upper Austrian Chamber (O.Ö. Raitkammerbücher) from the years 1547–1566, but also by correspondence in the TLA, Ferdinandea, e.g. cart. 219, Pos. 225.

96   Documents on the amounts paid out by the Royal Bohemian Chamber to the court accountant of Archduke Ferdinand II can be found in the accounts book of 1551 – Vorel 2005, p. 16, as well as in the TLA, Handschrift, inv. no. 1357 and also in the v NA, České oddělení dvorské komory (ČDKM) I, 1555.

97   *Sněmy české*, IV *(1574–1576)* (Prague, 1886), no. 75, pp. 242–254 (248–249).

Fig. 6. Anton Boys, Shooting competition at Prague Castle, in Paul Zehendtner vom Zehendtgrub, Ordenliche Beschreibung mit was staattlichen Ceremonien [...] den Orden deß Guldin Flüß in disem 85. Jahr zu Prag und Landshut empfangen und angenommen, Dillingen 1587 (Prague, National Library of the Czech Republic, sign. 65 D 003135, fol. 130–131)

In the course of time Archduke Ferdinand II acquired his own property in the Lands of the Bohemian Crown. In 1560 he purchased the estate of Chomutov and in 1565 also Křivoklát, the income from which he could use as he wished. Even this, however, was not enough and for this reason the archduke did leave large debts outstanding in the Bohemian Lands after his departure to the Tyrol. His creditors were often the Czech nobility who did, however, very willingly participate in the rich social life for which the court soon became famous.[98] Contributing to the imbalance between income and expenditure were the frequent hunts, banquets, tournaments and other entertainments that the archduke organised and which became an intrinsic part of his representation strategy. (Fig. 6) Organising skills, cultural acumen and contacts with leading artists and scholars made him the ideal organiser for the welcoming ceremony to greet the newly crowned Emperor Ferdinand I into Prague on the 8th of November 1558, and co-organiser of the coronation of Maximilian II as the King of Bohemia in 1562. The late 1550s to early 1560s was thus one of the most financially demanding periods of the archduke's life. An interesting testimony to the intensity of his social life is provided by a manuscript book documenting the high consumption of wine at his court in 1561, when not only his father but also his younger brother Archduke Karl were resident in Prague.[99]

---

98  In December 1562, for instance, the archduke asked the Royal Bohemian Chamber through its newly appointed President Volf Vřesovec of Vřesovice for assistance in the repayment of debts to a total of almost 36,000 *Thalers* – among the creditors were, for instance, Bořivoj of Donín, Václav of Lobkowicz, Jaroslav Smiřický, Reinold Nostic and others – see TLA, Ferdinandea, cart. 9, unfolioed.

99  TLA, Handschrift, inv. no. 5476, 1561: "Rechnung über den Weinverbrauch an der Hoftafel des Erzherzog Ferd. II. als kaiserl. Statthalter zu Prag".

## Ruler of Tyrol (1567–1595)

After the death of Emperor Ferdinand I in 1564 his second son became, in keeping with his will, ruler in the Tyrol. Even though Archduke Ferdinand II continued to hold the position of governor in the Bohemian Lands for two years after his father's death, he was in fact from that point on a sovereign ruler, politically and economically independent. However, he did of course continue to be closely linked with the whole Habsburg family. This new social standing and the administrative and representational obligations arising from it were logically also reflected in his court.

In contrast to his period as governor in the Lands of the Bohemian Crown, for which it is difficult for us to find summarising sources of evidence such as lists and so on, the third stage of development of Archduke Ferdinand II's court is very richly documented. First and foremost, a number of court lists have been preserved in the Tiroler Landesarchiv in Innsbruck, many of which are however undated or incomplete.[100] Nonetheless, we can also draw on instructions, lists of debts, or reports on attempts to reform the court. Financial management is documented in many *Oberösterreichische Raitkammerbücher* (accounts books from the Upper Austrian Chamber), and in the chamber's correspondence with the archduke and his individual officials.

Soon after the move to Innsbruck we can see changes in the form, size and composition of the archduke's court. Evidence of this is provided by an undated list, the date of which we can with the greatest probability determine as the turn of the years 1567/68.[101] The structure of the *Hofstaat* was already identical with the courts of Europe's ruling sovereigns, and the different parts of this structure were responsible for all the separate roles that a ruler's court fulfilled at that time. At the head of the court there was once again an *Obersthofmeister* (lord high steward), however this post was not occupied at the time the list was made. Listed as next in order is the *Obersthofmarschall* (supreme marshal) and immediately after him the *Oberstkämmerer* (lord chamberlain). This prestigious function was held in the first years of the court in Tyrol by Blasius Khuen of Belasy. For the political and administrative agenda the archduke had a five-member *Hofrat* (court council) led by Kaspar of Wolkenstein, then a *Hofkammer* (court chamber, for financial matters) and a *Hofkanzlei* (court chancery), at the head of which was the *Oberstkanzler* (supreme chancellor) Johann of Schneeberg. The administration of the lands ruled by the archduke – primarily the *Grafschaft* of Tyrol – came under the jurisdiction of these offices.

The increased demands on service also called for increased numbers in the staffing of the archduke's personal chamber. Already around 1568 his comfort and privacy were ensured by seven chamberlains, two chamber servants, a wardrobe master, a

---

100  TLA, Ferdinandea, esp. cart. 49, 57.

101  TLA, Ferdinandea, cart. 57, undated: "Verzaichnis der F. Dt. Erzherzogen Ferdinanden zu Österreich ganzen Hoffstats, aller und jeder derselben officier und diener auch was und wieviel ain jeder insonderheit von seinem offici und dienst zu jerlicher besoldung aus ir Dt. etc. hoffpfeningmaisters ambt zuempfahen hat, wie hernach underschidlichen volgt", unfolioed.

chamber doorkeeper, a chamber *fourrier*, a scribe and a stoker. There is a striking number of physicians and pharmacists (5), among whom were the above-mentioned Pietro Andrea Mattioli, acting along with Johann Willebroch as the archduke's personal physician, then Georg Handsch as the court physician (intended for members of the court),[102] Hilprandt Specilanzio, a medical practitioner, and Balzer Khlösl, the archduke's personal pharmacist.

Attention was also given, of course, to the essential need for proper representation, which is evident from the large number of servants at table (12) and servants looking after the silver tableware (5), headed by the *Stabelmeister* (master of ceremonies in the dining room) Kaspar of Schönach. There was also an increase in the number of employees in the kitchen and the cellars (26), members of the court chapel (5 chaplains), musicians (4), singers (15) and boy singers headed by chapel master Wilhelm Bruneau (Brauneau). Continuing in the function of *Oberstallmeister* (supreme equerry) was Kaspar of Wolkenstein, whose staff in the stables had however increased in number, as was also the case for the regular hunting retinue. On the list of craftsmen and other artisans there also appear completely new professions. Apart from the archduke's personal tailor and bootmaker, whose products were intended exclusively for the archduke and his family, we find here an upholsterer, another tailor, and a Turkish tailor, whose products supplied the entire court. Among the members of the court we also find the armourer Giovanni Battista Ligoza, master-builder Giulio Fontana, painter Battista Fontana, a specialist in waterworks (*Wasserkünstler*) Georg Schlundt, *Ballmacher* (ball-maker) Jeronimus of Pern, locksmith Hans Schön, gardener Wolf Dousent Schön and also a further gardener at Ambras. As in preceding years, the archduke was guarded by a group of bodyguards led by *Trabantenhauptmann* Franz of Spaur. After arriving in Tyrol there were around 25 members of the armed foot guard. The court of Archduke Ferdinand II, then, comprised some 240 persons at the turn of 1567/68, which was still less than half the size of the court of his brother, Maximilian II, Emperor from 1564.[103]

On the basis of sources we can observe that in the succeeding years the archduke continued to slightly expand his court with new paid positions, to which he appointed the officials required for the exercise of his rule in Tyrol, and a permanent place on the payment records of the court was also given to other persons, such as valets, table servants, personal guards, musicians, craftsmen, artists and others.[104] The court, however, basically maintained its structure and approximate size up to the end of the archduke's life – at the end of his rule in 1595 the number of court members was estimated at only around 270.[105] In comparison with the court of Emperor Rudolf II, whose court

---

102  According to an undated court list (perhaps before 1573) G. Handsch became later the archduke's personal physician – TLA, Ferdinandea, cart. 49 (Pos. 54), unfolioed.

103  According to sources, in 1567 the Emperor Maximilian employed around 790 persons. See Hausenblasová 2002, p. 61.

104  Cf. the chapter to this volume by Elisabeth Reitter.

105  Josef Hirn, *Erzherzog Ferdinand II. von Tirol. Geschichte seiner Regierung und seiner Länder*, II (Innsbruck, 1888), pp. 466–504; Bůžek 2000, p. 272.

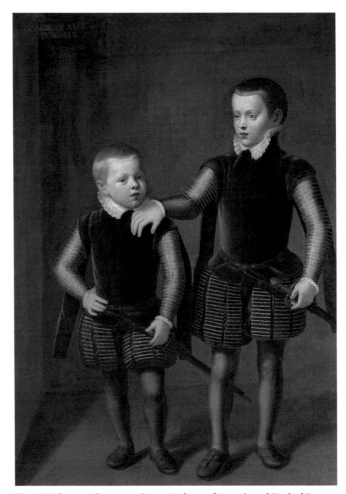

Fig. 7. Unknown German painter, Andreas of Austria and Karl of Burgau
as children, around 1565 (Vienna, Kunsthistorisches Museum,
Picture Gallery, inv. no. GG 8033)

increased in size by more than half in the years of his reign (1576–1612), so that at the
end of his rule there were more than a thousand people in it,[106] such a small increase in
numbers is surprising. The Imperial Court, however, undoubtedly served as a model
according to which Archduke Ferdinand II resolved questions of the conception and
functioning not only of his administrative apparatus as a whole, but also of its indi-
vidual offices. Thus in 1591, for instance, he requested that an authorised copy of the
instructions for Rudolf II's *Obersthofmarschall*, Paul Sixt Trautson (1582), be sent to
him from Prague. This document then evidently served as an example for the defini-
tion of the competencies and obligations of the holder of this important office in Inns-
bruck. This communication with the Imperial Court shows, among other things, that

---

106  Hausenblasová 2002, pp. 105–107.

Archduke Ferdinand II took care of his court right up to the end of his life and rule in 1595.[107]

It appears that Archduke Ferdinand II could not afford to expand his court too much and that his main financial source, the Upper Austrian Chamber, had only restricted financial capacities. The Upper Austrian Chamber also had to finance the court of Philippine Welser,[108] the courts of the archduke's sons Andreas and Karl,[109] (Fig. 7) and later also of his second wife Anna Caterina Gonzaga. In 1575 the archduke thus had to turn to the Tyrolean estates with a request for the provision of the considerable sum of 1.6 million *Gulden* for the running of all the courts, which was released from taxes collected.[110]

Even though the archduke continued to have a court that was multinational in character, from the lists it is evident at first glance that his residence in Tyrol, as well as the political and to a certain extent also financial dependence on the Tyrolean estates, brought with it considerable restrictions when filling posts at the court. Particularly noticeable is the reduction in the portion of Czech nobles. Formerly (during his residence in the Bohemian Lands), the Czechs not only successfully competed with the Austrians for posts as valets and table servants, they could also be found in other prestigious offices; in contrast, in the lists of the highest court officials from the years 1581–1593 there is no longer anyone from the Czech nobility. Only the post of chamberlain was held long-term by Jaroslav Libšteinský of Kolowraty, although in comparison with 1581, when he first held the position, probably as *Oberstkämmerer* or lord chamberlain, he moved in the years 1582–1593 to the position of an ordinary chamberlain. His leading position was taken by the Tyrolean nobleman Hans Albrecht of Sprinzenstein.[111] Among the valets we also find Bedřich of Říčany.[112] The Tyrolean court did not however escape from Spanish and especially Italian influences, certainly due to the background of the archduke's second wife Anna Caterina Gonzaga, who came from Mantua.[113]

---

107  TLA, Ferdinandea, cart. 50, 1591, unfolioed.

108  TLA, Handschrift, inv. no. 596, 1562–1576: "Außgab was Ir Fr. Dur. erzherzoge Ferdinanden zu Österreich etc. meinem genedigsten herrn ich Erhart Reutter, alls ich zu derselben pfeningmaister furgenumben werden, zu aigen handen an parem gelt und anderm, was auf Ir Fl. Dr. bevelch bezalt worden geben und zuegeschriben, wie volgt", fol. 1r–88r.

109  TLA, Ferdinandea, cart. 57, unfolioed – these are the lists of the courts of Archduke Ferdinand II's sons Andreas and Karl and documents concerning the reform of their court; TLA, Handschrift, no. 596 – see note 111.

110  Heinz Noflatscher, Erzherzog Ferdinand II. als Tiroler Landesfürst, in *Ferdinand II. 450 Years Sovereign Ruler of Tyrol. Jubilee Exhibition*, ed. by Sabine Haag and Veronika Sandbichler, exh. cat. (Innsbruck and Vienna, 2017), pp. 31–37 (33), after Werner Köfler, *Land, Landschaft, Landtag* (Innsbruck, 1985).

111  TLA, Ferdinandea, cart. 57, unfolioed.

112  Ibidem. See on this also Bůžek 2009, pp. 248–278 – he does, however, somewhat overestimate the share of the Czech nobles and their influence on the court.

113  Evidence of this can be found in the lists of the supreme officials of the court in the years 1582–1593 – see TLA, Ferdinandea, cart. 57, unfolioed.

Even though taking over the rule of the Tyrol was a long-awaited source of satisfaction and an improvement in both social prestige and material sources of income, it is possible to observe a certain disenchantment with the conditions in the 'new' city of residence and the possibilities for the provision of the court in the archduke's correspondence from this time. Soon after his arrival he turned to the merchants in Innsbruck with the complaint that it was only possible to buy gold and silver cloth, silks, woollen cloth and similar goods from them at far higher prices than was the case in Prague and demanded that they correct this.[114] Not only problems with supplying the court with luxury goods, but also with other products to which they had become accustomed in the years 1547–1567, led the archduke to maintain economic contacts with Czech nobles, from whose farm estates he continued to order foodstuffs (fish, oxen, wild fowl and so on).[115] The effort to maintain political and cultural contacts, especially after the court of Emperor Rudolf II settled in Prague in 1583, was the reason behind the archduke's frequent visits to Bohemia[116] and the continual effort to maintain a constant connection through a network of agents and informers who were – apart from artists, scholars and craftsmen – part of his wider court circle.[117]

## Conclusion

The court of Archduke Ferdinand II underwent continual development during the years 1529–1595. The development of the court's structure, size and composition of personnel, as well as the changing life at the court, played a varying role during different periods in the formation of the archduke's personality.

The period of childhood and early youth, when the archduke had not yet legally come of age and did not have his own financial resources, can be characterised as the complete dependence of a son – in this case also a possible heir to the royal throne – on his father King Ferdinand I. The archduke was the passive object of his father's political concepts and plans. The structure, size and operation of the king's children's courts, their material equipment and style of living all depended on the financial capacities of the monarch, their father.

In the period of childhood and youth, during which the archduke's upbringing was shaped by persons selected by the king, we can find the roots of his later interest in science, art and literature, but also the causes behind some of the archduke's adult decisions as regards his personal life, which are sometimes difficult to comprehend. The twenty years that the archduke spent in the Bohemian Lands should be considered of great importance, as it was there that he amassed valuable experience for his later rule in Tyrol. In addition, the emancipation from his father's control enabled him to develop

---

114 Response of Innsbruck merchants to the archduke's complaint – TLA, Ferdinandea, cart. 35. Pos. 34, fol. 574–585: 1567, 24 July, Innsbruck.
115 See for example TLA, Ferdinandea, cart. 8.
116 See a chapter 'The life of Archduke Ferdinand II: Between ambitions and reality' in this book.
117 TLA, Ferdinandea, cart. 8, 9, 34.

his own opinions on the appropriate 'content' for the life of a Renaissance cavalier, and similarly also on the functioning of his court and the persons by whom he wished to be surrounded. The archduke then realised these ideas, to a limited extent, during the last phase of his life.

It appears that for the entire duration of its existence, the court apparatus was linked both organisationally and through personnel to the royal and imperial courts, even though this bond slackened from 1567 on. The archduke evidently did not have ambitions of his own in terms of the introduction of new offices or functions. However, the social and cultural role that Archduke Ferdinand II's court circle played in Europe during that period was, thanks to his intensive support for the sciences and art, irreplaceable.

Markéta Ježková

# Archduke Ferdinand II and his journeys to the Netherlands

On his travels across Europe Archduke Ferdinand II acquired substantial experience during his two journeys to the Netherlands in 1544 and 1555. So far only marginal attention has been paid to these visits in current scholarly literature, and in addition much of the information given about them has been inaccurate. Researchers have generally been more interested in the archduke's second visit to the Netherlands, which was first mentioned by Josef Hirn.[1] Elisabeth Scheicher was one of the first researchers to devote attention to the archduke's first visit, and emphasised that a large part of it consisted of participation in festivities.[2] In more recent literature, Václav Bůžek in particular has referred to the first journey, mainly in relation to the archduke's entourage.[3] However, so far nobody has provided a more detailed description of these two visits. The present text therefore focuses on four basic questions: in the first section it concentrates on the reasons for Archduke Ferdinand II's 1544 and 1555 journeys to the Netherlands. It outlines the political situation in which the festivities of 1544 took place, then examines the extant sources concerning both the celebrations in 1544 and 1555. Finally, it indicates how the archduke himself was involved, and how this experience may have influenced him in later years.

## The year 1544 – Ferdinand's visit to Speyer

In many respects, the years 1543–1544 marked a turning point for the future archduke. As Jaroslava Hausenblasová remarks in her article, it was during this period that Ferdinand I decided to get his sons involved in the world of politics and diplomacy, and hence took them with him on several journeys.[4] (Fig. 1) The main stops on his first journey were the towns of Nuremberg and Speyer, and then Brussels. A large part of the time spent in Speyer and Brussels was taken up by participation in various festivities. During this journey Archduke Ferdinand II experienced a whole series of different events at a high social level, ranging from banquets and the conferring of lands to be held as fiefs, to tournaments, hunting, a marriage, and several triumphal entries into cities. The young Archduke Ferdinand II must have already witnessed a number of celebrations during his childhood in Innsbruck. However, none of them would have

1    Josef Hirn, *Erzherzog Ferdinand II. von Tirol. Geschichte seiner Regierung und seiner Länder*, I, (Innsbruck, 1885), p. 23.
2    Elisabeth Scheicher, *Die Kunst- und Wunderkammern der Habsburger* (Vienna, 1979), p. 77.
3    Václav Bůžek, *Ferdinand von Tirol zwischen Prag und Innsbruck. Der Adel aus den böhmischen Ländern auf dem Weg zu den Höfen der ersten Habsburger* (Vienna, Cologne and Weimar, 2009), p. 82.
4    See the chapter 'The life of Archduke Ferdinand II: Between ambitions and reality' in this volume, written by Jaroslava Hausenblasová.

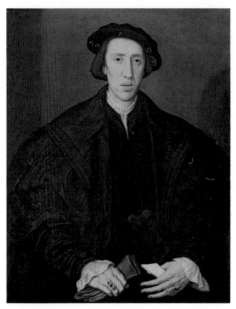 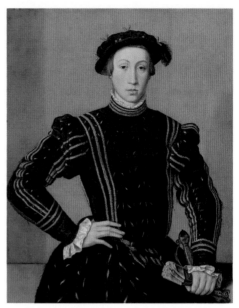

Fig. 1. Guillaume Scrots, Portrait of Ferdinand I, before 1549 (Vienna, Kunsthistorisches Museum, Picture Gallery, inv. no. GG 890)

Fig. 2. Guillaume Scrots, Portrait of Maximilian II, 1544 (Vienna, Kunsthistorisches Museum, Picture Gallery, inv. no. GG 2749)

been so spectacular as the festive events of 1544, at which he was in addition an active participant. During the first festivities in Speyer he was part of the entourage of the Emperor Charles V, and during the following ones he met with other relatives.

The main source of information about these events, and one that has so far been neglected by scholars, is the travel journal (*Journal de voyage*) of an official in the entourage of Emperor Charles V, Jean de Vandenesse.[5] This diary provides valuable testimony of how these events were regarded by contemporary eyewitnesses. Records of journeys by monarchs were a common type of document in the 16th century, and there were several secretaries in the service of the emperor who described the individual events from various points of view.[6] Vandenesse's diary can be compared, for example, with the notes made by the emperor's Flemish courtier Laurento Vitale.[7] It is

---

5    Bibliothèque Municipale de Besançon, Ms Granvelle 43. Vandenesse was not the only one who kept records of this type. Other journal records were compiled by Jean Barillon from the circle of the French King Francis I in 1515, and by Paride de'Grassi, who accompanied Pope Leo X at his meeting with Francis I. Bonner Mitchell, 'Notes for a History of the Printed Festival Book in Renaissance Italy', *Daphnis* 32 (2003), pp. 41–56 (43); *Journal de Jean Barillon secrétaire du Chancelier Duprat*, ed. by Pierre de Vaissiere (Paris, 1897–1899); *Il diario di Leone X di Paride de'Grassi*, ed. by Pio Delicati and Mariano Armellina (Rome, 1884).

6    For more on this: Richard L. Kagan, *Clio and the Crown: The Politics of History in Medieval and Early Modern Spain* (Baltimore, 2009), p. 67.

7    For more on Vitale's description, Pilar Bosqued Lacambra, 'Los paisajes de Carlos V: primer viaje a España', *Espacio, tiempo y forma, Serie VII. Historia del Arte*, 22–23 (2009–2010), pp. 103–140.

evident that the content of the journal entries of the various writers differed according to their profession and the potential addressee. Jean de Vandenesse came from Burgundy, and, if we can rely on the age he gives in this diary, he was born in 1497.[8] His father and his elder brother had already served at court, but Jean was the first member of the family to work his way up to a higher function. He tells us that he accompanied Charles V on his journeys from as early as 1514, and in 1530 he is recorded in the function of *varlet servant* (valet). By the year of the Imperial Diet in Speyer and the entry of Queen Eleanor into Brussels he held the post of *controleur* (roughly equivalent to the post of chief steward at the English court) of the household of Charles V.[9] His duties consisted of supervising the finances and ensuring that they were distributed according to the relevant orders, and he also oversaw the inventory of furniture and household goods.[10] Vandenesse dedicated his journal to Cardinal de Granvelle, whose participation in political negotiations is mentioned regularly in the journal, as are the diplomatic events in which his father Nicolas de Granvelle took part. Vandenesse travelled with the emperor and described the course of his journey step by step. In the diary he depicts only events of a public character, in which other members of Charles' court also took part. His description of each day therefore concludes with the statement that the courtiers left the festivities for the places where they were staying. Unlike Vandenesse's predecessors, his descriptions correspond to his interests and his profession as *controleur*. He carefully records details of all events and places visited, and who was accommodated where, sometimes adding a note about the most costly piece of equipment or clothing of one of the participants. Because he was responsible among other things for supervising the financing of the banquets, he pays great attention to whose house and which room they took place in, how many people were eating, and how many courses were served. He also frequently takes note of who sat next to whom, and places emphasis on the titles of the participants. From the point of view of his profession this information determined who would be served which dishes. In view of the costly nature of the festivities that usually followed the meals, he describes what took place at least in outline. As regards the political negotiations, he only mentions where they took place and the participants, but not the details of what was discussed. Vandenesse's journal is therefore a valuable source for helping us form an idea

---

8    On the basis of surviving copies, a critical edition of the text was first published by the French archivist Louis-Prosper Gachard in 1874, together with other descriptions of earlier journeys by Charles V. *Collection des voyages des souverains des Pays-Bas, tome deuxième. Itinéraire de Charles-Quint de 1506 a 1531. Journal des voyages de Charles-Quint, de 1514–1551*, ed. by Louis-Prosper Gachard, II (Brussels, 1874). A list of the manuscripts that Gachard used can be found on p. XXIV. For the purposes of the present article, the relevant passages were compared with the manuscript in the Bibliothèque Municipale de Besançon, Ms Granvelle 43, p. VII.

9    Gachard 1874, p. XI.

10   Gachard refers to a document in Spanish from the year 1545, which defines the duties of the various professions at the imperial court. "Le controleur est chargé de voir si tout ce qui est apporté et acheté pour la table de Sa Majesté ainsi pour l'état des maitres d'hotel, et ce qui est donné en argent pour les rations des offices, se distribue conformément aux ordonnances (...)". Gachard 1874, p. XII.

about Archduke Ferdinand II's journey to the Netherlands, as it informs us about the places and events where the archduke was present in the entourage of Charles V.

Vandenesse first wrote about the young Archduke Ferdinand II in the spring of 1544, when he described the Imperial Diet in Speyer. As Vandenesse tells us, after Ferdinand I and his sons arrived in the city, they attended a vigil together with Charles V on the 1st of May 1544, and on the following day a Mass for the Empress on the fifth anniversary of her death.[11] On the 5th of May the secretary recorded their attendance at another ceremony, which took place in the local town hall. Here, Charles V invested Wolfgang Schutzbar, Grandmaster of the Order of Teutonic Knights, with the fief of Prussia.[12] Three days later on the 8th of May, the wedding of one of the leading military commanders of Charles V, Lamoral Count of Egmont, Prince of Gavere, took place in Speyer. He married Sabina, Duchess of Bavaria, the daughter of John II, Count Palatine of Simmern, the emperor's representative in the *Reichsregiment* (imperial government). The marriage took place in the residence of Elector Frederick II of the Palatinate, whose wife was the emperor's niece, Dorothea of Denmark and Norway: she was also present at the wedding.[13] This new marital alliance in the family was evidently the prelude to a peace treaty between the Empire and Denmark, which was signed on the 23rd of May 1544. There was thus a symbolical dimension to the participation of the Habsburg family in the event, with individual members of the family accompanying the bridal pair around the city and in the palace where the revelries took place. While Charles V and Ferdinand I accompanied the groom as he made his way through the city, Ferdinand I's sons – the young archdukes Maximilian and Ferdinand – had the task of escorting the bride through the residence and leading her to "une salle basse", a lower hall.[14] (Fig. 2 and 3) The nuptial mass was followed by a banquet, which in keeping with tradition ended with dancing late into the evening.[15] In the spirit of Habsburg tradition as described by Margot Rauch, such a festivity represented an experience for all the senses and an opportunity to present the roles played by the different

---

11   Gachard 1874, p. 285.

12   Vandenesse only adds a brief description that documents the usual way of visualising the social hierarchy at such events in a secular setting during this period. Charles V came attired "en son habit imperial" (in his imperial robes) and seated himself on his throne. The Prince-Electors, as the most important participants, sat on a podium, while the others remained standing during the ceremony. Gachard 1874, p. 285.

13   Vandenesse thought that she was the bride's aunt, but this does not correspond to the historical reality and is rather an indication of how warmly the bride was accepted by the imperial family. Gachard 1874, p. 285.

14   A description of this wedding has also been preserved in another source, which corresponds to Vandenesse's account, and which has already been examined by Gachard: Chronique des seigneurs et comtes d'Egmont, par un anonyme. See Adolph Friedrich Stenzler, 'Chronique des seigneurs et comtes d'Egmont, par un anonyme', *Bulletin de la Commission royale d'Histoire* 9 (1857), pp. 13–70 (62).

15   A list of participants is given by both sources. Gachard 1874, p. 286, Stenzler 1857, p. 62. For more information on what Habsburg banquets looked like and on their importance Margot Rauch, 'Bankett, Tanz und Feuerwerk', in *Wir sind Helden: habsburgische Feste in der Renaissance*, ed. by Alfred Auer, Margot Rauch and Wilfried Seipel, exh. cat. (Vienna, 2005), pp. 135–138.

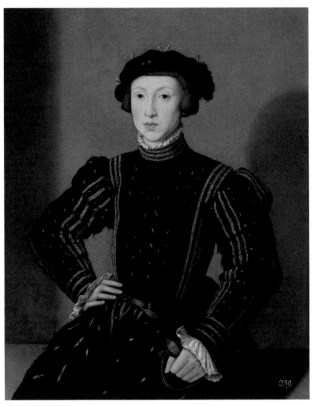

Fig. 3. Guillaume Scrots, Portrait of Ferdinand II, 1544 (Vienna, Kunsthistorisches Museum, Picture Gallery, inv. no. GG 2603)

members of the court, and was intended to demonstrate peace and political stability.[16] From this point of view, the wedding ceremony and the subsequent celebrations appear in stark contrast to the uncertain political situation of Charles V in the year 1544. Vandenesse, who was responsible for overseeing the financing of the festive table, naturally adds detailed information about the seating arrangements, which underlined the court hierarchy.[17] The importance of the event was emphasised by the use of expensive silver tableware with the Bavarian crest, which did not escape the notice of the guests.[18]

The following day the archdukes Maximilian and Ferdinand escorted the bride, together with Elector Frederick II's wife Dorothea of Denmark and Norway, who as stated above was the daughter of Charles V's younger sister and was also the ward of his second sister Mary of Hungary.

The festivities came to an end at the beginning of June, when news came to the emperor that Luxembourg had been attacked by the French.[19] He and Archduke Maximilian (Ferdinand I's eldest son, the future Maximilian II) left for France, while Archduke Ferdinand II set off for the court of Mary of Hungary in Brussels, evidence

---

16    Rauch 2005, p. 135.

17    The entire company was seated around a single table in the form of the letter T, with the emperor seated at the head of it. The bride, the two young archdukes, and most of the ladies were seated on one side, while the gentlemen sat on the opposite side. The midday meal was followed by dancing and supper, and the company did not disperse to the places where they were staying until after midnight. The Chronicle of the Egmont family provides the additional information that 35 counts served at the main table, that there were tables for the courtiers in other rooms of the residence, and that the retinue of each of the most important participants had its own table available. Stenzler 1857, p. 62.

18    Stenzler 1857, p. 62.

19    Gachard 1874, p. 286.

for which is provided, among other sources, by dispatches from the Venetian envoy at the imperial court, Bernardo Navagero (1507–1565).[20] By June, Navagero had already informed the Doge that the young archduke had arrived at Mary's court, and on the 25th of September 1544 he sent a report that Archduke Ferdinand II had accompanied Mary on her journey to Cambrai, where they awaited the arrival of Charles V.[21] Vandenesse did not meet Archduke Ferdinand II again until October 1544.

## Brussels 1544

Archduke Ferdinand II's independent court was in fact created as a direct result of his journey to the Netherlands in 1544.[22] The considerable expenses of running this court, and the surviving bills for luxury objects, personal items, and fabrics testify to the serious approach taken with regards to representation during the journey.[23] In the case of Archduke Ferdinand II, the main purpose of this journey was not, as Václav Bůžek has stated, "to acquire military experience in battles" but on the contrary to take part in the festivities that set the seal on the peace after the battles.[24] The main festivity to which the archduke was sent was the triumphal entry of the French Queen Eleanor, wife of Francis I, into Brussels in the autumn of 1544.[25] This entry marked the end of the long-standing feuds between France and the Empire.

As has been cogently described by R.J. Knecht, the relationships between the Holy Roman Empire and France underwent a number of fundamental upheavals in the first half of the 16th century.[26] The French King Francis I (ruled 1515–1547) was even invited to be a candidate in the election for Holy Roman Emperor, but in the given situation his candidacy could not have been successful.[27] Instead, it was Charles V who

---

20   Gachard 1874, p. 294, note 4. Gachard refers to dispatches from the Venetian envoy Navagero, in which he states on 5. 6. 1544 that Ferdinand has left for the court of Mary of Hungary in the Netherlands, and on 29. 9. 1544 Ferdinand is said to have accompanied Mary on her journey to Cambrai to meet Charles V. Gachard 1874, p. 294, note 4. The dispatches are held in the Archivio di Stato di Venezia, Arch. Proprio Germania, 1, Bernardo Navagero amb.

21   Gachard 1874, p. 294.

22   For more details see a text by Jaroslava Hausenblasová, 'The Court of Archduke Ferdinand II – its organisation, function and financing' in this book; Bůžek 2009, p. 82.

23   For more details on these expenses, including references to sources, see a chapter by Jaroslava Hausenblasová 'The Life of Archduke Ferdinand II: Between Ambitions and Reality' in this volume.

24   Bůžek 2009, p. 82.

25   So far, this entry has only been covered in detail by Edmond Roobaert, 'De ontvangst van koningin Eleonora', *Archives et bibliothèques de Belgique (Kunst en kunstambachten in de 16de eeuw te Brussel)* 74 (2004), pp. 125–232. His valuable study focuses mostly on identification of artists who created the subtleties (statues formed from sugar dough) for the festive banquet, the banquet's visual iconography, the creation and iconography of tapestries ordered for the occasion of the entrance of Queen Eleanor, and jewellery made for the queen as a precious gift.

26   R. J. Knecht, 'Charles V's Journey through France, 1539–1540', in *Court Festivals of the European Renaissance: Art, Politics and Performance*, ed. by J.R. Mulryne and Elizabeth Goldring (Aldershot, 2002), pp. 153–170 (153–158).

27   Knecht 2002, p. 153.

was elected in 1519 and he thus became ruler of the Duchy of Milan, which, however, Francis I had already brought under his control in 1515. The disputes that followed eventually led to war, which culminated in 1525 with Francis' defeat at the Battle of Pavia and his subsequent imprisonment. In 1529 a peace treaty was signed in Cambrai, and as a sign of reconciliation Francis I married Eleanor, the sister of Charles V.[28] Nevertheless, conflicts continued even after this. In 1543 the emperor joined forces with the English king Henry VIII, who attempted to gain control of territory in northern France. However, financial problems prevented Charles V from continuing effectively in his struggle against France, and so in September 1544 he decided to conclude a separate peace with France. The peace treaty was signed in the French town of Crépy-en-Laonnois on the 18th of September 1544, and the following day during Mass Charles V vowed to observe the peace settlement.[29]

It was necessary to quickly spread, propagate, and celebrate the news of this event throughout the empire, and this task was undertaken by Queen Eleanor together with the King's official mistress, the Duchess of Étampes. Eleanor thus took on the role of mediator in these reconciliations, as had been the case in July 1538, when her intervention had helped bring about a meeting between the two monarchs in Aigues-Mortes after nearly two years of enmity.[30]

The aim of the festivities in Brussels was to present France as a friend and ally of the Holy Roman Empire, and to bring about general acceptance of the peace conditions on both sides. As a sign of the renewed links between the rulers, festivities were therefore planned in connection with the queen's triumphal entry into the city. Here she was supposed to meet her brother Charles V and her sister Mary of Hungary, Governess of the Habsburg Netherlands.[31] Mary was one of the principal organisers of the Netherlandish festivities and, like Eleanor, had already played an important role in the relationship between France and the empire, when she had signed a treaty of cooperation with Francis I in Compiègne in October 1538, after a series of banquets, balls, and hunts.[32]

28 For more details on the continually neglected figure of Eleanor of Austria: Ghislaine De Boom, *Eléonore d'Autriche* (Brussels, 2003); Michel Combet, *Éléonore d'Autriche* (Paris, 2008). On her activities as patron of the arts: Annemarie Jordan Gschwend, 'Leonor of Austria. Queen of Portugal and France. Patronage, collecting and the arts at the Avis and Valois courts', in *Patronnes et mécènes en France à la Renaissance*, ed. by Kathleen Wilson-Chevalier and Eugénie Pascal (Saint-Étienne, 2007), pp. 341–380.

29 Gachard 1874, p. 293.

30 Wim Blockmans, *Emperor Charles V* (London, 2002), p. 127.

31 In a letter dated the 10th of October and addressed to Antoine de Granvelle, the French Admiral Claude D'Annebault already assumed that the queen would soon set out on a journey to visit her brother, and that Antoine would also be on his way back to the imperial court. For more on this: *Calendar of letters, despatches and State papers relating to the negotiations between England and Spain, preserved in the archives at Simancas, Vienna, Brussels and elsewhere, Vol. 7. Henry VIII, 1544*, ed. by Pascual de Gayangos (London, 1899), p. 411. The original of the document is said to be held in the Österreichische Staatsarchiv, but the exact location is not specified.

32 Blockmans 2002, p. 126.

Because a number of questions remained unresolved after the peace treaty, the representatives of the main parties came together in Brussels.[33] In addition to the public entertainment, a large number of festive events took place that were intended only for selected participants, and which formed the background for further political negotiations. As was usual in such cases, the 'message' of the public festivities was intended for the general population, while the message of the private festivities was addressed to court circles.[34]

The main task of the young Archduke Ferdinand II was to take part in the procession during the triumphal entry. However, he was not just a passive witness, but an active participant in the subsequent festivities.

As has been repeatedly stated in scholarly literature, the main function of triumphal entries was to publicly demonstrate the power of the monarch in a highly visual form.[35] Particularly in the early modern age, when power presented by aggressive means was proving more and more ineffective, triumphal entries became increasingly important. Their aim was to arouse loyalty to the king or emperor and his family among the population in a non-aggressive way.[36] Thus triumphal entries were simultaneously a way of creating an image for the ruler and the principles and methods of his government: in other words, different aspects of his propaganda.[37] Ceremonial entries represented one of the main expressions of royal ideology, and the capacity to carry them out was a relatively important privilege granted to those in power. They were also an opportunity to confirm the status of the various members of the court.[38] Although the processions during the entries did not offer too many opportunities to present this hierarchy, the order of the participants in the procession did have a symbolic significance.[39] In short, the ruler and his court stood on one side of such ceremonial entries, while on the other side the affirmative response of the population legitimised the status of the ruling elite.[40] While a monarch would only celebrate his chris-

---

33    David Linley Potter, *Henry VIII and Francis I: The Final Conflict* (Leiden and Boston, 2011), p. 392.

34    On the theme of public and semi-private representation: Jean Jacquot, 'Joyeuse et triomphante entrée', in *Les fêtes de la renaissance*, ed. by Jean Jacquot (Paris, 1956), pp. 10–11.

35    For interpretations of the triumphal entry as a demonstration of power and the associated dimension of communication: *Ceremonial Entries in Early Modern Europe: The Iconography of Power*, ed. by J.R. Mulryne, Maria Ines Aliverti and Anna Maria Testaverde (Farnham, 2015); Florence Alazard and Paul-Alexis Mellet, 'De la propagande à l'obéissance, du dialogue à la domination: les enjeux de pouvoir dans les entrées solennelles', in *Entrées épiscopales, royales et princières dans les villes du Centre-Ouest de la France (xive–xvie siècles)*, ed. by David Rivaud (Geneva, 2013), 9–22 (10). See also the monographs and numerous studies by Harriet Rudolph.

36    Alazard / Mellet 2013, p. 10.

37    For more on this, including references to the literature, and on other methodological approaches to entries: Alazard / Mellet 2013, pp. 10–11.

38    For more on entries and confirmation of court hierarchy: Fanny Cosandey, 'Entrer dans le rang', in *Les jeux de l'échange: entrées solennelles et divertissements du XVe au XVIIe siècle*, ed. by Marie-France Wagner, Louise Frappier and Claire Latraverse (Paris, 2007), pp. 17–46.

39    Cosandey 2007, p. 27.

40    Alazard / Mellet, pp. 10–11.

tening once in his lifetime, and his marriage perhaps twice (in some cases more), ceremonial entries could be used many times to repeatedly confirm his legitimacy.[41]

Eleanor's triumphal entry was evidently the last in a series of more than 75 similar festive occasions that took place during the long reign of the French King Francis I.[42] In its essentials it did not differ from other ceremonial entries in the Netherlands or France at that time. During such entries tribute was paid to the monarchs by representatives of their subjects, such as members of the guilds, and the clergy, and all of these spectators would witness a procession of the most important people in the empire.

Triumphal entries by female monarchs or consorts differed from those of male rulers in certain specific aspects, and this generally applied to Eleanor as well. As was typical, no municipal rights and privileges were confirmed in Eleanor's case, this being a male privilege.[43] Eleanor's entry was also typical in that it was connected with a peace settlement; as in other cases, here the queen symbolically embodied peace and maternal protection.[44] For this reason there was no *cortège civique* (escort made up of civilian citizens, usually including local government and magistrates) waiting for the queen at the city gates, but rather the Emperor Charles V himself. Eleanor was representing France, and the warm reception she received confirmed once more the peace between Francis I and Charles V, and between France and the Habsburg Empire. Similarly, female monarchs or consorts did not enter cities on horseback during such triumphal processions, as men usually did; most often they were carried *en litière* (in a litter) under a ceremonial canopy. Eleanor's entry did not have any allegorical programme and represented a simpler alternative to the often complex themes of other eremonial entries. Following tradition, after the opening festivities there was a Mass (not necessarily on the same day), and the ceremonial entry concluded with a banquet in the palace.[45] A particular feature was the large number of accompanying events, especially hunting, which was extremely popular with both the Netherlandish Governor and the French queen.[46]

---

41 Alazard / Mellet, p. 14.

42 For more on these festive occasions and changes in the printed information about them: William Kemp, 'Transformations in the Printing of Royal Entries during the Reign of François Ier: The Role of Geofroy Tory', in *French Ceremonial Entries in the Sixteenth Century: Event, Image, Text,* ed. by Nicholas Russell and Hélène Visentin (Toronto, 2007), pp. 111–132.

43 For entries by queens into French towns: Cynthia Jane Brown, 'Introduction', in Pierre Gringore, *Oeuvres,* II: *Les Entrées royales à Paris de Marie d'Angleterre (1514) et Claude de France (1514),* ed. by Cynthia Jane Brown (Geneva, 2005), pp. 22–23. For details of the characteristics of entries by women: Brown 2005, pp. 28–30.

44 Brown 2005, pp. 28–30 quotes Fanny Cosandey: "La reine comme symbole de paix exprimant une forme de protection maternelle est signifié jusque dans les discours qui lui sont adressés."

45 On the structure of entries by French kings and especially queens: Brown 2005, p. 24.

46 For more on this: Christoph Niedermann, 'Marie de Hongrie et la chasse', in *Marie de Hongrie. Politique et culture sous la Renaissance aux Pays-Bas. Actes du colloque tenu au Musée royal de Mariemont les 11 et 12 novembre 2005,* ed. by Bertrand Federinov and Gilles Docquier (Morlanwelz, 2008), pp. 115–123.

At present we have three main sources of information about the ceremonial entry of the French Queen Eleanor into Brussels in October 1544. We have already referred to Vandenesse's journal, which provides a detailed record of the course of the festivities from the arrival of Queen Eleanor to the departure of Charles V. Two printed pamphlets also describe the event. The bibliography of Renaissance festivities published by Helen Watanabe-O'Kelly only mentions one official printed "leaflet": *Li gran trionphi et feste fatte alla corte...*, published in Italian and dated 4th of November 1544.[47] The author of this text, signing himself with the initials V.M.V.A., refers to the Duke of Camerino as his "patrone" (patron), but his identity remains unknown.[48] To this text we can now add a second description entitled *Le littere...*, dated 25th of October 1544, which concludes its account of the celebrations on that same day.[49] (Fig. 4) Neither text is accompanied by illustrations: the title page of *Le littere...* is decorated with the coats of arms of Charles V and the French queen (with three *fleurs-de-lis*), while a historiated initial 'D' showing a wild man appears at the beginning of the first page.[50] This text also specifies the addressee, who is "Signor Cosmo", most probably, Cosimo I de' Medici, who was this time supported by the Emperor Charles V.[51] Wolfgang Kemp has divided propaganda pamphlets like this into two groups, which he called "entry leaflets", and "entry booklets" or "entry books". The Italian description falls into the category of "leaflet" or newsletter.[52] It thus belongs to the group of cheaper printed descriptions of ceremonial entries, intended to disseminate the basic information as quickly and inexpensively as possible. As was often the case with similar leaflets, this description of the entry does not contain the names of the author of the text, the publisher, or the printer, nor the place where it was published, which made it easier for other booksellers or merchants to sell it. On the basis of these contemporary

47   A., V. M. V., *Li gran trionphi et fbste fatte alla corte de la Cesarea Maesta per la pace fatta tra sua Maesta [et] il Re Christianissimo. La solenne intrata in Burcelles de la Regina di Francia. Le giostre, [et] torniamenti fatti in carezzar detta regina, con le superbe liuree, e richi pregi donati ai vincitori di detti torniamenti* (s. l., s. d).
     Text accessible at: https://www.bl.uk/treasures/festivalbooks/pageview.aspx?strFest=0112&strPage=1
     The text is referred to in: Helen Watanabe-O'Kelly and Anne Simon, *Festivals and Ceremonies: A Bibliography of Works Relating to Court, Civic, and Religious Festivals in Europe 1500–1800* (London and New York, 2000), nos. 2702 and 1591 on pp. 257 and 426.
48   The Duke of Camerino appears in texts as the joint organiser of several festivities. He was probably Mattia Varano di Camerino, a nobleman who strove in vain to have the family duchy returned to him. Carlo Botta, 'Storia d'Italia di Carlo Botta', in *Storia d'Italia di Carlo Denina*, I (Pavia, 1814), p. 459.
49   *Le littere de li honorati et superbi trionphi tra la Maesta Cesarea de l'Imperatore [et] el Christianissimo Re di Franza con el numero de li gran Signori Principi Duchi [et] Marchesi e Conti e Cauallieri...* (Venice, 1544). Accesible at :https://www.bl.uk/treasures/festivalbooks/pageview.aspx?strFest=0113&strPage=1
50   *Le littere* 1544, p. 1.
51   For relationships between the Emperor Charles V and Cosimo I de' Medici: Henk Th. van Veen, *Cosimo I de' Medici and his Self-Representation in Florentine Art and Culture* (Groningen, 2006), p. 2.
52   For more on this distinction: Kemp 2007, p. 113. The author refers to the example of "Li gran trionphi..." in the BNF in Paris (BNF R 70378), already mentioned by Watanabe-O'Kelly / Simon 2000.

reports, the event was then retold by Jaecques Stroobant in his 1670 survey of triumphal entries into Brussels.[53] His text did not provide any new information, but it helped to maintain awareness of this ceremonial entry, and repeated the information about the involvement of the young archdukes Ferdinand and Maximilian.

All three sources, Vandenesse's journal and the two Italian texts, describe the same sequence of events. The course of the festivities and the young Archduke Ferdinand II's involvement in them can be reconstructed virtually day by day, as follows.

When the Emperor Charles V received an official report of Eleanor's journey, he sent several noblemen, including the above-mentioned Lamoral Count of Egmont, to wait at the border for the queen's arrival and escort her first to the town of Hal and then on to Mons. As the Italian writer testifies, the site chosen for the meeting between the two monarchs was not far from the town of Mons, in

Fig. 4. Le littere de li honorati et superbi trionphi tra la Maesta Cesarea de l'Imperatore, Venice 1544 (London, British Library)

the middle of "belissima Campagnola" (beautiful countryside), at a place where it was possible for the protagonists to dismount from their horses and, as the author remarks, "not fall into the mud".[54] After the emperor himself had welcomed the queen, the young archdukes Maximilian and Ferdinand also dismounted and went to kiss the queen's hand and then to "kiss Madame di Tampes on the mouth according to the French custom".[55] After this the queen entered in triumphal fashion into the town of Mons, where "the leading citizens of the town, clergy, and tradespeople, with about 2000 lighted torches, came to welcome her according to the customs of these countries". The Italian reporter then recounts that after the evening meal the distinguished guests, including the two archdukes, engaged in conversation with the French queen for more than two hours.[56] After breakfast the next day, the company set out for the Forêt de Soignies (Zugni in the Italian text), where the French queen's sister, Mary of Hungary, welcomed them.[57] The two ladies spent the night at Mary of Hungary's palace in Tervuren, but according to the Italian author their comfort was quite

53   Jaecques Stroobant, *Brusselsche Eer-Triumphen* (Brussels, 1670), pp. 7–8.
54   *Le littere* 1544, p. 1.
55   *Le littere* 1544, p. 1.
56   *Le littere* 1544, p. 2.
57   *Le littere* 1544, p. 1.

"restricted".[58] The next day, Tuesday the 21st of October, they set out for another palace, that of the Habsburg governor in Hal, where the French queen remained for the night alone, while the emperor and Mary of Hungary continued on to Brussels. On Wednesday the 22nd of October in the afternoon the entire company, including the two archdukes, rode out of Brussels to meet the French queen. According to Vandenesse's account, the queen's entry was planned for the early evening. The route from the city gate to Coudenberg Palace was lined with representatives of the various guilds, each with a torch in their hand. The procession was led by "trompettes" (trumpeters), followed by "massiers et roys d'armes de Sa Majesté" (mace-bearers and 'kings of arms', a kind of herald-at-arms, of his majesty).[59] They were followed by the queen and Madame d'Étampes in litters with canopies, and these litters were carried by "gouverneurs" of the city of Brussels, who were dressed in white satin.[60] Vandenesse does not explicitly mention where the two archdukes were at this time. Charles V and Mary of Hungary received the queen and her retinue at the entrance to the palace and led her to her apartment. The Italian writer also mentions dancing that evening, which went on until late in the night.[61]

The main organisers of the festivities on Thursday the 23rd of October were the representatives of the city of Brussels, as well as the Duke of Camerino and Prince Lamoral of Egmont, whom we have already mentioned. Archduke Ferdinand II had already met Lamoral of Egmont in Speyer. Firstly, on what is today the Grand Place in front of the town hall, a *giostra* (joust) with lances took place. This did not come under Vandenesse's remit, so he merely evaluated it briefly as "fort triumphantes" (very successful). The Italian author, by contrast, spared no detail in describing the arrangement of the area for the tournament, writing about the splendid colours of the horses' caparisons and the plumes on the helmets, and the outstanding musicians. However, he had a negative view of the choice of horses: he wrote that the horses chosen were not used to tournament jousting and were unwilling to enter into combat. Furthermore, numerous falls spoilt the experience for the audience.[62] The second Italian text refrained from criticism. On the contrary, it mentioned the enthusiasm of the public and added that the archdukes Maximilian and Ferdinand were among the active participants in the tournament.[63] During the interval the legend of Theseus was performed on the square. However, we do not have any details about this performance; the Italian writer merely

---

58    Gachard 1874 refers to it as 'Soignies', see p. 295.

59    Gachard 1874, p. 295.

60    Ibidem. For more on the itineraries of entries into Brussels in the 16th century: Cécilia Paredes and Stéphane Demeter, 'Quand la marche raconte la ville. Quelques itinéraires de la cour à Bruxelles (XVIe–XVIIe siècles)', *Clara* 1 (2013), pp. 81–101.

61    *Le littere* 1544, p. 3

62    *Le littere* 1544, p. 4.

63    *Li gran trionphi*, p. 2. More on tournaments: Matthias Pfaffenbichler, 'Die Turniere an den Höfen der österreichischen Habsburger im 16. Jahrhundert', in *Turnier. 1000 Jahre Ritterspiele*, ed. by Matthias Pfaffenbichler and Stefan Krause (Vienna, 2018), pp. 155–169.

mentions the part connected with the thread of Ariadne.[64] Theseus was a popular figure in Greek mythology, and was compared to Hercules, with whom he took part in the expedition against the Amazons. One of the guests at Archduke Ferdinand II's marriage to Anna Caterina Gonzaga in 1582 came dressed as Theseus and helped to 'defeat' the Amazons at the performance held on that occasion.[65]

The tournament was followed by a banquet in the town hall, which was laid on for the emperor and the queen by the city authorities. The company was seated at two separate tables, with the two archdukes at the same one as the emperor and the ladies.[66] The city of Brussels spared no expense when organising the festivities – according to Vandenesse's account the evening meal was followed by "beaulx masques et danses" (pretty masques and dances), which continued until midnight, when the company dispersed to the places where they were staying. The Italian writer adds details about the colourful masquerade costumes of the janissaries, and the expensive fabrics and masks worn by the "serene princes", archdukes Ferdinand and Maximilian, for the dances.[67] The second Italian text noted other costumes besides those of the two archdukes. Prominent among them was a group of 12 Amazons. It can therefore be assumed that the evening ball continued the theme of the play about Theseus presented during the interval of the tournament. The text also mentions six masquerade costumes "alla turcchese" (in the Turkish style).[68] The two young archdukes also had the opportunity to display the results of their education and upbringing in Innsbruck.[69] It is reported that "..[i]t was delightful to see how well and how gracefully the princes danced", all the more so as the rapid *gagliarda* that they were performing was not among the easiest dances.[70] There was an intermission in the ball at midnight, during which the noble lords wanted to hide, but their conspicuous costumes of gold and silver material revealed them.[71]

At the end of his text the Italian writer mentions a tournament on foot, which was to be held "this evening", in other words on the 25th of October.[72] According to Vandenesse, in the morning everybody attended Mass at the Church of St Gudula and had lunch, and then at around two o'clock the entire company went to the palace courtyard. Here the archdukes Ferdinand and Maximilian engaged in a foot tournament featuring fencing with wasters (wooden sticks used in place of swords for friendly tournaments), acting as "mantenitori" (defenders), meaning they were chosen as trained and experienced fighters who were trying to protect the arena of battle. The

---

64   *Le littere* 1544, p. 4.

65   Bůžek 2009, p. 262.

66   Gachard 1874, p. 296.

67   *Le littere* 1544, p. 4.

68   *Li gran trionphi*, p. 2.

69   For more on Ferdinand's education and training in dexterity: Bůžek 2009, p. 82.

70   *Le littere* 1544, p. 4. On the Gagliarda in greater detail Curt Sachs, *World History of the Dance* (New York, 1965), pp. 358–359.

71   *Le littere* 1544, p. 4.

72   *Le littere* 1544, p. 5.

task of other participants of the joust was to defeat them in a physically challenging match.[73] Vandenesse regarded it as a "passe-temps fort bon" (very fine entertainment).[74] The second Italian text naturally did not forget to provide a detailed description of the apparel and the progression of the contests.[75] The tournament ended with the staging of a battle against the Turks.[76] For Vandenesse, the evening meal that followed was the high point of the entire festivities. Once again he took special note of the guests, the tableware used, and the number of tables and courses. The company was seated around three tables in a large hall, the "grand salle", for which the name Aula Magna later came to be used in the literature.[77] Vandenesse did not fail to notice the traditional buffet (a special piece of furniture designed for such banquets) with a total of eight (sic!) tiers, on which "gold and gilded" tableware was displayed.[78] His attention was also caught by seven pieces of horn, apparently from a unicorn.[79] These were prestigious collector's items with a practical use, for according to tradition when they came into contact with liquid or with food they were able to reveal the presence of poison.[80] Five courses were served, and then came dancing in "beaulx et riches" (pretty and luxurious) masquerade costumes, which continued until midnight. The second Italian text did not neglect to mention that the costumes worn by the archdukes Ferdinand and Maximilian were "La piu bella, e la piu riccha" (even more beautiful, and more luxurious).[81] Following this another lavish banquet was provided in the hall above the chapel, with 'subtleties': statues made from a sugar dough.[82] According to Mary of Hungary's apothecary, the display included more than 480 pounds (lb) of sugar pastries.[83] According to the accounts, the banquet had a complex iconography. In the middle of the table stood an iron fountain around which wax flowers were displayed. Several other subtleties represented Hercules and Cyrus, David and Goliath, Hercules

---

73  "Mantenadores". For full description of this role see: Bůžek 2009, p. 211.
74  Gachard 1874, p. 296.
75  *Li gran trionphi*, p. 3.
76  *Li gran trionphi*, p. 3.
77  This hall was built during the reign of Philip the Good, and to a large extent it retained the same appearance under the reign of the Emperor Charles V. It measured more then 40 × 16 metres (150 × 60 feet) and was 16 m high, thus providing sufficient space for official events of many different types. The hall was a source of wonder for the general public at that time because of its construction, with a wooden ceiling without any central support. For more on the architectural appearance of the building and the hall: Michel Fourny, 'Les vestiges archéologiques de la période bourguignonne', in *Le palais du Coudenberg à Bruxelles*, ed. by Laetitia Cnockaert, Vincent Heymans and Frédérique Honoré (Brussels, 2014), pp. 71–91 (82–93).
78  Gachard 1874, p. 296.
79  Gachard 1874, p. 296.
80  Frederick William Fairholt, *Miscellanea Graphica: Representations of Ancient, Medieval, and Renaissance Remains* (London, 1858), p. 26.
81  *Li gran trionphi*, p. 3.
82  "ung bien riche banquet de confictures et succades." Gachard 1874, p. 297. This hall was probably the Aula Magna once more, as it was adjacent to the chapel.
83  For more detail see: Roobaert 2004, p. 137.

and Proserpina leaving the inferno, Adam and Eve, and Cerberus.[84] The figure of Hercules was one of the most prominent figures in the emperor's representational iconography as witnessed by the young Archduke Ferdinand II in Brussels.

The next stage of the festivities was a hunt which Mary of Hungary had organised in the Forêt de Soignies, not far from the Tervuren Palace (Palais des ducs de Brabant) mentioned above, on Tuesday the 28th of October.[85] For the comfort of the ladies Mary of Hungary had had a "casa di legno" (wooden building) constructed, where they could rest and take refreshments during the hunt.[86] According to the archival sources, nearby in Boendale, in the Forêt de Soignies, the lodge was completed by a wooden gallery which provided comfortable place for the noble spectators of the joust.[87] We have a good idea of what this gallery looked like from a painting showing the structure four years later, in 1549.[88]

As is frequently mentioned in the literature, hunting played an extremely important role in the life of Mary of Hungary. She was even referred to as "mâle chasseresse" (literally, a 'very masculine huntress', which given the gender politics of the time was of course a high compliment).[89] Her favourite sister Eleanor also shared the same passion.[90] A hunt would therefore naturally have to be part of the festivities, in which the main role was played by Eleanor. It would seem that the Italian writer was not a devotee of hunting, because what interested him most was the *escarmouche* that followed the hunt – a combat between 100 knights on horseback which also took place in the forest. Vandenesse again appraised it as "fort bonne" (excellent).[91]

The next joust did not take place until Saturday the 1st of November, in the garden (Parcq) of the Coudenberg Palace. It was once again organised by that tried and trusted pair, Lamoral of Egmont and the Duke of Camerino, and the Italian author again spares no detail concerning the apparel of the participants.[92] On the 2nd of November the "spagnolo molto ricco" (very wealthy Spaniard), the young Spanish Count of Feria,[93] staged a "jeu de Cannes" (a friendly fencing match using wooden swords or sticks called 'wasters') in front of Brussels town hall.[94] The theme of a combat with the

---

84    For more details and links to archive records see: Roobaert 2004, pp. 136–145.

85    For more details on Mary of Hungary and hunting: Niedermann 2008, pp. 115–123.

86    *Li gran trionphi*, p. 3–4.

87    For more details on the gallery see: Roobaert 2004, p. 138.

88    See Roobaert 2004, pp. 144–145. *Carolus. Charles Quint 1500–1558*, ed. by Hugo Soly and Johan Van de Wiele, exh. cat. (Gent, 1999), pp. 219–222, cat. no. 86.

89    Niedermann, p. 115. For more on the place where a hunt was held see also Gorter-van Royen, *Correspondance de Marie de Hongrie avec Charles Quint et Nicolas de Granvelle* (Turnhout, 2009), p. 46, note 3.

90    For more on the passion for hunting of the two sisters: Niedermann, p. 117.

91    Gachard 1874, p. 297.

92    Gachard 1874, p. 297.

93    Pedro I Fernández de Córdoba y Figueroa (1518–1552), IVth count of Feria (1528–1552).

94    Gachard 1874, p. 297; *Li gran trionphi*, p. 4.

Turks was repeated, staged by 60 knights.[95] This time the Italian writer was fascinated by the unusual type of "bastoni" (probably a kind of club or rod) that recalled Turkish weapons, used instead of the usual wasters.[96] At six o'clock the company returned to the main hall of the palace, and after the evening meal there was another dance in splendid masquerade costumes. However, the hall was big enough for knightly combats to be held there, too. There are descriptions of such combat displays being held there from at least the early 16th century, especially in bad weather.[97] On this occasion 14 knights in full armour and on horseback with lances took part in the tournament, followed by a round of swordplay on foot. At the end of the tournament there was another match on foot, five against five. Vandenesse had never seen such a large hall in which tournaments could be held anywhere else, and for this reason he evaluated it very positively and regarded it as an "exceptional thing".[98] The Italian authors, by contrast, did not seem surprised in any way.

Eleanor's visit to Brussels came to an end on Monday the 3rd of November. Following tradition, at the conclusion of the festivities the emperor showered the French queen with gifts and accompanied her out of the city to the city gates.[99] The two young archdukes escorted the queen further to the town of Mons, where, as on the first journey, she spent two nights in the nearby town of Hal. Subsequently the Duke of Arschot accompanied her to the borders of the Empire.[100] The last time Vandenesse mentioned the archdukes was on the 2nd of December 1544, when they spent the night in the town of Alost with the emperor and Mary of Hungary. Their further movements are not entirely clear, but on the 2nd of December the emperor left with the archdukes for the town of Alost, where they spent the night, and then for Ghent, where they stayed for the whole of December.[101] His stay there marked the end of the Archduke Ferdinand II's journey through the Netherlands.

This journey through the Netherlands was Archduke Ferdinand II's first lengthy sojourn outside the territory of the Habsburg monarchy. For the first time, the young archduke had the opportunity to become more familiar with the high culture of the imperial court, and at the same time make use of his education and abilities. In the palaces in Brussels and Mechelen where his aunt Mary of Hungary stayed, he must have also become acquainted with her collection of artworks, and probably also met with Netherlandish artists from the circles of the court. In this connection, Blanka

---

95  *Li gran trionphi*, p. 5.
96  *Li gran trionphi*, p. 4.
97  Piet Lombaerde, 'Le parc et les jardins', in *Le palais du Coudenberg à Bruxelles*, ed. by Laetitia Cnockaert, Vincent Heymans and Frédérique Honoré (Brussels, 2014), pp. 191–215 (192). The author here refers to the testimony of Cardinal Louis of Aragon, who described how tournaments were held in the hall in the years 1517–1518, if the weather did not permit them taking place on the Place des Bailles in front of the palace.
98  Gachard 1874, p. 297.
99  For the list of gifts and their identification see Roobaert 2004, pp. 146–155.
100  Gachard 1874, p. 298.
101  Gachard 1874, p. 298.

Kubíková has drawn attention to a portrait of the archdukes Ferdinand and Maximilian that depicts them at an early age and is complemented by a portrait of their father, Ferdinand I. Its style is that of artists of the Netherlandish school, and can probably be specifically identified as that of Guillaume Scrots (flourished 1537–1553).[102] It can therefore be assumed that the portraits were created during this journey to the Netherlands.[103]

As shown by the latest research, Mary's collections had an aesthetic function, but were also intended to serve as tools of political propaganda.[104] Following the example of her own aunt Margaret of Austria, Mary of Hungary assembled a portrait gallery in her palace which strongly showcased the cult of Charles V. The emperor was considered to be the *pater familiae* of the entire Habsburg house. Similar strategies could also be found in the collections of the Central European Habsburgs.

As demonstrated above, the sources show that in 1544 the young Archduke Ferdinand II did not set out on a journey to battlefields, but rather to attend important court festivities. In Speyer and the Netherlands, together with his brother Maximilian, he represented the Central European branch of the Habsburgs. He was present at highly ritualised events: after the wedding in Speyer he took part in the triumphal entries of Queen Eleanor of France into the towns of Mons and Brussels, and subsequently also participated in spectacular tournaments, one of which he even helped to organise. In addition, he danced in lavish costumes and participated in a hunt. This active participation also explains the large sums that Ferdinand I had to spend on his sons' material representation for this journey.[105]

The young Archduke Ferdinand II became familiar with the structure of the tournament, which had its origins in the court milieu of late medieval Burgundian culture.[106] He was present at a tournament that included the staging of a story from Antique mythology, and which was followed by an evening dance in masquerade costume. He also witnessed the extremely popular tournament theme of a staged fight against the Turks, with this theme continuing in the evening ball, where the dancers wore costumes representing the same figures. He can be shown to have visited the

---

102  Blanka Kubíková, 'The image of Archduke Ferdinand II in his portraits', in *Ferdinand II. 450 Years Sovereign Ruler of Tyrol. Jubilee Exhibition*, ed. by Sabine Haag and Veronika Sandbichler, exh. cat. (Innsbruck and Vienna, 2017), pp. 55–59, esp. 55–56; *Kaiser Ferdinand I. 1503–1564. Das Werden der Habsburgermonarchie*, ed. by Wilfried Seipel, exh. cat. (Vienna 2003), p. 466, cat. no. VII. 18.

103  Kubíková 2017, pp. 55–56; Thomas Kuster, 'Archduke Maximilian II and Archduke Ferdinand II', in Exh. Cat. Innsbruck 2017, cat. no. 2.10, p. 126. Associated with the two portraits is a similar portrait of Ferdinand I (today in Vienna, Kunsthistorisches Museum). Thomas Kuster believes that the portraits were made in Speyer, where Ferdinand I was in the same place as his two sons for the last time during this journey to the Netherlands.

104  Paul Huvenne, 'La peinture dans les dix-sept provinces', in *Carolus. Charles Quint 1500–1558*, ed. by Hugo Soly and Johan Van de Wiele, exh. cat. (Gent, 1999), pp. 133–155 (133).

105  For more details on this see a chapter by Jaroslava Hausenblasová, 'The Court of Archduke Ferdinand II – its organisation, function and financing', in this volume.

106  For more on the tournaments that Archduke Ferdinand II organised and hosted: Bůžek 2009, pp. 210–214.

Habsburg residences in the towns of Brussels, Mons, and Ghent, and he also experienced more modest accommodation in houses in Hal and Alost. He saw a spectacular tournament held inside a hall in the palace in Brussels, and he also saw tournaments held in a courtyard and on the plain outside the city. He had the opportunity to observe the architecture of the main residence in the city, and also the facilities for hunting in the nearby countryside. Last but not least, he established valuable close contacts with leading members of the Netherlandish and Italian nobility. Later, during his time in Prague, the archduke was able to make use of these newly acquired experiences in the many tournaments and hunts that he held there as part of various festivities. The allegorical form of tournament, in which Christian warriors confronted knights in Turkish costumes, must have particularly impressed him. Later we find a more complicated variant of this feature in the tournaments that Archduke Ferdinand II held in Prague and Plzeň in 1553 and 1555.[107]

## The second journey of Archduke Ferdinand to the Netherlands

Archduke Ferdinand II's second journey to western Europe took place in 1555. It has already been mentioned by Josef Hirn, with reference to the published correspondence of Charles V.[108] During the Imperial Diet in Augsburg in 1555 the Emperor Charles V announced his intention to abdicate and pass on the throne. In view of the current political situation, however, Ferdinand I did not agree with this step by his brother, and sent him letters trying to persuade him to retain his title as emperor until the next Imperial Diet.[109] According to these letters, in the autumn of the same year Charles invited his brother Ferdinand I to an informal personal meeting.[110] However, Ferdinand I sent his middle son, the Archduke Ferdinand II, in his place.[111] As Hirn summarised the situation, the archduke's mission was, at his father's request, to try to postpone the emperor's planned abdication.[112] At this time Charles V was afflicted by

---

107  Elisabeth Scheicher, 'Ein Fest am Hofe Erzherzog Ferdinands II', *Jahrbuch der Kunsthistorischen Sammlungen in Wien* 77 (1981), pp. 119–154 (119).

108  Hirn 1885, p. 23.

109  Charles V sums up the situation in a letter to Ferdinand I dated 19th of October 1555: "Et au regard de linsistance que me faictes de differer mon partement, et afin que je retienne le tiltre, ou du moins que je tienne secret ce que jen vouldray faire, jusques au temps de la diette prouchaine, et les diligences qui vous semblent se devoir faire prealablement, (...) jay respondu point par point audict de Gosman, et y a encoires temps dicy au partement de ceulx que je dois despecher pour ladicte ambassade, et dicy a la, et par eulx entendrez vous plus particuluerement le chemin auquel je resoldray pour encheminer ce que dessus; (...)". Karl Lanz, *Correspondenz des Kaisers Karl V.*, III, *1550–1556* (Leipzig, 1846), p. 688.

110  In a letter dated 31st of October 1555, Ferdinand I regrets that circumstances well known to the emperor do not allow him to come in person. "...le desir que jay la venir visiter et avant son partement communicques avec icelle personnellement nest moindre comme celluy de vostredicte maieste, (...)". Lanz 1846, p. 691.

111  Gachard 1854–1855, p. 19, where he refers to the emperor's published correspondence (Lanz 1846, p. 674).

112  Hirn 1885, p. 23.

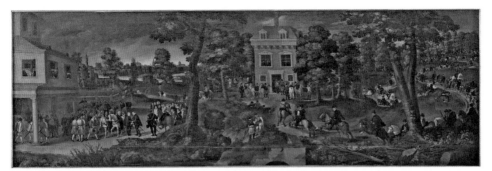

Fig. 5. Netherlandish painter, Journey of Archduke Ferdinand to Brussels (Vienna, Kunsthistorisches Museum, Picture Gallery, inv. no. GG 5782)

gout and confined to his bed in Brussels. The archduke probably arrived in Brussels between the 21st and 22nd of October 1555.[113] A delayed ceremony formalising the handover of rule over the Netherlands to Philip II took place on the 25th of October, and descriptions and illustrations of this event have been preserved in a number of publications and pamphlets. Archduke Ferdinand II's mission seems to have met with success: it was indeed not until later that Charles abdicated as emperor and passed on the imperial title to Ferdinand I, on the 3rd of August 1556.

As Gachard has already noted, so far no source has been discovered confirming Archduke Ferdinand II's participation in the ceremony of handing over rule of the Netherlands in Brussels in October 1555 and giving details of his role there.[114] In this connection, Elisabeth Scheicher has drawn attention to the painting *Erzherzog Ferdinands Postreise nach Brüsel*, displayed in Ambras Castle.[115] (Fig. 5) It is first described in the archduke's estate inventory in 1597.[116] It evidently depicts, from right to left, the different stages of this journey, which was clearly full of difficulties at the outset. In the centre can be seen the figures of two postilions on horses, who accompanied travellers for a fee and directed them.[117] In this case, however, the second postilion seems to have a purely representative function: he merely blows on his post horn to announce the arrival of a prominent person – Archduke Ferdinand II, who is following him in a black cloak. The building in the centre of the painting may therefore be a posting sta-

---

113 Gachard refers to dispatches from Mary of Hungary, who on 20 October ordered the town councils of Tongres, Saint-Trond, and Mechelen to provide Ferdinand and his retinue with horses and everything that they would need on the journey Gachard 1854–1855, p. 19.

114 For Gachard's doubts about Ferdinand's participation: Gachard 1854–1855, p. 28.

115 Scheicher 1979, p. 77. For more on the painting: *Meisterwerke der Sammlungen Schloss Ambras*, ed. by Wilfried Seipel (Vienna, 2008), p. 140; Sabine Weiss, *Aufbruch nach Europa: fünf Jahrhunderte Wien-Brüssel* (Graz, 2004), p. 200.

116 Today the painting is dated to the second half of the 16th century, oil on canvas, 128 × 419 cm, Vienna, Kunsthistorisches Museum, inv. no. GG 5682. It is described in the estate inventory ÖNB on fol. 637 (see Boeheim, 1888)

117 I am extremely grateful to Martin Jahoda at the Postal Museum in Prague for consultations about the painting and the information given here.

tion, where weary horses were exchanged for fresh ones (although it is not identified by the usual sign of a post horn).[118]

On the left of the painting we see the imperial residence with the city of Brussels in the background. At this time Charles V was no longer resident in the Coudenberg Palace as he was during Archduke Ferdinand II's journey in 1544, but had instead established his residence close by, at the edge of the complex of gardens and game preserves, in the area traditionally known as the *warande* and later as the *parc*.[119] The emperor had bought a small house here, with a garden in the rear (northern) part of the game preserve adjacent to what is today the Rue de Louvain.[120] No contemporary picture of this house has survived, however, and the residence itself was damaged by a fire in 1673 and subsequently reconstructed. However, a plan of the house and a report by the court architect Françoise de la Vigne from the year 1685 have been preserved.[121] It was a two-storey building, with the imperial apartment, consisting of the main hall and an antechamber, on the first floor.[122] Adjoining the rooms was a balcony, and a small gallery connected the emperor's room with a small chapel. The sources also mention that the rooms were painted green. While the painting of the residence from the collection of Archduke Ferdinand II is not a topographically exact record from a specific standpoint, on a symbolical level it does contain a substantial amount of basic information that is confirmed by the sources. The location of the emperor's apartment on the first floor, the staircase leading outside the building, and the green colour of the rooms (even if the painter creatively used this colour for the covering of the emperor's bed) – all of these features correspond to the descriptions given in the sources.[123] It is true that the painting does not contain the garden, which we find illustrated in some detail on the plan, but to the right of the residence it depicts a small game preserve for deer, which was also part of this *warrande*.[124] On the horizon the panorama of the city of Brussels is visible, with the twin towers of the Cathedral of St Gudula on the left, and a slender tower which evidently belongs to the town hall. The lower building between the cathedral and the town hall represents in simplified form the Aula Magna building and the adjacent chapel. However, the location of the river does not accurately correspond to the situation at that time.

---

118  Martin Jahoda, information communicated verbally.

119  For more on the area today known as the *Parc*: Lombaerde 2014, pp. 191–215.

120  It was originally the residence of Philibert de Mastaing, seigneur de Sassignies, and was adapted for the emperor's needs by the architect Jacques Du Brœucq (1505–1584). A plan of the house and adjoining garden has been preserved and published by Piet Lombaerde. The house was demolished in 1778. For more on the building: Gachard 1854–1855, p. 23. For details of the history of the house and its reconstruction: Lombaerde 2014, pp. 195–196; Paulo Charruadas, Shipé Guri and Marc Meganck, 'Évolution et développement du quartier de la cour', in *Le palais du Coudenberg à Bruxelles*, ed. by Laetitia Cnockaert, Vincent Heymans and Frédérique Honoré (Brussels, 2014), pp. 218–253 (228).

121  Charruadas / Guri / Meganck 2014, p. 228.

122  Gachard 1854–1855, p. 79.

123  Gachard 1854–1855, p. 79.

124  Lombaerde 2014, p. 195.

In front of the house the figure of Archduke Ferdinand II in a black decorated cloak appears again, being welcomed by one of the emperor's courtiers. One of the principal motifs of the work is the figure of the Emperor Charles V in bed with a group of noblemen close by, clearly visible through the window of the emperor's residence. The informal character of the painting indirectly confirms that the main aim of the archduke's journey was indeed the private, intrafamilial diplomatic mission to the emperor described above, and not participation in the handover ceremony. This second journey only lasted a very short time, and the archduke was back in Prague before the 3rd of November.[125]

The experience that Archduke Ferdinand II gained during his visits to the Netherlands helped to shape the way he presented himself, following the model of the Habsburg courts in the 16th century. They played a no less of an important role than his more well-known journeys to Italy, about which much has been published.[126] These new interpretations of primary sources in the form of diary entries and leaflets throw fresh light on this hitherto little-known part of the archduke's life, and provide a valuable contemporary appraisal of his debut into the world of politics and culture. He was later able to draw on this experience during his rule in both Prague and Innsbruck, as is shown in particular by the lavish descriptions of the festivities he held in both cities, and by his collections of artworks and building activities in both residences.

---

125  Gachard 1854–1855, p. 19 refers to Lanz 1846, p. 693. In a letter dated 3rd of November 1555, the emperor expresses his pleasure at the meeting with his nephew, although he still regrets that Ferdinand I has been prevented from coming by "grandes et urgentes causes" (great and urgent matters). He also regrets that Archduke Ferdinand II had to leave so soon.

126  For details of his journeys to Italy in 1549, 1579, and 1561: Bůžek 2009, pp. 260–261; Veronika Sandbichler, 'Festkultur am Hof Erzherzog Ferdinands II.', in *Der Innsbrucker Hof. Residenz und höfische Gesellschaft in Tirol vom 15. bis 19. Jh*, ed. by Heinz Noflatscher (Vienna, 2005), pp. 159–174 (166–167); Peter Diemer, 'Vergnügungsfahrt mit Hindernissen: Erzherzog Ferdinands Reise nach Venedig, Ferrara und Mantua im Frühjahr 1579', *Archiv für Kulturgeschichte* 66 (1984), pp. 249–314.

Stanislav Hrbatý

# Archduke Ferdinand II of Tyrol and his court armourer's workshop in Prague

Weapons and armour have accompanied the history of human civilization from its early beginnings. Apart from their practical uses, they were also a significant symbol of superiority and strength. This is why weapons and armour had an inalienable place in the earliest ancient collections of valuable objects, not only as symbols of power, but also as products of the highest craftsmanship. The peak of such collections of weaponry and armour is associated with the arrival of the Renaissance. At that time, there was a significant advancement in the manufacture of arms, in terms of both aesthetics and technologies. In Europe, specialised centres formed for the production of weapons and armour, and these centres satisfied the most demanding commissions from the leading sovereign houses. The centres south of the Alps were concentrated in Lombardy, in the cities of Milan and Brescia. North of the Alps, weapons production was mostly centred in Innsbruck, Landshut, Augsburg and Nuremberg. With the development of tournament games, the products of these workshops began to fill the armouries of the high aristocracy all over Europe. These special collections of weaponry and armour, which began as private family collections, were separated from the purely practical military armouries early in the 15th century, and were gradually transformed into classical collections with a representative character during the 16th century. Weapons and armour assumed an equal status to the traditional collector's holdings of fine arts, and were given special spaces: the *Rüstkammer* (chamber of arms, or armoury).

The armoury of Archduke Ferdinand II at Ambras Castle in Tyrol was already recognised as one of Europe's most important collections of its kind during the archduke's own lifetime. At the time of archduke's death in 1595, his collection of armour was exhibited over five rooms in two buildings of the Lower Castle. Weapons and other equipment for tournaments were stored in the first room, while the second room was mostly occupied by suits of armour from different members of the House of Habsburg, and the third room held Archduke Ferdinand II's personal armoury. Another smaller room called the *Türkenkämmerl* (Turkish room) contained Ottoman armour and military equipment, saddles, arrows, and other spoils from the battlefield. Finally, the archduke had created a unique collection project called the *Heldenrüstkammer* (Heroes' Armoury). This room contained a display of 121 suits of armour. All of this armour had belonged to specifically selected heroes and worthy persons (both contemporary and from previous centuries) and were displayed alongside their owners' weaponry and portraits. The *Heldenrüstkammer* was intended to focus primarily on important representatives of the Habsburg dynasty, as well as significant European personalities of the 15th and 16th centuries. The main virtue of this collection, besides its art-historical value, is the accumulation of documentation and records for the indi-

vidual items, and the compilation of this documentation into a compendium, the *Armamentarium Heroicum* (1601).[1] (Fig. 1)

A significant amount of research has been devoted to this collection, a large part of which remains on permanent display at Ambras Castle.[2] However, there remain two fundamental questions: did Archduke Ferdinand II begin his collection of the military materials during his earlier residence in Prague, or only after he relocated to Innsbruck? Thanks to his participation in tournaments in Prague, we can assume that his personal armoury existed. However, what exactly was the contents of that armoury during his residency in Prague?[3] Unfortunately, there is no known inventory for the archduke's holdings from this period, meaning there is little material available for initial research. Only two lengthier inventories of the armouries at Prague Castle (the armouries intended to serve for its defence) have been preserved, dating from 1547 and 1550.[4]

In order to correctly interpret the situation in Prague, it is important to distinguish between the armouries that served the military defence of Prague Castle, and the archduke's personal gear and equipment. The basic storeroom for the weapons and armour intended predominantly for the defence of Prague Castle was the *Zeughaus* (castle

---

1   Jakob Schrenck von Notzing, *Armamentarium Heroicum* (Innsbruck [?], 1601) [German version: Schrenck von Notzing, *Heldenrüstkammer* (Innsbruck, 1603)] is sometimes considered as the very earliest preserved collection catalogue, although there are large discrepancies between the actual objects and pieces recorded; the *Armamentarium* should rather be seen as an additional product of Archduke Ferdinand II's collection, from a more historical-literature type of perspective. See especially the edition *Jakob Schrenck von Notzing. Die Helden Rüstkammer (Armamentarium Heroicum) Erzherzog Ferdinands II. auf Schloß Ambras bei Innsbruck*, ed. by Bruno Thomas (Osnabrück, 1981); *Werke für die Ewigkeit. Kaiser Maximilian I. und Erzherzog Ferdinand II.*, ed. by Wilfried Seipel, exh. cat. (Innsbruck, 2002), pp. 79–81; most recently Thomas Kuster, 'dises heroische theatrum': The Heldenrüstkammer at Ambras Castle, in *Ferdinand II. 450 Years Sovereign Ruler of Tyrol. Jubilee Exhibition*, ed. by Sabine Haag and Veronika Sandbichler, exh. cat. (Innsbruck and Vienna, 2017), pp. 83–87, with a bibliography.

2   Wendelin Boeheim, 'Der Hofplattner des Erzherzogs Ferdinand von Tirol Jakob Topf und seine Werke', *Jahrbuch der kunsthistorischen Sammlungen des Allerhöchsten Kaiserhauses* (hereafter as *JKSAK*) 18 (1897), pp. 262–276; *Vorzüglichsten Rüstungen und Waffen der k.k. Ambraser-Sammlung in original-photographien*, ed. by Eduard von Sacken (Vienna, 1859–1862); Bruno Thomas and Ortwin Gamber, *Katalog der Leibrüstkammer*, Vol. I. (Vienna, 1976); Elisabeth Scheicher, Ortwin Gamber and Alfred Auer, *Die Rüstkammern auf Schloß Ambras* (Vienna, 1981); Alfred Auer, 'Das Inventarium der Ambraser Sammlungen aus dem Jahre 1621, 1. Teil: Die Rüstkammern', *Jahrbuch der Kunsthistorischen Sammlungen in Wien* (hereafter as *JKSW*) 80 (1984), pp. I–CXXI; Ortwin Gamber and Christian Beaufort-Spontin, *Katalog der Leibrüstkammer*, Vol. II (Vienna, 1990); Kuster 2017.

3   Compare with: Ortwin Gamber, 'Die Kriegrüstungen Erzherzog Ferdinands II. aus der Prager Hofplattnerei', *JKSW* 68 (1972) [N. F. 32 (1972)], pp. 109–152; Alfred Auer, 'Die Sammeltätigkeit Erzherzog Ferdinands II.', in *Kaiser Ferdinand I. 1503–1564. Das Werden der Habsburgermonarchie*, ed. by Wilfried Seipel, exh. cat. (Vienna, 2003), pp. 296–303; Thomas Kuster, 'Die Plattnerei in Prag and in Innsbruck zur Zeit Erzherzog Ferdinands II. (1529–1595)', in *Turnier. 1000 Jahre Ritterspiele*, ed. by Matthias Pfaffenbichler and Stefan Krause (Vienna, 2018), pp. 217–221.

4   Petr Uličný, 'Bella, & Rara armaria di sua Altezza. Zbrojnice Pražského hradu v době Ferdinanda Tyrolského', *Průzkumy památek* 25:1 (2018), pp. 25–46; National Archives in Prague (hereafter NA), ML, 1546–1547, cart. 2; NA, ČDKM IV-P, cart.187, fol. 917r–934r.

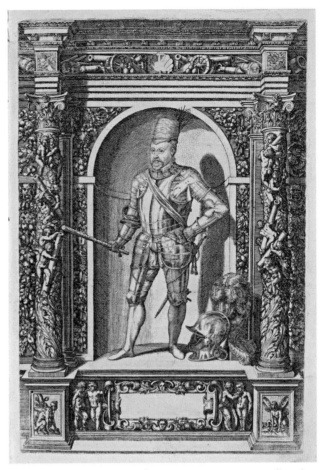

Fig. 1. Dominicus Custos after Giovanni B. Fontana, Ferdinand II,
in Jakob Schrenck von Notzing, Armamentarium Heroicum, s.l. 1601
(National Gallery in Prague, inv. no. R 235576)

armoury), which contained the castle garrison's arms and equipment. As is clear from the aforementioned inventories made in 1547 and 1550, these military materials were stored across several locations within Prague Castle. These storerooms seem to have mostly been requisitioned or alternative spaces that were not primarily intended for the placement of this type of material. The inventory from 1550 marks four places where artillery was stored. The first was in the rooms adjacent to the foundry for the casting of cannons, between Vikářská Street and the northern rampart. The second was within the premises of the former dean's house, which stood in the northwest part of the castle. The third storage space was the armoury at the school in Vikářská Street, where lighter cannons and mortars were kept. The last space is harder to identify, because it is not more closely specified in the inventory. The document only mentions that this final space was next to an *eisenkamer* ('iron chamber', probably room con-

taining iron goods), which would correspond to the locality of the east wing of the Old Royal Palace.[5] Only lighter firearms and stone balls were stored here. The cloister and chapel of St George's Monastery also served as storehouses for other types of weapons, such as smaller pistols and armour. We can find more premises for the deposition of weapons and armour above the Diet Hall, where small arms were kept, and above Vladislaus Hall, where a large amount of armour was stored. This storage situation may have been a temporary solution after the fire in 1541, but it nonetheless remained almost unchanged until the end of the 16th century. According to the inventory list, all of the military equipment was separated by the individual types of weapons, and stored according to this categorisation. As in the majority of urban armouries, artillery and cannon munitions were stored in the ground-floor areas, while other equipment was stored on the higher floors. Gunpowder was usually kept separate from these areas. This particular inventory mentions that the gunpowder was stored in the White Tower behind St George's Monastery.[6]

From a military perspective, the greatest emphasis was placed on large firearms. These were considered the most valuable and strategically crucial part of the armoury. We also very often encounter the redeployment of these weapons, for example to another residence or field encampments, based on the current defensive needs of the land.[7] The importance of these objects is also underlined by the fact that in the inventories and checklists of the armouries, the maximum amount of descriptive information is devoted especially to artillery, whereas arms and sidearms are only marginally mentioned, or omitted completely. Neither the 1547 or the 1550 inventory mentions short sidearms such as swords, hunting knives or even loose blades, which were used for the repair of weapons. The 1550 inventory only mentions long wooden weapons (polearms), namely halberds and pikes, but without any closer description. There is only a very general description of the armour in the 1550 inventory, and it is quite difficult to set a precise quantification based on this description. In connection with the armoury there was a foundry workshop operating at the castle, which dealt with the production and repairs of cannons, including their maintenance.[8] Nevertheless, there are no period records of similar workshops dealing with plate armour. Maintenance work for the armour was probably ordered as independent, one-off commissions.[9] The armourers working in the court workshop at Prague Castle were always recorded separately in the payroll of the archduke's court and in the accounts of the Royal

---

5   Uličný 2018, p. 28.

6   A detailed description of the arrangement of individual types of weapons held in various spaces at Prague Castle, based on the inventory of 1550, is given in the article by Uličný 2018, pp. 24–26, with a transcription of both inventories.

7   František Roubík, *Regesta fondu militare archivu ministerstva vnitra RČS. v Praze*, I (Prague, 1937), pp. 82–83.

8   Miroslav Mudra, 'Pražská zbrojnice v druhé polovici 16. a na počátku 17. století', *Historie a vojenství* 2 (1957), pp. 251–258.

9   We have evidence of such 'one-off' maintenance work for armour: for example, in the armoury of Castle Křivoklát, see Roubík 1937, pp. 341–342.

Bohemian chamber: unlike the founders and gunsmiths, these men were not listed as employees of the armoury.[10]

The administrator of the military armoury of Prague Castle was the *Zeugmeister* (master of arms).[11] For the entire period of Archduke Ferdinand II's activity in Prague, this post was held by Kryštof of Schneeberg, who was replaced in 1568 by Jakub Riedlinger.[12] The master of arms was directly responsible for the munitions stores, and directed the maintenance and production of military material. He was also very often consulted as a specialist by the sovereign when making purchases, and in the evaluation of the quality of the cannons.[13]

Another person mentioned in the sources in connection with the castle armoury was Hans of Sparnekl, who in April 1548 was asked by Archduke Ferdinand II (in the name of his father, the king) to have several suits of armour prepared for the *trabants* (bodyguards on foot).[14] Sparnekl's post has not been clearly identified. Sparnekl, hired in 1548 as a captain *hejtman* (captain) of *die streiffende Rot* ("raiding company"), is thus known to have been in the services of the archduke, but was soon released from that service.[15]

A year later, King Ferdinand I seconded the municipal polishing mill from the members of the armoury guild of Prague, so that it could be exclusively used by the king's *Zeugmeister*. The guild was to receive remuneration, and another mill.[16] In this case, these services were probably not intended for the equipment of the archduke himself. It is more likely that this was a measure intended to ensure a good capacity for the maintenance of the arms and equipment from the castle's military armoury. This could have been related to the arrival of Archduke Ferdinand II and formation of his court, which would have required maintenance for the arms of the *trabants* in his service. Furthermore, it may have been to ensure the good maintenance of arms for the military garrison responsible for the protection of the castle and the preservation of order in Prague after the Bohemian Revolt of 1547.[17]

It appears that the archduke's personal armoury only began to form after his arrival in Prague. Considering the collection's growing demands for space, its location could have changed several times, or it may have been divided across several spaces. The

---

10  For an overview of the employees of the armoury, see Mudra 1957, p. 257. For an overview of the payments made by the court of Archduke Ferdinand II from 1550–1551, see Petr Vorel, 'Místodržitelský dvůr arciknížete Ferdinanda Habsburského v Praze roku 1551 ve světle účetní dokumentace', *Folia Historica Bohemica* 21 (2005), pp. 7–66. (24). For an overview of payments made to the employees of the court of Rudolf II, see Jaroslava Hausenblasová, *Der Hof Kaiser Rudolfs II. Eine Edition der Hofstaatsverzeichnisse 1576–1612* (Prague, 2002).

11  Some sources use the term *zeugwart* or *ceykwart*, i.e. armourer.

12  Mudra 1957, p. 251.

13  Roubík 1937, p. 106.

14  Karl Köpl, 'Urkunden, Acten, Regesten und Inventare aus dem k.k. Statthalterei-Archiv in Prag', *JKSAK* 10 (1889), pp. LXIII–CC (CIV), reg. 6087.

15  Roubík 1937, p. 63.

16  Köpl 1889, p. CVII, reg. 6101.

17  Roubík 1937, p. 61.

information on its placement is currently not entirely clear, but it is possible to deduce from brief mentions in several of the preserved written sources that the armoury was held in the spaces above the castle gate at the White Tower, hence in close proximity to the archduke's palace. Another, more luxurious armoury located at the foot of the White tower is briefly mentioned in the 1558 descriptions of the coronation of Ferdinand I written by Collinus and Cuthaneus, as well as in Mattioli's description of this event.[18] It is possible to create a partial idea of this armoury's contents by summarising the archduke's correspondence during this period with armourers from the important production centres in Germany and Italy, and by examining the preserved examples in the collections of the Kunsthistorisches Museum in Vienna.

At age 18, Archduke Ferdinand II assumed the post of governor in Prague, and as his royal father's representative he tried to ensure that he represented the House of Habsburg in a dignified way. However, it was not merely his efforts towards the distinguished representation of his family that motivated his purchases of armour. He was a great admirer of chivalric virtues and an enthusiastic participant in tournament games. His stay in Prague provided him with a great opportunity to develop this passion fully, but for this, he needed the appropriate arms and equipment. The archduke also had the full support of his father King Ferdinand I in this particular passion. In the year 1546, the king ordered his court armourer Jörg Seusenhofer to make a suit of tournament armour for his son, which was named the *Adlergarnitur* (the Eagle Garniture) after the decoration with small eagles.[19] (Fig. 2) This unique suit was finished in 1547 in Innsbruck and taken, accompanied by Seusenhofer himself, first to Augsburg and then on to Prague.[20] Since this was a large and very expensive commission, and one for which the final cost exceeded the agreed price, Jörg Seusenhofer was only immediately remunerated for a part of his expenses, and the rest of his fee was paid in instalments up until 1551.[21]

We find records of more commissions from Archduke Ferdinand II for Jörg Seusenhofer's workshop in 1549, when the archduke requested the production of other parts for his armour, ordering that these new parts be shipped before Shrovetide along with another piece that he had ordered for his court.[22] This was most likely the *Bindenschildgarnitur* (a suit of armour with the Babenberg escutcheon).[23] Archduke Ferdinand II pressed for the delivery of this order in February 1550, requesting the

---

18  Uličný 2018, pp. 33–36; M. Collinus and M. Cuthaneus, *Brevis et svccincta pompae in honorem [...] imperatoris Ferdinandi primi [...]* (Prague, 1558), f. Hiir-Hiiv; P. A. Mattioli, *Le solenni pompe [...]* (Prague, 1559), fol. Eiir-Eiiv.

19  David von Schönherr, 'Urkunden und Regesten aus dem k.k. Statthalterei-Archiv in Innsbruck', *JKSAK* 11 (1890), p. XCVIII, reg. 6700. Currently held at the Kunsthistorisches Museum in Vienna (inv. no. A 638). For the latest, see *Exh. Cat. Innsbruck* 2017, pp. 152–143, cat. no. 4.2, with the earlier literature.

20  Schönherr 1890, p. C, reg. 6712.

21  Schönherr 1890, p. CXXIV, reg. 6883.

22  Schönherr 1890, p. CXVIII, reg. 6821.

23  Currently held at the Kunsthistorisches Museum in Vienna (inv. nos. A 530a, 530b, 530d); see Gamber / Beaufort-Spontin 1990, p. 165; see also Gamber 1972.

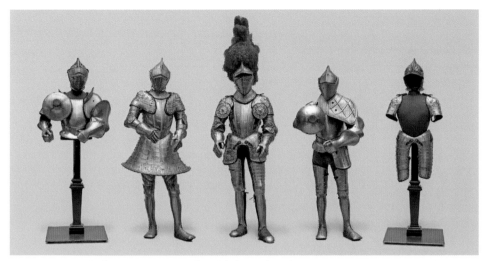

Fig. 2. Jörg Seusenhofer, Eagle garniture of Archduke Ferdinand II, 1547 (Vienna, Kunsthistorisches Museum, Hofjagd- und Rüstkammer, inv. no. A 638)

delivery of all the commissioned armour including several new pieces "according to the list to his size".[24] As is obvious from the correspondence between King Ferdinand I, the *Oberösterreichische Kammer* (Upper Austrian chamber) in Innsbruck, and the archduke, the orders were relatively extensive and demanding, and additional work was added to the commission during their realisation. This caused problems in fulfilling the negotiated deadlines on the part of the armourers, but also caused some difficulties with financing on the part of the archduke.

Other armour that Archduke Ferdinand II may have owned at the time of his arrival in Prague includes a full set of equestrian armour (both suit and barding) in the antique style for a horse and rider, originating from the Italian workshop of Giovanni Paolo Negroli. It is dated to 1545–1550, but the precise year of production is not known.[25]

Besides the tournament games, the archduke greatly appreciated and admired the military skills of his courtiers, and he tried to set an example for them himself. He acquired a passion for the 'exotic' style of arms during his participation in the military campaign against the Ottoman expansion. This is why he had the *Silberne Huszarische Rüstung* (Silver Hussars armour) made by German armourers in 1555–1557.[26]

The inspiration that the archduke found in his experiences abroad was also reflected in the arrangement of the 'Hussar tournaments', which celebrated his military suc-

---

24    Schönherr 1890, p. CXIX, reg. 6888.

25    Currently held at the Kunsthistorisches Museum in Vienna (A 783); Christian Beaufort-Spontin and Matthias Pfaffenbichler, *Meisterwerke der Hofjagd- und Rüstkammer. Kurzführer durch das Kunsthistorische Museum Wien*, III (Vienna, 2005), p. 158.

26    This has not been preserved in its entirety up to the present day, the torso is held at the Kunsthistorisches Museum in Vienna (inv. no. A 878), see Beaufort-Spontin / Pfaffenbichler 2005, p. 170.

cesses in Hungary. The famous Hussar masks were also produced for these tourna-ments.[27] These masks consisted of the upper part of a helmet's visor, with a slit, and were made in the anthropomorphic shape of a human face with the addition of a beard. These visors were placed on the helmets at the tournament games in 1557 in Prague, and their production is attributed to the Prague court workshop.[28]

### What was the relationship between the court workshop and the Prague armourers?

The armourer's craft had a tradition in the Bohemian lands reaching back to the 14th century, but since the products of these workshops were anonymous, and many have not been preserved, it is very difficult to assess their level of technical skill and knowl-edge. It can however be said that with some exceptions these products satisfied the needs of the local market, which mostly meant the equipment of the local urban and castle armouries.

In Prague, the armourers were most strongly represented in the Old Town, where they were 'headquartered' in Platnéřská (Armourers') Street. (Fig. 3) The earliest record of the armourers' guild organisation dates from 1336.[29] To a lesser degree, armourers also appeared in Prague's New Town, but these were usually individual craftsmen.[30] Examining the armourers' names, it is possible to assess that besides the Bohemians, it was mainly Germans or Italians who worked in Prague, and to a lesser extent the Dutch. It is clear that Prague was not an important production centre for armour on an international level: this is attested to by the fact that the armourers had relatively regular financial problems, and were forced to pawn their tools, products, or even property.[31]

During the 16th century, the second most important centre for the production of armour in the Bohemian Lands after Prague was Cheb, where the local armourers also satisfied foreign demands for military arms and armours.[32]

The armourer's craft was much more poorly represented in the other towns of Bohemia and Moravia in comparison with Prague and Cheb. Most larger towns employed an armourer, but his services were usually used by the entire local region. These craftsmen dealt primarily with the maintenance of municipal armouries or with

27  Several of these are held at the Kunsthistorisches Museum in Vienna (inv. nos. B 62, 67, 69), nine pieces were exhibited at the exhibition *Ferdinand II. 450 Years Sovereign Ruler of Tyrol. Jubilee Exhibition* in 2017–2018. In the catalogues, only one or two masques are always depicted, see Gamber 1972; *Wir sind Helden: habsburgische Feste in der Renaissance*, ed. by Alfred Auer, Margot Rauch and Wilfried Seipel, exh. cat. (Vienna, 2005), p. 69, cat. no. 33.
28  Sabine Haag and Veronika Sandbichler, *Die Hochzeit Erzherzog Ferdinands II. Eine Bildreportage des 16. Jahrhunderts*, exh. cat. (Innsbruck, 2010), p. 42.
29  Zikmund Winter, *Řemeslnictvo a živnosti XVI. věku v Čechách* (Prague, 1909), p. 492.
30  Miloslav Polívka, 'Vývoj zbrojních řemesel v Praze na konci 14. a v první polovině 15. století', *Documenta Pragensia* VI:1 (1986), pp. 47–74 (52).
31  Winter 1909, p. 491.
32  Karl Köpl, 'Urkunden, Acten und Regesten aus dem k.k. Statthalterei-Archiv in Prag', *JKSAK* 12 (1891), p. LI, reg. 8164.

the production of necessary equipment for the garrisons of the surrounding castles. Permanently employed armourers hardly appear at all in any of the aristocratic seats.[33]

During his stay in Prague, Archduke Ferdinand II probably did not use the services of the local armourers. In any case, no record of this has been preserved. The quality, and technically demanding nature of the archduke's commissions may have played a role in this: it is possible that the workshops in Prague would not have been able to satisfy his requirements. Another very prosaic reason for this situation was the rivalry between the Prague armourers' guild and the court workshop, which the guild saw as very unwelcome competition. The court workshop was under the direct rule of the sovereign and therefore not bound by guild regulations, which gave the court armourers significant advantages. The Prague guilds only tried to limit the production of the court workshop during the period of the archduke's residence at Prague Castle, but without any great success. It is therefore no surprise that the members of the Prague guild only submitted to any needs of the court workshop – whether it was borrowing tools or the assignment of the polishing company at Charles Bridge –with great unwillingness.[34] The records show that the court workshop cooperated directly with the Charles Bridge polishers, who were part of the armourers' guild. For instance, the polishing company demanded payment for work performed for the court armourer at Prague Castle through the guild in 1563.[35]

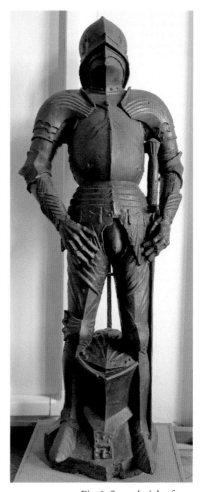

Fig. 3. Stone knight, from Platnéřská street, Prague, 15th century (The City of Prague Museum, sign. no. H 001413)

The court workshop was thus relatively isolated from the armourers' guild in Prague's Old Town, and there was a quick succession of different masters at the castle during the workshop's short lifespan. The workshop's output was probably focused on smooth armour for military campaigns and tournaments: the archduke continued to send the majority of his more demanding orders abroad.

---

33 Winter 1909, p. 492.
34 Köpl 1889, p. CVII, reg. 6101.
35 Winter 1909, p. 493.

Some works attributed to the court workshop use a certain specific solution for the construction of particular details, which is usually considered to be the typical style of armour produced in Prague.[36] However, this feature is not a unifying link typical for the general Prague milieu. As is clear from the statements above, relations between the Prague guild of armourers and the court workshop were very tense, and the armourers from the court workshop were mainly Germans. It is therefore necessary to view this special construction technique as either the invention of one specific master, without a wider connection to the milieu, or as the result of a special demand from the customer.

### What were the circumstances surrounding the creation of the Prague court workshop? Who were the armourers working there?

Archduke Ferdinand II's passion for tournament games required significant flexibility in the production of armour intended for these games, and therefore the question of where to place the orders had to be solved. As has already been stated, the Bohemian workshops were unsuitable for these purposes and as a consequence of this the archduke found it necessary to turn to the famous workshops abroad. However, these well-known workshops were often overwhelmed with other orders and were not able to react quickly and efficiently to his demands. The only solution was to establish a workshop at Prague Castle, which would be able to satisfy the archduke's needs for new arms and armaments, and also to ensure the efficient repair of the existing equipment.

The first mention of an armourer working at the castle dates to 1550. This man also held the post of a *trabant*. From 1550 on, then, we may speak of the beginnings of the armourers' workshop at Prague Castle. However, the concurrence of these two functions in one employee – armourer and *trabant* – was not ideal, and so in September of the same year the archduke asked his father King Ferdinand I to release the armourer from his service as a bodyguard so he could fully devote himself to working in the armoury.[37] In the list naming the men of the archduke's *trabants*, we find Wolf Kieser, from Bamberg.[38] A man by the name of Wolf Khesser (Kaiser) appears on the payroll as an armourer in 1550, thus it is reasonable to conclude that this was the man who initially held these two positions.[39] This master armourer probably entered the archduke's service in 1549, since he is mentioned as an armourer in Nuremberg in records dating from 1548.[40] After some time, he was released from service in Prague and returned to Nuremberg, where he married. We do not know how long he was employed at Prague Castle.

---

36   Gamber 1972, p. 150.
37   Schönherr 1890, p. CXXII, reg. 6859.
38   Polívka 1986, pp. 34–35.
39   Vorel 2005, p. 25.
40   Grieb 2007, p. 769.

At the same time, an armourer named Sebold also worked for Archduke Ferdinand II, namely on several suits of armour for *Rennen* (jousting with a sharp lance).[41] This master was loaned to him by one of courtiers, Count Sigmund Lodron, who held the position of *Oberststallmeister* (master of the horse) at the court of Ferdinand I, but Sebold's works unfortunately remain unidentified.

In the payroll documents from 1550, a *Harnischmeister* by the name of Franciscus Ligotza is also mentioned.[42] His role, however, is not entirely clear. From the different descriptions and recorded financial compensations, it is only possible to deduce that he did not perform the same duties as Khesser. His title *Harnischmeister* might mean that he was the administrator of the archduke's personal armoury, often called the *Harnischkammer* (a synonym for *Rüstkammer*).

Between 1549 and 1551, the production of armour took place in provisional conditions at Prague Castle, and encountered a wide range of obstacles. These consisted mainly of a lack of tools, and complications with the use of the guild polishing company, combined with the unwillingness of the Prague armourers' guild to undertake any kind of cooperation. The archduke therefore began to strive towards the construction of his own armourers' workshop and turned to his father, Ferdinand I, with this plan. In a letter from the 30th of June 1551, the archduke stated that he often devoted himself to the tournament games of *Stechen* and *Rennen*, and that during these games armour was regularly damaged, and therefore needed to be repaired, and at the same time it was also necessary to produce entirely new armour for these purposes.[43] He further stated that there was no workshop at the castle, and the armourer had to borrow tools from the masters in the Old Town, who lent them with great reluctance. It was therefore necessary to establish his own armourers' workshop directly within the castle, and he asked his father for his consent. He attached an overview of the expenses

---

41   Schönherr 1890, p. CXX, reg. 6841. *Rennen* (jousting) was a form of equestrian competition mainly conducted on an open track. The aim was to hit your opponent's large shield, which was part of the special type of armour called *Rennzeug* (tournament armour), and thus throw your opponent from the saddle, or break the lance. In this discipline, a lance with a sharp point was used. This type of competition took many other forms as well, which differed from one another via various modifications to the armour worn. For instance, *Geschiftrennen* (joust with targets or pectoral shields), *Scharfrennen* (joust with the aim being to unseat the opponent), *Bundrennen* (without body armour) or *Anzogenrennen* (using a pavise) and others.

42   Vorel 2005, p. 24.

43   *Stechen* (joust) was an equestrian tournament discipline popular in the 15th and 16th centuries. This method of jousting had a few diverse modifications, such as *Rennen*, that varied according to the specific tournament. In its basic form, *Stechen* can be divided into two forms: *Alte Deutsche Gestech* (Old German Jousting) which was very popular at the turn of the 16th century and took place on an open track without a barrier. For this competition, special armour was used (*Stechzeug*) and a dull lance with a coronal. The aim of the attack was to splinter the lance or knock your opponent from the saddle. In the Italian milieu at the beginning of the 16th century, a new form of this discipline emerged, where the two jousters were separated by a barrier. This type of tournament also soon gained great popularity in the German lands, and was called *Neu Welsche Gestech* (New Italian or *Welsch* Mode). For this new form of tournament, the basic field armour was used with a complement of reinforcing plates.

for the workshop's construction, prepared by Master Paolo della Stella, to this letter.[44] Based on this request and the justification provided by the archduke, King Ferdinand I granted permission for the construction of a court armourer's workshop within Prague Castle in August 1551. The workshop's precise location is not known, but it seems the original plan was to have it built inside the outer castle gates opposite *Hradschin* (Hradčany), under the wall in the place of the locksmith's workshop.[45]

Through his servants, Archduke Ferdinand II tried to obtain materials and accomplished armourers for his workshop from the major centres of armour production abroad. As early as 1551, he wrote to Walter Häring at the ironworks in Leoben and ordered material for the production of armour at the Prague court workshop. The order included one and a half bundles of plates for visors, one and half bundles of plates for frontal works, one and a half bundles of plates for the posterior works, one and a half bundles of plates for greaves and thigh sheaths (holsters), and one and a half bundles of plates for reinforcing plates and other sections of armour.[46]

In 1551, the archduke placed several orders with other armourers, prior to the completion of the construction of the court workshop. He ordered one suit of armour in Augsburg, and this was to be prepared by St George's day (23rd of April). On the 6th of May he had a letter delivered to Johann Jakob Fugger to find out when the armour would be finished, and on which date it would be delivered.[47] The preserved correspondence shows that this armour was completed at the end of May, then sent to Linz and subsequently, along with other freight, on to Prague.[48] The same year, the archduke placed another order in Innsbruck with Jörg Seusenhofer, who was to produce a suit of armour modelled on that of the archduke's courtier Julio of Riva, who temporarily loaned the armour to his master for this purpose.[49] In September, Archduke Ferdinand II also complained in a letter to Duke Heinrich of Meissen (Plauen) that he had ordered two suits of armour the year before, from the Innsbruck armourer Jakob Schnatz. These commissions should have been completed by Candlemas, and therefore the archduke ordered that only a reduced renumeration be paid, and requested that Schnatz be called before the *Oberösterreichische Kammer* (Upper Austrian chamber) in Innsbruck to be rebuked for laxness in fulfilling his commission.[50]

The date of the completion of the construction of the court workshop at Prague Castle is not known; nevertheless, during its construction the production of armour probably continued uninterrupted under provisional, more modest conditions. The staffing of the workshop is also unclear. A permanent master, perhaps Wolf Khesser (variously given as Keser, Kaiser, or Kieser), undoubtedly worked here, but the precise

44   Köpl 1889, p. CXXVI, reg. 6906.
45   Uličný 2018, pp. 28–31.
46   Köpl 1889, p. CXXVI, reg. 6906.
47   Köpl 1889, p. CXXV, reg. 6895.
48   Schönherr 1890, p. CXXVI, reg. 6899.
49   Schönherr 1890, p. CXXVI, reg. 6902.
50   Schönherr 1890, p. CXXVII, reg. 6916.

period of his activity in the workshop can-
not be clearly demonstrated. Sometime
between 1551 and 1560 he was released
from Archduke Ferdinand II's service,
because the archduke was not satisfied
with his work and reproached him for
sluggishness and unreliability. He did
however return to the archduke's service
in the spring of 1561 through the interces-
sion of Matthäus Ebner. At this time,
Khesser accompanied a cargo of six suits
of armour for *Stechen*. Four of them had
been produced to order in Nuremberg,
and two were purchased by Ebner for the
archduke in Plassenburg. In his letter,
Ebner reported that he had tested the
armour purchased in Plassenburg with
several hard hits and that both suits had
remained undamaged and unbroken. The
archduke subsequently approved the pur-
chase of this armour, and gave permission
for Khesser to bring them to Prague.[51]

The second armourer connected with
the Prague milieu is Melchior Pfeiffer. A
reference to him appears in 1559, when he
travelled to Pilsen: at this point, he was
already officially referred to as the arch-
duke's armourer.[52] It is likely that he
replaced Wolf Khesser in this post, but
there is very little further information
about the activity of Melchior Pfeiffer in
Prague. The vast majority of the works
produced in Prague court workshop

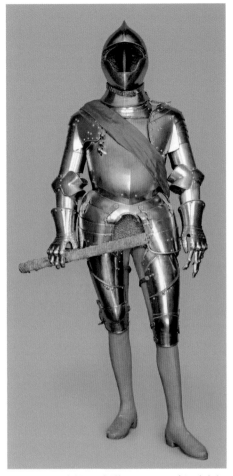

Fig. 4. Melchior Pfeiffer, Armour of Archduke
Ferdinand II, Prague, around 1555 (Vienna,
Kunsthistorisches Museum, Hofjagd- und
Rüstkammer, inv. no. A 767)

between 1555 and 1560 are usually attributed to him, but it is not possible to clearly
determine when he began his employment in the archduke's workshop. The armours
attributed to Pfeiffer are not hallmarked, and considering the lack of any earlier men-
tion of him (before 1559), we cannot consider his authorship to be clearly demon-
strated for the whole period. In earlier literature on this topic, these armours were
usually considered to be the works of Wolf Khesser, but even in his case we do not

51   Schönherr 1890, p. CXCI, reg. 7448.
52   Schönherr 1890, p. CLXXXI, reg. 7343.

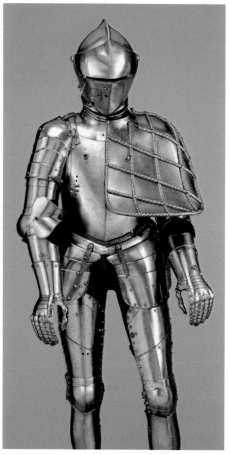

Fig. 5. Prague court workshop, Armour for an Italian mode jousting (Plankengestech), around 1555/1560 (Vienna, Kunsthistorisches Museum, Hofjagd- und Rüstkammer, inv. no. A 685)

have source documents recording his activity between 1551 and 1560.[53] One of the most famous works produced by the Prague court workshop is the suit of armour for a mounted rider used by Archduke Ferdinand II during the campaign into Hungary in 1556 (Fig. 4). The archduke is depicted wearing this specific suit of armour in the *Armamentarium heroicum,* the compendium of heroes' arms and armour from Archduke Ferdinand II's *Heldenrüstkammer (Armamentarium Historicum)* compiled by Jakob Schrenck of Notzing (see Fig. 1).[54] Besides this armour, there are four sets of barding for horses (namely shaffrons and saddle steels) and four suits of field armour attributed to the archduke's court workshop.[55] (Fig. 5) None of these pieces, neither those for the riders nor those for the horses, are hallmarked. They are usually attributed to Khesser or Pfeiffer, but we must admit the possibility that the unmarked armour produced in Prague between 1555 and 1560 for Archduke Ferdinand II could have come from an entirely different manufacturer.

As is clear from the preserved correspondence, apart from the permanent armourers, various masters were called to Prague Castle to work temporarily in the court workshop. For example, the city of Nuremberg sent the master armourer Hans Müllner with his two journeymen to Prague in April 1555 at the archduke's request, to make armour according to the archduke's orders at the court workshop there. After performing this work, they were to return home.[56] Furthermore, in 1555, the archduke ordered armour from outside the Prague court workshop from his father's armourer,

---

53   Gamber 1972, pp. 109–150.

54   Schrenck von Notzing 1601, p. 175; Gamber 1972, p. 117. The armour is exhibited at Ambras Castle, inv. no. A 767.

55   All of this armour is currently held in the Kunsthistorisches Museum in Vienna. It comprises the half-suit of armour A 1050, the three-quarter suit of armour A 1488, the complete equestrian armour A 689, and the light equestrian armour A 982. See Gamber 1972, pp. 145–147.

56   Schönherr 1890, p. CLII, reg. 7113; Grieb 2007, p. 1050.

Master Thomas Reitmayr. The archduke requested that this armour be sent to Prague along with the helmet of his brother Maximilian, which had been designed for *Rennen* and from which he wanted to have a copy made in Prague.[57] We find another attempt to acquire an armourer for the Prague workshop in correspondence from February 1556: the archduke asked Christoph of Karlowitz to contact an accomplished armourer in St Annaberg, who also worked for the Saxon court, with an offer of longer-term cooperation in Prague.[58] This may have been the master armourer Peter of Speyr. Speyr, originally from Nuremburg, worked from 1540 in St Annaberg (Góra Świętej Anny) and was the court armourer of the Saxon electors until 1560.[59] However, it is not known if he accepted the archduke's offer and also worked in Prague. Further, in 1557 Archduke Ferdinand II asked a courtier of his father, Wilhelm of Krieg, whether Wilhelm's armourer David Schmid could continue to work for him in Prague for a longer period of time.[60]

However, no known armour can be clearly attributed to Schmid. The archduke invested a great deal in his initiative to acquire the Augsburg armourer Konrad Richter, from whom he had ordered several suits of armour during 1557–1558 for himself and his courtiers, as well as for the elector Augustus of Saxony.[61] Through Andreas Brenker, the archduke's agent in Augsburg, the archduke tried to induce Richter to move to Prague.[62] Richter agreed to consider this offer, and also agreed to deliver the completed commissions to Prague and inform the archduke of his decision at that time. Richter probably set out for Prague to accompany the completed commissions, but whether he remained in Prague cannot be determined using the written sources. Richter's trip to Prague was also mentioned in a letter from the 15th of March 1558. In this letter, Richter asked Archduke Ferdinand II to intercede with the city of Augsburg on behalf of Richter's journeyman Hanz Prinz. Richter apparently wanted to secure a good living for Prinz before he left for Prague.[63] Judging by this letter, it seems reasonable to conclude that Richter expected a longer stay in Prague. After his arrival in Prague, Richter was sent to the court of Augustus of Saxony with the armour he had produced for the Saxon elector. In an accompanying letter, the archduke apologised, stating that his obligations would not allow him to hand the armour over in person, but that he has sent the armour with his armourer, who could show the elector how to fit the reinforcing tournament plate to the armour.[64] As thanks, the Saxon elector ordered armour for *Rennen* for the archduke from his own armourer in Dresden. Although the name of the armourer is not explicitly mentioned in the documents, it

57   Schönherr 1890, p. CLII, reg. 7114.
58   Schönherr 1890, p. CLXIV, reg. 7200.
59   Gurlitt 1889, pp. 29–31.
60   Schönherr 1890, p. CLXXII, reg. 7257.
61   Schönherr 1890, p. CLXII, reg. 7255.
62   Schönherr 1890, p. CLXXIV, reg. 7272.
63   Schönherr 1890, p. CLXXV, reg. 7288.
64   Schönherr 1890, p. CLXXVII, reg. 7302.

was probably made by Hans Rockenberger (Rosenberger).[65] The last mention of Archduke Ferdinand II's use of the Saxon armourers is a request from 1565 to Augustus of Saxony, asking whether he might send his own armourer to Prague for three weeks, as the archduke wanted several suits of armours made in his own size. The Saxon elector very willingly accommodated the archduke's request and ordered his armourer to leave for Prague and fulfil the archduke's demands with great diligence.[66] This armourer was Wolf of Speyer from Annaberg.[67]

Besides the famous workshops in Germany, Archduke Ferdinand II also sought armour from craftsmen in Lombardy. In May 1558, the archduke ordered decorated armour with a circular shield from Giovanni Battista Panzieri, working in Milan. He made this order through master of ceremonies Andreas Teufel. Alongside Panzieri, Marco Antonio Fava also participated in this particular commission.[68] The armour was delivered to the archduke in 1560 and is referred to today as the *Mailander Rüstung* (Milan Armour).[69] An ensemble of five coloured suits of armour and barding for riders and horses also dates from the period of the archduke's residency in Prague. These are not complete suits of armour, but rather costumes including parts of the usual armour. Each of these suits is harmonized in one colour and they are usually referred to as the *Silberne Rüstung, Rote Rüstung, Schwarze Rüstung, Aschfarbene Rüstung, Blaue Rüstung* (*Silver Rider, Red Rider, Black Rider, Grey Rider* and *Blue Rider*). The precise date of production and provenance of these pieces remain unknown but the system of decoration, especially that employed on the barding, is reminiscent of the Mannerism of the Mantua armourer Caremolo Modrone. They are therefore labelled as being in the style of Modrone, and dated to 1555–1560.[70] (Fig. 6) From 1559 until the departure of the archduke for Innsbruck, it is likely that Melchior Pfeiffer worked in the Prague court workshop. Pfeiffer then moved to Innsbruck sometime after 1567, where his residency is mentioned in 1570, but he could not even find suitable accommodation or

---

65 Gurlitt 1889, p. 46. In some literature, it is attributed to his relative Sigmund Rockenberger (Rosenberger) from Wittenberg. For relations between the Saxon court and Archduke Ferdinand II see most recently *Ambras & Dresden. Kunskammerschätze der Renaissance*, ed. by Sabine Haag, exh. cat. (Vienna, 2012), for armour mentioned here see cat. no. 3.16, Vienna, Kunsthistorisches Museum, inv. no. B 144; for other armours esp. cat. nos. 3.7–3.18 and the text by Thomas Kuster, 'Eur Lieb gannz wiliger Brueder. Fürstliche freundschaft am politischen Parkett? Die Beziehung der Habsburger und der Wettiner in der frühen Neuzeit', in Exh. cat. Vienna 2012, pp. 43–53.

66 David von Schönherr, 'Urkunden und Regesten aus dem k.k. Statthalterei-Archiv in Innsbruck', *JKSAK* 14 (1893), pp. LXXI–CCXIII (LXXXVI), reg. 9847.

67 Gurlitt 1889, pp. 53–54.

68 Silvio Leydi, 'Registre des documents en langue originale', in José-A. Godoy and Silvio Leydi, *Parures Triomphales. Le manierisme dans l'art de l'armure italienne*, exh. cat. (Milan, 2003), p. 560.

69 Currently held in the Kunsthistorisches Museum in Vienna (inv. no. A 785); Beaufort-Spontin / Pfaffenbichler 2005, p. 160.

70 Currently held in the Kunsthistorisches Museum in Vienna, *Black Rider* (sign. A 963c, A 1398), *Red Rider* (A 1377), *Blue Rider* (A 1398), *Grey Rider* (A 979, A 552); *Silver Rider* is mentioned in Luchner, but without inventory number, so it is not preserved or is dimantled. E.g. Gamber / Beaufort-Spontin 1990, pp. 138–156.

workshop space in the city, and lived for some time in the municipal armoury.[71] Two works have been preserved from Pfeiffer's time in Innsbruck, held today in the Kunsthistorisches Museum in Vienna. The pieces are two boy's suits of armour produced in 1570 for the sons of Archduke Ferdinand II, Andreas and Karl.[72]

After the departure of Archduke Ferdinand II for Tyrol, the significance of the court workshop in Prague declined and there are no further reports on it. One of the last armourers at Prague Castle was probably Ulrich Oertl (Ortl), who is mentioned in the payroll records of the court in 1576, 1580, 1584 and 1589, and died in 1590.[73] In 1601 and 1612, the armourer Georg Ziler was still paid by the court.[74] The works of these armourers are not known and it could be that they were solely employed for the maintenance and repair of the castle armoury or in the sovereign's personal armoury. By that time, the court workshop at Prague Castle was also probably closed.

### What was the armoury equipment of the archduke at the time of his departure from Prague?

We can only estimate the size of Archduke Ferdinand II's personal armoury upon leaving Prague by examining the number of pieces from the relevant period that have been preserved in the collections of Ambras Castle and the Kunsthistorisches Museum in Vienna. These comprise more than 20 suits of armour for riders and several sets of barding (especially shaffrons) from various workshops in Prague, Germany and Italy.

This collection was probably kept at Prague Castle in rooms that were part of the castle's representational spaces, and judging from the preserved sources the original collection may have actually been larger than the one that has been preserved up to the present day. Certain guidelines as to the size of the archduke's personal armoury can be found in the reconstruction of the Third Armoury at Ambras Castle, which was conducted by Laurin Luchner based on documents from 1596.[75] Seventeen life-size horse figurines are mentioned here, including their barding, and armour for seventeen riders (though not every rider had a full set of armour). Furthermore, three suits of armour for *Rennen*, as well as the *Adlergarnitur* (Eagle Garniture), were installed on four life-size figurines in the hall at that time. The last part of the personal armoury contained another three suits of armour, one of which was the 1582 wedding set with a saddle from the workshop of Jakob Topf (Thoft). If we want to gain a rough idea of the contents of Archduke Ferdinand II's Prague *Harnischkammer* in 1565, when the

---

71　Schönherr 1893, p. CXXVII, reg. 10240.

72　These suits of armour are held in the Kunsthistorisches Museum in Vienna (inv. nos. A1186, A1496/97), see *Der Glanz des europäischen Rittertums. Prunkvolle Rüstungen für Mann und Pferd vom Spätmittelalter bis ins 16. Jahrhundert / The Splendour of European Knights*, exh. cat., (Yokohama, 1998); Roberto Capucci, *Roben wie Rüstungen. Mode in Stahl einst und heute*, exh. cat. (Vienna, 1990), p. 279.

73　Hausenblasová 2002, p. 430.

74　Hausenblasová 2002, p. 430.

75　Gamber 1972, p. 110; Luchner 1958.

collection was moved to Tyrol, we have to omit the three tournament suits produced for the archduke in Innsbruck by Jakob Topf in 1580–1590, and the wedding suit of armour from 1582 from the total amount of armour mentioned above.

Concerning the transport of the armour from Prague Castle, a letter from the *Oberösterreichische Kammer* (Upper Austrian chamber) in Innsbruck dated 4th of September 1565 has been preserved. This letter informed the archduke of details concerning the transfer of his personal armour, and other armour, accompanied by the armourers Wolf Khesser and Giovanni Battista Ligoza from Linz to Innsbruck. There is also a mention here of the weight of the freight: 347 cents and 27 pounds, which corresponds to the weight of 17.5 tonnes.[76] Taking into account that the weight was reported so that the necessary ship- and wagon loads could be calculated, this weight was probably the weight of the cargo including its packaging, and not just the weight of the armour itself. If we assume that the weight of the packaging comprised about one third of the total weight, then about 12 tons of armour was probably transported. If we calculate that a complete set of an armour for a rider weighed circa 30 kg, this shipment would have contained 400 complete sets of armour. This number significantly exceeds the collection of Ferdinand's personal arms and equipment preserved at Ambras Castle. So, where did the extra armour recorded here originate from? Part of the cargo undoubtedly comprised the duke's personal armoury, which could have been supplemented by the figurines of the horses for displaying the barding. What is interesting here is the information presented in the correspondence regarding the "other armour". There are several explanations for this "other armour". It may have been armour belonging to the archduke's *trabants*, or the courtiers who followed him to Tyrol. Some of the other suits of armour may have been gifts that were later included in the *Heldenrüstkammer* (Heroes' Armoury). This armour and weaponry was probably initially stored in the Hofburg in Innsbruck, or it may have been integrated into the three existing armouries at the Ambras Castle. To clarify this transfer, we must recall that the *Heldenrüstkammer* was installed in the late 1570s or early 1580s, but the special building for this collection was only finished around 1589. Nevertheless, Thomas Kuster specifically dates the foundation of the *Heldenrüstkammer* to the middle of 1570s.[77]

The theory that the shipment of armour from Prague also included the armour of Archduke Ferdinand II's *trabants* is indirectly supported by a letter from the 20th of January 1570, in which Emperor Maximilian II orders the Bohemian chamber to "pay the Prague master of armour Jakub Riedlinger 7 threescore of Meissen groschen for the armours loaned at the order of Archduke Ferdinand from the armoury, for their purchase".[78] This was therefore armour that had been requisitioned from the castle

---

76  Schönherr 1893, p. LXXXIII, reg. 9816.

77  Kuster 2017.

78  Prague Castle Archives, here a typescript by an archivist Jiří Svoboda, *Inventář fondu archivu Pražského hradu č. 5. (Česká) dvorská komora z let 1529–1621, sg. DK*, unpublished typescript (Prague Castle Archives, s.d.), p. 28, item no. 338.

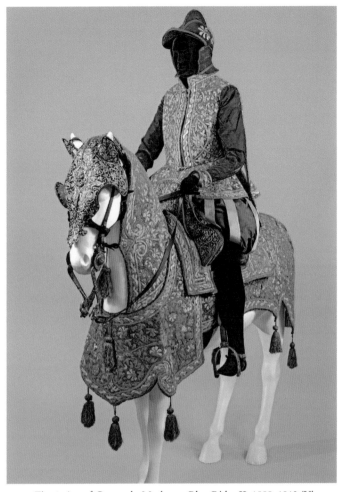

Fig. 6. Art of Caremolo Modrone, Blue Rider II, 1555–1560 (Vienna, Kunsthistorisches Museum, Hofjagd- und Rüstkammer, inv. no. A 1398)

armoury on the archduke's orders, and the financial remuneration was supposed to compensate for its loss. The transport of the archduke's personal armoury was probably conducted in several stages, as evidenced by the archduke's order for Gabriel Mittermayer, dated 28th of August 1566, to make an inventory of all the archduke's belongings from his personal chamber and armoury that still remained in Prague, then to "deposit" them and "hammer" them (probably into crates).[79] It further arises from the letter that these items were to be sent about three weeks later to Linz, and from there to Innsbruck. For this purpose, the archduke sent a servant to Prague, who was to take care of the transport of the items to Linz, and subsequently "by water" to

---

79    TLA Innsbruck, Kunstsachen (KS), sign. I. 622.

Innsbruck. Unfortunately, the inventory mentioned above has not been preserved and so we can only speculate as to how many items it included. These could well have been less important and less valuable items that were transported in 1565.

The basic question remains as to whether or not Archduke Ferdinand II's armoury in Prague was created according to a 'collector's concept', as we understand it from Jakob Schrenck's work.[80] Taking into account that Archduke Ferdinand II spent a large part of his physically active life in Prague (where he participated in many tournaments and so on), his personal armoury was probably a practical and purpose-made 'wardrobe' that he could use daily. Over time, with his changing physical disposition and proportions, it was not possible for him to use his older armour, and this armour became rather a collection of commemorative artefacts. This 'wardrobe of memories' then also became a component of his greater collection, which he had specially placed in the third hall of the armoury at Ambras Castle.

---

80   Schrenck von Notzing 1601; Schrenck von Notzing 1603.

Václav Bůžek

# Self-presentation of Archduke Ferdinand in hunting entertainment during his activity as governor in the Kingdom of Bohemia

The quantities and types of wild animals that Archduke Ferdinand II killed with his own hands in the hunts he arranged during his time as governor in the Kingdom of Bohemia (1547–1567) were not the only measure of the archduke's chivalric values and prowess.[1] A hunter's capacity to present his abilities and characteristics as those of a Early Modern man was also determined by the manner in which he vanquished these beasts and birds during the hunts and chases that took place both in the wild and in game preserves. The experiences of one such hunter are mirrored in the unbroken record preserved in the *Jagdbücher* (hunting books) of Archduke Ferdinand II, dating from 1558 through to 1566.[2] By analysing these books, which recorded the number of animals hunted and the manner in which they were felled, it becomes clear that these records were not made in the archduke's own hand. These records of the hunt were most likely entered by the archduke's personal chamberlains, who also noted all of the more everyday activities of the Prague governor in their diaries.[3] Although these hunting books represent an historical source with an uncommonly broad testimonial value, they have not yet received significant scholarly attention.[4]

Since the hunting books typically contain detailed data on the dates of the hunts organised by Archduke Ferdinand II, it has been possible to determine at least approximately how many days per calendar year he actually devoted to this pastime during his period as governor in the Kingdom of Bohemia. From the end of the 1550s to the middle of the 1560s, he spent an annual total of at least 60 to 80 days (and sometimes up to 140 days) on the hunt, with these days being spread out over several yearly hunting seasons.[5] The data in the hunting books confirms the information given in the accounts of the governor's court from 1551, and this has allowed us to reassemble the itineraries for his hunting trips in that year.[6] In 1551 then, the archduke spent at least

---

1    Václav Bůžek, *Ferdinand von Tirol zwischen Prag und Innsbruck. Der Adel aus den böhmischen Ländern auf dem Weg zu den Höfen der ersten Habsburger* (Vienna, Cologne and Weimar, 2009), pp. 230–239.

2    Österreichische Nationalbibliothek, Vienna (hereafter ÖNB), Cod. 8308 (1558), Cod. 8307 (1559), Cod. 8304 (1560), Cod. 8279 (1561), Cod. 8256 (1562 and 1563), Cod. 8257 (1564), Cod. 7337 (1565), Cod. 8255 (according to the date on the leather binding, apparently 1566).

3    Cf. ÖNB, Cod. 8270.

4    See briefly, *Herrlich Wild. Höfische Jagd in Tirol*, ed. by Wilfried Seipel, exh. cat. (Vienna, 2004), pp. 37–41.

5    This analysis is based on my study of the hunting books cited in note 2. Archduke Ferdinand spent more than 100 days hunting in 1562–1563 (ÖNB, Cod. 8256) and 1564–1565 (ÖNB, Cod. 8257, Cod. 7337).

6    Petr Vorel, 'Místodržitelský dvůr arciknížete Ferdinanda Habsburského v Praze roku 1551 ve světle účetní dokumentace', *Folia Historica Bohemica* 21 (2005), pp. 7–66 (62–65).

60 days on the hunt. In actual fact, we know he spent much more time than this travel-
ling "on entertainment in hunting", because the archduke's own hunting books do not
contain data on the hunts he participated in as a guest, organised on the estates of the
Czech and Austrian aristocracy.[7]

For instance, the year 1564 demonstrates this issue concerning the reliability of the
data presented in the archduke's hunting books quite well: in 1564, we can compare the
records of Archduke Ferdinand II's hunting book, and the diary kept by his chamber-
lain Johann of Guarient, which recorded the routes and details of all the trips the arch-
duke made.[8] Unlike the hunting books, the diary records contain data on the places
where Archduke Ferdinand ate lunch and dinner, and where he slept overnight on his
trips, including all of his hunting trips. Moreover, the notes in the diary confirm that the
hunts were either arranged as independent events, or as components of longer, multi-
day programmes of chivalric entertainments: this was especially the case with wedding
celebrations. Hunting trips into the forest with invited guests also provided a welcome
framework for private talks on important political and religious issues within the land.[9]

If Archduke Ferdinand II, during his thirties, spent an annual total of approxi-
mately three to five months on the hunt (spread out over the year), we cannot question
his outstanding physical fitness, but according to the repeated objections of his physi-
cians, hunts in the cool and damp forests contributed significantly to the worsening
health of the governor. His later personal physician Georg Handsch was disturbed by
this activity, especially by the archduke's early rising in unfavourable weather in order
to begin his hunting trips.[10]

Although Archduke Ferdinand II set out to hunt regularly throughout the year, he
most often devoted himself to hunting during the peak season of the summer months:
July, August, and September. The second peak of the hunting season was in the autumn
and during the winter, from the end of October to January. On the contrary, from
February to May, the number of hunts that he organised declined significantly.[11]

---

7   Bůžek 2009, p. 231.

8   ÖNB, Cod. 8270.

9   Cf. the 1564 hunting book (ÖNB, Cod. 8257) and calendar notes on the journeys of Archduke
    Ferdinand II (ÖNB, Cod. 8270). From the 12th to 18th of April 1564, Archduke Ferdinand resided at
    Křivoklát, where he attended a wedding, wedding reception and hunting entertainments. The atten-
    dance of Archduke Ferdinand II in a wedding on the 17th of July 1564 preceded a hunt in Strašice.
    Another wedding at Křivoklát on the19th of September 1564 ended with a hunt. Archduke Ferdi-
    nand II organized a two-day hunting trip from Prague to the estate of Přerov nad Labem from the 6th
    through to the 8th of November 1564 in honour of the papal nuncio: before the trip, the archduke
    held negotiations with the papal nuncio in Prague.

10  For more, see Katharina Seidl, "'... how to assuage all outer and inner malady ...": Medicine at the
    court of Archduke Ferdinand II', in *Ferdinand II. 450 Years Sovereign Ruler of Tyrol. Jubilee
    Exhibition*, ed. by Sabine Haag and Veronika Sandbichler, exh. cat. (Innsbruck and Vienna, 2017),
    pp. 67–71 (68); Josef Smolka and Marta Vaculínová, 'Renesanční lékař Georg Handsch (1529–1578)',
    *Dějiny vědy a techniky* 43 (2010), pp. 1–26.

11  This analysis is based on my study of the hunting books cited in note 2. For instance, in 1563 and
    1564, Archduke Ferdinand II spent almost all of July hunting, mainly in the Křivoklát forests (ÖNB,
    Cod. 8265 and Cod. 8257).

Though he set out to the forest less often in April and May – this was the nesting period for many wild animals – he requested that the administrators of the *Kammer-herrschaften* (chamber estates) make special reports on the number of eggs laid in the nests of grouse, pheasant, and cranes. This information would help the archduke prepare for the summer hunting season. At the end of September and beginning of October, when Archduke Ferdinand II limited the number of hunting trips for the rutting season, he also asked the administrators of chamber estates to send him detailed data on the places where deer in heat had been seen. He would then set out to hunt in the recorded localities during November and December.[12]

According to the data contained in the hunting books, Archduke Ferdinand II hunted most frequently at the Křivoklát estate, which he acquired in October 1565 from Maximilian II, holding it as a pledge.[13] From the end of the 1550s to the middle of the 1560s, approximately a third of all of his hunts took place in the forests between Křivoklát, Rakovník, and Strašice.[14] The hunting books contain descriptions of meadows, forest glades, secluded places, and routes in the distant surroundings of Křivoklát, where wild animals were hunted.[15] Archduke Ferdinand II also hunted close to the castle, sometimes in the older fenced game preserve, but mainly in the newly built enclosure for wild pigs.[16] In exceptional cases, the archduke set out from Prague to hunt in the forests surrounding the distant Chomutov, which he had acquired in 1560.[17]

The second geographical area in which Archduke Ferdinand II organised his hunting was the continuous belt of *Kammerherrschaften* (chamber estates) in the Central Labe (Elbe) Basin between Brandýs nad Labem, Přerov nad Labem, Lysá nad Labem, Poděbrady and Chlumec nad Cidlinou. The archduke travelled to these locations for hunting roughly as often as he did to the Křivoklát forests.[18] Besides hunting, he tried to increase his farm revenues, and focused on the establishment of fishponds and the

---

12  This is proven by the letters of the administrator of Křivoklát estate Václav Oulička of Oulice from the end of the 1560s and first half of the 1570s, held in the Tiroler Landesarchiv Innsbruck (hereafter TLA), Ferdinandea, cart. 128.

13  Cf. letter from Maximilian II addressed to Archduke Ferdinand from the 9th of October 1565 in TLA, Ferdinandea, cart. 128.

14  This analysis is based on my study of the hunting books cited in note 2.

15  More closely, see ÖNB, Cod. 8308 (1558) – record 11 May 1558, 17 August 1558; Cod. 8279 (1561) – record 21 March 1561, 24 March 1561, 17 May 1561, 29 August 1561, 1 September 1561; Cod. 8256 (1562) – record 9 July 1562, 11 August 1562, 20 August 1562, 12 October 1562, 23 October 1562, 15 December 1562; Cod. 8256 (1563) – record 24 July 1563; Cod. 8257 (1564) – record 29 June 1564, 18 July 1564; Cod. 7337 (1565) – record 28 August 1565; Cod. 8225 (1566) – record 21 March 1566, 1–5 April 1566.

16  August Sedláček, *Hrady, zámky a tvrze Království českého*, VIII (Prague, 1996³), pp. 50–59; ÖNB, Cod. 8279 (1561) – record 29 January 1561, 8–9 July 1561, 29 January 1561, 3 December 1561; Cod. 8256 (1562) – record 7 July 1562; Cod. 8255 (1566) – record 7 February 1566.

17  Sedláček 1996, p. 320.

18  This analysis is based on my study of the hunting books cited in note 2; further cf. Eduard Maur, 'Vznik a územní proměny majetkového komplexu českých panovníků ve středních Čechách v 16. a 17. století', *Středočeský sborník historický* 11 (1976), pp. 53–63.

breeding of sheep.[19] In the hunts on the mentioned chamber estates, he preferred the forests surrounding Brandýs nad Labem and Poděbrady. At the castle in Poděbrady, there was a sprawling game park enclosed by a wooden fence, which had a pheasantry with a hunting house and a breeding station for birds of prey (hunting raptors): from here, the birds were transported to the location of the hunt in cages.[20] There was also a fenced game preserve at the nearby castle in Chlumec nad Cidlinou.[21] In Kersko near Sadská, Archduke Ferdinand II sought out the extensive enclosure for the hunting of wild pigs, which were also bred in this enclosure.[22] He rarely hunted in the enclosure at the castle in Pardubice, which was included among the chamber estates in 1560.[23]

Apart from his hunting activities at Křivoklát and the chamber estates in the Central Labe basin, Archduke Ferdinand II also organised elaborate hunting parties in several places around Prague during his time as governor of the Kingdom of Bohemia: these hunts took place at different times throughout the year. In Prague, the hunting of flightless birds, especially pheasants, partridges, and quails, was probably concentrated in the new pheasantry located west of the Royal Garden. For the hunting of deer, fallow deer and wild pigs, the archduke travelled to the old royal enclosure within the territory of the settlement of Ovenec. As soon as the enclosing wall around the new game preserve at the Star Summer Palace was completed in 1556, its forests became the location of Archduke Ferdinand II's regular Prague hunts: here, he hunted deer and pheasant in particular.[24]

The archduke's hunting parties made strikingly frequent use of falconry (hunting with trained birds of prey) for hunts in the new enclosure. (Fig. 1) The archduke chiefly hunted with hawks, falcons and sparrow hawks, all of which were bred in an aviary near the Star Summer Palace.[25] Around the mid-16th century, there seems also to have been an aviary at Prague castle for breeding these birds of prey raised for fal-

---

19  Václav Pešák, 'Hospodářství a správa komorních panství v Čechách za Maxmiliána II.', *Časopis pro dějiny venkova* 16 (1929), pp. 50–58.

20  Sylva Dobalová, *Zahrady Rudolfa II. Jejich vznik a vývoj* (Prague, 2009), pp. 260–261.

21  ÖNB, Cod. 8256 (1562) – record 10 June 1562.

22  ÖNB, Cod. 8255 (1566) – record 1 July 1566.

23  Petr Vorel, *Páni z Pernštejna. Vzestup a pád rodu zubří hlavy v dějinách Čech a Moravy* (Prague, 1999), pp. 209–210.

24  Ivan P. Muchka, Ivo Purš, Sylva Dobalová and Jaroslava Hausenblasová, *Hvězda. Arcivévoda Ferdinand Tyrolský a jeho letohrádek v evropském kontextu* (Prague, 2014; in English 2017); Dobalová 2009, pp. 155–159, 172–174, 203–219; ÖNB, Cod. 8308 (1558) – record 19 February 1558, 27 April 1558, 8 June 1558, 25 June 1558, 22 July 1558, 3 August 1558, 20 December 1558; Cod. 8304 (1560) – record 15 March 1560, 15 July 1560, 17 August 1560; Cod. 8279 (1561) – record 21–24 January 1561, 30 January 1561, 4 February 1561, 9 February 1561, 13–15 February 1561, 8 May 1561, 21 June 1561; Cod. 8256 (1562) – record 26 June 1562, 11–12 July 1562, 23 July 1562, 14–15 August 1562, 17–18 August 1562; Cod. 8256 (1563) – record 4. June 1563, 24 June 1563, 8 July 1563, 4.–5 August 1563, 25 September 1563, 16–20 August 1563, 16–18 December 1563; Cod. 8257 (1564) – record 4 January 1564, 10 January 1564, 8 April 1564, 9–10 June 1564, 24 July 1564; Cod. 7337 (1565) – record 20–22 August 1565, 10–11 October 1565; Cod. 8255 (1566) – record 27 June 1566, 3 July 1566.

25  Dobalová 2009, pp. 204, 219.

Fig. 1. Falcon of Archduke Ferdinand II, 16th century
(Vienna, Kunsthistorisches Museum, Picture Gallery,
inv. no. GG 8293)

conry, located in a small garden beneath the windows of the archduke's own palace. Although Archduke Ferdinand II raised his own birds of prey in Poděbrady and in the new enclosure in the vicinity of the Star Summer Palace, he ordered hawks, sparrow hawks, falcons, and lanner falcons from noble suppliers based in the forests of the Žatec District, Chrudim District, and Čáslav District every year in July and August. He personally examined the delivered birds, then handed them over to his falconer for further training. The hunting birds from Archduke Ferdinand II's aviaries wore golden bells around their necks to allow them to be found more easily if they were lost during hunts.[26]

---

26  Dobalová 2009, p. 260; Bůžek 2009, pp. 234–235.

According to the hunting books, during the Archduke Ferdinand II's period as governor, game was occasionally hunted on the forested slopes above Břevnov Abbey of St. Margaret, towards White Mountain, as well as in several Prague vineyards, near Vyšehrad, near the Royal Summer Palace, and on the island of Štvanice, where the hunters found facilities in the mill. They also travelled to the valley of Šárka to hunt singing birds and most especially the hares, bred there in a modest enclosure for small animals.[27]

The records in the hunting books of Archduke Ferdinand II were divided by the type of animal hunted, in the individual districts and according to the days of the year, all listed from the end of the 1550s to the middle of the 1560s.[28] In the first place, all of the prestigious kills of stags were thoroughly listed: the massive sizes of the stags' branched antlers were described in particular detail. Then followed the boars, hares, predators (mainly bears, wolves, bobcats, and foxes), further flightless birds (grouse, pheasants, partridges, and quail), and finally water and forest fowl. (Fig. 2) The higher the hunted animal was listed in the hierarchy demonstrated in the hunting books, the greater the symbolic value the kill would have brought to the hunter. For example, the hunter had to invest more physical fitness, bravery, energy and ingenuity in the capture of a mature stag with massive branched antlers out in the open forest than was needed for, say, shooting wild ducks.

The celebration of the chivalric or knightly virtues demonstrated by a successful hunter was extended in the hunting books by the provision of further characteristics of each species of the animals killed. Besides the number of kills, there is an explicit record of whether the animal was shot down by Archduke Ferdinand personally, or by another member of the hunting party. Further, the hunting books record whether the animal was chased down, the method of its capture, and, most importantly, how many wounds it had received from the hunting rifle. In the hunting books dating from the end of the 1550s and the beginning of the 1560s, even the total number of all shots fired at the animal is recorded, including those which did not hit their mark.[29]

The hunting abilities of Archduke Ferdinand were therefore not only mirrored in the number of separate kills achieved in each individual hunt, but even more so in the number of successful shots: shots that managed to kill an exceptional animal that stood out for its extraordinary natural characteristics, and therefore occupied a prime place in the hierarchy demonstrated by the hunting books. The lower the number of total shots taken to bring the animal down, the higher the symbolic value the kill repre-

---

27  ÖNB, Cod. 8279 (1561) – record 16 January 1561, 20 January 1561, 22 January 1561, 10 February 1561, 6 March 1561; Cod. 8256 (1562) – record 23. June 1562, 20–21 July 1562, 24 July 1562, 3– 5 August 1562, 14 August 1562, 29 August 1562, 5 September 1562, 21 September 1562, 25 September 1562, 5 October 1562; Cod. 8256 (1563) – record 1 July 1563, 29–30 July 1563, 1 August 1563; Cod. 8257 (1564) – record 3 January 1564, 7–8 January 1564, 13 January 1564, 16 January 1564, 9–10 June 1564, 21–22 June 1564, 21 July 1564, 23 July 1564; Cod. 7337 (1565) – 26–27 August 1565, 12 November 1565, 17–18 November 1565.

28  This analysis is based on my study of the hunting books cited in note 2.

29  ÖNB, Cod. 8308 (1558), Cod. 8304 (1560), Cod. 8279 (1561); Exh. Cat. Vienna 2004, pp. 39–41.

Fig. 2. Boar hunting, depiction on a wheellock pistol (Innsbruck, Tiroler Landesmuseum Ferdinandeum, inv. no. ES 2, 1999–58)

sented. Where it is reported that Archduke Ferdinand II, in exceptional cases, supposedly managed to kill as many as two or three robust animals with a single shot simultaneously, especially if these were stags with massive antlers, such shots were considered to be miraculous, like those recorded in the secret hunting book of his great grandfather Maximilian I from the beginning of the 16th century.[30] The image of the successful hunter endowed with chivalric virtues and extraordinary abilities was one of the traditional models determining the anticipated behaviour and actions of a nobleman in the Habsburg dynasty during the early modern period. The successful hunter of wild animals in the forest acted in exactly the same manner as the triumphant knight on the tournament tiltyard, where the number of hits to the opponent's body with the lance decided his victory.[31]

30  More closely, see *Das Jagdbuch Kaiser Maximilians I.*, ed. by Michael Mayr (Innsbruck, 1901); especially *Kaiser Maximilians I. geheimes Jagdbuch und von den Zeichen des Hirsches eine Abhandlung des vierzehnten Jahrhunderts*, ed. by Th. G. Karajan (Vienna, 1881²), p. 45, 49; *Emperor Maxmilian I and the Age of Dürer*, ed. by Eva Michel and Maria Luise Sternath, exh. cat. (Munich, 2012), p. 314.

31  Matthias Pfaffenbichler, 'Die Turniere an den Höfen der österreichischen Habsburger im 16. Jahrhundert', in *Turnier. 1000 Jahre Ritterspiele*, ed. by Matthias Pfaffenbichler and Stefan Krause (Vienna, 2018), pp. 155–169; Bůžek 2009, pp. 207–230; Jaroslav Pánek, 'Der Adel im Turnierbuch Erzherzog Ferdinands II. von Tirol (Ein Beitrag zur Geschichte des Hoflebens und der Hofkultur in der Zeit seiner Statthalterschaft in Böhmen)', *Folia Historica Bohemica* 16 (1993), pp. 77–96.

Archduke Ferdinand II's repeated shooting down of a robust fourteen-point stag with a single shot from his own gun confirmed the expected chivalric virtues of a successful hunter in the eyes of the other members of his retinue. This image quickly spread amongst the noble classes of the Kingdom of Bohemia, especially via personal letters and the written recollections of those who had participated in these hunts.[32] The chivalric virtues that Archduke Ferdinand II demonstrated through his actions while hunting were not only preserved in his own hunting books, but also in the depictions of kills in the form of murals, and of course his hunting trophies such as the antlers on display in his residence at Ambras Castle, where he often stayed after he assumed rule in Tyrol and Further Austria.[33] Animals with an unusual appearance, such as an irregularly shaped skull and antlers, were displayed in the archduke's *Wunderkammer*.[34]

It is clear from the evidence provided in the hunting books regarding the chasing, cornering, and shooting of the quarry, that the methods used for each individual recorded hunt were distinctly different. Archduke Ferdinand II particularly enjoyed organising hunts for deer, fallow deer, roe deer, wild pigs, hares, and bears. In these cases, the hunting dogs or birds of prey would chase the frightened quarry into prepared nets, where it became the target for the hunters, who shot at the quarry using guns, handguns, and crossbows, or stabbed it using blade weapons, most often a spear and daggers.[35] A stag's antlers were cut from its body while it was still alive, and it was then slaughtered with a dagger to the heart so that the hunters could ritually drink the fresh heart's blood while it was still hot. First, the archduke would have drunk several mouthfuls, followed by his closest courtiers and noble guests. Finally, the rest of the hunting party would drink the blood, accompanied by expressions of boisterous joy over the prestigious kill.[36] The blood of the stag supposedly strengthened the body of the successful hunters and was at the same time a symbol of their cleansing against the activity of the mysterious forces whose malevolence they had to face when hunting in the depths of the forest, a superstition still held well after the middle of the 16th century.[37] The drinking of the blood of the slaughtered stag was a celebration of chivalric virtues, and of the individual abilities of the hunter that had allowed them to vanquish this wild animal with its massive antlers.

Deer and stags in particular were not only hunted 'in chase': Archduke Ferdinand II would also undertake what is known today as blind or stand hunting. This

---

32   *Paměti Pavla Korky z Korkyně. Zápisky křesťanského rytíře z počátku novověku*, ed. by Zdeněk Vybíral, Prameny k českým dějinám 16.–18. století, series B, IV (České Budějovice, 2014), p. 105; Václav Březan, *Životy posledních Rožmberků*, I, ed. by Jaroslav Pánek (Prague, 1985), pp. 181–182.

33   Bůžek 2009, pp. 278–303; Heinz Noflatscher, 'Archduke Ferdinand II as Sovereign Ruler of Tyrol', in *Ferdinand II. 450 Years Sovereign Ruler of Tyrol. Jubilee Exhibition*, ed. by Sabine Haag and Veronika Sandbichler, exh. cat. (Innsbruck and Vienna, 2017), pp. 31–37.

34   Margot Rauch, 'Trophäen und Mirabilien', in *Herrlich Wild. Höfische Jagd in Tirol*, ed. by Wilfried Seipel, exh. cat. (Vienna, 2004), pp. 49–51.

35   Cf. Mayr 1901; Jan Čabart, *Vývoj české myslivosti* (Prague, 1958), pp. 80–81.

36   Vybíral 2014, pp. 137–138.

37   Jacques Le Goff, *Kultura středověké Evropy* (Prague, 1991), pp. 143–145.

meant he would come with his small retinue to a previously determined location, perhaps a forest glade, where he would wait in silence for the arrival of a deer or stag and then shoot it at the opportune moment. The testimony of the archduke's hunting retinue confirms that he was able to walk through the forest for several hours without a break until he reached a place where the gamekeepers who accompanied him judged that he might encounter a good stag.[38] In many cases, the shots fired only wounded the quarry. Although the shot quarry would be followed by the hunting dogs, they sometimes returned without announcing their prey, to the displeasure of the disappointed hunters. Much later after the hunt, the administrators of the estates sometimes reported that the gamekeepers had found a larger than usual number of dead animals in the forests.[39]

Archduke Ferdinand II used his own pack of hunting dogs for hunts and chases, which included a significant number of greyhounds and large white dogs of an English breed,[40] which he most likely bred from 1557 on in a kennel located in Prague's Lesser Town.[41] He regularly expanded his breeding programme through the purchase of new greyhounds that had proved themselves in hunts on the estates of the Bohemian aristocracy.[42] The archduke did not hesitate to pay more money for a well-trained greyhound than he would have for a high-quality handgun.[43] (Fig. 3) He also appreciated the abilities of experienced gamekeepers who handled the hunting dogs and birds of prey during hunts held on the estates of the aristocracy, and would regularly request the loan of such gamekeepers for his own hunting preserves.[44] In the purchasing of hunting dogs, seeking out the young birds of prey, and the borrowing of gamekeepers, mutually advantageous ties were created between Archduke Ferdinand and the Bohemian aristocracy. These ties may have served to protect the regional interests of the aristocracy, or to the support of the power base of the archduke in his role as Bohemian governer. Karel of Žerotín was among the renowned suppliers of trained white greyhounds to the kennel at Prague Castle during the second half of the 1550s. The archduke visited Karel, an experienced warrior, at his castle rebuilt in Renaissance style

---

38  Vybíral 2014, p. 106; TLA, Ferdinandea, cart. 10 – Jindřich Počepický of Počepice to Archduke Ferdinand II (13 August 1568), cart. 56 – Václav Oulička of Oulice to Archduke Ferdinand II (14 August 1568), cart. 128 – Václav Oulička of Oulice described to Archduke Ferdinand II (29 September 1572) the places on the Křivoklát estate where gamekeepers had seen and heard deer in heat.

39  Vybíral 2014, p. 106; ÖNB, Cod. 8304 (1560) – record 21. February 1560; Cod. 8256 (1562) – record 5 October 1562.

40  Vorel 2005, pp. 52–53.

41  Bůžek 2009, pp. 234–235; Dobalová 2009, p. 219.

42  TLA, Ferdinandea, cart. 9 – Archduke Ferdinand to Zdeněk of Sternberg (29 March 1564), Archduke Ferdinand to Jaroslav Smiřický of Smiřice (25 July 1564), Archduke Ferdinand to Jindřich Počepický of Počepice (23 December 1564), Archduke Ferdinand to Fridrich Mičan of Klinštejn (17 December 1564), cart. 10 – Jan of Valdštejn to Archduke Ferdinand (22 October 1571); State Regional Archive Třeboň (hereinafter SOA Třeboň), Cizí rody – registratura, ze Švamberka, sign. 16/33 (2 November 1557).

43  Bůžek 2009, p. 235.

44  SOA Třeboň, Historica Třeboň, sign. 4348 – Archduke Ferdinand to Jindřich the Elder of Švamberk (29 December 1555).

Fig. 3. Giorgio Liberale, Hunting dog of Archduke Ferdinand II (Vienna, Österreichische Nationalbibliothek, Cod. Ser. no. 2669)

at Kolín, and was a regular participant in the chivalric tournaments Karel organised there. The archduke also joined the hunting parties held on Karel's estates, and was the godfather of his son, Jan Jetřich.[45]

The programme of hunting entertainments included the popular chasing of bears. (Fig. 4) Here, the bears were compelled to leave their dens by the roar of a strategically placed gunpowder charge. Packs of hunting dogs then drove the frightened bears into prepared nets, where they became the prey of the waiting and doubtless highly excited hunters.[46] Young and infant bears were not usually killed, but rather sent as a gift to Archduke Ferdinand II. The archduke had them released into various of his game preserves, where they would eventually, upon reaching adulthood, become quarry for the archduke's hunts: new objects, as it were, for his ongoing passion for hunting.[47]

45   Václav Bůžek, František Koreš, Petr Mareš and Miroslav Žitný, *Rytíři renesančních Čech ve válkách* (Prague, 2016), pp. 36–38; Vybíral 2014, p. 95; Sedláček 1998, XII, pp. 119–120.

46   Pánek 1985, pp. 181–182; Vybíral 2014, p. 137.

47   Cf. Thomas Kuster, '"Zu der Pracht eines Herren gehören Pferde, Hunde [...], Vögel [...] und fremde Thiere". Die Tiergärten Erzherzog Ferdinands II. in Innsbruck', in *Echt tierisch! Die Menagerie des Fürsten*, ed. by Sabine Haag, exh. cat. (Vienna, 2015), pp. 49–54 (52).

Raptors, especially hawks, falcons, sparrow hawks and lanner falcons, were employed in hunting for grouse, pheasants, partridges, and quails. These hawks and falcons would pursue the flightless birds into nets, making them easy targets for the hunters.[48] By contrast, water fowl, including geese, ducks, swans, and herons, were flushed by the hounds, whereupon they would fly low over the surface of the ponds, presenting good targets for the waiting hunters. Singing birds were also caught in nets. From the end of the 1550s to the middle of the 1560s, only the number of birds and fowl killed is presented in the hunting books, and not the total number of shots fired and successful shots. Archduke Ferdinand II made regular requests to the pheasantries of the Bohemian aristocracy for fresh supplies of young partridges, and most especially pheasants with coloured feathers.[49] He typically had the donated birds placed in the pheasantries built in the new garden at Prague Castle, as well as those in Křivoklát and Poděbrady, where he wanted to expand his breeding programme. From the end of the 1560s, shipments of pheasants and partridges left Bohemia bound for the pheasantries that the archduke had had built at Ambras Castle and in the garden close to the Hofburg in Innsbruck.[50] He carefully admonished the servants organising the birds' transportation to ensure that the birds had sufficient space in their cages.[51] When Archduke Ferdinand II organised the hunting games referred to as *Federspiel*, he ordered the birds moved into mobile cages from which they were then gradually released. Trained hawks and sparrow hawks were released to dive upon the fattened pheasants, pigeons and partridges, and reportedly tore at their prey while the gathered spectators watched this cruel spectacle.[52]

After his departure for Innsbruck, the archduke still paid extraordinary attention to the number of grouse in the Křivoklát forests. The administrator of the estate sent the annual report of the *Waldschreiber* (chief forester) to the Tyrolean metropolis each year. This report stated how many eggs had been collected by the gamekeepers, herdsmen and *Richter* (administrators of villages) from the nests of the grouse on the Křivoklát estate and taken to the farm building at the castle, where they were placed under the nesting domesticated hens.[53] The archduke was also interested in whether the two women who took care of the black grouse in an artificial hatchery were ensur-

---

48  During his time as the governor in the Kingdom of Bohemia, Archduke Ferdinand II built up a network of suppliers of birds of prey. On this, see TLA, Hofregistratur, cart. 4 – Jan Hruška of Březno to Archduke Ferdinand II (13 July 1561), Petr Hlavsa of Liboslav to Archduke Ferdinand II (17 August 1561), cart. 5 – Jan Hruška of Březno to Archduke Ferdinand II (25 July 1562), cart. 6 – Jan Hruška of Březno to Archduke Ferdinand II (20 July 1563); Ferdinandea, cart. 9 – Archduke Ferdinand II to Jan Bořita of Martinice (1 July 1562), Archduke Ferdinand II to Janu Hruškovi z Března (21 July 1563), Archduke Ferdinand II to Jan Bořita of Martinice (13 July 1564).

49  TLA, Ferdinandea, cart. 9 – Archduke Ferdinand II to Jindřich of Donín (23 April 1564).

50  TLA, Ferdinandea, cart. 10 – Jan of Valdštejn to Archduke Ferdinand II (10 February 1568).

51  TLA, Ferdinandea, cart. 10 – Jindřich Počepický of Počepice to Archduke Ferdinand II (7 August 1568).

52  Vorel 2005, p. 52.

53  TLA, Ferdinandea, cart. 128 – Křivoklát captain Václav Oulička of Oulice to Archduke Ferdinand II (25 July 1575, 12 June 1576).

ing that the hatched birds had enough suitable food, which included ants, groats and pieces of rolls. Roughly two months from hatching, the grouse were placed along with the young pheasants and partridges in cages and transported by carriage to Ambras, where they would enrich the breeding programme for flightless birds in the famous pheasantry there. Archduke Ferdinand II had also procured pheasants from Florence, Milan, Munich, and the Netherlands for this facility.[54] In the selection of new pheasants for breeding, he devoted extraordinary attention to the colouring of the birds' feathers.[55]

Although Archduke Ferdinand II organised hunts in forests and game preserves during his period as governor in Bohemia, according to the records in the hunting books he also shot a number of wild animals on his journeys to these hunts. The archduke travelled to the hunt on horseback, and shot at fowl and larger animals directly from the saddle. These frightened animals were most often shot by the archduke on the route between Prague and Křivoklát, or between Brandýs nad Labem and Poděbrady.[56] Apparently, even animals that were not usually hunted, such as eagles, vultures, and squirrels, learned to fear the sound of horses' hooves in these forests.[57] Archduke Ferdinand II relied on thoroughbreds bred in his own stables, and at the beginning of the 1550s, these horses were cared for by approximately twenty grooms in the stables at Prague Castle.[58] A more detailed view of the stables at the Hofburg in Innsbruck and at Ambras Castle is provided by an inventory of the horses purchased after Archduke Ferdinand II's death. However, this inventory has received little scholarly attention.[59]

Even at the beginning of the 1550s, Archduke Ferdinand II would still spend nights in rural cottages, rectories, inns, and hunters' camps in the forest when he journeyed around on hunting parties that lasted several days. In the hunters' camps, he would consume the day's kill by the campfire along with the other hunters.[60] Ten years later, he often spent nights at the castle Křivoklát when on the hunt. When he made hunting trips to another *Kammerherrschaft* (chamber estate) the archduke sometimes chose to sleep in the *Forsthaus* (a gamekeeper's house) in Hlavenec, as well as in the small hunt-

---

54   Kuster 2015, p. 52.
55   TLA, Ferdinandea, cart. 9 – Archduke Ferdinand II to Jindřich of Donín (23 April 1564).
56   ÖNB, Cod. 8308 (1558) – record 11 May 1558, 13 July 1558, 11–12 August 1558, 17–18 August 1558; Cod. 8304 (1560) – record 10 January 1560, 21 February 1560, 6 August 1560; Cod. 8279 (1561) – record 3 March 1561, 21 March 1561, 17 May 1561, 29 August 1561, 18 September 1561; Cod. 8256 (1562) – record 22 March 1562, 3 – 4 April 1562, 20 April 1562, 11–12 May 1562, 15 May 1562, 15 June 1562, 9 July 1562, 30–31 July 1562, 1 August 1562, 6 August 1562, 11 August 1562, 15–16 December 1562; Cod. 8256 (1563) – record 24 May 1563, 24 July 1563, 26 August 1563; Cod. 8257 (1564) – record 10 July 1564, 18 July 1564; Cod. 7337 (1565) – record 28 May 1565; Cod. 8255 (1566).
57   As follows from the analysis of records in the hunting books of Archduke Ferdinand II cited in the footnote 2.
58   Vorel 2005, p. 25.
59   Kuster 2015, p. 52.
60   Vorel 2005, p. 59.

Fig. 4. Bear Hunting, second half of the 16th century
(Vienna, Kunsthistorisches Museum, inv. no. GG 5741)

ing lodges in Lysá nad Labem, Přerov nad Labem and Sadská, but chiefly he slept at the castles in Brandýs nad Labem and Poděbrady.[61] The archduke's increasing demand for comfortable accommodation while on the hunt corresponded, during the first half of the 1560s, to his higher requirements for personal hygiene and the dignified serving of the evening feast, at which the game was served on silver plates and the archduke himself ate with a silver spoon, fork, and knife with golden handles.[62] It is recorded that in the spring of 1565 that before the archduke arrived to stay overnight at the castle in Poděbrady, his *Hofmeister* (chief steward) Franz, Count of Thurn had to prepare enough hot water for the sovereign's evening bath.[63]

Archduke Ferdinand II's hunting books record that Emperor Ferdinand I, the archduke's brothers Maximilian II and Karl II, various imperial princes, the papal nuncio Zaccaria Dolfino, the Spanish ambassador Claudio Fernández Vigil de Quinones, and a number of Bohemian aristocrats occasionally attended selected hunts organised by the archduke in Prague, at Křivoklát, and on the chamber estates from the end of the 1550s to the middle of the 1560s.[64] At the same time, Archduke Ferdinand II also set out into the forests to hunt at the invitation of those lords and knights who were influential either as land or court officials. These included Florián Griespek of Griespach, Pavel Korka of Korkyně, Jan the Younger Popel of Lobkowicz, Jaroslav of Pernštejn, Vilém of Rožmberk [Rosenberg], Adam of Šternberk [Sternberg], Jindřich of Švamberk [Swamberg], and Vilém Trčka of Lípa.[65]

The hunts attended by a larger number of noble persons were usually components of multi-day chivalric entertainments, most frequently celebrations of weddings, or sports competitions. These would include horse races, cock fights, greyhound races, target shooting, long jumps, and target tosses.[66] Such major entertainments offered the

---

61   Cf. data for 1564 (ÖNB, Cod. 8270) – 6 March 1564 stayed overnight in Přerov nad Labem, 12 April 1564 stayed overnight at Křivoklát, 5 June 1564 stayed overnight in Sadská, 6 June 1564 stayed overnight in Přerov nad Labem, 12 June 1564 stayed overnight in Brandýs nad Labem, 19 June 1564 stayed overnight in Sadská, 20 June 1564 stayed overnight in Přerov nad Labem, 14 July 1564 stayed overnight at Křivoklát, 17 July 1564 stayed overnight in Strašnice, 26 July 1564 stayed overnight in Brandýs nad Labem, 15 November 1564 stayed overnight in Přerov nad Labem, 16 November 1564 stayed overnight in Poděbrady, 19 November 1564 stayed overnight in Přerov nad Labem, 4 December 1564 stayed overnight in Přerov nad Labem, 5 December 1564 stayed overnight in Poděbrady, 15 December 1564 stayed overnight in Přerov nad Labem, 19 December 1564 stayed overnight in Hlavenec; Dobalová 2009, pp. 243–249, 256–262.

62   TLA, Ferdinandea, cart. 9 – Archduke Ferdinand II to Rupert Chrustenský of Malovary (30 July 1565).

63   TLA, Ferdinandea, cart. 9 – Archduke Ferdinand II to Franz of Thurn (22 April 1565).

64   ÖNB, Cod. 8308 (1558) – record 30 June 1558; Cod. 8279 (1561) – record 9 September 1561, 24 September 1561; Cod. 8256 (1562) – record 14 – 15 May 1562, 25 May 1562, 10 June 1562, 22 June 1562, 26 – 27 June 1562, 3 – 5 July 1562, 7 July 1562, 16. July 1562, 6 August 1562, 2 September 1562; Cod. 8256 (1563) – record 29 – 30 January 1563; Cod. 8270 – record 8 April 1564, 6 – 7 November 1564; Cod. 7337 (1565) – record 5 May 1565, 18 August 1565, 11 September 1565.

65   Vorel 2005, p. 59; *Česká a moravská aristokracie v polovině 16. století. Edice register listů bratří z Pernštejna z let 1550–1551*, ed. by Petr Vorel (Pardubice, 1997), pp. 161–162; Vybíral 2014, pp. 105–106, 137–138; ÖNB, Cod. 8270.

66   Bůžek 2009, pp. 238–239.

participants the opportunity to exchange opinions concerning the resolution of problematic political issues. For example, in the second half of April 1561, Archduke Ferdinand II arrived at a series of chivalric entertainments accompanying a hunt and chase organised by Vilém of Rožmberk at Veselí nad Lužnicí. Here, he also met Jan the Younger Popel of Lobkowicz and on the orders of his elder brother Maximilian II, the archduke was tasked with convincing both Jan and his host Vilém to become guarantors for the debts of Jaroslav of Pernštejn at the estate of Pardubice.[67]

The hunting books, accounts, and letters of Archduke Ferdinand II, which include invitations to hunting parties and requests for shipments of new hunting dogs and birds of prey, sporadically contain not only the names of his huntsmen, falconers, dog handlers, and the other servants who accompanied him on the hunt, but also the names of the administrators of the kennels and breeding coops for flightless birds.[68] The information provided by these sources therefore adds to our incomplete knowledge of the composition of the archduke's court in Prague, and the functions of that court: something that cannot be reliably determined from the other scant surviving sources.

If we calculate that from the end of the 1550s to the middle of the 1560s Archduke Ferdinand II spent a total of approximately three to five months per year in the forests and game preserves (spread out over the different annual hunting seasons) participating in the "entertainments in hunting" that he organised for himself and his guests, then hunting was clearly the most significant means by which the archduke chose to publicly present his chivalric virtues, which he ostentatiously claimed through his behaviour and actions while on the hunt.[69] According to the incomplete data recorded in the tournament books, Archduke Ferdinand II organised tournaments at the end of the 1540s and during the 1550s in various places, especially in and around Prague. If we consider the decoration of the tiltyards, the theatrical conception of well-known tournament themes (drawn mainly from ancient history), the sporting competitions with large numbers of participants dressed in varied costumes and competing with excited screams, it would seem that as a presentation of the archduke's chivalric virtues, the tournament entertainments offered spectators a sensorially stronger experience.[70] However, in contrast to the months devoted to hunts and chases, Archduke Ferdinand II spent only a few days a year at on the tournament tiltyards. At the end of the 1550s, a period when he spent approximately 80 days per year on hunts and chases in the forests and game preserves, we can very roughly estimate that he attended the tiltyard for only eight to ten days per year, regardless of whether he himself had organ-

---

67  SOA Třeboň, Historica Třeboň, sign. 4447 a, b, c; Pánek 1985, pp. 181–182.
68  For instance, ÖNB, Cod. 8257 (1564) – record 15 January 1564, 14 December 1564; Vorel 2005, pp. 23–26; TLA, Ferdinandea, cart. 9 – Archduke Ferdinand II to Fridrich Tuchořovský of Tuchořovice (16 June 1565); cart. 10 – Jindřich Počepický of Počepice to Archduke Ferdinand II (3 August 1573).
69  Václav Bůžek, 'Ferdinand II. Tyrolský v souřadnicích politiky Habsburků a jeho sebeprezentace', in *Knihovna arcivévody Ferdinanda II. Tyrolského*, I: *Texty*, ed. by Ivo Purš and Hedvika Kuchařová (Prague, 2015), pp. 13–40 (31–40).
70  Pánek 1993, pp. 77–96.

ised the tournament, or was there as an invited guest.[71] Although the archduke regularly included tournaments in the annual Shrovetide celebrations,[72] during the rest of the year he simply organised them according to his current needs.

In conclusion, it can be summarised that during Archduke Ferdinand II's time as governor in the Kingdom of Bohemia, multi-day hunting trips into various forests and game preserves formed a solid part of his highly regulated annual hunting programme. This annual programme's fairly inflexible form was of course largely determined by the reproductive cycles of the various quarry, and the archduke's great enthusiasm for the hunt, which meant he wished to take full advantage of each hunting season. During this period of Archduke Ferdinand II's life in the mid-16th century, his enjoyment of physical exercise out in open nature and his desire to prove his chivalric virtues were united in his passion for hunting.[73] A short-term disturbance of the annual hunting programme could only be caused by extraordinary circumstances: for instance, following the death of Ferdinand I at the end of July 1564,[74] the archduke failed to attend the usual hunts in August. He did however continue hunting in the succeeding months according to his usual programme, even though he assumed responsibility for the arrangement of his father's funeral.[75]

---

71  The number of chivalric tournaments organised by Archduke Ferdinand II during his period as governor in the Kingdom of Bohemia cannot be proven with any great precision. Apart from the data in the tournament books (Pánek 1993, pp. 86–91), various letters from Archduke Ferdinand II have also been preserved, in which he calls upon selected lords and knights to participate in tournament competitions. The dates on these letters do not, however, correspond to the data presented in the tournament book. Archduke Ferdinand II also attended other tournaments at the invitation of aristocrats, who organised such events on their estates.

72  Pánek 1993, pp. 86–91; Bůžek 2009, pp. 213–214.

73  In the broader context, see Václav Bůžek, Ideály křesťanského rytířství v chování urozeného muže předbělohorské doby, in Radmila Švaříčková Slabáková, Jitka Kohoutová, Radmila Pavlíčková, Jiří Hutečka and others, Konstrukce maskulinní identity v minulosti a současnosti. Koncepty, metody, perspektivy (Prague, 2012), pp. 47–60, 416–421.

74  Václav Bůžek, 'Ferdinand I. ve svědectvích o jeho nemocech, smrti a posledních rozloučeních', Český časopis historický 112 (2014), pp. 402–431.

75  Cf. ÖNB, Cod. 8257 (1564).

Jan Baťa

# The musical element of festivities organised by Archduke Ferdinand II

Archduke Ferdinand II was famed for his passion for festivities and entertainments.[1] During his twenty years as governor of Bohemia (1547–1567) he became an active organiser and supporter of such events, some of which – especially the ceremonial arrival of Emperor Ferdinand I in Prague in 1558 – were among the greatest Renaissance celebrations organised in the Bohemian Lands. After the return of the archduke to Innsbruck (his seat as governor of the Tyrol), he also developed his organisational activities there, but nevertheless remained in close contact with the Bohemian Lands.[2]

So far specialist literature has devoted attention to Archduke Ferdinand II as a lover and organiser of Renaissance festivities, but only makes very brief mention of the music accompanying such events.[3] This is hardly surprising, because music, as a temporal art, was the most ephemeral component of such celebrations. Its intangibility is augmented by the fact that it often arose *ad hoc* without any need to leave a more permanent trace in the form of written musical or annotated sources and, significantly, also fulfilled a very specific functional role, rather than a primarily artistic one: together with other components it was intended to enhance the impact on those participating in the celebrations.[4] The musical compositions performed therefore often had a life just as brief as the architectural elements of the processions, such as triumphal arches and

---

1   I would like to thank His Excellency Charles Philip Count Clam Martinic, Registrar of the Order of the Golden Fleece, for the opportunity to study archive material on the history of the Order of the Golden Fleece deposited in the Haus-, Hof- und Staatsarchiv in Vienna (hereafter HHStA) in the section Sonderbestände: Nachlässe, Familien- und Herrschaftsarchive, Orden vom Goldenen Vlies (1431–1942).
    On this subject, see Josef Hirn, *Erzherzog Ferdinand II. von Tirol. Geschichte seiner Regierung und seiner Länder*, 2 vols. (Innsbruck, 1885–1888) (on celebrations in particular II, pp. 476–485); the Bohemian part of the archduke's life is reflected in particular in Václav Bůžek, *Ferdinand von Tirol zwischen Prag und Innsbruck. Der Adel aus den böhmischen Ländern auf dem Weg zu den Höfen der ersten Habsburger* (Vienna, Cologne and Weimar, 2009). Cf. also Matthias Pfaffenbichler, 'Das Turnierfest zwischen Reiterkampf und Oper', in *Feste Feiern*, ed. Sabine Haag and Gudrun Swoboda, exh. cat. (Vienna, 2016), pp. 43–53 (46).
2   On this in particular, see Bůžek 2009, pp. 241–278.
3   Cf. Walter Senn, *Musik und Theater am Hof zu Innsbruck. Geschichte der Hofkapelle vom 15. Jahrhundert bis zu deren Auflösung im Jahre 1748* (Innsbruck, 1954), pp. 174–181; Thomas DaCosta Kaufmann, *Variations of the Imperial Theme in the Age of Maximilian II and Rudolf II* (New York, 1978), passim; Jaroslav Pánek, 'Der Adel im Turnierbuch Erzherzog Ferdinands II. von Tirol (Ein Beitrag zur Geschichte des Hoflebens und der Hofkultur in der Zeit seiner Statthalterschaft in Böhmen)', *Folia Historica Bohemica* 16 (1993), pp. 77–96; Veronika Sandbichler, 'Festkultur am Hof Erzherzog Ferdinands II.', in *Der Innsbrucker Hof. Residenz und höfische Gesellschaft in Tirol vom 15. bis 19. Jh*, ed. by Heinz Noflatscher (Vienna, 2005), pp. 159–174; Bůžek 2009, pp. 168–190, 207–239, 254–256, 286–299.
4   On functional music in 16th century society cf. Heinrich Besseler, 'Umgangsmusik und Darbietungsmusik im 16. Jahrhundert', *Archiv für Musikwissenschaft* 16 (1959), pp. 21–43.

other set pieces. The following text thus sets itself a difficult task – to better acquaint us with the musical element of the festivities in Prague and Innsbruck in which Archduke Ferdinand II played an organisational role, and which exceed his other enterprises in terms of both their importance and level of preservation in contemporary sources.

## Prague 1558

The greatest Prague celebration of the 16th century, which was engineered by Archduke Ferdinand II and also left a permanent impression on its participants, was the ceremonial entry of the Bohemian King Ferdinand I as the newly crowned Emperor of the Holy Roman Empire. This event, which took place on the 8th and 9th of November 1558, signified a certain turning-point in the life of the Kingdom of Bohemia. The ceremony achieved this not only thanks to its impressive nature and well-thought-out management, but also and especially due to the political impression it created. The majority of the participants in the ceremony would still have had recent memories of the foiled uprising of the estates against Ferdinand I in 1547, which aroused the monarch's anger, leading to a drastic restriction of delegated economic and political power, especially that of the royal boroughs.[5] Ferdinand I's triumphant arrival in Prague in 1558 was then seen as both an act of reconciliation, and a recognition of the ruler's sovereignty.

The two-day celebration is described in many narrative sources and humanist poems of the time.[6] Some of these descriptions were completed directly on the orders of Archduke Ferdinand II, who was clearly mindful of the appropriate presentation of this event. In this respect he did not differ from other organisers of similar types of ceremonies at the time, because much of the significance carried by a given festivity was intended to not only have an impact on those actually present, but also on the wider population via printed descriptions.[7] These usually included both texts and illustrations. The surviving contemporary descriptions of the Prague festivities from

---

5   Jaroslav Pánek et al., *A History of the Czech Lands* (Prague, 2009), pp. 199–201. Cf. also Pfaffenbichler 2016, p. 48.

6   The most important of these are two detailed descriptions – Martin Cuthenus, *Brevis et succincta Descriptio Pompae in Honorem Sacratissimi ac Invictissimi Imperatoris Ferdinandi Primi [...]* (Pragae, [s. a.]); Pietro Andrea Mattioli, *Le solenni pompe, i superbi, et gloriosi apparati, i trionfi, i fuochi, et gli altri splendidi & dilettevoli spettacoli, fatti alla venuta dell'Invitissimo Imperadore Ferdinando primo [...]* (Prague, 1559). Further relevant sources are listed by Čeněk Zíbrt, *Bibliografie české historie*, III/2 (Prague, 1905), pp. 432–434, *Rukověť humanistického básnictví v Čechách a na Moravě*, II, ed. by Josef Hejnic and Jan Martínek (Prague, 1966), p. 139, Helen Watanabe-O'Kelly and Anne Simon, *Festivals and Ceremonies: A Bibliography of Works Relating to Court, Civic, and Religious Festivals in Europe 1500–1800* (London and New York, 2000), p. 4 and a database Bibliography of books printed in the German speaking countries of the sixteenth century (VD 16, http://www.vd16.de). Cf. also Jan Bažant, *Pražský Belvedér a severská renesance* (Prague, 2006), pp. 219–236.

7   Cf. Roy Strong, *Splendour at Court. Renaissance Spectacle and Illusion* (London, 1973); Frances Amelia Yates, *Astraea. The Imperial Theme in the Sixteenth Century* (Harmondsworth, 1977).

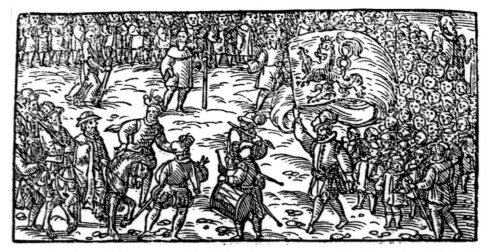

Fig. 1. The welcome of the Emperor Ferdinand I into Prague 1558, in Bartoloměj Paprocký z Hlohol and Paprocké vůle, Diadochos, IV, Prague 1602, p. 141 (Prague, National Library of Czech Republic, sign. 65 C 001796)

1558 do however lack visual material. Several depictions appeared almost half a century later in the *Diadochos*, a work devoted to the history of the Kingdom of Bohemia by the Polish humanist Bartoloměj Paprocký of Hlohol (circa 1543–1614).[8] The collection of woodcuts unfortunately shows hardly any musical production (although there was a great deal of music included in the course of the celebrations) apart from one scene showing a flautist and a drummer.[9] (Fig. 1)

Official descriptions state that the Emperor was first welcomed in front of the walls of the New Town of Prague not only by the archduke himself, but also by the highest provincial officials, lords and knights with an escort totalling five thousand horsemen, and then set out on a festive procession through the streets of the towns of Prague towards Prague Castle. By the Horse Gate he met with church and academic dignitaries who, while praising God, welcomed the sovereign with the singing of a polyphonic hymn.[10] The scribes do not, unfortunately, mention either the hymn's text or its author. It may however be assumed with the greatest probability that this would have been a simple polyphonic arrangement of the song of praise *Te Deum laudamus*. Part of the presentation made to the monarch was the performance of nine singing Muses, represented by the pupils of the leading Prague parish schools and students of the university.[11] Six Muses were located in various parts of the New Town of Prague.

---

8   Bartoloměj Paprocký z Hlohol a Paprocké Vůle, *Diadochos id est successio jinák posloupnost knížat a králův českých, biskupův i arcibiskupův pražských a všech třech stavův slavného království českého, to jest panského rytířského a městského krátce sebraná a vydaná*, 4 vols. (Prague 1602).

9   Paprocký 1602, IV, p. 141.

10  Cuthenus, f. D ij$^r$; Mattioli 1559, f. B iij$^v$: "[…] tutto il clero comincio a cantare un bello hinno in canto figurato pregando, et dando laude al Signore."

11  The following interpretation is based on the texts of Cuthenus, ff. D ij$^r$-F iij$^r$ and Mattioli 1559, ff. B [iv]$^r$-C iij$^v$.

The first of these – Calliope – was accompanied by the singing of the pupils of the St Henry School. The second, Thalia, was supported by the school choir of the Church of St Gallus. Students of the Charles College assisted the third Muse Euterpe. Clio was accompanied by the choir of pupils from the Týn School. Performing with the fifth Muse, Polyhymnia, was the school choir of the Church of St Giles. The St Nicholas scholars sang with Urania. Twelve trumpeters and drummers then welcomed the Emperor at the gate to the Old Town of Prague. The seventh Muse, Terpsichore, paid homage to the monarch together with the choir of pupils from the School of St Peter. The eighth, Erato, greeted Ferdinand I with the choir of St Stephen's. The last Muse – Melpomene – was accompanied by the pupils of the Lesser Town schools. All these choirs sang polyphonic music.[12] The sources, however, quote only the sung texts, which were composed of many different metrical forms (odes, Sapphic strophes, elegiac couplets and hymns). We may assume that they were not set to original music, but rather used existing music. A permanent set repertoire formed an intrinsic part of contemporary teaching in parish schools.[13] This repertoire was comprised of simple homorythmic, polyphonic patterns, to which it was possible to set any text with a corresponding metre. For this reason it was not difficult for pupils to learn and sing these compositions by heart.[14]

In addition, Emperor Ferdinand I was given an enthusiastic welcome by a choir of Prague teachers who, according to surviving accounts, also sang a polyphonic composition – an eleven-syllable verse set to a five-part piece of music. This was without a doubt a composition in the same style as those sung by the school pupils with the Muses.[15] A noteworthy part of the celebration was the participation of Jewish musicians, who performed polyphonic adaptations of Hebrew psalms for the Emperor as he passed.[16] The ceremonial arrival was also a great opportunity for the Jesuit Order, which was able to present itself in public for the first time since its arrival in Prague in April 1556. The pageant of the God of War, Mars, overcome by Peace and Justice, was accompanied by the *Gloria* of an unspecified polyphonic Mass.[17]

---

12  Mentioned in sources as *variorum vocum modulatio* or *vocum concentus* (Cuthenus), or else *canto figurato* or *aggredevolissimo concento* (Mattioli).

13  On this see in particular Klaus Wolfgang Niemöller, *Untersuchungen zu Musikpflege und Musikunterricht an den deutschen Lateinschulen vom ausgehenden Mittelalter bis um 1600*, Kölner Beiträge zur Musikforschung 54 (Regensburg, 1969); for the Czech milieu cf. Markéta Kabelková, 'Hudba a škola v období české renesance' (unpublished magister thesis, Charles University in Prague, 1984).

14  Cf. Martin Horyna, 'Vícehlasá hudba v Čechách v 15. a 16. století a její interpreti', *Hudební věda* 43 (2006), pp. 117–134.

15  Cuthenus, f. E iijʳ: "Hinc versus sinistram in alium vicum, praeter castellum, et adiacentem huic lacum, declinantes turmas consecutus Imperator, praeteribat coetum cantorum, quos ita vocant, qui ex aliis atq[ue] alis ludis in angulum eius vici non procul a lacu dissitum confluxerant. Canebatur autem ab his variato quinq[ue] vocum modulamine […] hendecasyllabum."

16  Cuthenus, f. C [i]ʳ: "Psalmos Hebraica lingua concentu vario decantantes."; Mattioli, f. C iijᵛ: „[…] i quali cantavano psalmi in Hebreo, in vari modi […]."

17  Cuthenus, f. F iijʳ: "A musis venit deinde Caesarea Maiestas ad fratres de societate Iesu, qui et ipsi cum coetu suorum discipulorum eius Maiestatem exceperunt, instructi certo quondam apparatu, nimirum erecta statua Martis a Pace et Iusticia prostrati. Et praeterea puero super mensa tapetibus,

The highlight of the first day of the celebrations was a series of tableaux vivants and triumphal arches before the gates and within the area of Prague Castle, culminating in a ceremonial welcome by the Catholic clergy in St Vitus Cathedral. Music accompanied the Emperor even as he entered the cathedral: upon his approach, the hymn *Veni, Creator Spiritus* was performed by cathedral clerics and choristers with a mighty accompaniment of wind and percussion instruments.[18] In conclusion the cathedral itself resounded with a festive *Te Deum laudamus*.[19] One description of the events makes the interesting comment that this hymn was sung not only by the clerics and the cathedral choristers, but also by most of those present. This was therefore clearly a widely known monophonic hymn that the gathered congregation knew by heart. If we consider the heterogeneity of the assembled company, they most probably sang the *Te Deum laudamus* in Latin, because otherwise there would have to have been a choice made between the hymn's Czech or (more likely) its German sung paraphrase.[20]

For the following day, the 9th of November, Archduke Ferdinand II had prepared an even more impressive spectacle in the garden in front of the Royal Summer Palace: this event also served as the ceremonial opening of this palace after many years under construction, even though it was in fact still not quite completed. This theatrical production, which included many amazing special effects and is described in detail by both official printed descriptions of the celebrations, depicted the victory of Jupiter

contecta, locato, a quo hymnus ille angelicus, Gloria in excelsis Deo [et caetera], praecinebatur, reliquis vario modulamine vocum eum cantum prosequentibus."

18 Cuthenus, ff. H [i]ᵛ: "[...] Cum his dictis scenam subiit, ac pedes sub ea in arcis templum cathedrale sese contulit cum magno tubarum, tibiarum[que], nec non tympanorum ac bombardarum clangore, concentu, [et] strepitu, praecedentibus suam Maiestatem praeposito, [et] reliquo clero cum scholasticis canentibus hymnum Veni, Creator Spiritus [et caetera] [...].";  Mattioli 1559, ff. E [i]ᵛ: "[...] Finite queste parole entro sua Ma[esta] cosi a piedi sotto al ricco balracchino caminando con il clero, il quale cantava uno hinno dello Spirito Santo molto solennemente, di lungo via fino al duomo, con grandissima allegrezza d'infinite bombarde, che mai non fecero fine di tirare, [et] parimente di gran numero di grossissime campane, di trombe, cornetti, piffare, [et] tamburi. Il che faceva risentire ogn'uno, per il mirabil rimbombo insieme con il concento de suoni, che si sentivano nell'aria. [...]"

19 Cuthenus, ff. H iijʳ-H iijᵛ: "[...] Ingressus in templum Imperator in ipso limine aqua lustrali de more conspersus est; mox reverenter, ac devote ad altare maius in choro, ut vocant, flexis genibus aeterno Regi regum ac Imperatori imperantium preces suas obtulit, resonantibus interim per totum templum tam plebeis, quam magnatibus voce intensissima Te, Deum laudamus [et caetera] ac recitantibus praeterea Ecclesiae ministris quasdam precationes.[...]"; Mattioli 1559, f. E iiijᵛ: "[...] Per questa strada (come ho detto) camino sua Ma[esta] a piedi sotto al baldacchino con il clero in processione fino al tempio, nel quale intrato, [et] pervenuto in choro avanti all'altare maggiore, se inginocchio molto reverentemente facendo oratione all'Omnipotente Iddio, ringratiandolo d'ogni benefitio ricevuto, mentre, che da infinite voci non solamente de sacerdoti, [et] de cantori del choro, ma de i Magnati anchora, [et] di gran parte del populo si cantava, con gl'organi Te Deum laudamus, con grandissimo rimbombo di quel bel tempio. [...]"

20 Cf. *Graduale triplex seu Graduale Romanum Pauli pp. VI, cura recognitum & rhythmicis signis a Solesmensibus monachis ornatum neumis laudunensibus (cod. 239) et sangallensibus (codicum San Gallensis 359 et Einsidlensis 121) nunc auctum* (Solesmis, 1979), pp. 838–847. On German sung paraphrases cf. Karl-Heinz Schlager and Winfried Kirsch, 'Te Deum', in *Die Musik in Geschichte und Gegenwart. Allgemeine Enzyklopädie der Musik. Sachteil*, IX, ed. by Ludwig Finscher (Kassel, 1998), col. 433.

over the five Gigants.[21] This can be seen as an allegory of the political struggle of Ferdinand I with the Czech Estates, which culminated in the suppressed uprising of 1547.

Both the sources and current literature are silent regarding the authorship of this performance. Its form, including the elaborate effects, would probably have corresponded more to a type of intermedium than to that of a theatrical drama in the true sense of the word.[22] The archduke's source of inspiration was most probably Mantua, with particular regard to that city's architectural wealth, and mature musical and theatrical culture, which Archduke Ferdinand II had become personally acquainted with in 1549 during the wedding celebrations of his sister Catherine and Francesco III Gonzaga.[23] He had in fact already come across the musical life of Mantua several years earlier in Vienna via the Jewish musician Abraham Halevi dell'Arpa, who was the musical preceptor for the family of Ferdinand I for a brief period.[24] It is interesting to note that Jacopo Strada (1515–1588) was also from Mantua, and began in 1558 to compete for the favour of Ferdinand I, entering his service a year later as an antiquary and architect. Among Strada's preserved works we also find several series of proposed drawings for court festivities, although they date from a later period.[25]

We, of course, are mainly interested in the musical component of the Prague performance: in the written descriptions, there is explicit mention of trumpeters and drummers standing on top of two towers flanking a backdrop of the volcano Vesuvius and welcoming the arriving guests with fanfares.[26] It is also impossible to imagine the

---

21  Cuthenus, ff. H iij^v-[H v]^v; Mattioli 1559, ff. E iiij^v-[E vi]^v. Cf. also *Dějiny českého divadla I: Od počátků do sklonku osmnáctého století*, ed. by František Černý (Prague, 1968), pp 139–140; in greater detail Bažant 2006, pp. 230–236. Cf. also Pfaffenbichler 2016, p. 48.

22  On intermedia overall see Nino Pirrotta and Elena Povoledo, *Music and Theatre from Poliziano to Monteverdi* (Cambridge, 1982), esp. p. 173–236.

23  Cf. Bůžek 2009, pp. 83–84. On Mantua theatrical and musical culture cf. Iain Fenlon, *Music and Patronage in Sixteenth-Century Mantua*, I (Cambridge, 1980), passim. Here there is also further literature. For parallels with the decoration of the Palazzo del Te in more detail see Bažant 2006, pp. 231–235.

24  Cf. Cecil Roth, *The Jews in the Renaissance* (New York, 1959), p. 283; Alfred Sendrey, *The Music of the Jews in the Diaspora (up to 1800). A Contribution to the Social and Cultural History of the Jews* (New York, 1970), p. 256; Shlomo Simonsohn, *History of the Jews in the Duchy of Mantua* (Jerusalem, 1977), esp. pp. 670–671. All the authors start out from the text of Max Grunwald, *History of Jews in Vienna* (Philadelphia, 1936), p. 78.

25  On the life and work of Jacopo Strada, see most recently Dirk Jacob Jansen, *Jacopo Strada and Cultural Patronage at the Imperial Court. The Antique as Innovation*, 2 vols. (Leiden, 2019), also referencing older literature. On Strada's engagement with the Habsburg court and on court celebrations cf. esp. pp. 193–200 and 225–245.

26  Cuthenus, ff. H iiij^r: "Constructae erant du[ae] admodum alt[ae] turres, in quarum utraq[ue] erant tubicines et tympanist[ae] serenissimi archiducis Ferdinandi, qui [et] ad primum Sacrae Maiestatis conspectum grata admodum tubarum [et] tympanorum harmonia suae Maiestati honorem [et] reverentiam debitam exhibeant, [et] postea iucundos audituros sonos subinde ciebant."; Mattioli 1559, ff. E v^r: "Da amendue i lati poi cosi dalla parte di sotto, come di sopra della piazza, erano edificate due torri di non picciola altezza, sopra le quali erano tutti li trombeti del serenissimo archiduca Ferdinando, i quali nello imbrunir della notte, et nel primo lampeggiar delle stelle, fecero a vicenda una gagliarda, [et] bellissima sonata facendo cosi reverenza a sua Ma[esta] Cesarea, [et] suegliando ciascuno a tener l'occhio a pennello a tutto quello, che doveva succedere." Cf. also Černý 1968, p. 139; Kaufmann 1978, p. 23; Exh. Cat. Vienna 2016, pp. 138–139.

actual production without the music, because the piece lacked any spoken text and the music therefore formed its most fundamental and irreplaceable performative component. There were evidently dances included in the performance – for example, at the moment when monkeys were born from the blood of the slaughtered Gigants and embarked on an unspecified dance and also at the very end, when a *Moresque* was danced (a Renaissance dance with exotic elements, usually in the form of a stylised combat intended to remind the viewer of the battle between Christians and Moors after which it was named).[27] Apart from the trumpeters, whose instruments – natural trumpets – were only capable of playing simpler signal music, in the case of dance music we would expect the participation of at least those wind instruments suitable for an outdoor performance, such as cornetts, shawms, pumorts, dulcians and trombones. In this connection we must mention that three years earlier the Wroclaw town musicians Bartholomäus and Paulus Hess dedicated a collection of dances to Archduke Ferdinand II, some of which were quite likely used in this case.[28]

## Prague 1562 and 1567

The final years of Archduke Ferdinand II's governorship in Bohemia were brightened in particular by two famous ceremonial entrances into Prague, both by the archduke's older brother Maximilian – the 'Coronation' (1562)[29] and the 'Imperial' entrances (1567).[30]

The first of these ceremonial arrivals was accompanied by performances of the Nine Muses, similar to the arrival of Maximilian's father in 1558 (in contrast to that occasion, however, we have no preserved sources containing the declaimed texts).[31] This entrance also linked with Ferdinand I's by other common elements such as the significant participation of the Jesuit College, the presence of the Prague Jews, and the

---

27  Cf. Cuthenus, ff. H iiij$^v$-[H v]$^r$; Mattioli 1559, ff. E v$^r$-[E vi]$^r$. On the Moresque in greater detail Curt Sachs, *World History of the Dance* (New York, 1965), pp. 333–341.

28  Bartholomäus Hess and Paulus Hess, *Ettlicher gutter Teutscher und Polnischer Tentz biß in die anderthalbhundert mit fünff und vier stimmen zugebrauchen auff allerley Instrument dienstlich* (Breslau, 1555). Cf. Howard Meyer Brown, *Instrumental Music Printed Before 1600. A Bibliography* (Cambridge, Mass., 1965), p. 167; Wolfgang Suppan, 'A Collection of European Dances Breslau 1555', *Studia Musicologica Academiae Scientiarum Hungaricae* 7 (1965), pp. 165–169; Franz Gratl, 'Music at the Court of Archduke Ferdinand II within the Network of Dynastic Relationships', in *Ferdinand II. 450 Years Sovereign Ruler of Tyrol. Jubilee Exhibition*, ed. by Sabine Haag and Veronika Sandbichler, exh. cat. (Innsbruck and Vienna, 2017), pp. 61–71 (61).

29  A list of sources is given by Zíbrt 1905, pp. 450–451. Cf. also Watanabe-O'Kelly / Simon 2000, p. 5, *Warhafftige beschreibung vnd verzeichnuß welcher gestalt die K[oe]nigkliche Wirde Maximilian vnnd Freuwlin Maria geborne K[oe]nigin auß Hispanien dero Gemahl zu Behemischen K[oe]nig vnd K[oe] nigin in Prag den 20. Septembris dises 1562. jars gekr[oe]net sind worden* (Frankfurt am Main, 1562) VD16 W 231 and esp. *Die Krönungen Maximilians II. zum König von Böhmen, Römischen König und König von Ungarn (1562/63) nach der Beschreibung des Hans Habersack, ediert nach CVP 7890*, ed. by Friedrich Edelmayer et al., Fontes rerum austriacarum, I/13 (Vienna, 1990).

30  A list of sources given by Zíbrt 1905, p. 453.

31  Edelmayer 1990, p. 101: "Item es sein in den drey prager stetten an unnderschidlichen orten neun Musae augestellt gewest mit sonnderlichen inscriptionen, irer küningclichen Würde zu lob und ehrn."

ending of the procession in St Vitus Cathedral, which once more resounded with the
ceremonial hymn *Te Deum laudamus*. On the other hand, Maximilian's coronation
entrance differed from Ferdinand I's imperial procession in its inclusion of six camels
bearing musicians with their faces painted black (in imitation of dark-skinned people),
playing on bagpipes and shawms.[32] The descriptions of the actual coronation reflect
the coronation procedure of the kings of Bohemia, in which monophonic choral sing-
ing was used to particular effect, climaxing with the *Te Deum laudamus* already men-
tioned several times above.[33] In spite of this accepted protocol, we find some mention
of the use of figural music in the sources. However, this is too general for us to be able
to judge which concrete compositions may have been used.[34] The presence of music –
or more precisely a musical backdrop – was also to be expected during banquets and
tournaments, both of which formed an intrinsic part of the coronation celebrations.[35]
From the surviving pictorial documentation of other celebrations (see below), we can
observe that at open-air tournaments trumpeters and drummers were the main musi-
cians employed, probably to play fanfares.

From a musical-historical standpoint we actually have much better information
concerning the second ceremonial entrance of Maximilian II into Prague: his arrival in
February 1567 as the new Holy Roman Emperor. Archduke Ferdinand II did not
attend in this event person, because he had left a month earlier for Tyrol. Two leading
Czech humanists and professors of Charles University – Prokop Lupáč († 1587) and
Petr Codicillus (1533–1589) – published a collection of twelve Latin poems that were
declaimed before the monarch by teachers and students of Prague University in a sim-
ilar manner to the presentations accompanying the arrival of Emperor Ferdinand I in
November 1558 and Maximilian II's own September 1562 entrance.[36] These poems,
almost certainly sung as polyphonic verses, were delivered by the god Apollo, the nine
Muses and the three Graces. The final poem – *Qui colitis Pragam* – was set to music
for six voices by Michael-Charles Des Buissons (active in 1560–1570). We know very

---

32   Edelmayer 1990, p. 100: "Darauf seind gevolgt die hussärn, über vierhundert starckh, die auf irer
     küningclichen Würde uncosten herein migezzogen und auf das stattlichst und zierlichst mit schönen
     rossen, klaidern, gezeug, guldenem und silberenem schmuckh und federpuschen geputzt und gerüsst
     gewest, haben irer trommeter und hörtrummel, auch sechs camelthier vorheer, darnach im hauffen
     auch ain sackhpfeiffer und schalmeyen gehabt, auch vil ledige roß und ire copi mit rott und weissen
     fahnen auf husärische art gefüert."

33   More detail on the coronation order in *Korunovační řád českých králů*, ed. by Jiří Kuthan and
     Miroslav Šmied (Prague, 2009), p. 220–257.

34   Cf. *Warhafftige beschreibung* 1562, ff. B [i]ᵛ – B ijʳ: "Dazumal hat man das Hochampt de Sancta
     Trinitate angefangen vnd das Solenniter mit herrlichen Ceremonien als der Key[serlicher] May[estät]
     Music vn[d] Orgel gehalten allda jr Koen[igliche] W[ürde] vnz nach der Epistel im Sitz bliben."

35   On the problem of tournaments cf. esp. Matthias Pfaffenbichler, 'Die Turniere an den Höfen der
     österreichischen Habsburger im 16. Jahrhundert', in *Turnier. 1000 Jahre Ritterspiele*, ed. by Matthias
     Pfaffenbichler and Stefan Krause (Vienna, 2018), pp. 155–169; Veronika Sandbichler, '"Ain […] puech
     darinnen ir fürstlich durchlaucht allerlei turnier" – die Turnierbücher Erzherzog Ferdinands II.', in
     *Turnier. 1000 Jahre Ritterspiele*, ed. by Matthias Pfaffenbichler and Stefan Krause (Vienna, 2018),
     pp. 203–215. Cf. also literature in notes 1 and 3.

36   *In Adventu […] Imperatoris Maximilianii II. […] Chorus Musarum* (Prague, 1567).

little about this composer's life. In 1559 he entered the service of Emperor Ferdinand I and remained in service until the monarch's death in 1564. He then became a member of Archduke Ferdinand II's musical corps and remained so until his own death sometime before 1570.[37] Des Buissons' works were published in two editions – in the extensive five-volume motet anthology *Novus thesaurus musicus*, compiled in 1568 by Pietro Giovannelli (c.1530-c.1583), an Italian merchant settled in Vienna,[38] and in the posthumously published author's collection of motets entitled *Cantiones aliquot musicae, quae vulgo muteta vocant, quatuor, quinque, et sex vocum*.[39] We find six-part compositions in both collections. The setting of the poetic text to the given music is not, however, convincing. Its subtitle *Carmen illigatum modis* indicates that this is a text in quantitative verse, which requires – like other collections of poems – a unique and customised musical scoring. It therefore appears likely that the composer created original music for the given text, but unfortunately this has not been preserved.

In searching for further musical compositions that might have accompanied Maximilian's 1567 entrance into Prague, it is necessary to devote particular attention to the last volume of the above-mentioned anthology *Novus thesaurus musicus*.[40] This volume is devoted to a particular type of repertoire, referred to in specialist literature as "Huldigungsmotette" or "Staatsmotette".[41] This is a motet with a Latin text, not liturgical but secular, created for a specific ceremonial occasion. In the context of our theme these are compositions singing the praises of the Habsburg dynasty. Six of these compositions celebrate the new Emperor Maximilian II:

– Jacobus Vaet (c.1529–1567): *Qui gerit Augusti diademata Caesaris ales*, 4v
– Jacobus Vaet: *Ascendetis post filium meum*, 6v
– Jacobus Vaet: *Aurea nunc tandem rutilante sidere fulgent*, 6v
– Jacob de Brouck († 1583): *Ut vigilum densa silvam cingente corona*, 6v
– Jacob Regnart (1540/45–1599): *Ut vigilum densa silvam cingente corona*, 6v
– Christian Hollander (1510/15–1568/69): *Nobile virtutum culmen Rex inclite salve*, 6v.

It is possible that some of the above-mentioned motets might have been performed during Maximilian II's 1567 entrance. Among their authors we find not only imperial musicians (Vaet, Brouck, Regnart), but also a member of Archduke Ferdinand II's

---

37   Frank Dobbins, Des Buissons [Desbuissons], Michael-Charles, in *The New Grove Dictionary of Music and Musicians. Second Edition*, ed. by Stanley Sadie and John Tyrrell, VII (Oxford, 2001), p. 233.

38   *Novus thesaurus musicus*, 5 vols. (Venice, 1568).

39   Michael-Charles Des Buissons, *Cantiones aliquot musicae, quae vulgo muteta vocant, quatuor, quinque, et sex vocum* (Munich, 1573).

40   Modern critical edition *Novi thesauri musici a Petro Ioannello collecti. Volumen V*, ed. by Albert Dunning, Corpus mensurabilis musicae 64 (s. l., 1974).

41   Cf. Albert Dunning, *Die Staatsmotette 1480–1555* (Utrecht, 1970); Victoria Panagl, *Lateinische Huldigungsmotetten für Angehörige des Hauses Habsburg. Vertonte Gelegenheitsdichtung im Rahmen neulateinischer Herrscherpanegyrik*, Europäische Hochschulschriften, 15, Klassische Sprachen und Literaturen 92 (Frankfurt am Main, 2004).

music chapel, Christian Hollander. If we take into consideration the above-mentioned collection of Latin poems of Prokop Lupáč and Petr Codicillus, which contained a Des Buissons motet, as well as the fifth part of the anthology *Novus thesaurus musicus*, it appears that the compositions by the archduke's musicians included in both collections do not appear there by chance. This could point to Archduke Ferdinand II's active participation in the organisation of the celebrations – given the inclusion of the choir of Muses, the 1567 entrance actually has many elements in common with the festivities of 1558, which were organised entirely according to the archduke's orders.

## Innsbruck 1567

After the death of Emperor Ferdinand I, Archduke Ferdinand II remained in the Bohemian Lands until the beginning of 1567, when he left for his new duties as ruler of the Tyrol.

The archduke entered Innsbruck festively to the sound of trumpets and drums on the 17th of January 1567, and the celebrations of his arrival continued into the following day.[42] Unfortunately we have no information concerning the concrete musical compositions that may have been performed on this occasion. A look into the above-mentioned collection *Novus thesaurus musicus,* however, reveals three motets that were dedicated directly to the archduke:

– Jacob Regnart: *Quicquid Graeca loquax memorat facundiae quicquid*, 5v (Fig. 2)
– Jacobus Vaet: *Ferdinande imperio princeps dignissime sumo*, 5v
– Andrea Gabrieli (1532/33–1585): *Lucia ceu fulvo*, 5v.

Even though these are texts praising Archduke Ferdinand II's virtues on a general level, it is easy to imagine them in the context of the archduke's triumphal entrance into his new city of residence.

## Innsbruck 1580

Innsbruck, Archduke Ferdinand II's city of residence, experienced many socially important events during his almost thirty-year rule – court celebrations on the occasion of visits from other members of the Habsburg dynasty or allied and related nobility, as well as weddings, knightly tournaments as well as shooting tournaments, hunts, and so on.[43] In this article, however, we shall concentrate solely on the two most important events that took place during the archduke's reign.

---

42  M. A. Chisholm, 'A Question of Power: Count, Aristocracy and Bishop of Trent – The Progress of Archduke Ferdinand II into the Tyrol in 1567', in *Der Innsbrucker Hof. Residenz und höfische Gesellschaft in Tirol vom 15. bis 19. Jh*, ed. by Heinz Noflatscher (Vienna, 2005), pp. 398–400. Cf. also *Wir sind Helden: habsburgische Feste in der Renaissance*, ed. by Alfred Auer, Margot Rauch and Wilfried Seipel, exh. cat. (Vienna, 2005), pp. 30–33.

43  On this subject cf. Sandbichler 2005.

Fig. 2. Jacob Regnart, Quicquid Graeca loquax memorat facundiae quicquid, in Liber quintus et ultimus [Novi thesauri musici], quo variae [...] harmoniae comprehenduntur [...] octo, sex, quinque, quatuor vocum a praestantissimis nostri saeculi musicis compositae [...], 1568, pp. 423–424 (Munich, Bayerische Staatsbibliothek, 4 Mus.pr. 46, adl. 4)

The first was a wedding that took place between the 14th and 16th of February, 1580. The groom and central figure was the archduke's chamberlain Jan Libšteinský of Kolowraty, and the bride was Catherine Boymont of Payersberg. The chief organiser of the wedding celebrations was the archduke himself, who prepared a three-day celebration for his courtier's nuptials, including several knightly tournaments and a triumphal procession of masks in which he also participated as the god Jupiter.[44] (Fig. 3)

---

44    Dealing with the wedding in greater detail see, in particular, Elisabeth Scheicher, 'Ein Fest am Hofe Erzherzog Ferdinands II', *JKSW* 77 (1981), pp. 119–154 and Petr Daněk, 'Svatba, hudba a hudebníci v období vrcholné renesance. Na příkladu svatby Jana Krakovského z Kolovrat v Innsbrucku roku 1580', in *Slavnosti a zábavy na dvorech a v rezidenčních městech raného novověku*, ed. by Pavel Král and Václav Bůžek (České Budějovice, 2000), pp. 207–264. Cf. also Sabine Haag and Veronika Sandbichler, *Die Hochzeit Erzherzog Ferdinands II. Eine Bildreportage des 16. Jahrhunderts*, exh. cat. (Innsbruck, 2010), pp. 14–17 and Exh. Cat. Vienna 2016, pp. 210–211.

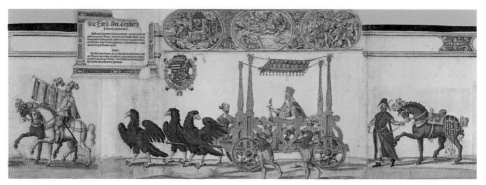

Fig. 3. Sigmund Elsässer, Archduke Ferdinand II as Jupiter, in the Wedding Codex of Johann Libšteinský of Kolowraty (Vienna, Kunsthistorisches Museum, Kunstkammer, inv. no. KK 5269)

This event was noteworthy from the musical-historical viewpoint in that several valuable pictorial sources have been preserved, which apart from the noble bride and groom and their wedding guests, also depict a great number of musicians who took part in the allegorical processions, along with their instruments. These were very faithfully depicted and thus allow us to identify the individual instruments.[45] The vast majority of them – with the exception of the harp and the flute – are truly best suited for playing in the open air: trumpets, shawms, cornetts, trombones and dulcians.

### Innsbruck 1582

On the 24th of April, 1580 Archduke Ferdinand II's beloved wife Philippina Welser (1527–1580) died. Two years later the archduke married again, this time to his young niece Anna Caterina Gonzaga (1566–1621). The festivities, which took place between the 14th and 17th of May 1582, are described in detail via both text and illustrations, and furthermore in three separate copies of the same work.[46]

The musical accompaniment is depicted first and foremost in the descriptions and illustrations of several allegorical processions, in which the archduke once again figured as an active participant. In the procession of Hussars there were trumpeters, and in the procession inspired by classical mythology music was played on shawms, flutes and drums.[47] (Fig. 4) These sources are however silent witnesses, for in neither case do we have any more detailed report that would enable us to determine the concrete compositions that might have been performed on these occasions.

---

45   Identification and detailed description were made by Daněk 2000, pp. 221–224.

46   Karl Vocelka, *Die Habsbургische Hochzeiten 1550–1600. Kulturgeschichtliche Studien zum manieristischen Repräsentationsfest*, Veröffentlichungen der Kommission für neuere Geschichte Österreichs 65 (Graz, 1976), pp. 112–119; Veronika Sandbichler, 'In nuptias Ferdinandi. Der Hochzeitskodex Erzherzog Ferdinands II.', in *Slavnosti a zábavy na dvorech a v rezidenčních městech raného novověku*, ed. by Pavel Král and Václav Bůžek (České Budějovice, 2000), pp. 281–292; cf. also Exh. Cat. Innsbruck 2010 and Exh. Cat. Vienna 2016, pp. 221–225.

47   Cf. Exh. Cat. Innsbruck 2010.

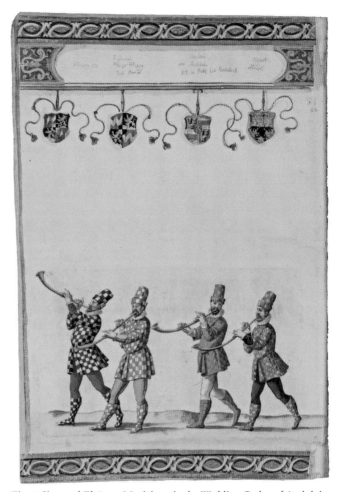

Fig. 4. Sigmund Elsässer, Musicians, in the Wedding Codex of Archduke
Ferdinand II, Innsbuck (Johann Baur) 1580 and 1582
(Vienna, Kunsthistorisches Museum, Kunstkammer,
inv. no. KK 5270, fol. 45v)

## Prague 1585

The last important event in which Archduke Ferdinand II played a fundamental part
was the celebration accompanying the awarding of the Order of the Golden Fleece in
Prague on the 2nd and 3rd of June, 1585.[48]

In the course of the celebrations the Order was awarded to Emperor Rudolf II
(1552–1612), his brother Ernst (1553–1595) and his uncle Karl II, Archduke of Austria
(1540–1590), as well as two important nobles – Vilém of Rožmberk (1535–1592) and
Leonard of Harrach (1514–1590). The newly elected knights received the Order from

---

48    Cf. Exh. Cat. Vienna 2016, pp. 94–97.

the hand of Archduke Ferdinand II, who had received the Order in 1557 for bravery on the Hungarian battlefield, and who had also been entrusted with the task of awarding the Order on this occasion by the Order's sovereign, the Spanish King Philip II (1527–1598). The entire event is described in detail in a printed report written by the archduke's secretary, Paul Zehendtner of Zehendtgrub.[49] In addition to the narrative sources, a rich pictorial record of these events has been preserved in the work of the painter Anthoni Boys (1543–1615).[50] His depictions also appear in a smaller format as illustrations within Zehendtner's description. (Fig. 5)

The main part of the ceremony took place in St Vitus Cathedral during a special Mass. Paul Zehendtner mentions musical productions in several places. Firstly at the moment when the festive procession entered the cathedral and was welcomed by the imperial trumpeters and drummers.[51] Their participation is also recorded during the actual awarding of the Order.[52] The most interesting note is also the most mysterious: in Zehendtner's account we read that during the offertory outstanding and splendid music was performed by four separate choirs, two standing in the side naves and two in the choir beside the organ.[53] Opinions differ as to which composition this may have been. Michael Silies, in his monograph devoted to the motet compositions of Philippe de Monte (1521–1603), the chapelmaster of Rudolf II, argues in favour of the triple choir twelve-part motet *Benedictio et claritas*.[54] The author of this text speculated

---

49  Paul Zehendtner vom Zehendtgrub, *Ordentliche Beschereibung mit was stattlichen Ceremonien und Zierlichheiten, die Röm[ische] Kay[serliche] May[estät], unser aller gnedigster Herr, sampt etlich andern Ertzherzogen, Fürsten und Herrn den Ordens deß Guldin Flüß in di[e]sem 85. Jahr zu Prag und Landshut empfangen und angenommen [...]* (Dilingen, 1587); VD 16 Z 225.

50  Vienna, Kunsthistorisches Museum, Sammlung für Plastik und Kunstgewerbe, inv. no. P 5348; Vienna, Österreichische Nationalbibliothek, Cod. 7906 Han. Cf. *Rudolf II and Prague: The Court and the City*, ed by Eliška Fučíková et al., exh. cat. (Prague, London and Milan, 1997), p. 226; Exh. Cat. Innsbruck 2005, pp. 20–22.

51  Zehendtner vom Zehendtgrub 1587, p. 101: "Wie mann nun also in die Haupt Kirch deß Schloß kommen / darinnen dann der Chor schon darvor zu disem Herrlichen Actu von Prettern was erhoecht / und mit koestlichen guldinen Tapezereyen / auch sonst aller notturfft nach herrlich und stattlich zuegericht unnd geziert gewesen / haben alß bald die ob der Porkiche neben der grossen Orgl / verordnete Kayserliche Hoerpaugger und Trummetter / sich zu ihr er Kay[serliche] M[ayestä]t und der andern Ertzhertzogen unnd Fürsten eingang hoeren lassen. [...]"

52  Zehendtner vom Zehendtgrub 1587, p. 108.

53  Zehendtner vom Zehendtgrub 1587, pp. 111–112: "Neben demselben man eben in der Ordnung / wie man in die Kirchen kommen / vom Altar hinbauff in ihr Kay[serliche] May[estät] Oratorium gangen / sich derauff das Ampt / || welliches durch mehrberuehrte ihr F[ürstliche] G[naden] den Herrn Ertzbischofen gehalten worden / angefangen / ihr Kay[serliche] M[ayestä]t hierzu ein treffenliche schoene Music von vier underschidlichen Chorn / deren die zwen herunden bey der Cappellen / die zwen andere aber auff der Porkirchen / bey der Orgel / fast lieblich und künstlich zuhoern gewesen. [...]"

54  Michael Silies, *Die Motetten des Philippe de Monte (1521–1603)* (Göttingen, 2009), pp. 247–250. Cf. also Veronika Sandbichler, 'Elements of Power in Court Festivals of Habsburg Emperors, in *Ceremonial Entries in Early Modern Europe: The Iconography of Power*, ed. by J. R. Mulryne, Maria Ines Aliverti and Anna Maria Testaverde (Farnham, 2015), pp. 167–187, esp. pp. 182–183. A criticism of this hypothesis of Silies was carried out by Erika Supria Honisch, 'Sacred Music in Prague, 1580–1612' (unpublished dissertation thesis, University of Chicago, 2011), p. 171.

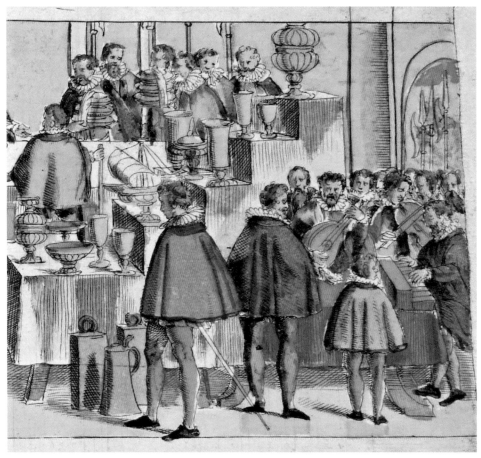

Fig. 5. Anton Boys, Banquet at the Prague Castle, a detail with musicians, in Paul Zehendtner vom Zehendtgrub, Ordenliche Beschreibung mit was staattlichen Ceremonien [...] den Orden deß Guldin Flüß in disem 85. Jahr zu Prag und Landshut empfangen und angenommen, Dillingen 1587 (Prague, National Library of the Czech Republic, sign. 65 D 003135, fol. 114–115)

elsewhere about a further multi-choral composition – the motet *Ecce beatam lucem* for forty voices by the Mantua composer and instrumentalist Alessandro Striggio (1536/37–1592), who composed this piece for the text written by the German musician and humanist poet Paul Schede Melissus (1539–1602).[55] As an aside, we can note that this writer was in close contact with the Czech humanists and with intellectuals from the circle of the imperial court, including Kašpar Cropacius (1539–1580), Petr Codicillus of Tulechov (1533–1589) and Samuel Radešínský (1571–1609).[56] Further questions

---

55  Jan Baťa, 'Remarks on the Festivities of the Order of the Golden Fleece in Prague (1585)', *Musicologica Brunensia* 51 (2016), pp. 25–35.

56  Cf. *Rukověť humanistického básnictví v Čechách a na Moravě*, III, ed. by Josef Hejnic and Jan Martínek (Prague, 1966), p. 311.

on this problem are raised by the newly discovered manuscript description of the
Prague celebration written by the Registrar of the Order, Oudard Cornu, alias Bour-
gogne († 6. 5. 1594), which has not yet been examined and is thus not reflected in cur-
rent literature.[57] Cornu/Bourgogne devoted quite detailed attention to the music, and
described the same moment as Zehendtner quite differently. He declared that the unu-
sual and outstanding music of the imperial chapelmaster Philippe de Monte was per-
formed – a Mass for thirteen voices divided into three choirs which, apart from the
singers, also included trombones, cornetts, violas and dulcians. The entire ensemble
must undoubtedly have produced a remarkably effective performance, as it is noted
that the music 'completely filled' the space of the cathedral.[58] Today, however, we are
not able to identify the composition because no such Mass appears amongst the works
of Monte currently known to us.

Apart from the liturgical part of the celebration, there were also secular entertain-
ments taking place in Prague Castle, such as tournaments, receptions, balls and other
amusements, some of which – for instance the shooting tournament – were initiated by
Archduke Ferdinand II. In many of these cases a pictorial record survives, testifying to
the fact that "beautiful music" (in the words of Paul Zehendtner) played the role here
of a kind of audio background, which again corresponds to the functional role of
music during celebrations of this type.[59]

From this glimpse of selected celebrations it is evident that Archduke Ferdinand II
was without doubt a key figure in the development of the culture of Renaissance fes-
tivities in the Bohemian Lands. He was actively engaged in the formation of the ideo-
logical programmes, as well as the actual organisation of the most significant celebra-
tions of the time, in which he played an active part even after moving his residence
from Prague to Innsbruck in 1567. Music played an irreplaceable, if peripheral, part in
these festivities – it contributed to a more intensive experience of the celebratory
events for the participants, linking the profound visual impressions with auditive
impressions. As is evident from the plentiful narrative and few pictorial sources, signal
music was most commonly performed during open air events, i.e. fanfares performed
by trumpeters and drummers, or simple music for loud instruments, which could be
played from memory. The installed tableaux vivants with choirs of Muses then offered
more demanding music, which nonetheless did not exceed the level of the usual reper-

57   HHStA, Archiv vom Orden des Goldenen Vlies, Burgundisch – Spanisches Archiv, II. Abteilung, § 3
     Ritterernennungen nach dem aufhören der General – Capitel liste vom Nr. 236–342, package 12,
     no. 249/40 (Rodolphe II, Empereur des Romains).
58   HHStA, Archiv vom Orden des Goldenen Vlies, Burgundisch – Spanisches Archiv, II. Abteilung, § 3
     Ritterernennungen nach dem aufhören der General – Capitel liste vom Nr. 236–342, package 12,
     no. 249/40: "La fut aussi la musique rare et singuliere, aiant de M[aistr]e de la chapelle plusieurs iours
     au parauant, et ordonnante de l'empereur, composé une messe a treize parties, qui fu chantée a trois
     choeurs, deux embas au estoit le clergé, les chantres entresmesléz de trombons, sacqueboutes et cor-
     netz, le troizieme enhault auec les orgues acompagnéz de violons, doucaines et aultres instruments
     auec chantres a l'eslite, et estoit la resonnance si grande de la musique et le retentissem[ent] de la
     vaulsure et a cause de la haulteur du chant, qu'il sembloit proprement q[ue] Dieu tonnait."
59   For iconographic documents cf. Exh. Cat. Vienna 2016, pp. 94–97. Cf. also note 4.

toire that the pupils of the city parish schools were expected to memorise. The highest artistic level was represented by the music heard during the religious ceremonies which, apart from the monophonic Gregorian chant, included both liturgical and non-liturgical texts set to demanding polyphonic music. The above-mentioned "Huldigungsmotette" in particular often formed the 'aural accompaniment' to the secular finales of these events, most usually a banquet with other entertainments. The surviving contemporary records, however lacking they may be in terms of more detailed information about the music performed, nonetheless leave us with a permanent memory of these musical elements.

Joseph F. Patrouch

## Sisters, cousins, nieces, nephews, (and an aunt):

### The female dynastic contexts of Archduke Ferdinand in the transitional year of 1567

When discussing the situation of Archduke Ferdinand II in 1567, as he and his family moved from Prague to Innsbruck, we should not only look at his domestic situation, with his wife and two children, or even simply at his relations with his two famous brothers, the Emperor Maximilian II and Archduke Karl. In order to fully understand the political and cultural contexts of Archduke Ferdinand II it is important to also look at his relations with his female relatives, particularly with his sisters, and to some extent with his cousins. The following essay will also briefly mention Archduke Ferdinand II's important aunt, the dowager Queen of Portugal Katharina, as well as his two dozen nieces and nephews.[1] This analysis is part of a larger project which seeks to understand the histories of the Holy Roman Empire in the early modern period as enmeshed in dense networks of female relationships.[2] It is not possible to understand the Holy Roman Empire and the Habsburg dynasty's relationship to it without understanding the ways in which the women of that dynasty operated, the options and opportunities open to them, and the consequences of their actions.[3]

Archduke Ferdinand II's parents, Anna and Ferdinand I, had fifteen children over the course of the two and a half decades of their life together, from their marriage in 1521 until Anna's death in 1547. Ferdinand was the fourth, born in Linz in 1529. In 1567, ten of his siblings were still alive. These included the aforementioned Maximilian, by then Emperor Maximilian II and Archduke Ferdinand II's senior by a bit less than two years, and their younger brother, the unmarried Archduke Karl, who had

---

1   In addition to the original presentation at the conference in Prague on 23 February 2018, a revised and extended version of this paper was presented at the Center for Austrian Studies, European Forum at the Hebrew University Jerusalem on 25 June, 2018. My thanks to the audience members for their comments, and especially to the students in the European Studies programme there who enrolled in my course on the Habsburg Dynasty.

2   For an overview, see Joseph F. Patrouch, '"Bella gerant alii." Laodamia's Sisters/Habsburg Brides: Leaving Home for the Sake of the House,' in *Early Modern Habsburg Women: Transnational Contexts, Cultural Conflicts, Dynastic Continuities*, ed. by Anne J. Cruz and Maria Galli Stampino (Farnham, 2013), pp. 25–38. An important early work on the subject is Magdalena S. Sánchez, *The Empress, the Queen, and the Nun. Women and Power at the Court of Philip III of Spain* (Baltimore, 1998). The empress in the title was Archduke Ferdinand II's sister-in-law María (to be discussed below) and the other two women were his nieces: Archduchesses Margarete (1567–1633) and Margarete (1584–1611).

3   As one case study: Joseph F. Patrouch, *Queen's Apprentice: Archduchess Elizabeth, Empress María, the Habsburgs, and the Holy Roman Empire, 1554–1569* (Leiden, 2010). See esp. pp. 248–256 for the period of interest to this essay. For a perspective from the imperial court, see *Nur die Frau des Kaisers? Kaiserinnen in der Frühen Neuzeit*, ed. by Bettina Braun, Katrin Keller and Matthias Schnettger (Vienna, 2016).

been granted rule over the Inner Austrian lands.[4] In addition, Archduke Ferdinand II had eight sisters with establishments and connections reaching far across the continent, from Lithuania in the northeast, to Cleves in the northwest, the neighbouring Bavaria, and south down the Italian peninsula as far as Tuscany. Although two of his younger sisters, Magdalena and Helena, had chosen the religious life and established themselves in a convent being built at that time at Hall in the Tyrol, the remaining six were important royal or ducal consorts. Archduke Ferdinand II's first cousins included Portuguese princesses, Italian duchesses and duchesses dowager, a dowager electress and a female claimant (or, arguably, two claimants) to the Danish royal throne.

The female familial network of Archduke Ferdinand II in 1567, including his influential sister-in-law (and cousin) Empress María, will be outlined below. Mention will be made of the archduke's three nieces and six nephews originating from her family, but the focus of the discussion will be more on his sisters. At the time of their move from Prague to Innsbruck, Archduke Ferdinand II and his wife Philippine had nine nieces and another half a dozen nephews through his sisters. One of these nieces, the baby Anna Caterina, would go on to become the archduke's second wife. In order to more fully understand the complex cultural and patronage networks in which the archduke lived and worked, it is important to remember his sisters: Anna, duchess of Bavaria; Maria, duchess of Julich-Cleves-Berg; Eleonora, duchess of Mantua; Barbara, duchess of Ferrara; Johanna, future grand duchess of Tuscany; and the exiled queen and grand duchess Katharina.[5] Some mention will also be made of his six female and two male first cousins, as well as of the two important grandsons of his aunt, the previously-mentioned Queen Dowager Katharina of Portugal: Carlos (heir to the Spanish thrones) and Sebastian, King of Portugal.

In 1567, the archduke's aunt Katharina was sixty years old. She had been born in Spain and spent the first years of her life at the side of her troubled mother, the widowed queen of Castile, Joanna.[6] Named after her aunt Catherine of Aragon, former queen of England, this Katharina married King John III of Portugal in 1525. For the next four decades and more, Katharina played key roles in the political and cultural worlds of Iberia: first as queen consort, and then after King John's death in 1557 as

4    On the king and emperor Maximilian II: Paula Sutter Fichtner, *Emperor Maximilian II* (London, 2001) and *Kaiser Maximilian II.: Kultur, und Politik im 16. Jahrhundert*, ed. by Friedrich Edelmayer and Alfred Kohler (Vienna, 1992). Archduke Karl would later go on to marry his niece Duchess Maria Anna of Bavaria (1551–1608), daughter of his older sister Anna (to be discussed below). On Maria Anna: Katrin Keller, *Erzherzogin Maria von Innerösterreich (1551–1608): Zwischen Habsburg und Wittelsbach* (Vienna, 2012). The standard reference work to identify Habsburg Dynasty members remains *Die Habsburger: Ein biographisches Lexikon*, ed. by Brigitte Hamann (Vienna, 1988). On the western Habsburg courts and their interrelationships: *A Constellation of Courts: The Courts and Households of Habsburg Europe 1555–1665*, ed. by José Eloy Hortal Muñoz, René Vermeir and Dries Raeymaekers (Leuven, 2014).

5    See their portraits in this book.

6    Bethany Aram, *Juana the Mad: Sovereignty and Dynasty in Renaissance Europe* (Baltimore, 2005). On the archduke's aunt Katherine: 235–36. On widowhood in general: *Witwenschaft in der frühen Neuzeit*, ed. by Martina Schattkowsky (Leipzig, 2003).

queen dowager and sometime regent for her grandson, King Sebastian. (King Sebastian was only thirteen in 1567.) Although Queen Katharina and her husband had nine children, none of them were still living by the time Archduke Ferdinand II transferred his court from Prague to Innsbruck. Only her two grandsons survived: King Sebastian and the archduke's cousin, Carlos of Spain, Prince of Asturias, the mentally unstable twenty-two-year-old heir to the royal titles who would soon after be imprisoned by his father King Philip II.

This sketch of the familial relations of Dowager Queen Katharina sheds some light on the extent of Archduke Ferdinand II's network of female relatives. As the sister of two emperors (Charles V and Ferdinand I), Katharina enjoyed tremendous prestige and rank. Both of Katharina's elder sisters had also been queens of two separate realms.[7] Archduke Ferdinand II's aunt Katharina was a significant patron of the arts as well as a key procurer of exotic plants and animals from around the world. As art historian Annemarie Jordan Gschwend wrote, "[f]ew European royals could compete with her singular position as queen of an overseas empire, ... Nor could they match the financial resources that made her ventures possible."[8]

The circle of Archduke Ferdinand II's first cousins was wide: in 1567, he had six female and two male cousins. The two male cousins are well known: the archduke's cousin King Philip II of Spain was the head of the senior branch of the Habsburg Dynasty, and the son of the archduke's aunt Empress Isabella (who had passed away when he was ten) and his by then deceased uncle Emperor Charles V. Philip II had taken power as king of Spain after the death of his own father a decade or so before, in 1556. In addition to serving as the Spanish monarch, Philip II was the Duke of Burgundy and the head or 'sovereign' of the prestigious international chivalric order of the Knights of the Golden Fleece.[9] Archduke Ferdinand II had been inducted into the order in 1555 and therefore was tied via membership not only to his cousin Philip II, but also to almost three dozen leading nobles and their families across the continent, from Italy and Iberia to Bavaria and Bohemia (with a large cohort from the Low Countries, the historic heartland of the order).

Archduke Ferdinand II's other male first cousin had been inducted into the Order just one year before him, in 1544. This was John of Austria, the illegitimate son of the late Emperor Charles V and the Regensburg *Bürgerin* (female burgher) Barbara

---

7   Her sister Eleonora was first queen of Portugal and then queen of France. See below for information about her daughter Maria. Eleonora's sister Isabella had been queen of Denmark, and her sister Mary had been queen of Bohemia and Hungary.

8   Annemarie Jordan Gschwend, *The Story of Süleyman: Celebrity Elephants and Other Exotica in Renaissance Portugal* (Zurich, 2010), p. 8. Jordan Gschwend discusses at some length the arrival and role of an elephant Queen Katharina sent to Central Europe in 1563. It was still there at least until 1577: pp. 35–48. The story of the gift of the elephant was made into a novel by the Portuguese author Jose Saramago, *A Viagem do Elefante* (São Paulo, 2008). The English translation appeared in 2010 by Margaret Jull Costa with the title *The Elephant's Journey*.

9   For the importance of the Order of the Golden Fleece in Habsburg ideology: Marie Tanner, *The Last Descendant of Aeneas: The Hapsburgs and the Mythic Image of the Emperor* (London, 1993), pp. 146–161.

Blomberg. Blomberg had since married an imperial official and moved to Brussels, where she and her husband had had three children together. As was the case with Archduke Ferdinand II's relatives via his wife, the Augsburg *Bürgerin* (female burgher) Philippine Welser (who will be discussed briefly below), the connections to Blomberg and her family do not seem to have been close, although in her widowhood Blomberg was granted a pension and moved to Spain. There she outlived her son John. In 1567, now twenty years old, John was preparing to embark on the military career that would make him famous. His half-brother King Philip II issued decrees early in the year that would soon lead to open rebellion among the *morisco* population of southern Iberia. John would be named commander of the Habsburg military forces sent to deal with the rebellion.

Of more concern to this analysis are the six female members of this circle of Archduke Ferdinand II's cousins. These women ranged in age from 32 to 47 and represented connections to territories within the Holy Roman Empire such as the Palatinate, Lorraine, the Low Countries, Bohemia, and Imperial Italy, as well as to territories and courts outside of the empire such as Denmark, Portugal, and Hungary. Like the archduke's male cousin John mentioned above, one of his female cousins, Margaret, was also illegitimate. Again, his uncle Emperor Charles V had fathered this child through a relationship with a young woman to whom he was not married.

Margaret's mother's name was Johanna Maria van der Gheynst. She had died in 1541, when Archduke Ferdinand II was twelve. Johanna Maria's parents Gilles and Johanna had been active in textile manufacturing in Flanders. Their daughter had entered the service of the Seigneur of Montigny, a local lord with close ties to the Habsburgs' courts in the Low Countries. Her court position had provided her with the opportunity to meet Emperor Charles V. Two close relatives of the seigneur, Floris de Montmorency and Antoine de Lalaing, were inducted into the Order of the Golden Fleece in 1559 and were becoming increasingly enmeshed in the religious and political conflicts in the area that had resulted in iconoclastic riots in 1566 and King Philip II's dispatch the following summer of another knight of that order, the late Emperor Charles V's *mayordomo mayor del rey*, Fernando Álvarez de Toledo, third Duke of Alva de Tomes, with a large contingent of troops to restore order. They arrived in the summer of 1567. War was to follow in the next year. The Duke of Alva replaced Archduke Ferdinand II's cousin Margaret as the Habsburgs' regent in the Low Countries, representing her half-brother, King Philip II. The 45-year-old Margaret had served as the territories' ruler since 1559, and would return to that office in 1578–82.[10]

Margaret's family position as the half-sister of the king of Spain and cousin to Archduke Ferdinand II was supplemented and complicated by two other titles that she held by marriage: she had been the duchess consort of Florence for a year when she was a teenager, before her husband, the Pope's nephew, was assassinated. The following year, 1538, she married another Knight of the Golden Fleece, Ottavio Farnese. He would eventually be Duke of Parma, Piacenza, and Castro. Margaret was therefore a

---

10   Charlie R. Steen, *Margaret of Parma: A Life* (Leiden, 2013). Hamann 1988, pp. 275–277.

dowager duchess of Florence as well as the duchess consort of those three key northern Italian principalities. She would hold those titles in addition to exercising her delegated governing responsibilities in the Netherlands. Margaret and Ottavio had three children: two daughters and a son. Their son Alexander would go on to inherit his parents' duchies—and serve in his mother's office as regent of the Low Countries. He was 22 in 1567.

The oldest of Archduke Ferdinand II's eight first cousins was the dowager electress Palatine, Dorothea. 47 years old in 1567, Dorothea was the daughter of the archduke's aunt Isabella, the deposed queen of Denmark. Isabella had died in 1526, before the archduke was born, but Dorothea and her sister Christina (who was one year younger than her) would continue to press claims to the Danish, Norwegian and Swedish thrones. Both of these cousins of Archduke Ferdinand II spent time in the Low Countries at the courts of his great aunt Margaret and aunt Mary, but they had complex independent lives as well, starting when they were fifteen and twelve respectively.[11] Dorothea married the Knight of the Golden Fleece and later Elector Palatine Frederick II ("the Wise") of the Wittelsbach Dynasty, converting to Protestantism with him in an effort to better their chances for the northern thrones that they were pursuing. The couple had no children. Frederick died in 1556, but in 1567 Dorothea still headed a modest court in Castle Neumarkt, a stylish Renaissance construction located in the Upper Palatinate.

Her sister Christina had married the thirty-eight-year-old Duke Francesco II of Milan in 1533 when she was twelve. He had died two years later, before the couple had any offspring, ending the Sforzas' rule over the duchy of Milan. The extinction of that dynasty would result in the beginning of the Habsburgs' control of the duchy. The young dowager duchess was granted rights over the principality of Tortona in northern Italy. She moved back to Brussels for a while before marrying Francis, Duke of Bar, in 1541. Three years later he inherited the rest of the joint duchy, Lorraine, but died in 1544, leaving Archduke Ferdinand II's cousin Christina as the regent and dowager of this important imperial territory. Christina, with three children in their early twenties in 1567, was a key political figure in the relations between the Holy Roman Empire and France, and continued to press for the royal throne of Denmark and its related kingdoms.[12]

The sixth of Archduke Ferdinand II's cousins to be discussed here is Maria, the duchess of Viseu. It is possible that the archduke had met this daughter of his aunt

---

11    Margarete, dowager princess of Asturias and dowager duchess of Savoy, died in 1530 when Archduke Ferdinand II's cousins Dorothea and Christina were young girls. She served as Habsburg governess of the Low Countries from 1507–1530. See the exhibition catalogue: *Women of Distinction: Margaret of York, Margaret of Austria*, ed. by Dagmar Eichberger (Davidsfonds, 2005). Mary, dowager queen of Bohemia and Hungary, had died in 1558 after serving as governess of the Habsburg Low Countries for over two decades (1531–1555). See Jacqueline Kerkhoff, 'The Court of Mary of Hungary, 1531–1558', in *Mary of Hungary: The Queen and her Court 1521–1531*, ed. by Orsolya Réthelyi et al., exh. cat. (Budapest, 2005), pp. 136–151.

12    An older biography of Ferdinand's cousin Christina exists: Julia Cartwright, *Christina of Denmark* (New York, 1913).

Eleonora during his early childhood, when Maria had lived in central Europe for a while after the death of her father, King Manuel I of Portugal, in 1521 (Eleonora had died in 1558). By 1567, the 46-year-old unmarried duchess Maria was back in Iberia, where she was active at the Portuguese court as a patroness of the arts and titular holder of the royal duchy of Viseu. Like Archduke Ferdinand II's aunt Katharina, the dowager queen of Portugal discussed above, his wealthy cousin Maria connected him to the wider world beyond Bohemia and Tyrol: to Iberia and beyond the seas.

Another Portuguese connection for Archduke Ferdinand II was the seventh of his first cousins, Joanna, the queen mother and dowager princess of Portugal, widow of the crown prince John Manuel.[13] Joanna and John Manuel had married when Ferdinand had been twenty-three, in 1552; she had delivered a son a few days after her husband's death two years later. This son, Sebastian, would ascend to the Portuguese throne at the age of three. In 1567 the kingdom and empire of the then thirteen-year-old King Sebastian was ruled not by his mother Joanna (she had returned to the Spanish court many years before to be near her father, Archduke Ferdinand II's uncle Emperor Charles V), but rather by his great uncle, the Cardinal-*Infante* and Archbishop of Lisbon, Henry. Henry would go on to succeed Sebastian as King of Portugal in 1578, the last ruler of that kingdom from the Avis Dynasty. Archduke Ferdinand II's widowed cousin Joanna played a major role in the Habsburgs' Spanish court, founding an important convent in Madrid and supporting the Jesuit Order. When thinking about Archduke Ferdinand II's familial connections in 1567, one should remember the Spanish and Portuguese ties: Iberia was much more closely tied to central Europe in 1567 and the decades that followed than it is today.

The next circle of Archduke Ferdinand II's relatives to be discussed is that of his immediate siblings, his eight sisters and two brothers and their families. The circles described here sometimes intersected or overlapped. As mentioned at the outset of this essay, the archduke's well-known brothers Emperor Maximilian II and Archduke Karl, the ruler of Inner Austria (including the hereditary lands of Styria, Carinthia, and Carniola) were significant political players in 1567. Although Karl was still unmarried, Emperor Maximilian II had married one of the brothers' cousins, María, in 1548.[14] In 1567, this María, the eighth of Ferdinand's first cousins and daughter of his aunt Isabella, was thirty-nine years old and the mother of three daughters and six sons.

Other familial circles which can only be briefly mentioned and which seem to have played minor roles in the political and cultural worlds of Archduke Ferdinand II in 1567 include his mother's family, the Jagiellonians. Not only had the archduke's mother Anna passed away two decades before, when he was just a teenager, but Anna's

---

13   Anne J. Cruz, 'Juana of Austria. Patron of the Arts and Regent of Spain, 1554–59', in *The Rule of Women in Early Modern Europe*, ed. by Anne J. Cruz and Mihoko Suzuki (Chicago, 2009), pp. 103–122. Hamann 1988, pp. 183–84.

14   Archduke Ferdinand II's sister-in-law María is increasingly being recognized as one of the most significant early modern empresses. See Alexander Koller, 'Maria von Spanien, die katholische Kaiserin', in Braun / Keller / Schnettger 2016, pp. 85–97. See also Patrouch 2010, Sánchez 1998, and Hamann 1988, pp. 287–288.

brother, his uncle Louis, king of Bohemia and Hungary, had also died leaving no legit-
imate children and a widowed wife, the archduke's aunt Mary. Little record apparently
remains of Louis's illegitimate son John, born to one of his mother's ladies-in-waiting,
Angelitha Wass. Archduke Ferdinand II's maternal grandparents Louis II Jagiellon
(who had been a Habsburg on his mother's side) and his consort Queen Anna of the
important Foix family in France also reveal the horizons and networks of the arch-
duke, which extended at least in principle to the significant neighbouring kingdoms of
Poland and France. Additional ties to the Jagiellonians through the successive mar-
riages of two of Archduke Ferdinand II's sisters to the King of Poland Sigismund II
will be discussed below.

Unlike most Habsburgs of the period, Archduke Ferdinand II did not have sig-
nificant political ties via his wife's family. Due to his secret marriage twenty years
before with Philippine Welser, the daughter of the important Augsburg patricians
Franz Welser and Anna Adler, the archduke had non-noble relatives through his con-
sort, who was forty years old in 1567. The couple had two children, Andreas and Karl,
who therefore grew up with the relative disadvantage of unequal familial ties: their
father's highly noteworthy lineage did not completely compensate for their mother's
bourgeois roots. There is some evidence that at least a few of the archduke's sisters
maintained friendly ties to his wife. Philippine's sister Regina married into the service
nobility at the imperial court. Philippine's brother Hans Georg reportedly served as
*Hofrat* (an official) at the archducal court in Innsbruck when it moved there in 1567.[15]

Archduke Ferdinand II's unusual choice of a marriage partner made his political
position in the complex network of social relations of the Holy Roman Empire and
Europe peculiar; his ties to his sisters and their families were more typical. By looking
at the female siblings of the archduke, some of the ways in which the Habsburgs influ-
enced cultural and political relations in the later sixteenth century can be seen. In order
to understand this rather unusual period of internal peace in the empire between the
religious peace settlement at Augsburg in 1555 and the outbreak of the Thirty Years
War in 1618, an understanding of Habsburg familial politics and the roles of these
archduchesses in them is important.

In late 1567, Archduke Ferdinand II had eight surviving sisters. His older sister
Elizabeth had passed away in 1545, when he was only a teenager. She had briefly been
queen and grand duchess consort of the sprawling territories of Poland-Lithuania to
the east. Ferdinand and Elizabeth's younger sister Katharina had subsequently taken
over this position in 1553, when she married the twice-widowered King and Grand
Duke Sigismund II "Augustus". This is further discussed below. Archduke Ferdi-
nand II's brother Johann had passed away as an infant when the archduke was around
ten, and his baby sister Ursula had died at age two, when he was fourteen. The arch-
duke's younger sister Margarete, a close friend and religious ally of his sisters Magda-
lena and Helena to be discussed further below, passed away in March 1567 at the age

15   Josef Hirn, *Erzherzog Ferdinand II. von Tirol. Geschichte seiner Regierung und seiner Länder*, II
     (Innsbruck, 1888), pp. 335, 359–360.

of thirty-one, less than two months after her brother the archduke (and count) had made his ceremonial entry into his Tyrolean lands.[16]

The spheres of influence and activity of Archduke Ferdinand II's surviving sisters in 1567 can be grouped as follows: two of them, Anna (thirty-nine years old) and Maria (thirty-six), were married to important dukes and officials of the Holy Roman Empire. Three of his sisters were married into important ducal families in Imperial Italy: Eleanora (thirty-three), Barbara (twenty-eight) and Johanna (twenty). A sixth, the thirty-four-year-old Katharina, had been similarly married to an Italian duke, but by 1567 her tumultuous life had already taken her from northern Italy into the complex Kingdom of Poland and Grand Duchy of Lithuania, and then back into Austria.

Two of the archduke's sisters had chosen the religious life and remained unmarried. As mentioned above in connection with the deceased archduchess Margarete, the thirty-five-year-old Magdalena and twenty-four-year-old Helena were working on establishing a new religious foundation and house for pious women in the town of Hall in Tyrol just as Archduke Ferdinand II, his family, and his court relocated to that selfsame Alpine principality.[17] The activities of the archduke's sisters in Hall can be seen as part of the Habsburgs' broader responses to the Counter-Reformation, as a way of helping to secure the 'heavenly' as well as the northern Italian fronts, given the strict religious orientation of the Papal States' new ruler, Pope Pius V. He had taken office in Rome only a year or so before Archduke Ferdinand II and his court moved to Innsbruck. This Pope, an austere Dominican inquisitor from the Habsburg-governed Duchy of Milan, was tied to the reforming party close to the new archbishop of Milan, Cardinal Charles Borromeo, who had formally entered his seat just over a year before Archduke Ferdinand II took over rule of the Tyrol.

The archduke's elder sister, the thirty-nine-year old Anna, had married Albrecht, a prince from the influential Wittelsbach Dynasty in 1546.[18] (Fig. 1) One of the more active figures in the political scene of the mid-century Holy Roman Empire, four years

---

16  This archduchess Margarete (1536–1567), Archduke Ferdinand II's sister, is not to be confused with the more famous archduchess, Margarete, his niece, who had been born just a few weeks before in Vienna. On the dramatic circumstances surrounding her birth, see Patrouch 2010, pp. 357–358. Like her aunt, this archduchess was drawn to the religious life. She later moved to Spain and entered the Descalzas convent in Madrid which had been set up by Archduke Ferdinand II's widowed cousin Joanna. (See above). The archduke's niece is now known as "Margaret of the Cross" and is one of the title characters in Sánchez 1998. Archduke Ferdinand II's sister Katharina, the childless queen and grand duchess consort of Poland-Lithuania, served as Margarete's godmother at the baptism in Vienna.

17  See Julia Hodapp, 'Die Stiftung des Königlichen Damenstiftes in Hall in Tirol, 1569', in Julia Hodapp, *Habsburgerinnen und Konfessionalisierung im späten 16. Jahrhundert* (Münster, 2018), pp. 27–81.

18  Hamann 1988, pp. 54–55; *Kleinodienbuch der Herzogin Anna von Bayern*, 2 vols., ed. by Kurt Löcher (Berlin, 2008). On the Wittelsbach Dynasty generally: Andrew L. Thomas, *A House Divided: Wittelsbach Confessional Court Cultures in the Holy Roman Empire c. 1550–1650* (Leiden, 2010). This marriage later was used in establishing claims to Habsburg properties advanced by the Wittelsbach Elector – Duke Karl I in 1740 and played a role in his election as Holy Roman Emperor Charles VII in 1742.

later he became the ruling Duke of Bavaria. Anna and her husband headed a rich court in Munich, assembling a large collection of jewellery, art, and antiquities. They had seven children, and five of these nieces and nephews of Archduke Ferdinand II were living and unmarried in the key year 1567. Anna's daughter Maria Anna – sixteen in 1567 – would marry her uncle, Anna and Archduke Ferdinand II's brother Karl, four years later. This made her both Archduke Ferdinand II's niece and sister-in-law, bringing the Wittelsbach and Habsburg Dynasties ever closer as the century progressed. In 1567 Anna and Albrecht's son Ernst was already well on his way to the illustrious ecclesiastical career which awaited him: the thirteen-year-old was the *Fürstenbischof* (prince-bishop) of Freising as well as a member of numerous cathedral chapters such as the influential one in the prince-archbishopric of Salzburg.

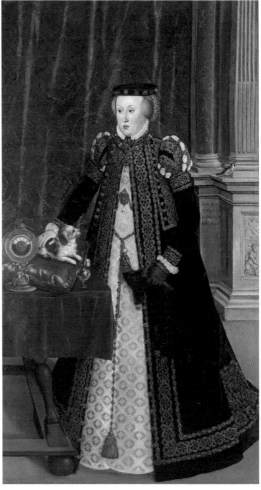

Fig. 1. Hans Mielich, Portrait of Archduchess Anna, Duchess of Bavaria, 1556 (Vienna, Kunsthistorisches Museum, Picture Gallery, inv. no. GG 3847)

The intertwining of honorific, economic, and political powers can be seen clearly in the case of the marriage of Archduke Ferdinand II's sister Anna to Duke Albrecht. For example, the archduke's brother-in-law was a Knight of the Golden Fleece, as was the archduke himself. Albrecht had entered the order in the influential intake of 1546, over a decade before Archduke Ferdinand II, with the likes of the archduke's older brother Emperor Maximilian II and the dukes of Alva and Parma mentioned above, among others. The wealthy Wittelsbach Dynasty had acquired significant property holdings in the Kingdom of Bohemia over time as well. In 1567, Emperor Maximilian II succeeded in reacquiring the alienated Duchy of Kłodzko in Silesia from his sister Anna's husband Albrecht. Perhaps most importantly for the political affairs in the Holy Roman Empire, the duke of Bavaria also exercised the role of *Kreisobrist* (military leader) of the Bavarian Circle, one of the intermediate levels of authority in

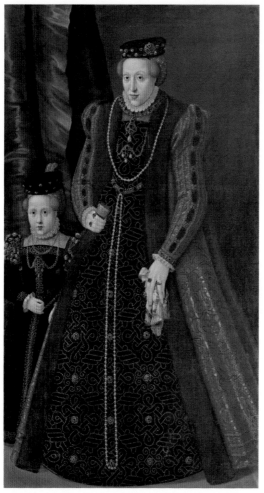

Fig. 2. Jakob Seisenegger, Portrait of Archduchess Maria, Duchess of Julich, Cleve and Berg, c. 1555 (Vienna, Kunsthistorisches Museum, Picture Gallery, inv. no. GG 2577)

the empire, and a level which played a particularly important role in this period, as will be discussed below. The *Fürstbischöfe* (prince-archbishops) of Salzburg normally alternated with the Dukes of Bavaria as chairs of the circle's assembly.

Archduke Ferdinand II's sister Maria, two years his junior, played a role in the empire similar to that of their sister Anna. Maria had married the fifteen-year older Duke Wilhelm ("the Rich") of the convoluted lower Rhenish political entity normally called "Julich-Cleves-Berg" in 1546.[19] (Fig. 2) The couple had six surviving and unmarried children in 1567. The youngest, Archduke Ferdinand II's niece Sybille, ten in 1567, would later marry his son Karl a few years after the archduke's death. Sybille and Karl would have no children. The number of children (two sons and four daughters) meant that Duchess Maria's family was extremely significant in the marital politics of the following decade. Her husband Duke Wilhelm had however created potentially devastating problems for the family by challenging Archduke Ferdinand II's uncle Emperor Charles V more than two decades before over territorial claims in the Low Countries, and never enjoyed the honorific prestige of his brothers-in-law, who became Knights of the Golden Fleece. Duke Wilhelm held the same military position as Duke Albrecht of Bavaria. Like Duke Albrecht, Wilhelm was the military leader of an Imperial Circle: in his case, the Westphalian Circle.

---

19   Duke Wilhelm's sister Anne had been briefly queen of England in 1540 (commonly known as Anne of Cleves). She had died there in 1557. On Archduke Ferdinand II's sister Maria, see Hamann 1988, p. 288. On the consolidated duchies see the exhibition catalogue: *Land im Mittelpunkt der Mächte: die Herzogtümer Jülich, Kleve, Berg*, 3rd edition, exh. cat. (Cleve, 1985).

In the period after the Peace of Augsburg of 1555, the Imperial Circles played a significant role in the internal administration of the Holy Roman Empire.[20] In 1566–67 they had been put to the test by the activities of the unruly Duke of Saxony, Johann Friedrich, and his support for the rebellious nobleman Wilhelm of Grumbach. The circles had various responsibilities in the empire, including some related to external security and to the new monetary policies which were being implemented, but in this case their responsibilities for internal order were paramount. 1567 marked the culmination of the famous "Grumbach'sche Händel": the "Gotha Execution" where troops from various Imperial Circles were delegated to put down Grumbach's uprising by besieging the fortress at Gotha. From late December, 1566 through mid-April, 1567, Imperial Circle troops surrounded and bombarded the rebels. After the fortress capitulated, Grumbach was executed and Duke Johann Friedrich was arrested. He would spend the rest of his life in imperial captivity.[21]

For the political contexts of Archduke Ferdinand II's family, it can be seen how his sisters' marriages to the military leaders of the Westphalian and Bavarian Imperial Circles helped to strengthen the Habsburgs' ties to these significant (if now often underestimated) units of imperial governance. While the Bavarian Circle played no formal role in the events surrounding Grumbach, the Westphalian one did. Given the fraught nature of the disputed borders between the Holy Roman Empire and the Burgundian Circle in the Low Countries, ties to the military leader of the Westphalian Circle were increasingly crucial. The ramifications of Archduke Ferdinand II's cousin King Philip II's decision to respond to religious riots which occurred in 1566 through the transfer of Italian and Spanish military forces into the area (as discussed above) would result in a destabilization of the region that would last for generations. The presence of Archduchess Maria in the area meant dynastic as well as political ties to a problem region.

Another problem region for the Habsburgs had been the unruly Italian peninsula. By 1567, they were beginning the final phases of their clampdown on the disparate political units that comprised Italy at that time. Since French troops had forced their way south of the Alps at the end of the previous century, intense and complex conflicts had wracked the area. Archduke Ferdinand II's uncle Emperor Charles V had countered the Valois kings' various strategies in Italy, and the archduke's sisters had been sent down to help consolidate the family's positions there. For historians of art and music, this moving of Habsburg archduchesses into the rulers' palazzi of the strategically crucial duchies of Mantua, Ferrara, and Florence is vital to understanding how

---

20   Helmut Neuhaus, *Reichsständische Repräsentationsformen im 16. Jahrhundert. Reichstag-Reichskreistag-Reichsdeputationstag* (Berlin, 1982).

21   This feud is discussed as the last of its kind in Hillay Zmora, *State and Nobility in Early Modern Germany: The Knightly Feud in Franconia, 1440–1567* (Cambridge, 1997), pp. 143–145. The costs of this imperial action against Grumbach and the role of the Westphalian Circle and its commander Archduke Ferdinand II's brother-in-law Wilhelm were discussed at length at the *Reichstag* held in Regensburg and the *Reichskreistag* in Erfurt (both in 1567): *Der Reichstag zu Regensburg 1567; und der Reichskreistag zu Erfurt 1567*, ed. by Josef Leeb, Arno Strohmeyer and Wolfgang Wagner (Munich, 2007).

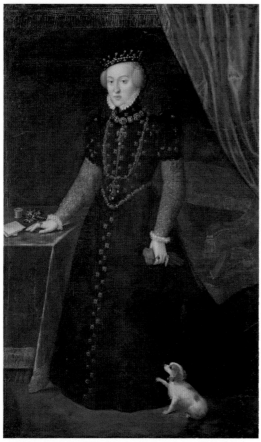

Fig. 3. Anonymous, Portrait of Archduchess Eleonora, later Duchess of Mantua, around 1555 (Vienna, Kunsthistorisches Museum, Picture Gallery, inv. no. GG 3998)

the tastes and fashions, innovations and styles of the late Italian Renaissance made their way into the Habsburgs' courts in places such as Prague, Innsbruck, and Vienna.

Archduke Ferdinand II's sister Archduchess Eleonora was thirty-three in 1567.[22] (Fig. 3) Six years before, at the unusually mature age of 27, she had married the Duke of Mantua, Guglielmo of the House of Gonzaga, a man four years her junior. In 1549 Eleonora's (and therefore of course the archduke's) sister Katharina had married William's older brother and predecessor in office, Francesco III, but he had drowned a few months later, leaving the archduchess a widow before she turned seventeen. Katharina would go on to marry the King of Poland: this is discussed further below. Archduke Ferdinand II had accompanied his sister Katharina to her wedding and had been personally involved in the marriage negotiations leading up to the second, more successful attempt at a marriage alliance with the family ruling the new and militarily strategic Duchy of Mantua (which had been created by his uncle the emperor in 1530.) After Archduke Ferdinand II and his court moved to Innsbruck, he maintained close ties to Eleonora, who enjoyed visiting her brother in Tyrol.[23] Together Eleonora and Guglielmo ruled over a rich and vibrant principality, which may have reached its cultural highpoint during their rule. The couple had a son and two daughters. All three were still very young in 1567, but the eldest, Vincenzo, would go on to rule the duchy, and the youngest, Anna Catarina, would go on to become Archduke Ferdinand II's second wife fifteen years later. Vincenzo would marry Margherita (born in 1567 in Parma), the granddaughter and namesake of Archduke Ferdinand II's cousin Margaret.

---

22  Hamann 1988, pp. 77–78. Antonio Possevino, *Vita et morte della serenissima Eleonora, arciduchessa di Austria et duchessa di Mantoua* (Mantua, 1594).

23  Hirn 1888, p. 223.

Archduchess Eleonora was not the only one of Archduke Ferdinand II's sisters to travel with her bridal party into northern Italy: their sisters Barbara and Johanna had similarly made that journey just two years before, in 1565.[24] The twenty-eight-year old Barbara, like Eleonora rather old to be starting a family in this period, became duchess consort of Ferrara as the second wife of its ruling duke, Alfonso II d'Este.[25] (Fig. 4) The couple would remain childless. Such alliances with imaginative Italian dukes would sometimes pay off for the Habsburgs in terms of military support, as was the case with this new marriage. In late summer 1566, as Archduke Ferdinand II and his brothers Emperor Maximilian II and Archduke Karl were on a military campaign in the disputed territory of Hungary fighting the Ottomans, Duke Alfonso joined them with a contingent of Ferrara troops (there were Florentines present in this army as well.)[26]

The last of the archduke's sisters to marry into the northern Italian nobility was the youngest of his siblings, Johanna.[27] Only twenty in

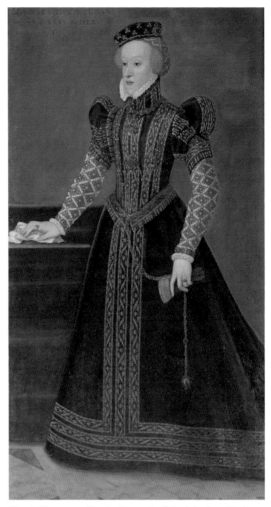

Fig. 4. Francesco Terzio, Portrait of Archduchess Barbara, Duchess of Ferrara, c. 1565 (Vienna, Kunsthistorisches Museum, Picture Gallery, inv. no. GG 3994)

---

24   Brigitte Grohs, 'Italienische Hochzeiten. Die Vermählung der Erzherzoginnen Barbara und Johanna von Habsburg im Jahre 1565', *Mitteilungen des Instituts für österreichische Geschichtsforschung* 96 (1988), pp. 331–381.

25   Hamann 1988, pp. 64–65. The negotiations prior to this marriage became the subject of Robert Browning's famous poem "The Last Duchess" (1842) as well as Richard Howell's response "Nikolaus Mardruz to his Master Ferdinand, Count of Tyrol, 1565" (1929). The Canadian author Margaret Atwood made an analysis of Browning's poem into the background of her short story of the same name: Margaret Atwood, *Moral Disorder* (Toronto, 2006), pp. 50–76.

26   See the emperor's report about this campaign presented at the Imperial Circle Assembly in Erfurt, August 11, 1567: Leeb / Strohmeyer / Wagner 2007, pp. 581–599 (596).

27   Alice E. Sanger, *Art, Gender and Religious Devotion in Grand Ducal Tuscany* (Farnham, 2014); Sarah Bercusson, 'Giovanna d'Austria and the Art of Appearances: Textiles and Dress at the Florentine Court', *Renaissance Studies* 29:5 (2015), pp. 683–700; Hamann 1988, pp. 184–85.

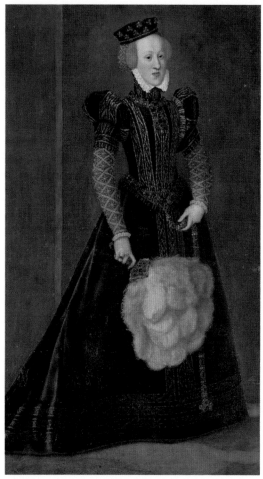

Fig. 5. Francesco Terzio, Portrait of Archduchess Johanna, later Grand Duchess of Tuscany, 1565 (Vienna, Kunsthistorisches Museum, Picture Gallery, inv. No GG 3997)

1567, Johanna had married Francesco de' Medici, the heir presumptive to the relatively new Duchy of Florence (like Mantua, this duchy was a creation of Archduke Ferdinand II's uncle Emperor Charles V). Johanna's new father-in-law, the grasping and successful Duke Cosimo I, was manoeuvring between the popes and the emperor to expand his territory's prestige. His manoeuvres would soon result in his coronation in the Sistine Chapel in 1570 as "Grand Duke of Tuscany" by Pope Pius V. This meant that when Cosimo's son Francesco succeeded him upon Cosimo's death in 1574, Archduchess Johanna would become grand duchess consort of Tuscany. (Fig. 5)

In the pivotal year of 1567, Johanna gave birth to a daughter, Eleonora. Eleonora was the first of Johanna's eight children, but only three would survive into adulthood in Florence. This Eleanora, Archduke Ferdinand II's new niece, would be the second wife of his nephew Vincenzo, Duke of Mantua. Johanna's daughter Anna, who would be born in 1569, was briefly betrothed to Archduke Ferdinand II's son Karl when she was a girl, but the wedding never took place. Anna passed away unmarried and not yet fifteen years old. Johanna's third daughter, Maria, would be born in 1575 and went on to become queen consort and then queen regent of France, as well as mother of the queen consort of England, Scotland and Ireland and of the queen consort (and occasional queen regent) of Spain and Portugal.

1567 saw the Habsburgs firmly established throughout the empire and northern Italy through the marriages of five of Archduke Ferdinand II's sisters. A sixth, the thirty-four year-old Katharina, has been briefly mentioned above in reference to her first, short marriage to a duke of Mantua in 1549.[28] (Fig. 6) Archduke Ferdinand and

---

28   Patrouch 2010, pp. 263–68; Hamann 1988, pp. 236–37.

Katharina's sister, Queen Consort of Poland and Lithuania, Elisabeth, had passed away in 1545 and her husband, the crowned King of Poland and Grand Duke of Lithuania Sigismund II, had remarried. (He officially succeeded his father in 1548.) Sigismund was the grandson of the Habsburg duchess Elisabeth, queen of Poland, who had played a large role in the marital politics of central Europe during the later fifteenth century as queen consort of Poland. She died in 1505 but, unlike her successor Archduchess Elisabeth, who had been buried in Vilnius Cathedral, Queen Elisabeth lay in Wawel Cathedral in Krakow.

Archduchess and Dowager Duchess of Mantua Katharina married her late sister's husband Sigismund in 1553 and was crowned in Wawel Cathedral where her Habsburg predecessor was entombed. This marriage,

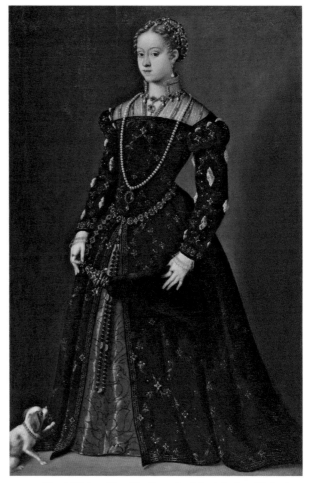

Fig. 6. Tiziano Vecellio, Portrait of Archduchess Katharina, Duchess of Mantua, later Queen of Poland, 1548/49 (Oelsnitz, Voigtsberg Castle)

similar to her sister Elisabeth's marriage to Sigismund, was extremely unhappy, but it was part of the Habsburgs' larger strategy of retaining influence in the huge neighbouring lands of Poland-Lithuania. Archduke Ferdinand II and his brother Archduke Maximilian (later Emperor Maximilian II) had accompanied their sister Katharina to Poland for the wedding. The two brothers would keep their options open as possible candidates for the thrones there, especially as it became clear that Sigismund would have no heirs and his dynasty, the Jagiellonian, would die out in the male line. In the years following the wedding of his sister, various plans for Archduke Ferdinand II to marry a Polish princess were vetted, but these were of course prevented by his marriage to Philippine Welser.

Relations between Katharina and Sigismund deteriorated to such an extent that it was decided to arrange for the childless Katharina to return to the Austrian hereditary

lands. In the winter of 1566–67 the thirty-four-year-old queen and grand duchess was back in Vienna, having been repudiated by her husband. Later in 1567 she moved with her modest court to the Habsburg castle up the Danube in Linz. She passed away five years later. Her body was not interred in the Polish or Lithuanian royal burial sites in Krakow or Vilnius, but in the modest castle chapel in Linz. Decades later her nephew Emperor Rudolf II would have her body moved to the nearby Augustinian canonry at St. Florian, and her body has remained there ever since.

The next circle of relatives that could be discussed and analysed has already been touched on above on a couple of occasions: this is the circle formed by Archduke Ferdinand II's dozens of nieces and nephews. In 1567, he had twenty-four nieces and nephews (twelve of each gender), ranging in age from newborn to nineteen. His role as uncle is perhaps best commemorated by the famous saltcellar crafted by Benvenuto Cellini, which the archduke received in exchange for the role he played in his niece Elizabeth's wedding in 1570 and which became one of the best-known pieces of the Habsburgs' art collection. There is not space here to go into more detail about the archduke as an uncle, and much of the significance of that story belongs to the period after 1567 when he was clearly ensconced in Tyrol and his nieces and nephews grew into significant political and dynastic actors of their own.

The importance of the dynastic strategies outlined above was not lost on contemporaries. This is evidenced by the investigation mandated by Archduke Ferdinand II's brother Emperor Maximilian II into the appearance of an incendiary rhymed pamphlet in circulation in the Holy Roman Empire in 1567. At the *Reichskreistag* (Imperial Circles Assembly) held in Erfurt as a follow-up to the *Reichstag* (Imperial Diet) which had just adjourned in May of that year in Regensburg, Emperor Maximilian II added a third subsidiary proposition to the agenda. Discussed by the assembly on the 22nd of September, 1567, this proposition concentrated on a defamatory poem currently in circulation within the Holy Roman Empire, which was called *Alliance of the Pope, Emperor, King of Spain and that of Portugal, the Duke of Bavaria and others of their relatives including the Duke of Savoy into which one wishes to involve the King of France to eliminate all of the Christians one refers to as Huguenots and Lutherans.*[29]

The pamphlet reportedly outlined a plan to destroy Protestantism by replacing the electors of Saxony and of the Palatinate with Archduke Ferdinand II and his brother Archduke Karl via a military campaign led by Archduke Ferdinand II's brother-in-law Duke Albrecht of Bavaria. In order to bring France into the alliance one of the archduke's nieces (a daughter of his sister-in-law María and brother Emperor Maximilian II) was to marry the French king. Spain, led by the archduke's cousin Philip II, was to move against England and replace the queen there as well. In the formal concluding document of the assembly signed on the 27th of September 1567 in Erfurt, the representatives committed themselves and those people and institutions from across the

---

29   "Verpuntnus des bapsts, kaisers, kunigs zu Hispanien, dessen in Portugal, des herzogen in Bayern und anderer irer mitverwandtenm auch des herzogen von Saphoy, dazue hat man ziehen wellen den kunig in Frankreich, auszurotten alle cristenm so man Hugenotten und Lutherischen nennet …"

empire which they represented to enforce the imperial legislation against all such writings and "*Gemalde*" (illustrations).[30] The assembled leaders knew how politics functioned within the empire, and understood how these politics were closely tied to dynastic concerns and often implemented through marital alliances.

In order to fully understand the political and cultural situation in the Holy Roman Empire in 1567, when Archduke Ferdinand II moved from Prague to Innsbruck, it is essential to analyse his position in a broader dynastic context, one which includes not only his immediate family or his famous brothers, but also his sisters, aunt, cousins, nieces, and nephews. In the analysis above, the far-reaching network of close relatives in which the archduke operated was sketched, with particular emphasis on the various roles played by his sisters. Through such an analysis, avenues of cultural contact as well as routes of political influence can be traced. In early modern Europe no man stood alone, and Archduke Ferdinand II was no exception to this rule. More research is needed to document the consequences of these dynastic contexts. It is hoped that this essay points out many of these interconnections, and outlines a structure into which this new research can be placed.

Although the Habsburgs pursued these kinds of dynastic strategies for longer and perhaps with greater success than their various rivals, a similar analysis of these competing families would show a similar, if less extensive network of female relations, one often overlooked by historians because of the emphasis given to male relatives. The Jagiellonian Dynasty, for example, mentioned above in connection with the Habsburgs' marriages to kings in Poland, Hungary, and Bohemia can be seen as another important case study. Examples from western Europe and the Italian peninsula can also be adduced.[31] Stepping back and widening the perspective even further, we can see how the dynastic strategies employed by Archduke Ferdinand II and his family fit into global histories as well.[32]

---

30  The original "*Dritte Nebenproposition*" is found in Leeb / Strohmeyer / Wagner 2007, pp. 362–365. The reference in the concluding document ("*Abschied*") is on pp. 727–728. The title of the pamphlet is given in p. 362, note 3.

31  For an overview giving recent literature, see Katrin Keller, 'Frauen und dynastische Herrschaft. Eine Einführung', in Braun / Keller / Schnettger, pp. 13–26.

32  See for example *Royal Courts in Dynastic States and Empires. A Global Perspective*, ed. by Jeroen Duindam, Tülay Artan and Metin Kunt (Leiden, 2011), with particular reference to Ottoman princesses and their marriages as outlined in Artan's chapter 'Royal Weddings and the Grand Vizirate: Institutional and Symbolic Change in the Early Eighteenth Century', pp. 339–399. The late sixteenth-century context is discussed on pp. 345–348.

Architecture:
Residences in Prague and in Innsbruck

Petr Uličný

## The architecture of Prague Castle during the governorship of Archduke Ferdinand II (1547–1567): How to read it?

It was in the first half of the 16th century that Renaissance architecture began to take root in all parts of Central Europe. The royal courts of the Bohemian lands, Austria, Poland, Saxony and Bavaria commissioned important architectural projects from Italian architects and thus embraced a new artistic direction first promoted amongst the sovereigns north of the Alps by King Matthias Corvinus of Hungary during the last quarter of the 15th century.[1] He was followed in this by Vladislaus Jagiellon[2] in Buda and Prague, and later by Ferdinand I with the *Lusthaus* he had built in the Royal Garden at Prague Castle (commonly called the Royal Summer Palace in English).

When the King and future Holy Roman Emperor Ferdinand I was elected to the Bohemian throne in 1526, he arrived at Prague Castle to find a palace dominated by the magnificent Vladislaus Hall, and the Louis Wing, which was modelled on an Italian examples from the early period of the Renaissance. The king was thus able to focus his attention on building the Royal Summer Palace, work on which began during 1538 in the newly laid out garden under the direction of Giovanni Spazio and Paolo della Stella.[3] The Royal Summer Palace continues to spark wonder in those who see it because of its unusual design, which features a long arcade with decorative reliefs on every side, as well as highly detailed portals and windows displaying a level of quality that was uncommon even in Italy at the time.

A structure of the very opposite type might seem to be represented by the Hvězda (commonly known in English as the Star Summer Palace), the hunting lodge that Archduke Ferdinand II built in 1555–1556 at a location that was outside of, but not far from, Prague at that time. Designed by the archduke himself as a combination of a circle and a six-pointed star,[4] the Star Summer Palace stands apart from anything that builders in Italy were creating at the time. It forms a contrast to the Royal Summer

---

1   More recently, *Italy and Hungary: Humanism and Art in the Early Renaissance*, ed. by Péter Farbaky and Louis A. Waldman (Florence, 2011); *Mattia Corvino e Firenze: arte e umanesimo alla corte del re di Ungheria*, ed. by Péter Farbaky, Dániel Pócs and Magnolia Scudieri (Florence, 2013).

2   On the buildings that Vladislaus Jagiellon had built at Prague Castle, see Václav Mencl, 'Architektura', in Jaromír Homolka et al., *Pozdně gotické umění (1471–1526)* (Prague, 1978), pp. 80–87 and 94–129, and Petr Chotěbor, 'K jagellonské přestavbě Starého královského paláce na Pražském hradě', *Castellologica Bohemica* 13 (2016), pp. 119–152. See also Pavel Kalina, *Benedikt Ried a počátky záalpské renesance* (Prague, 2009); Jiří Kuthan, *Královské dílo za Jiřího z Poděbrad a dynastie Jagellonců I: Král a šlechta* (Prague, 2010), pp. 57–103.

3   Ivan P. Muchka, 'Die Bautätigkeit Kaiser Ferdinand I. in Prag', in *Kaiser Ferdinand I. 1503–1564. Das Werden der Habsburgermonarchie*, ed. by Wilfried Seipel, exh. cat. (Vienna, 2003), pp. 249–257; Jan Bažant, *The Prague Belvedere (1537–1563)* (Prague, 2011), Kindle Edition; Pavel Kalina, *Praha 1437–1610. Kapitoly o pozdně gotické a renesanční architektuře* (Prague, 2011), pp. 65–73.

4   Ivan Muchka, Ivo Purš, Sylva Dobalová and Jaroslava Hausenblasová, *The Star. Archduke Ferdinand II of Austria and His Summer Palace in Prague* (Prague, 2017).

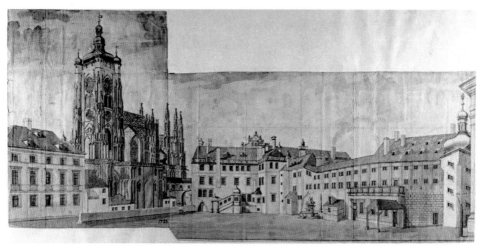

Fig. 1. Johann J. Dietzler, Prague Castle, west wing of the Old Royal Palace, view of the 3rd courtyard, 1733 (The Archives of the Prague Castle)

Palace, not just because of its architectural shape, but also thanks to the decorative stucco ceilings that it has inside.

The charming Royal Summer Palace in the Royal Garden and the enigmatic Star Summer Palace rightly rank among the icons of European Renaissance architecture;[5] the role of the Habsburgs in shaping Europe's architectural culture must thus be noted with favour. However, the process behind the construction of other buildings on the grounds of Prague Castle reveals another side to Habsburg architecture, one that was rather pragmatic. A significant factor in this was the devastating fire at the castle, which occurred in 1541. For this reason, it was not until around the time of the coronation of Ferdinand I as Holy Roman Emperor in 1558 that some projects of a more ambitious nature began to be built at the castle. It was during this period that Ferdinand I turned to more sophisticated forms of Renaissance architecture for the buildings that he commissioned for public spaces.[6] The question is whether the archduke was able to exert

---

5    Alexander Markschies, *Icons of Renaissance Architecture* (Munich, Berlin, London and New York, 2003), pp. 92–93 and 102–103.

6    On the building activity at Prague Castle during the time of Ferdinand I and Archduke Ferdinand II, see Eliška Fučíková, 'Kaiser Ferdinand I. und das Schicksal des Herrscherzyklus' im Alten Königspalast der Prager Burg', *Historie – Otázky – Problémy* 7:2 (2015), pp. 135–141; Sylva Dobalová and Ivan P. Muchka, 'Archduke Ferdinand II as Architectural Patron in Prague and Innsbruck', in *Ferdinand II. 450 Years Sovereign Ruler of Tyrol. Jubilee Exhibition*, ed. by Sabine Haag and Veronika Sandbichler, exh. cat. (Innsbruck and Vienna, 2017), pp. 38–45; Eliška Fučíková, 'Prague Castle under Archduke Ferdinand II: Rebuilding and Decoration', in *Ferdinand II. 450 Years Sovereign Ruler of Tyrol. Jubilee Exhibition*, ed. by Sabine Haag and Veronika Sandbichler, exh. cat. (Innsbruck and Vienna, 2017), pp. 46–53; Petr Uličný, 'The Making of the Habsburg Residence in Prague Castle. History of the Journey of the Imperial Palace from the Centre to the Periphery', *Umění/Art* 65 (2017), pp. 377–395.

his influence on the programme of construction during his twenty-year stay in Prague, and if so, how. This question is important from one reason: if we were to look for a building on the grounds of Prague Castle equal in sophistication to the Star Summer Palace, we would be disappointed. We should therefore be asking whether this situation resulted from a lack of funding or rather from a deliberately pragmatic approach to residential architecture. There is also the question of whether the archduke genuinely shared his father's approach to architecture, or was just passively carrying out the king's will. (Fig. 1)

## Between the lightness of temporary architecture and the gravity of the permanent form

In March 1558 in Frankfurt am Main, Ferdinand I was crowned Holy Roman Emperor. In November of the same year he travelled to Prague, where the Archduke Ferdinand II prepared a grand welcome for him. It had been a very long time since the Prague conurbation had seen such an elaborate celebration. The programme of festivities was made up of numerous components and culminated in a spectacular theatre performance held in the Royal Garden on the 9th of November. The official reception at which the archduke welcomed the emperor actually formed part of this event, and had taken place the day before on Hradčany Square in front of a large triumphal arch that had been commissioned by the archduke.

Among the written records of the celebrations, one that stands out is an account by Pietro Andrea Mattioli[7] that focuses on the artistic component of the programme of festivities. Mattioli's text devotes the most attention to the triumphal arch,[8] which was a structure divided up on either side by a group of four tall columns. Its iconography represented a celebration of the emperor as a Christian warrior and fearless ruler, and, Mattioli notes, was expressed in paintings that were "masterfully" rendered in the colour bronze, as well as by sculptures made out of imitation marble and bronze.[9] Mattioli also proudly shares the information that the arch was built with the aid of two of his countrymen: "a highly esteemed Italian painter" and "an exceptional master of stucco and relief work". That painter was most certainly Francesco Terzio, and the

---

7    Pietro Andrea Mattioli, *Le solenni pompe, i svperbi, et gloriosi apparati, i trionfi, i fvochi, et gli altri splendidi, et diletteuoli spettacoli [...]* (Prague, 1559). On the festivities, see Václav Bůžek, *Ferdinand von Tirol zwischen Prag und Innsbruck. Der Adel aus den böhmischen Ländern auf dem Weg zu den Höfen der ersten Habsburger* (Vienna, Cologne and Weimar, 2009), pp. 207–239; most recently Borbála Gulyás, 'Triumphal arches in court festivals under the new Holy Roman Emperor, Habsburg Ferdinand I.', in *Occasions of State: Early Modern European Festivals and the Negotiation of Power*, ed. by J. R. Mulryne, Krista de Jonge, R. L. M. Morris and Pieter Martens (New York, 2019), pp. 65–68.

8    Mattioli 1559, fol. Dii/r–Dii/v. For this, see Guido Carrai, 'Pietro Andrea Mattioli: architettura ed effi mero alla corte imperiale alla fine del XVI secolo / Pietro Andrea Mattioli: architektura a efemérnost na císařském dvoře na konci XVI. století', in *Humanitas latina in Bohemis*, ed. by Giorgio Cadorini and Jiří Spička (Kolín and Treviso, 2007), pp. 169–194.

9    Mattioli 1559, fol. Dii/r–Div/v; Bůžek 2009, pp. 152–154.

sculptor was very likely Antonio Brocco;[10] Brocco and his workshop were engaged in making the decorative work on the archduke's Star Summer Palace at that time. There is no mention of who the triumphal arch's architect was. It could have been one of a number of master-builders who were employed by the archduke and the emperor in 1558. These master-builders included, notably, Bonifaz Wolmut (before 1510 –1579) and Giovanni Lucchese (?–1581). In late 1558, two other unnamed architects arrived from Vienna, one of whom was probably Pietro Ferrabosco (circa 1512–after 1588), while the other may have been Francesco de Pozzo (1501/1502–1562). The possibility that the work was designed by the most talented architect living in Central Europe at the time and a great expert in classical culture, Mantovan Jacopo Strada (1507–1588), also cannot be ruled out. Strada came to Prague to work on a fountain commissioned by Archduke Ferdinand II in early 1557, and in spring 1558 he entered the services of King Ferdinand I.[11]

The triumphal arch continued for a time to vitalise the castle's suburbium, which still had not fully recovered from the devastating fire even twenty years later. It temporarily took the place of the castle's high entrance gate, as documented in a view from 1537, but was demolished after the fire, and its absence was keenly felt. In 1564 Hans Tirol, the former castle architect, called fruitlessly for a suitable new entrance to the castle to be built,[12] but this would not happen until the early 17th century and the time of Rudolf II, when a monumental gate (later called the Matthias Gate) would be built at this site – in the form of a triumphal arch.

## The Old Royal Palace and the first stage of rebuilding (1541–1548)

The fire in 1541 altered the appearance of many extraordinary buildings that stood in the castle grounds beyond recognition.[13] St Vitus' Cathedral and the grounds of the royal palace suffered the most damage. The magnificent All Saints Chapel next to Vladislaus Hall was so devastated that it was left in ruins for decades, and the palace's western wing close to the cathedral, where the king's apartments were located, was also damaged.[14] The least impacted area was the Louis Wing, which housed the offices of the provincial authorities. (Fig. 2, Fig. 3)

---

10   Carrai 2007, p. 173.

11   For more about these architects, see *Encyklopedie architektů, stavitelů, zedníků a kameníků v Čechách*, ed. by Pavel Vlček (Prague, 2004), pp. 165–166, 377–378 and 719–720; Dirk Jacob Jansen, *Jacopo Strada and Cultural Patronage at the Imperial Court. The Antique as Innovation*, 2 vols. (Leiden and Boston, 2019); Muchka / Purš / Dobalová / Hausenblasová 2017, pp. 56–58.

12   Uličný 2017, p. 380.

13   Václav Hájek of Libočany, *O nesstiastnee przihodie kteráž gse stala skrze ohen w Menssim Miestie Pražském, a na Hradie Swatého Waclawa, y na Hradčzanech etc.* (Prague, 1541).

14   A good idea of the scale of destruction and the continued viability of various parts of the palace after the fire is provided by a letter Ferdinand I wrote in late 1541, when he summoned the (Provincial) Assembly to convene at the palace, see Karl Köpl, 'Urkunden, Acten, Regesten und Inventare aus dem k.k. Statthalterei-Archiv in Prag', *Jahrbuch der kunsthistorischen Sammlungen des Allerhöchsten Kaiserhauses* (hereafter as JKSAK) 10 (1889), p. C, reg. 6060, from Ferdinand I to the Bohemian Chamber, Linz, 12 November 1541.

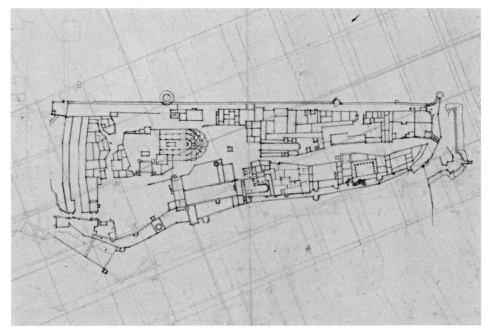

Fig. 2. Plan of Prague Castle from the period around 1560, copy from around 1620 (Florence, Uffizi, Gabinetto di disegni e stampe, 4521A)

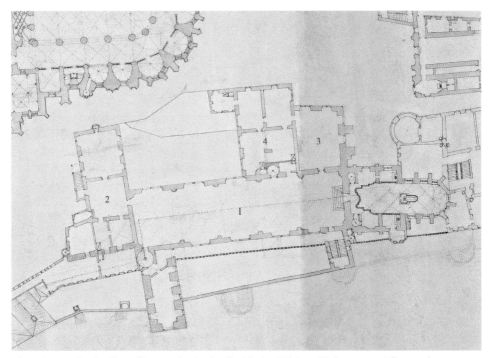

Fig. 3. Prague Castle, Plan of Prague Castle, detail with the Old Royal Palace, second floor, 18th century (Prague, The Archives of the Prague Castle, Old Plans Collection, sign. no. 157/35). 1: Vladislaus Hall, 2: King's Apartments, 3: Old Diet Hall, 4: Office of the Land Rolls.

Fig. 4. Prague Castle, Gable of the Vladislaus Hall as viewed from the eastern side of the Old Royal Palace, 1546

In 1543 Paolo della Stella began to construct an entirely new layout in the western wing, and in 1546 he compiled a budget for new roofing for the entire palace.[15] It was during this renovation work that gables were built on the roof, only one of which has survived – on the eastern side of Vladislaus Hall, marked with the date 1546 (Fig. 4).[16] This is essentially a dormer window inserted on top of an older Gothic gable, which is decorated in sgraffito with the symbols of the Order of the Golden Fleece. Historical iconography (for example the Peterle view from 1562, see Fig. 6) shows that the palace was lined with a great number of these dormer windows and it can be assumed that they too were decorated with the same symbols – it is thus possible to imagine that the same concept was applied to all gables of the palace. The symbols would therefore run around the palace in the same way as they do in the handrails and window friezes of the Royal Summer Palace in the Royal Garden.[17] A similar idea was planned by Paolo della Stella for the decoration of the vaults of the Vladislaus Hall in 1548, but this design was not implemented.[18] The palace's dormer windows ushered light into the attic space above Vladislaus Hall, into which a large armoury was moved. In 1550 this armoury contained more than two thousand pieces of armour, which were in all likelihood acquired via the confiscations that took place after the anti-Habsburg uprising was suppressed in

---

15   The Archives of Prague Castle (hereafter APH), DK, inv. no. 74, from Ferdinand I to Florian Griespek, 29 March 1543, Nuremberg. See also Köpl 1889, p. CI, reg. 6065, Nuremberg, 20 March 1543, where Ferdinand I calls on the Royal Bohemian Chamber to complete the work on his rooms and on the queen's rooms, and wants to have the newly stuccoed walls covered with tapestries on their arrival. The budget from 1546 is in the APH, DK, inv. no. 82.

16   Petr Uličný, 'Střešní architektura a renesanční make-up pražských měst za krále a císaře Ferdinanda I.', *Staletá Praha* 34:2 (2018), pp. 69–95 (86).

17   On the use of this symbol at Prague Castle and in the Hofburg in Vienna, see Renate Holzschuh-Hofer, 'Feuereisen im Dienst politischer Propaganda von Burgund bis Habsburg', *RIHA Journal* no. 0006 (2010), http://www.riha-journal.org/articles/2010/holzschuh-hofer-feuereisen-im-dienst-politischer-propaganda.

18   Petr Uličný, 'Od císaře k oráči a zase zpět. Panovnické cykly ve Starém královském paláci na Pražském hradě', *Umění/Art* 66 (2018), pp. 466–488 (475–477).

1547.[19] In the western residential wing, a trio of tall gables was added during the reconstruction process: these were decorated along the edges with volutes, and can also be seen in Peterle's view.

The new gables gave the royal palace back some of the elegance it had lost to the fire, as the fire had destroyed the Vladislaus Hall's unique roof structure, made up of five tall tented roofs and small triangular gables that ran along the edge of the hall. The structure was visually reminiscent of a crown and this may have been intentional.[20] However, for the Italian architect, tall gables were not elements commonly used in secular architecture. If it had been a new structure, he might have finished the palace with a low roof and furnished it with a cornice with lunettes,

Fig. 5. Prague Castle, Vladislaus Hall, portal to the western lobby

like the one on the northern gate of the Powder Bridge (Prašný most, probably second half of the 1530s) or Nelahozeves Castle, which Ferdinand I's counsellor Florian Griespek of Griespach had built from 1553 on. However, a roof design with gables was also used by the master-builder who built Rosenberg Palace in the grounds of Prague Castle after 1545. This design, then, became one of the characteristic features of the Bohemian Renaissance, because it represented an artful combination of the tradition of Gothic stepped gables with new Renaissance forms.[21]

---

19    Petr Uličný, 'Bella, & rara armaria di sua Altezza. Zbrojnice Pražského hradu v době Ferdinanda Tyrolského', *Průzkumy památek* 25:1 (2018), pp. 25–46 (27–28).

20    Petr Uličný, 'A Difficult Mission: The Building of St. Vitus Cathedral in the Time of Ferdinand I and Anna Jagiellon (1526–1547)', *Umění/Art* 68 (2020), pp. 47–66 (49).

21    The first mention of the gate by Powder Bridge dates from 1541; see Jan Morávek, 'Z počátků královské zahrady v Praze', *Umění* 11 (1938), pp. 530–536 (p. 535). On Nelahozeves, see Olga Frejková, *Palladianismus v české renesanci* (Prague, 1941), pp. 32–34 and 74–77. On the different types of Renaissance gables and their use Prague, see Uličný 2018c, pp. 69–95.

Reconstruction of the Old Royal Palace seems to have been fundamentally affected by insufficient funding. In the western wing, Stella removed the original architectural elements that had been damaged, including Benedikt Ried's Renaissance portals, and replaced them with simpler ones, such as the one leading into Vladislaus Hall from the west. (Fig. 5) This was done at about the same time that stone-cutting work of the highest quality was being produced for the Royal Summer Palace in the Royal Garden. Evidently the king had decided (or was forced by financial constraints) to invest exclusively in the summer palace, which he considered to be the main vehicle of his representative needs at that time, and to reconstruct the palace only to the extent that was absolutely necessary. However, this approach was more broadly characteristic of Habsburg architecture during the 16th century, as in the years that followed it could be seen in practice not only in Prague but also in the Hofburg in Vienna. Thus, it is possible that the restrained approach Ferdinand I took to his residential architecture was a deliberate strategy. Perhaps he was influenced by the situation in the court of the Archduchess Margaret of Austria, Governor of the Habsburg Netherlands, where Ferdinand I had spent some time in his youth.[22]

## The Palace of the Archduke by the White Tower (1553–1567)

When Archduke Ferdinand II assumed the function of governor of the Bohemian lands in 1547, it was difficult for him to find suitable accommodation for himself at Prague Castle. For this reason, the archduke lived for a while in the Louis Wing, evidently in an apartment on the upper floors, where his younger brother Karl later lived.[23] However, the archduke's residence also had to accommodate the members of his court. While the king could have added a new wing to the palace, as proposed later by the court master-builders Hans Tirol and Bonifaz Wolmut,[24] in the end an older building located to the southwest of the White Tower was chosen for renovation. This old building was a trapezoidal structure that extended beyond the confines of the castle grounds into the moat,[25] and its only advantage was that it faced out onto the city. (Fig. 6)

---

22 Renate Holzschuh-Hofer, 'Die Hofburg und ihre Ikonologie im 16. Jahrhundert', in *Die Wiener Hofburg 1521–1705: Baugeschichte, Funktion und Etablierung als Kaiserresidenz*, ed. by Herbert Karner (Vienna, 2014), pp. 543–544.

23 We learn this from a budget dated the 22nd of March 1548 that was drawn up by Paolo della Stella, which mentions repairs to the *Zwinger* (*parkán* or bailey) tower 'below the room of the most radiant prince', see National Archives in Prague (hereafter cited as NA), ČDKM IV-P, cart. 191, fol. 29r. On Karl's suite, see NA, ČDKM IV-P, cart. 192, fol. 602r–602v, from Bonifaz Wolmut to Maximilian II, 7 August 1569.

24 Uličný 2017, pp. 377–395.

25 Petr Uličný, 'The Palace of Queen Anne Jagiello and Archduke Ferdinand II of Tyrol by the White Tower in Prague Castle', *Historie – Otázky – Problémy* 7:2 (2015), pp. 142–161, where I also present the claim that the queen's rooms were located to the south of the White Tower at the site of the palace of Archduke Ferdinand II. It is more likely, however, that the queen's palace was located to the north of the White Tower.

Fig. 6. Jan Kozel and Michael Peterle, Prospect of Prague, detail with Prague Castle and the palace of Archduke Ferdinand II next to the White Tower, 1562, photolithographic reproduction from 1904 (The City of Prague Museum, inv. no. HP 2003 0042)

The construction work at this site was carried out from 1553 to 1555 under the direction of Hans Tirol, who had begun working at Prague Castle in 1552. Records from the time of the construction work refer to 'an old building' and 'a new building' and indicate that the two were adjoined. In December 1555 the archduke wrote to Hans Tirol about a fireplace that he had ordered to be installed and informed him that "this fireplace should be in a room in the old building that is called the small hall (sälel), which is reached from our dining room in the new building".[26] This old building was evidently directly attached to the White Tower, while by the new building he probably meant the trapezoidal structure in the process of being renovated. Located above the gate next to the White Tower, on the first or second floor, was the "beautiful and valuable" armoury, mentioned in Mattioli's text from 1558 cited above. The second armoury, mentioned in sources in 1555, where heavier weaponry was likely

---

26    Köpl 1889, pp. CXII–CXIII, reg. 6145 and 6146, and APH, DK, inv. no. 131; Franz Kreyczi, 'Urkunden und Regesten aus dem k. u. k. reichs-Finanz-Archiv, *JKSAK* 5:2 (1887), pp. XXV–CLXXVI (LXII), reg. 4204, 30 May 1553. Tiroler Landesarchiv, Innsbruck, Kunstsachen I., 1468, from Archduke Ferdinand II to Hans Tirol, Vienna, 6 December 1555: 'Betreffennd des kamin, so wir zuseczen befolhen, wirdet die unser öbrist chamerer der Berka desshalben anzaigung thun, damit du aber dessen noch mer bericht werdest, so wollen wir dir nit verhalten, das solcher camin in der stuben des alten paws, so man das sälel nent, darein man aus unnserer eßstuben des neuen paws geet, sein soll. Demnach wollest den ofen aus derselben.' David von Schönherr, 'Urkunden und Regesten k.k. Staathalterei-Archiv in Innsbruck', *JKSAK* 11 (1890), pp. LXXXIV–CCXLI (CLXII–CLXIII), reg. 7180; Uličný 2015b, p. 151.

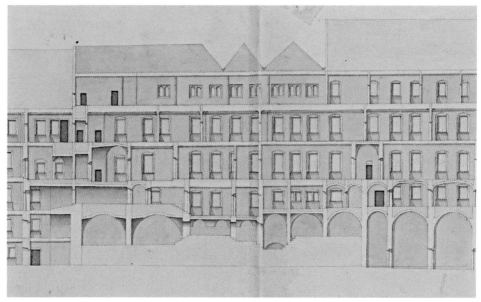

Fig. 7. Section of the former palace of Archduke Ferdinand II next the White Tower as in the 18th century (The Archives of the Prague Castle, Old Plans Collection, sign. 112A)

located, was on the western side of the White Tower on the ground floor.[27] The "new building", if the location we have identified for it is correct, was in reality not completely new. To the present day it contains a late Gothic hall on the ground floor, with a vault springing from a polygonal pillar, while a fragment of the jamb from the pointed window has been preserved on the first floor. These are the only surviving remains of the archduke's residence. (Fig. 7)

Several reports describing the other rooms in this building have survived. In 1553, a heating stove was installed in one of the archduke's rooms and roses were painted on the room's walls.[28] These paintings were probably produced by Hans Gumperger.[29] Another report comes from 1561, when Wolmut proposed that the doors of the archbishop's palace on Hradčany were to be made like those of the archduke's, which were made using the cheaper option of a wooden doorframe instead of stone.[30] Some idea of the archduke's now no longer extant apartments may be provided by Březnice Castle, the seat of Kateřina of Lokšany. The archduke journeyed regularly there to visit Kateřina's niece, Philippine Welser, during the 1550s. The surviving library interior there, which dates from 1558, may have been modelled on the appearance of the arch-

27    Mattioli 1559, fol. Ei/v–Eii/v; Uličný 2015b, p. 152; Uličný 2018a, pp. 31–35.

28    Milada Vilímková, *Stavebně historický průzkum Pražského hradu: Pražský hrad. Jižní křídlo. Dějiny*, (typescript of the Institute for the Reconstruction of Historical Towns and Buildings in Prague, 1972), p. 26.

29    Köpl 1889, p. CXX, reg. 6186, 14 June 1561.

30    Vilímková 1972, p. 28.

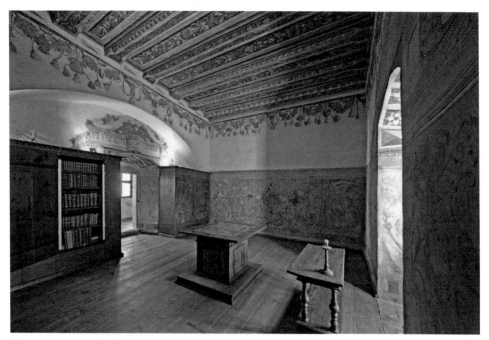

Fig. 8. Březnice Castle, library in the tower from 1558

duke's library in Prague. (Fig. 8) Although we only have records only about arch-duke's library at Ambras Castle, it must, like the armoury, have originated in Prague. What the fireplace in the small hall would have looked like can be imagined from the fireplaces that have been preserved on the first floor of the Star Summer Palace.[31]

While we can imagine that top-notch craftsmanship went into creating the interiors of the archduke's palace and that the rooms were probably richly decorated with works of art, the building itself was a small and simple structure that had three trian-gular gables, including round-headed biforas, on the side facing the city. The palace had no courtyard and no entrance façade, which was concealed by the lower-floor armoury and the castle's third gate. Its one striking feature was the White Tower, which was given a new three-stepped roof and gallery during the renovation of the palace.[32] The archduke commissioned a clock from Master Pavel of Litoměřice, and this was mounted on the western side of the tower in 1568.[33]

---

31  Muchka 2003, fig. 7 on p. 257 and Muchka / Purš / Dobalová / Hausenblasová 2017, fig. 60 on p. 69.

32  Schönherr 1890, pp. CLXII–CLXIII, reg. 7180, from Archduke Ferdinand II to Hans Tirol, Vienna, 6 December 1555. In 1554 Hans Tirol worked on the White Tower, but it is not clear exactly what work there was done by him; see APH, DK, inv. no. 785. Some work was performed there earlier, because the budget for 1546 planned for repairs to its cornice (APH, DK, inv. no. 82) and the budget for 1548 planned for unspecified work to be done on its exterior (NA, ČDKM IV-P, cart. 192, fol. 22r).

33  Kreyczi 1887, p. CVII, reg. 4418, from Bonifaz Wolmut to Maximilian II, Prague, 2 June 1568.

It was the king who determined the palace's external physical appearance. The evidence for this is found in a letter from December 1554, in which Ferdinand I invited the master-builders Ferrabosco and Wolmut to travel to Prague to develop the plans and budgets for a number of buildings, one of which was the residential wing of the Old Royal Palace and the archduke's "new building". Here, it was requested of the two master-builders that they try "to create the façade of Our building [i.e. the Old Royal Palace] and Our son's new building in such a way that they are as much as possible similar to each other".[34] This desired similarity may have applied to the number of gables and their shape – the western wing of the Old Palace housing the royal apartments also had three gables – or the simple sgraffito decoration resembling ashlar blocks that was applied to the outside of Vladislaus Hall after the fire, fragments of which were also found in the archduke's palace. However, it was the archduke, not the king, who made the decision to set up a small garden below the palace in the direction of the city in 1559. The garden had an aviary, an orchard, and a gazebo with an observation deck, later known as the Trubačská or 'Trumpeter's' Tower.[35]

### The Old Royal Palace and the second stage of rebuilding (1549–1567)

The second stage of reconstruction of the Old Royal Palace mainly affected the Old Diet Hall (Stará sněmovna), which was also the seat of the Bohemian Provincial Assembly; the room also served as a provincial courtroom. The Old Diet Hall was given only provisional repairs after the fire, while more thorough reconstruction work still needed to be done. The first surviving mention of this is from January 1558, when discussions first began to turn to the question of whether to preserve the Diet Hall the way it was with a joist ceiling, or to create a vault ceiling supported on a central column.[36] The final design, which Bonifaz Wolmut then actually built in 1559–1563, originated in a complicated process, which is comprehensively recorded in numerous archive materials.[37] However, the one document that is missing is the one that would provide us with an idea of the circumstances under which the first design originated in 1558. This plan was close to the one actually built: it included a tribune for the scribes designed in the Renaissance style and a Gothic vault, the form of which, however, was different from that we can see now. This first design, which has not survived, was the one reflected in the budgets that were drawn up for the renovation of the wing as a whole; the first

---

34  Kreyczi 1887, p. CLX, reg. 4529, Vienna, 5 December 1554. More briefly also in Köpl 1889, p. CXVI, reg. 6159, Vienna, 5 December 1554, from Ferdinand I to Archduke Ferdinand II.
35  Petr Uličný, 'The Garden of Archduke Ferdinand II at Prague Castle', *Studia Rudolphina* 17/18 (2018), pp. 23–34.
36  Sněmy české III, no. 8, p. 15, a meeting of the diet that opened on the 3rd of January 1558; Kreyczi 1887, p. LXXXI, reg. 4283.
37  These sources have been analysed in detailed by Frejková 1941, pp. 94–100, and Milada Vilímková, *Stavebně historický průzkum Pražského hradu. Starý palác. Dějiny* (typescript of the Institute for the Reconstruction of Historical Towns and Buildings in Prague, 1974), pp. 30–40. However, their interpretations differ on some substantial points, and my interpretation presented here also differs from theirs. I did not have access to Sarah Lynch's forthcoming publication on Wolmut.

budget (now lost) was prepared by Wolmut, and the second by the two unnamed Italian builders sent by the king from Vienna at the end of December that same year. As noted above, these two builders were probably Pietro Ferrabosco and Francesco de Pozzo, accompanied by Benedikt Kölbl.[38] The key point in the second budget, which the archduke sent to the emperor on 30 January 1559,[39] was the way in which the vaulting of the hall was to be executed and how the hall's walls would be articulated. This second budget thus allows us to develop some idea of what the first design was like.

The document describes the vault as a structure with "branches" (*rami*) that together would stretch 250 *pasa* in length. There were to be two square fields (*quadreli*) in the vault, at the centre of which the "beautiful" imperial coat of arms was to be produced in stone. The walls were to be divided up with "columns rising up from the ground, fitted with beautiful capitals over the springings of the vault", which started two feet above the floor. It describes the tribune as it was actually built, with an arcade of six Ionic columns, and a ledge.[40] The total for all the work of finishing and expanding the Diet Hall to include an extension into the courtyard (which came to be called the Office of the Land Rolls) amounted to a budget of 5669 *Thalers*, which was almost one and a half times the amount that Wolmut had requested (3300 *Thalers*).[41] Because the unit of measure used was the Viennese fathom (approx. 1.9 metres), the total length of the 'branches' can be calculated as 472 metres, which must mean there was supposed to be ribbing on the proposed vault ceiling. This arrangement, however, differs from what Wolmut ultimately built.

Once the emperor had been informed of the costs involved in the work, he decided in February 1559 in favour of Wolmut's proposal.[42] Wolmut immediately began the construction work. Archduke Ferdinand II, however, proposed paying Wolmut 5000 *Thalers*, thus acknowledging in effect that the Italians from Vienna had correctly estimated the necessary costs. Builder Andrea Aostalli and stonemason Giovanni

---

38    Kreyczi 1887, p. LXXVI, reg. 4277, on 26 December 1558, Maximilian II orders payment of 25 *Gulden*. To the master-builder Benedikt Kölbl for the journey to Prague, and to Pietro Ferrabosco towards the amount owed to him, if not in full, then at least in the amount of 50 *Gulden*.

39    NA, ČDKM IV–P, cart. 191, fol. 109r–115r, Archduke Ferdinand II to Ferdinand I, Prague, 30 January 1559: "E piu nella ditta stufa va in voltata a rami, segondo el modello, li rami soli sono pasa 250 e groso uno piede in quadro, uno paso fornito e miso in opera, uno paso per talari 5, fa suma .... talari 1250. Alto el principio del volta passa 2 sopra lo salezato con colone tirate da terra suso, et fatto li soi beli capiteli dove sinpeducia el volto. E piu lo volto della dita stufa, vole essere de doi quadreli, grosso lo volto sie in quadro pasa 59, uno passo per tolari 2, fa suma talari ... 413. E piu in mezi del ditto volto, una bella Arma Imperiale, di pietra tutta integra. Suma talari ... 50. E piu in ditta stufa, ci va uno palco, cioe logia dove stano li Iudici, con una scala alumaga, e una scala dritta, e 6 colone Ioniche, con la sua mixura, con li soi archi involtato, e noc uno parapetto tutto di pietra lavorata tutto ordine Ionicho bello, alta ditta logie dal piano dello salezato pasa 2, aparti ali peduci del volto, lo ditto palco dando pietra, e formito tutto noc quello ch ci perviene bello segondo il modello, costara suma talari ... 300." The introduction to the budget is printed in: Kreyczi 1887, p. LXXVI, reg. 4278. I am grateful to Guido Carrai for consultation on this text.

40    NA, ČDKM IV–P, cart. 191, fol. 112v.

41    Kreyczi 1887, p. LXXVI, reg. 4278.

42    Kreyczi 1887, p. LXXVI, reg. 4279, 16 February 1559, Augsburg, Ferdinand I assigned Archduke Ferdinand II with the task of signing a contract with Wolmut.

Campione immediately took advantage of this and submitted a new project using Hans Tirol's budget of 3941 *Thalers*. And at this point something particularly interesting in terms of the entire process occurred. When the emperor learned of this new project, he pressed for Wolmut to be removed from the job, and it was only thanks to the great favour in which this master-builder was held by the archduke that this did not happen.[43] The alternative project by Aostalli and Campione, which was evidently sketched by Francesco Terzio, and which was very strongly opposed by Wolmut, has survived to the present day. It shows a cavette vault with lunettes the centre of which was divided into two bays rimmed with stucco frames.[44]

Wolmut's design with the rib vault won, and the elegant Renaissance scribes' tribune came to be set against Gothic vaulting. A similar approach was applied to the design for Vladislaus Hall: Benedikt Ried had designed the support structure and the vault of this hall, while an anonymous Italian stonemason designed and partly executed the Renaissance windows.[45] Wolmut himself described this 'division of labour' in a letter he wrote in 1559, referring to the new stairway in a section of the Old Diet Hall. Wolmut wrote that he initially took the spiral staircase to the level of the first floor, but then had to demolish it and built it one story higher. The reason was a change introduced by the Italian builders from Vienna (they were in Prague again in June 1559), who added to his design "more than eight articles that were intended to make this stair loftier, four stories in height, and so that it would rise above the hall like a tower, whereby it would be possible to walk out of it under the roof, into the armoury over the hall, making this a grand and beautiful decorative piece of work".[46] This was the small staircase tower leading into the armoury above Vladislaus Hall that is visible in Peterle's view. Given that in this case Wolmut was clearly in a subordinate relationship to the Italian masters from Vienna, it can be assumed that the same also applied in the case of the Old Diet Hall, and that the Italian authors supplied the drawings for the scribes' tribune.[47]

This, however, contrasts with the way in which Wolmut opposed the two Italians from Prague and the design they came up with for the hall's ceiling. While he may have been trying to retain the notion, which Ried put forth for use in Vladislaus Hall in this way, it clearly and understandably resulted from his attempt to retain his position on the project.

---

43  Frejková 1941, pp. 97–98, no source given.

44  See, most recently, Exh. Cat. Prague 2017, cat. no. II/52, p. 152 and cat. no. II/52, p. 74.

45  See footnote 2.

46  NA, ČDKM IV–P, cart. 191, from Bonifaz Wolmut to Ferdinand I, 24 November 1559, point 4: "[…] die paumaister von Wien hieheer verordnet, welliche aber mein fürnemben noch mer als acht articuln hin zuegethan unnder welchen der schnegkhen das fürnembst namlichen da ser 4 gaden oder gemach hoch sein soll, und ain gemach wie ein sinderer thurn, uber den saal außgehen sall. Damit man aus ime under das dach in der harnisch chamer auf dem saal gehen muegen verordnet, welliches ain herrliche und schöne zier geben wurde." Vilímková 1974, p. 41. A roof was added to the stairway in 1564; see Vilímková 1974, p. 49.

47  This conclusion was already reached by Frejková 1941, pp. 94–95.

This well-documented process shows how the project for the Old Diet Hall came into being and reveals the complicated structure of mutual relationships between the individual actors involved. Emperor Ferdinand I initially selected Wolmut as the person who could built the Gothic-Renaissance project for the lowest price, but as soon as a cheaper project came along, a wholly Renaissance design, he did not hesitate to select that project instead. Ultimately, Wolmut won the battle for this commission, but probably only because he had already initiated work on the project at his own expense,[48] and because he enjoyed the support of the archduke in Prague. It therefore seems that although the projects were considered in terms of style – whether Gothic or Renaissance – it was money that played a crucial role in this case.

### St Vitus' Cathedral

Once Vladislaus Jagiellon had completed the extensive reconstruction of the Old Royal Palace and built new fortifications around the castle, he then turned his attention to completing the construction of St Vitus' Cathedral. The western side of the cathedral had been left unfinished ever since the Hussite wars had brought work to a halt. However, not long after the work recommenced under the direction of Benedikt Ried, it was interrupted again. After being named King of Bohemia, Ferdinand I took an active approach to this legacy and the cathedral became a priority during the first years of his rule. Under the direction of Master Urban, Ried's foreman, tall gables were built in the area of the eastern choir, and Ferdinand I was evidently planning to continue the construction of the north tower, whose foundation had been laid by Vladislaus. After the fire in 1541, Ferdinand I probably only began to focus on the cathedral's reconstruction again in 1547, from which time it gradually acquired a new and dignified appearance, primarily characterised by the roof of the southern tower and the construction of the organ loft.[49]

The reconstruction work was begun by Paolo della Stella, who among other things put a provisional roof on the southern bell tower. In 1560 the emperor invited three unnamed master-builders to create a new design for the bell tower, and he selected the one that had "enough height and decorations". Bonifaz Wolmut managed the construction work in 1561–1562, but like the scribes' tribune there is no evidence that he was the author of the chosen design.[50] The tower was not fully completed before the fire, but by this time Ferdinand I was no longer planning to continue with the Gothic style of stonework in the construction. The winning design (we know nothing about what the other two looked like) proposed a concept that had already been used at a

---

48   Kreyczi 1887, p. LXXXII, reg. 4283.

49   Uličný 2019.

50   Kamil Hilbert, 'Hudební kruchta v chrámě sv. Víta na Hradě Pražském', *Časopis Společnosti přátel starožitností českých* 17 (1909), pp. 1–17, 41–51; Frejková 1941, pp. 100–104 and 117–118; Richard Biegel, 'Bonifác Wolmut a dialog renesance s gotikou v české architektuře 16. století', in *Tvary, formy, ideje. Studie a eseje k dějinám a teorii architektury*, ed. by Taťána Petrasová and Marie Platovská (Prague, 2013), pp. 17–29.

number of locations in Central Europe: the domed roof. In 1525 the two towers of the Frauenkirche in Munich were fitted with domed roofs, in an obvious allusion to the roof structure on the Dome of the Rock in Jerusalem, which at the time was mistakenly believed to be Solomon's Temple. Even earlier than that the two towers of the royal palace in Wawel, Krakow, may have been built with a similar vision in mind. After them there was the tower of the Church of St Elizabeth in Wrocław in 1534–1535, as well as other examples.[51] The structure that was built at St Vitus' took this type of roof somewhat further with the addition of four small domes placed at the level of the galleries on the corners, the points where the unfinished Gothic buttresses led. It thereby resembled the Gothic roofs of many towers in Prague: those of Charles Bridge, the Old Town Hall, the Church of Our Lady before Týn, and many others. However, with the typical Prague motif transformed into the shape of a dome, the roof of the southern bell tower of St Vitus' then looked like a large crown. The roof of the cathedral may also have been viewed as a symbol meant to indicate that St Vitus' served as a coronation site, and was also the site where Emperor Ferdinand I planned to be buried.

Around the same time as the roof of the southern bell tower was being constructed, work also began on the building of a new organ loft. The cathedral's eastern choir had, since the time of Peter Parler, been closed off on the side facing into the transept by a provisional wall. In 1557 an 'internal' competition was held among the royal master-builders, with Giuseppe Soldata and Giovanni Campione participating on one side and Bonifaz Wolmut on the other. The first design earned a very uncomplimentary comment from Ferdinand I, who described it as "a coarse barbarian ugly work" and "unchurch-like", because Campione did not have a command of "measures and circles" or, in other words, of Gothic architecture grounded in geometry. The more fitting design according to those criteria was that produced by Wolmut, which, even though it too had a Renaissance facade, had a Gothic stone vault ceiling inside, and yet it still cost the same amount as the first design (500 *Thalers*).[52] His design was based on the facade of the Teatro di Marcello in Rome, published by Serlio in his third book in 1540. Thus, it had an imperial connotation, which may have been the aspect that pleased Ferdinand I most, as the loft gave the church an imperial dimension and could have been seen as a political symbol.[53]

---

51   Christopher Wood, *Forgery, Replica, Fiction: Temporalities of German Renaissance Art* (Chicago and London, 2008), pp. 270–272; Krzysztof J. Czyżewski, 'Kultura artystyczna Krakowa w pierwszej połowie XVI wieku / Die künstlerische Kultur Krakaus in der ersten Hälfte des 16. Jahrhunderts', in *Der Meister und Katharina. Hans von Kulmbach und seine Werke für Krakau / Mistrz i Katarzyna. Hans von Kulmbach i jego dzieła dla Krakowa*, ed. by Mirosław P. Kruk, Aleksandra Hola and Marek Walczak (Krakow, 2018), pp. 103–104; Frejková 1941, pp. 165–166.

52   Kreyczi 1887, pp. LXXII–LXXIII, reg. 4256, from Ferdinand I to Ferdinand II of Austria, Regensburg, 31 January 1557; Kreyczi 1887, p. LXXVIII, reg. 4283, from Ferdinand II of Austria to Ferdinand I, 13 June 1559; Frejková 1941, pp. 91–94, 113–115.

53   Oscar Pollak, 'Studien zur Geschichte der Architektur Prags 1520–1600', *JKSAK* 29 (1910–1911), pp. 85–170 (113); Jarmila Krčálová, 'Renesance', in *Katedrála sv. Víta v Praze: K 650. výročí založení*, ed. by Anežka Merhautová and (Prague, 1994), pp. 133–170 (139–142); Thomas DaCosta Kaufmann, *Court, Cloister & City. The Art and Culture of Central Europe 1450–1800* (London, 1995), p. 146.

Charles V abdicated as Holy Roman Emperor in August 1556 in favour of Ferdinand I (the abdication was not formally accepted by the Electors of the Empire until 1558). Ferdinand I's commissioning of the organ loft and the tower roof are thus clearly related to this event. Ferdinand I's organ, construction of which began in 1559, can like the triumphal arch in Hradčany be regarded as a symbol of victory in the sovereign's path to the highest secular throne in Europe, and in restoring the former glory of the ancient empire. The loft was enhanced by its central position on the cathedral's axis, and the monumental organ case, executed at great cost and with paintings by Francesco Terzio, became the cathedral's true crowning glory.

Evidence that Ferdinand I viewed the loft as a symbol of the sovereign's rule from the outset is provided by the letter from 1557 cited above, in which the king commented on individual designs. In this letter he immediately suggested that the wall to which the organ loft was attached should be adorned with three paintings on each floor (giving a total of six) depicting "the emperor reclining here below and the kings and their epitaphs". This was because the Emperor Charles IV and many other kings of Bohemia were buried at the foot of the loft in the former Virgin choir, and the fire had left the tombs considerably damaged – especially their wooden lids on which the epitaphs of the individual rulers were painted. Ferdinand I therefore came up with the new idea of restoring these epitaphs in monumental form on the walls of the organ loft.[54] Although this plan was ultimately never pursued, it reveals how tightly the organ loft was bound to the imperial and royal necropolis in St Vitus' Cathedral in the perception of the building's patrons. The organ loft was thus supposed to become an instrument for demonstrating the presence of the sovereign in the cathedral, as well as the continuity of Ferdinand I's rule. He could in this way regard the organ loft as a grand epitaph to his own rule, and also as a parallel to the monumental mausoleum of Maximilian I that was built during his lifetime in Innsbruck.

## Rebuilding the summer palace in the Royal Garden (1555–1563)

While it is clear that Archduke Ferdinand II usually served the role of intermediary between his father and the master-builders in the construction projects at Prague Castle, and for the most part just passively executed his father's wishes (which was moreover one of his duties according to the castle's building code),[55] in the case of one building project he may have played the opposite role. That project was the Royal Summer Palace in the Royal Garden and the addition of its second floor. (Fig. 9)

---

54   Kreyczi 1887, p. LXXIII, reg. 4256: "Und auf bemelten baiden gengen des orglfues an der hindern kirchenwand seien wir nahmals entschlossen, auf dem obern tail 3 und undern tail das gang auch 3 inwendig an die kirchenwand die daneben und darunder ligenden kaiser und kunigen mit iren epidaphium malen zue lassen." For the necropolis, see Petr Uličný, 'The Choirs of St Vitus's Cathedral in Prague: A Marriage of Liturgy, Coronation, Royal Necropolis and Piety', *Journal of the British Archaeological Association* 168 (2015), pp. 186–233 (204–217).

55   Dobalová / Muchka 2017, p. 39.

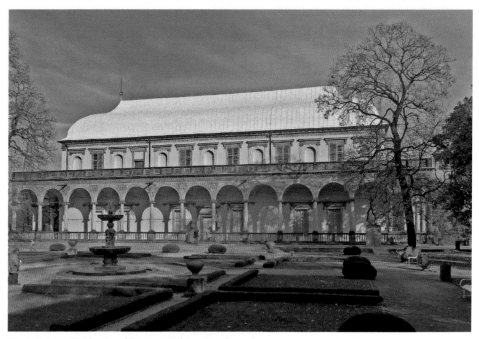

Fig. 9. Prague Castle, Royal Summer Palace, view from the west

The Royal Summer Palace was initially built as a single-story structure and its construction in that form was completed around the year 1552, when copper was purchased for its roof.[56] Three years later, however, an order was given to remove the roof and add another storey to the building. The construction of the second storey is mentioned for the first time in a document that was written during a visit of Wolmut, Tirol, and Ferrabosco to the king in Augsburg in July 1555, and that described the work that Tirol was to carry out in Prague. This source indicated that the new floor of the Royal Summer Palace was to conform in layout to the ground floor and "the best form" of roof was to be created for it. By the next year the shell construction had been completed.[57] In January 1557 there was a discussion about the external appearance of the new storey's walls. By this time Bonifaz Wolmut was in charge of the construction work, having replaced Hans Tirol, and he suggested to the king that he simplify the window and door decorations in the design and eliminate the decorative "foliage".[58] Ferdinand I considered this approach to be "pure" (*sauber*), and he also favoured it because it proposed replacing the stone pilasters that were to articulate the façade with brickwork and plastering that would imitate stone. Among the designs and budgets discussed, it was the simplest and consequently the cheapest one that triumphed. Although

56   APH, DK, inv. nos. 125, 126 and 129.

57   Kreyczi 1887, p. LXIX, reg. 4240, Augsburg, 20 July 1555; Frejková 1941, p. 86.

58   Kreyczi 1887, p. LXXII, reg. 4256, from Ferdinand I to Archduke Ferdinand II, Regensburg, 31 January 1557. I would like to thank Stefan Bartilla for consultation on this not easily intelligible letter.

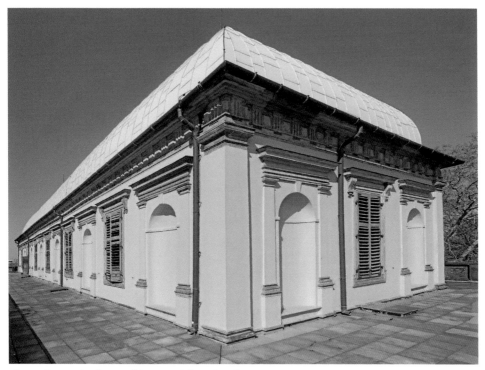

Fig. 10. Prague Castle, Royal Summer Palace, first floor

the king had the magnificently decorated portals and windows built on the ground floor of the Royal Summer Palace since 1538, fifteen years later he proposed abandoning this sophisticated style.

The new façade was adorned with distinctive aediculae and niches, alternating with the windows, and the entire new floor was crowned with an elegant keel-shaped roof. (Fig. 10) This design was probably inspired by the centrally planned Tempietto (the Church of San Pietro in Montorio), Rome, built by Donato Bramante sometime before 1502.[59] Bramante's design was no doubt provided by the aforementioned Serlio's third book, devoted to Antiquity. Serlio published the book in 1540 and Archduke Ferdinand II owned a copy.[60] We may assume that the archduke was already familiar with the book by the time the second storey was being conceived because of the clear

---

59  Bramante's influence more generally is mentioned in Karel B. Mádl, 'Renaissance v Čechách', *Zprávy spolku architektů a inženýrů v Čechách* 20:2 (1886), pp. 52–56 (56); more recently, Sarah Lynch, 'Architecture at the Prague Belvedere: Between Theory and Practice', in *Looking for Leisure. Court Residences and their Satellites 1400–1700*, ed. by Ivan P. Muchka and Sylva Dobalová, Palatium e-Publication 4 (Prague, 2017), pp. 204–214.

60  Frejková 1941, p. 132 and footnote 433 on p. 205; Serlio III, pp. XLI–XLIIII; *Knihovna arcivévody Ferdinanda II. Tyrolského*, ed. by Ivo Purš and Hedvika Kuchařová, 2 vols. (Prague, 2015), II, *Katalog*, p. 510: 5Co, no. 842. On Ferdinand's collection of architectural treatises, see Ivan P. Muchka, 'Literatura o architektuře', in Purš / Kuchařová 2015, I: *Texty*, pp. 279–285.

connection between the Tempietto and archduke's Star Summer Palace, built between 1555–1556. The central layout of Bramante's temple is very similar to the central section of the underground floor of the Star. The Tempietto's walls are divided up by an alternating series of four semi-circular and rectangular niches, which in the Star was transformed into an alternating series of six semi-circular and six rectangular passageways in the wall.[61]

If Bramante's structure had already caught the archduke's eye by 1555, he may have been the one who suggested that it serve as the model for the new storey for the Royal Summer Palace in the Royal Garden. However, there is no extant source that explicitly indicates who created the design for the new storey. It could have been one of the three builders involved, namely, Tirol, Wolmut, or Ferrabosco.[62] The idea that the design originated with the archduke himself could explain the unusual approach taken to the design of the façade, where the orders are reversed, in direct violation of Vitruvian principles:[63] Whereas Ionic columns appeared on the ground floor, the Doric pilasters were used on the floor above. While a regular Italian builder would have perhaps resisted this reversal, an amateur architect like Archduke Ferdinand II may have had a more relaxed relationship to these rules. A very creative interpretation of architectural forms is moreover similarly apparent in the unusual approach applied to the Star Summer Palace.

A connection can also be seen between Serlio's image of the dome of the Tempietto and the hemispherical shape of the ceiling of the Royal Summer Palace's upper floor. Nevertheless, this summer palace's roof has a more complicated shape, with a keel at the top and a flair at the base. Combined with the arcade on the ground floor, this looks very much like the Palazzo della Ragione in Padua, whose monumental roof and ceiling, built after the year 1420 to restore construction work that was done in 1306, form a pointed arch that is hipped on the shorter sides.[64] The Palazzo della Ragione in Vicenze, built in the 15th century, was modelled on the one in Padua, with a similar decorative roof and surrounding arcades, which Palladio later replaced with its famous Serlian structure. What is important in this connection is that Archduke Ferdinand II may have seen the building in Padua with his own eyes. In 1549, when his sister Anna Caterine married Francesco III Gonzaga, Duke of Mantua, he visited Mantua and travelled back through Venice.[65] It is possible, therefore, that he had a chance to see the famous 'palace' in Padua during this trip.

---

61   The archduke also drew on other plans for the structure, which has a different layout on each floor; most notably a series of prints titled *Temples et Logis domestiques* by Jacques Androuet du Cerceau; see Sylva Dobalová, 'Temples & Logis domestiques by Jacques Androuet du Cerceau and the Star Summer Palace in Prague', *Studia Rudolphina* 17/18 (2018), pp. 9–21.

62   Bonifaz Wolmut is usually regarded as the author of the architecture of the new storey; see, e. g., Jan Bažant, 'Emperor Ferdinand I, Boniface Wolmut and the Prague Belvedere', *Listy filologické* 126 (2003), pp. 32–52.

63   As noted by Lynch 2017, p. 210.

64   Pollak 1910–1911, pp. 109–110.

65   Josef Hirn, *Erzherzog Ferdinand II. von Tirol. Geschichte seiner Regierung und seiner Länder*, I (Innsbruck, 1885), pp. 20–21.

This kind of roofing, however, was just as popular for large halls in the Franco-Flemish region, so the inspiration for the Royal Summer Palace in Prague may also have come from elsewhere.[66] In 1545 Mary of Hungary embarked on a grand renovation of her palace in Binche, Belgium. When this construction project was completed in 1549, Mary's brother, Emperor Charles V, visited the renovated place together with his son Philip II. A drawing that was created on this occasion offers a look inside the palace's opulent main hall, with its Renaissance-styled walls and gallery, covered with a wooden vault adorned with panelling.[67] The idea that a possible connection exists between the two buildings is lent greater credence by the fact that just as the design for the Royal Summer Palace's first floor was being developed in 1555, the archduke travelled to the Spanish Netherlands. It is true that the palace in Binche had been severely damaged by French soldiers the year before, so the archduke would not have been able to view the hall in its original state. However, as with Bramante's Tempietto, illustrations would have been able to provide an idea of what it had looked like.

Archduke Ferdinand II may actually have been the one who came up with the idea to raise the height of the Royal Summer Palace in Prague. Sources show that this idea originated sometime in the spring of 1555, while the foundation stone of the Star Summer Palace was laid in June of the same year. Thus these two structures were designed at the same time. They also both had a large dance hall on the upper floor, which in the Royal Summer Palace was furnished with a platform for musicians, as well as wide niches intended for use as seating. It may have been the need to create such a space that convinced the king to make additions to this recently completed structure.

However, one of the archduke's proposals met with failure: he had proposed painting the coffers of the dance floor's wooden vault with "stars, planets, and celestial signs". This was a remarkable idea, but the emperor rejected it.[68] Archduke Ferdinand II was nevertheless able to bring this idea to life later in a different form at Ambras Castle. In the Royal Garden he at least had a free hand to design the terraces below the summer palace, where, next to the areas reserved for growing citrus fruit, he also wanted to build a pavilion in painted wood to house tanks with rare species of fish. Wolmut drew up several designs for this, but ultimately the tanks never came about either.[69]

---

66  For details on this, see Jan Bažant, *Pražský Belvedér a severská renesance* (Prague, 2006), pp. 57–64.

67  Robert Hedicke, *Jacques Dubroeucq von Mons. Ein niederländischer Meister aus der Frühzeit des italienischen Einflusses* (Strassburg, 1904), pp. 160–182; Albert Van de Put, 'Two Drawings of the Fêtes at Binche for Charles V and Philip (II) 1549', *Journal of the Warburg and Courtauld Institutes* 3 (1939–1940), pp. 49–55.

68  Schönherr 1890, p. CXCIV, reg. 7463, from Archduke Ferdinand II to Ferdinand I, Prague, 8 May 1561.

69  Sylva Dobalová, 'Erzherzog Ferdinand II. von Habsburg, das Lusthaus Belvedere und die Fischbehälter im Königlichen Garten der Prager Burg', *Die Gartenkunst* 20: 2 Beilage (2008), pp. 11–18; Wolfgang Lippmann, 'Der Fürst als Architekt', *Georges-Bloch-Jahrbuch des Kunsthistorischen Institutes der Universität Zürich* 8 (2001) [2003], pp. 110–135.

## Conclusion

After Ferdinand I assumed the Bohemian throne, he wanted to focus his attention on completing the construction of St Vitus' Cathedral and creating a garden with a stately summer palace. However, this plan moved forward at an increasingly slower pace, and in the case of the cathedral was ultimately prevented for two reasons: the first was the shortage of money caused by Turkish wars that had plagued Ferdinand I's government from its outset, and the second was the catastrophic fire in 1541. For the two decades after the fire, the King and from 1558 on Emperor Ferdinand I, with the aid of his son, Archduke Ferdinand II, was forced to invest almost all of his resources into rebuilding the structures that the fire had destroyed.

It is certainly true that the financial difficulties meant there was no other option but to apply a cost-saving approach to the reconstruction work. Nevertheless, it is necessary to draw attention to the admirable renovation of the Royal Palace undertaken at an earlier date by Vladislaus Jagiellon. He was one of the poorest kings ever to sit on the Bohemian throne. He had almost no possessions in the Lands of Bohemian Crown other than Prague Castle, and he had to cover all the expenses attached to it with revenue from a single source – the mint in Kutná Hora. Ferdinand I's financial circumstances were no worse than Vladislaus', but their priorities differed. While Vladislaus focused all his efforts on building Prague Castle (and Křivoklát), Ferdinand I turned his activities in a different direction. He restored the network of royal estates, which culminated in his purchasing Pardubice in 1560 for the enormous sum of 400,000 *kopas* [*kopa* = 60] of Meissner *Groschen*.[70] For this same sum it would almost have been possible to rebuild the castle entirely from its very foundations; the Jagiellonian renovations undertaken in 1486–1526 had cost just 80,000 *kopas* of Meissner *Groschen*.[71] It is possible that both Ferdinand I and Archduke Ferdinand II spent sums similar to Vladislaus on construction work in 1526–1567: during the period of the most construction activity, the budget for work on Prague Castle and its gardens in 1546 and 1548 was 16,500 *kopas* of Meissner *Groschen* in total.[72] However, if the amounts spent by the Jagiellonians and Ferdinand I and his son on Prague Castle's construction were roughly the same, the effect of their investments was quite different.

During the two decades of reconstruction work carried out after the fire in 1541 no major new structure was built on the grounds of Prague Castle itself. The problem of an essential shortage of suitable accommodation spaces reached a head during the cor-

---

70  On this see Jaroslava Hausenblasová, 'A New Monarch and a New System of Residences: Ferdinand I Habsburg as the Founder of the Network of Main and Occasional Residences in the Habsburg Empire', in *Looking for Leisure. Court Residences and their Satellites 1400–1700*, ed. by Ivan P. Muchka and Sylva Dobalová, Palatium e-Publication 4 (Prague, 2017), pp. 46–61; Petr Vorel, *Páni z Pernštejna. Vzestup a pád rodu zubří hlavy v dějinách Čech a Moravy* (Prague, 1999), p. 210.

71  I.e. 40,000 *kopas* of Meissner *Groschen*, see Emanuel Leminger, 'Stavba hradu pražského za krále Vladislava II.', *Památky archeologické a místopisné* 14:12 (1889), col. 626–630 (629).

72  The budget for the year 1546 was 9155 talers, i.e. 6713 *kopas* of Meissner *Groschen* [6713 x 60 Groschen] (APH, DK, inv. no. 82) and 13,405 talers, i.e. 9830 *kopas* of Meissner *Groschen* for the year 1548 (NA Prague, ČDKM IV-P, cart. 191, fol. 24v.).

onation of Maximilian II in 1562, when the archduke's rooms were explicitly described as "too cramped and small", while the Rosenberg and Pernstein (later Lobkowicz) palaces built in the castle district boasted "large and beautiful rooms with decorated halls".[73] The Habsburgs' master-builders, Hans Tirol and Bonifaz Wolmut, called in vain for a wing to be built that would connect the Old Royal Palace and the archduke's Palace next to the White Tower.[74] Even the newly built residence of Archduke Ferdinand II was overshadowed by the palaces of the nobility.

If this was a deliberate strategy on the part of both the archduke and his father, it was not met with comprehension. As early as in 1547, Bernardo Navagero, Venetian ambassador to Charles V, was commenting that Ferdinand I was poor and therefore was not able to pride himself on the possession of the types of palaces and interior furnishings that corresponded to his rank.[75] High-ranking visitors to Prague Castle still had this same feeling in 1562. It is obvious that the Habsburgs devoted the most care to their leisure architecture, which, in contrast to their simply structured residential buildings, came across as decorative and grand.

In the end, to outside observers the most striking legacy of the early Habsburgs was their construction of the roof architecture of Prague Castle. The fire in 1541 made it necessary to build new roofing for all the castle buildings, and the architects who worked for the both Ferdinand I and Archduke Ferdinand II excelled in the remarkable variety of structures they produced. In this respect, the highest praise should be awarded to the roof of the spire of St Vitus' Cathedral, where the rounded contours of its bulbous three-storey structure combined with the Gothic bell tower must be considered highly felicitous. What must have appeared equally striking was the division of the roof of the cathedral's choir section into black-and-white stripes across which a giant Bohemian lion was painted – the roof of the Royal Summer Palace was decorated in the same way.[76] With these well-chosen changes to the roof panorama, Prague Castle acquired the dignified look of an imperial residence.

How then should we 'read' and describe the architecture of Prague Castle in the time of Ferdinand I and his son Archduke Ferdinand II? In the first years of King Ferdinand I's rule we can direct some praise in the direction of the Royal Summer Palace in the new Royal Garden and its insuperably impeccable details. But as the years progressed, a pragmatic approach gained the upper hand. It was not until around 1558 that a certain shift occurred, when Ferdinand I was crowned as Emperor and several more ambitious construction projects were carried out at Prague Castle in direct or indirect connection with this coronation. Even here, however, it is not possible to speak of any distinctive construction programme on the grounds of the castle

73   Uličný 2017.
74   Uličný 2017, pp. 380–382.
75   Bernard von Bucholz, *Geschichte der Regierung Ferdinand des Ersten*, VI (Graz, 1968), p. 498.
76   Köpl 1889, p. CVIII, reg. 6113, Vienna, 27 May 1550, from Ferdinand I to Archduke Ferdinand II (cathedral) and Köpl 1889, p. CXX, reg. 6182, Vienna, 1 June 1561 (summer palace).

itself that would match the Habsburgs' recreational structures. Price was the central criterion.

The sole exception to this was the second storey that was added to the Royal Summer Palace in the Royal Garden, a project evidently initiated and conceived by Archduke Ferdinand II. As to the question of what influence the archduke may have had on the programme of construction for Prague Castle, only a limited answer can be offered. He was evidently only able to exercise a free hand in leisure architecture and, in addition to the Royal Summer Palace and the terraces below it, in the garden below his palace next to the White Tower. This modest palace was, in terms of its architectural appearance, probably overshadowed by all palaces built by the nobility on the castle grounds and in its immediate vicinity. The Star Summer Palace, however, was a true gem for which the archduke could be envied by all visitors.

Sarah W. Lynch

# The archduke and the architect: The personal and professional relationship between Archduke Ferdinand II and the architect Bonifaz Wolmut

The history of building at Prague Castle in the sixteenth century is generally well known and has been widely studied, especially the development of the castle under successive Habsburg monarchs Ferdinand I and his son and governor in Bohemia, Archduke Ferdinand II (later of the Tyrol), Maximilian II, and Rudolf II.[1] The earliest part of this period beginning with the foundation of the castle garden and Royal Summer Palace in 1534 until the archduke's departure from Prague in 1567 has been studied particularly intensively.[2] The architects active in Prague in this period are generally less well known, but a close examination of these figures, and especially their interactions with their royal patrons can shed light on the architectural development of the castle and the priorities and values of architectural work in mid-sixteenth century Central Europe in general.[3] Although often regarded as simple craftsmen or stonemasons, these architects held important positions at court and were respected for their experience and understanding of a wide range of architectural matters including materials, decorum, design, and structural stability. The relationship between one architect, Bonifaz Wolmut (c. 1500–1579), and Ferdinand I and Archduke Ferdinand II is particularly important for our understanding of the nature of Central European Renaissance architects and architectural work in this region.

---

1    I am grateful to Dr. Joshua Waters and Dr. Hans-Wolfgang Bergenhausen for their assistance with some of the transcriptions as well as Prof. Hermann Hipp, Prof. Axel Gotthard, and Prof. Christina Strunck for their comments on the translations.

2    On Ferdinand I as an architectural patron in Prague, see Ivan P. Muchka, 'Die Bautätigkeit Kaiser Ferdinand I. in Prag', in *Kaiser Ferdinand I. 1503–1564. Das Werden der Habsburgermonarchie*, ed. by Wilfried Seipel, exh. cat. (Vienna, 2003), pp. 249–257. Building works related to Ferdinand I and Archduke Ferdinand II in Prague are also discussed in Madelon Simons 'Presentation, Representation and Invisibility: Emperor Ferdinand I and His Son Archduke Ferdinand II of Austria in Prague (1547–1567)', in *The Habsburgs and Their Courts in Europe, 1400–1700: Between Cosmopolitism and Regionalism*, Palatium e-Publication 3, ed. by Herbert Karner, Ingrid Ciulisová and Bernardo J. García García (2014); Eliška Fučíková, 'Prague Castle under Rudolf II, His Predecessors and Successors', in *Rudolf II and Prague: The Imperial Court and Residential City as the Cultural and Spiritual Heart of Central Europe*, ed. by Eliška Fučíková, exh. cat. (Prague, London and Milan, 1997), pp. 2–71 (3–11); Sylva Dobalová and Ivan P. Muchka, 'Archduke Ferdinand II as Architectural Patron in Prague and Innsbruck', in *Ferdinand II. 450 Years Sovereign Ruler of Tyrol. Jubilee Exhibition*, ed. by Sabine Haag and Veronika Sandbichler, exh. cat. (Innsbruck and Vienna, 2017), pp. 39–45; Eliška Fučíková, 'Prague Castle under Archduke Ferdinand II: Rebuilding and Decoration', in *Ferdinand II. 450 Years Sovereign Ruler of Tyrol. Jubilee Exhibition*, ed. by Sabine Haag and Veronika Sandbichler, exh. cat. (Innsbruck and Vienna, 2017), pp. 47–53.

3    A general overview of the artists and architects active in Prague in the sixteenth century can be found in Zikmund Winter, Řemeslnictvo a živnosti XVI. věku v Čechách (Prague, 1909); Pavel Preiss, *Italští umělci v Praze: renesance, manýrismus, baroko* (Prague, 1986), pp. 18–55.

As governor of the Lands of the Bohemian Crown, Archduke Ferdinand II was charged with, among many other responsibilities, the management of royal construction projects on behalf of his father, Ferdinand I. This should not be seen as a secondary or minor aspect of the archduke's role in Bohemia. The castles, churches, chapels, administrative buildings and other structures under his care formed a critical aspect of Ferdinand I's self-presentation and representative activities in Bohemia. The king's artistic patronage was inevitably also a political activity, and the time, money, and care invested in these undertakings reflects their importance to the crown.

It would also be a mistake to see such activities as merely a cynical attempt to gain and retain power. Both the king and the archduke had a genuine interest in architecture, painting, and other art forms. In particular, Archduke Ferdinand II's collections were especially important in this period, and they reflect both the power of such displays of luxury and his own personal interest in different intellectual and artistic fields.[4]

Although all decisions regarding royal construction projects were ultimately made with the agreement of his father, the archduke was closely involved in the building and renovation of Prague Castle, and by extension with the all of the architects active there. The most important projects of this period were the Royal Summer Palace,[5] the construction of his own residence,[6] various renovations and works at Prague Cathedral,

---

4    For an overview of Archduke Ferdinand II's collection, which was broadly divided into three sections, the *Heldenrüstkammer* (arms and armor collection), the *Kunstkammer*, and the library, see Veronika Sandbichler, '"Innata Omnium Pulcherrimarum Rerum Inquisitio": Archduke Ferdinand II as a Collector', in *Ferdinand II. 450 Years Sovereign Ruler of Tyrol. Jubilee Exhibition*, ed. by Sabine Haag and Veronika Sandbichler, exh. cat. (Innsbruck and Vienna, 2017), pp. 77–81. On the *Heldenrüstkammer* in particular, see Thomas Kuster, 'dises heroische theatrum': The Heldenrüstkammer at Ambras Castle, in *Ferdinand II. 450 Years Sovereign Ruler of Tyrol. Jubilee Exhibition*, ed. by Sabine Haag and Veronika Sandbichler, exh. cat. (Innsbruck and Vienna, 2017), pp. 83–87. Literature on the *Kunstkammer* is extensive. For recent works with bibliography, see *Alle Wunder dieser Welt. Die kostbarsten Kunstschätze aus der Sammlung Erzherzog Ferdinands II. (1529–1595)*, ed. by Wilfried Seipel (Innsbruck, 2001); Alfred Auer, 'Die Sammeltätigkeit Erzherzog Ferdinands II.', in *Kaiser Ferdinand I. 1503–1564. Das Werden der Habsburgermonarchie*, ed. by Wilfried Seipel, exh. cat. (Vienna, 2003), pp. 297–303; Paulus Rainer, 'On Art and Wonders in an Extra-Moral Sense', in *Ferdinand II. 450 Years Sovereign Ruler of Tyrol*, ed. by Sabine Haag and Veronika Sandbichler (Innsbruck and Vienna, 2017), pp. 88–97. The archduke's library is discussed below.

5    For recent research on the Royal Summer Palace, see Jan Bažant, 'The Prague Belveder, Emperor Ferdinand I and Jupiter', *Umění/Art* 51 (2003), pp. 262–277; Jan Bažant, 'Emperor Ferdinand I, Boniface Wolmut and the Prague Belvedere', *Listy filologické* 126 (2003), pp. 32–52; Jan Bažant, *Pražský Belvedér a severská renesance* (Prague, 2006); Sylva Dobalová, 'Erzherzog Ferdinand II. von Habsburg, das Lusthaus Belvedere und die Fischbehälter im Königlichen Garten der Prager Burg', *Die Gartenkunst* 20:2 Beilage (2008), pp. 11–18; Jan Bažant, 'Villa Star in Prague', *Ars* 41:1 (2008), pp. 55–72; Sylva Dobalová, 'The Royal Summer Palace, Ferdinand I and Anne', *Historie — Otázky — Problémy* 7:2 (2015), pp. 163–175; Sarah Lynch, 'Architecture at the Prague Belvedere: Between Theory and Practice', in *Looking for Leisure. Court Residences and their Satellites 1400–1700*, Palatium e-Publication 4, ed. by Ivan P. Muchka and Sylva Dobalová (Prague, 2017), pp. 204–214.

6    Petr Uličný, 'The Making of the Habsburg Residence in Prague Castle. History of the Journey of the Imperial Palace from the Centre to the Periphery', *Umění/Art* 65 (2017), pp. 377–395.

including the new organ and organ loft and the completion of the south tower,[7] and the Diet Hall.[8] The archduke also commissioned and oversaw the construction of his own project, the Star Summer Palace.[9]

As the most prominent architect working in Prague between 1554 and 1570, Wolmut was active in some way on all of these projects.[10] Born in Überlingen on Lake Constance in c. 1500,[11] Wolmut first appeared in records in Vienna in 1534, when Ferdinand I proposed sending him to Prague to replace the recently deceased Benedikt Ried as chief architect at Prague Castle.[12] However, the Bohemian Diet declined this offer citing financial concerns.[13] Wolmut's early works are largely unknown, but a letter

7    On the works at the cathedral in this period see Jarmila Krčálová, 'Renesance', in *Katedrála sv. Víta v Praze: K 650. výročí založení*, ed. by Anežka Merhautová (Prague, 1994), pp. 133–170, with regard to Wolmut, see pp. 136–142; Dobroslav Líbal and Pavel Zahradník, *Katedrála svatého Víta na Pražském Hradě* (Prague, 1999), pp. 161–164; Jiři Kuthan and Jan Royt, *Katedrála Sv. Víta, Václava a Vojtěcha, svatyně českých patronů a králů* (Prague, 2011), pp. 421–427; Ivan P. Muchka, 'Architectura Ancilla musicae', in *The Habsburgs and Their Courts in Europe, 1400–1700: Between Cosmopolitism and Regionalism*, Palatium e-Publication 3, ed. by Herbert Karner, Ingrid Ciulisová and Bernardo J. García García (2014), pp. 46–54.

8    For recent literature on the Diet Hall, see Richard Biegel, 'Le dialogue entre gothique et Renaissance en Bohême au XVIe siècle' in *Le gothique de la Renaissance: Actes des quatrième Rencontres d'architecture européenne*, Paris 12–16 juin 2007, ed. by Monique Chatenet, et al. (Paris, 2007), pp. 89–102; Richard Biegel, 'Bonifác Wolmut a dialog renesance s gotikou v české architektuře 16. století', in *Tvary, formy, ideje. Studie a eseje k dějinám a teorii architektury*, ed. by Taťána Petrasová and Marie Platovská (Prague, 2013), pp. 17–29; Pavel Kalina, 'Tři tváře gotiky: Wohlmut, Santini, Mocker', in *Historismy: sborník příspěvků z 8. specializované konference stavebněhistorického průzkumu, uspořádané ve dnech 9.–12.6.2009 v Děčíně*, ed. by Olga Klapetková and Renata Kuperová (Prague, 2010), pp. 15–22; Fučíková 2017, pp. 48–50.

9    On the Star Summer Palace, see most recently, Ivan P. Muchka and Ivo Purš, 'Das Lustschloss Stern in Prag und die Villa Lante in Rom', *Studia Rudolphina* 11 (2012), pp. 127–132; Ivan P. Muchka, Ivo Purš, Sylva Dobalová and Jaroslava Hausenblasová, *Hvězda. Arcivévoda Ferdinand Tyrolský a jeho letohrádek v evropském kontextu* (Prague, 2014); Sylva Dobalová and Ivan Muchka, 'A Bibliography of the Star (Hvězda) Summer Palace in Prague', *Studia Rudolphina* 14 (2014), pp. 139–143; Ivan Prokop Muchka, Ivo Purš, Sylva Dobalová and Jaroslava Hausenblasová, *The Star: Archduke Ferdinand II of Austria and His Summer Palace in Prague* (Prague, 2017); Sylva Dobalová, ''La Barco' of the Star Summer Palace in Prague: A Unique Example of Renaissance Landscape Design', in *Looking for Leisure. Court Residences and their Satellites 1400–1700*, Palatium e-Publication 4, ed. by Ivan P. Muchka and Sylva Dobalová (Prague, 2017), pp. 257–273.

10   For a complete study of Bonifaz Wolmut, his life, works, library, and place within the architectural culture of sixteenth–century Europe, see the forthcoming book: Sarah W. Lynch, *The Habsburg Architect: Bonifaz Wolmut, Prague, and the European Renaissance*. Brief, earlier accounts of his activities can be found in Winter 1909, pp. 87–92; Olga Frejková, *Palladianismus v české renesanci* (Prague, 1941), pp. 77–85; Preiss 1986, pp. 27–30.

11   Wolmut named his city of birth in the inscriptions in three of his manuscript volumes, discussed below: Archiv Pražského hradu (The Archives of the Prague Castle, hereafter APH), Girolamo Cardano, 'Hieronimi Cardani Opera germanice Pars II', 1549, p. 1v; APH, Girolamo Cardano, 'Hieronimi Cardano Opera germanice. Pars III', 1549, p. 1r; APH, Ptolemy, 'Claudii Ptholemei von den Astrologischen Judiciis und Urtheilungen volgent hernach vier bücher', 1550, p. 1r.

12   Karl Köpl, 'Urkunden, Acten, Regesten und Inventare aus dem k.k. Statthalterei-Archiv in Prag', *Jahrbuch der kunsthistorischen Sammlungen des Allerhöchsten Kaiserhauses* (hereafter as *JKSAK*) 10 (1889), LXIII–CC (LXX), reg. 5961.

13   Köpl 1889, pp. LXXI, reg. 5966.

dated 1537 places Wolmut in Hungary, working for the nobleman Péter Perényi at the castle of Sárospatak.[14] His most important early work was the Vienna Plan of 1547, which he completed in collaboration with the painter and engraver Augustin Hirschvogel and the architect Benedikt Kölbl.[15] This was the first complete, ichnographic city map and represented a major cartographic milestone of the sixteenth century.[16]

Ferdinand I finally sent Wolmut to Prague in 1554.[17] From this date until his retirement in 1570 Wolmut dominated royal building activity both in Prague and throughout Bohemian lands. He took leading roles in the works on the Royal Summer Palace and Large Ball Court in the castle garden, the organ loft and tower of Prague Cathedral, and the Diet Hall in the castle. He was also responsible for the construction, although not the design, of the Star Summer Palace.[18]

Wolmut's work was remarkable in this period for its explicit engagement with published architectural theory. He was the first architect in Central Europe to use the so-called 'correct' progression of the orders according to the period's prevailing architectural theories – Doric, Ionic, Corinthian – and one of very few to use the proportions recommended in treatises.[19] At the same time, he built Gothic vaults in the Diet Hall and organ loft.

14   Mihály Détshy first published this letter in 1987, but unfortunately no part of Sárospatak can be firmly attributed to Wolmut. Mihály Détshy, 'Adalékok Perényi Péter Sárospataki várépítkezésének és mestereinek kérdéséhez', *Ars Hungarica* 15:2 (1987), pp. 123–132 (127); Karsten Falkenau, *Die "Concordantz Alt und News Testament" von 1550: ein Hauptwerk biblischer Typologie des 16. Jahrhunderts illustriert von Augustin Hirschvogel* (Regensburg, 1999), p. 18; Mihály Détshy, *Sárospatak vára* (Sárospatak, 2002), p. 61; *Concordantz des Alten und Neuen Testaments durch Pereny Petri und Augustin Hirschfogel gedruckt zu Wienn in Österreych durch Egidium Adler. 1550. = Egybersengés az ó- és újtestamentumban Perényi Péter és Augustin Hirschvogel szerzette Egidius Adler nyomtatta az ausztriai Bécsben 1550*, ed. and transl. by Péter Perényi, Augustin Hirschvogel and Imre Nagy (Páty, 2017), p. 103; Andreas Kühne, 'Augustin Hirschvogel und sein Beitrag zur praktischen Mathematik', in *Verfasser und Herausgeber mathematischer Texte der frühen Neuzeit: Tagungsband zum wissenschaftlichen Kolloquium vom 19. – 21. April 2002 in Annaberg-Buchholz*, ed. by Rainer Gebhardt (Annaberg-Buchholz, 2002), pp. 237–251, see p. 241.

15   Karl Fischer, 'Augustin Hirschvogels Stadtplan von Wien, 1547/1549 und seine Quadranten', *Cartographica Helvetica* 20 (1999), pp. 3–12; Kühne 2002, p. 239; Ferdinand Opll, 'Vienna from the 15th to the Middle of the 16th Century: Topography and Townscape', in *A World of Innovation: Cartography in the Time of Gerhard Mercator*, ed. by in Gerhard Holzer, Valerie Newby and Petra Svatek (Newcastle upon Tyne, 2015), pp. 27–39 (33); David Landau and Peter Parshall, *The Renaissance Print, 1470–1550* (New Haven and London, 1994), p. 240.

16   On the development of ichnographic urban maps and cartographic depictions of cities, see John A. Pinto, 'Origins and Development of the Ichnographic City Plan', *Journal of the Society of Architectural Historians* 35:1 (1976), pp. 35–50; Hilary Ballon and David Friedman, 'Portraying the City in Early Modern Europe: Measurement, Representation, and Planning', in *The History of Cartography, Volume Three (Part 1) Cartography in the European Renaissance*, ed. by David Woodward (Chicago and London, 2007), pp. 680–704 (681–687), for the Vienna Plan in particular, see pp. 685, 696–697.

17   Köpl 1889, pp. CXVI, reg. 6159.

18   A complete construction history of this building and Wolmut's contribution can be found Muchka / Purš / Dobalová / Hausenblasová 2017, pp. 54–56.

19   Thomas DaCosta Kaufmann, *Court, Cloister & City. The Art and Culture of Central Europe 1450–1800* (London, 1995), p. 146.

Wolmut was also an active participant in the intellectual culture at the Prague and Vienna courts. He owned a large personal library and added to this collection throughout his life. Despite his intellectual ambitions, Wolmut was not university educated and did not read Latin. To make up for this deficiency, he commissioned a number of German manuscript translations of published Latin texts (all made between 1549 and 1552), first identified by Antonín Podlaha and Ivo Kořán.[20] These include the earliest known German vernacular translation of Ptolemy's *Tetrabiblos*, a classical treatise on judicial astrology.[21] (Fig. 1) Unfortunately, Wolmut left few indications of his reading in these books. One exception is a hand drawn astrolabe found between the pages of the translation of Sebastian Münster's *Rudimenta Mathematica*, which indicates that Wolmut actively employed his reading in an amateur astronomical and astrological practice.[22] (Fig. 2) As these texts suggest, the main subject of Wolmut's interest was astrology and astronomy. However, the additional identification of some of Wolmut's printed books suggests a wider range of interests, including history and chronology, religion, and alchemy. In terms of architectural literature, Wolmut owned Cornelius Grapheus's account of the triumphal entry of Philip II and Charles V to

Fig. 1. Ptolemy, Claudii Ptholemei von den Astrologischen Judiciis und Urtheilungen volgent hernach vier bücher, Vienna 1550 (Prague, The metropolitan chapter of St. Vitus)

20  Antonín Podlaha, 'Rukopisy z majetku Bonifáce Wolmuta v knihovně metropolitní kapituly pražské', *Památky archaeologické* 31 (1919), pp. 97–98; Ivo Kořán, 'Knihovna architekta Bonifáce Wolmuta', *Umění* 8 (1960), pp. 522–527. A complete discussion of Wolmut's library and its implications for his position at court and architectural career can be found in chapter two of Lynch, *The Habsburg Architect*, forthcoming.

21  The first printed German translation of the *Tetrabiblos* did not appear until 1822. Tetrabiblos, I–II, ed. and transl. by J. W. von Pfaff, *Astrologisches Taschenbuch für das Jahr 1822–1823* (Erlangen, 1822–1823).

22  The astrolabe is found between pages 182r and 183v in APH, Georg von Peurbach, 'Etliche Prepositiones, Canones oder Regeln in die Tafeln der Ecclipsium des Magistri Georgii Purbachii... Seb. Münster: Anfang der Mathematicae', 1551.

Fig. 2. An astrolabe found between the pages of Georg of Peurbach, Etliche Prepositiones, Canones oder Regeln in die Tafeln der Ecclipsium des Magistri Georgii Purbachii..., Seb. Münster, Anfang der Mathematicae, Vienna, 1551 (Prague, The metropolitan chapter of St. Vitus)

Antwerp in 1549 (published in 1550), and Heinrich Lautensack's treatise on perspective and proportion (1564).[23]

This collection provides insight into Wolmut's role at the courts in Vienna and Prague and his own relationship with Archduke Ferdinand II. Wolmut must have had the assistance of intellectual figures in order to commission his manuscript translations, or even to identify which texts should be chosen. Considering his involvement with the Vienna Plan, it is likely that he turned to the court librarian, historian, and professor of medicine, Wolfgang Lazius for help.[24] Lazius was also one of the most important cartographers working in Central Europe in the sixteenth century, and he must have taken an interest in the Vienna Plan and those working on it.[25] In 1554 the imperial accounts record a meeting concerning an architectural problem:

23  Cornelius Scribonius Grapheus and Pieter Coecke van Aelst, De seer wonderlijcke, schoone, triumphelijcke incompst, van den hooghmogenden Prince Philips, Prince van Spaignen, Caroli des vijfden, Keysers sone: inde stadt van Antwerpen, anno M.CCCCC.XLIX (Antwerp 1550); Heinrich Lautensack, Des Circkels vnnd Richtscheyts, auch der Perspectiua, vnd Porportion der Menschen vnd Rosse, kurtze, doch gründtliche vnderweisung, deß rechten gebrauchs (Frankfurt am Main, 1564).

24  On Lazius' life and position at court, see Petra Svatek, 'Wolfgang Lazius Leben und Werk eines Wiener Gelehrten des 16. Jahrhunderts', Wiener Geschichtsblätter 61:1 (2006), pp. 1–22; Thomas DaCosta Kaufmann, Arcimboldo: Visual Jokes, Natural History, and Still–Life Painting (Chicago, 2009), pp. 72–75.

25  On Lazius' work as a cartographer and his role in the second mathematical school of Vienna, see Peter H. Meurer, 'Cartography in the German Lands, 1450 –1650', The History of Cartography. Volume Three (Part 2) Cartography in the European Renaissance (Chicago and London, 2007), pp. 1172–1245, see p. 1191; Petra Svatek, 'Die Geschichtskarten des Wolfgang Lazius: die Anfänge der thematischen Kartographie in Österreich', Cartographica Helvetica: Fachzeitschrift für Kartengeschichte 37 (2008), pp. 35–43.

> After... the Lord Mayor and emissaries from Frankfurt, Doctor
> Wolfgang Lazius and other gentlemen of the council and lower
> chamber, the church master, the royal *Baumeister* Bonifaz Wolmut,
> Lienhart Eickl, Wolfgang Reiberstorfer, the legal administrator, and
> other workers and journeymen have discussed and described the
> deficiencies in the tower, a light meal of fish, baked goods and other
> items has been eaten up in the tower....[26]

Although it is not clear from the text which church tower was in question, this document confirms that certain architects participated in the social life of the court and were in social and professional contact with Lazius and other humanist figures. Wolmut's presence at this meeting and meal likely indicates that he not only had relevant professional expertise but also cultivated manners, and could engage in conversation with people from a wide range of backgrounds, including those from more elevated classes.

Wolmut probably had access to the same kinds of intellectual circles in Prague. One probable connection is Tadeáš Hájek of Hájek, a Prague physician interested in astronomy, astrology, and alchemy. He studied in Vienna and published prognostic calendars for the city from 1549 to 1555, just at the same moment that Wolmut was commissioning manuscript translations of astrological texts.[27] On his arrival in Prague, Wolmut would have found Hájek well established as a doctor and astronomer. Additionally, Wolmut worked on the renovation of the courtyard of the House of the Two Golden Bears between 1567 and 1575.[28] This house was owned by Jan Kosořský of Kosoř, a prominent printer and publisher who produced the Czech adaptation of Sebastian Münster's *Cosmographia* in 1554.[29] This suggests that Wolmut also had close ties to the book printers and sellers of Prague.

---

26  "nachdem... die herrn bürgermaister und gesandten von Frankfurt, herrn doctor Wolfgang Latz und etliche herrn des rats sambt undercamerer, kirchmaister, der kgl. maj. paumaister Bonofacii Wolmuet, Lienhart Eickl, Wolfgang Reiberstorfer, gerichtschreiber und andere werchmaistern und diener die mengel im thuern beschaut, beratschlagt und beschriben worden, dasselb mal oben im thuern ain jausen von fischen auch pachens und anders gegessen..." Karl Uhlirz, 'Urkunden und Regesten aus dem Archiv der k.k. Reichshaupt- und Residenzstadt Wien', *JKSAK* 18 (1897), pp. LXIII–LXV, reg. 15751. Eickl and Reiberstorfer appear frequently throughout the records at this time, described as *Steinmetz* or *Maurer*, but without the title "königlicher Baumeister," indicating that Wolmut was in a more elevated professional position at this time. In 1551 Reiberstorfer is noted with the title *Stadtwerkmeister* (chief architect of the city), itself a very prestigious position. Ibidem, no. 15705, 15708, 15712, 15715, 15718, 15720, 15738, 15743, 15746. However, such titles are often omitted from records, and Wolmut himself often appears only as a *Steinmetz* (Ibidem, no. 15715, 15718, 15720, 15738) or without a title at all (Ibidem, no. 15705, 15712, 15717, 15720, 15742, 15750).

27  Ivo Purš, 'Tadeáš Hájek of Hájek and His Alchemical Circle', in Purš and Karpenko, *Alchemy and Rudolf II: Exploring the Secrets of Nature in Central Europe in the 16th and Early 17th Centuries* (Prague, 2016), pp. 423–457, see p. 433.

28  Jarmila Krčálová, 'Renesanční architektura v Čechách a na Moravě', in *Dějiny českého výtvarného umění*, II/1, ed. by Pavel Vlček (Prague, 1989), pp. 6–62, see p. 47. Pavel Vlček disputes the attribution to Wolmut. *Umělecké památky Prahy: Staré Město, Josefov*, ed. by Pavel Vlček (Prague, 1996), p. 328. For a full discussion of Wolmut's oeuvre and attributions, see chapters 4 and 5 in Lynch, *The Habsburg Architect*, forthcoming.

29  Milan Kopecký, *Český humanismus* (Prague, 1988), p. 144.

Wolmut's book bindings offer another suggestion of his position at the Prague court, and more specifically his relationship with Archduke Ferdinand II. Each of the volumes identified from his Prague period is bound in white leather over boards with roll stamps, all the work of a single bookbinder.[30] (Fig. 3) Similar bindings appear in the collection of books at the Prague archdiocese, and on books owned by Archduke Ferdinand II. Although the number of bookbinders active in Prague during this period must have been relatively small, it is nonetheless significant that Wolmut used the same bookbinder as the archduke and selected the same style of binding. It indicates an awareness of the material aspects of the archduke's library and the preferred manner of treating books by the city's elite.

This was not the only way in which Wolmut's book collection was related to the archduke's library. Their interests also overlapped in the areas of alchemy and architecture. It is significant that of the four volumes of printed books identified as belonging to Wolmut, two of them contain treatises by famous alchemical practitioners, Paracelsus and Leonhard Thurneisser zum Thurm. Both of these texts are related to medical issues rather than what Ivo Purš has identified as the archduke's primary alchemical interest, metallurgy.[31] Nonetheless, the archduke actively collected Paracelsus's medical works and had no objections to physicians in his immediate circle practicing Paracelsian medicine.[32] Additionally, the archduke employed Thurneisser in Tyrol in a metallurgical capacity from 1563 to 1566.[33] In total, archduke owned ten books by or related to Paracelsus and seven works by Thurneisser, including the two texts that Wolmut owned, Paracelsus's *Große Wundartznei* and Thurneisser's 1571 *Protokatalepsis*, a treatise on urine analysis.[34]

---

30  Numerous examples of this kind of binding are illustrated in *Knihovna arcivévody Ferdinanda II. Tyrolského*, ed. by Ivo Purš and Hedvika Kuchařová, 2 vols. (Prague, 2015), II, *Katalog*. See especially the illustrations of the volume of Gabriello Falloppio's *De morbo Gallico liber absolvtissimus…* (1564) for an example of this kind of binding (p. 639, no. 83). Several other similar examples from the archduke's tenure in Prague are also illustrated.

31  Ivo Purš, 'Das Interesse Erzherzog Ferdinands II. an Alchemie und Bergbau und seine Widerspiegelung in siener Bibliothek', *Studia Rudolphina* 7 (2007), pp. 75–109 (76); Ivo Purš, 'The Habsburgs on the Bohemian Throne and Their Interest in Alchemy and the Occult Sciences', in Purš and Karpenko, *Alchemy and Rudolf II: Exploring the Secrets of Nature in Central Europe in the 16th and Early 17th Centuries* (Prague, 2016), pp. 93–127 (103); Yves Schumacher, *Leonhard Thurneysser. Artz – Alchemist – Abenteurer* (Zurich, 2011), pp. 61–85.

32  Ivo Purš, 'Alchymická, hornická a metalurgická literatura' in Purš / Kuchařová 2015, I, pp. 369–404 (385); Katharina Seidl, "…How to Assuage All Outer and Inner Malady…': Medicine at the Court of Archduke Ferdinand II', in *Ferdinand II: 450 Years Sovereign Ruler of Tyrol, Jubilee Exhibition*, ed. by Sabine Haag and Veronica Sandbichler (Innsbruck and Vienna, 2017), pp. 67–71 (70–71).

33  Purš 2007, p. 78.

34  Wolmut owned Christian Egenolff's 1561 edition of Paracelsus's surgery manual (Paracelsus, *Wundt und Leibartznei: Die gantze Chirurgei belangend…*, Frankfurt, 1561), while Archduke Ferdinand II owned a later edition printed in Basel by Peter Perna (Paracelsus, *Kleine Wundartzney Theophrasti von Hohenheim…*, Basel, 1579). Purš / Kuchařová 2015, II, p. 219. Both Wolmut and the archduke owned the same edition of Thurneisser's treatise. Leonhardt Thurneysser zum Thurn, *Prokatalēpsis oder Praeoccupatio: durch zwölff verscheidenlicher Tractaten, gemachter Harm[!] Proben* (Eichorn, 1571). Archduke Ferdinand II actively sought out Paracelsian publications and acquired ten titles by the controversial doctor. For the archduke's collection of Paracelsian texts, see Purš 2015,

It must be noted here that there is no direct evidence for alchemical or medical discussions between the archduke and his architect. The Paracelsus text is in any case a surgical manual rather than a strictly alchemical-medical text. Wolmut acquired the Thurneisser book only after the archduke had left Prague and after Thurneisser had left the archduke's service. Nonetheless, this coincidence in interests between the two men suggests that Wolmut was closely connected to the intellectual circles active in Prague, and therefore occupied a more prominent place at the Prague court than has previously been suspected.

One final book confirms the similarity of intellectual interests between Wolmut and the archduke, and as it is a text related to architecture, it offers a key insight into the architect's work and his professional relationship to his patrons. Both Wolmut and Archduke Ferdinand II owned a copy of Hans Lautensack's 1564 treatise on geometry, perspective and proportion.[35] The archduke owned an extensive collection of books and texts related to architecture, geometry, topography, and other related subjects. It is likely that Wolmut had access to these books. Although no strictly architectural treatises (such as those by Serlio, du Cerceau, or other heavily illustrated texts) can be identified as having belonged to the architect's collection, Wolmut used Serlio's illustration of the Theater of Marcellus as the model for his design for the organ loft in Prague Cathedral.[36]

Fig. 3. Roll-stamped cover of a volume from Wolmut's library (Collection of the Archdiocese of Prague)

---

pp. 390–396. – Purš / Kuchařová 2015, II, pp. 211, 219, 221, 226, 477, 481, 485, 516, 536. In addition to personally employing Thurneisser, Archduke Ferdinand II owned seven of his books, including the same treatise on uroscopy found in Wolmut's collection. An eighth book, whose exact identity is unclear from the inventory of the library taken at the archduke's death, may also be associated with Thurneisser. Ibidem, II, pp. 237, 242, 417, 418, 442–44, 456, 487.

35  Lautensack 1564; Ivan P. Muchka, 'Literatura o architektuře', in Purš / Kuchařová 2015, I, pp. 279–285 (281–282); Purš / Kuchařová 2015, II, pp. 447, 672.

36  Oskar Pollak was the first to observe the relationship between the organ loft and Serlio's illustration. Oskar Pollak, 'Studien zur Geschichte der Architektur Prags 1529–1600', *JKSAK* 29 (1911), pp. 85–170, see p. 112. On the organ loft see also Muchka 2014.

It appears that the archduke's collection of architectural literature had a profound influence on Wolmut's designs. At the inventory taken at his death in 1595, the archduke owned twenty-six books on architecture, including Hieronymus Coecke's 1542 German translation of Sebastiano Serlio's Book IV and the 1544 edition of Serlio's Books I and II. He also owned an unidentified edition of Book III, the *Libro extraordinario*, and a further unidentified edition of Books I and II.[37] From these Wolmut could acquire not just the forms of Renaissance architecture, but some theory as well, especially in terms of proportion and the use of the orders. In the 1550s, just at the time of Wolmut's arrival in Prague, the archduke already owned works by Serlio, Albrecht Dürer, Diego de Sagredo, Walther Ryff and was currently collecting volumes by Leon Battista Alberti, Pietro Cataneo, Androuet du Cerceau, Paschasius Hammellius, Antonio Labacco, Vitruvius, as well as further publications by Serlio.[38]

Significantly, Archduke Ferdinand II owned only one print series by the engraver and architect Hans Vredeman de Vries, the 1560 *Scenographia sine perspectivae*. This series of etchings was included in one of three albums of architectural prints belonging to the archduke.[39] De Vries was perhaps the most popular author-artist of architectural literature in sixteenth-century Central Europe. The *Scenographiae* is a series of twenty images of architecture in perspective accompanied by a frontispiece. Although popular, it did not receive the attention or achieve the circulation of the more theoretically structured treatise, the *Architectura*, published in 1577.

Vredeman de Vries's works had a profound effect on architecture across the region, and even in Prague,[40] but his distinctive style had no discernable effect on Wolmut's work. Instead, in Wolmut's latest major work, the Large Ball Court in Prague Castle Garden (1567), the architect developed a monumental classical style, which has been compared to Vasari's concept of the *maniera grande*.[41] Although Wolmut's latest known work, the church of St. Peter and Paul in Kralovice (completed 1583), seems to engage more with certain aspects of Central European architecture, such as the deco-

---

37  Sebastiano Serlio, *Die gemaynen Regeln von der Architectur ...* (Antwerp 1542); Sebastiano Serlio, *Il ... libro d'Architettura. Le ... liure d'Architecture. 1.2. ...* (Paris, 1544); Sebastiano Serlio, *Liure extraordinaire de architectvre de Sebastien Serlio ...* (Lyon, 1551); Sebastiano Serlio, *Il primo [-secondo] libro d'architettvra di m. Sebastiano Serlio, Bolognese* (Venice, 1551).

38  Muchka 2015, p. 282

39  Peter Parhshall, 'The Print Collection of Ferdinand, Archduke of Tyrol', *Jahrbuch der Kunsthistorischen Sammlungen in Wien* 78 (1982), pp. 139–184, see p. 169; Ivan P. Muchka, 'Hans Vredeman de Vries in den bömischen Bibliotheken', *Studia Rudolphina* 3 (2003), pp. 29–40 (30, 33). On the lack of works by Vredeman de Vries in the Archduke's library (as distinct from the prints in his *Kunstkammer*), see Muchka 2015, p. 280; but some albums were part of Archduke's collection of prints.

40  De Vries was active in Prague in 1589, but his prints had already inspired designs for other works in the city, notably for the royal tomb in the cathedral, which was begun in 1566. Ivan Muchka, 'Hans Vredeman de Vries und die böhmische Architektur', in *Hans Vredeman de Vries und die Renaissance im Norden*, ed. by Heiner Borggrefe, Vera Lüpkes, and Ben van Beneden (Munich, 2002), pp. 107–114, see p. 107.

41  Erich Hubala, 'Palast- und Schlossbau, Villa und Gartenarchitektur in Prag und Böhmen', in *Renaissance in Böhmen: Geschichte, Wissenschaft, Architektur, Plastik, Malerei, Kunsthandwerk*, ed. by Ferdinand Seibt (Munich, 1985), pp. 27–114 (105–108).

Fig. 4. Church of St. Peter and Paul, Kralovice

rated gable and uncanonical uses of classical architectural elements, there is no trace of the de Vriesian strapwork that was then gaining acceptance across the region.[42] (Fig. 4) Wolmut may have been too early to truly engage with Vredeman de Vries's publications, but the intense classicism of his work at the Royal Summer Palace, organ loft, tribune in the Diet Hall, the Large Ball Court, and St. Peter and Paul indicates an unusual familiarity with contemporary architectural publications and theories, all of which were available to him in Archduke Ferdinand II's library.

The existence of the treatise by Lautensack in both collections, however, suggests an interest not only in the ornament illustrated in treatises such as those by Serlio, but

---

42   The renovation of this medieval church was carried out in phases from the 1560s to the 1580s. Pavel Vlček, 'Die St. Peter und Paul-Kirche in Kralovice und Bonifaz Wolmut?', *Studia Rudolphina* 11 (2012), pp. 25–38, see p. 27. Wolmut probably became involved in the project just at the end of his life and provided the design, but he did not live to see the church completed. See Lynch, *The Habsburg Architect*, forthcoming, chapter 4.

also in the mathematical and geometrical aspects of contemporary art and architectural theory. This had been a key part of Central European discussions and publications on art since Albrecht Dürer's treatises on measurement (1525) and human proportions (1528).[43] Lautensack's text was in fact a direct response to Dürer's theories of proportion, one that attempted to simplify the earlier artist's system.[44]

Wolmut's familiarity with both the mathematical-proportional and classical ornamental aspects of architectural theory made him a valuable architectural advisor. Most of his advice on architecture to Archduke Ferdinand must have been made in conversation. Evidence of such consultation occurs in one letter the archduke wrote to his father, responding to the suggestion of building a cloister for the cathedral. The archduke reported that:

> Building a cloister, [Wolmut] thinks, would be inappropriate; these are for monasteries, not parish churches or cathedrals and the church also would only be an eyesore if it were not made in the same form as the other church building.[45]

The archduke reported Wolmut's opinion without offering his own, suggesting that he agreed with this assessment. Direct evidence for such conversations occurs in a letter from 1557 in which Ferdinand I wrote to his son reminding him that the Royal Summer Palace should be finished 'as we then... orally [*mundlich*] ordered Master Bonifaz',[46] indicating a personal conversation between the king, the archduke and the architect. Additionally, although the archduke was a sophisticated architectural patron, he was not himself a designer and therefore had to work closely with architects.[47]

---

43  Albrecht Dürer, *Underweysung der Messung, mit dem Zirckel und Richtscheyt, in Linien, Ebenen unnd gantzen corporen* (Nuremberg, 1525); Albrecht Dürer, *Hierinn sind begriffen vier Bucher von menschlicher Proportion...* (Nuremberg, 1528). On perspective and measurement as the foundation architectural theory in Central Europe, see Sebastian Fitzner, *Architekturzeichnungen der deutschen Renaissance: Funktion und Bildlichkeit zeichnerischer Produktion 1500–1650* (Cologne, 2015), pp. 25–49.

44  Christopher P. Heuer, 'Kinesis and Death in Lautensack', in *The Primacy of the Image in Northern European Art, 1400–1700: Essays in Honor of Larry Silver*, ed. by Debra Taylor Cashion, Henry Luttikhuizen and Ashley D. West (Leiden and Boston, 2017), pp. 178–192, see p. 181.

45  'Einen Kreuzgang zu bauen, halte er hingegen für unstatthaft, da dieser wohl für Klöster aber nicht für Pfarr- und Domkirchen passe und der Kirche auch nur zur Unzierde gereichen würde, wenn er nicht dem andern kirchengebäu gleichförmig gemache würde'. The letter is dated the 8th of May 1561. David von Schönherr, 'Urkunden und Regesten k.k. Staathalterei-Archiv in Innsbruck', *JKSAK* 11 (1890), LXXXIV–CCXLI (CXCIII–CXCIV), reg. 7463. See also Krčálová 1994, p. 134.

46  'wie wir dann... dem maister Bonifaci mundlich bevolhen...' Franz Kreyczi, 'Urkunden und Regesten aus dem k. u. k. Reichs-Finanz-Archiv', *JKSAK* 5 (1887), pp. XXV–CXIX (LXXII–LXXIII), reg. 4256.

47  In one exchange of letters involving the archduke, Ferdinand I and Wolmut, Archduke Ferdinand II conceived the idea for a complicated fountain and fishpond on the terrace of the Prague Castle Gardens but apologized for not providing a suitable drawing as he did not have a painter available. This incident indicates that although he was widely knowledgeable about architecture, the archduke did not have the ability to create plans himself. Muchka / Purš / Dobalová / Hausenblasová 2017, pp. 84–85. See also Dobalová / Muchka 2017, p. 42.

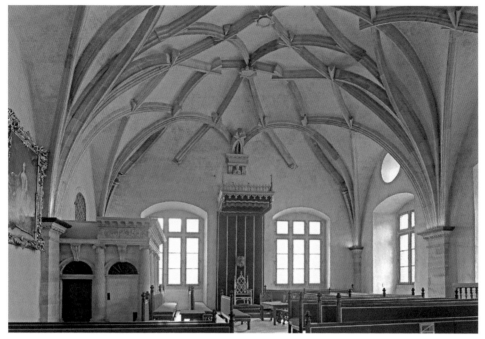

Fig. 5. Diet Hall, Prague Castle

Thus, when in the same 1557 letter Ferdinand I requested that Wolmut build the roof of the Royal Summer Palace 'according to your [Archduke Ferdinand II's] preference',[48] it implies that the design was the result of a consultation between the archduke and the architect. Again, in 1559 in discussing potential designs for the Diet Hall, Archduke Ferdinand II remarked, 'Baumeister Bonifaz Wolmut, who is constantly coming to me…' suggesting that Wolmut frequently consulted personally with the archduke on architectural matters.[49]

There was one occasion, however, on which Wolmut and the archduke may not have seen eye-to-eye on a major architectural matter, the design of the Diet Hall. There were two competing models for the Diet Hall, one proposed by Wolmut featuring a large Gothic vault, and another by two of his Italian colleagues, Andrea Aostalli and Giovanni Campione, with Renaissance-style stucco decoration.

Wolmut's design for the Diet Hall, which included a sweeping Gothic vault and a classicizing tribune, was approved in February of 1559, and he appears to have begun work right away.[50] (Fig. 5) That spring another *Baumeister*, Hans Tirol, who was charged with financial oversight of all building works at Prague Castle, sent Ferdinand I

48　'wie dann dein lieb wissen'. Kreyczi 1887, pp. LXXII–LXXIII, reg. 4256.

49　'pawmeister Bonifatium Wolmueth, als der embsig bey mir, anhalten thuet…' National Archives, Prague (hereafter NA), ČDKM IV-P, fol. 149v.

50　Wolmut's design was assessed by two anonymous Italian masters sent from Vienna on 30 January 1559 and was officially approved by 16 February of the same year. NA, ČDKM IV-P, 191, fol. 110r-115r; Kreyczi 1887, pp. LXXXIV–LXXXV, reg. 4287.

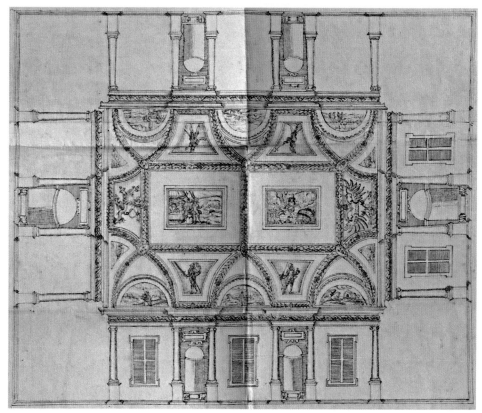

Fig. 6. Plan for the Diet Hall, 1559 (Prague, National Archives of the Czech Republic, ČDKM IV-P, 191, fol. 158)

a letter accusing Wolmut of financial mismanagement and suggesting that Aostalli and Campione could build the Diet Hall to the same design for a much lower cost. The king naturally demanded an explanation and ordered that if Wolmut was found to be irresponsible or dishonest, he should be removed from the project.[51] Archduke Ferdinand II responded with a letter in June accompanied by an alternative design for the Diet Hall ceiling and two lengthy letters from Wolmut wherein he defended his own design and accused his colleagues of being both incompetent and conniving.[52]

This correspondence would seem to offer a chance to understand the archduke's attitude towards Wolmut's Gothic design in confrontation with the alternative proposed by Aostalli and Campione. The new plan, which was probably drawn by Francesco Terzio, the archduke's court painter, proposed a vault decorated with stucco in a style then popular in palaces and churches around Italy and increasingly in Central Europe.[53] (Fig. 6) The walls were lined with Ionic half-columns or pilasters alternating

---

51  Kreyczi 1887, p. LXXVI, reg. 4279.
52  NA, ČDKM IV-P, 191, fol. 140r–171v; Kreyczi 1887, p. LXXVII, reg. 4282.
53  Fučíková 2017, p. 48.

with niches or windows. The archduke's letter in fact has very little to say about style, nor does he detail any element of either design. Instead, he is preoccupied with financial concerns, such as how much money had already been spent, how much should be spent, and what costs and delays might be incurred by changing the design (and therefore the architect and the builders as well) as work had already begun.[54]

The archduke concluded the letter by acknowledging the difficulties of making such a change at this stage, but he also sent the new design to his father accompanied by a letter from Wolmut, originally written for the archduke, in which the architect responded negatively to the alternative plan in the strongest terms possible.[55] At no point did the archduke suggest that the Gothic vault was inappropriate for the Diet Hall, or that the Renaissance design was preferable because of its modernity and relationship to contemporary fashions. His attitude toward the two proposals is rather ambiguous, and it is not clear whether he sent the alternative plan in hopes of persuading his father into approving a more modern design, or out of obligation to provide the king with all the available information about the situation. Had he been firmly persuaded of either proposal, he would likely have voiced his opinion or chosen either to suppress the new design or Wolmut's strongly argued case against it.

Wolmut's defense of the Gothic vault in stylistic terms is particularly revealing, and it explicitly supports the understanding of Gothic as a historic architectural style in Central Europe, seen as 'local' in contrast to the foreign, Italianate forms that were introduced in the period around 1500.[56] Although the sixteenth century saw the increasing use of Italianate or Renaissance architectural forms, Gothic architecture, in particular Gothic vaults, remained an important element of the region's architectural culture, above all in religious contexts.[57] Renaissance architecture, rather than being perceived as a revival of Roman antiquity, was considered foreign (*welsch*), while Gothic held strong associations with local traditions.[58]

This attitude is clearly apparent in Wolmut's own discussion of his design for the Diet Hall and its relationship to an earlier work in the castle, Benedikt Ried's Vladislaus Hall (c. 1500). (Fig. 7) Ried was arguably the last, great Gothic architect in Central

---

54   Kreyczi 1887, p. LXXVII, reg. 4282.

55   NA, ČDKM IV-P, 191, fol. 162r–171v; Kreyczi 1887, p. LXXVII, reg. 4282.

56   On the importance of Gothic in early modern Bohemia and at the Diet Hall in particular, see Biegel 2007; Kalina 2009a; Biegel 2013.

57   Hermann Hipp, *Studien zur 'Nachgotik' des 16. und 17. Jahrhunderts in Deutschland, Böhmen, Österreich und der Schweiz*, 3 vols. (Tübingen, 1979), I, pp. 49–58; Ethan Matt Kavaler, 'The Late German Gothic Vault and the Creation of Sacred Space', in *Spatial Practices. Medieval/Modern*, ed. by Markus Stock and Nicola Vöhringer (Göttingen, 2014), pp. 165–168 (176).

58   Baxandall discussed the relative clarity of the concept of 'welsch' in Central European art as opposed to the less well defined 'deutsch'. See Michael Baxandall, *The Limewood Sculptors of Renaissance Germany, 1475–1525: Images and Circumstances* (New Haven, 1980), pp. 135–142. Thomas Eser provides a nuanced examination of the term "welsch" in the sixteenth century, and its development as at concept that encompassed at first foreignness or Italianness and later ideas of luxury or modernity. Thomas Eser, "'auf welsch und deutschen sitten'. Italianismus als Stilkriterium für die deutsche Skulptur zwischen 1500 und 1550", in *Deutschland und Italien in ihren wechselseitigen Beziehungen während der Renaissance*, ed. by Bodo Guthmüller (Wiesbaden, 2000), pp. 319–361.

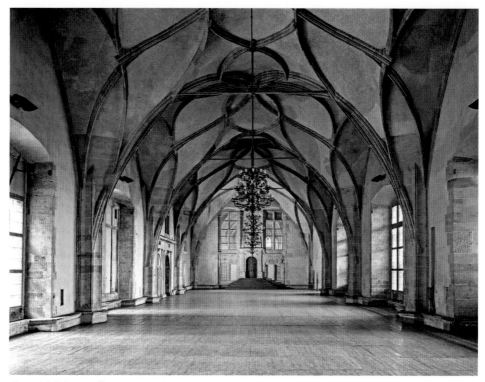

Fig. 7. Vladislaus Hall, Prague Castle

Europe, as well as a pioneer of Renaissance forms in the region. His most important work for the preceding Jagiellonian dynasty was this hall, which constituted the primary ceremonial space in Prague Castle.[59] The Diet Hall directly adjoins the Vladislaus Hall, which is clearly visible through the Diet Hall's door. Wolmut made specific reference to the Vladislaus Hall in writing about his design for the Diet Hall, deliberately invoking his predecessor's work:

> …but I have compelling arguments as your Princely Highness will soon hear, regarding this matter, I did not to want to advise and agree but rather I recommend a form that is as useful, artful, and beautiful as the hall next to it, which is famous among all the people knowledgeable about art in the whole world. I also advise to do this in no other way, because the Diet Hall should be made and vaulted in the same form as

59  Kaufmann 1995b, p. 59; Pavel Kalina, 'A Bastard Renaissance? Benedikt Ried, Master IP and the Question of Renaissance in Central Europe', in *Crossing Cultures: Conflict, Migration and Convergence: Proceedings of the 32nd International Congress in the History of Art, 13–18 January 2008*, ed. by Jaynie Anderson (Victoria, 2009), pp. 199–202 (199); Pavel Kalina, 'Benedikt Ried e Francesco di Giorgio Martini. I problemi della diffusione dell'architettura rinascimentale nell'Europa Centrale', in *Architettura Pittura e Società tra Medioevo e XVII secolo*, ed. by Corrado Bozzoni and Augusto Roca De Amicis (Rome, 2011), pp. 49–70 (51).

> the hall next to it. Afterward Your Imperial Majesty would like to have
> made and painted beautiful old *historien* including kings of Bohemia all
> around on the four sides, as Your Imperial Majesty has ordered, and I
> have distributed them neatly between the vaults and windows in the
> new model.[60]

Wolmut's admiration for the Vladislaus Hall and Ried is clear in this passage. He also deliberately associates the Gothic vault not only with the building tradition at the castle, but also with Bohemian history, in the form of the *historia* of dynasties of kings of Bohemia that should be painted around the room. His use of the term *historia* to indicate narrative paintings is derived from Alberti's *De pictura*,[61] a reference which highlights Wolmut's familiarity with contemporary theories, concepts, and texts in artistic and architectural matters even as he argues for the primacy of Gothic in Central Europe.

Wolmut also discussed the Diet Hall in terms of proportion, arguing that, 'the Diet Hall especially [was] given a correct and orderly proportion in [the ratio of] height to width'.[62] and went on to describe the exact dimensions of the room. He also discussed the superiority of his materials (stone) over the stucco decoration proposed by Aostalli and Campione, which he stated was,

> certainly no work of the stonemasons' art, rather it belongs to the
> carpenters' art, a painted wooden ceiling or a brick vault with stucco as
> they are making in your Grace's game preserve [the Star Summer
> Palace], which they have already been working on for three years, and
> which perhaps in another year still will not be finished.[63]

---

60  '... ich aber hab zue solchem fuernemen aus beweglichen ursachen, wie eur furstlich durchlaucht hiernach vernemen warden, niht radten und bewilligen wollen aber zue ainem solchen nuczlichen, kunstlichen auch schönen form, wie dan der sall darneben, welcher von allen kunstverstendigen in der ganzen welt beruempt, geradten. Ich radt auch noch auf kain andern weeg, ursach das die landstueben dem sall darneben zue gleichformig gemacht und gewelbt sol werden. Es mochten auch nachmallen ihr Romisch kais. maj. etc. zwischen das gehauen sainwerch allenthalben schone alte historien machen und mallen lasen sambt den Behamischen kinnigen neben an den vier seiten herumb, wie dan ihr Romisch kais. maj. etc. dieselben verordnet und ich sie zwischen das gewelb und fenster neües models ordenlichen ausgethilt.' NA, ČDKM IV-P, cart. 191, folder 1, fol. 162r–162v; Kreyczi 1887, reg. 4283.

61  Kaufmann 1995b, p. 147.

62  'der landstueben in sonderhait ain rechte und ordenliche proporcion in die hoch zue erer weiten gegeben...' NA, ČDKM IV-P, cart. 191, folder 1, fol. 165r; Kreyczi 1887, pp. LXXVII–LXXXIV, reg. 4283.

63  '... khain pauverstendiger dorfier achten und erkehen wierdt, dan es gewislichen auf kain stainmeczenart gestelt sonder sich vilmer auf tischlerisch zue ainem gemallten huelzinen poden reimet oder zue ainem zieglgewelbt mit ankhlebten stuckwerch wie sie dergleichen ains in eur furstlich durchlaucht neuen tiergarten machen, an welchem sie schon bis ins drit jar arbaiten und werden vielleicht noch in ainem jar khaum vertig'. NA, ČDKM IV-P, cart. 191, folder 1, fol. 164r; Kreyczi 1887, pp. LXXVII–LXXXIV, reg. 4283. This passage is also referenced in Eva Šamánková, *Architektura české renesance* (Prague, 1961), p. 35; Muchka 2003, p. 250.

Here Wolmut speaks dismissively of the work currently under way at the Star Summer Palace at White Mountain. This building and its elegant stucco decorations constitute one of the highlights of sixteenth-century architecture in Central Europe, but Wolmut's reaction suggests that he did not consider this kind of decoration suitable for the ceremonial space of the castle.

When the Diet Hall was finished in 1563, Wolmut wrote,

> That I, by the grace of the almighty God, but nevertheless with great
> effort and labour, and with exceptional diligence, and with greater care
> each day have completed this work and vault of the Diet Hall in Prague
> on the fifth day of September with the beatific blessing of God, it is
> finished, clean, beautiful, artful, and enduring, so I hope to God, that
> Your Imperial Majesty will consider it a gracious favour, but also that it
> will be an honourable jewel and monument to the whole of the
> Bohemian crown and your descendants...[64]

Wolmut hoped the hall would be a memorial for Ferdinand I and a valuable gift for the Habsburg dynasty. Equally important, he considered this work his masterpiece, writing in 1559 that it would be his 'epitaph',[65] and he also compared his work favourably with the Vladislaus hall for which, he hinted, Benedikt Ried had received a 'high honorary title'.[66]

Ultimately Wolmut was able to build the Diet Hall vault according to his own design, but this episode offers insight into the relationship between the architect, the archduke, and the king. Wolmut was an architect who could be consulted for advice on architectural matters of all kinds. He was familiar with the needs of decorum and had mastered both Renaissance and Gothic design. He was also someone whose advice could be taken in place of that of the king's own son (for example regarding the question of building a cloister for the cathedral), whose knowledge of architectural matters was very advanced and who took a personal interest in the subject throughout his life. Finally, however, the conflict over the Diet Hall indicates that no matter how valued Wolmut's advice and expertise was, his position was always rather precarious. Other architects could attempt to take control of projects already underway, and his patrons would not necessarily defend him in these matters. Wolmut therefore required a broad range of both professional and social skills to maintain his position at court. His ability

---

64  'Das ich aus der gnaden des allmechtigen gottes aber gleichwol mit grosser mühe und arbeit auch sunders fleisses mit täglicher grosser sorg dises werkh und gewelb der landrechtstuben zu Prag am fünften tag septembris mit glücksaligem segen gottes zuegeschlossen auch sauber, schön, khünstlich und bestendig gemacht, also das ich zu got verhoff, euer Römisch kais. maj. die werden nicht allein ein gnadiges gefallen sonder der ganzen cron Behaimb und derselben nachkhumen ein eerlich kleinat und gedachtnusz sein...' NA, SM S 21/4, fol. 541r; Köpl 1889, reg. 6210.

65  'epitafium', NA, ČDKM IV-P, cart. 191, folder 1, fol. 176v; Kreyczi 1887, pp. LXXVII–LXXXIV, reg. 4283.

66  'ein hoher eerntitl', NA, SM S 21/4, fol. 541r; Köpl 1889, reg. 6210.

to advise and council his patrons was certainly due to his accomplishments, experience, and specialized expertise, but the fact that he could make such persuasive arguments in writing (and presumably equally well in conversation) as to sway his patrons' opinions is only possible because of his education and participation in the humanistic court culture in both Vienna and Prague.

Nonetheless, when Archduke Ferdinand II left Bohemia in 1567 to take up his position as the sovereign ruler of the Tyrol, he left Wolmut in Prague. Other artists and architects accompanied the archduke to Innsbruck, notably Francesco Terzio, the painter whose design for the Diet Hall had so offended Wolmut as well as the stucco artist Antonio Brocco, the painter Domenico Pozzo, and the architects Pietro Ferrabosco and Giovanni Lucchese.[67] In this case, it is unlikely that this arrangement was intended as a slight or resulted from a disagreement between the archduke and Wolmut. As the chief architect of Prague Castle and a *königlicher Baumeister* (royal architect), Wolmut likely remained in Prague to ensure continuity in the management of royal building projects in Bohemia.

However close his relationship with Archduke Ferdinand II may have been, Wolmut was actually employed by the king and after Ferdinand I's death in 1564 he continued in this position under Maximilian II. Indeed, upon his retirement the architect received a pension from the king in honour of his career spent in royal service. Maximilian's letter on this occasion recalls Wolmut's works on behalf of himself and his father in more emotional terms, rather than a concrete list of tasks accomplished. He wrote,

> the faithful, honest, sincere and willing service that our former *Baumeister* the faithful Bonifaz Wolmut has most humbly shown and proved to the Emperor Ferdinand etc., our beloved lord and blessed father and most honourable memory, and to us, over many long years in Hungary, Austria and in this kingdom of Bohemia…

The Emperor then went on to decree that Wolmut receive a pension of 100 *Thaler* per year.[68]

Archduke Ferdinand II's later building activities at Innsbruck and Ambras may, however, suggest that he considered Wolmut's adherence to the Gothic vault in the Diet Hall a bit old fashioned or at least an exceptional circumstance. The Spanish Hall at Ambras (1569–1572), for example, is among the most forward-looking buildings of

---

67  Francesco Terzio was in service as the archduke's court painter from 1551/52 until 1571/72. Jiří Kropáček, *Francesco Terzio, pittore di Bergamo e Praga* (Florence, 1999), p. 349; Dobalová / Muchka 2017, p. 42.

68  'di getrewen ehrlichen aufrichtigen und willigen dienst, die unser gewester paumeister und getrewer lieber Bonifaci Wolmueth not weilend Kaiser Ferdinanden etc., unserm geliebten herrn und vattern gotseliger und hochlöblicher gedachtnus, und uns vil lange jar in Hungern, Österreich und in disem künigreich Behaimb allerunderthenigist erzaigt und bewisen hat…' Kreyczi 1887, pp. CX–CXI, reg. 4449.

the period.[69] Its flat, wooden coffered ceiling and fresco and stucco decoration are much closer in spirit to the alternative plan for the Diet Hall than Wolmut's design.

Wolmut's use of the Gothic design in a secular context in the mid-sixteenth century was certainly unusual.[70] However, considering the room's position within the context of Prague Castle, where it stands directly between the apse of St. Vitus Cathedral and the Vladislaus Hall, the design is highly sensitive to the existing architectural environment. This, as well as the financial and practical aspects, however, may not have been enough to save the Gothic design alone. In his letters Wolmut refers not only to the needs and plans of Ferdinand I and his esteemed predecessor, Benedikt Ried, but also to his own feelings. While most of his defense is devoted to the critical architectural subjects of materials, stability, cost, and decorum, he also frames the alternative proposal as a personal insult and makes the conflict a matter of not just design and finances, but also of his honour. Indeed, an architect and court servant of Wolmut's standing could not easily be ignored in this kind of matter. References to his conversing not only with the archduke but also the king on architectural matters suggest that although these consultations must certainly have adhered to the rules governing court etiquette, he was not only personally acquainted with his patrons, but free to (politely) offer advice or alternative opinions in the presence of the royal family.

This elevated if somewhat ambiguous position made it possible for Wolmut to appeal to the king's judgement even when the archduke's opinion might not necessarily coincide with his own. Although Wolmut was obviously a much lower-ranking dependent than the king's son and future ruler of the Tyrol, his valuable professional skills and expertise, his education, and his apparently courtly manners meant that he had a willing audience in his patrons.

---

69   *Ambras Castle Innsbruck*, ed. by Sabine Haag (Vienna, 2012), pp. 35–36.

70   Hermann Hipp counts only two uses of secular Gothic in the mid-sixteenth century, the Diet Hall and the small tower of the Strasbourg town hall in 1556. Hipp 1979, pp. 396–403.

Ivan Prokop Muchka

# Inventories as the source of knowledge of the architecture of Archduke Ferdinand II in Tyrol

Questions concerning the architectural legacy of Archduke Ferdinand II of Habsburg, which structures and innovations can actually be attributed him, what might have inspired his building programme and who, on the contrary, it might have influenced, were first asked by the historian Josef Hirn in his monograph, published in two stages in the years 1885 and 1888.[1] However, we must state straight away that Hirn's answers are far from convincing.[2] Hirn states that: "Already in Bohemia he was occupied with various projects and thus there began in 1555, in a hunting ground in Prague, the construction of the strangely designed Hvězda (Star) Summer Palace, which the archduke *invented and designed.* This activity of his could develop even more freely when he became the independent ruler in Tyrol. First of all he began the extensive reconstruction of Ambras Castle."[3] Hirn devotes considerable attention to the second residence mentioned (Ambras Castle), but even in this case we do not learn very much about how the reconstruction took place. Hirn did not make use of the facts contained in the highly detailed estate inventory of 1596, which was prepared for publication by his contemporary Wendelin Boeheim and is kept today in the Österreichische National-bibliothek (sign. Cod. 8228, hereafter estate inventory ÖNB).[4] Evidently Josef Hirn was not yet aware during this period that inventories were particularly valuable sources for addressing questions concerning the functions of rooms and everyday culture in castles and manors: indeed, it must be admitted that even today the value of inventories has not been sufficiently appreciated in research on castles.[5]

---

1   Josef Hirn, *Erzherzog Ferdinand II. von Tirol. Geschichte seiner Regierung und seiner Länder*, 2 vols. (Innsbruck, 1885–1888).

2   On the contrary, Laurin Luchner, *Schlösser in Österreich*, II: *Residenzen und Landsitze in Oberösterreich, Steiermark, Kärnten, Salzburg, Tirol und Vorarlberg* (Munich, 1983), lists the following buildings in the vicinity of Innsbruck: Krippach, Hall, Weiherburg, Hohenburg, Martinsbühel, Mentelberg, Tratzberg, Freundsberg, Aschach, Friedberg, Kolbenturm, Taxburg and Ambras. Of these buildings Hirn mentions only Ambras Castle.

3   Hirn 1885, p. 384.

4   Österreichische Nationalbibliothek, Vienna, Sammlung von Handschriften und alten Drucken (department of manuscripts and rare books), sign. Cod. 8228 (*Inventarium germanicum rerum mobilium archiducis Ferdinandi Oenipontani*). Hereafter: Estate inventory ÖNB, published by Wendelin Boeheim, 'Urkunden und Regesten aus der k.k. Hofbibliothek', *Jahrbuch der kunsthistorischen Sammlungen des Allerhöchsten Kaiserhauses* (hereafter as *JKSAK*) 7 (1888), pp. XCI–CCCXIII, (CCXXVI–CCCXIII), reg. 5556; idem, 'Urkunden und Regesten aus der k.k. Hofbibliothek (Forsetzung)', *JKSAK* 10 (1889), pp. I–XIX (pp. I–X), reg. 5556.

5   Ulrich G. Großmann and Anja Grebe, *Burgen. Geschichte – Kultur – Alltagsleben* (Berlin, 2016), p. 91: "Für die Frage der Raumfunktionen und der Alltagskultur auf Burgen sind die Inventare besonders wertvolle Quellen, die bislang in der Burgforschung noch zu wenig Beachtung gefunden haben."

Without even mentioning what changes the archduke had made to his castles and mansions, Hirn names first of all the "garden palace" of Ruhelust and lastly the buildings in the so-called lower valley of the river Inn: "Rotholz (Thurnegg), Grüneck, also known as Hirschlust and Wohlgemutsheim." The only facts here are the statement on the construction of chapels in these buildings and the mention that they were hunting lodges. Hirn also states that instructions were issued for the restoration of Tyrol Castle, the hunting lodge Moos near Sterzing, Gutenberg Castle (by Feldkirch) and Günzburg Castle in Vorlandösterreich (Foreland Austria).[6] Hirn also mentions that all these buildings were later reconstructed and adapted to a considerable extent, which is unfortunately true, even though some of them were in fact altered after the publication of Hirn's book. A few pages later Hirn also mentions comparable buildings held by the aristocracy – the summer palace of Velthurn above Brixen, and Rodenegg Castle.[7]

### Archduke Ferdinand II's chief constructions

Before we turn our attention to the so-called small constructions of Archduke Ferdinand II within the Tyrol, let us mention at least with the utmost brevity his main activities after leaving Prague in 1567. In Prague the archduke was governor, representing his father, King Ferdinand I. This role included, for instance, control over the building programme at Prague Castle. During the 1550s this meant, in particular, the completion of the North Royal Garden with its main dominant feature, the Royal Summer Palace, but also repairs to and reconstruction of other buildings following the destructive fire of 1541. In Innsbruck the situation was repeated to some extent, because the Hofburg had been partially destroyed by fire in 1534. The King was nevertheless also interested in the Innsbruck Garden. I suspect construction may have begun then on the *Böhmisches Lusthaus* (Bohemian Summer Palace) at the far end of the garden, although this is just a hypothesis. Archduke Ferdinand II did, however, begin building projects even before he had moved his residence to the Tyrol. Before this date he had already acquired Ambras Castle and had plans prepared for it, and in 1563 he entrusted the architect Giovanni Lucchese with its expansion and modernisation.[8] The so-called Upper Castle was raised to include a third floor – as shown by several portals dated to 1566 – evidently intended to serve as the floor for the *fraucimor* (the 'ladies' maids' rooms'), which will be further discussed in the excursus at the close of the article). The greatest handicap to these improvements, however, turned out to be the medieval origin of the building. The enclosed layout with narrow wings limited the eventual size of the main hall, which was intended to be the focal point of every representative residence. This led to the construction of the so-called Spanish

---

6   Hirn 1885, pp. 386–387; Vorderösterreich, earlier "die Vorlande", was the joint name for the estates of the Habsburgs at that time located to the west of Tyrol and Bavaria.

7   Hirn 1885, p. 391.

8   Sylva Dobalová and Ivan Muchka, Archduke Ferdinand II as Architectural Patron in Prague and Innsbruck, in *Ferdinand II. 450 Years Sovereign Ruler of Tyrol. Jubilee Exhibition*, ed. by Sabine Haag and Veronika Sandbichler, exh. cat. (Innsbruck and Vienna, 2017), pp. 39–45.

Hall, a separate building with its own basement and anteroom, but joined directly to the south wing of the Upper Castle, like a sort of 'pedestal'. In the area below the castle a whole new building programme was developed, including in particular the ballgame hall, which closed off the garden with its long side. Near the entrance to the castle there was also the *Kornschüttengebäude* (granary), which incorporated stables and the collection rooms under a single roof, as was the case, for instance, at the court of the Bavarian Dukes in Munich and later also at Prague Castle during the reign of Emperor Rudolf II.

Unfortunately, we know relatively little of the building development of the ruler's main residence in Tyrol – the Innsbruck Hofburg, which Archduke Ferdinand II repaired immediately after his ceremonial arrival in the town on the 17th of January 1567.[9] Our impression of this residence in the 16th century is mostly influenced by two drawings of the main courtyard by Albrecht Dürer, which evidently date from 1496. According to these the residence was composed of individual buildings with single outside staircases sheltered by shed roofs, an arrangement we can imagine today using the castle of Hasegg in the mining town of Hall near Innsbruck as a model. The residence recorded by Dürer looks more like a street in a medieval town than what modern viewers consider a palace. After the beginning of Ferdinand I's reign the Hofburg underwent reconstruction, also necessitated by the fire of 1534. He planned costly repairs to the so-called "Paradeisbau" (Paradise Building), the central hall, for which Lucius Spazio and other masters were engaged.[10]

According to information that he found in the Innsbruck archive (today the Tiroler Landesarchiv), Hirn states that the great hall of the Innsbruck residence was adapted in 1565 by Master Lucchese in the Italian manner.[11] In the 17th century the hall described as the *salle à l'italienne* was a hall taking up two storeys – the question is whether this description was already in use a hundred years earlier. Hirn also states that immediately afterwards work was done on the bathrooms and the corridors. In 1575, according to him, the order was given to add an extension to the northern side of the Hofburg.[12] His statement is problematic: whereas there is no doubt that the area of the Hofburg was expanded and altered in the southwest corner, in the Hofgasse, Hirn's report of an extension on the side facing the court garden is difficult to verify. The last archive report found by Hirn also reads quite curiously: this document states that in

---

9   Hirn 1885, p. 65, uses the characteristic concept of the "alte Hofburg" (Old Castle). For more detail on Hofburg see especially Ricarda Oettinger and Karl Oettinger, Hofburg, in *Die Kunstdenkmäler der Stadt Innsbruck, Die Hofbauten*, ed. by Johanna Felmayer, Österreichische Kunsttopographie 47 (Vienna, 1986), pp. 55–197.

10  This reconstruction is documented by sources in the Tiroler Landesarchiv, Innsbruck (hereafter TLA), KS I. 711. See also Konrad Fischnaler, *Innsbrucker Chronik*, II (Innsbruck, 1930), p. 84; David von Schönherr, 'Urkunden und Regesten aus dem k.k. Statthalterei-Archiv in Innsbruck (Forsetzung)', *JKSAK* 11 (1890), pp. LXXXIV–CCXLI (CXIX–CXX), reg. 6833, 6845, 6846, 6848, from a year 1550.

11  Hirn 1885, p. 385, "der grosse Saal wurde 1565 durch seinen Meister Luchesi so zugerichtet, wie es in Italia gebreuchig", acc. to "k.k. Statthalterei-Archiv in Innsbruck", today TLA.

12  Hirn 1885, p. 385.

1581 Archduke Ferdinand II was compelled to complain that the roofing was so insuf-
ficient that water got into his bedroom when it rained.[13] All that we can deduce from
this is that the archduke's bedroom was on the top floor – it is highly probable that the
Hofburg had been raised by one floor at this time. However, the 18th century altera-
tions make it difficult to reconstruct the situation at the time of Archduke Ferdi-
nand II. We can determine that the northeast corner rondel is older; corner towers, as
we shall see further on in the article, also became a characteristic part of the archduke's
smaller hunting lodges. All that having been said, it is quite easy to imagine the situat-
ing of residential rooms in the east wing with a view of the large garden.

The part of the estate inventory ÖNB with the heading "Inventari über die alte
purg und derselben underschidliche gepeu" (Inventory of the old castle and its various
buildings)[14] mentions the following rooms on the top floor of the east wing, described
as "gegen dem rennplacz" (opposite the racetrack): the "fürstenzimmern" (princes'
rooms), comprising the "griencamer" (green room), "paradeisstuben" (paradise rooms,
probably those reconstructed by Lucchese), and "runde gulden zimer" (round golden
room), as well as other rooms, including the kitchen and a large dining room. These
were evidently in the westernmost part of the north wing, which is in keeping with the
historical plans. The 'middle' floor of the east wing also contained royal apartments,
and the corner rondel evidently contained a bedroom and living room – this specific
arrangement will be further discussed in relation to Thurnegg Castle. Apart from this,
we also find here a typical configuration, the triad comprised of the "wartestube"
(anteroom or waiting-room for servants or visitors), the "fürstenzimmer" (royal
apartments) and the "gwelbcamer" (vaulted room). Following this, as we would expect

---

13   Hirn 1885, p. 385.
14   Estate inventory ÖNB, p. CCXLVI, mentions *Inventari über die alte purg und derselben
     underschidliche gepeu*" (Inventory of the old castle and its various buildings). This very formulation
     indicates that the commissioners working on the inventory did not know how to deal with the certain
     lack of order in the Hofburg, due to the existence of individual separate buildings. This concerns in
     particular the main eastern part of the Hofburg, where they tried to differentiate between the parts
     "gegen dem rennplatz" (opposite the racecourse), which means more to the south, and then "auf der
     anderen Seiten gegen dem hofgarten" (on the other side opposite the court garden), in other words
     more to the north. The least problematic location is given by the proximity of the church of St. James
     – "gegen der pfarrkhirchen" (opposite the parish church), i.e. roughly the northwest part of the area.
     Popular turns of phrase also found in other inventories are the concepts "vordere" (front) and
     "hintere" (rear), and eventually "untere" (lower) and "obere" (upper) – the problem then is always
     what these designations relate to. Also in the 1596 inventory ÖNB we finds the concepts of "hinder
     vergatterte burg" (rear fenced castle) and "Die mittere und vorder purg" (middle and front castle),
     evidently as seen from the centre of the town. The final guidelines are names in local usage, in the case
     of the area of the Hofburg these are mainly the "paredeistuben" (perhaps due to paintings of the
     biblical heaven), which already appear at an earlier date, e. g. in the correspondence of the town
     leadership and the Bishop of Trent, who at that time was Cristoforo Madruzzo, cf. Luca Siracusano,
     *L'epistolario di Cristoforo Madruzzo come fonte per la storia dell'arte con un'appendice di documenti
     dal notarile di Roma*, Collana Studi e Ricerche 1 (Trento, 2018), p. 61. We also find here, for instance,
     "khürnstuben" according to the decoration with antlers (das *Gehörn*); in 1628 Philipp Hainhofer
     used the concept "Das gehürn partiment", viz Oscar Doering, *Des Augsburger Patriciers Philipp
     Hainhofer Reisen nach Innsbruck und Dresden*, Quellenschriften für Kunstgeschichte und Kunst-
     technik des Mittelalters und der Neuzeit, N.F., 10 (Vienna, 1901), p. 52.

from comparison with the archduke's other buildings, was the room of the *Hofmeister* (chamberlain or steward).

The commissioners who produced the inventory of this part of the castle, which they describe as the "hinder vergatterten purg" (the rear fenced castle), then moved on to the part designated as "die mittere und vorderburg" (the middle and main front castle). The main part of this section was the "grosse saal" (great hall), in substance evidently the same as the present hall. This hall might have had painted decoration with a Herculean iconography dating from the time of the King and later Emperor Ferdinand I, as mentioned by the Augsburg merchant and collector Philipp Hainhofer in his 1628 travel diary.[15] It is difficult to more specifically determine the function and appearance of the rooms in this part of the castle, which can only really be located near to the central courtyard. It is surprising that the inventory does not mention the area of the gallery, the typological and aesthetic appearance of which would particularly interest us as it was evidently one of the first examples of this type in Transalpine Europe. According to Austrian researchers this may have been a room in the south wing, with a total of ten window axes; Hainhofer's description is again used here.[16] Preserved historical ground-plans do not, however, provide any support for this hypothesis; we can also consider the possibility that the room had only five windows on each side. In sketches of the main façade from the period before the Theresian adaptation[17] five large windows can be seen on the façade, right beside the *Wappenturm* (Armorial Tower) on the third floor, above which there are further small circular or oval windows – we even recognize this configuration from several places at Ambras Castle.[18]

As yet there is no detailed study demonstrating the evolutionary development of the Hofburg from castle to palace, which consisted mainly of the regulation of its external appearance and its internal layout. There is more be gained from the data in the description by Philipp Hainhofer, who mentions among other things that "from the vice-regent Archduke Leopold [Leopold V, Archduke of Further Austria] he also

---

15    Doering 1901, p. 48; Hainhofer's estimate of the length of the hall as "50 schrit lang" – 50 steps (ca 80 cm) considerably exceeds the current real length (31.5 m).

16    Oettinger and Oettinger 1986, p. 65; Doering 1901, p. 38. Hainhofer states that this was a room with windows on both sides, between which there was a total of 36 female portraits of the wives of monarchs. Hainhofer contemplated putting his writing desk into this room and describes it in great detail, including the decoration with painted emblems and the floor with white, yellow and blue glazed tiles.

17    Oettinger and Oettinger 1986, Figs. 44 and 56.

18    The drawings of the Hofburg before the Theresian unification show a main hall with large windows in the central section, which are either rectangular, as shown by the *veduta* by Walter (Oettinger and Oettinger 1986, Fig. 56) or rounded at the top in Strickner's *veduta* (ibidem, Fig. 44), with the façade culminating in a lunette moulding, which may also have existed in the Spanish Hall at Ambras, as is mentioned in the study by Dobalová and Muchka 2017. Kühnel, on the other hand, attempts to add the lunette moulding already in the period when Lucius Spazio was active in Tyrol, i.e. 1536–1538, cf. Harry Kühnel, 'Beiträge zur Geschichte der Künstlerfamilie Spazio in Österreich', *Arte Lombarda* 13:2 (1968), pp. 85–102 (99). This could well have been the case, but the spreading of the lunette moulding in Transalpine Europe is unequivocally typical of the second half of the 16th century.

learnt of his fond wish to demolish the entire building and construct it completely anew according to contemporary rules of architecture."[19]

If we were to attempt to summarise uncompleted research questions, then it must be said that the role of Archduke Ferdinand II was significant and ambitious. He was active in the field of memorial architecture, and this activity has been better researched – I am thinking in particular of the Habsburg mausoleum in the court church, and the Silberne Kapelle (Silver Chapel), which he extended after the death of his first wife Philippine Welser to its present state. However, whenever possible the archduke was also active in the sphere of residential architecture and state representation, to which not much attention has been paid so far.[20] Even though the archduke preferred to stay in the new building of Ruhelust Palace, which he evidently had built from the beginning of his residency in Innsbruck, he did not neglect the modernisation of the Hofburg, the individual apartments of which could then serve as accommodation for monarchs, ambassadors and honoured guests, as we learn in a number of descriptions from Hainhofer's "travelogue".

### Grüneck – Wohlgemutsheim – Thurnegg

Archduke Ferdinand II's little castle of Grüneck, part of the town of Mils/Hall, was already nothing but a ruin in the 19th century, according to the *veduta* of Johanna von Isser (1830).[21] It was accessed via a tree-lined avenue, with a further single-storey building, which still had a roof, showing the polygonal end of the building.[22] In contrast to this, a further building – the *Wohlgemutsheim* – was also located close to the town of Hall in the current municipality of Baumkirchen, and appears in a *veduta* by the same artist to be in a good state of structural repair, including the kitchen garden in the foreground.[23] The *veduta* shows the side entrance façade of a two-storey, two-axis building with two prismatic oriel corners. This reflects the little castle's current appearance: today it functions as a monastery, for which purpose it was considerably extended

---

19   Doering 1901, p. 39: "Dise Alte Burg ist ain sehr weitleuffes gebew von villem vnderkommen, aber gar melancholisch vnd altfränckhisch erbawet, dahero Ihre Drlt. Vorhabens sein, mitlerweil die gantze Burg abzutragen vnd alla moderna fürstlich erbawen zu lassen".

20   Karin Elke Tschenett, Die Baumeisterfamilie Luchese in Tirol (magistral thesis Leopold-Franzens-Universität Innsbruck, 1998); Peter Fidler, Renaissancearchitektur, in *Kunst in Tirol*, I, *Von den Anfängen bis zur Renaissance*, ed. by Paul Naredi-Rainer and Lucas Madersbacher (Innsbruck, 2007), pp. 571–588.

21   ÖNB, Johanna von Isser, Ruinen von Grüneck bei Mils, 1830, http://data.onb.ac.at/rec/baa13710489 (searched 27.10.2019)

22   The question is whether Hirn, when he mentioned Grüneck in the municipality of Mils, actually meant another Renaissance chateau, which still exists, i.e. Schneeburg, built around 1581 by Rupert of Schneeberg, a two-storey rectangular building with corner oriels, one of which still culminates in a turret, cf. *Die Kunstdenkmäler Österreichs. Tirol* (Vienna, 1960), p. 135. The inclusion of this building in the typological group that we are trying to put together here in a preliminary manner would be logical.

23   ÖNB, Welf von Isser-Gaudententhurn, Wohlgemuthsheim bei Baumkirchen, 1864, inv. no. Z104869306.

Fig. 1. Wohlgemutsheim

between the years 2010–2014. (Fig. 1) The interior design, with an asymmetric entrance hall from which visitors ascend to the two upper floors with large halls featuring oriel lookouts, is clearly original. (Fig. 2) The characteristic emphasis on the corners shown here will also appear again later in the discussion.[24] The archduke gave both of these

---

24  The building is now owned by the nuns of order of Don Bosco, to whom I would like to express my gratitude for their assistance and the provision of present plans. From these it emerges that this is an older building, extended into a rectangle (circa 23 metres × 10.5 metres) with the shorter side to the south, giving a view of the valley between two corner oriels. On the view as a determining factor of a ground plan there is extensive treatment by Stefan Hoppe, *Die funktionale und räumliche Struktur des frühen Schloßbaus in Mitteldeutschland. Untersucht an Beispielen landesherrlichen Bauten der Zeit zwischen 1470–1570* (Cologne, 1996), p. 377 (chapter: "Belichtung und Ausblick als Determinanten der Wohnraumplazierung"). The spiral staircase rising on the east side is perhaps original, but is, of course, inserted into a square tower. The south entrance leads into a hall with ridged vaulting; otherwise, following the interesting historicising reconstruction in the 19th century (coffered wooden ceilings) and modernisation, the Renaissance phase is not very visible in any of the structure's details.

Fig. 2. Wohlgemutsheim, interior

buildings to his new wife Anna Caterina Gonzaga as places for summer repose and hunting parties.[25]

The last hunting lodge mentioned by Hirn is Thurnegg (Thurneck), in the village of Rotholz by Jenbach.[26] (Fig. 3) This lodge, which was reconstructed several times at later dates, is important to us from the typological viewpoint, especially due to the two imposing cylindrical towers, each with a diameter of almost ten metres; it would be justifiable to describe them in the terms of fortified architecture as *Eckrondell* (corner rondels). The rondels frame the edges of the main rectangular building, which lies almost parallel to the river Inn. The building is only a few tens of metres from the river; it was separated from it by an enclosing wall, and a typical small cylindrical tower from that original wall has been preserved.

According to the 1596 estate inventory ÖNB, the cylindrical towers of the castle contained the main residential rooms, comprising a bedroom and a study. The archduke had his apartments on the first floor, and his wife had hers on the second floor.[27] The windows of the towers face north to the splendid scenery of the Karwendel Alps above Jenbach.

---

25   Elena Taddei, Hin- und herüber die Alpen. Die Reisen von Anna Caterina Gonzaga (1566–1621), Erzherzogin von Österreich, in *Prinzessinnen unterwegs. Reisen fürstlicher Frauen in der frühen Neuzeit*, ed. by Annette C. Cremer, Anette Baumann and Eva Bender (Giessen, 2017), pp. 57–76 (60).

26   Boeheim 1889, p. IX, mentions "Schlosz Türnegg oder Rotholtz", today an agricultural school.

27   Ibidem.

Fig. 3. Thurnegg

Thurnegg is one of the group of buildings in which use was made of the *castellum* type of castle ground-plan, used for several of the archduke's building projects. Unfortunately, the construction data for this hunting lodge is not reliable: Archduke Ferdinand II allegedly established it for his wife Philippine Welser as a hunting lodge in 1567 and the builder was apparently Alberto Lucchese.[28] The extensive hunting ground, fenced by a high wall, is still visible today. These grounds allegedly continued on the opposite, northern bank of the river. The information provided by the 1596 estate inventory ÖNB must however be taken with considerable caution, especially with regard to the number and location of the interiors, even though the basic

---

28    Helmut Krämer and Anton Prockh, *Die schönsten Tiroler Burgen & Schlösser* (Innsbruck, 2009), pp. 138–139; Wilfried Bahnmüller, *Burgen und Schlösser in Tirol, Südtirol und Vorarlberg* (St. Pölten, 2004), pp. 25–26.

Fig. 4. Thurnegg, marble fireplace

procedures of the commissioners compiling it seem to be similar for all the buildings in the inventory. In general, they start from the top floor and work down. The initial record is of interest: it states that the bedroom, study and third room of the archduch-ess were "In ... runden thurn" (in the round tower).[29] This is interesting because our impressions of the use of such corner towers are so far generally very fragmentary. We can form a certain impression on the basis of comparison with the rooms on the first floor of the nearby Fugger castle of Tratzberg, where the towers form part of the suite of rooms known as the *Fuggerstube* (the Fugger rooms) and the *Königinzimmer* (the queen's rooms), which are luxuriously decorated with coffered ceilings (author Hans Waldner, 1560) and wood panelling; the view from them over the valley of the river Inn is imposing. In Thurnegg the inventory states that the archduchess's apartments adjoin the rooms of the *oberste Kammerfrau* (chief lady's maid), as well as the other rooms of the *fraucimor*, including a dining room. A hall is also mentioned and the floor is completed by the "frau landvögtin camer" (room of the governor's wife),[30] a detail that may remind us of the governor's room in Ruhelust Palace, which will be discussed presently.

29  Boeheim 1889, p. IX.
30  Boeheim 1889, p. IX.

At Thurnegg the archduke resided on the first floor and again there is mention of a study in the round tower, although the bedroom is omitted in the 1596 estate inventory ÖNB, meaning that we can merely speculate that the layout of the rooms was perhaps identical on both floors. The dining room and "wartstube" (anteroom/waiting room) lead on from here, followed once again by the servants' rooms and the "Obersten camerers camer" (room of the lord chamberlain), which also included the rooms of the "edlknaben" (pages) and the "doctor" (doctor). There is also mention of a hall, clearly accessed directly from the staircase. On the ground floor the description is mainly concerned with the chapel.[31]

Without a contemporary ground plan this data remains fragmentary, but it is still valuable. For instance, it demonstrates that the assertation often given in literature that the corner towers at Thurnegg were almost Baroque is evidently not based on the truth. This is especially evident if we ignore the form of their roofs. The white marble fireplace in the upstairs dining room stands out from the present-day furnishing of the interiors – i.e. the Baroque and neo-Baroque framing of the doors, the other fireplaces, and so on. (Fig. 4) The main questions arising are when and from where this fireplace may have been brought into the interior – with its very high-quality stonework details it is evidently not in keeping with the Baroque and historicising morphology of this castle.

There is another interesting analogy with the competitions in drinking from large vessels, called *vilkums*, which we know of from Ambras Castle and which also clearly took place at Thurnegg in the hall on the first floor. The inventory mentions "princes', counts', lords' and nobles' large drinking glasses– 'vilkums', which were used in the hall and of which we have here fifty-one different ones".[32]

## Tirol – Moos – Gutenberg – Günzburg – Rodenegg – Velthurns

Let us continue in the identification of the buildings listed by Hirn in connection with Archduke Ferdinand II's building projects. What concretely may have taken place in the castle of Tyrol, today part of the town of Merano/Meran, is not completely obvious – the renaissance interiors there have not been preserved. The hunting lodge of Moos (municipality of Prati/Wiesen) east of the town of Vipiteno/Sterzing was reconstructed from a medieval castle. This is a three-storey building on an irregular cubic ground plan with a square tower on the north side and a main façade with five window frames facing the Wipptal valley to the south, and a lookout oriel on the third floor, the three-sided roof of which also projects into the main roof. The windows on the first floor have a straight moulding above them.

The inclusion of the castle of Gutenberg among the buildings linked to Archduke Ferdinand II is somewhat surprising, because the village of Feldkirch, in which it

---

31    Boeheim 1889, p. IX.
32    Boeheim 1889, p. IX, "Item der fursten, graven, freiherrn und adlspersonen, so zu Turnegg den willigkhumb gedrunkhen, gaben, so im saal aufgemacht worden und 51 underschidliche stuck sein".

Fig. 5. Velthurns, interior

stands, is a considerable distance from Innsbruck[33] and the idea that the archduke was active here is somewhat improbable. The same obviously applies to the last building in Hirn's list – the castle of Günzburg, lying on the Danube roughly halfway between Augsburg and Stuttgart. It is interesting, however, that in the area close to Günzburg there are many more similar renaissance buildings that take the architectural layout of a *castellum* type of castle (Höchstadt, Leipheim, Jettingen, Harthausen, to name a few).

Hirn lists only two buildings as comparable to a *castellum*. The first is Wolkenstein Castle of Rodenegg, to the north of Brixen.[34] This has a medieval mountain castle layout with subtle modern adaptations that characterise it as a castle palace, with only one cylindrical corner tower. The second building is the summer palace of the Brixen Velturno/Feldthurns bishops, which can certainly be compared with the group of hunting lodges identified as originating from or renovated under Archduke Ferdinand II's patronage. This is a uniquely preserved rectangular two-storey building with a farm building alongside, called a *dürnitz*. It is rightly considered one of the best preserved

---

33   Cf. Cornelia Herrmann: *Die Kunstdenkmäler des Fürstentums Liechtenstein*, II, *Das Oberland*, Die Kunstdenkmäler der Schweiz, 112 (Bern, 2007).

34   Castello di Rodengo, township of Rodengo/Rodeneck, in the vicinity of Rio di Pusteria/Mühlbach. In 1491 Maximilian I gave the castle of Rodenegg to Veit (Vít) I of Wolkenstein. His descendents Veit II and Christoph I rebuilt the castle as a modern fortress. Cf. Friedrich Wilhelm Krahe, *Burgen des deutschen Mittelalters* (Augsburg, 1996); Oswald Trapp, *Tiroler Burgenbuch*, IV: *Eisacktal* (Bozen, 1984).

renaissance buildings of South Tyrol.[35] On both floors the centre of the layout is one entrance room, called a "flecz"[36] and on the right it has two enormous hall-like interiors of roughly 8 metres × 9 metres – a residential room, "Ihr hochfürstlich Gnaden Stube" (the room of his grace the prince) with a viewing oriel, and a bedroom ("Cammer hinein" – chamber within) with an oriel toilet.[37] The décor dating from the 1680s includes on the one hand wall panelling with intricate joinery work and fresco painting, and on the other hand coffered ceilings inspired by the designs of Serlio. (Fig. 5)

The furnishings include luxury ceramic stoves. This, then, demonstrates a more definite parallel to the buildings in whose design Archduke Ferdinand II played an active role, and to some extent provides an indication of how his (now no longer extant) interiors might have looked.

## Ruhelust Palace

Hirn mentions the palace of Ruhelust several times. He did not, however, provide a more extensive analysis of it; he merely assumed that it was a building with half-timbered walls. It is one of the ironies of fate that it is often those works that could be considered essential to the history of art that completely or almost completely vanish – in the case of Prague Castle this fate applies to the results of the building activities of both Archduke Ferdinand II and Emperor Rudolf II. In the case of the former we have the (somewhat limited) good fortune that at least one piece of his architecture considered significant for Europe has survived – the Star Summer Palace and the hunting ground for which this building was named – the Hvězda, or 'star'. This enables us to observe that the archduke had an outstanding feeling for architecture. In Innsbruck and its immediate vicinity his building activity was divided mainly between two localities – Ambras Castle, and Ruhelust Palace situated on the foreground of the royal garden of the Hofburg. The very name Ruhelust (literally, 'desire for peace and quiet') suggests the idea of an ephemeral summer palace in the summer garden, only used during that season. This fact together with disappearance of the palace meant there has been little interest in this building on the part of researchers.[38] There is the question of

---

35    Karl Wolfsgruber, Barbara Schütz and Helmut Stamper, *Schloss Velthurns* (Bozen, 2007).

36    Cf. Horst H. Stierhof, *Das biblisch gemäl. Die Kapelle im Ottheinrichsbau des Schlosses Neuburg an der Donau* (München, 1993), p. 23: "Von der Galerie des Ottheinrichsbaues aus gelangt man zunächst in das "Flez"... bildete(e) den langgestreckten – eigentlich „breitgestreckten" – Vorraum zu den ehemaligen vier Räumen im Hauptgeschoß des Westflügels..." (From the gallery of the Ottheinrich building one can gain access to the "Fletz" ... formed by an entrance hall spreading lengthwise – or extending width-wise – to the original four rooms of the main floor of the west wing).

37    Wolfsgruber 2007, p. 41.

38    Johanna Felmayer, 'Ruhelust', in *Die Kunstdenkmäler der Stadt Innsbruck, Die Hofbauten*, ed. by eadem, Österreichische Kunsttopographie 47 (Vienna, 1986), pp. 626–639 (p. 632), defined a research question regarding the location of Ruhelust Castle (archaeological finds of remnants of the remains of cellars are, however, certainly welcome, see p. 636), but in reality avoided the fundamental questions of what the exterior of the buildings of Ruhelust looked like (e. g. the attic half-floor or the turrets above the staircase), and what the composition of the interiors may have been. In other words, the question of how the archduke lived in this residence was not answered. Equally if not more impor-

where Ruhelust Palace actually stood – in any case it must have been to the east of the area of the *Rennplatz* and the street called the Rennweg,[39] but we should mainly be interested in attempting to discover the interior layout of the building.

Ruhelust Palace was built between the years 1562–1582 by Giovanni and Alberto Lucchese to accommodate Archduke Ferdinand II and Philippine Welser on their soujourns.[40] The name Ruhelust (or *Ruelust*) appears in the 1596 estate inventory ÖNB. A further important source are three ground-plans from 1619.[41] The three-winged building depicted in these plans can however be identified as the so-called *Witwensitz*, that is the widow's residence of Anna Caterina Gonzaga. The plans are supplemented by descriptions of the rooms, from which it clearly emerges that the building we refer to as Archduke Ferdinand II's *Ruelust* was in fact situated to the left (north) of the depicted building. However, the ground-plan for Ruhelust Castle is not depicted. The third important source in considering this building is the travelogue of Philipp Hainhofer.[42] He, however, uses a different designation: alongside the actual Ruhelust Castle he speaks of another so-called "Vndere Ruhelust" (Lower Ruhelust): "Ruhelust has by its sides (?) the lower (front) Ruhelust, which is all of wood and painted white."[43] He then uses a further designation for Ruhelust in the text: the "obere Ruhelust" (Upper Ruhelust). A certain confusion regarding our impression of two buildings arises at the moment when he mentions a hall that he saw "im Neuen Ruhelust" (in the new Ruhelust).[44] From his description, which implies that the *Untere Ruhelust* was built onto the original one, we must consider that perhaps with the word *neuen* here he actually meant *untere*, which would mean he was in fact referring to the *Witwensitz* residence here.

There is some importance in the connection of the area of the two 'Ruhelusts' by means of covered passages (as was commonplace in the period) with the court church, the Hofburg, the ball-game hall and the so-called *Regelhaus*, which was in fact the convent house of the Servite order that the widowed archduchess established and in which she was personally active. In 1636 one or perhaps both of the Ruhelust buildings were destroyed by fire, and in time completely new buildings were constructed here.

---

tant is the question of the whole area including the garden as such – in Prague the extent and shape of the Royal Gardens were already measured by Ferdinand I and the individual buildings were mainly added to the area around its periphery – this applies also to the Royal Summer Palace and the separate kitchen established for it with its own yard, and also for the oldest ball-game hall, etc. The mentions of the corridors in Innsbruck are also unclear, with Felmayer giving no answer as to where they led and what they looked like.

39 Hainhofer also uses the word: Rennbahn, viz Doering 1901, p. 36.
40 Acc. to Felmayer 1986, p. 626; according to her the "Ruhelust summer palace" consisted of the main wing of "Obere Ruhelust", and the cross wing of "Untere Ruhelust".
41 TLA, Kunstsachen, KS I. 994.
42 Doering 1901, p. 35 etc.
43 Doering 1901, p. 36, "An diesem Ruhelust hat es nach der seitten hero den Vnderen Ruhelust, welcher ganz hültzin vnd mauerfarb geweisset vnd angestrichen ist...". ("Alongside this Ruhelust is the lower Ruhelust, made completely of wood and whitewashed and painted with mason's paints.")
44 Doering 1901, p. 89.

The very existence of the list of furnishings, which traditionally also included wall decorations such as tapestries and wallpapers, and also the inclusion of this building in Hainhofer's report, which concentrates more on works of art than on the description of architecture, shows that Ruhelust Palace was seen as a fully-fledged royal residence. The archduke and his family lived in it all year round, he died there and his body lay in state there. This was not just an occasional summer palace. Boeheim, author of the transcription of the 1596 estate inventory ÖNB, writes in several places that he abbreviated the parts where the inventory commissioners were describing only utilitarian, not 'artistic' furnishings. However, he recorded all the rooms with their names and locations in full. Hainhofer, in contrast to this, describes both buildings in a summary manner. According to him, the *Obere Ruhelust* had fifty beautiful, high and wide rooms, part of them with wallpapers and ceiling paintings.[45] The further description, however, contradicts the inventory ÖNB, because the division of the building with the archduke's apartments on the first floor and those of the archduchess and the *fraucimor* on the second floor is not found in the inventory, or rather there is no explicit mention there of rooms definitely inhabited by the archduke. Hainhofer further describes the lower Ruhelust as a wooden building with thirty rooms, a chapel and a hall decorated with paintings.[46] Despite these fragments, in the absence of any groundplans the 1596 inventory ÖNB continues to be nothing more than an insufficient methodological aid.

## Witwensitz

Hirn does not mention the *Witwensitz* (dower residence) on the south side of Ruhelust Castle,[47] which we must probably see as a case of him mistaking the part for the whole. This is a pity because, although the building was evidently constructed practically in parallel with Ruhelust Palace, the aforementioned plans of 1619 show that the *Witwensitz* was a separate building. As opposed to Ruhelust, we know precisely where this building stood because the *Rennplatz* is drawn on the plans describing it, and

---

45    According to Franz Carl Zoller, *Geschichte und Denkwürdigkeiten der Stadt Innsbruck und der umliegenden Gegend* (Innsbruck, 1825), p. 110. How Hainhofer acquired this data is not so important, and need not "automatically" throw doubt on his data, as stated by *Die Kunstdenkmäler der Stadt Innsbruck*; one must realise that a historical reconstruction is like a mosaic consisting of the most varied types of verifiable and less verifiable data.

46    At the time of his visit to Innsbruck there was a splendid celebration here to mark the christening of the Archduke Ferdinand Karl, who was baptised in the Church of the Sacrifice of Our Lady in the so-called *Regelhaus*, when there was still a functioning connecting passageway to Ruhelust Castle. The *Regelhaus* was allegedly destroyed in 1844.

47    Apart from Hirn 1888, p. 333 – this however omits the sentence where Archduke Ferdinand II in his 1570 will and testament urges his brothers, in the case of his death, "Phillippinen einen ehrlichen Witwensitz anweisen..." (to award to Philippine an honourable widow's residence). In 1594 Archduke Ferdinand II granted his second wife (by means of a so-called *Codizilla*) "as a widow's residence Ruhelust with two gardens"; viz Felmayer 1986, p. 627: "Codizill zum Testament Erzherzog Ferdinands II."; for an excerpt from this regest viz ibidem, p. 644.

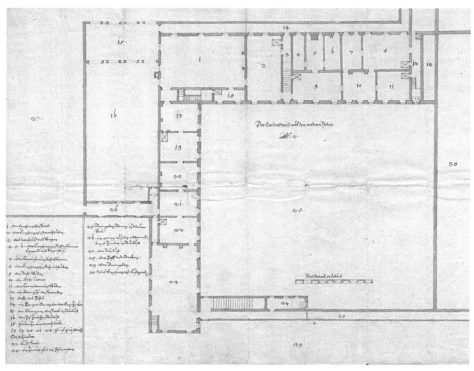

Fig. 6. Plan of the first floor of the Witwensitz, Innsbruck, 1619 (Tiroler Landesarchiv, Innsbruck, inv. no Kunstsachen I/994)

likewise the plan of the ground floor records a small part of the ball-game hall, the locality of which is known.

The rooms on all three floors are numbered and provided with descriptive texts that inform us about their functional arrangement. It is hardly necessary to stress that such detailed information about Renaissance or Early Baroque buildings is something of a rare exception. On the plan there is a compass giving the cardinal points, but in addition the plans also include a scale, making it possible to reconstruct the size of the interiors with a reasonable degree of reliability. To give some idea of this, we can say that the great hall, for instance, which covered the height of the first and second floors, measured roughly 17.5 metres × 9.5 metres, the archduchess's chapel on the first floor was around 6.3 metres × 3.3 metres, and her bedroom circa 6.3 metres × 1.8 metres.

If we wanted to analyse the area with the building of the *Witwensitz* in detail, this would mean expanding the extent of this paper considerably – the ground floor alone has a total of forty-five descriptions, the first floor thirty descriptions, and the second floor twenty-three descriptions.[48] (Fig. 6) The ground floor mainly comprised the

---

48   Sabine Weiss, *Claudia de' Medici: eine italienische Prinzessin als Landesfürstin von Tirol (1604–1648)* (Innsbruck, 2004), pp. 109, 115, 178. I quote descriptions after plans in this book.

kitchen and connected rooms (the area ascribed to the kitchen might also include the *Vischkhalter*, or fish-tanks, in the neighbouring courtyard), then also the larder, marked on the plan as no. 19 "Am ProdtCamer" (bread chamber) and no. 26 "Am Groß hof Keller" (large court cellar), then several rooms for the pharmacy and its staff. The description begins with no. 1 "des Pfenningmeister Stuben" (the accountant's room) and no. 2 "der Herzogin Hofmeisters Stuben" (room of the duchess's steward), whereas "des obristen Hofmeister Zimber" (the rooms of the Lord Chamberlain) continue on the second floor with the numbers 19–21.

Otherwise the first floor may be described roughly as the archduchess's floor; Anna Caterina Gonzaga resided in its east wing, whereas in the north wing there were rooms for guests. The second floor was reserved for her daughter and is described on the plan as the floor of the "young archduchess". The residential apartments of these two ladies were then supplemented by rooms for chambermaids and the *fraucimor*, and also the rooms "der Frauen Junkfrauen und dienerinen Zimber" (rooms of the ladies of the chamber and servants). From the turn of phrase it emerges that more than one person lived in each room, as there is no differentiation here between *stube* (living area) and *cammer* (chamber, here in the sense of bedroom), as there is in the case of the chambermaids; but we also find their common dining-rooms here.

Archduchess Anna Caterina had her bedchamber "der Erzherzogin Schlaf Camer" in the close vicinity of the chapel (with an altar indicated on the east side), and here there was also "der Erzherzogin Schreibstuben" (the archduchess's study) and evidently "die Tafl Stuben" (dining-room). Access to the apartment was through "die Ante Camera" (anteroom), whereas the main hall was reached through a room with a 'simpler' name – "der Erzherzogin Wartstuben" (anteroom or waiting room for the archduchess's hall) and before this "das Vorhaus und Stiegen" (corridor or passage and staircase). At the end of the apartment there also appears a hygienic innovation "ein Gang zu den Secreten" (corridor to the toilet), with the toilets marked in the same place on the plan for all floors, as well as on the corridor linking the north wing to Ruhelust Palace, where guests and staff also had several such cabins at their disposal.

There remains the briefest possible description of the second floor where the young archduchess resided, in the east wing above Archduchess Anna Caterina's apartments. The young archduchess's floor was, of course, considerably smaller due to the two-storey main hall. Two floors above the ground-floor kitchen was the "Mundkuchl" (a kitchen reserved for the preparation of meals for the archduchess); further to the south the layout of the first floor was more or less repeated, apart from the chapel. Mother and daughter seem to have shared the Archduchess Anna Caterina's chapel on the first floor, which the young archduchess could reach by going down one flight of stairs. In place of the study or office, the term "Studier Stuben" (study room)[49] is used, and unlike her mother the young archduchess also had a separate "Gwardaroba" (room for the storage of clothes and jewels). The attic is also included in the description of the

---

49   Hoppe 1996, p. 383, who devotes the chapter: "Schreib- oder Studierstuben als Teil des Apparte-
ments" to these rooms.

second floor. It was evidently situated exclusively above the east wing, with storage spaces including "Zway Zimber für die Krambley", which can probably be translated with slight exaggeration as 'junk rooms'.

The specific layout that we have just described should be further expanded by the more general layout principles of Archduke Ferdinand II's architecture. The elements representing 'communication' between spaces are different in the north wing and the east wing – for example a continuous passage is missing in the east wing – and this gives rise to questions about changes to the plan during the different building phases. In contrast, the establishment of a two-storey hall as part of Archduchess Anna Caterina's apartments and the existence of a similarly large, albeit only one-storey hall, the *Lustsaal*, (even if this hall only really forms the endpoint to a series of guest rooms) are all progressive traits from the point of view of the history of architecture. The alternating use of stoves (in the *Stube*, or residential rooms) and fireplaces (in the *Cammer*, or bedrooms), testifies to the richness of the furnishings in the dower palace, especially when they are drawn in on the plans very carefully, so that it is possible to distinguish, for instance, the stoking of a stove from the rear. The privies (toilets) are also drawn in with equal care.

The question remains as to whether it would be possible to apply this detailed knowledge of the *Witwensitz* building to Ruhelust Palace, which was separated from this residence by a courtyard measuring approximately 24.5 metres × 13.5 metres and connected at the northeast corner by a corridor on the first-floor level. The corridor on the plan is designated with double pillars, which supported the roof of the open arcades. The joining of these two buildings exclusively at the first-floor level may indicate that the archduke's rooms in Ruhelust were on that same floor (hence the need for a direct connection to Archduchess Anna Caterina's apartments). But unfortunately this fact does not help us to form a more concrete impression of the Ruhelust building, which was undoubtedly the focal point of the archduke's activities.

Let us at least consider, as briefly as possible, the development of the residential functions of interior architecture, as described in the architectural texts of the Italian Sebastiano Serlio, a 'favourite' author of Ferdinand II. In Serlio's Volume VII, published for the first time in 1575, the suitable arrangement of the rooms was described as follows: using the word *Alloggiamento* (a word with a large range of meanings, from accommodation for troops to an apartment) Serlio refers to the overall ground-plan or layout, which consists of apartments, often in a mirror arrangement along the main axis.[50] The *Appartamento* in its most simple and basic form consists of two rooms, the *camera* (or *camera grande*) and the *dietro camera*, ("al servizio della camera"), in which there may be a *scaffa* – a bed alcove, and finally a possible third room, the *camerino* (*piccolo* or *picciol camerino*). Both the *camera* and the *dietro camera* have fireplaces. Serlio does not record toilet alcoves, baths, and so on. Serlio does not record this, but they may have been situated in the basements, which were used mainly for kitchens, but may also have had other purposes. In more complex apartments there was also the

---

50   Cf. Libro VII / Cap. II.

*anticamera*, meaning the antechamber or waiting room the room where visitors awaited an audience (or where servants awaited their master's orders).[51]

A comparison between the development of residential architectural layouts in the Transalpine area and those in in Italy would of course require far more time, but it would undoubtedly be highly desirable.

### 'Pulverturm' Summer Palace

The existence of a hunting ground and hunting lodge by the river at Ulfiwiese (in the Innsbruck locality of Höttinger Au) to the west of the town has already been mentioned briefly in a previous article summarising Archduke Ferdinand II's contribution to architecture.[52] This is a smallish rectangular building of two storeys (dimensions 30.5 metres × 22.5 metres), originally with cylindrical corner towers (the ground-plan of which was marked out on the terrain during a recent adaptation) and also with a preserved tower containing a spiral staircase. Later adaptations and a completely new usage in recent times have, of course, considerably changed the internal layout of the building. Here we can at least suppose the existence a central entrance room or *flecz*, and a rear entrance to the staircase, which is walled up today. On the first floor, in the northwest hall, wall paintings have been preserved on the window jambs, showing motifs of flora and fauna. It will however be impossible to locate the kitchen on the ground floor, or to reconstruct the ground-plans of the residential rooms upstairs unless we manage to find the appropriate documentation from the various adaptations made to this structure. In any case, this was originally a *castellum* layout, one of a whole series of similarly designed buildings from the second half of the 16th century.

### Achensee

Let us take a look at some further buildings neglected by Hirn. After the inspection of the Hofburg for the 1596 estate inventory ÖNB, the commissioners included a section referred to as "Ahental". In Boeheim's transcription this part is abbreviated, because the items listed in this part of the inventory are characterised as being "of cultural-historical, but not art-historical value". The sub-title of this part of the transcription is: "Movable items from three hunting lodges in Eben and Pertisau".[53] These were hunt-

---

51    The word 'apartment' was first used in France in the middle of the 16th century; cf. Myra N. Rosenfeld (review), 'Sebastiano Serlio on Architecture, Volume Two, Books VI–VII', *Journal of the Society of Architectural Historians* 61 (2002), pp. 225–227 (226).

52    Cf. Sylva Dobalová and Ivan Muchka, 'Archduke Ferdinand II as Architectural Patron in Prague and Innsbruck', in *Ferdinand II. 450 Years Sovereign Ruler of Tyrol. Jubilee Exhibition*, ed. by Sabine Haag and Veronika Sandbichler, exh. cat. (Innsbruck and Vienna, 2017), pp. 38–45.

53    Boeheim 1888, p. CCLVIII: "Ahental. Varnus in den drei jagheüsern aufm Ebm und Perdiszaw". In Pertisau itself this could also apply to the currently empty building of the hotel Könighof, surrounded by centuries-old trees. This is a rectangular building about 10 m wide (three window frames), which must of course have been considerably extended in the 19th century when it was also furnished with wooden balconies. I do not dare to speculate on the location of the third hunting lodge.

Fig. 7. Pertisau

ing lodges in the localities of Pertisau and Eben am Achensee, only one of which is known today (called the *Fürstenhaus*), lying almost on the banks of the Achensee. (Fig. 7) According to the estate inventory ÖNB, the *Fürstenhaus* was actually a large fishing house, the equipment of which comprised "galea, Rennschiffe und Schiffe" (galleys, fast boats and boats) with rich furnishings which indicate not only fishing, but also the holding of water festivities for noble visitors. The *Fürstenhaus*, which in the dimensions and proportions of its rectangular two-storey building (circa 21 metres × 14.5 metres) is reminiscent of the Pulverturm at Ulfiwiese, was later reconstructed. Nevertheless, a striking detail – an oriel on the south side, replaced here by a corner turret – is evidently original. As opposed to the other examples of oriel alcoves and corner turrets, which unequivocally serve to provide splendid views of the country-side (as at Wohlgemutsheim and Thurnegg), the oriel here does not face directly towards the waters of the lake. The layout has been changed recently due to the use of the building as a hotel, but it is obvious that the entrance from the longer side on the northwest led into a large ground-floor room (*flecz*), roughly 5 metres wide and spanning the whole depth of the layout in length, where it may have ended in a staircase. More interesting than the objects in the inventory, however, are the people who lived in these lodges and also even had reserved rooms here – for instance Kateřina of Lokšany (Katharina of Loxan).

It is difficult to generalise the findings made by the investigation into the lodges and summer palaces mentioned. Concerning the *castellum* type of layout, which is

Fig. 8. Stumm

Fig. 9. Vohenßtraus

observable in Thurnegg, Wohlgemutsheim and perhaps other, unlocatable properties of this type belonging to Archduke Ferdinand II, all we can say is that this layout was widespread in the Tyrol. Examples should at least include Stumm (Fig. 8),[54] Aschach,[55] Büchsenhausen in the heart of Innsbruck, Tratzberg, and Ehrenburg. Further representatives of this type of building beyond the Tyrol are, for instance, Vohenstrauß (Fig. 9) and Jagdschloß Grünau near Neuburg on the Danube.

The question is whether the particular kind of symbolic fortress of the *castellum* layout prevalent in these buildings held any specific meaning for the archduke, who had military interests (compare for example his collecting activities) – indeed, this might well be the case. What is clear is that the archduke favoured an architectural layout and type with a very strong occurrence in Central Europe and the German lands during the 16th century.

### Excursus: Typology of Ambras Castle

I would further like to use the analysis of the 1596 estate inventory ÖNB as an aid for presenting a more general method of understanding inventories in terms of the divisions of the internal spaces of buildings. The inventory summarises the valuable furnishings from several buildings and demonstrates how the commissioners who produced this inventory over a period of six months or so worked according to certain principles. For example, they generally proceeded through each building from top to bottom and stated the floor they were entering as they began a new section. However, if we compare the inventory with the ground-plans of the four floors of Ambras Castle (Fig. 10), some discrepancies do unfortunately arise: the floor listed as the "Mittlerer poden" (middle floor), where the archduke's apartments are situated, works out as the third from the bottom (in other words the second floor), but the inventory ÖNB lists areas of the oratory of the chapel on this floor. However, the chapel had to be, and indeed still is, on the ground floor. The chapel itself is listed in the inventory on the floor designated as "Undrist poden vom hof hinein" (the lowest floor, entered from the courtyard). Above this is the "undern poden" (lower floor, i.e. the first floor), which contained the main guest rooms. The third floor is called the "Frauenzimmerboden" (the *fraucimor* floor), the floor which also contained the archduchess's apartments.[56] The inventory further lists the "gschlosz under dem tach", the attic, but with only three rooms.

---

54   It belonged to metal-caster Gregor Löffler, an artist in the service of Ferdinand II.

55   It belonged to Ernst of Rauchenberg, who was *Haushofmeister* (estate chamberlain or house steward) of Ferdinand II.

56   A comprehensive analysis of the typology of Ambras Castle in the Renaissance does not exist, apart from some mentions of specific areas, such as the situation of the apartments of Philippine Welser on the second floor of the entire north wing of the building; cf. *Philippine Welser & Anna Catharina Gonzaga. Die Gemahlinnen Erzherzog Ferdinands II.*, ed. by Alfred Auer, exh. cat. (Innsbruck, 1998), p. 9; The statement that this was the so-called "Frauenzimmerboden", the floor of the *fraucimor*, is however problematic, as this was most probably on the third floor and not the second floor of the building.

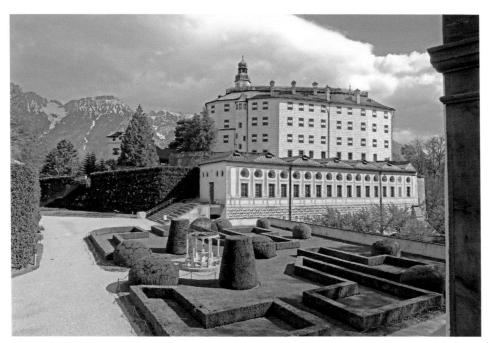

Fig. 10. Ambras Castle

If we compare the present ground-plans of all the floors of Ambras Castle, we discover that there is hardly any difference between them (which is not really surprising, if only for structural reasons) and each floor has around 15 rooms. In contrast to this the 1596 estate inventory ÖNB gives completely different data: according to the inventory, the "Frauenzimerpoden" (the *fraucimor* floor) has about twenty-one rooms, the "Mittlerer poden" around thirty-one rooms, and on the contrary the "under poden" has only around ten rooms. A certain system may be found in the naming of the interiors; there is a prevalence of *stube* for residential spaces and *camer* (chamber) is used for bedrooms. The "stube – camer" coupling formed the basic living unit in the middle of the 16th century. The archduke and his wife evidently had almost identical "apartments" consisting of an entrance hall, known as the "flecz" or "tenne", followed by the "taflstube" (dining-room), "saal" (hall), transition rooms, and a bedchamber, in this case designated by its full title of "schlafcamer". The archduke also had a study or office – "geheime schreibstübl" (secret or private study) and this was abutted by the servants' quarters, including those of the archduke's valets and food bearers ("truchsässen camer").

Alongside the archduchess, on the other hand, there lived the ladies of the court, and only one room (or perhaps only part of one room) evidently served as a small private oratory. We can probably assume with some certainty that the large rooms of the dining-room and the halls were in the area by the entrance staircase. The north wing was used for the nobles attending or visiting the archduke and archduchess, and the south wing, with a lesser view of the landscape, accommodated the servants.

According to a less extensive, older inventory[57] it appears that this distribution of the rooms already existed following the reconstruction of the castle undertaken between the years 1564–1571. Other buildings described in the 1596 inventory ÖNB have a similar arrangement – the archduchess living on the floor above the archduke in apartments with a similar number of rooms, even though in these other buildings there is sometimes also an anteroom or "wartstube", in other words the anteroom to the representative apartments. At Ambras Castle it seems that the 'hall' fulfilled the function of both of these two rooms – the antechamber and audience chamber – that later became the universal norm.

So far we have practically ignored the arrangement of the communication spaces – *Stiege* and *Gänge* (stairs and corridors) – for which the inventory does not in any case provide much extensive and relevant data. The connection between the bedchambers of the archduke and archduchess one above the other by means of a small spiral staircase is one example of such architectural 'communication'. On the other hand, the spiral staircase in the south round tower may have been used to carry food to the upper floors – indeed, we may regard the kitchen described as existing on the floor of the *fraucimor* as a practical measure to facilitate the heating of food brought from the main kitchen in the north wing.[58] From medieval times the aforementioned entrance halls – the *flecz* and *tenne*, which were often quite large – were often also used as a means of connecting different spaces within the castle, and therefore were also 'communicative'.[59] We can find excellent examples of such rooms, for instance, in the castles of Vohenstrauss or Velthurns. Even more widely used in castellology, however, was a term with similar meaning: *Dürnitz*,[60] which does not, however, occur in Archduke Ferdinand II's 1596 estate inventory ÖNB.[61] It continues to be a problem for researchers that the word *tenne* (threshing floor – the central passage through a barn where the grain was threshed and the straw thrown to the sides) is used only on the *fraucimor* floor, whereas similar rooms on the other floors are described exclusively by

57   Boeheim 1888, pp. CLI–CLXIII, reg. 5273: *(1571–1572) Inventar der gesammten im Schlosse zu Innsbruck, im Schosse zu Ambras […] vorhandenen Fahrnisse Erzhertzogs Ferdinand von Tirol und seiner Gemahlin.*

58   In Baroque chateaux usually called the *rechaudofen* (food-warming oven).

59   These are medieval terms used in urban architecture, cf. http://www.retrobibliothek.de/retrobib/seite.html?id=115606 *Tenne*, s. *Scheune*; Otto Stolz, ,Über die Bauart der Innsbrucker Bürgerhäuser im Mittelalter', *Veröffentlichungen des Museum Ferdinandeum* 20–25 (1940–45), pp. 17–26.

60   Cf. for instance Neuburg an der Donau – Große Dürnitz, Kleine Dürnitz.

61   Hans Koepf and Günther Binding, *Bildwörterbuch der Architektur* (Stuttgart, 2005), p. 148, states that "Dürnitz" (slaw. dwornitza, turnitza, i.e. Feuerstätte), is the name for a room with heating or a hall in a castle. The term "Türnitz" also exists, which could be used for an entire building, as is the case of the farm building in the area of the castle of Velthurns, cf. Leo Andergassen, *Schloss Velthurns. Sommerresidenz der Fürstbischöfe* (Regensburg, 2010), p. 46: "Das Stöcklgebäude (Türnitz)"; further see Stephan Hoppe, Hofstube und Tafelstube. Funktionale Raumdifferenzierungen auf mitteleuropäischen Adelssitzen seit dem Hochmittelalter, in *Die Burg. Wissenschaftlicher Begleitband zu den Ausstellungen "Burg und Herrschaft" und "Mythos Burg"*, ed. by G. Ulrich Großmann and Hans Ottomeyer (Berlin, Nürnberg and Dresden, 2010), pp. 196–207.

the word *flecz* (entrance hall). Speculation that there could be a certain hierarchy expressed in the meaning of these words is outside the scope of this article.

The need for a reliable index of terms does of course apply to all inventories in general, because in them we find on the one hand frequent discrepancies in the transcription of words, and on the other hand some expressions that are used very subjectively, in keeping with the nature and education of the inventory compiler. Achieving a one hundred percent accurate understanding of the language used in such texts would of course be desirable, but in practice it is impossible. The conclusion of this brief discussion could perhaps be best summarised in the finding that the castle typology of the second half of the 16th century in the Transalpine countries was still influenced by northern urban architecture. In the compiling of estate inventories the commissioners therefore utilised with a certain amount of inventiveness and were even capable of describing castle interiors, for example at Ambras Castle, with terms – I have in mind *flecz* or *tenne* – normally used for farmsteads.

Eliška Fučíková

## Archduke Ferdinand II and building activities of Hans Tirol at the Bohemian court

In a letter to his father Emperor Ferdinand I dated 2nd of October 1563, Archduke Ferdinand II summarised the case of the former court builder Hans Tirol. Apart from the emperor and his son, both the Royal Bohemian Chamber and the Court Chamber of Ferdinand I had been engaged with this matter for a rather long period of time.[1] The main issue was the undocumented settlement of construction works which were carried out at Prague Castle and within the domains of the Royal Bohemian Chamber under the supervision of the court *Baumeister* (master builder) Hans Tirol. The archduke found it inexcusable that Tirol had not kept a record of his income and expenses even though he was obliged to do so under the relevant building regulations. The history of Hans Tirol's sojourn in Bohemia thus provides us with a special insight into life at the royal court during this period. Moreover, it is an interesting testimony to the activities of Archduke Ferdinand II, the governor of Bohemia, and his engagement with the building activities at Prague Castle and throughout the Royal Bohemian Chamber domains on behalf of his father, Emperor Ferdinand I.

Hans Tirol is commonly recorded as having been born in Augsburg in 1505/1506. He was apprenticed as a painter in the studio of Jörg Breu the Elder, married Breu's daughter, and then decorated the Weberhaus in Augsburg along with his father-in-law. He also published a work entitled *Römer Kaiserl. Maiestat Carolij der Fünfften Belehrung über das Haws Österreich* based on the drawings of Jörg Breu the Elder and Jörg Breu the Younger. Hans Tirol was Augsburg's *Bauvogt* and later *Baumeister* (construction manager and then master builder for the city of Augsburg) between 1542 and 1548; from 1544 on he was responsible for the city's new fortifications. Ferdinand I, the current king of Bohemia and the future emperor, invited Tirol to Prague in 1551 where he collaborated with Bonifaz Wolmut on the construction of the upper part of the Royal Summer Palace. He supervised the reconstruction of palaces in Kostelec nad Černými Lesy, Poděbrady, Brandýs nad Labem, and Křivoklát and also contributed to the construction of the Hvězda Summer Palace. We assume that he collaborated with Pietro Ferrabosco and Bonifaz Wolmut; historical sources reveal his restoration plans (intentions) for Saint Vitus Cathedral and some of his professional reports. It is also incorrectly said that Tirol was appointed chief builder of the Bohemian Lands in 1559. Four years later, he was dismissed and shortly afterwards impris-

---

1    Prague, The Archives of the Prague Castle (hereafter as APH), Česká dvorská komora, cart. II, inv. no. 176, original of the letter, see also Karl Köpl, 'Urkunden, Acten, Regesten und Inventare aus der k.k. Statthalterei-Archiv in Prag', *Jahrbuch der kunsthistorischen Sammlungen des Allerhöchsten Kaiserhauses* (hereafter as *JKSAK*) 10 (1889), pp. LXIII–CC (CXXVI), reg. 6208 (Copialbuch. 74, fol. 182).

oned for debts. In 1570, he returned to Augsburg, received an annual pension from
Emperor Maximilian II, and died there in 1575/1576.[2]

However, should the reader rely on this common narrative of Tirol's life, the pic-
ture he or she forms of Hans Tirol will in fact be completely erroneous. The published,
and even more so the unpublished, archival documents shed a rather different light on
Hans Tirol in the service of the Habsburgs.[3] The surviving correspondence of the king
Ferdinand I with Archduke Ferdinand II and Hans Tirol, as well as the reports of
officials and the 1555 memorandum of the commission of experts charged with review-
ing the existing and planned construction at Prague Castle and in the Royal Bohemian
Chamber domains, still only provide an incomplete picture of the builder's activities
during the period in which the king's son and governor Ferdinand II supervised the
building activities in Bohemia. This picture is nonetheless more plausible than that
given by the basic narrative outlined above.

Hans Tirol's period in Augsburg was exceptionally successful. He contributed to
two codices with remarkable contents: both were in fact richly decorated world
chronicles. They are currently held in the Eton College Library in England and in the
Real Bibliotheca de San Lorenzo de El Escorial in Spain. Heidrun M. Lange dedicated
a detailed study to both of these, which was published in the catalogue of the *Bürger-
macht & Bücherpracht* exhibition held in Augsburg in 2011.[4] Similar to many other
authors, Lange assumes that Hans Tirol was not the real author of the codices but
rather that he compiled them from multiple texts – classical, older, and contemporary
ones – some of which have not yet been identified. There is also a similar situation
concerning a famous woodcut from 1536 showing Emperor Charles V granting Ferdi-
nand I the fief rights to the Austrian hereditary lands. It does not provide any evidence
indicating Tirol's own production, although he financially supported the publishing of
this woodcut in Augsburg.

Lange states that in the dedication of the Eton Codex to Henry VIII, King of Eng-
land, Tirol indicates that he is descended from a family of *Herolds* (heralds).[5] Heralds
were proper court officials well versed in court etiquette, heraldry, and ceremonies,
who kept chronicles and books of coats of arms. They were organised in a guild to

2    Ludger Alscher et al, *Lexikon der Kunst, Architektur, Bildende Kunst, Angewandte Kunst, Industrie-
     gestaltung, Kunsttheorie*, I (West Berlin, 1984), p. 183.
3    Pavel Vlček, *Encyklopedie architektů, stavitelů, zedníků a kameníků v Čechách* (Prague, 2004), p. 664
     (incl. earlier bibliography); Madelon Simons, 'Up at the Castle and Down Town Prague. The Position
     of the Baumeister at the Habsburg Courts in Prague and Vienna in the middle of the Sixteenth Cen-
     tury', in *The Artist between Court and City (1300–1600)*, ed. Dagmar Eichberger, Philippe Lorentz
     and Andreas Tacke (Paderborn, 2017), pp. 147–161.
4    The two codices were analysed in detail in the second volume of the exhibition catalogue of *Bürger-
     macht & Bücherpracht*: see Heidrun M. Lange, 'Die Augsburger Prachtcodices in Eton und im
     Escorial', in *Bürgermacht & Bücherpracht: Katalogband zur Ausstellung im Maximilianmuseum
     Augsburg vom 18. Märtz bis 19. Juni 2011*, ed. by Christoph Emmendörfer and Helmut Zäh, exh. cat.
     (Augsburg, 2011).
5    Lange 2011, p. 49.

Fig. 1. Sententia Heroaldi Joannes Tirollus, Eton Codex (Eton College
Library, sign. MS 92, the verso of the last leaf of the index)

which they could be admitted following a rigorous seven-year training period.[6] The
position of imperial herald was the highest goal for such men. The Bayerische Staats-
bibliothek holds a book of coats of arms in which Anton Tirol is indeed recorded;
however, as Heidrun M. Lange remarks, his relationship with Hans Tirol remains
unclear – he could have been his father or even grandfather. It does appear that Hans
Tirol owed his exceptional education and ability to collect such a monumental sum of
knowledge and compile it into a single compendium to his upbringing and family

6    *Meyers Konversations Lexicon*, 5th Edition (Leipzig and Vienna, 1897), p. 701 (Herold); for a
summary of the heraldic institution see Nils Bock, *Die Herolde im römisch-deutschen Reich. Studie
zur adligen Kommunikation im späten Mittelalter* (Ostfildern, 2015).

background. The first volume, fol. 9v preceding the chapter *Sentencia heroaldi* of the Eton Codex, features a herald's figure commissioned by Hans Tirol, which might have been intended to represent him.[7] (Fig. 1) He even dedicated a special section to heralds and their activities although he was not a member of the herald's guild at that time. Yet, he proudly mentioned his then-current profession: 'Joannes Tirollus, Rei publicae Augustanae aedificiorem publicorum Praefectus', meaning the one who supervises the construction works in Augsburg: the municipal construction manager in today's language.

Tirol's marriage to a daughter of Jörg Breu the Elder as well as his collaboration with Breu's son in their family studio allowed him to make good use of his extensive expert knowledge, organisational skills, and a doubtless substantial talent for business in producing the two above-mentioned codices. Because of the enormous demands of the project, the Augsburg City Council had to be involved in both the codices' commission and financing. At that time, working on compilation of both codices, Tirol was the best-paid employee of the city, with an annual income of 300 guilders. In 1541 he was appointed also as *Bauvogt* (construction manager), and in 1542 as *Baumeister* (master builder).[8] As *Baumeister*, he contributed to the construction of Augsburg's fortifications. After finishing his work on codices, Tirol's salary (only 50 guilders) as the city's *Baumeister*, fell far below his previous income and evidently did not correspond with his expectations: he terminated his work for the city of Augsburg, probably as early as 1548, in order to seek new employment.

The Escorial Codex was completed during 1548, and because Jörg Breu the Younger had died the previous year, Hans Tirol had to supervise its finalisation since he was familiar with the running of the painter's studio. Tirol certainly would not have missed the moment when Cardinal Truchsess of Waldburg, as the highest catholic authority of the city, presented the Escorial Codex to Philip II of Spain during the Spanish king's visit to Augsburg on the 24th of February 1549.[9] It is probably also no coincidence that Tirol dedicated another work to Philip II in the same month, namely his handwritten 65-folio text entitled *Quomodo rei militaris certa et utilis disciplina ad christiane reipublicae…. commodum et salutem quo victotiam adversus ostes suos…acquirant institui reformari ac suspici debeat brevis descriptio et declaratio.*[10] In addition to the voluminous

---

7    See more in Lange 2011, p. 11.

8    Lange 2011, p. 49. He was already 37 years old when he was admitted to the guild in Augsburg.

9    Elisabeth Scheicher, 'Eine Augsburger Handschrift als Geschenk für König Philipp II. von Spanien: Zum Œvre Jörg Breus der Jüngere', *Münchner Jahrbuch der Bildenden Kunst*, 3.F. 44 (1993), pp. 151–179 (152–153).

10   *Quomodo rei militaris certa et utilis disciplina ad christiane reipub. atqve sacre catholicae caesareae et regiae maiest. earundemque successorum et omnium Ro. Imp. statuum commodum et salutemquo victoriam adversus hostes suos et precipue contra Turcam acquirant institui reformari ac suscipi debeat brevis descripti et declaratio.* Autore Ioanni Tirollo. Anno M. D XLVIIII mense Februario. The manuscript is deposited in: Prague, Vojenský historický ústav, sign. IIR F 345, paper, 42.5 ×30 cm; f. 2r–2v dedicated to Philip II of Spain, signed with the author's name, Ioannes Tyrolus, civis Augustanus; fol. 3r–4v a poem dedicated to Charles V and Ferdinand I, bilingual text, identical in Latin and German; the prologue is followed by two parts: Pars prior de veterum Romanorum

world chronicle of the Escorial Codex, which the cardinal presented to Philip II and was to become part of the royal library, this other work by Tirol, perhaps originally intended as a personal gift for the Spanish king, would have served to emphasise the author's broad scope of knowledge and skills. Tirol's treatise on military matters, *Quomodo*, which was submitted along with the Escorial Codex, could have also discretely indicated that Tirol with his versatile talents might also have been a suitable candidate for a position at the Spanish court. Yet it seems that he did not succeed with his gift; he did not even get a chance to present it. The treatise did not arrive at the San Lorenzo Library along with the codex given to Philip II, and the observable plethora of corrections and interlinear notes indicates that someone revised Tirol's neatly handwritten text. It could even have been Tirol himself, adjusting the edited version for a new potential recipient.

No specific records about Tirol appear in the surviving documents from the following two years. Having seen the Escorial Codex handed over to Philip II, Tirol terminated his collaboration with the Augsburg City Council and resigned from his poorly paid position as the city's *Baumeister*. After 1548, he no longer appeared in the city's official records in that position. Yet, he still had a reason to stay in Augsburg. When Emperor Charles V failed to arrange the election of his son Philip II as the King of the Romans during the Imperial Diet held from 1547 to 1548, he made another attempt during the next session. Between 1550 and 1551 the Imperial Diet gathered again in Augsburg. Charles V had to renounce his plans because of opposition from the coalition of his brother Ferdinand I and the Protestant electors. As some Catholic princes joined the latter, the members of the House of Habsburg concluded a *Successionvertrag* in March 1551, which was an agreement on the succession within the empire. This would now devolve upon the Central European lineage, through Charles V's brother Ferdinand I.[11]

All the most significant and most powerful representatives of the empire gathered at the Imperial Diet in Augsburg, providing an ideal opportunity for Hans Tirol to search for a suitable future employer. His works, the Eton and Escorial codices, had arrived at the English and Spanish courts and Tirol could present himself as an exceptionally successful creator with versatile talents. It was at the 1550–1551 Imperial Diet that Tirol might have first encountered King Ferdinand I and Archduke Ferdinand II.

According to an unpublished document reporting on Hans Tirol's court service and the ensuing financial settlement, drawn up by *Puchhalter* and *Rait Rath* (the accountants of the Royal Bohemian Chamber) in 1563, Ferdinand I took Tirol into court service in 1552.[12] However, it is likely that Tirol had arrived in Prague several

---

disciplina militaris, from f. 22r Posterior pars huius libri de disciplina militari hoc nostro tempore necessario restituenta. Before it came to Vojenský historický ústav in Prague, the book was deposited in the Dietrichstein library in Mikulov, sign. 185. The entire content may be downloaded from the digital library *manuscriptorium* (www.manuscriptorium.com).

11    On this point see Alfred Kohler, 'Vom Habsburgischen Gesamtsystem Karls V. zu den Teilsystemen Philipps II. und Maximilians II.', in *Kaiser Maximilian II. Kultur und Politik im 16. Jahrhundert*, ed. by Friedrich Edelmayer and Alfred Kohler (Vienna, 1992), pp. 13–54.

12    APH, Česká dvorská komora, cart. II, inv. no. 176.

months earlier. In March 1553 he wrote to the king that – despite his separation from his wife and children, who stayed in Augsburg – he had been serving the sovereign loyally for two years.[13] At that time, the builder Paolo della Stella was still employed at the court. In a letter dated 5th of October 1552, Ferdinand I asked his son, Archduke Ferdinand II, to send Paolo della Stella and Hans Tirol from Prague to Vienna to present themselves at the Court Chamber.[14] There was a delay which the archduke explained to his father in a letter from the 12th of October, relating that the two builders had had a dispute which caused their late departure for Vienna.[15] The correspondence between the father and son was very swift: as early as the 21st of October,[16] Ferdinand I replied that he did not attach any importance to the squabbles between the two builders. Because Paolo della Stella died immediately afterwards, the situation was simplified. Ferdinand I attached a proposal to this letter, which detailed works by Tirol that he was prepared to implement. The stone arches in the chapels [of St. Vitus Cathedral] were to be painted "fieletisch... das ist ein farb, wie es eur maj. über den stein hie anziehen lassen [...]" (violet clay, used for internal paint of buildings, e. g. on stone). Tirol suggests also, that "complying with the king's wish, the centre of the choir would be decorated with the Bohemian lion, the choir loft would be equipped with the coat of arms of his deceased wife, to the right side of the choir would be the coats of arms of all the kingdoms (of the Holy Roman Empire and of the German nation), and to the left would be the coats of arms of all the hereditary Habsburg lands. Furthermore, the tombstones of all the deceased emperors, kings, dukes, and princes would be repaired. Saint Sigismund Chapel was to be painted with that saint's legend – Tirol reportedly did not have the drawing with him in Prague but promised that the king would find it agreeable when it arrived. The entire cathedral would be repaired both externally and internally, and the lattice encircling the queen's grave would be gilded. The cost of the work was estimated at 1,800 *Thalers*."

In the above-mentioned letter from the 21st of October 1552, Ferdinand I finally asked his son to see that the works at Prague Castle were done according to this list from Tirol, including the copper roofs on the chapels and copper gutters.[17]

Having no more competition, Hans Tirol was in a position to demonstrate that the ruler's decision to engage him in the court's service was a sound one. In his letter dated 30th of March 1553, Tirol presented his future plans, and we can observe that he was already using the title *Ehrnholt und Baumeister*.[18] Tirol indicated to King Ferdinand I that his work had already cost him 10,000 guilders. He stated that he had served the king loyally and protected him from multiple frauds. Tirol was convinced that if the king empowered him to get "power of attorney", he would be able to spare the Royal

---

13  Franz Kreyczi, 'Urkunden und Regesten aus dem K. u. K. Reichs-Finanz-Archiv', *JKSAK* 5 (1887), pp. XXV–CXIX (LXII), reg. 4204.
14  Köpl 1889, p. CXII, reg. 6145.
15  Köpl 1889, p. CXII, reg. 6145.
16  Köpl 1889, p. CXVIII, reg. 6146.
17  Köpl 1889, p. CXVIII, reg. 6146.
18  Kreyczi 1887, p. LXII, reg. 4204.

Bohemian Chamber significant expenses. Tirol explained in the following sentences of his letter that he was in extreme financial difficulty and therefore asked that the king inform him of his decision regarding this proposed 'empowerment' via Doctor Ludwig Schrädin. Tirol further confirmed that he would be the king's loyal servant for the rest of his life. It appears from the official records that this question was then delegated by Ferdinand I to Archduke Ferdinand II.

A document attached to this official record clarifies the matter in detail. Tirol requested that a property identified as the St. Prokopsberg estate, worth 125 *Thalers*, be ceded to him.[19] In return, he would supply the Prague construction sites with timber that the Royal Bohemian Chamber would otherwise buy at a high price. If Tirol's request was met and he received St. Prokopsberg, he would require a quarterly payment of 750 *Thalers* (3,000 *Thalers* per year) as his salary. He further requested that all structures to be built at the king's order be carried out according to his designs, subject to his budget approval and the relevant building regulations. Tirol also stated that if he received a further 75 *Thalers* per week, he would procure stone, bricks, and lime. The building timber and boards would be supplied from his estate at St. Prokopsberg. This meant that the total expenditure for Tirol's household and building material would amount to 7,000 *Thalers* compared to 14,000 *Thalers* spent in the previous year. In the same letter, Tirol further stated that Archduke Ferdinand II had asked him to create models for structures in Prague, Poděbrady, and Brandýs. As the king ordered, the works on these Royal Bohemian Chamber estates would cost 25 *Thalers* per week and per each floor of each palace – and Tirol could take care of that. Concerning the installation of the water and irrigation systems for Prague Castle and its gardens, the king only wanted to release 10 *Thalers* per week. However, not much could be procured for that amount and accordingly Tirol stated that he would do as much as he could – mainly supervise the project to ensure its success. For the money that the king was ready to release for the Prague cathedral, the builder would ensure that the reconstruction will bring glory to the Kingdom of Bohemia and would be completed within six months. Tirol suggested that Saint Sigismund Chapel could be beautifully painted and made a proposal as to how to decorate it. Regarding the roofing of the chapels, Tirol disagreed with using copper because of its high price. Instead he suggested slate, which was easily available: its availability was similar to that of bricks. He asked the king for approval and promised that everything would serve the king's honour and delight.[20]

Apparently, Tirol's activities at court raised issues with those employed in other professions at court. For example, as early as the 16th of July 1554, Ferdinand I asked his son and the Royal Bohemian Chamber to settle a dispute over a payment for material obtained between Hans Tirol and the brickmaker Petr Ciggino.[21] Based on the

---

19    The question arises as to whether this was an 'estate in the Prokop Valley near Prague' as stated by Vlček 2004 or the mines in Skalice near Kutná Hora (referred to as Hora sv. Prokopa / St Procopius Mountain); see Otokar Leminger, *Práce o historii Kutné Hory* (Kutná Hora, 2009).

20    Kreyczi 1887, p. LXII, reg. 4204.

21    Köpl 1889, p. CXV, reg. 6155; APH, Česká dvorská komora, cart. I, inv. no. 146.

Fig. 2. A signature of Hans Tirol (Armer Diener / und Ernholt / Hans Tirol) on the report to Ferdinand I,
December 1554 (The Archives of the Prague Castle, Collection Bohemian Department of the Court
Camber, no. 785)

stance of the Court Chamber, Ferdinand I rejected Tirol's request regarding the estate
in St. Prokopsberg on the 21$^{st}$ of November 1554, as well as his financial demands for
the construction, consenting merely to the admission of Tirol's son Paul to the court's
service (to be employed as his father's assistant), with a salary of 10 Rhenish guilders a
month, and covering expenses for one horse.[22]

While Archduke Ferdinand II was resident in Plzeň between 1554 and 1555, seek-
ing refuge from the plague that had affected Prague, Tirol paid him a visit. It appears
that Tirol addressed King Ferdinand I with his request for help after this encounter,
sending him a very extensive letter in December 1554 which has not yet been pub-
lished.[23] (Fig. 2) Over the previous three years, Hans Tirol had been pointing out, both
in writing and orally, the dishonesty and financial losses taking place on the Habs-
burgs' construction sites. However, he seems to have received no response. At first
Tirol pointed out a need for new building regulations which, when observed, would
prevent huge financial losses. Secondly, he noted that the damage caused by the Prague
Castle fire had yet not been remedied. Thirdly, he stated that the following structures
at Prague Castle had to be prioritised: the royal apartments, the archduke's house, the
White Tower, the Summer Palace, the Diet Hall, the orangery, and the corridor leading
to the church. Tirol wanted to carry out all of the above-mentioned works in 1555 as
well as preparing the material for joiners, lime, stone, and iron bars to reinforce the
White Tower. Tirol wanted to observe the new building regulations but needed docu-

---

22    APH, Česká dvorská komora, cart. I, inv. nos. 148, 149.
23    Ibidem, inv. no. 785, Tirol signed this letter only with the *Ehrnholt* title.

mentation for the structures and so he asked the court chamber to provide it. Instead of receiving a reply, he was sent to Budějovice to an *"ungebildet"* (ignorant) officer, who was tasked with monitoring the Vltava riverbed for timber rafting. Nearly the whole two following pages contain advice and plans on how to improve the transportation of timber from South Bohemia to Prague, and how to reduce the price. Instead, Tirol was then sent to Plzeň to find a source of finances to pay for the timber transportation. He stayed there for three weeks and learned from the archduke that there were no finances available. He probably also heard the unpleasant news about two experts arriving in Prague from Vienna to review the proceeding construction works at Prague Castle. This alludes to the conjecture that neither Ferdinand I nor his son and governor in Bohemia were satisfied with Tirol's building works at the court. Clearly humiliated and offended, Tirol went on to emphasise to the king that he lived in permanent poverty and financed the construction works himself. He claimed that had they followed his proposals, the king would have saved money. Tirol requested that the Royal Bohemian Chamber provide him with an advance payment 1,200 *Thalers* for 1555 to prepare the construction. He stated that this was the only way to prevent damage and financial losses, and only this way he would be able to complete the structures. He wrote that he needed money for the church [i.e. cathedral] tower reconstruction, wanted to paint the church interior and roof eight chapels with copper (seven were yet to be finished). Furthermore, the church still needed glazing. Tirol discussed the form of the organ loft with the organ maker but made it clear he could not start anything until the king specified his wishes. He seemed confident, saying the Vienna builders could arrive: he regretted nothing. He wrote that he would only like to finish what he had started with a clear conscience. The letter concludes with Tirol's lamentation about how he suffered from malevolence, envy, lack of finances, and his family's poverty. This is why he would travel to Prague to meet the commission. He asked the king for instructions and a reply, so he could see what stance to adopt.[24]

As indicated by the date on the letter – December 1554 – Tirol drew up his plans for the following year in his letter after he learned about the planned arrival of the commission during his Plzeň visit. He emphasised that he himself had already prepared exactly what the commission was to examine and that sending the experts to review the existing and planned construction at Prague Castle and Bohemian Chamber domains was pointless.

Fortunately, the visit of the group of experts led by Bonifaz Wolmut and Pietro Ferrabosco is well-recorded in the surviving archival sources. As early as the 5th of December 1554, the king asked his son, Archduke Ferdinand II, to send Wolmut and Ferrabosco from Vienna to Prague as soon as the danger of plague had receded. Their task was to examine all the structures and review their condition.[25] Along with the rest of the commission members, including the archduke, the *Hauptmann* (administrator)

---

24    Ibidem.
25    Heinrich Zimerman, 'Urkunden, Acten und Regesten aus dem Archiv des k.k. Ministeriums des Innern', *JKSAK* 5 (1887), pp. CXX–CLXXVI (CLX), reg. 4529; Köpl 1889, p. CXVI, reg. 6159.

of Prague Castle, and other building experts, they would inspect the buildings, measure them, and suggest further steps or, if need be, prepare new models. They were asked to write a thorough report summarising the situation and, in case of a dispute, each of them was required to supply an individual statement. Ferdinand I particularly asked for their recommendations in relation to his residential apartments, the White Tower, the corridor to the garden, the armoury, his stables, the storeys of his apartments and the new buildings for his son, the water drainage from the kitchen and the well, and rainwater drainage. Furthermore, he requested that the facades of his house be made the same height as those of his son's house. The wall between the church and the king's courtyard was to be demolished to form a single open space. The list of works continues with his order to irrigate the garden, pave the floors of the Summer Palace, equip it with a chimney and a stove, and reconstruct the doors and windows in the royal apartments. On the 18th of January 1555, the king once again asked his son to command the *Rat* (councillor) Hermes Schallauzer to send the two master builders from Vienna to review the Prague construction sites.[26] Archduke Ferdinand II replied on the 28th of January 1555, while still in Plzeň, that he would leave for Prague during the upcoming 'dry days' and would arrange that the two master builders come to Prague immediately.[27] Hans Tirol, undoubtedly familiar with the ruler's requirements, basically repeated these requirements in the aforesaid letter,[28] saying that he had planned everything in the same way for the subsequent year.

The commission did examine the building sites at Prague Castle; thus Ferdinand I was able to write to Archduke Ferdinand II on the 22nd of July 1555 from Augsburg, saying that he had listened to Wolmut and Ferrabosco's report after their return from Prague. He asked his son to commence with the building activities according to the commission's conclusions and recommendations at the earliest possible convenience during the year, and added that he looked forward to viewing the results during his next visit to Prague. The memorandum assembled by the commission was published in three copies, one for Ferdinand I, one for Archduke Ferdinand II, and one for Hans Tirol.[29] The situation did not develop in Tirol's favour: his efforts to become the sole master builder in charge of determining the building activities at Prague Castle and in the Bohemian Chamber domains foundered with the commission's review and conclusions. He was obliged to observe the instructions prepared by the commission of experts. Moreover, it became clear that a good many of works that Tirol had already declared as completed or prepared for construction were not in fact completed or prepared.

Before long, the construction works at Prague Castle and in the Royal Bohemian Chamber domains passed to the authority of Bonifaz Wolmut. On the 15th of June 1556, Wolmut, who was still in Vienna, requested a decision from Ferdinand I regarding the Royal Summer Palace in order to roof it before winter. Furthermore, he asked

---

26   APH, Česká dvorská komora, cart. I, inv. no. 151.
27   APH, Česká dvorská komora, cart. I, inv. no. 152.
28   See APH, Česká dvorská komora, cart. I, inv. no. 785.
29   Kreyczi 1887, pp. LXVIII–LXX, reg. 4240, deposited in Herrschaftacten, Böhmen, Fasc. P. V./i.

for finances to continue the construction works in the church [i.e. cathedral] and for an advance payment to furnish his household and buy food.[30] Five days later, on 20 June, Ferdinand I issued a passport for Wolmut to travel with 'a barrel of clothes and other things': from this, we understand that he was relocating to Prague.[31] As early as the 15th of October, Wolmut informed the archduke in a letter about the proceeding works at the Hvězda Summer Palace in Prague. In the letter's conclusion he complained that despite his embarrassment, he felt he had to mention the grudge Tirol held against him because he, and not Tirol, had been entrusted with the works on the archduke's summer palace.[32] Several days later, the archduke responded by praising Wolmut's work to date and assuring him that neither he nor the emperor attached any weight to Tirol's slander.[33] In the next letter dated 15th of November, while still in Vienna, the archduke announced his pending arrival in Prague and expressed his wish that the construction works at Prague Castle be completed if at all possible.[34] This leads us to the conclusion that Tirol was no longer commissioned for large construction work at Prague Castle or elsewhere.

Having been informed about the oral and written observations of Bonifaz Wolmut and Pietro Ferrabosco, as well as those of the Italian stonemason Giovanni Campione and the bricklayer Guiseppe Soldata, King Ferdinand I informed the archduke in a letter dated 31st of January 1557 about his decisions concerning the Summer Palace in the Royal Garden, the organ loft in the cathedral, and the building activities in Poděbrady.[35] Wolmut, alongside Campione and Soldata, would continue with the construction of the first storey of the Summer Palace; the king negotiated a better price with them compared to the one proposed by Hans Tirol. Campione designed the organ loft but the king did not like it and preferred Wolmut's more elegant design. He wanted to send Campione to Poděbrady to work on the old staircase, the corridor, the portals for the palace, and the fountain in the courtyard. Tirol was instructed to give Campione 215 *Thalers* for this project. Archduke Ferdinand II replied to the king's instructions, saying he had received the aforesaid designs and would attempt to have them implemented within the shortest possible time. However, he pointed out a desperate shortage of money: Campione, Soldata, and many others had already been working in Poděbrady, Kostelec, Prague, and many other sites for some time and had not received any payment for an extended period.[36] Moreover, the archduke stated that he had already sent the new regulations for the construction works at Prague Castle for the king's approval. Ferdinand I forwarded these to the councillor Hermes Schallautzer in Vienna for scrutiny. He was asked to amend the text if necessary and

30  APH, Česká dvorská komora, cart. I, inv. no. 158.
31  Ibidem, inv. no. 159.
32  David von Schönherr, 'Urkunden und Regesten aus dem k.k. Statthalterei-Archiv in Innsbruck', *JKSAK* 11 (1890), pp. LXXXIV–CCXLI (CLXVII), reg. 7227.
33  Schönherr 1890, p. CLXVII, reg. 7229, Vienna, 1 November 1556.
34  Schönherr 1890, p. CLXVIII, reg. 7233.
35  Kreyczi 1887, p. LXXII, reg. 4256.
36  Kreyczi 1887, p. LXXII, reg. 4257.

send it back, so that Ferdinand I would have the finished document before his travel to Prague.[37]

After that, Hans Tirol only occasionally appeared at Prague Castle; after all, he had not even been commissioned with any major construction works during the earlier phase when he held the position of court *Baumeister*. From 1556 on, Bonifaz Wolmut proved a more than adequate replacement for him. Nevertheless, Tirol was extremely flexible and quickly found a new area of work. Tirol's name occurs in published sources from a later period in relation to ore processing. According to these sources Hans Tirol, alongside Sebastian Essen and other assistants, offered a new method of ore processing, 'Schmelzkunst', suggesting that this method should be kindly adopted by the emperor and promising that it would serve for His Majesty's amusement. Ferdinand I asked Archduke Ferdinand II to organise a review, or rather a test, of Tirol's suggested method by the experts in Kutná Hora and to then inform him of the outcome. In his letter dated the 27th of March 1560, the archduke informed his father that he had done so and was expecting the result of their examination.[38] Nonetheless, the father and son had also exchanged letters on this topic several months earlier, on the 23rd of February 1559, when the archduke replied to the emperor's request dated September that year, related to the plea of Hans Tirol. The latter had asked for an audience with the emperor in Augsburg to present him the new 'wasch-und puchwerschkunst'.[39] But it was not Tirol's first attempt to search for success in a completely different field to that of architecture.

The "Dvorská komora" *Fonds* (Bohemian Court Chamber archivals) in the Prague Castle Archives includes an extensive file on Hans Tirol under the inventory number 164, which has not received any scholarly attention even though it concerns his mining business.[40] The majority of the documents in this file are related to the year 1557, after the end of the turbulent period following the Schmalkaldic War, and the resolution of the problems of the succession to the throne of the Holy Roman Empire. The fatal lack of finances once again caused Ferdinand I to turn his attention to the extraction of silver and copper (the raw materials needed for ore processing), and Tirol again grasped at the opportunity this presented.[41]

The above-mentioned documents on mining contain further details that ought to be added to Tirol's curriculum vitae. In the first extensive letter to Ferdinand I, Hans

---

37  Kreyczi 1887, pp. LXXII–LXXIV, reg. 4258.

38  Köpl 1889, p. CXVIII, reg. 6176.

39  In ibidem, Köpl refers to Copialbuch no. 63, fol. 76. Copialbuch no 68, fol. 52: the archduke replied on the 23rd of February to the emperor's request concerning Tirol, and informs that his method is identical with that submitted earlier by Hans Rudolf Plauneckher, which he had previously informed the emperor about. Since such proposals occur rather frequently, the archduke writes that it must be discussed with the experts in Kutná Hora.

40  APH, Česká dvorská komora, cart. II, inv. no. 164. The content of these archival materials is extremely significant, mostly for scholars examining ore mining and processing in the Lands of the Bohemian Crown, Upper Austria, and Hungary.

41  John A. Noris, 'Mining and Metalogenesis in Bohemia during the Sixteenth Century', in *Alchemy and Rudolf II: Exploring the Secrets of Nature in Central Europe in the 16th and 17th Centuries*, ed. by Ivo Purš and Vladimír Karpenko (Prague, 2011), pp. 657–670.

Tirol stated that Ferdinand I had asked his son Archduke Ferdinand II to accept Hans Tirol into the court service (folio 4). According to Tirol, this occurred on the 12th of January 1552. Tirol attached a copy of the decree, which was however issued on the 25th of October 1552 in Ebersdorf (folio 7). In his letter dated 20th of July 1557, Tirol referred to himself only as *Ehrnhold*, and primarily demanded the outstanding payment of his salary, as well as pointing out the various sources of finances for the *Hoffinanzkammer* (Royal Bohemian Chamber Treasury) such as escheats or taxes from Silesian domains [fol. 4–6], that could be used to pay him. It appears that he was in fact no longer interested in building activities in Prague and the Royal Bohemian Chamber domains, because he had found a more profitable field. He was now focused on the extraction of raw materials for processing of ore, which is the subject of the other sections of this newly discovered file. Tirol was apparently even interested in the position of *Oberbergmeister* (chief administrator of mining) which King Ferdinand had reputedly promised to him. His activities were certainly aimed towards two goals: having his debts relieved by the king, and acquiring an office to secure his living.

Although Tirol was not an officially authorised *Baumeister* at the court during this period, he emerges in various documents in connection with the Prague Castle building activities. Prior to the 11th of May 1559, he wrote to Emperor Ferdinand I that the prelates of Prague had asked him for approval to make openings for two doors on the organ loft's ground floor.[42] He also asked for 500 *Thalers* to complete the beautiful fireplace at Poděbrady Castle, where Campione was working. Furthermore, he had become familiar with Bonifaz Wolmut's budget for the Diet Hall construction and with the design submitted by Aostalli and Campione. Tirol accused Wolmut of creating a less economical design, claiming he had asked for 1,631 *Thalers* more than the Italians.[43] On the contrary, Wolmut's budget was in fact 1,631 *Thalers* cheaper than that proposed by the Italians. Archduke Ferdinand II provided an extensive explanation of this matter to his father in June 1559.[44] According to the archduke, the prelates knew nothing about the doors, and had not ordered them, and hence he asked the emperor to decide upon this matter when he arrived in Prague. Concerning the construction of the Diet Hall, negotiations on the price reduction with the Italians were difficult. Moreover, they did not want to work with Bohemian and German artisans; there was a constant friction with them. But the archduke attached the Italian *"modell"* to the letter to give his father an idea of the proposal.[45] In his letter dated 27th of June

---

42  Kreyczi 1887, p. LXXVII, reg. 4282.

43  Kreyczi 1887, p. LXXVI, reg. 4278, 30 January 1559, the archduke attached the offer from the Italians, who asked for 5,668 *Thalers*, stating that Wolmut wanted to build the same structure for 3,300 *Thalers*.

44  Ibidem, pp. LXXVII–LXXXIV, reg. 4283.

45  For more information and drawing reproductions see most recently *Arcivévoda Ferdinand II. Habsburský: Renesanční vladař a mecenáš: Mezi Prahou a Innsbruckem / Ferdinand II. Erzherzog von Österreich aus dem Hause Habsburg. Renaissace-herrscher und Mäzen zwischen Prag und Innsbruck*, ed. by Blanka Kubíková, Jaroslava Hausenblasová and Sylva Dobalová (Prague, 2017), cat. no. II/52, pp. 152–153 and II/52, p. 74.

1559, the emperor instructed the archduke to prepare the necessary documents for Wolmut to commence the building of the Diet Hall.[46]

Despite the fact that Tirol, as it emerges from the above documents, still commented on building activities at Prague Castle during this period, his main focus was on mining and its associated activities. On the 2nd of February 1560, Archduke Ferdinand II replied to the emperor's order to ascertain the legitimacy of Hans Tirol's proposal regarding the new method for ore processing.[47] The archduke reminded the emperor that he had also sent a similar proposal from Hans Rudolf Plaueneckher describing the new method, which was also assessed by the Kutná Hora commissioners. He said he would forward this proposal by Hans Tirol and Sebastian Essen to the commission as well, and would inform the emperor of their opinion.

In the following year, 1561, Archduke Ferdinand II had to repeatedly deal with unresolved past financial issues caused by Hans Tirol. Having read the report of Christoph of Kärlingen, who had previously paid 8,000 *Thalers* to the Tirol for various construction works at Prague Castle and who demanded that Tirol provide a written statement of the expenses, the archduke intervened in person.[48] The archduke wrote that half a year earlier he already asked Tirol to settle everything. Yet Tirol did not appear before the archduke, even though he was close to Prague in Kutná Hora; instead, he made excuses, citing illness and his upcoming journey to Vienna, and claiming that he had not been informed about the financial settlement results. The archduke gave orders to have Tirol's illness verified, and made efforts to force him to appear in Prague to explain his actions in person. Nevertheless, none of these issues were resolved with Tirol at that time. Although Tirol had provided some accounts to the *Boehmische Kammerbuchhalterei* (accounting office of the Royal Bohemian Chamber) in the previous year that were correct,[49] the chamber was still missing receipts from Tirol amounting to 4,229 *Thalers*, 24 *Groschen*, and 4 and a half *Pfennig*: this meant that this sum was not accounted for in the verifiable building expenses. Tirol made excuses, admitting that he had delayed sending the information, but the archduke clearly remembered that they had discussed the issue two years before, and that he had even sent an equestrian messenger to Tirol. Reportedly, Tirol would constantly say he was ill, and even if he appeared at court he never submitted any receipts. Instead, he continuously wrote pleas and eventually convinced the archduke that ore processing had not proven as profitable as Tirol had expected. Because of this, the archduke offered to forget about the financial settlement with Tirol and erase the debts he had incurred as the former court *Baumeister*.

It may be no coincidence that Hans Tirol presented a gift to King Maximilian II via Archduke Ferdinand II at that exact time (1563). This gift consisted of various documents from Tirol's time as court *Baumeister,* including those he had brought from his

---

46    Kreyczi 1887, p. LXXXIV, reg. 4284.
47    Köpl 1889, p. CXVIII, reg. 6176, including a reference to Copialbuch, no. 63, fol. 76.
48    Köpl 1889, p. CXXI, reg. 6187 of 23 July 1561.
49    Köpl 1889, p. CXXIV, reg. 6203 of 30 June 1563.

previous engagement in Augsburg. These consisted primarily of a collection of forty pen and ink drawings depicting armoured figures that may have been used as templates for genealogical painting cycles.[50] The "hiebeÿliegenden Schriften" also formed part of this gift, among them one concerning "widerstandt gegen den Türgkhen".[51] The gift was clearly motivated by Tirol's desire to attract the attention of the future emperor, and win his favour. Though Maximilian II's immediate reaction was not recorded, Tirol received favours from him several years later in the form of financial support during the former court *Baumeister*'s declining years in Augsburg.

The resolution of this lengthy case, which simultaneously sheds light on further details of Hans Tirol's life, is known via a letter from Archduke Ferdinand II to the emperor which to date has only been published in the form of a *Regest*.[52] The original letter is held in the Prague Castle Archives.[53] Except for the salutation, this text is identical to the *Regest*'s version. However, the version in the *Regest* omits the important document originally attached to this letter. Prior to responding to the emperor, the archduke asked *Puchhalter* and *Rait Rat* (accountants to the Royal Bohemian Chamber) to provide further elaboration on a report concerning the way in which Hans Tirol's activities were recorded in the chamber's records. Hans Tirol did not successfully defend his expenditure and the purchases he had made, and hence he asked respectfully to be excused from submitting these expenses. Afterwards, the emperor sought expert advice as to whether this was legally possible. The two officials confirmed that Tirol had been hired as the official *Baumeister* at Prague Castle in 1552, and held this position until 1556 when the *die Herren Kammerrath und Herr Landtschreiber* (court councillor and the land scrivener) informed him that Bonifaz Wolmut had been appointed court *Baumeister* in his place. In his defence, Tirol said that he had no instructions to request receipts for monies paid to the 'Parteyen', evidently meaning the suppliers of material and labour. He further described the chaotic payment of wages to bricklayers, which was apparently caused by the unclarified

---

50    Eliška Fučíková, 'Ein Zyklus von Zeichnungen Habsburger Herrscher im Nationalarchiv in Prag', *Umění/Art* 66 (2018), pp. 60–71.

51    Prague, National Archives, České oddělení dvorské komory (ČDKM), inv. no. 562, sign. I.E.1, cart. 22: "Demnach mir der Rö. Kaij. Mjt. unsers Allermechtigsten geliebten Herrn und Vatter gewesner Ernholdt und Paumaister alhie aufm Prager Schloß Hanns Tÿrol hiebeÿligende Schriften und abgemalte Figuren des hochlöblichen Haus Österreÿch Plüntlini, unnd dann auch das hirige Schloß gebeÿ unnd widerstandt gegen den Türgkhen – betrefendt übergeben. So hab ich solche Sachen zu Sünlicher verschauung Ihrer Kaÿ. Mjl. an niemanden anderst fueglicher unnd billicher weiter gelangen lassen, unnd zuüberschickhen sollen als E. Kun Mtl. Unnd Lieb, sonderlich weil Er Tÿrol solche wichtige Sachen und nutzbarkait fürgeben thuet, welche gleichwol meines bedunckens nit allerdings zuverachten, unnd Er vielleücht in etlichen Sachen etwas mer als andere wüssten mächte. Darauf werden nun E. Khn. Mjt. Unnd Lieb angeregte Schrifften unnd Sachen zu Irer gelegenhait genedigist zuersehen, unnd sich weitter darüber zuresolvieren, unnd mir dieselbige Resolution zuekhommen zulassen wüssen, damit Ich Ime Tyrol derselben verner(?) beschaiden lassen müge, E. Kun. Mjt. Unnd Lieb mich damit zu gnaden und Brüderlichen hulden gehorsamblich beuelchendt."

52    Köpl 1889, p. CXXVI, reg. 6208 of 2 October 1563.

53    APH, Česká dvorská komora, cart. II, inv. no. 176.

powers of particular officials. It was necessary to discover whether Tirol had received an advance payment of several hundred *Thalers* for a certain structure. However, this structure was already completed, and the archduke was in fact resident there.[54] Tirol failed to explain a sum of expenses amounting 3,181 *Thalers*, and the officials confirmed this to the archduke in their statement. Eventually, the emperor agreed to pay this amount. The officials had no information about Tirol's current residence and activities; they had nothing to report. Regarding Tirol's salary, in 1556 he was still in the court's service, and was dismissed by the court councillors thereafter. Nonetheless, he received a salary of 1,049 *Thalers* between 1557 and 1560, as evidenced by the accounts of the former treasurer Hans Riegl (Siegl?). During these four years he was not in the service of the archduke or the emperor, but was instead devoted to his ore processing activities elsewhere. For this reason, the officials requested a decision from the archduke and the emperor as to whether Tirol was entitled to this salary from a period when he was no longer in the court's service.[55]

Based on the report of the *Buchhalter* and *Rait Rat*, Archduke Ferdinand II could finally assemble a summary report for the emperor. Tirol's excuse of having no instructions to follow could not be accepted because there were building regulations in force at Prague Castle. Regarding the structures which were actually erected during the period when Tirol was an active *Baumeister* in Prague – structures whose existence is confirmed – it may be assumed that these were paid for from the finances he had received and paid to workers. It remained unclear whether he had spent some of this money on his personal needs, sold anything, or borrowed money from other sources. The archduke had been informed by a trusted source that Tirol had nothing. However, he should have returned the salary that he received unrightfully after his dismissal from court service. But because Tirol was destitute by this point, reduced to the status of a beggar, sending him to prison would serve no purpose. He had no other income at the court, the archduke knew nothing about Tirol's herald's office, and although he had the records of the Royal Bohemian Chamber searched, this did not reveal any documents confirming Tirol's position.[56]

Although Hans Tirol was descended from a family of heralds, universally educated men well versed in court ceremonies, heraldry, and genealogy, he never achieved this title himself. To be an *Ehrnhold*, a herald, was often an honourable representative function.[57] If we wished to find a modern equivalent to this title, he would be an honorary consul, a person self-financing his or her office. Accordingly, Tirol could easily appropriate and use such a title in order to make himself appear 'special' and to indicate that he was not merely a *Baumeister* or master builder, but also held a higher status on account of the knowledge and skills acquired from his family background.

---

54   It appears that it concerned the construction of the archduke's house.
55   APH, Česká dvorská komora, cart. II, inv. no. 176.
56   Köpl 1889, p. CXXIV, reg. 6203.
57   *Meyers Konversations Lexicon*, 5th edition (Leipzig and Vienna, 1897), p. 701 (Herold), p. 419 (Ehre); Lange 2011, p. 49.

Archduke Ferdinand II's report on the financial settlement, sent to the emperor in 1563, did not however bring the case to an end. The following year, on the 13th of October 1564, the "former builder and *Ehrnhold*", meaning Tirol, addressed Antonín Brus of Mohelnice, Archbishop of Prague, with his customary complaints about the ore processing issues, the construction of the royal apartments at Prague Castle and the armoury, as well as the Ottoman threat.[58] This contact might have been inspired by the fact that the archbishop had commenced renovating the former Griespeck Palace at Hradčany district as his new residence, having received it in 1562. Tirol clearly wanted to attract the archbishop's attention, hoping to be hired by him. Tirol most definitely needed a job, because the following year he was imprisoned for debts he owed to Gregor of Disterwald.[59] He fled to Augsburg but the creditor pursued him there and exacted the debt from Tirol's son.

Tirol's case was not resolved until the rule of Emperor Maximilian II. On the 5th of October 1568, the new emperor ordered the Royal Bohemian Chamber to report on the previously requested financial statement from Hans Tirol. He was interested in when the court hired Tirol, when he was dismissed, the amount of his salary, how much money he had received, and how much he owed.[60] It took nearly a year before the emperor terminated the case. He informed the Royal Bohemian Chamber that the undocumented expenses amounting to 4,232 *Thalers*, 7 *Groschen*, and 3 and a half *Pfennig* originated from the period when daily wages at the court construction sites were not matched with receipts. The structures commissioned during that time were completed and Tirol had nothing. Therefore, the emperor decided to forgive him for his disorderly documentation and to cease requests for receipts for this sum. As it emerges from the report, Tirol was to receive a further 581 guilders and 10 *Kreutzer*. Because his rent and other expenses from the time of his service at the court were not included in the settlement, he was to receive an additional 600 guilders as an "expectanz". Tirol spent his declining years in Augsburg, and the exact date of his death remains unknown, perhaps 1575 or 1576.

In reality, the official engagement of Hans Tirol in the court's service was short and rather unsuccessful. He embarked on his building career quite late, at the age of 37, and apparently had insufficient experience; thus even in Augsburg he was not commissioned to complete any significant construction work. He searched for a position *pro futuro*, one in which he would be able to make good use of his organisational skills and manage the work of others. He found the royal court of the Bohemian Lands prestigious enough to match his high ambitions. Nonetheless, King Ferdinand I and his son, Archduke Ferdinand II, were both experienced in commissioning building and construction work in their domains and soon recognised that taking Tirol into court service was a mistake; not only because of his inability to design and responsibly implement construction works, but also because of his inability to observe the required

---

58   APH, Česká dvorská komora, cart. II, inv. no. 193.
59   Lange 2011, p. 49.
60   APH, Česká dvorská komora, cart. II, inv. no. 284.

building regulations. Moreover, he was a contentious person, unfit to negotiate with other professionals and often attempting to blame his mistakes on others. Paradoxically, his supervision and management of the archduke's palace construction at Prague Castle appears to have actually accelerated his dismissal from court service. He certainly did not design the structures – they should rather be credited to some of his predecessors. Had he designed them, he would have mentioned it in his written reports, letters, and pleas.

Tirol's hopes of success in service at the imperial court were not fulfilled. The confrontation with the enlightened ruler and the archduke, as well as with construction experts who worked at the castle, revealed his lack of ability as a court builder.

# The Fine Arts and Their Protagonists

Sylva Dobalová

# Architectonic sculpture, relief and fountains at the court of Archduke Ferdinand II

"[The] Renaissance came to Eastern Europe as a royal fancy … the role of taste or fashion can be emphasised in the adaptation and spread of newer forms of art."[1] Even fifty years after Jan Białostocki wrote these words, there is nothing in this statement that we could object to. At the Habsburg court in Prague, the 'newer forms' referred to here appeared mainly in architecture and architectonic sculpture, and stucco decorations, and this was similarly the case at the court of Matthias Corvinus in Hungary, and among the Jagellonians in Krakow, Poland.[2] These newer forms were first and foremost an indicator of the existence of indelible ties to Italy, and more precisely of the continuity of the classical tradition. Free-standing sculptural work was not a widely embraced sculptural form in this region, with one exception – fountains. In 1538 King Ferdinand I expressed the wish to have two fountains created for his residence in Prague: "ainer schenen newen art zierlich und lustig" (of a new and beautiful type, delicate and delightful).[3] Although he commissioned the fountains made from bronze casts in Mühlau near Innsbruck rather than ordering works executed in marble from Italy that would have reflected a greater inspiration from classical sources, it was certainly possible for the iconography of these fountains to express a link to the classical heritage.

There were good reasons behind the popularity of architectonic sculpture and stucco work in Central Europe during the renaissance period, as the growing influence of humanism and a demand for classical fine arts and there was also a tradition of using these forms in the region (for example in tombstone sculpture and portals).[4] The primary role in the spread of art during the Renaissance was played by itinerant Italian builders and sculptors (mostly artists working in stone or doing stucco work), who set out across the Alps from the regions of Canton Ticino, the areas around Lake Lugano

---

1    Jan Białostocki, *The Art of the Renaissance in Eastern Europe: Hungary, Bohemia, Poland* (Oxford, 1976); cf. Thomas DaCosta Kaufmann, *Toward a Geography of Art* (Chicago, 2004), p. 207.

2    Thomas DaCosta Kaufmann, 'Italian Sculptors and Sculpture Outside of Italy (Chiefly in Central Europe): Problems of Approach, Posibilities of Reception', in *Reframing the Renaissance. Visual Culture in Europe and Latin America 1450–1650*, ed. by Claire Farago (New Haven, NJ and London, 1995), pp. 46–66 (60).

3    See Heinrich Zimerman, 'Urkunden, Acten und Regesten aus dem Archiv des k.k. Ministeriums des Innern', *Jahrbuch der kunsthistorischen Sammlungen des Allerhöchsten Kaiserhauses* 5 (hereafter as *JKSAK*) (1887), pp. CXX–CLXXVI, reg. 4519 on p. CXXXI.

4    On the growing popularity of relief sculpture, cf. Jeffrey Chipps Smith, Sculpture and Architecture, in idem, *German Sculpture of the Later Renaissance c. 1520–1580* (Princeton, NJ, 1994), pp. 245–269; Jan Chlíbec, *Italští sochaři v českých zemích v období renesance* (Prague, 2011), e. g. p. 56; Petr Čehovský, 'Early Renaissance Architectural Sculpture in Lower Austria', *Umění/Art* 64:2 (2016), pp. 102–112.

and northern Lombardy, Lake Como, and founded a tradition that would continue to shape the appearance of Central European art well into the baroque period.[5] The geographical region of northern Italy specifically is important in this respect, as the influence of artists from Tuscany or Rome was indirect. It is also worth nothing that during the Renaissance it was sculpture, rather than painting, that was considered the purest *all' antica* art; relief sculpture had a role in this, as early archaeologists excavated antique stucco works, which were then copied by sculptors and draughtsmen. Central European humanists were also drawn more to sculpture than to painting, as many classical works of sculpture and their inscriptions had survived and were thus available to study.[6] Alberti had also recommended in his treatise that patrons should mainly collect sculpture, a premise that Gabriel Kaltenmarck elaborated on further in his treatise *Kunstkammer* (1587).[7]

There was an interest not just in authentic works of classical sculpture, but also in copies of such works. Mary of Hungary, whose court in Brussels the Archduke Ferdinand II had visited in his youth (see the paper by Markéta Ježková in this volume), is regarded as the main driving force behind the interest in bronze and plaster castings modelled on classical works amongst the Central European Habsburgs. The French King Francis I played a similar role in western Europe.[8] One incident that became famous was when Mary, along with her brother King Ferdinand I, wanted to acquire the sculpture of a young man (known as the *Youth of Magdelensberg*) that had been discovered in Carinthia in 1502. Ferdinand I ultimately obtained a perfect copy of the sculpture in bronze to place it in the grotto at the Vienna Hofburg, while the original remained with Mary.[9] There is also ample evidence that Archduke Ferdinand II had a

5   Kaufmann 2004, Chapter 6, pp. 187–216.

6   The art of sculpture won out over painting during the 16th century in terms of the question of *paragone*, a comparison of which forms of art are more 'eloquent'; see, e.g., Ulrich Pfisterer, 'Paragone', in *Historisches Wörterbuch der Rhetorik*, ed. Gert Ueding (Tübingen, 2003), VI, pp. 528–546; Hannah Baader, 'Paragone', in *Metzler Lexikon Kunstwissenschaft. Ideen, Methoden, Begriffe*, ed. by Ulrich Pfisterer (Ulm, 2003), pp. 261–265. The most important literature on this vast subject and in reference specifically to the subject of reliefs is summarised, for example, in Lubomír Konečný, 'Considering *Rilievo, Hemisphaera* and *Paragone* in Rudolfine Art', *Studia Rudolphina* 14 (2014), pp. 114–118.

7   Leon Battista Alberti, *De re aedificatoria* (Florence, 1485); in Book 7 he recommends using stucco reliefs as a Classical building technique; on the relationship between sculpture and Antiquity see also for example, a work of extreme popularity in Central Europe: Francesco Petrarca, *De Remediis utrisque formae*, chapter 41, On statues.

8   The Habsburgs' interest in Antiquity has been summarised by Friedrich Polleross, 'Romanitas in der habsburgischen Repräsentation von Karl V. bis Maximilian II.', in *Kaiserhof – Papsthof 16.–18. Jahrhundert*, ed. by Rochard Bösel, Grete Klingenstein and Alexander Koller (Vienna, 2006), pp. 207–223; see also *Kaiser Ferdinand I. 1503–1564. Das Werden der Habsburgermonarchie*, ed. by Wilfried Seipel, exh. cat. (Vienna, 2003); on Archduke Ferdinand II in this respect, see the catalogue *All Antica. Götter & Helden auf Schloss Ambras*, ed. by Sabine Haag, exh. cat. (Vienna, 2011).

9   Most recently on this well-known issue, see Walter Cupperi, 'Giving away the moulds will cause no damage to his Majesty's casts' – New Documents on the Vienna Jügling and the Sixteenth-Century Dissemination of Casts after the Antique in the Holy Roman Empire, in *Plaster Casts. Making, Collecting and Displaying from Clasiccal Antiquity to the Present*, ed. by Rune Frederiksen and Eckart Marchand (Berlin and New York, 2010), pp. 81–98.

liking for smaller-sized sculptural works: the thirteenth cabinet in his *Kunstkammer* at Ambras contained 850 small bronze objects.[10] He obviously also collected objects made of wood, having commissioned wood reliefs in Prague from the Nuremburg-born sculptor Hans Peisser in 1562.[11] In this way, archival sources provide evidence that his collections of objects must have been developed while he was still in Prague.[12] Nevertheless, neither free-standing statuary nor small sculptures are the subject of this article, and I refer to the study of this phenomenon as represented by the literature cited in the notes.

In contrast to the sculptural pieces, we do not have many reports on the painted works commissioned by Ferdinand I and Archduke Ferdinand II in Prague. The ones we do know something about (and I shall mention these below) had strong political motivations. When necessary, masters were invited to Prague from abroad, usually from northern Italy and the German lands for painting commissions. Panel painting serving confessional needs by local masters in the non-Catholic Bohemian lands was reduced to merely creating epitaphs, whose pictorial surface was filled with inscriptions. There was also demand for paintings that were created as faithful copies based on prints produced in Augsburg or Nuremberg. The only place we might find images of better quality is in illuminated liturgical manuscripts, which enjoyed unique popularity especially between Bohemian utraquists. The standard of artistic work was maintained by the guilds. The situation of 'renaissance' painting in the Bohemian lands was most recently and accurately assessed by Milena Bartlová,[13] though her primary focus was on the formation of the category of 'reformation art' and not court art supported by the patronage of the Habsburgs. Bartlová points to the heightened need for art to be modelled on prints during the first half of the 16th century; she considers the possibility that this was the result of the need to demonstrate the visual identity of the reformed Christian confessions. In this environment, a painter who learned to paint by using prints would obviously lag behind in terms of the essential skills required to work in their medium. Following her arguments, I would remark that this phenome-

10    Veronika Sandbichler, 'Innata omnium pulcherrimarum rerum iquisitio. Archduke Ferdinand II as a Collector', in *Ferdinand II. 450 Years Sovereign Ruler of Tyrol. Jubilee Exhibition*, ed. by Sabine Haag and Veronika Sandbichler, exh. cat. (Innsbruck and Vienna, 2017), pp. 77–81 (79).

11    Klaus Pechstein, Zu den Altarskulpturen und Kunstkammernstücken von Hans Peisser, *Anzeiger des Germanischen Nationalmuseums* (1974), pp. 38–47 (46); here Pechstein suggests other works that may belong to Hans Peisser's Prague period and would thus also be among the works he completed for Archduke Ferdinand II. Several of his sculptural works have survived in the collections of the Kunsthistorisches Museum in Vienna. Questions about the early stages of the archduke's collecting practices in Prague have been discussed, e. g., in Veronika Sandbichler, 'AMBRAS [...] worinnen eine wunderwürdig, ohnschäzbare Rüst=Kunst und Raritaeten Kammer anzutreffen'. Erzherzog Ferdinand II. und die Sammlungen auf Schloss Ambras, in *Dresden & Ambras. Kunstkammerschätze der Renaissance*, ed. by Sabine Haag, exh. cat. (Vienna, 2012), pp. 31–41 (35).

12    Smith 1994, p. 311; *Katalog der Sammlung für Plastik und Kunstgewerbe, II. Teil – Renaissance* (Vienna, 1966); Manfred Leithe-Jasper, *Renaissance Master Bronzes from the Collection of the Kunsthistorisches Museum Vienna* (Washington DC, 1986).

13    Milena Bartlová, 'Renaissance and Reformation in Czech Art History: Issues of Period and Interpretation', *Umění/Art* 59 (2011), pp. 2–19 (14).

non was a part of a general tendency; prints, but also drawings, were similarly the main source for understanding antique, Italian and other art amongst the Central European Habsburgs. This also applies *vice-versa* to the catholic church and the Habsburgs in our case. For patrons, using a printed or drawn model was helpful when inspecting and paying the commissioned work. The problem this presented – that this controlled procedure could diminish the element of artistic creativity in the work – was simply not a priority for a ruling elite.[14]

Among Ferdinand I's court artists, there are few significant names that can be identified with specific works. The main one is the portrait artist Jakob Seisenegger, who spent time in Prague on several occasions.[15] Among the painters, Francesco Terzio of Bergamo was Archduke Ferdinand II's most important artist during his governorship in Prague: he turned to Terzio for typical Habsburg commissions, such as painting portraits and decorating the arches for triumphal entries, as well as various other projects (for example, the to design a Singing Fountain in Prague or the cenotaph of Maximilian I in Innsbruck).[16] Portrait painting is linked to the practice of collecting paintings to hang in 'galleries' (for the Habsburgs these mainly took the form of galleries of famous predecssors), and is dealt with in this volume in the article by Blanka Kubíková. While classical history and mythology (including the renaissance interpretations thereof) were not considered as independent subject matter for court painters, they were used to form the iconographic context of portraits and the decorations of triumphal arches, as well as to inspire the costumes worn in festive parades.[17]

As well as portraits, another important type of painting commission was the decoration of interiors with wall paintings. Ferdinand I's plan to adorn the walls of Vladislaus Hall, the Royal Palace, and perhaps also the Diet Hall with depictions of the rulers of the Bohemian lands (among whom the Habsburgs included themselves) had to be postponed several times, despite all of Archduke Ferdinand II's efforts to accomplish this project.[18]

---

14   Artists of the Habsburgs' before Rudolf II were accused of suffering from stagnation and a loss of creative ability, see for example David von Schönherr, 'Erzherzog Ferdinand von Tirol als Architect', *Repertorium für Kunstwissenschaft* 1 (1876), pp. 28–44; Elisabeth Scheicher, Ortwin Gamber and Alfred Auer, *Die Kunstkammer. KHM, Sammlungen Schloß Ambras*, Führer durch das Kunsthistorische Museum, 24 (Innsbruck, 1977), pp. 17–18. Elisabeth Scheicher, *Kunst- und Wunderkammern der Habsburger* (Vienna, Munich and Zürich, 1979), p. 76.

15   Karl Schütz, 'Die bildende Kunst in Österreich während der Herrschaft Ferdinands I.', in *Kaiser Ferdinand I. 1503–1564*, pp. 190–199; Georg Kugler, 'Kunst und Geschichte im Leben Ferdinands I.', in *ibidem*, pp. 200–213.

16   Mila Pistoi, 'Francesco Terzi', in *I pittori bergamaschi dal XIII al XIX secolo*, III/2, *Il Cinquecento*, ed. by Pietro Zampetti and Gian Alberto Dell'Acqua (Bergamo, 1976), pp. 593–609; on the decorations on the triumphal arch, see Guido Carrai, 'Pietro Andrea Mattioli: architettura ed effimero alla corte imperiale alla fine del XVI secolo', in *Humanitas latina in Bohemis*, ed. by Giorgio Cadorini and Jiří Špička (Kolín and Treviso, 2007), pp. 169–194 (173).

17   Cf. Exh. Cat. Innsbruck 2017.

18   Petr Uličný, 'Od císaře k oráči a zase zpět. Panovnické cykly ve Starém královském paláci na Pražském hradě', *Umění/Art* 66 (2018), pp. 466–488; Eliška Fučíková, 'Pražský hrad a jeho výzdoba za arcivévody Ferdinanda II.' / 'Die Prager Burg unter Erzherzog Ferdinand II.: Umbau und

It would be natural to expect the Habsburgs to have made changes to Prague Castle's churches and chapels. All Saints Chapel, adjoining Vladislaus Hall, had been decorated since the time of Charles IV with gemstones and colourful stained-glass windows. During the fire that broke out in Malá Strana and Prague Castle in 1541, however, the chapel was almost completely lost. It was not restored until 1576/77–1580 by Elisabeth of Austria (1554–1592), the daughter of Maximilian II, and among other things she donated an alterpiece of French origin to the chapel.[19] Among the decorations of St Vitus' Cathedral there was a three-part altarpiece featuring the Virgin Mary surrounded by female saints created by Lucas Cranach in 1515–1520 that tends to be associated with the ascension of Louis II of Hungary and Mary of Hungary to the Bohemian throne.[20] We can only speculate upon who the donor of the painting showing the beheading of St Wenceslas in the Wenceslas Chapel may have been. Its inscription dates to 1543, and it may have been painted by Cranach's student, Master IW.[21] Sometime before 1530 Ferdinand I commissioned the casting of a large new bell for the cathedral, but it broke during transport and had to be cast again.[22] The cathedral was badly damaged during the fire at Prague Castle, the bells broke and the roof was destroyed. Therefore, as well as having the cathedral repaired, Ferdinand I also took steps to have a new Zikmund bell cast by Tomáš Jaroš (1549), decorating it with casts of medals and two figural reliefs based on the work of Albrecht Dürer. Anonymous drawings submitted to the king by Hans Tirol in 1553 show designs for painting the interior of the damaged Chapel of St Zikmund, a project that was ultimately never realised. However, a new organ was installed, which Ferdinand I referred to as the biggest and most beautiful organ in the entire Christian world.[23] Set on a two-storey organ loft by Bonifaz Wolmut, it was built in stages by several organ designers, one of whom was Georg Ebert, who also designed the organ in the Hofkirche in Innsbruck. The paintings on the organ wings were created by Francesco Terzio.

---

künstlerische Gestaltung', in *Arcivévoda Ferdinand II. Habsburský. Renesanční vladař a mecenáš mezi Prahou a Innsbruckem / Ferdinand II. Erzherzog von Österreich aus dem Hause Habsburg. Renaissance-Herrscher und Mäzen zwischen Prag und Innsbruck*, ed. by Blanka Kubíková, Jaroslava Hausenblasová and Sylva Dobalová, exh. cat. (Prague, 2017), pp. 38–43 / pp. 27–30 and cat. nos. II/52, II/54 and II/57.

19  *Umělecké památky Prahy. Pražský hrad a Hradčany*, ed. Pavel Vlček (Prague, 2000), pp. 64–68; Lubomír Konečný, 'Charles Dorigny a obraz *Snímání s kříže* v kostele Všech svatých na Pražském hradě', *Umění* 37 (1989), pp. 163–165 (with a summary in French on pp. 165–166).

20  Magdaléna Nespěšná Hamsíková, *Lucas Cranach a malířství v českých zemích (1500–1550)* (Prague, 2016), pp. 114–119, 214.

21  Nespěšná Hamsíková, 2016, pp. 233–236; she questions the notion that Master IW created the painting given the poor quality of the painting work, particularly in the background landscape. The coats of arms of the Kingdom of Bohemia and St Wenceslas are pictured in the painting.

22  Petr Vácha, *Zvony a hodinové cimbály Katedrály sv. Víta, Václava a Vojtěcha* (Hradec Králové, 2013), pp. 7–23.

23  Ivan P. Muchka, 'Architectura ancilla musicae. Architektur in der Beziehung zur Musik am Prager Hof der Habsburger', in *The Habsburgs and Their Courts in Europe, 1400–1700. Between Cosmopolitism and Regionalism*, ed. by Herbert Karner, Ingrid Ciulisová and Bernardo J. García García Palatium e-Publication 3 (2014), pp. 46–54.

If we wish to show how important a role architectonic sculpture played at Prague Castle, it is necessary to discuss the Royal Summer Palace commissioned by Ferdinand I. In the 1530s he bought a section of land to the north of the castle and created a large garden there. The location chosen for the summer palace was consistent with the principles that Leon Battista Alberti recommended in his treatise for the building of a villa.[24] This stipulated that the chosen location should afford a view of the town in its vicinity and the surrounding natural environment, but the villa itself should also be clearly visible from the town. In 1537 Ferdinand I commissioned a 'model' for the summer palace from Paolo della Stella, who was a sculptor as well as an architect: the combination of these two professions in one person was nothing unusual at the time, and we can take the example of Jacopo Sansovino as quite typical, for instance.[25] The construction of the summer palace and the arrival of della Stella and his assistants is regarded as the key moment from which Italians began arriving in the Bohemian lands.[26]

Della Stella came to Prague from Genoa. He was invited, among other things, to execute the sandstone reliefs that covered the Royal Summer Palace. The lower floor of the summer palace, adorned with figural motifs, was completed after 1550. Della Stella was eventually sent back to Italy, where he died. The addition of a second floor to the structure, on the initiative of Archduke Ferdinand II during his time as governor, is the subject of the article by Petr Uličný in this volume; no reliefs were then added to this new floor. It was instead embellished with a stone ballustrade featuring carved motifs of the Golden Fleece. Jan Bažant, the author of a thorough monograph on the Royal Summer Palace, has calculated that the palace is decorated with more than 100 figural reliefs.[27]

The largest space for figural creations comprised the rectangular fields in the spandrels above the ground-floor arcades, where there are 40 figural scenes. The iconography of these scenes is decidedly dynastic and stately in focus; mythological subject matter and scenes from Roman history are combined here with eight scenes representing King Ferdinand I or Emperor Charles V. The short southern façade looking onto

---

24   The book was in the library of humanist Bohuslav Hasištejnský of Lobkowicz, see *Básník a král: Bohuslav Hasištejnský z Lobkovic v zrcadle jagellonské doby*, ed. by Ivana Kyzourová, exh. cat. (Prague, 2007), p. 38, cat. no. 23.

25   On the profession of sculptor and architect, cf. e. g., Alina Payne, 'The Sculpture-Architect Drawing and Exchanges Between the Arts', in *Donatello, Michelangelo, Cellini. Sculptor's Drawings from Renaisance Italy*, ed. by Michael Cole, exh. cat. (Boston, 2014), pp. 56–73; on della Stella and his possible relationship to Sansovino, see Anne Markham-Schulz, 'Paolo Stella Milanese', *Mitteilungen des Kunsthistorischen Institutes in Florenz* 29:1 (1985), pp. 79–110 (the author herself acknowledges, however, that whether the della Stella who worked in Prague and the well-known Italian della Stella were the same person is still in question; see p. 80), more recently see Fernando Loffredo, 'Il monument Euffreducci in San Francesco a Fermo: Bartolomeo Bergamasco e Pietro Paolo Stella', *Arte Veneta* 70 (2013), pp. 69–81.

26   Thomas DaCosta Kaufmann, *Court, Cloister & City. The Art and Culture of Central Europe 1450–1800* (London, 1995), pp. 142–151.

27   Jan Bažant, *Pražský Belvedér a severská renesance* (Prague, 2004), and many other articles published in world languages by this author; Sylva Dobalová, 'Royal Summer Palace, Ferdinand I and Anna', *Historie – Otázky – Problémy* 7:2 (2015), pp. 162–175.

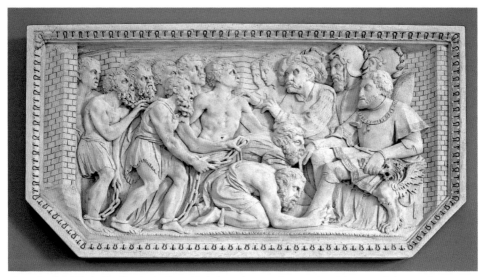

Fig. 1. Paolo della Stella, Charles V frees Christian prisoners, Prague, Royal Summer Palace, a plaster copy of a relief (Collections of the Prague Castle)

the town is dominated by a scene representing the victory of the Habsburgs over the Turks, allegorically portrayed as the hunt for the Calydonian Boar. The scenes on the eastern façade represent the Golden Age and the African campaign of Charles V. (Fig. 1) The northern façade features allegories of dynastic succession. The iconography on the western façade, facing onto the garden, represents the summer palace's builder, Ferdinand I: here we find Jupiter's Loves, but also a depiction of the king and his wife, Anna Jagiellon, Queen of Bohemia and Hungary. In this way, the Royal Summer Palace is an unquestionable example of the statement that 'monument makes memory'.

The Royal Summer Palace's reliefs are somewhat uneven in quality. Della Stella and his workshop were evidently inexperienced in working with sandstone, which was used here instead of expensive marble. This is nevertheless an extremely valuable group of reliefs, whose iconography most certainly drew inspiration from classical (or renaissance) visual sources. But which sources could these have been? Are we to assume that della Stella brought drawings or prints of classical works with him from Italy, or with the help of some conceptual advisor looked through the illustrations of literary works for inspiration? Are the façades of the Royal Summer Palace an attempt to evoke the world of Roman villas, whose façades were decorated with classical reliefs? Or do they follow the Lombardy model – which della Stella may have known – of richly decorating sacral and profane architecture with festoons, putti, and reliefs fashioned after bronze plaques, medals, and ancient coins?[28] Although the content of the art

---

28    On this Lombardian practice, see Marika Leino, *Fashion, Devotion and Contemplation. The Status and Function of Italian Renaissance Plaquettes* (Oxford and New York, 2013); della Stella's sources among reliefs of Classical sarcophagi and Renaissance plaquettes are noted in Chlíbec 2011, pp. 85–86.

collections owned by Ferdinand I remains largely unknown, his passion for coins is well established.[29] A catalogue of his coin collection from around 1547/50 compiled by Leopold Heyperger, the emperor's treasurer, is actually the only comprehensive evidence we have of his collecting activities. What is most likely is that della Stella based the reliefs on a variety of different sources. Only a very small number of the scenes are similar in composition to the slightly later stucco reliefs that decorate the interior of the Hvězda (commonly known in English as the Star Summer Palace) commissioned in 1555–1556 by Archduke Ferdinand II. It was he who obtained for the emperor's coin collection and also for example books upon the latter's death.

Archduke Ferdinand II turned again to nothern Italian artists when he wanted to decorate the interior of Star Summer Palace, which was built in a hunting reserve not far from Prague Castle. The laying of the foundation stone of this summer palace was celebrated on the 28th of June 1555. This event was commemorated in some lines of festive verse that refer to the archduke as the one who "das Werk erdacht und cirkulirt" (made and measured the work), referring to the Star Summer Palace. A representative collection of plans of the palace, with a dedication written in Italian, were probably also connected with this event.[30]

Stucco work was exclusively the domain of the Italian artists; their practice of dividing the ceiling up into smaller geometric fields is a method that can be traced back to the time of Roman Antiquity.[31] All the castle builders, both Italian and German, alternated in the work of building the Star Summer Palace, but a specialist had to be summoned for the decorations. That specialist was Antonio Brocco, an artist from Campione in nothern Italy, and his brother (probably Giovanni Campione). Brocco and his workshop had decorated five rooms in the Dresden residence of Augustus, Elector of Saxony in 1554.[32] Brocco's name is not mentioned in written sources referring to Star Summer Palace, but from comparisons with his other work there is no

29   Almost all the coins in the collection are of Ancient Roman origin, cf. Dirk Jacob Jansen, 'Emperor Ferdinand I and the Antique: the Antique as Innovation', *Historie – Otázky – Problémy* 7:2 (2015), pp. 202–218, on the collecting activites of Ferdinand I, see in detail Beket Bukovinská, 'Kunstkammer Ferdinands I.: viele Fragen, wenige Antworten', *Dresden – Prag um 1600*, Studia Rudolphina Sonderheft, 2 (2018), pp. 69–86; Polleross 2006; Karl Rudolf, 'Arcimboldo in kulinarischen Wissensraum. Die Kunstkammer Kaisers Ferdinand I. (1503–1564)', in *Das Haus Habsburg und die Welt der fürstlichen Kunstkammern im 16. und 17. Jahrhundert*, ed. by Sabine Haag, Franz Kirchweger and Paulus Rainer (Vienna, 2015), pp. 133–166.

30   For verses see David Ritter von Schönherr, 'Urkunden und Regesten aus dem k.k. Statthalterei-Archiv in Innsbruck', *JKSAK* 11 (1890), pp. LXXXIV–CCXLI (CLV), reg. 7143; for plans ÖNB, sign. Cod. Min. 108; for details compare: Ivan Prokop Muchka, Ivo Purš, Sylva Dobalová and Jaroslava Hausenblasová, *The Star. Archduke Ferdinand II of Austria and His Summer Palace in Prague* (Prague, 2017), pp. 86–93.

31   For more on this issue as it relates to the Star Summer Palace, see Ivan Muchka et al. 2017; for a history of stucco, see Eckard Marchant, 'Material Distinctions: Plaster, Terracotta, and Wax in the Renaissance Artist's Workshop', in *The Matter of Art: Materials, Practises, Cultural Logics, c. 1250–1750*, ed. by Christy Anderson et al. (Manchester, 2014), pp. 160–179.

32   Archduke Ferdinand II would have had an opportunity to see his work in situ, at least in 1556, when he was touring Dresden, if not also on other occasions, see *Dresden & Ambras. Kunstkammerschätze der Renaissance*, ed. by Sabine Haag, exh. cat. (Vienna 2012), p. 48.

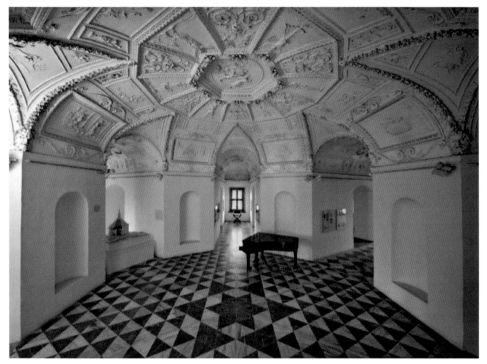

Fig. 2. Interior of the main hall in the Star Summer Palace, Prague

doubt that he was involved: Brocco worked on the palace from 1556.[33] His name was also listed restrospectively in a record of work on the Singing Fountain in Prague, built in the 1560s, for which he created the middle stem featuring sculptures of satyrs and the top part of the fountain with a putto figure.[34]

At the Star Summer Palace, Brocco and his workshop decorated the ceiling of the central circular hall and the eleven smaller rooms surrounding the hall with stucco work. (Fig. 2) Multi-figural scenes are only found in the central space; each of the side rooms is dominated by the central figure of an ancient deity, surrounded by animals, grotesques, estoons, *amors* at play, satyrs dancing with nymphs, and in some cases mythical and allegorical figures. The central scene in the middle hall is Aeneas' flight from the burning Troy, a subject from Virgil's *Aeneid*. This hero, the founder of the

---

33  There are multiple sources that refer to the work on the stucco (decorations) at the Star Summer Palace, which began over the course of 1556; for example, on 27 September 1556 Volf of Vřesovice wrote that the stucco workers were making too slow progress in their task; see NA, Sbírka opisů Innsbruck, cart. without signature, signed only (–1561); see also Franc Kreyczi, 'Urkunden und Regesten aus dem k. und k. Reichs-Finanz-Archiv', *JKSAK* 5 (1887), pp. XXV–CXIX, reg. 4283 on pp. LXXVII–LXXXIV, from the year 1559, where Wolmut criticised the stucco ceilings and stated that the stucco work had been going on for three years already and the work was far from complete.

34  A record from 1571, see Dorothea Diemer, 'Antonio Brocco und der 'Singende Brunnen' in Prag', *Jahrbuch der Kunsthistorischen Sammlungen in Wien* 31 (1995), pp. 18–36 (21).

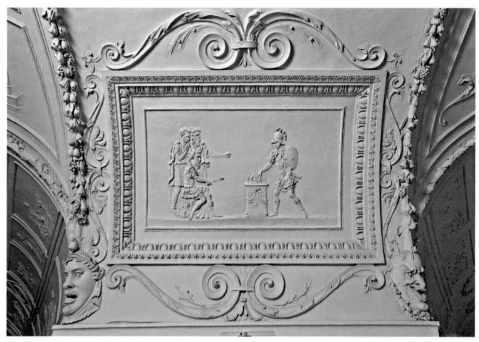

Fig. 3. Antonio Brocco, Mucius Scaevola, Star Summer Palace, Prague

Roman Empire, was celebrated by the Habsburgs as their mythical genealogical ances-
tor. While it is evident that the depiction of the young Julius, as well as that of Aeneas
carrying his father Anchises on his back were both based on a print by Raphael, we are
unable to find any direct source of inspiration for the figure of Creusa (or her appari-
tion) accompanying the hero that would have been available when these reliefs were
created.[35] The iconography of the remaining six stucco reliefs in the hall is consistent
with the space's function of representing the Habsburgs' status: four of these reliefs
depict heroes from the legends of Roman history (Fig. 3) and two of them can be
viewed as examples of the moral values of parental love. Certain accompanying motifs
such as the sea monsters and the funereal symbolism might appear to be directly based
on the ceilings of tombs and sarcophagi in Rome, but here, as in the figural scenes, we
can still see Brocco's artistic qualities at work.

Frequent note has been made of the alabaster-white colour of the halls in the Star
Summer Palace, but in 2019 restoration research revealed that originally shading had
been applied to the stucco work, probably to create the impression of plasticity, and in
some places gilding had evidently been applied to the surface – for example, on the
stucco framing of individual scenes.

---

35   Jan Bažant pointed this out in the paper he presented at the conference 'The Archduke Ferdinand II
     of Austria (1529–1595) and His Cultural Patronage between Prague and Innsbruck', Prague, IAH
     CAS 2018.

At the end of the 1560s Antonio Brocco followed Archduke Ferdinand II to Tyrol, where he took part in decorating an unnamed *Sommerhaus* in Innsbruck. At Ambras Castle, he created the stucco friezes in the Spanish Hall and in its ante-chamber (the *Kaisersaal*, or Imperial hall) he made also the busts of the Classical emperors.[36] However, there are very noticeable differences between the decoration of the Star Summer Palace in Prague and Brocco's Tyrolean work. As noted above, Brocco probably did not create the stucco ceilings in Tyrol; it was suggested that he did his work as a stucco specialist under the auspices of Alexander Colin's workshop, which received – among others – commissions for various types of work in marble, terracotta and also stucco from Archduke Ferdinand II.[37]

There are two scenes in the frieze of the Imperial Hall in Ambras Castle that have motifs identical to those in the Star Summer Palace, one of them a scene with Mucius Scaevola and one with Marcus Curtius. But here the semi-figures in stucco have more material substance and greater plasticity than the more delicately handled Prague stucco works. Instead of a stucco ceiling, at Ambras the two rooms mentioned above were given wooden coffer ceilings; Archduke Ferdinand II thus clearly did not want to repeat the use of stucco ceilings, not even in the smaller Imperial Hall. Nevertheless, the archduke is credited with having first brought the stucco technique to the Tyrolean region.[38]

There are surviving archival sources that can help clarify what work Brocco performed in the Hofburg in Innsbruck and in Ambras Castle. They show that the archduke wanted to be personally present when decisions were being made about Brocco's stucco decorations, but also about the work of the other artists. His aesthetic outlook and his ability to organise and guide artists, both in Innsbruck and on other Tyrolean projects, manifested itself in full.[39] Archduke Ferdinand II even created the concept of the painted decorations, and perhaps the overall appearance of the Spanish Hall in Ambras Castle: the archduke put together the selection of Tyrolean rulers with the aid

---

36  Alfred Auer, 'Das Kaiserzimmer auf Schoss Ambras. Versuch einer Chronologie der Ausgestaltung', *Österreichische Zeitschrift für Kunst und Denkmalpflege* 38 (1984), pp. 15–25.

37  Diemer suggests that hypothetical relation of Brocco and Colin, see Diemer 1995, p. 33. Colin created terracotta figures in Innsbruck, just as he had during his youth in Heidelberg; 134 large figures of gods were presented near the 'bird garden' of one of the small summer palaces of Hofburg in 1579/80, see Helga Dressler, *Alexander Colin* (Karlsruhe, 1973), pp. 89–90; Monika Frenzel, *Historische Gartenanlagen und Gartenpavillons in Tirol* (unpublished doctoral dissertation, University of Innsbruck, 1978), p. 108, according to TLA, Kustsachen I, 823. 'Ovidian stories' were rendered in stucco for the summer palace in the garden by the Hofburg, cf. Dressler 1973, pp. 81–82; Felmayer believed that this work was for the decorations of a room in the lower Ruhelust. See Johana Felmayer, 'Ruhelust', in *Die Kunstdenkmäler der Stadt Innsbruck, Die Hofbauten*, ed. by Johanna Felmayer, Österreichische Kunsttopographie 47 (Vienna, 1986), pp. 626–639.

38  Martha von Klebersberg, 'Stuckarbeiten des 16. und 17. Jahrhunderts in Nordtirol I.', *Veröffentlichungen des Museum Ferdinandeum* 20/25 (1940/1945), pp. 175–214 (189).

39  Fehlmayer 1986, p. 640, no. 10, 13, 14,15, 20 from 1566, when Ferdinand was preparing to depart for Innsbruck; also, especially, David von Schönherr, 'Urkunden und Regesten aus dem k.k. Statthalterei-Archiv in Innsbruck', *JKSAK* 14 (1893), reg. 10337 (20 September 1571), or alternatively reg. 10333.

Fig. 4. List with pasted engravings from J. A. du Cerceau, from the album "Architectura" (Vienna, Kunsthistorisches Museum, Kunstkammer, inv. no. KK 5337, fol. 43)

of the librarian Gerard van Roo, based on his own medal collection.[40] Unlike the work done in Prague, where it is difficult to determine the sources of inspiration, many of the sources for the archduke's decorations in Tyrol came from his own collections. For example, Alfred Auer has proposed that Brocco could have drawn inspiration for the busts of the emperors in the Imperial Room from drawings by Jacopo Strada, which were based on the cycle of emperors Titian created for the Palazzo Ducale in Mantua – the archduke had visited this palace and possessed copies of the paintings.[41] Brocco's individualised busts at Ambras belong to a different stylistic category to the medallions of emperors in the Star Summer Palace in Prague, which cannot be individually identified.

In the case of the Spanish Hall, Elisabeth Scheicher has looked for possible sources of inspiration for its ornamental components in Archduke Ferdinand II's albums of prints (*Klebebände*).[42] There were almost thirty such albums stored in eighth cabinet in the archduke's *Kunstkammer*, and they contained thematically sorted prints and individual drawings. Examining the content of these albums, we find that during the period of their compilation, the archduke owned hundreds of print reproductions of

40    Elisabeth Scheicher, 'Der Spanische Saal von Schloss Ambras', *Jahrbuch der Kunsthistorischen Sammlungen in Wien* 71 (1975), pp. 39–94; on the texts below the paintings, see Walter Dietl, *Die Elogien der Ambraser Fürstenbildnisse* (Innsbruck, 2000); Petr Fidler, 'Spanische Säle – Architektur-typologie oder -semiotik?', in *Spanien und Österreich in der Renaissance*, ed. by Wofgang Krömer (Innsbruck, 1989), pp. 157–173; for an assessment of the type of hall, see AS, '[cat. entry] no. 277', in *Geschichte der Bildenden Kunst in Österreich, III: Spätmittelalter und Renaissance*, ed. by Arthur Rosenauer (Vienna, 2003), pp. 519–520.

41    Auer 1984, p. 20 and footnote 21, which mentions additional literature; the drawings have been preserved in the Kunstmuseum Düsseldorf.

42    Scheicher 1975, p. 86, in particular Vienna, Kunsthistorisches Museum, Kunstkammer, inv. no. 6640.

classical Roman buildings, their architectural details, and structural plans (the thickest album, *Architectura*, has 143 folios, but they are pasted with 524 prints and 2 drawings, Fig. 4), but also, for example, reproductions of triumphal arches, ornamentation, and portraits of rulers from Antiquity. A large part of this collection was made up of sub-groups of prints devoted to different themes such as religious morality, images of the saints, different varieties of 'histories', as well as two albums of prints and drawings by Albrecht Dürer, and so forth.[43] The eighth cabinet also included albums that contain paintings on parchment created by Archduke Ferdinand II's (court) artist Giorgio Liberale. Mention should be made, in particular, of his album of the sea fauna of the Adriatic Sea, because, as we shall see, similar images may have served as the source for other sculptural works, and works executed in gold.[44]

## Fountains

We can observe how closely the archduke was involved with artistic projects connected to sculpture through the example of one of the most popular types of commissions in Central European courts during the Renaissance – bronze fountains.[45] The Habsburgs' renaissance fountains were intended to be placed in private gardens, not in public spaces. Were we to look for examples of free-standing sculptures or other 'monuments' located in public areas at Prague Castle during that period, we would find only one. This is the bronze equestrian statue of St George slaying the dragon that was probably brought to Prague from Hungary by Vladislaus II of Hungary (Jagiellon). There exists a record from 1541, which describes it as a decoration on a fountain in the courtyard in front of the Royal Palace, so it is possible, that the final composition was created thanks to King Ferdinand I.[46] The public contribution made by Ferdinand I of Habsburg was surely his installation of new water tunnels leading from Střešovice, which brought water to the castle, and the digging of a new well at the

---

43   Peter W. Parshall, 'The print collection of Ferdinand, Archduke of Tyrol', *Jahrbuch der Kunst-historischen Sammlungen in Wien* 78 (1982), pp. 139–190; Peter W. Parshall, 'Art and Theatre of Knowledge: The Origins of Print Collecting in Northern Europe', in *Print Collecting in Sixteenth and Eighteenth Century Europe*, Harvard University Art Museum Bulletin 2:3 (Cambridge, 1994/95), pp. 7–36; most recently Sylva Dobalová, '*Temples & Logis domestiques* by Jacques Androuet du Cerceau and the Star Summer Palace in Prague', *Studia Rudolphina* 17–18 (2018), pp. 9–21.

44   See *Natur und Kunst. Handschriften und Alben aus der Ambraser Sammlung Erzherzog Ferdinands II. (1529–1595)*, ed. by Alfred Auer and Eva Irblich, exh. cat. (Vienna, 1995), pp. 67–76, cat. nos. 13–19, with a bibliography.

45   For an overwiev see Smith 1994.

46   Barbara D. Boehm and Jiří Fajt, 'Martin a Jiří z Kluže, Sv. Jiří zabíjející draka', in *Karel IV., Císař z boží milosti. Kultura a umění za vlády Lucemburků 1310–1437*, ed. by Jiří Fajt and Barbara D. Boehm, exh. cat. (Prague, 2006), pp. 229–230 (for German version see *Karl IV, Kaiser von Gottes Gnaden* [Munich 2006]); cf. Viktor Kotrba, 'Die Bronzeskulptur des Hl. Georg auf der Burg zu Prag', *Anzeiger des Germanischen Nationalmuseums* (1969), pp. 9–28. The status of St George standing "above a pipe" in mentioned in the report of the fire by Václav Hájek of Libočany, *O nesstiastnee przihode kteráž gse stala skrze ohen w Menssim Miestie Pražském, a na Hradie Swatého Waclawa, y na Hradčanech etc. Leta M.D.xxxj* (Prague, 1541).

castle itself.[47] A similar project was developed by Ferdinand I in Vienna, and the grateful townspeople there thanked him by erecting a commemorative plaque.[48]

The primary use for bronze sculpture in Prague, then, was as a form of fountain decoration (and also a sepulchral monument). This kind of art is naturally best-suited for use as garden ornaments, and as noted above, the Habsburgs placed a great emphasis on the decoration of their gardens. Recently, more attention has been devoted to the social function of gardens from this period, as well as their recreational purposes. In particular, recent research highlights that fact that these gardens and their 'lives' were tied up with various social and diplomatic rituals,[49] which were also of enormous importance to the Habsburgs, and especially to Archduke Ferdinand II during his time in Prague.

It may seem paradoxical that fountains in bronze were favoured in Prague, where they were much more complicated and expensive to make than stone and even marble fountains would have been. However, the Habsburgs had a great deal of experience in working with bronze and metals. There were natural sources of metal located in Innsbruck and the surrounding region, and there were workshops in place to process these raw metals. Some insight into this can be obtained by looking at the creation of the tomb and later the cenotaph of Maximilian I in the Court Church at Innsbruck. This work was originally supposed to be accompanied by dozens of bronze figures, though finally a smaller number were in fact executed. Following the death of Stefan Godl in 1534, it was difficult to find an artist in Innsbruck who knew how to cast bronze figures; ultimately most of the work on this project was taken up by Bernard Godl and Gregor Löffler, whose son was later engaged by Archduke Ferdinand II to do further work in Prague. In the end Maximilian I's cenotaph was decorated with marble reliefs inspired by the work of the Italian masters, and the final form of the cenotaph was also shaped by the ideas of Jacopo Strada.[50] The inherent reasons for the popularity of metal during the Renaissance, which had to do with it being viewed as a natural substance and with the respect attached to the process of its transformation,[51] were even

47   Věra Vávrová, 'Voda pro Pražský hrad', in *Klenot města: historický vývoj pražského vodárenství*, ed. by Jaroslav Jásek (Prague, 1997), pp. 15–28; for a comparison, see Katherine W. Rinne, 'Water, Currency of Cardinals in Late Renaissance Rome', in *La Civilta` delle Acque tra Medioevo e Rinascimento*, ed. by Arturo Calzona and Daniela Lamberini (Florence, 2010), pp. 367–387.

48   On the panel located on the northern side of the 'Old Castle' of the Habsburgs' Vienna residence, see Herbert Karner (ed.), *Die Wiener Hofburg 1521–1705: Baugeschichte, Funktion und Etablierung als Kaiserresidenz* (Vienna, 2014), pp. 207–208; in Innsbruck cf. 'Gedenktafel zut Erneuerung der Fernpaßstraße', see Rosenauer 2003, p. 376.

49   Rinne 2010, pp. 367–87.

50   Christoph Haidacher and Dorothea Diemer, *Maximilian I. Der Kenotaph in der Hofkirche zu Innsbruck* (Innsbruck, 2004).

51   Pamela H. Smith, 'The Matter of Ideas in the Working of Metals in Early Modern Europe', in *The Matter of Art*, ed. by Pamela H. Smith (Manchester, 2014), pp. 42–67; the situation in the Bohemian lands in this respect has most recently been summed up by Jan Chlíbec, 'Bronzová sepulkrální plastika v Čechách od středověku do konce vlády Ferdinanda I.', *Epigraphica & Sepulcralia* 6 (2015), pp. 91–104; see also Ivo Purš, 'Das Interesse Erzherzog Ferdinands II. an Alchemie und Bergbau und seine Widerspiegelung in seiner Bibliothek', *Studia Rudolphina* 7 (2007), pp. 75–109.

more strongly embraced by Archduke Ferdinand II because of his passion for metallurgy, which he also hoped would inject some money into his coffers.

After creating the Royal Garden, in 1538 the now King Ferdinand I asked Schurf, the caretaker of Ambras Castle, to discuss installing two fountains. As noted in the introduction to this text, the king wanted these fountains to have a new and fashionable appearance. Schurf immediately sent the king some drawings.[52] The king pushed for the fountains to be built in 1550, probably in connection with the discovery of a strong new spring that was diverted to flow into the Royal Garden. There was, however, already a foundry at Prague Castle at the time, which was run by the master Tomáš Jaroš (died 1570/71). Jaroš had persuaded the king

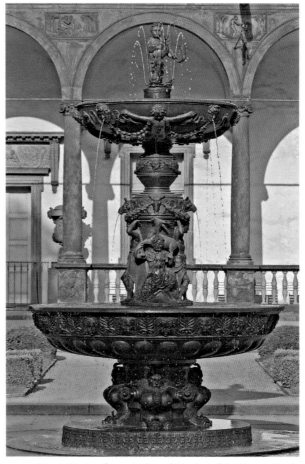

Fig. 5. Singing fountain, Royal Garden of the Prague Castle

of his abilities through his work as a gunsmith and cannon caster and, most importantly, by the fact that he had already cast several bells for the cathedral. Some progress began to be made in 1562, when Ferdinand I came to Prague to make the preparations for the coronation of his eldest son Maximilian II. Archduke Ferdinand II was assigned with the task of getting the fountains made and finally he commissioned a design from Francesco Terzio. The drawing from the *Prunwerch* album in the KHM Wien that came from the collection of Archduke Ferdinand II was put under consideration in

52    Hilda Lietzmann, *Irdische Paradiese. Beispiele höfischer Gartenkunst der I. Hälfte des 16. Jahrhunderts* (München and Berlin, 2007), pp. 74–75; Heinrich Zimerman, 'Archiv des k.k. Ministeriums des Innern', *JKSAK* 5 (1887), pp. CXX–CLXXVI, reg. 4519 on p. CXXXI; David von Schönherr, 'Urkunden und Regesten aus dem k.k. Statthalterei-Archiv in Innsbruck', *JKSAK* 2 (1884), pp. I–CLXXII, here p. CLX, reg. 2089 and p. CLXI, reg. 2094, 26 January and 18 February 1538.

this context by several experts.[53] It differs from the fountain as it was finally bulit. (Fig. 5) But in reality, when creating this kind of work the more important role was played not by drawings but by the model that was made of the work, usually in clay or in wood, and then presented to the patron, and by the 'model' then made for the mould in which the final metal form was cast.[54] In the case of this fountain, sources indicate that the sculptor Hans Peisser created a wooden moulds for the lower 'foot', rendering in the form of four animal hooves shaped like devils with female breasts, and the larger basin of the fountain.[55] The upper column, with the figures of satyrs and atlantes, the smaller upper bowl, and the putto figure with the bagpipes were modelled by Antonio Brocco. By the time work on the fountain had reached this stage Archduke Ferdinand II had already moved to Innsbruck, so its completion and installation were left in the hands of his brother, now Emperor Maximilian II.

Several years earlier, Archduke Ferdinand II had tried to acquire an even more exquisite fountain. He tried to commission it from Wenzel Jamnitzer, a famous goldsmith in Nuremburg. The design for this fountain has been identified as the one depicted in a drawing that is now held at castle Veste Coburg (Fig. 6), and a smaller copy of the design that has been preserved in the Kunstmuseum Basel. Some researchers who have studied the Coburg drawing have established a link between it and the archduke, but claim that he commissioned the fountain for his residence in Innsbruck.[56] Archival research, however, indicates that it could have been intended for Prague and specifically for the Star Summer Palace, because construction work was in fact underway on one Jamnitzer fountain at the same time that the work on the Star Summer Palace's interiors was reaching completion, and the archduke was no longer in contact with Jamnitzer in later years.[57]

53  Vienna, Kunsthistorisches Museum, Kunstkammer, inv. no. KK 5350; the album is presented as containing the designs for various fountains that were considered in Prague and Innsbruck. Most recently, see Sylva Dobalová and Thomas Kuster, Album mit eingeklebten Zeichnungen von Springbrunnen – „Prunwerch", Arcivévoda Ferdinand II. Habsburský. Renesanční vladař a mecenáš mezi Prahou a Innsbruckem / Ferdinand II. Erzherzog von Österreich aus dem Hause Habsburg. Renaissance-Herrscher und Mäzen zwischen Prag und Innsbruck, ed. by Blanka Kubíková, Jaroslava Hausenblasová and Sylva Dobalová, exh. cat. (Prague, 2017), p. 148 / p. 73, cat. no. II/49.

54  There are a number of studies on the subject of drawings in sculpture and on sculptural practices that also discuss 'models', most recently, for example, Michael Cole, Ambitious Form. Giambologna, Ammanati, and Danti in Florence (Princeton, 2011).

55  For details see Diemer 1995.

56  Wenzel Jamnitzer und die Nürnberger Goldschmiedekunst 1500–1700: Goldschmiedearbeiten-Entwürfe, Modelle, Medaillen, Ornamentstiche, Schmuck, Porträts, ed. by Gerhard Bott, exh. cat. (Munich, 1985), on the fountain drawing from Coburg, see pp. 344–345, cat. no. 303, the height of the depicted fountain is 135 cm; copy is deposited in Kunstmuseum Basel, Kupferstichkabinett, for a bibliography see ibidem, p. 131, fig. 103; Von Dürer bis Gober. 101 Meisterzeichnungen aus dem Kupferstichkabinett des Kunstmuseums Basel, ed. by Christian Müller (Basel, 2009), p. 31; Petra Kayser, 'Wenzel Jamnitzer and Bernard Palissy uncover the secrets of nature', Australian and New Zealand Journal of Art 7:2 (2006), pp. 45–61; Hildegard Wiewelhove, Tischbrunnen. Forschungen zur europäischen Tischkultur (Berlin, 2002), p. 73.

57  For a new account of the sources for this commission, see Ivan Prokop Muchka, Ivo Purš, Sylva Dobalová and Jaroslava Hausenblasová, The Star: Archduke Ferdinand II of Austria and His Summer Palace in Prague (Prague, 2017), pp. 56–59.

Archduke Ferdinand II most likely met the famous goldsmith while on a 'stopover' in Vienna in 1556, and during this meeting he commissioned an unspecified extraordinary object that was to be executed in silver and gold.[58] Jamnitzer recommended getting assistance in this work from Jacopo Strada, and in a letter from Strada we learn that the luxurious object was to have 'Adam and Eve in Paradise' as its theme, accompanied by motifs of small animals and birds.[59] The letter also reveals that in order to make the object, a model or plan had to be created first, 'much like the ones that are made when palaces are being built'. Strada promised to secure and arrange everything necessary and said that he could employ a beautiful painted atlas of animals and fish as his source, and that gemstones would be used to decorate the finished piece. At the beginning of February 1558 Strada came from Nuremberg to Prague and brought little enamel animals with him for the archduke to consider.[60] It is only in a letter dated 8 July 1558 from the archduke to Jamnitzer that we finally learn the object the archduke had commissioned from Jamnitzer was in fact a *Wasserwerk* (fountain).[61]

The fountain in the Coburg drawing has three tiers. The bottom section is decorated with the rocks and crags of grotto scenery, along with plants and various types of small animal figures. The fountain is supported on a hexagonal column

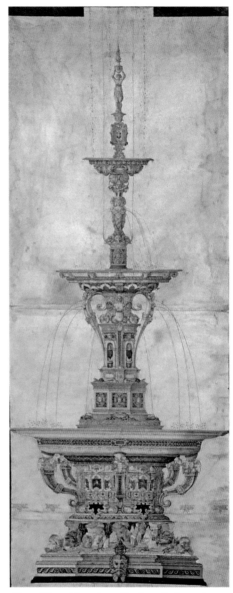

Fig. 6. Wenzel Jamnitzer, Design of a fountain (Collections of Veste Coburg Castle, inv. no. Z2860)

58   David von Schönherr, 'Urkunden und Regesten aus dem k.k. Statthalterei-Archiv in Innsbruck', *JKSAK* 11 (1890), pp. LXXXIV–CCXLI (CLXVII), reg. 7236.

59   Schönherr 1890, p. CLXVII, reg. 7237.

60   Schönherr 1890, p. CLXIX, reg. 7247 ('geschmeltzte dierlein').

61   Schönherr 1890, p. CLXXVI, reg. 7300: '…einen guten künstler, der mit dem verporgen über sich werfenden prunnwerch, so man in die lustgärten von kurzweil wegen zu machen pflegt, umzugeen und zu machen weiss'.

adorned with herms, cartouches, and mascaron ornaments. The figures of Adam and Eve are nowhere to be seen in the picture. The archduke was clearly interested in acquiring a fountain, but he may have changed his mind about the Adam and Eve iconography. In the meantime, Jamnitzer offered the archduke a fountain by another master (which he did not accept), so the question arises as to whether the drawing from Coburg might represent this new work.[62]

The question that remains is where exactly the Jamnitzer fountain commissioned by the archduke was supposed to be installed. If we examine the surviving drawing (it is on a scale of 1:1, and it is 135 cm high), it is clear that the fountain would have been rather large, and it is easy to imagine it being installed in the main ground-floor hall in the Star Summer Palace beneath the above-mentioned stucco decorations. The process of getting the fountain made, however, became very drawn out and ultimately it was never produced.

Nevertheless, this was just the start of the Archduke Ferdinand II's continued efforts to make decorative use of fountains. An exceptionally interesting resource on this subject is an album entitled *Prunnwerck* that was held in the archduke's *Kunstkammer* and is now in the Kunsthistorisches Museum in Vienna.[63] The album contains designs for seven fountains drawn by various masters. Some of the fountains have been the subject of research, others have been entirely overlooked. We can itemise them briefly here as: 'an octagonal fountain wth a sea fish'; a design for a fountain that looks like a small pavilion;[64] a fountain with a pelican on it; a fountain bearing the inscription 'Ferdinandus Erzherzog zu Österreich'; a fountain with a putto figure riding a swan (discussed above in the context of Terzio);[65] and two fountains that take Actaeon as their subject.[66] A total of eleven drawings are collected in the album, but some of them are simply different versions of the same object.

Among the drawings that have been overlooked, there is one depicting a specific type of fountain that was probably drawn by an architect rather than a painter, and is pasted into the very first page of the album. It contains two plan views and one frontal view. An unusual square pool inserted within the main octagonal basin might serve as a fish tank. According to the scale, the diameter of the fountain would have been just under 7 metres. The central column adorned with satyrs supports a smaller basin

62  Dirk Jakob Jansen, *Jacopo Strada and Cultural Patronage at the Imperial Court. The antique as Innovation*, 2 vols. (Leiden and Boston, 2019), pp. 94–96, indicates that Adam and Eve were supposed to decorate a *Tafelaufsatz* or *Credenz*.

63  Vienna, Kunsthistorisches Museum, Kunstkammer, inv. no. KK 5350; cf. most recently, see Exh. Cat. Prague 2017, p. 148 / p. 73, cat. no. II/49, with a bibliography.

64  Sylva Dobalová, 'Erzherzog Ferdinand II. von Habsburg, das Lusthaus Belvedere und die Fischbehälter im Königlichen Garten der Prager Burg', *Die Gartenkunst* 20: 2 Beilage (2008), pp. 11–18. There is currently a similarly shaped fountain in front of Ambras Castle that dates from 1914, see Frenzel 1978, p. 326.

65  After Albert Ilg's article on Terzio noticed by Schlosser 1901, pp. 15–16.

66  *Ferdinand II. 450 Years Sovereign Ruler of Tyrol. Jubilee Exhibition*, ed. by Sabine Haag and Veronika Sandbichler, exh. cat. (Innsbruck and Vienna, 2017), p. 264, cat. no. 6.5.5; Wiewelhove 2002, pp. 19 and 134, fig. 11.

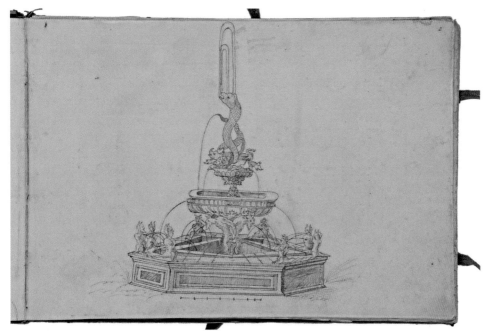

Fig. 7. Fountain with a large fish, from album with drawings of fountains (Vienna, Kunsthistorisches Museum, Kunstkammer, inv. no. KK 5350, fol. 3v)

above. The fountain is topped with monsters and a sculpture of a large fish. It is most probably connected with Maximilan II.[67] (Fig. 7)

If we turn to the question of the nature of the artist-patron relationship, the drawings of the two fountains taking Actaeon as their theme are particularly interesting. Helga Dressler, in her dissertation on the Dutch sculptor Alexander Colin, established a link between the Actaeon drawings and Archduke Ferdinand II's commission for a game preserve near the Hofburg in Innsbruck.[68] There, according to archival sources, a fountain *all'antica* was built on an Ovidian theme, featuring Actaeon transformed into a deer by Diana and surrounded by three nymphs. We know also that Archduke Ferdinand II sent a 'model' (probably a drawing) to Innsbruck, from which Colin was then supposed to produce a wax model. However, Colin was highly critical of the design. He argued that the figures were too small and also that it would be impossible to build the basin of the fountain as it had been designed. The archduke insisted that the fountain – including the precise size of the basin and figures – had to be executed

---

67   A discussion about a fountain topped by a large sea fish is known from correspondence between Maximilian II and Marx Labenwolf, see Hilda Lietzmann, 'Hans Reisingers Brunnen für den Garten der Herzogin in München', *Münchner Jahrbuch der bildenden Kunst* 3.F. 46. (1995 [1996]), pp. 117–142 (129).

68   Dressler 1973, pp. 60–62.

exactly as depicted in the *gmäl* (drawing?), as he stated in his letter.[69] Colin's description of the image he was criticising is not very intelligible, but he does discuss the column that Actaeon was supposed to stand on. This means that the image he was criticising is not exactly the same as the two slightly different drawings (of poor artistic quality) preserved in the *Prunnwerck* album, but the discussion itself is nonetheless illuminating. Was it perhaps the archduke himself who created that specific *gmäl*?

A second fountain featuring Actaeon, which curiously presents him not only transformed into a deer, but also riding a deer, offers a different solution whereby the fountain is placed in the middle of a room. (Fig. 8) In this drawing we see two stories of a building with a system of water tanks, and water flowing from the upper floor through the fountain to the lower floor. We might expect that such a system could have been planned for the interior of one of the archduke's hunting lodges.

The last fountain I would like to mention is presented in two drawings with the inscription 'FERDINANDUS VON GOTES GNADEN ERCHERZOG [...]' (for an illustration see Fig. 3 in the article by Reitter in this volume). This fountain can thus be assigned to the period of the archduke's residence in Innsbruck. The large basin of this fountain is supported by lions, while the top section rises to a peak with caryatids and putti supporting the figure of a nymph with a vase. The composition is much like Wenzel Jamnitzer's fountain in the Coburg drawing. The similarities are especially apparent in the part of the fountain with the caryatids, the central column, and in the figures on the top tier. One of the drawings is certainly more opulent, including gilding. The archduke no doubt wanted to keep one copy for himself, while giving the second copy of the drawing to the workshop (see the similar case of the Coburg drawing).

It is difficult to connect the fountains from the *Prunnwerck* album to any actual commissions. However, we know that Archduke Ferdinand II had a surprisingly large number of fountains installed at Ambras, and in various gardens in Innsbruck.[70] He commissioned the first (unnamed) fountain from Nuremburg in 1569.[71] There is also a detailed and specific description, for example, of a fountain in the Hofburg gardens in Innsbruck, which had four bronze satyrs, each of them holding a shell in their hands.

---

69   On this discussion, see David von Schönherr, 'Urkunden und Regesten aus dem k.k. Statthalterei-Archiv in Innsbruck', *JKSAK* 14 (1893), reg. 9710 and 9712–9730; on the fountains with Actaeon, see Klaus Pechstein, *Nürnberger Brunnenfiguren der Renaissance* (Nuremberg, 1969); Lietzmann 1995 [1996], p. 131.

70   Sources on fountains have been summarised in Frenzel 1978, pp. 61–122; an interpretation based on Frenzel is also provided in a text by Felmayer 1986, Ruhelust, pp. 626–639. As well as archival sources and estate inventories, fountains are also mentioned by the travellers Stephanus Pighius (1574) and Hans Georg Ernstinger (1579). The interesting context that Florence represents is indicated by a request from 'Waaserkünstler Ambrosius Bitzozero' from 1581 to be paid 'machung aines Modls und Probierung aines Wasserkunstwercks zu Ombras', which is brought to our attention in David von Schönherr, 'Ein fürstlichen Architekt und Bauherr', *Mitteilungen des Instituts für Österrechische Geschichtsforschung* 4 (1893), pp. 465–470, according to TLA, M. and H. 1581, fol. 442, C 737b. Bizzozero eventually, under Rudolf II, tried to obtain the exclusive right to installing the water conduits.

71   Frenzel 1978, p. 100; TLA, KS I, 737.

There is also mention of two marble fountains, a fountain by the sculptor Thomas Scalabrin in the *Irrgarten* (hedge maze) near Ruhelust (1583),[72] and a white marble fountain including nine enclosing columns that supported bronze sculptures spouting water ("darafsteen neun schene von gloggspeis gossne pilder, welche wasser geben, sambt irer postamentl").[73] The 1596 inventory of Archduke Ferdinand II's estate held in the Österreichische Nationalbibliothek (sign. Cod. 8228, hereafter estate inventory ÖNB) also contains records of numerous table fountains and of fountains installed indoors (see for example this mention of one such case, "im Saal ain zineren prunnen mit ainem gebirg von allerlei schenen handsteinen"), and there is also a record of a bagpiper *aus Zinn* (made from metal) that belonged to

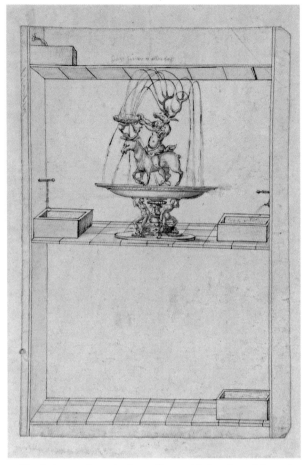

Fig. 8. Acteon fountain, from album with drawings of fountains (Vienna, Kunsthistorisches Museum, Kunstkammer, inv. no. KK 5350, fol. 5v)

a fountain.[74] At Ruhelust Palace there was even an entire spa with an elaborate system of water effects and fountains.[75] Only Philippine Welser's more modest spa at Ambras Castle has survived, it is however remarkable for its well-developed heating system.

The *Prunnwerck* album of unidentified and unidentifiable drawings of fountains is the only testimony remaining to this type of decoration in Archduke Ferdinand II's residences. Although we cannot formulate a very detailed idea of what the individual objects were like from this collection of drawings, it is possible to view them in the

---

72  Felmayer 1986, p. 636.
73  Frenzel 1978, p. 116, according to estate inventory ÖNB.
74  Felmayer 1986, p. 635.
75  On the spa in Ruhelust, see Felmayer 1986, p. 632; the budget for the work of the pipe maker (Wasserkünstler) Georg Schlundt from 1569, see Felmayer 1986, p. 641 (no. 34).

Fig. 9. Florian Abel, Design for a cenotaph of Emperor Maximilian I, 1561 (?) (Vienna, Kunsthistorisches Museum, Kunstkammer, inv. no. KK 4971)

context of information about the practices of the archduke's renaissance workshops. Fountains made of bronze were typical of the kind of commission that involved several different branches of artisanal and technical labour, all intersecting to complete the work. Bronze fountains required cooperation between designers, sculptors or carvers, casters, experts on chasing and ciselling, and even necessitated the presence of a 'water engineer' (pipe maker).

The final product, however, would doubtlessly have differed from what is pictured in the drawings. Michael Cole has reached the same conclusion in the studies he has conducted on sculptors' drawings.[76] Obviously, these two-dimensional drawings had to later be converted into the three-dimensional medium of sculpture.

It is difficult to create a sculpture from a drawing. It is, however, possible to make a good relief. Evidence of this is provided in the enormous drawing by Florian Abel, which was created to convey the design for Maximilian I's cenotaph, executed by Colin in the Court Church in Innsbruck. (Fig. 9) The dimensions of this drawing correspond proportionally to those of the mausoleum as it was built, and the figural scenes shown match those in the final work.[77] The gap between a drawing and the final three-dimensional outcome is tellingly illustrated by the debate between Colin and the archduke, where the sculptor was unable to execute the commission according to the drawings. Even though Colin tended to draw his own designs, this was not the only

---

76  Cole 2011, p. 17.

77  *Werke für Ewigkeit. Kaiser Maximilian I. und Erzherzog Ferdinand II.*, ed. by Wilfried Seipl, exh. cat. (Vienna, 2002), pp. 123–126, cat. no. 53; Haidacher / Diemer 2004; I would like to add the fact that Sigmund Elsässer, who created Ferdinand's Innsbruck tournaments sheets, came out of the Prague workshop of Florian Abel (after protocols of the painter's guild of the Old Town); see Karel Chytil, *Malířstvo pražské XV. a XVI. věku a jeho cechovní kniha staroměstská z let 1490–1582* (Prague, 1906), p. 77 (in 1565 as Abel's a disciple mentioned Sigmund Glseser).

case where he was working from drawings made by someone else (see the case of the mausoleum just mentioned) – and this was a standard practice in other workshops as well.

## Conclusion

Sculptural works, especially those that served as accessories to architecture and as garden ornamentation, represented an important area of Archdule Ferdinand II's artistic patronage. Fountains in particular were among the most expensive, protracted, and highly complicated types of commissions at this time, and required the combined cooperation of artists, tradesmen, and technical experts.[78] Artists were obliged to cooperate with each other, irrespective of their origin or language. The field of bronze casting can be said to have been dominated by artisans from the Germanic regions, while Italians, such as Terzio and Strada who are mentioned above, were more often found in the role of designers. Concerning Antonio Brocco, little of his work in Innsbruck has survived in comparison with Prague. We should remember that he may also have received commissions to create works for various festivities or celebrations organised by the archduke,[79] but such works were often done in plaster, burned clay or paper mache and their lifespan would therefore have been rather limited. In gardens as well, it was common for sculptures to be done in lime-plaster stucco, which is not an enduring medium.[80]

As a patron of the arts, Archduke Ferdinand II was not only educated but also extremely creative himself.[81] He understood architecture, he knew how to blow glass and carve wooden objects, he wrote play for the theatre, made decisions about the costumes and scripts for his ceremonies, and curated his own collections. In many branches of the arts his role as a patron stands out. It is a well-known fact that the patron's 'oversight' was even more essential in the case of sculptural commissions (and commissions of works in bronze) because the material was very expensive. The archduke's role as a kind of manager of artistic production was important and more 'conspicuous', so to speak, partly because the artists he worked with (with the exception of some, like Alexander Colin and Francesco Terzio) were not usually masters on a grand scale. This fact is certainly of some significance. Taking the court of the early Medicis as an example, Bullard has shown that if an artist is truly one of extraordinary artistic skill, the role of the patron recedes into the background, regardless of how much the

---

78   This is the theme of an illuminating publication by Richard J. Tuttle, *Neptun Fountain in Bologna. Bronze, Marble, and Water in the Making of the Papal City*, ed. by Nadja Aksamija and Francesco Ceccarelli (London, 2015), p. 72.

79   In Prague, two Italien artists – probably Terzio and Brocco – are mentioned in a description of a triumphal arch, erected in 1562, see Carrai 2007, p. 173.

80   Eckart Marchand, 'Plaster and Plaster Casts in Renaissance Italy', in Frederiksen and Marchand 2010, pp. 49–79.

81   Archduke Ferdinand II has also been discussed in the context of patronage at other Central European courts by Kaufmann 1995, see especially chapters 8 and 9.

patron wants to intervene in the creation of a work of art.[82] She also notes that the kind of 'mega-patrons' who were personally responsible for shaping Renaissance culture relied foremost on well-functioning workshops, as well as having an administrative apparatus at their disposal to arrange and coordinate their artistic commissions and collecting activities. It is however clear that in several Central European courts there were rulers who were also capable of arranging such activities, even if it was on a smaller scale. Archduke Ferdinand II's Tyrolean court is an illustrative example of this.

The areas of architectonic, sculptural, and relief work discussed here with particular regard for fountains shed great light on the process of close cooperation between the patron and his artists, in which an especially important role was played by drawings as a new Renaissance medium for communicating artistic ideas. Paradoxically, it is these drawings, and the prints in the archduke's collection of albums, that have survived, unlike the actual works of art themselves. Archduke Ferdinand II's educated servants, whose abilities were often nurtured and allowed to grow and develop while at his court, (as demonstrated in the article by Ivo Purš in this volume) were often able to even take unfinished ideas and sort and catalogue them. In this way, they managed to process an enormous amount of material.

The patronage of sculpture generally tends to be overlooked when compared to the focus of art historians on the patronage of painting of all kinds, and architectural commissions.[83] In this case, however, there is no overlooking the significance of sculpture. Archduke Ferdinand II evidently had no great interest in painting or other types of art that functioned purely as mediums for 'mere' aesthetic qualities. The transformation of a work of art into a 'collector's artefact' was still underway during the archduke's lifetime, and was not yet something that was an even remotely assumed or obvious occurrence.[84] The archduke's collections primarily contained works that always had some kind of concrete purpose, or that were a phenomenon of nature or technical achievement, or represented some form of historical testimony. The survival of the monumental sculptural commissions that I have presented in this article have long remained tied up with a particular location and thus with the figure of Archduke Ferdinand II himself, and it is also true that their iconography reflected political and symbolic messages. These works performed an important social function in court rituals, but in the archduke's case these works did not appear in the public space (with the exception of the tombs and sepulchres of the archduke's forebears). This meant they

---

82   Mellisa Merriam Bullard, 'Heroes and their workshops: Medici Patronage and the Problem of Shared Agency', in *The Italian Renaissance: The Essential Readings. Blackwell Essential Readings in History*, ed. Paula Findlen (Malden, 2002); Ernst H. Gombrich, 'The Early Medici as Patrons of Art', in idem, *Norm and Form: Studies in the Art of Renaissance* (London, 1996), pp. 35–57.

83   After Kathleen Wren Christian and David J. Drogin, 'Introduction: The virtues of the medium: the patronage of sculpture in Renaissance Italy', in *Patronage and Italian Renaissance Sculpture*, ed. by Kathleen Christian (New York, 2016), pp. 1–20.

84   Cf. *Giorgio Vasari and the Birth of the Museum*, ed. by Maia Wellington Gahtan (Farnham, 2014); Ulrich Pfisterer and Gabriele Wimböck, *Novità: Neuheitskonzepte in den Bildkünsten um 1600* (Zürich, 2011).

could only be admired by a select circle of visitors. In the process of commissioning these works of art Archduke Ferdinand II most certainly built a vast network of local ties and established certain standards that, even after his death, continued to have an influence on artistic production in the region and also Central Europe.[85]

---

85  Until now, reasearch did not point out how many artists working for a longer or shorter period in Innsbruck also worked in Prague at the court of Rudolf II, during the lifetime of an archduke and also after his death – we can name, for example, Colin, Hoefnagel or a son of Antonio Brocco, Giovanni Antonio Brocco.

Blanka Kubíková

# Portraiture at the archduke's court and in the Bohemian Lands

The Habsburg dynasty paid a great deal of attention to how the family was represented in portraits, and gradually started to use portraiture to develop a distinct promotional strategy.[1] Archduke Ferdinand II was no exception; in fact, he had an extraordinary interest in portraits of various forms and meaning.[2] His attitude towards portraiture was formed chiefly by family tradition, specifically the commissions placed by his father, Ferdinand I,[3] and other members of his family; the most important stimulus was the typologically very diverse patronage of Emperor Maximilian I.[4] Archduke Ferdinand II succeeded Maximilian I as the Tyrolean ruler, and precisely because of this, the legacy of this important ancestor was very significant for him.[5] He built on the concept of per-

---

1   There is a great amount of literature on the theme, e. g. Günter Heinz, Studien zur Porträtmalerei an den Höfen der österreichischen Erblande, *Jahrbuch der Kunsthistorischen Sammlungen in Wien* (hereafter as *JKSW*) 59 (1963), pp. 99–224; Karl Vocelka, *Die politische Propaganda Kaiser Rudolfs II. (1576–1612)* (Vienna, 1981); Francesco Checa Cremades, *Carlos V y la imagen del héroe ed el renacimiento* (Madrid, 1987); *Un príncipe del renacimiento: Felipe II, un monarca y su época*, ed. by Fernando Checa Cremades, exh. cat. (Madrid, 1998); Fernando Checa Cremades, Miguel Falomir Faus and Javier Portús Pérez, *Retratos de familia* (Madrid, 2000); Leticia Ruiz Gómez, 'Retratos de corte en la monarquía española (1530–1660)', in *El retrato español: del Greco a Picasso*, ed. by Javier Portús Pérez and José Alvarez Lopera (Madrid, 2004), pp. 92–119; Diane Bodart, *Pouvoirs du portrait sous les Habsbourg d'Espagne* (Paris, 2011); the studies by Friedrich Polleross, e. g. Friedrich B. Polleross, 'Zur Repräsentation der Habsburger in der bildenden Kunst', in *Welt der Barock*, ed. by Ruprecht Feuchtmüller and Elisabeth Kovács, exh. cat. (Vienna, Freiburg and Basel, 1986), pp. 87–104; Friedrich B. Polleross, 'Kaiser, König, Landesfürst: Habsburgische „Dreifaltigkeit" im Porträt', in *Bildnis, Fürst und Territorium*, ed. by Andreas Beyer, Ulrich Schütte and Lutz Unbehaun (Munich and Berlin, 2000), pp. 189–218, and many other stimulating treatises.
2   For more, see Friedrich Kenner, 'Die Porträtsammlung des Erzherzogs Ferdinand von Tirol', *Jahrbuch der kunsthistorischen Sammlungen des Allerhöchsten Kaiserhauses* (hereafter as *JKSAK*) 14 (1893), pp. 37–186; *JKSAK* 15 (1893), pp. 147–259; *JKSAK* 17 (1896), pp. 101–274; *JKSAK* 18 (1897), pp. 135–261; *JKSAK* 19 (1898), pp. 6–146; Karl Schütz, 'Die Porträtsammlung Erzherzog Ferdinands II.', in *Werke für die Ewigkeit. Kaiser Maximilian I. und Erzherzog Ferdinand II.*, ed. by Wilfried Seipel, exh. cat. (Innsbruck, 2002), pp. 19–23; Blanka Kubíková, 'The Image of Archduke Ferdinand II in his portraits', in *Ferdinand II. 450 Years Sovereign Ruler of Tyrol. Jubilee Exhibition*, ed. by Sabine Haag and Veronika Sandbichler, exh. cat. (Innsbruck and Vienna, 2017), pp. 55–60.
3   On the portrait iconography of Ferdinand I, see Wolfgang Hilger, *Ikonographie Kaiser Ferdinands I. (1503–1564)* (Vienna, 1969); Wolfgang Hilger, 'Das Bild vom König und Kaiser. Ammerkungen zu Verbreitung und Wirkungsgeschichte von Herrscherdarstellungen am Beispiel Ferdinands I.', in *Kaiser Ferdinand I. 1503–1564. Das Werden der Habsburgermonarchie*, ed. by Wilfried Seipel, exh. cat. (Vienna, 2003), pp. 231–241.
4   On the patronage of Emperor Maximilian I, see more with Larry Silver, *Marketing Maximilian. The Visual Ideology of a Holy Roman Emperor* (Princeton, 2008); *Emperor Maximilian I and the Age of Dürer,* ed. by Eva Michel and Maria Luise Sternath, exh. cat. (Vienna, 2012).
5   On the connection of Archduke Ferdinand to the legacy of his grandfather, see *Werke für die Ewigkeit. Kaiser Maximilian I. und Erzherzog Ferdinand II.*, ed. by Wilfried Seipel, exh. cat. (Innsbruck, 2002).

sonal and dynastic representation that his grandfather had worked to develop into rich displays of majestic splendour.[6] An important role in Maximilian I's representation and propaganda was played by the historical point of view – it can be seen as an attempt to both seek out and record the family's roots, in both written and pictorial form. Both rulers supported and stimulated genealogical research. The key aspect of Maximilian I's patronage was the preservation of monuments to his own person and to his family for future generations. For this, the emperor used diverse artistic media, including illuminated manuscripts, illustrated printed books, and huge woodcut prints, reliefs or portrait paintings. Maximilian I's monumental memorial is an extraordinary work of art, which was finally established in Innsbruck's Hofkirche.[7] The cenotaph decorated with reliefs depicting the significant events of Maximilian I's life was to be accompanied by forty bronze statues of the Habsburg ancestors in larger-than-life size, thirty-four busts of the Roman emperors, and a hundred saints connected with the Habsburg dynasty. The realisation of the monument was demanding and the work — the outward appearance of which was already under discussion in 1502 — was only completed during the reign of Archduke Ferdinand II in the 1580s. Although the number of figures was reduced, the monument represents an entirely exceptional artistic act. The remarkably impressive sculpture ensemble fundamentally influenced Habsburg portrait iconography, and the concept of successive Habsburg works with genealogical themes.[8]

Other powerful impulses affecting portrait representation came from the Italian courts, with which the Habsburgs had many connections thanks to their marital politics, as well as the archduke's participation in the Imperial Diets and his residencies elsewhere. The archduke spent twenty years in the Bohemian Lands, where there was a long tradition of representative portraits dating back to the rule of Emperor Charles IV in the fourteenth century.[9] Portraiture significantly developed during the rule of the Jagiellonian dynasty, and there was a substantial increase in production from the mid-16th century on, particularly amongst the wealthy and well-travelled members of prominent aristocratic families.[10]

---

6   See Silver 2008.

7   For monographs on the memorial, see especially Christoph Haidacher and Dorothea Diemer, *Maximilian I. Der Kenotaph in der Hofkirche zu Innsbruck* (Innsbruck, 2004). Emperor Maximilian planned to place the tomb in the chapel of St. George at Wiener Neustadt.

8   Such as, e.g., the album *Imagines gentis Austriacae*, a five-volume Habsburg genealogy, which is the work of Francesco Terzio. This court painter of Archduke Ferdinand organized the whole enterprise and made the drawn models. Some figures were made after the statues in Hofkirche. The author of the engravings is Gaspare Oselli called Patavinus. On the album in detail, see Elisabeth Scheicher, 'Die „Imagines gentis Austriacae" des Francesco Terzio', *JKSW* 79 (1983), pp. 43–92.

9   The fundamental treatise on the portraiture in Bohemia at the time of Charles IV was written by Antonín Matějček, 'Podíl Čech na vzniku portrétu v 14. století', *Umění* 10 (1937), pp. 65–74; on the emperor's depictions, see also *Magister Theodoricus, dvorní malíř císaře Karla IV.*, ed. by Jiří Fajt, exh. cat. (Prague, 1997).

10  For a monographic treatment of Renaissance portraiture in the Bohemian lands, see Eva Bukolská, *Renesanční portrét v Čechách a na Moravě* (unpublished doctoral thesis, Czechoslovak Academy of Sciences, Prague, 1968); Blanka Kubíková, *Portrét v renesančním malířství v českých zemích. Jeho ikonografie a funkce ve šlechtické reprezentaci* (Prague, 2016).

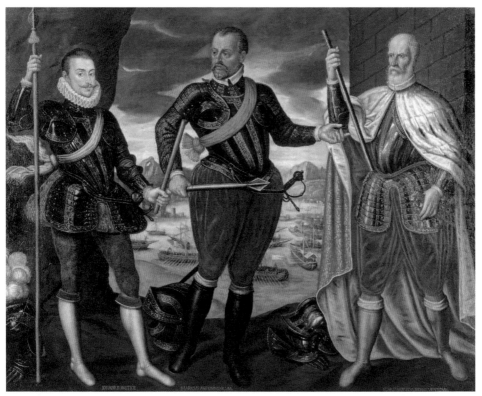

Fig. 1. John of Austria, Marcantonio II Colonna and Sebastiano Venier, victorious commanders of the battle of Lepanto, between 1571–1595 (Vienna, Kunsthistorisches Museum, Picture Gallery, inv. no. GG 8270)

As governor of the Bohemian Lands, Archduke Ferdinand II was in a very important position. During the time he spent in Bohemia, from 1547 to 1567, he developed strong contacts with the Bohemian and Moravian nobility.[11] These links remained in place even after he left for Tyrol. This study aims to answer the question of whether the archduke's interest in portraiture had an impact on portrait representation and the Bohemian nobility's patronage of portraiture, and conversely, what imprint Archduke Ferdinand II's stay in Bohemia might have left on this area of his interest.

---

11	On the relationship of the archduke to Bohemia, see especially Václav Bůžek, *Ferdinand von Tirol zwischen Prag und Innsbruck. Der Adel aus den böhmischen Ländern auf dem Weg zu den Höfen der ersten Habsburger* (Vienna, Cologne and Weimar, 2009); Jaroslava Hausenblasová, 'Arcivévoda Ferdinand II. Tyrolský – správce a místodržící zemí Koruny české / Erzherzog Ferdinand II. – Verweser und Statthalter der Länder der Böhmischen Krone', in *Arcivévoda Ferdinand II. Habsburský. Renesanční vladař a mecenáš mezi Prahou a Innsbruckem / Ferdinand II. Erzherzog von Österreich aus dem Hause Habsburg. Renaissance-Herrscher und Mäzen zwischen Prag und Innsbruck*, ed. by Blanka Kubíková, Jaroslava Hausenblasová and Sylva Dobalová, exh. cat. (Prague, 2017), pp. 18–23/13–16.

## Archduke Ferdinand II: A role model for the Bohemian nobility

Archduke Ferdinand II gained renown as an avid collector, and his collections included portrait paintings.[12] The inventories made after his death in January 1595 provide us with a great deal of information about the collections that he amassed at his residences in Innsbruck, as well as about the furnishings of these residences.[13] These inventories also contain information on the placement of the paintings, the majority of which were portraits and paintings on religious themes. So, at Ruhelust Castle in Innsbruck, a series of painted portrayals of significant persons were hung in the *grossen Saal* (great hall), including full-length portraits of Christopher Columbus, Constantine the Great, Andrea Doria, and Sultan Suleiman, as well as the triple portrait of the victorious commanders of the Christian armies from the battle at Lepanto (1571): John of Austria, Marcantonio II Colonna, and Sebastiano Venier.[14] (Fig. 1) A large number of other portrait depictions were deposited in the chests in the hallway across from the chapel.[15] In the "Altenburg" – that is the Hofburg in the centre of Innsbruck – there were thirty-two large portraits of Austrian rulers in the *grossen Saal* (great hall).[16] There was also an abundance of portraits at Ambras Castle, decorating the library, the walls of the

---

12   On the collections of Archduke Ferdinand II, e. g. Josef Hirn, *Erzherzog Ferdinand II. von Tirol. Geschichte seiner Regierung und seiner Länder*, 2 vols. (Innsbruck, 1885–1888); Laurin Luchner, *Denkmal eines Renaissancefürsten: Versuch einer Rekonstruktion des Ambraser Museums von 1583* (Vienna, 1958); Elisabeth Scheicher, Kurt Wegerer, Ortwin Gamber and Alfred Auer, *Die Kunstkammer. Kunsthistorisches Museum, Sammlungen Schloß Ambras, Führer durch das Kunsthistorische Museum*, 24 (Innsbruck, 1977); Elisabeth Scheicher, 'Historiography and display. The „Heldenrüstkammer" of Archduke Ferdinand II in Schloss Ambras', *Journal of the History of Collections* 1 (1990), pp. 69–79; from the numerous catalogues of the Kunsthistorisches Museum e. g.: *Natur und Kunst. Handschriften und Alben aus der Ambraser Sammlung Erzherzog Ferdinands II. (1529–1595)*, ed. by Alfred Auer and Eva Irblich, exh. cat. (Innsbruck, 1995); *Alle Wunder dieser Welt. Die kostbarsten Kunstschätze aus der Sammlung Erzherzog Ferdinands II. (1529–1595)*, ed. by Wilfried Seipel, exh. cat. (Innsbruck, 2001); *Die Entdeckung der Natur. Naturalien in den Kunstkammern des 16. und 17. Jahrhunderts,* ed. by Wilfried Seipel, exh. cat. (Innsbruck, 2006); Exh. Cat. Innsbruck 2017; Exh. Cat. Prague 2017; on the archduke's book collections in detail, see *Knihovna arcivévody Ferdinanda II. Tyrolského*, ed. by Ivo Purš and Hedvika Kuchařová, 2 vols. (Prague, 2015), with German summary.

13   Especially *Inventarium germanicum rerum mobilium archiducis Ferdinandi Oenipontati verfasser. Karl von Wolkenstein*, Vienna, Österreichisches Nationalbibliothek (hereafter ÖNB), sign. Cod. 8228, published by Wendelin Boeheim, 'Urkunden und Regesten aus der k.k. Hofbibliothek', *JKSAK* 7 (1888); *Haubt Inventary Uber das fürstlich Schloss Ombras sambt der Kunst- Auch Rüsst Camer und Bibliodeca* [...], Kunsthistorisches Museum Vienna, Kunstkammer, inv. no. KK 6654, published by: Alfred Auer, 'Das Inventarium der Ambraser Sammlungen aus dem Jahre 1621, 1. Teil: Die Rüstkammern', *JKSW* 80 (1984), pp. I–CXXI; Alfred Auer, 'Das Inventarium der Ambraser Sammlungen aus dem Jahre 1621, II. Teil: Bibliothek', *Jahrbuch des Kunsthistorischen Museums Wien* 2 (2001), pp. 282–346; and an unpublished inventory *Inventary Weyland der Frh:Drt: Erzherzog Ferdinannden Zu Ossterreich etc. lobseeligister gedechtnuß Varnussen Unnd mobilien [...],* Vienna, Kunsthistorisches Museum, Kunstkammer, inv. no. KK 6652, which Thomas Kuster and Elisabeth Reitter from the Schloss Ambras Innsbruck are preparing for publication.

14   Boeheim 1888, p. CCXXXVI, fol. 55–56. The mentioned portraits are on display today at Ambras castle.

15   Boeheim 1888, p. CCXXXII, fol. 30.

16   Boeheim 1888, p. CCXLVII, fol. 154.

*Kunstkammer*, and the residential rooms.[17] Besides the portrait images, the painted works that have been preserved from the archduke's collections seem to mainly relate to his passion for hunting (depictions of quarry or a hunting falcon, for example), to document the common moments of his life (for example, portrayals of pets), or to record curiosities such as the image of an extraordinarily large pig, exotic animals, or servants at the court with physical abnormalities and so on.

In comparison with Archduke Ferdinand II's period of residency in Tyrol, we have only very little information about his painting commissions from the time he spent in Bohemia. It is possible to obtain at least an idea about these commissions on the basis of the written materials, in combination with those paintings originating from the archduke's Bohemian period that have been preserved. These primarily consist of portraits of Archduke Ferdinand II himself. There is a full-length portrait of the archduke, signed by King Ferdinand I's court painter, Jakob Seisenegger, that is dated 1548.[18] (Fig. 2) At that time, the young archduke was only nineteen, but he had already served as governor in

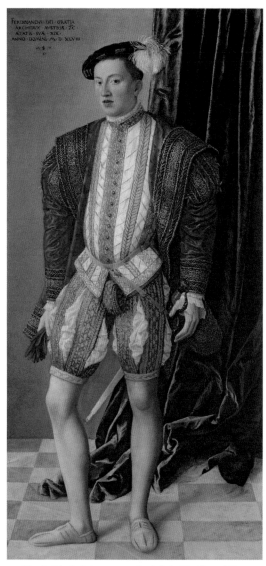

Fig. 2. Jakob Seisenegger, Archduke Ferdinand II, 1548 (Vienna, Kunsthistorisches Museum, Picture Gallery, inv. no. GG 5947)

17   See Boeheim 1888, pp. CCLVIII and further, passim; Wendelin Boeheim, 'Urkunden und Regesten aus der k.k. Hofbibliothek', *JKSAK* 10 (1889), pp. CCXXVI–CCCXIII, reg. 5556, passim. A very graphic reconstruction of the display of paintings in the *Kunstkammer* was conducted according to the inventories by Veronika Sandbichler and Thomas Kuster for the exhibition *Ferdinand II. 450 Jahre Tiroler Landesfürst*, which took place at Ambras castle in 2017. See also article by Sandbichler in this volume.

18   Vienna, Kunsthistorisches Museum, Picture Gallery, inv. no. 5947. Kurt Löcher, *Jakob Seisenegger. Hofmaler Kaiser Ferdinands I.* (Berlin, 1962), pp. 49, 87, cat. no. 29.

the Kingdom of Bohemia for a year. It is very likely that this portrait was painted in Bohemia. Seisenegger was active in both countries, according to the king's needs, and served King Ferdinand I from 1531 on, but from 1541 to 1548 he remained mainly in Bohemia.[19]

Several other portraits have been preserved from the archduke's time in Bohemia. Specifically, these are: a portrait of Archduke Ferdinand II in the *Adlergarnitur* (the *Eagle Armour*), which is generally believed to have been made in 1556 (Fig. 3);[20] a portrait of him in white attire and the Order of the Golden Fleece dated by scholars to around 1557;[21] a portrait of his wife, Philippine Welser, probably painted at the same time;[22] and finally a double portrait of their sons, Andreas and Karl, which was apparently completed around 1565.[23] It is highly likely that these portraits decorated the archduke's residences in Bohemia and could thus be admired by visitors. From the written records, we have also learned something about Archduke Ferdinand II's active acquisitions of portraits of his relatives; for example in 1557, he received a portrait of Emperor Charles V (probably a copy after Titian) from Cardinal Antoine Perrenot de Granvelle, a diplomat and counsellor to the emperor;[24] in 1558, he had two portraits of Rudolf I of Habsburg sent from Innsbruck to Prague; through Hans Jakob Fugger he also acquired a painting of Princess Maria of Portugal, the first wife of King Philip II of Spain.[25] In 1565, he asked Adam of Dietrichstein, the emperor's ambassador to Spain, to send him portraits of Philip's current wife, as well as his former spouses, the English Queen Mary Tudor (1516–1558) and Elisabeth of Valois (1545–1568), and also one of Phillip's son Carlos, Prince of Asturias (1545–1568).[26] The portraits of the ancestors, as well as the image of Emperor Charles V and the other members of the Spanish branch of the House of Habsburg, all had a chiefly representative role. The portrait gallery of the Habsburg family symbolized the unity of the powerful dynasty: it brought the distant members of the family 'closer' to observers at the other end of the empire. It also convincingly demonstrated the dynasty's affinity with other leading royal families, and via this depiction of power and alliance, strengthened the position of the Habsburgs in the eyes of the Bohemian nobility. It seems extremely likely that

---

19  For a monographic treatment on Seisenegger, see Löcher 1962; the author summarised the new knowledge and revision in Kurt Löcher, 'Jakob Seisenegger. Hofmaler Kaiser Ferdinands I. – Neue Funde und Stand der Forschung', *Münchner Jahrbuch der Bildenden Kunst* 58 (2012), pp. 103–146.

20  Vienna, Kunsthistorisches Museum, Picture Gallery, inv. no. 8063. On the dating, see Exh. Cat Prague 2017, p. 113, cat. no. II/18 (Thomas Kuster).

21  Vienna, Kunsthistorisches Museum, Picture Gallery, inv. no. 7971. On the dating, see Exh. Cat. Prague 2017, cat. no. II/32, p. 128 and II/32, p. 67 (Thomas Kuster).

22  Vienna, Kunsthistorisches Museum, Picture Gallery, inv. no. 8012.

23  Vienna, Kunsthistorisches Museum, Picture Gallery, inv. no. 8033.

24  Josef Hirn, *Erzherzog Ferdinand II. von Tirol. Geschichte seiner Regierung und seiner Länder*, 2 (Innsbruck, 1888), p. 432.

25  Hirn 1888, p. 432. Innsbruck, Tiroler Landesarchiv (hereafter TLA), Ambraser Memorabilien 1557, 1558.

26  Kenner 1893, p. 39, after David von Schönherr, 'Urkunden und Regesten aus dem k.k. Stadthalterei-Archiv in Innsbruck', *JKSAK* 14 (1893), p. LXXIII, reg. 9718.

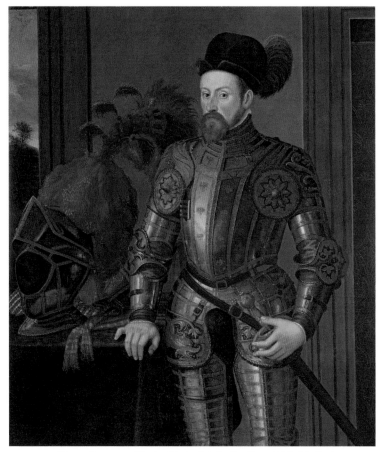

Fig. 3. Francesco Terzio (?), Archduke Ferdinand II in his Eagle armour,
1556–1557 (Vienna, Kunsthistorisches Museum, Picture Gallery,
inv. no. GG 8063)

these portraits were displayed in a place accessible to Archduke Ferdinand II's visitors: they were probably 'flaunted', that is deliberately placed to maximise their visibility, and thus played a major role in the propaganda of the Habsburg family. The archduke's imposing portrait gallery could in fact also have inspired the Bohemian aristocracy to follow his lead and acquire similar dynastic portrait series.

Without a doubt, the presence of the painters employed by the archduke was beneficial to painting production in the Bohemian Lands. The North Italian painter Francesco Terzio (1523–1591) entered the archduke's service in 1551,[27] and proved capable of introducing Italian decorum and splendour to the popular compositional formula of the representational portrait. There are no known portraits from Terzio's first years at the archduke's court. However, in the 1960s the portraits of the archduke

27    Mila Pistoi, 'Francesco Terzi', in *I pittori bergamaschi dal XIII al XIX secolo*, III/2, *Il Cinquecento*,
      ed. by Pietro Zampetti and Gian Alberto Dell'Acqua (Bergamo, 1976), pp. 593–609 (593).

from 1556 and 1557 were ascribed to Terzio by Günther Heinz,[28] although this attribution has sometimes been doubted in the intervening years, and the paintings are
sometimes said to be the work of an artist from either southern Germany, Tyrol or
Nothern Italy.[29] We also have a portrait of emperor Charles V signed by Francesco
Terzio and dated 1550. However, this work was most likely painted later, following a
model, and antedated.[30] Two letters by Archduke Ferdinand II sent from Prague during 1553 prove that he sent Terzio to Vienna to paint the portraits of four archduchesses, the sisters of Archduke Ferdinand.[31] Written sources also mention that the
Bohemian Chamber had paid Francesco Terzio his fee, in February 1565, for the completed painting of the new organ in Prague's cathedral, for "prunnenfurmb" in the
castle garden, and for three portraits.[32] We might be able to identify these three paintings as the full-length portraits of the Archduchesses Joanna, Barbara, and Magdalena
(?) that have been preserved in the Ambras Castle collections – two of them are dated
with this year and one is signed with the initials "FT". However, they could also be
three other portraits, perhaps with a closer connection to Prague Castle: this seems
likely if we take into account that they were paid for by the Bohemian Chamber, and
had apparently already been completed before February 1565, when the painter was
paid for them. Moreover, the three portrayals were in all probability painted in Innsbruck where they also remained. The portraits follow the standard structure of full-
length portraits and the painting technique is of a high quality. What is surprising is the
fairly low degree of idealisation in the depiction of the young womens' faces, which
might indicate the influence of the nothern Italian school of painting; however, the
elegant painterly presentation confirms they were made by a good painter familiar with
Venetian painting. The written sources also mention that Terzio brought an assistant
from Bergamo to Prague in October 1557 – the painter Francesco Gozzi (1539–1607).[33]

---

28    Günter Heinz, 'Studien zur Porträtmalerei an den Höfen der österreichischen Erblande', *Jahrbuch
      der Kunsthistorischen Sammlungen in Wien* 59 (1963), pp. 99–224, p. 167, cat. no. 10 and 11.
29    E.g. Exh. Cat. Vienna 2003, p. 297, where there is an attribution of the *Adlergarnitur* portrait to
      Terzio, listed with a question mark (Albrecht Auer); Exh. Cat. Innsbruck 2017, p. 132, cat. no. 3.1.;
      p. 144. cat. no. 4.3. (both by Thomas Kuster) express doubt as to the authorship of the two portraits,
      which are attributed to a painter of German or North Italian provenience, without ruling out the
      authorship of Jakob Seisenegger or Francesco Terzio.
30    Vienna, Kunsthistorisches Museum, inv. n. GG 1533.
31    David von Schönherr, 'Urkunden und Regesten aus dem k.k. Statthalterei-Archiv in Innsbruck',
      *JKSAK* 11 (1890), pp. LXXXIV–CCXLI (CXXXVI), reg. 6995; p. CXXXVII, reg. 7010; Wilhelm
      Suida, 'Terzio (Terzi, Terzo), Francesco (Giov. Fr.)', in *Thieme-Becker. Allgemeines Lexikon der
      bildenden Künstler von der Antike bis zur Gegenwart*, XXXII, ed. by Hans Vollmer (Leipzig, 1938),
      pp. 546–548 (546).
32    Franz Kreyczi, 'Urkunden und Regesten aus dem K. und K. Reichs-Finanz-Archiv', *JKSAK* 5 (1887),
      pp. XXV–CXIX (CI), reg. 4380: "Die böhmische Kammer wird beauftragt,[…] hofmaler Franciszco
      de Tertiis die vierhundert funfundfunfzig shockh Meisznish und zwenunddreissig kreuzer, […]
      von mallung der flügl an der grossen orgl in der sloszkirchen zu Prag, dann wider von dreien
      abcontrafeten und von ainem prunnenfurmb im lustgarten […] zu bezahlen."
33    Albert Ilg, 'Francesco Terzio, der Hofmaler Erzherzogs Ferdinand von Tirol', *JKSAK* 9 (1889),
      pp. 229–263 (238); Pistoi 1976, pp. 594, 599.

They concluded a working contract for a period of three and a half years. This implies that Terzio must have been enjoying success, and that he had a great deal of work at that time. From 1558, perhaps even earlier, he worked on the model drawings for the graphic album *Imagines gentis Austriacae,* a monumental genealogy of the Habsburgs including 74 fulllength portraits of the members of the dynasty, which was published in five volumes between 1569 and 1573.[34] (Fig. 4) At the beginning of the 1560s, Terzio completed the decoration of the new organ in the church of St. Vitus and also completed the design of the Singing Fountain in the Royal Garden of Prague Castle. He most likely also took part in the decoration of the renovated Old Diet Hall in the Old Royal Palace.[35] On the

Fig. 4. Gaspare Oselli after Francesco Terzio, Rudolf I of Germany, from Imagines gentis Austriacae, Innsbruck, 1569–1573 (National Gallery Prague, inv. no. R 190111)

basis of his participation in the decoration of the Granovský Palace in Prague,[36] and his extensive work – undertaken from 1565 – on the drawings for the illustration of the fourth edition of the *Czech Bible* published by the Bohemian printer Jiří Melantrich of

---

34    For more on the album, see Ilg 1889; Scheicher 1983; most recently Exh. Cat. Prague 2017, pp. 306–307, cat. no. VI/2 (Thomas Kuster).

35    This issue was recently dealt with by Eliška Fučíková, 'Pražský hrad a jeho výzdoba za arcivévody Ferdinanda II.' / 'Die Prager Burg unter Erzherzog Ferdinand II.: Umbau und künstlerische Gestaltung', in Exh. Cat. Prague 2017, pp. 38–43 / 27–30; Sylva Dobalová and Ivan Prokop Muchka, 'Stavební projekty arcivévody Ferdinanda' / 'Erzherzog Ferdinand II. als Bauherr in Prag und Innsbruck', in Exh. Cat. Prague 2017, pp. 32–37 / 23–26.

36    This attribution was first published by Herain 1908, who is quoted by *Umělecké památky Prahy. Staré Město a Josefov,* ed. by Pavel Vlček (Prague, 1996), p. 431 and most recently by Lenka Babická, *Palác Granovských v Ungeltu* (unpublished bachelor thesis, Charles University in Prague, 2014), pp. 7, 52.

Aventino,[37] it is apparent that Terzio did not work exclusively for the archduke. We know that he moved to Innsbruck with his family in 1564,[38] and therefore must have completed these commissions from a distance.

Only a few examples of 16th century Bohemian portraiture have been preserved. Nevertheless, around the middle of the century there was a considerable increase in commissions, and together with this increase there was a shift from the older portrait type using the more rigid figures known from Seisenegger's paintings, to the significantly more elegant and majestic portraits following Titian's style. Familiarity with Italian portraits spread to Bohemia from different sources, the most important of which were the Imperial court and the Imperial Diets that were attended not only by aristocrats and politicians, but also by artists, thus leading to encounters with artists from beyond the Alps and Italy.[39] Italian art was also personally discovered by noblemen and by artists during their journeys abroad. However, there is no doubt that a significant role in the reception of new artistic stimuli was also played by Archduke Ferdinand II, his court artists, and his portrait collection.

The intermediary role of Archduke Ferdinand II may be seen more clearly in the collections of portraits of important men and women, known as *viri illustri* or *uomini famosi*. The first collection of this type was established by the Italian bishop, doctor and humanist Paolo Giovio (1483–1552) in his villa in Borgovico near Lake Como.[40] All of the portraits were of the same dimensions, portraying only the head and shoulders of the subject. This collection became more widely known through Giovio's books *Elogia virorum bellica virtute illustrium* (1st published in Florence in 1551; the illustrated edition was published in 1575), and *Elogia doctorum virorum*, which was

---

37   Most recently on that edition of Melantrich's bible see Exh. Cat. Prague 2017, cat. no. II/24, p. 120 and II/24, p. 64 (Petr Voit); cat. no. II/25, p. 121 and II/25, pp. 64–65 (Blanka Kubíková).

38   Pistoi 1976, p. 600: on May 5, 1564 Terzio left for Italy but stopped in Innsbruck, where he remained for four years.

39   For more on that theme, see Rudolf Arthur Peltzer, 'Tizian in Augsburg', *Das Schwäbische Museum* 1 (1925), pp. 31–45; Kurt Löcher, 'Die Malerei in Augsburg 1530–1550', in *Welt im Umbruch. Augsburg zwischen Renaissance und Barock*, II (Augsburg, 1980), pp. 29–30, pp. 29–30; Günter Schweikhart, 'Tizian in Augsburg', in *Kunst und ihre Auftraggeber im 16. Jahrhundert: Venedig und Augsburg im Vergleich*, ed. by Klaus Bergolt and Jochen Brüning (Berlin, 1997), pp. 21–42. For the response in the portrait collection of the lords of Rosenberg, see Blanka Kubíková, 'Závěsné malířství v rezidencích posledních Rožmberků', in *Rožmberkové. Rod českých velmožů a jeho cesta dějinami*, ed. by Jaroslav Pánek (České Budějovice, 2011), pp. 482–489 (in German translation Blanka Kubíková, 'Gemälde in den Residenzen der letzten Rosenberger', in *Die Rosenberger. Eine mitteleuropäische Magnatenfamilie*, ed. by Martin Gaži, Jaroslav Pánek and Pavel Pavelec (České Budějovice, 2015), pp. 436–455.

40   There is abundant literature on the topic, here we mention Luigi Rovelli, *L'opera storica ed artistica di Paolo Giovio, comasco, Vescovo di Nocera: [Paulus Jovius.] Il museo dei ritratti* (Como, 1928); Paul Ortwin Rave, 'Das Museo Giovio zu Como', *Miscellanea Bibliothecae Hertzianae* 16 (1961), pp. 275–284; Matteo Gianoncelli, *L'antico museo di Paolo Giovio in Borgovico* (Como, 1977); Rosanna Pavoni, 'Paolo Giovio, et son musée de portraits: à propos d'une exposition', *Gazette des Beaux-Arts* 105 (1985), pp. 109–116; T. C. Price Zimmermann, *Paolo Giovio: the historian and the crisis of sixteenth-century Italy* (Princeton, 1995).

later published under the title *Elogia virorum literis illustrium* (with illustrations).[41] Archduke Ferdinand II owned several copies of the earlier books as well as of the later, illustrated versions.[42]

As early as 1552 Cosimo de' Medici started to replicate this collection, and he sent the painter Cristofano dell'Altissimo to make copies of the paintings in the Giovio series. Archduke Ferdinand II compiled a similar collection, which contained a very impressive 915 portraits.[43] Karl Schütz specifies that the oldest written mention of the archduke's collection of portraits of prominent men and women dates back to 1578, when the archduke asked the Saxon elector to send him portraits of the Saxon princes, all of a specific size, and executed in oil on paper. He sent a similar request to Venice. It is therefore apparent that the archduke started building his collection before 1578, however, we do not know when. Archduke Ferdinand II's earlier written requests for portraits have been preserved, but it is not certain whether these requests were related to the formally unified cycle of portraits depicting famous personalities, or rather to his collection of armours and weapons in the *Heldenrüstkammer* (*Heroes' Armoury*). This is because portraits of the military commanders commemorated in the *Heldenrüstkammer* were exhibited near their armour. One such request was dated 1566 and addressed to Peter Ernst Count Mansfeld in Brussels. In it, Archduke Ferdinand II requested that Mansfeld's armour and portrait be sent to him.[44] A second letter from 1575 was sent to Florence, to the archduke's brother-in-law Grand Duke Francesco de' Medici, with an appeal to send the armour and portrait of his father Cosimo, as well as Francesco's own portrait.[45]

The concept of portraits of famous men was received with much acclaim in Bohemia. Paul Sixt I Trautson (1550–1621), Emperor Rudolf II's *Obersthofmarschall* (chief steward) and the President of the Aulic Council, owned quite a sizeable collection. The French ambassador to the Emperor's court, Jacques Esprinchard, visited his residence in 1597, and noted: "Madame Trautson dined with us in a large chamber, the walls of which were covered with more than four hundred portraits of all the great men of this century."[46]

Yet another *uomini famosi* collection was compiled very systematically by the well-educated Moravian aristocrat, politician, and representative of the non-Catholic opposition, Karel of Žerotín the Elder (1564–1636).[47] In order to ensure greater historical accuracy, Karel, like Archduke Ferdinand II, ordered these portraits from

---

41  The woodcut illustrations were created following the models from Tobias Stimmer.

42  See Purš / Kuchařová 2015, p. 250, no. 22; p. 289, no. 250; p. 330, no. 498; p. 331, no. 499; p. 376, no. 788; p. 535, no. 1010; p. 547, no. 1090.

43  Schütz 2002, pp. 19–21.

44  I would like to thank Thomas Kuster for pointing out these two reports. The first letter is deposited in the TLA, Kunstsachen I, no. 691/1.

45  The second letter is also deposited in the TLA, Kunstsachen I, no. 1479.

46  *Tři francouzští kavalíři v renesanční Praze*, ed. by Eliška Fučíková (Prague, 1989), p. 57.

47  For a monographic treatment of his person, see Tomáš Knoz, *Karel starší ze Žerotína: Don Quijote v labyrintu světa* (Prague, 2008).

abroad. He commissioned portraits of Martin Luther and Philip Melanchton in Saxony. [48] He even submitted the proper dimensions, so that these portraits would fit in well with the rest of his collection. In a letter dated June 1600, Karel of Žerotín the Elder asked his *Hofmeister* (controller of the household) and agent, Marcantonio Lombardo, to obtain for him in France "portraits and copies of paintings of Charlemagne and the kings and his descendants" and of members of the French noble families: those mentioned included the military commander Gaston de Foix; the writer and historian Philippe de Commines; the humanist and military marshal Blaise de Monluc; the Duke Claude de Guise, who served as a general under King Francis I of France; Gabriel de Lorges, Count of Montgomery, who served, and mortally wounded, King Henry II of France during a jousting tournament. Karel also wished to obtain portraits of Saint Bernard, Cardinal Rohan, Chancellor Michel de l'Hospital, Anne de Bourges, Philippe Duplessis–Mornay, Julius Caesar, and many others, saying that he "always wanted them to be in sight".[49]

Collections of portraits of prominent men could also be found in other aristocratic seats, such as in Litomyšl castle, which was built by the *Oberstkanzler* (Supreme Chancellor) of the Kingdom of Bohemia, Vratislav of Pernštejn.[50] From the estate inventory compiled in 1608, after the death of Vratislav's widow Maria Manrique de Lara, it appears that there was a series of portraits of prominent men in the castle library: "on the walls [of the library], there were 53 oil portraits on canvas, all of the same size…".[51] Based on this, we may assume that this was a collection of portraits of famous individuals, which was compiled by the owners of this aristocratic seat. It is probably also safe to assume that similar collections were owned by other Bohemian and Moravian noble families.

It is possible that Archduke Ferdinand II did not begin systematically building his collection of portraits of prominent personalities – *uomini famosi* – until he took up residence in Tyrol. However, this does not at all exclude the possibility that the archduke was specifically responsible for encouraging this particular type of collection amongst the Bohemian and Moravian aristocracy. This aristocracy remained in contact with the archduke even after he departed for Tyrol, and Innsbruck was frequently a stopping point on their journeys, as well as a common final destination. As a result, many of the Bohemian lords had the opportunity to personally view Archduke Ferdinand II's collection. Additionally, it is reasonable to assume that they could identify better culturally with the archduke, who had spent twenty years in their country and

48  See Kubíková 2016, pp. 38–39; cited from the letters published in: *Moravská korespondence a akta z let 1620–1636, II, 1625–1636 (Listy Karla st. ze Žerotína 1628–1636)*, ed. by František Hrubý (Brno, 1937), pp. 303–304, letter no. 183.

49  Otakar Odložilík, *Karel starší ze Žerotína* (Prague, 1936), p. 57.

50  See Kubíková 2016, p. 34.

51  Zdeněk Wirth, 'Inventář zámku litomyšlského z r. 1608', *Časopis Společnosti přátel starožitností* 21 (1913), pp. 123–125 (125). Vratislav of Pernstein died in 1582; the inventory was made after the death of his wife in 1608. However, as is the case with all estate inventories, it is not possible to determine when the individual items were purchased or otherwise obtained.

with whom they shared a similar lifestyle and interests, than with the Italian rulers or aristocrats from a different cultural environment.[52]

## A reflection of the Bohemian environment?

Now let us take a look at the relationship between Archduke Ferdinand II and the Bohemian environment from the other direction: is there evidence of Bohemian influences in the archduke's portraits and portrait collection? The series of rulers' portraits offers itself quite naturally for discussion. A set of portraits of the world's kings and emperors was kept in the Prague Royal Castle as early as the rule of Charles IV. However, we know nothing about the appearance of these works, or even if they were executed as murals or panel paintings, as they were already destroyed before 1490.[53] During the rule of the Jagiellonian dynasty, there was an effort to renew the monarchic series, but the new paintings were destroyed by a fire in Prague Castle in 1541.[54] Only a very few written descriptions and visual records of these later paintings exist,[55] specifically in the *Hasenburg Codex* (a copy of a manuscript from the library of the Bohemian nobleman Jan Zajíc of Házmburk, which is said to contain drawings made after the paintings at the castle).[56] Jan Zajíc gave the *Hasenburg Codex* to Ferdinand I, so that it could be used as a model for re-creating the series of paintings.

A letter written by Archduke Ferdinand II to his father, and dated 30ᵗʰ of June 1548, indicates that at that time the archduke was already intensively involved in renewing the series of rulers' portraits, and that discussions were well underway for

---

52 A similar collection of portraits of 327 famous men has been preserved up to the present day at Château Beauregard in France, with the original hanging, in the original location, but this collection was only created in the course of the 17ᵗʰ century. I thank Veronika Sandbichler for this valuable information.

53 For more detail on the cycle, see Josef Neuwirth, *Mittelalterliche Wandgemälde und Tafelbilder der Burg Karlstein in Böhmen* (Prague, 1896); Karel Stejskal, 'Klášter Na Slovanech, pražská katedrála a dvorská malba doby Karlovy', in *Dějiny českého výtvarného umění*, I/2, ed. by Rudolf Chadraba and Josef Krása (Prague, 1984), pp. 329–354 (328); Jaromír Homolka, 'Malíři a dílny pracující na výzdobě kaple sv. Kříže vedle Mistra Theodorika', in *Magister Theodoricus: dvorní malíř císaře Karla IV. Umělecká výzdoba posvátných prostor hradu Karlštejna*, ed. by Jiří Fajt, exh. cat. (Prague, 1997), pp. 351–361 (358); recently Petr Uličný, 'Od císaře k oráči a zase zpět. Panovnické cykly ve Starém královském paláci na Pražském hradě', *Umění/Art* 66 (2018), pp. 466–488. We assume the presence of the cycle from two medieval inscriptions that were found on the south side of the palace. The inscriptions designated the portraits of Emperors Leo IV and Charles III the Fat. We do not know when the cycle was destroyed. However, the palace was burnt out during the reign of Wenceslas IV and probably again during the Hussite wars. The Throne Room of Emperor Charles IV where the portrait cycle was situated ceased to exist with the construction of the Vladislaus Hall on its place that began after 1490. For more details see Uličný 2018b, p. 471.

54 Most recently on this issue, see Fučíková 2017.

55 For more on this, see Pavel Preiss, 'Cykly českých panovníků na státních zámcích. Příspěvek k ikonografii českých knížat a králů', *Zprávy památkové péče* 17 (1957), pp. 65–78; Exh. Cat. Prague 2017, cat. no. II/57, p. 158 and cat. no. II/57, p. 76 (Martina Šárovcová); Uličný 2018b.

56 ÖNB, sign. Cod. 8043. Most recently on the manuscript, Exh. Cat. Prague 2017, cat. no. II/57, p. 158 and cat. no. II/57, p. 76 (Martina Šárovcová).

entrusting the work to a painter named Hans, from Salzburg.[57] The archduke wrote:
"[…] so that on the walls and between the windows there would be painted his ances-
tors, the princes, emperors, and kings who ruled in Bohemia, with captions on plinths
beneath them." On the front wall with a large window, next to the Old Diet Hall, there
was to be a portrait of the king seated on his throne, a portrait of his deceased wife,
Queen Anna, and portraits of his three sons on the right as well as those of his daugh-
ters on the left.[58]

On his father's orders, Archduke Ferdinand II invited the painter Giovanni Bat-
tista Ferro (who may be the aforementioned Hans, given he was named in the letter as
Johann Baptista Ferro) to Prague to prepare a model, and determine the costs.[59] The
calculated amount was high: the work included the participation of twelve painters
who Ferro wanted to summon from Rome, regions of the Marche, and Lombardy, as
well as four gilders and twelve assistants.[60] It was estimated that the work would take
twenty months, not including the four-month break that would have to be taken in the
winter, when it would not be possible to work. The decision to realise the project was
postponed and ultimately rejected.[61] Nevertheless, the plan to create a series of por-
traits of the Bohemian rulers was not completely abandoned. This plan reappeared at
least once more at the beginning of the 1560s, and in 1563, when the archduke consid-
ered having the series of paintings – to be completed by Domenico Pozzo – in the
restored Old Diet Hall.[62] This plan, however, was also cancelled. As we can see here,
the planned commission of such a series of portraits was an idea that engaged Arch-
duke Ferdinand II during his entire period in Bohemia.

After the move to Tyrol, an important milestone in the construction of new and
representative buildings was the completion of the ceremonial Spanish Hall
(1569–1572) in Ambras Castle, and its decoration with a series of full-length portraits
depicting twenty-seven historically documented Tyrolean rulers.[63] (Fig. 5) The series
was a celebration of Tyrol, its rulers, and the continuity of rule in the country, which
also reinforced the legitimacy of the Habsburg ruler.

57   Kreyczi 1887, p. L, reg. 4145.
58   Ibidem. These sources are also related to the discussion: Kreyczi 1887, pp. L–LII, reg. 4152–4155;
     Karl Köpl, 'Urkunden, Acten, Regesten und Inventare aus dem k.k. Statthalterei-Archiv in Prag',
     JKSAK 10 (1889), pp. LXIII–CC (CV–CVI), reg. 6090, 6094. For more, see Eliška Fučíková, 'Kaiser
     Ferdinand I. und das Schicksal des Herrscherzyklus' im Alten Königspalast der Prager Burg',
     Historie – Otázky – Problémy 7:2 (2015), pp. 135–141 (135–138).
59   Kreyczi 1887, p. LI, reg. 4152. In the context of the activity of Archduke Ferdinand at Prague Castle
     most recently, see Fučíková 2017; Dobalová / Muchka 2017.
60   Kreyczi 1887, pp. LI–LII, reg. 4153.
61   Kreyczi 1887, p. LII, reg. 4155.
62   For a detailed treatment of this, see Fučíková 2017, pp. 41–42.
63   Elisabeth Scheicher, 'Der Spanische Saal von Schloss Ambras', JKSW 71 (1975), pp. 39–94. The first
     testimony on the completion of this cycle of the sovereigns portraits' in the hall was dated 1574,
     namely from Stephanus Winandus Pighius, see Alois Primisser, Die kaiserlich-königliche Ambraser-
     Sammlung (Vienna, 1819), p. 36.

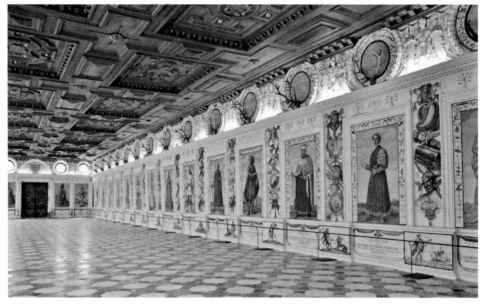

Fig. 5. Spanish Hall with a cycle of portraits of Tyrolean rulers, 1569–1572, Innsbruck, Ambras Castle

Prague was certainly not the only place where the archduke had the opportunity to encounter a series of monarchic portraits. As early as the 15th century, town halls in the Low Countries were decorated with portraits of their princes.[64] Another example existed closer to Austria, in Munich. However, this was a dynastic portrait series – between 1530 and 1535, the Bavarian Duke Wilhelm IV commissioned the painter Barthel Beham to paint a series of portraits of the members of the House of Wittelsbach, both those living, and their deceased ancestors.[65] Nevertheless it seems fairly logical that Archduke Ferdinand II, who for almost all of the time he was active in Bohemia dealt with the issue of a monarchic series, adopted the idea of the portrait collection as a means for visualising monarchical continuity, and after his own (greatly desired) assumption of rule in Tyrol, incorporated this idea into the broader concept of his own public representation. In comparison with the situation in Bohemia, where the implementation of both his and his father's plans was prevented by both financial and practical issues, once Archduke Ferdinand II was established in Tyrol, he succeeded quite quickly in realising his objective.

In conclusion, it seems reasonable to expect to find Bohemian influences in the form of portraits of Bohemian lords within the archduke's portrait collection. However, it seems that there were only a very few such portraits, and they only seem to have occurred in connection with the archduke's other interests. There are indeed por-

64    Lorne Campbell, *Renaissance Portraits, European Portrait–Painting in the 14th, 15th and 16th Centuries* (New Haven and London, 1990), p. 41.

65    Kurt Löcher, *Barthel Beham: ein Maler aus dem Dürerkreis* (Munich, 1999), pp. 135–167.

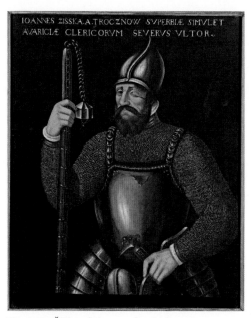

IOANNES ZISSKA.A.TROCZNOW SVPERBIÆ SIMVLET
AVARICIÆ CLERICORVM SEVERVS VLTOR.

Fig. 6. Jan Žižka of Trocnov, late 16th century
(Vienna, Kunsthistorisches Museum, Picture Gallery,
inv. no. GG 2743)

trait depictions of Bohemian lords in his collections, but the subjects are usually depicted 'in action': for example, during tournaments. Bohemian lords appear in several series of etchings and drawings of tournaments that were held in Bohemia and in Innsbruck.[66] Thus far, only two separate portraits of Bohemian noblemen are known to be part of the Ambras Castle collections. The first is a fictional portrait of Jan Žižka of Trocnov (1360–1424), the much-feared warrior and Hussite leader, whose sword the archduke claimed to have had in his collection (though of course it is difficult to say whether or not the piece was authentic).[67] (Fig. 6) Žižka's portrait was displayed in the *Heldenrüstkammer* (*Heroes' Armoury*). Žižka was still very much remembered in the 16th century. The painting was often reproduced in prints in later years.[68]

The second portrait of a Bohemian personality is visually much more interesting. It is a full-length portrait of the nobleman and soldier Karel of Žerotín (1509–1560) (Fig. 7), an aristocrat descending from an ancient Moravian family.[69] The portrait is not

---

66   In the tournament book of Archduke Ferdinand II, after 1557, pen drawing, gouache, aquarelle, Vienna, Kunsthistorisches Museum, Kunstkammer, inv. no. KK 5134. Or in the coloured etchings of the tournament entertainments of the so-called *Wedding Codex of Archduke Ferdinand II* from 1580/1582, etchings by Sigmund Elsässer, Vienna, Kunsthistorisches Museum, Kunstkammer, inv. no. KK 5270, where the inscriptions identify e. g. Jan of Kolowraty or Jiří of Šternberk.

67   Germany, end of the 16th century, oil, canvas, 100 × 83 cm, Vienna, Kunsthistorisches Museum, Picture Gallery, inv. no. GG 2743. Displayed at Ambras.

68   The earliest depiction of Žižka that uses this painting as its model is the full-length portrayal in the album *Armamentarium Heroicum,* which was engraved by Dominicus Custos after the drawing by Giovanni Battista Fontana, see Exh. Cat. Prague 2017, cat. no. IV/3, p. 211 and cat. no. IV/3, p. 89–90 (Thomas Kuster). The album contained reproductions of portraits owned by Archduke Ferdinand II of the famous warriors in armour, complemented by the biographies of these famous men. The volume was first issued in 1601 in Latin, entitled *Armamentarium Heroicum*, and three years later in a German translation as *Heldenrüstkammer.*

69   Central Europe, oil, canvas, 205 × 91 cm, Vienna, Kunsthistorisches Museum, Picture Gallery, inv. no. GG 8202. Currently held in the depository of Ambras castle. For more details about the portrait see *Wir sind Helden: habsburgische Feste in der Renaissance*, ed. by Alfred Auer, Margot Rauch and Wilfried Seipel, exh. cat. (Vienna, 2005), pp. 111–112, cat. no. 3.38 (Katharina Seidl); Blanka Kubíková, 'Charles of Žerotín, a Commander of Noble Moravian Descent, in the Heldenrüstkammer of Archduke Ferdinand II at Ambras Castle', *Studia Rudolphina* 19 (2019), pp. 8–17.

signed nor dated, however according to the fashion of the clothes, composition and style of the painting we can assume that it was painted around 1550. The portrait is reminiscent of paintings made by the Flemish artist Nicolas Neufchatel (c. 1527 – c. 1590) however, the brushwork of the author of Žerotín's portrait is more simplified and schematic, and that is why the painting is considered a work made by a German or Austrian painter under the Netherlandish influence.

Karel of Žerotín may have gained his first military experience in the army led by Louis II of Hungary; from 1526 on, he always stood at the side of the Habsburgs during their various military campaigns.[70] As a young man he participated in, amongst other things, King Charles V's wartime expedition to Algiers and Tunis. After returning to his homeland, he subsequently participated in expeditions against the Ottomans as well as in battles against the Schmalkaldic League. His last military adventure was the foray into Hungary under the command of Archduke Ferdinand II in 1556, which was the only military success achieved by Archduke Ferdinand II: he commemorated it

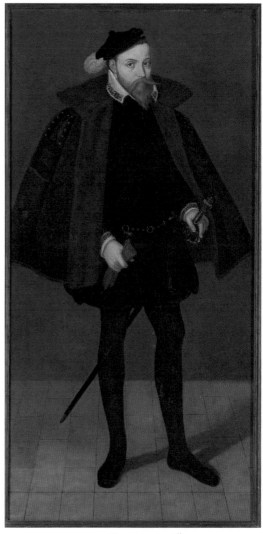

Fig. 7. Karel of Žerotín, 1550–1560
(Vienna, Kunsthistorisches Museum, Picture Gallery, inv. no. GG 8202)

very proudly for the rest of his life. Žerotín led a division of 1,000 men. After returning home, he maintained a friendly relationship with Archduke Ferdinand II. Evidence that the archduke also held Žerotín in esteem may be indicated by the fact that Žerotín was one of only three Bohemian warriors whose arms or armour the archduke chose to include in his *Heldenrüstkammer* (*Heroes' Armoury*). The archduke enriched his

---

70    On this historic figure, see František Bous, *Karel z Žerotína, bojovník proti islámu* (Prague, 1965); Jana Vrkotová, 'Žerotínové na Kolínsku ve světle jejich korespondence s českou komorou' (unpublished bachelor's thesis, Masaryk University in Brno, 2006), pp. 3–10.

collection of armours by asking selected warriors to send him their armours or weapons, especially those that had been used in important battles.[71] At the same time Archduke Ferdinand II asked for portraits of the warriors that served as models for smaller portrait paintings, of the same form and dimensions all over the *Heldenrüstkammer*, that were hung next to each suit of armour. The portrait paintings were also later used as models for engravings of warriors in the printed illustrated catalogue of the *Heldenrüstkammer* that was published after many years of preparation in 1601 in the Latin version, and in 1603 in German. The full-length portrait of Karel of Žerotín was also copied for this purpose.

Archduke Ferdinand II resided for a long period in Bohemia, and played a significant role, not only as the king's representative, but also as a connecting link between Bohemian society, the Habsburg dynasty, and the Austrian lands: this was a role that lasted up to his death. The mutual relationships between all of these 'protagonists' were multi-layered, rich and complex. It is without doubt a topic that has not yet been exhausted and deserves further attention.[72] The issue of Archduke Ferdinand II's patronage, as well as the patronage of the majority of the Habsburgs during the Renaissance period, should be approached in a more comprehensive way – one that does not exclude regional specifics, but applies more attention to mutual influences.

---

71    There is plentiful and diverse literature concerning the *Heldenrüstkammer*, e.g. Luchner 1958; Auer 1984, pp. I–CXVIII; Scheicher 1990, pp. 69–79; Thomas Kuster, "dises heroische theatrum': The Heldenrüstkammer at Ambras Castle', in Exh. Cat. Innsbruck 2017, pp. 83–87.

72    This is even more the case, because the modern political divisions of Europe continue to influence research into the history of Central Europe. The linguistic diversity of this region, and the simple practical challenges facing scholars undertaking research there make it difficult to achieve in-depth research that takes a broader perspective. This is why it is so valuable to build upon the cooperation between researchers from different countries that we have observe in recent years, and to which the recent exhibitions and conferences on the person of Archduke Ferdinand II have contributed, see e.g. Exh. Cat. Innsbruck 2017 and Exh. Cat. Prague 2017.

Elisabeth Reitter

# The court artists of Archduke Ferdinand II (1567–1595)

With the arrival of Archduke Ferdinand II in Innsbruck in January 1567, a new era began for Tyrol. His moderate political stance meant the region enjoyed a long period of peace, and the archduke, alongside all the necessary affairs of state, could take great pleasure in dedicating himself to all areas of culture and the arts. As was common at the time, Archduke Ferdinand II employed master builders, numerous sculptors, painters, goldsmiths, clockmakers, medal-casters, engravers, tinsmiths, copper-engravers, carpenters, locksmiths and blacksmiths, stone masons, plasterers, glass-blowers, tapestriers, silk-embroiderers, armourers, gardeners and water-artists. (Fig. 1) Martin

Fig. 1. Conrad Gotfrid and a workshop, Medal and coin cabinet, 1592 (Schloss Ambras Innsbruck, inv. no. PA 2203)

Warnke created an image of the court artist's profession using the support of numerous examples from across Europe, and over a long period of time reaching from the late Middle Ages to the French Revolution. In his much-cited work[1] he describes the special economic and social situation of this group of professionals at the different European courts, taking the 'classic' court artists as his example: architects, sculptors, and painters. These artists mostly enjoyed a privileged financial and hierarchical

---

1   Martin Warnke, *Hofkünstler*, *Zur Vorgeschichte des modernen Künstlers*, 2nd revised edition (Cologne, 1996) (developed from his 1970 postdoctoral thesis).

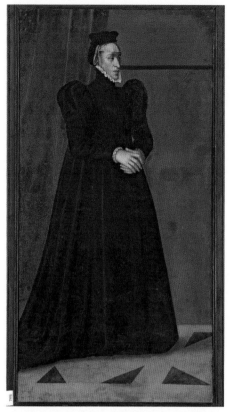

Fig. 2. Francesco Terzio, Archduchess Magdalena, 1564/1568 (Vienna, Kunsthistorisches Museum, Picture Gallery, inv. no. GG 8042)

position, which according to Warnke gave them the freedom necessary for personal development, and opened up the path to what we now understand as artistic autonomy. However, in the case of Innsbruck this grouping, comprised mainly of the classical triad of court artists, is certainly too restrictive. The awarding of the coveted title of court membership to people in the area of arts and crafts shows how much significance these professions held for Archduke Ferdinand II. The term 'court artist' does not appear in the archives of this period, the archduke always refers to the representatives of these professions as "Handwerchsleut" ("craftspeople").[2] In the state archives they are also found under the colourful and equally imprecise heading "allerlai Diener" ("sundry servants").[3]

Who belonged to this group, and how were these artists chosen? Under what conditions did they work at the court, and which privileges in the form of extra payments, titles, coat of arms, and other advantages were given to them by Archduke Ferdinand II? There are no lists of the court artists at Innsbruck during this period. The register produced by David von Schönherr,[4] and the somewhat older but nonetheless foundational monograph by Josef

2    For example, in the Tiroler Landesarchiv in Innsbruck (hereafter TLA), Geschäft von Hof (G.v.H.) 1572, 286v–287, or David von Schönherr, 'Urkunden und Regesten aus dem k.k. Statthalterei-Archiv in Innsbruck', *Jahrbuch der kunsthistorischen Sammlungen des Allerhöchsten Kaiserhauses* (hereafter as *JKSAK*) 14 (1893), pp. LXXI–CCXIII (CCIV), reg. 11107 (10 November 1584): "Giovanni Battista Fontana soll sich wie andere Handwerksleute bezahlen lassen" (Giovanni Battista Fontana should let himself be paid the same as other artisans); TLA, Kunstsachen (hereafter KS) III 20.33 (no date given): The painter Sigmund Elsässer describes himself as a "poor artisan" ("armen Handtwerchsman").

3    These include, alongside two painters, a form-cutter, a clockmaker, and a missal scribe, as well as the court furrier, *Lichtkämmerer* (responsible for all lighting, the purchase and care of candles, lamps etc.), personal tailor, personal shoes, court porter, and a upholsterer, his personal laundress, personal *Mundgewandwäscherin* (literally: 'mouth-linen laundress', responsible for the washing of serviettes), the court laundress, court provost, gunsmith in charge of ornamentation, and balloon maker; TLA, Codex 5328/3, 11v–12v.

4    David von Schönherr, 'Urkunden und Regesten aus dem k.k. Statthalterei-Archiv in Innsbruck', *JKSAK* 11 (1890), 14 (1893) and 17 (1896).

Hirn,[5] as well as the unbelievable wealth of archival material held in the Tiroler Landesarchiv in Innsbruck (Tyrolean Regional Archives) allow us to surmise a group of court artists (excluding the court musicians) numbering more than one hundred persons[6] with some kind of contractual relationship to Archduke Ferdinand II.[7] These people were not all simultaneously present at court, but rather worked at different times over a period of thirty years, with some appointed for longer employment, and others engaged for single tasks. Archduke Ferdinand II, as an educated and above all discerning patron of many extremely varied artistic genres, emerges to play a decisive role as the shaper of the Tyrolean artistic landscape during the second half of the 16th century. He himself produced small artworks of many different kinds in his own workshops.[8] In addition to this, he possessed a rich and extensive library,[9] and was familiar, through his own family connections, with many magnificent courts across Europe. These provided inspiration, but were also of great use for the exchange of artists.

How did individual artists gain access to the court at Innsbruck? There were varied routes. Archduke Ferdinand II brought some artists with him from Prague, like the painter Francesco Terzio (Fig. 2),[10] while others came to the court bearing letters of recommendation.[11] The Prince Elector of Saxony assisted in the search for an appropriate armourer: in order to be sure of the craftsman's skills, he was required to produce a test-piece, and only then would the Prince Elector send him to Innsbruck.[12] Some of the archduke's friends were in fact not so pleased when he took a great liking to their own artists. They expressed this discontent, albeit unsuccessfully, as we can observe in the example of Antoni Boys, a painter from Antwerp. Boys met Jakob Hannibal of Hohenems in 1574 in the Netherlands, and was appointed to his court.

5   Josef Hirn, *Erzherzog Ferdinand II. von Tirol. Geschichte seiner Regierung und seiner Länder*, 2 vols. (Innsbruck, 1885–1888); here I, pp. 370–410.

6   The largest group by number of persons is that of the painters.

7   There are several different versions of spelling for most artists' names. For the sake of an easier reading, one spelling has been chosen and used consistently throughout the following text.

8   Schönherr 1893, p. CLXXXVII, reg. 10897 (26 May 1581): glasswork executed by Archduke Ferdinand II; Veronika Sandbichler, in *Alle Wunder dieser Welt. Die kostbarsten Kunstschätze aus der Sammlung Erzherzog Ferdinands II. (1529–1595)*, ed. by Wilfried Seipel (Innsbruck, 2001), p. 88: Apart from this, the archduke also worked in his own wood-turning workshop and locksmith's shop.

9   Cf. Ivo Purš, 'Die Bibliothek Erzherzog Ferdinands II auf Schloss Ambras', in *Ferdinand II. 450 Years Sovereign Ruler of Tyrol. Jubilee Exhibition*, ed. by Sabine Haag and Veronika Sandbichler, exh. cat. (Innsbruck and Vienna, 2017), pp. 99–103.

10  Apart from Terzio also Heinrich Teufel, Sigmund Waldhueter, Giovanni Lucchese, Antonio Brocco: cf. Sylva Dobalová and Ivan P. Muchka, 'Archduke Ferdinand II as Architectural Patron in Prague and Innsbruck', in *Ferdinand II. 450 Years Sovereign Ruler of Tyrol. Jubilee Exhibition*, ed. by Sabine Haag and Veronika Sandbichler, exh. cat. (Innsbruck and Vienna, 2017), pp. 38–45, und Erich Egg, 'Die Innsbrucker Malerei des 16. Jahrhunderts', *Festschrift für Karl Schadelbauer*, Veröffentlichungen des Innsbrucker Stadtarchivs NF 3 (1972), pp. 39–53; Konrad Fischnaler, *Innsbrucker Chronik*, V (Innsbruck, 1934), pp. 144, 232, 248.

11  Hans Hochenegg, *Die Tiroler Kupferstecher, Graphische Kunst in Tirol vom 16. bis zur Mitte des 19. Jahrhunderts* (Innsbruck, 1963), p. 17: The copper-engraver Dominicus Custos probably gained access to the court at Innsbruck with Fugger's help.

12  TLA, KS I 1505 (28 August 1581, Dresden).

Archduke Ferdinand II, obviously inspired by the painter's ability, named Boys his personal *Conterfeter* (portrait painter) on the 14ᵗʰ of June 1580, an appointment which Jakob Hannibal contested bitterly, but without success.[13] Nonetheless, artists could not be forcibly compelled to accept employment at the archduke's court, and there were some who defied the will of the archduke. For example, Archduke Ferdinand II wanted to engage the organist and instrument maker Servatius Rorif in his service, but Rorif did not agree at first, and later still did not come to the court, but merely agreed to give priority to any commissions from the archduke.[14]

Sometimes the archduke also sought out suitable artists for individual projects, a process assisted by intermediaries working on location. In 1570 he requested the imperial envoy Veit of Dornberg to seek out a glassmaker in Venice. A document provides information concerning the conditions of employment: the glassmaker was not to be permanently engaged, but would rather work for the archduke as and when needed; accommodation and a workshop in the court gardens would be made available. Apart from this the artisan did not need a great deal of imagination, but should bring his own tools and raw materials with him.[15] This indicates an important aspect concerning the awarding of contracts, one that emerges from the correspondence between the archduke and individual artists: The archduke wanted to be involved in the creative process. He examined and commented upon preparatory drawings and sketches, some of which have survived, collected into dedicated albums.[16] (Fig. 3) Some projects simply did not make it past this preparatory phase, because they did not please the archduke.[17] Many artists also took the initiative[18] and tried to solicit the benefits of a court appointment for themselves, though not always with success. The handwritten documents form an important source for this subject area, and often provide information about the capabilities and expectations of artists.[19] For example, the painter Abraham de Hel reckoned with support for himself and his horse, should he be employed at the court,

---

13    Eva Pflauder, *Genealogische Untersuchungen zur Hohenemsischen Portraitgalerie im Zeitraum von 1530–1590*, Innsbrucker Historische Studien 20/21 (Innsbruck, 1999), pp. 149, 155 and 181.

14    Schönherr 1890, p. CCXXXVI, reg. 7891 (24 October 1564, Prague).

15    TLA, KS III, 46.3.7 (23 July 1570).

16    Known as "Klebebände" – albums with drawings and engravings tipped or glued in Vienna, Kunsthistorisches Museum [hereafter: KHM].

17    This was the case with certain fountains. Cf. Thomas Kuster and Sylva Dobalová in Exh. Cat. Prague 2017, cat. no. II/49, p. 148 and II/49, p. 73.

18    TLA, KS III 21.120: The clockmaker Andreas Illmair reported that the Emperor, several princes and other persons were "very happy" ("wol zufriden") with the watches he had made for them, he was now "of the most humble inclination and desire to give [himself] in service as a most obedient subject of the Archduke Ferdinand II as my true-born Lord and Prince" ("der underthenigisten Naigung und Begirdt, mich als ein gehorsamister Underthan in E.Fr.Dt. als meins angebornen Herrn und Landtsfürsten Dienste underthenigist zu begeben").

19    TLA, KS III 20 (27 Dezember 1567): Hans Polhammer, a painter, repeated his request for a maintenance allowance or a retainer, saying he "could be useful for painting, etching or house-painting, or sketching the gardens, meadows and fields" ("Mallen, Ozzen [ätzen] oder Anstreychen [...] oder Abzaichung der Gärtten, Wissen [Wiesen] und Äckher").

and for this promised to appear in Innsbruck three or four times a year.[20] There was also a tradition of passing down appointments within the family. In many areas we find fathers and sons, such as in the master-builder-family Lucchese, the painter-family Polhammer, the book-printer-family Paur, and the potter-family Gantner. (Fig. 4) There were also cases like that of Anthoni Ort, court goldsmith, whose father-in-law had already been in court service.[21]

Which countries did the court artists come from? The court of Archduke Ferdinand II showed itself to be multinational, and alongside the native artists the majority were of Italian, Dutch or southern German origin. The affinity for foreign employees was also clearly visible in the civil service.[22] The Upper

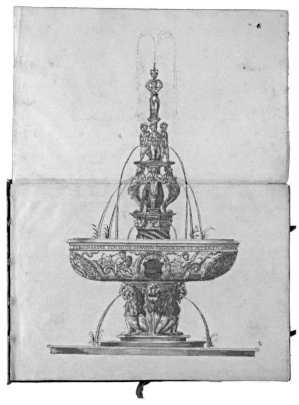

Fig. 3. Fountain of Archduke Ferdinand of Tyrol, from album with drawings of fountains (Vienna, Kunsthistorisches Museum, Kunstkammer, inv. no. KK 5350)

Austrian Chamber (sometimes also called the Tyrolean Chamber) resisted the appointment of Italian masters to court service with particular vehemence, for one obvious reason: the southern artisans were much more expensive.[23] This unequal remuneration gave rise to many archivally documented altercations. The conflict between the Upper Austrian Chamber and the archduke over the appointment of Giovanni Lucchese was

---

20  TLA, KS I 845 (16 January 1571, Augsburg).

21  Schönherr 1890, p. CLXXXIV, reg. 7376, (5 January 1560): Hans Altensteig, father-in-law to Anton Ort, was the court goldsmith to the imperial princesses.

22  Dr. Johann Wellinger from Silesia had already been named in Prague, and was set under the authority of the Tyrolean Chancellor Köckler, cf. Manfred Schmid, *Behörden und Verwaltungsorganisation Tirols unter Erzherzog Ferdinand II. in den Jahren 1564–1585, Beamtenschematismus der drei ober-österreichischen Wesen* (unpublished doctoral theses, Innsbruck, 1971), pp. 6 und 38.

23  Cf. Schmid 1971, p. 28: The daily wages for basic labour varied greatly, and advantaged the Italian workers, so that in 1572 for example, a southern mason earned 18 *Kreuzer*, but a German one only 12 *Kreuzer*.

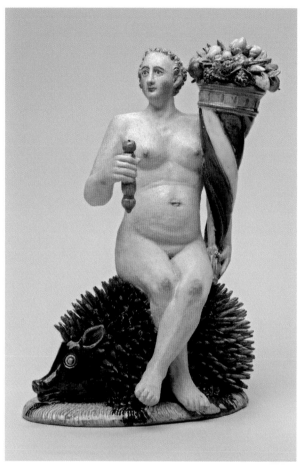

Fig. 4. Christoph Gantner, Joke figure, 1590/1600
(Vienna, Kunsthistorisches Museum, Kunstkammer,
inv. no. KK 3109)

particularly conspicuous. An animated exchange of letters between the Chamber and the archduke preceded the contracting of the Italian master-builder: According to the wishes of Archduke Ferdinand II, Paul Uschall (the court master-builder appointed by Ferdinand I) would be engaged otherwise. In Uschall's place, the archduke wanted to take Giovanni Lucchese into court service. The Chamber judged Lucchese to be fundamentally under-qualified, and argued against him on the basis of his poor linguistic ability.[24] This was a viable objection, since the Upper Austrian Chamber always demanded thorough written reports from the master-builder.[25]

This resistance was nonetheless unsuccessful. The Chamber was able to delay the appointment, but the wishes of the archduke were not to be hindered: in 1568 Giovanni Lucchese was named master-builder of the court, and Paul Uschall became a book-keeper, though his salary remained the same.[26] The "peaceful competition" between the nations[27] described by Josef Hirn was not actually always so peaceful. Occasionally unbridgeable differences emerged, especially in large collaborative pro-

---

24   TLA, Missiven an Hof (M.a.H.) 1565, fol. 304v–305: "not sufficiently qualified" ("nit fur genuegsam quallifiziert") and "too inexperienced with speaking and using German, and not knowledgeable at all in German writing and reckoning" ("der teutschen Sprach unnd Gebreuch [...] nit genuegsam erfarn, des teutschen schreibens und raitten [...] gar nit khundig").

25   TLA, Gutachten an Hof 1565, fol. 303v (7 May 1565).

26   TLA, Geschäft von Hof (G.v.H) 1568, fol.342/343 (9 September 1568); Schmid 1971, pp. 197, 314–317.

27   "friedliche Wettstreit", Hirn 1885, p. 370.

jects involving various art-
ists. Dionys van Hallaert, a
Dutch painter, complained
about having to work along-
side a foreign master during
his work on the Spanish hall
at Schloss Ambras. (Fig. 5)
He was convinced that this
situation would lead to envy,
hatred and enmity.[28] We also
know of disagreements
between Alexander Colin
and Albrecht Lucchese.
Colin could not stand Luc-
chese at all, probably not on
the grounds of their respec-
tive nationalities, but rather
because of their respective
positions: Albrecht Luc-
chese was charged with
reviewing Alexander Colin's
estimates of cost.[29]

Archduke Ferdinand II
lived in a time of confes-
sional changes, but his atti-
tude towards religion in
relation to his court artists
was not consistent. In a man-
date from the 19th of August
1570, he ordered that all per-

Fig. 5. Dionys van Hallaert, window arches in the Spanish Hall,
Ambras Castle, 1571

sons holding a royal office, or in the royal service, had to take an oath of true allegiance
to the Catholic church, and were obliged to demand the same from all those working
beneath them. [30] The iron-cutter Peter Wegerich from Chur made an excellent impres-
sion on the basis of his skills during a probationary period at court, but was not
accepted into royal service on the grounds that he was not a member of the Catholic
church. [31] Hans Steppach, a master-potter from Hall, had to submit himself to the
Jesuit's efforts to convert him after his Lutheran sympathies became known. When

28  TLA, KS III 20.43 (16 June 1571): "alongside a foreign painter, so unknown to me and not of the
    same nationality" ("neben ainem frembden Maler, so mir unbekhant unnd nit gleicher Nation").
29  TLA, Missiven an Hof 1588, fol. 71/71v (21 March 1588).
30  TLA, Geschäft von Hof (G.v.H.) 1570, fol. 186v–187v: "Catholisch Religion und Aidspflicht."
31  Heinz Moser and Heinz Tursky, Die Münzstätte Hall in Tirol, 1477–1665 (Innsbruck, 1977), p. 172.

this attempt at conversion failed, however, he was expelled from the land.[32] Yet the situation seems to have been different for other court artists. In the description of the goldsmith Anthoni Ort's duties, preserved in a transcript from 22nd February 1573, there is no mention whatsoever of the Catholic religion. [33]

The *ad personam* (individual) officiated contracts could be dissolved by either party. Some artists left the court at Innsbruck of their accord,[34] others were asked to quit their service early because of conflicts,[35] "schädlichem Unfleiss" ("harmful laziness")[36] or scandals,[37] and still others were found to be no longer fit for service on the basis of their age. [38] There are more seldom examples of artists wanting to leave the court against the archduke's will: the form-cutter Leonhard Waldburger tried several times to quit his service, but without success. The archduke threatened him with consequences, should he try to leave the land.[39] Following the death of the archduke there were naturally no new commissions, and because of this many artists disappear from the records.

Which tasks did court artists fulfil? In contrast to the officials, there were no precise job profiles for the individual artists – only the work of the court's master-builder was relatively clearly outlined. He held an office,[40] and this position was always filled when it fell vacant. His main task was to organise and coordinate the progress of works. It was also necessary to negotiate, and sometimes re-negotiate, with individual

---

32    Georg Kienberger, 'Geschichte der Stadt Hall, 1564–1595', in *Haller Buch (Festschrift zur 650-Jahr-feier der Stadterhebung)* (Innsbruck, 1953), p. 194.

33    TLA, KS III, 21.59 (22 February 1573).

34    For example, Francesco Terzio received letters of passage in 1568 allowing him to move "ten horse-back-loads of household goods" ("zehen Säm Hauß Plunder") to Trient: TLA, KS I 756, 24 April 1568.

35    Thomas Kuster, 'Hallart Denis', in *Allgemeines Künstlerlexikon, Die Bildenden Künstler aller Zeiten und Völker*, 68 (Berlin and New York, 2011), p. 248.

36    Ulrich Ursenthaler, coinsmith, Schönherr 1893, p. CXXVII, reg. 10238 (14 June 1570).

37    In the case of the Venetian painter Giovanni Contarini, a scandal over a court lady: cf. Giovanna Nepi Sciré, Giovanni Contarini, in *Dizionario Biografico degli Italiani*, 28 (Rome, 1983). URL: http://www.treccani.it/enciclopedia/giovannicontarini_%28DizionarioBiografico%29/. (Accessed 22/1/2018)

38    As the stonemason Hieronymus de Longhi who was – due to his age ("Alters und Leibs Unvermuglichait halben") – no longer able to finish his commissioned work at the court church in Innsbruck, TLA, Entbieten und Befelch 1572, fol. 203/203v (31 March 1572).

39    TLA, KS III 20.62: According to his own extremely detailed report, he had sought to be freed from court service not once, but five times: "I asked five times, most subserviently and in the name of God, to be freed from this contract, but then I was ordered most severely to remain in the land, and the prince told me that if I should try to leave without his knowledge and permission, he would find me wherever I went", ( "fünfmaln underthenigist und um Gotes Willen gebetten, mich solcher Versprechung frey und ledig ze lassen und das ich in deme unverpunden sein möge" [...] "dann Ir Fr. Dt. etc. auf solches mir alles Ernsts alhie und in dem Landt ze bleiben anbevolchen unnd da ich hierüber one unnd außer deren gnedigisten Vorwissen und Bewilligung von dann und hinaus ziechen, so soll ich wissen, das dieselb Ir Fr.Dht. etc. lanng Armb haben, die mich dennoch woll erraichen werden [...]").

40    TLA, G.v.H 1568, fol. 342/343 (9 September 1568).

Fig. 6. Georg Schmidhammer, Iron gate to the cenotaph of Emperor Maximilian I, 1572/73 (Innsbruck, Court Church)

artist and artisans.[41] The court master-builder was not only responsible for the court buildings, but also for the *Archen* (embankments), the farmhouses, the care of the fields, the market-gardens, the court fountains, and the purchasing of timber.[42] The completed works were reviewed by the master-builder, and sometimes also appraised: this often required the presence of an artists who understood the particular form of work. According to the results of such assessments, there would either be new negotiations, or a positive message would be sent to the government and payment of the relevant artisans settled.[43] Martin Warnke describes the master-builders of various

41   TLA, Entbieten und Befelch 1570, fol. 794/794v (4 December 1570) and Schönherr 1893, p. CXXX, reg. 10276 (4 December 1570). The work of the painters Cristoff Perkhamer, Romanus Fleschawer and Alexander Meurl seemed too expensive, Giovanni Lucchese should therefore re–negotiate; or the painter Hans Grändl: he also presented an unacceptably high invoice and the matter needed to be re-negotiated, TLA, KS I 838 (29 January 1575).

42   TLA, M.a.H. 1565, fol. 303v–305v: "Hofpawmeisteramt zu Insprugg" ("Court master-builder at Innsbruck") – includes a more exact description of the court master-builder's tasks.

43   TLA, KS I 770 (4 February 1572): The court master-builder and the scribe responsible for building works report that the works of the painters Ritterle and Maisfelder are to be viewed and appraised by two foreign painters.

courts as not necessarily architecturally competent, and it is clear that this office was, in principle, also open to painters and sculptors.[44] However, during Archduke Ferdinand II's time at Innsbruck, only three men held this position: Paul Uschall, and Giovanni and Albrecht Lucchese; the latter came from the building industry.

Sculptors and stone-masons were responsible for the breaking of raw materials and their transport to the court, alongside their actual artisanal and artistic work. They had to personally travel to the quarries (found at Sterzing, Ratschings, Trient, and Fleims), to choose sections of marble and prepare them for transportation. They often also accompanied the finished works to their final destination.[45] It was also specified in the smiths' contracts, that they themselves would transport their finished pieces to the desired destination, an undertaking that was often difficult due to the size and weight of the works. For example, a payment of 1500 *Gulden* was negotiated with the Prague smith Georg Schmidhammer, who was charged with producing the "zierliche" ("fragile") latticework for Emperor Maximilian I's memorial, and this included also the transport of the finished work from Prague to Linz, and its installation at Innsbruck.[46] (Fig. 6) The resident smiths such as Benedikt Dillitz did not only receive commissions for elaborate lattices, they were also required to furnish the houses badly affected by the earthquakes of the 1570s with earthquake 'slings' or braces.[47]

Painters, of course, delivered portraits and panel paintings, but they also decorated walls and ceilings, produced templates for metalwork, wallpaper, and copperplate engravings. Apart from this, they also produced coats of arms and pennants for funerary ceremonies, targets for festivals, and occasionally created maps. They also carried out simple house-painting and *Fassarbeit* (gilding work). One generally conspicuous point is the fact that foreign painters received the prestigious commissions for portraits or large paintings, while native artists were more often engaged for 'inferior' tasks such as the producing of coats of arms, pennants, targets, processional or funerary decorations, gilding and house-painting. These tasks were often completed collectively, whereby the composition of the groups was very varied.[48] The necessary raw materials,

44   Warnke 1996, p. 241.
45   Schönherr 1893, p. CL, reg. 10488 (11 November 1573): The stone-mason Thomas Scalabrin accompanied the marble pieces (for the funerary monument of Emperor Ferdinand I and his wife) to Linz, and from there the pieces were accompanied by the sculptor Alexander Colin to Prague. Or as in Schönherr 1893, p. CL, reg. 10490, 17th November 1573: In 1573 Thomas Guarient, also a stone-mason, had to travel to Ratschings for the quarry-cutting and transport of a large piece of white marble (for a fountain: *Lustbrunnen*).
46   Schönherr 1893, p. CXI, reg. 10111 (28 March 1568) und p. CXI–CXII, reg. 10113 (31 March 1568): a more precise description of the commission.
47   Schönherr 1893, p. CXLI, reg. 10394 (23 June 1572): The court church and the building of the *Goldene Dachl* (an oriel with a gilded roof considered a symbol of the city of Innsbruck) were to be provided with iron braces.
48   For example: TLA, KS I 770 (23 October 1590): Christoph Perkhammer and Hans Maisfelder worked together in Rotholz, Schönherr 1896, p. XXIV, reg. 14261 (14 May 1592): The painters Georg Fellengibl, Konrad Leutgeb and Kaspar Rorer produce coats of arms for a funeral together.

such as gold, marble, and iron, were usually made available separately.[49] Alongside their specific professional activities, individual artists would also be assigned other tasks unrelated to their artistic practice. For example, the glass-blower sought for the court at Innsbruck was also, according to the job description given by the archduke, supposed to tend to the fowl in the *Fasanengarten* (pheasant-garden).[50] Many artists had numerous talents and interests: Pietro de Pomis, a remarkable painter, architect and honoured medal-caster, was named above all as the (only) universal artist at court.

A few court artists pursued various passions alongside their official work, with greater or lesser success: the painter Georg Rott applied himself to astrological studies and petitioned the archduke for his support in that pursuit,[51] and the court painter Giovanni Battista Fontana sought out soap-maker's privileges.[52] Apart from this, in 1585 and 1588 Fontana received the privilege to sell Trentino wine in North Tyrol, though against the will of the Diet.[53] Gerard de Roo also displayed varied qualities and interests: he began his service at the court as a bassist in the archducal chapel, and finally became a *Kunstkämmerer* (responsible for duties in the *Kunstkammer*), librarian and historiographer.[54]

The intentional acquisition of art for the *Kunstkammer* did not rest by default in the hands of the court artists, nevertheless from time to time they were trusted with the new acquisition of artworks and curiosities.[55] The private secretary Jakob Schrenck of Notzing was, along with the *Kunstkämmerer* and librarian Gerard de Roo, responsible for the acquisition of new armour. The maintenance of the armour nonetheless lay in the hands of the relevant court armourers.[56]

Court artists were usually not guild members, and were generally paid somewhat better than the city-guild masters.[57] It was no secret that the city guild painters did not count among the better-paid artists. Hence the remark in a report from the *Salzmaier-*

49   TLA, KS I 578 (16 March 1568): Hans Christoph Löffler demanded the necessary metal for the casting of the cannon; reg. 10110 (28 March 1568): Iron ore was to be made available to Georg Schmidhammer, a smith from Prague, for the latticework for the funeral monument of Emperor Maximilian I in Innsbruck; TLA, G.v.H. 1581, 67v–68: An order for jewels and gold for Anton Ort, court goldsmith.
50   TLA, KS III, 46.3.7, as in footnote 14.
51   TLA, KS I 823 (26 January 1581).
52   TLA, G.v.H. 1573, fol. 296/296v (20 November 1573).
53   Fischnaler 1934, p. 76.
54   Cf. Walter Senn, *Musik und Theater am Hof zu Innsbruck. Geschichte der Hofkapelle vom 15. Jahrhundert bis zu deren Auflösung im Jahre 1748* (Innsbruck, 1954), p. 108–109.
55   TLA, G.v.H. 1579, fol. 1127/1127v (7 December 1579): Ferdinand II ordered, that Giovanni Battista Fontana should receive 200 *Gulden* and one month's wages, to allow him to travel to Italy for the purpose of "purchasing a number of special items" ("um für den "Ankauf etlicher sonderer Sachen").
56   Thomas Kuster, 'dises heroische theatrum': The Heldenrüstkammer at Ambras Castle, in *Ferdinand II. 450 Years Sovereign Ruler of Tyrol. Jubilee Exhibition*, ed. by Sabine Haag and Veronika Sandbichler, exh. cat. (Innsbruck and Vienna, 2017), pp. 83–87 (84–85).
57   Schönherr 1893, p. CXIV, reg. 10149 (4 November 1568): The court painters Sigmund Waldhueter and Heinrich Teufl were paid at the same rate as the city-guild painters, on the express orders of Archduke Ferdinand II.

*amt* (lit. the salt-masters' office, the administrative body responsible for those in charge of harvesting salt) concerning the request for a weekly charitable donation for the widow of the painter Alexander Maisfelder, since her husband had only made a wretchedly poor livelihood from his art.[58] Painters often had financial difficulties for another very simple reason: there were just too many of them.[59] As soon as an artist or artisan became a servant of the court, he was no longer subject to civil law, but was rather subject of the authority of the *Hofmeister* or *Hofmarschall* (court steward or chamberlain). Therefore, in all legal concerns, the court judiciary was responsible for him.[60] In 1572, Emperor Maximilian II issued specific regulations for tradesmen, court-merchants and court artisans. This last group were released from any bond with the guilds, but had to be provided with a charter which made them members of the court.[61] In Innsbruck, so as to make this court-status even clearer, written certificates were also displayed.[62]

Nonetheless, it seems the number of these charters increased greatly, since in 1602 Emperor Matthias promised, during his hereditary homage, to spare the city of Innsbruck from these kinds of licenses in the future.[63] Foreign artists were quite naturally not terribly warmly welcomed by the guilds,[64] and for this reason they tried to gain a court appointment as quickly as possible. One further advantage of serving the court was peculiar to the court goldsmiths: according to the regulation of their profession at court, they were permitted to run a shop alongside their court duties, though with the understanding that the archduke's commissions would be given priority.[65] Numerous

---

58    TLA, KS I 770 (31 October 1587).

59    Egg 1972, p. 41.

60    TLA, KS III 21.57: Elias Starck, court goldsmith, wished to know how he was to conduct himself as he was obliged to sit with citizens and court officials at a session of the civil court of criminal law (*Malefizrecht*). The answer is extremely striking: he should only feel answerable to the law of the royal court. (19 July 1567). TLA, KS III 21.121 und KS III 21.120: The clockmaker Andre Illmair asked to have all his civil obligations lifted.

61    Herbert Haupt, *Das Hof- und hofbefreite Handwerk im barocken Wien, 1620 bis 1770* (Innsbruck, Vienna and Bozen, 2007), p. 91.

62    TLA, KS III 21.60 (19 February 1573): Antoni Ort, court goldsmith, requests a "written certificate" ("schrifftlichen Schein"), apparently on the grounds that the citizenry "do not wish to believe that the Archduke Ferdinand II has taken me on as his own court goldsmith" ("nit glauben wellen, daß E.F.Dt. mich zu derselben Hofgoldschmid angenommen [...]").

63    TLA, KS III, 21.10, 12 August 1602.

64    TLA, KS III, 21.10 (after the death of Archduke Ferdinand II): Lucas Reimer, a goldsmith from Munich, wishes to become a court goldsmith. The local goldsmiths wish to prevent this, on the grounds that they could execute the work requested by the court just as "fairly, well and delicately" ("gerecht, guet und zierlich") as any other goldsmiths; Egg 1972, p. 62: The painters of Innsbruck called for the expulsion of the foreign painter Hans Vogler. Archduke Ferdinand II. did not however expel Vogler immediately, as the painter had in fact taken over commissions for Schrenck of Notzing and the archduke's personal barber. Vogler finally settled in Brixen rather than Innsbruck, and these quarrels clearly played a role in this decision.

65    Schönherr 1896, p. VIII, reg. 14127 (14 September 1589): Andreas Schmidgraber, court goldsmith was permitted to set up a goldsmith's shop either directly yet the court or in the city; he was also permitted to sell his finished pieces in gold and silver directly from his shop; TLA, KS III 21.59/3: Antoni Ort likewise mentions a "shop" ("Laden").

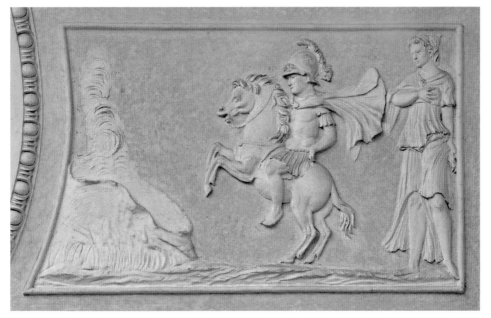

Fig. 7. Antonio Brocco and workshop, Marcus Curtius, Emperor's room at the Ambras Castle, 1571/72

Innsbruck court artists ran their own workshops, often attached to their home within the city.[66] There were however also workshops in the *Hofburg* (main residence in Innsbruck)[67] and the *Hofgarten* (court garden).[68]

The number of assistants was not regulated, but was often given as the grounds for requesting faster payment. Occasionally the artists would find themselves in an embarrassing situation, since on the one hand the archduke wanted to see rapid progress in the work, which meant engaging more assistants, but on the other hand the artists were always delayed (through no fault of their own) and the master had to continue to support his assistants even when there were no commissions. Artists often fell into financial difficulties this way (for example Antonio Brocco and Thoman Scalabrin).[69] (Fig. 7)

Court artists were paid according to varying regulations. There were the salaried court artists, who according to the records received a weekly, monthly or yearly stipend. But the Upper Austrian Chamber also paid fees for specific projects. The individual professions also received different levels of pay, and their wages and salaries appear at the end of each year in the ledgers. The master-builder of the court usually

---

66   Fischnaler 1934 names numerous artists' addresses in the old city of Innsbruck.

67   Fischnaler 1934, p. 248: Sigmund Waldhueter worked in a workshop on the upper floor of the castle.

68   TLA, KS III 46.3.7: In a letter to Veit of Dornberg there is mention of a workshop in the court gardens.

69   TLA, KS I 879: Antonio Brocco, in addition to his two assistants, also took two further assistants on, and requested the payment that had been agreed. Or as in TLA, KS I 942: Thoman Scalabrin, a stone mason, pleaded urgently for money, in order to be able to pay his 12 helpers.

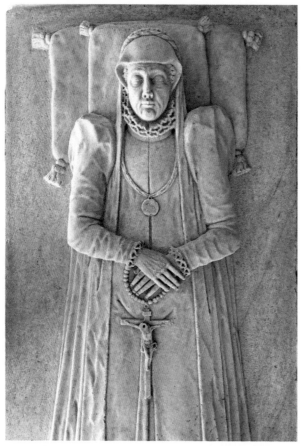

Fig. 8. Alexander Colin, Tombstone of Katharina of Loxan, Innsbruck, Court Church

received the highest individual pay, followed by the court sculptor (Alexander Colin, Fig. 8),[70] and then foreign painters, gardeners, armourers, local painters and book-printers. This payment is often difficult to compare, since individual artists sometimes received a very low yearly salary, but were paid extra for work on specific projects. A set salary alone was also not a clear sign that the artisan in question belonged to the court, there were actually other positions at the court. The court clockmaker Andre Ilmair formulated this idea in his letter seeking appointment as the court's clockmaker, and offering to accept the position without a salary.[71] According to his own records, the court goldsmith Anthoni Ort also served the court for 35 years with receiving either donations or a salary.[72] Both Andre Ilmair and Anthoni Ort belonged – as many others – to a category of artists who were only paid for individual projects. This usually necessitated a review, the finished work was appraised, and subsequently there would be a lively exchange of letters between the appraiser (usually the court master-builder or another expert), and the Upper Austrian Chamber.[73] A large part of

---

70  Alexander Colin received court commissions throughout the entirety of Archduke Ferdinand II's reign.

71  TLA, KS III 21.120: "even without graciously receiving any retainer" ("doch an [ohne] ainiche Besoldung gnedigist an- und aufzunehmen").

72  TLA, KS III 21.59, Anthoni Ort, court goldsmith described his career in a request for a yearly pension, he had served for many years "without any salary or retainer" ("ohne ainiche Besoldung oder Dienstgeld").

73  The altarpiece painted by the court painter Giovanni Battista Fontana in Seefeld had to be viewed and appraised by two uninvolved painters after its completion: TLA, Gemeine Missiven 1576/I, fol. 552 (11 May 1576) and Schönherr 1893, p. CLXIII, reg. 10628 (11 May 1576).

archival information concerning the artworks can be traced back to these reviews and the *Supplicationen* (supplications) made either to the Chamber, or directly to the archduke himself, in order to remind them of outstanding payments. If the archduke was convinced of the need to pay the sum agreed,[74] this would mostly take the form of an instruction for partial payment given to one of the numerous *Zollämter* (customs-offices such as those in Fleims, Sacco, Fernstein, or Zirl: there were twenty-one such offices in the whole region),[75] or to the *Salzmaieramt* in Hall.

This measure also seldom worked on the first attempt, for the most part further urging was required. Numerous letters of solicitation give evidence of the Upper Austrian Chamber's inability to pay its bills. The unpaid wages and salaries often totalled such enormous sums that the survival of the artists' families under such conditions of employment appears as nothing less than a wonder. These repeated, and in part openly subservient, requests for payment often brought the archduke's displeasure, if not his open anger, down upon the artists.[76] The archduke accused the painter Sigmund Waldhueter in all seriousness of immodesty, even though he owed the painter 835 *Gulden* and 40 *Kreuzer*.[77] The court artists often fell into debt,[78] were threatened with the prospect of imprisonment and ended up in unsolvable situations.[79] It was virtually normal that wages and salaries could not be paid: the court owed debts to virtually all the court artists, and not merely debts of a few *Kreuzer*.[80]

---

74   The wording changes in the documents: the payment should not be made "as is convenient" ("bei glegenheit"), but rather "in all haste" ("ehendist").

75   Schmid 1971, p. 19.

76   TLA, KS III 20.73: 14 *Gulden* are still owed to the stone-mason Hans Perssian, money that he urgently needs for himself, "his wife and small children" ("sein Weib und klainen Kindln"); in his plea for payment he calls upon "a princely act of kindness" ("ain fürstliches Werckh der Barmherzigkeit").

77   TLA, KS I 721 (6 July 1569): Archduke Ferdinand II ordered that the artist be paid, "so that we will be spared any future requests of the kind we are already fed up with, as well as his insults and scorn, which are like to follow on account of his immodesty" ("[...] damit wir seines fernern Ansuechens uberhoben sein mugen, auch Schimpf und Spott, so seiner brauchenden Unbeschaidenhait halben daraus volgen möchte, verhüet werde.")

78   This is proven by numerous documents, for example TLA, KS I 901: The painter Sigmund Elsasser describes how he "is currently trapped in great and dire distress" ("derzeit in grosser und dieffer Not steckhe").

79   Schönherr 1893, p. CLII, reg. 10516 (17 March 1574): Hieronymus de Longi requested the remaining payment due to him, since he was being threatened with imprisonment by his creditors. TLA, G.v.H. 1581, 128v–129v: Likewise, the potter Hans Gantner had to go into debt, and pawned a meadow on account of his lack of cash funds. TLA, KS III 20.62: The form-cutter Hans Lienhardt Waldburger described the concerns he had over money, despite his 27 years of service at court; TLA, KS III 20: Hans Polhammer reported that he could not support his wife and eight small children due to the rise in the cost of living, he therefore wished to move to Prague and pleaded for a charitable donation.

80   There exist lots of debt lists, including the names of many court artists, for example: TLA, G.v.H. 1581, fol. 432v (19 October 1581); TLA, G.v.H. 1584, fol. 268v/271v (9 March 1584); TLA, G.v.H. 1585, fol. 277v (21 November 1585); TLA, G.v.H. 1589, fol.143v (19 August 1589).

In some cases the court artists were also paid in natural produce,[81] in monetary equivalents such as land,[82] or in the form of promissory notes, namely with 'options' on the expected royal income.[83] This financial juggling act should not come as a surprise, the economic situation of the court and the state was more than worrying. Nonetheless, it must be recognised that Archduke Ferdinand II was concerned to keep orderly accounts: everything was to be done correctly, documented in writing and recorded with receipts, as is proven by the mass of extant directives.[84] However, these provisions were also not able to fill the empty coffers of the Upper Austrian Chamber: as early as the 13th of August 1568 the governors, rulers and officials of the *Kammerräte* (members of the Upper Austrian Chamber) of Innsbruck claimed that the loyal servants and labourers could no longer be paid for their work.[85] At the beginning of 1570, the Upper Austrian Chamber wrote in a letter that they were exhausted and in great need.[86]

On the 21st of April 1570, the archduke was finally asked to stop the building works, court labourers and artisans were persisting ceaselessly on being paid, and the Upper Austrian Chamber could not afford this.[87] During the 1570s Archduke Ferdinand II began withdrawing court artists' retainers and salaries, and ending appointments and contracts.[88] In June 1571 the Chamber once again reported its financial misery and demanded the termination of the painter Franscesco Terzio's retainer, just as they had previously done with Giorgio Liberale.[89] The situation did not really improve, in 1577 they were still not able to pay the workers for the "never-ending" building works, and reported these employees' beseeching pleas for payment.[90] In 1581 the Upper Austrian Chamber was no longer able to pay the court armourer Jakob

---

81  TLA, KS I 827 (16 December 1581): Leonhard Waldburger, a sculptor, received rye and wheat from the royal grain stores as payment; TLA, Gemeine Missiven 1579/II, fol. 1329 (21 August 1579): Georg Rott, painter, received rye as a partial payment of a debt.

82  Exh. Cat. Innsbruck 2017, Claviorganum, cat. no. 8.9, p. 329: Servatius Rorif received a tract of land worth 900 *Gulden*.

83  TLA, G.v.H. 1589, fol. 72–73: The issuing of a promissory note for over 1000(!) *Gulden* to the court secretary Paul Zehendtner.

84  TLA, KS I 683 (14 August 1567) or KS III 20 (6 August 1581).

85  Schönherr 1893, p. CXIV, reg. 10137 (13 August 1568)

86  TLA, Gutachten an Hof 1570, fol. 101/102v (23 February 1570) and Schönherr 1893, p. CXX, reg. 10208 (23 February 1570).

87  TLA, Gutachten an Hof 1570, fol. 130/131 (21 March 1570) and Schönherr 1893, p. CXXIII, reg. 10233 (21. April 1570).

88  TLA, Gutachten an Hof 1570, fol. 101v/102 (23 February 1570): The government suggested stopping the sculptor Alexander Colin's retainer, saying it would be possible to find another master who would complete the same work for the same commission-prices, without a retainer...

89  Schönherr 1893, p. CXXXV, reg. 10326 (18 June 1571).

90  "unaufhörlichen" building works. Schönherr 1893, p. CLXIX, reg. 10689 (20 May 1577): "the pursuit and entreaties and pleas [from the workers] for the payment of their wages are such, that there are no such words for it, it is piteous." ("es sei ain solches Nachlaufen und Flehen und Bitten [der Arbeiter] um Bezahlung ihres Lidlons, dass es gleich zu erparmen und nit genuegsam zu erzelen ist"), and p. CLXXV, reg. 10764 (12 November 1578).

Topf, and graphically described how they were not even in a position to pay the arch-duke's daily kitchen expenses.[91]

Against this background, the large number of court artists, the massive number of commissions given, and the luxurious and archivally documented purchasing habits of the archduke himself all seem unbelievable. The archduke commissioned numerous gold and silver pieces of jewellery, rare stones, corals, silverware, goblets, clocks, and books, from artisans in Venice, Milan, and Augsburg.[92]

In contrast to the civil servants, there was no precisely defined hierarchy for the individual court artisans and artists,[93] though the court master-builder, alongside the duties discussed earlier, was also responsible for court artisans of distinctly lower rank.[94] The reason for this was that many large financial transactions were processed by his office, and he therefore held numerous powerful mandates.[95] In an undated registry of the royal household, which probably dates from the end of Archduke Ferdinand II's reign, all those serving at court were listed, along with their yearly salary. The positioning of individual artists' entries in this document is most informative. They appear under the heading "sundry servants," followed by the section "servers at table."[96] Neither the positioning in this document nor the salaries listed allow us to determine whether these artists were considered important or significant at court. It seems nevertheless clear that a position in service of the court offered many advantages, even if it was unpaid. The most significant advantage was probably the exemption from all citizen's obligations and functions.[97] Although even this was not always the case: a few court artists held important civil appointments. For example the court tinsmith, Nikolaus Yenpacher, was the *Bürgermeister* (mayor) of Innsbruck in 1586, 1588 and 1595.[98]

---

91   Schönherr 1893, p. CLXXXVI, reg. 10891 (26 April 1581).

92   Schönherr 1893, p. CLXIX, reg. 10688 (17 May 1577): Purchases (originally not delivered) through Hans Khevenhüller: emeralds, jewels, rings, uncut stones... Also p. CLXXII, reg. 10719 (26 January 1578); p. CLXXV, reg. 10877 (11 February 1581): Jewellery from Augsburg; p. CLXXXIX, reg. 10924 (28 November 1581): Coral to the value of 1500 *Gulden*: the Upper Austrian Chamber initially refused to pay for this purchase, citing their lack of funds: p. CLXXXIX, reg. 10925 (2 December 1581); p. CLXXXIX, reg. 10944 (16 January 1582): Books from Augsburg; p. CCIII, reg. 11084 (9 March 1584): cups for shooting, court cups for christenings, a necklace with jewels, and one desk with silver fittings.

93   Schmid 1971, p. 8.

94   TLA, M.a.H. 1565, fol. 303v–305: "court master-builder at Innsbruck" ("Hofpaumaisterambt zu Insprugg"), 7 May 1565.

95   Warnke 1996, pp. 224–225.

96   "allerlai Diener" [...] "Tafeldiener", TLA, Codex 5328/3, fol. 11v–12v.

97   TLA, KS III 21.120: Andre Ilmair, "citizen and clockmaker..." ("Burger und Urmacher alhie") asked that he be "furthermore freed, with all his civil duties and burdens mercifully lifted" ("fürterhin aller burgerlichen Ambter und Beschwärdten [...] gnedigist [zu] entheben und befreien").

98   Rudolf Granichstaedten-Czerva, *Alt- Innsbrucker Stadthäuser und ihre Besitzer*, I (Innsbruck, 1962), p. 38; Christoph Haidacher, *Zur Bevölkerungsgeschichte von Innsbruck im Mittelalter und in der beginnenden Neuzeit*, Veröffentlichungen des Innsbrucker Stadtarchivs, Neue Folge, 15 (Innsbruck, 1984), pp. 169 and 175.

On the social level various groupings formed, and there were family connections between many artists. A few artists were married into each other's families,[99] stood as godparents to each other's children,[100] or married the daughters[101] or widows of other court artists.[102] This did however mostly take place within single nationalities.

The archduke granted a great many privileges, though this was not done according to any apparent system. A single severance payment following the end of court service, or a kind of pension that promised support for a longer period (sometimes even for the recipient's lifetime) were granted again and again, but there was no specific, legal entitlement to these privileges. Both severance payments and pensions were only ever granted to those who had been salaried at court, they both varied greatly and were very much dependent upon the financial situation of the Chamber and probably also the mood of the archduke. It was usual for artists who had served at court for a few years to receive a single severance payment, which mostly amounted to the equivalent of three months' wages.[103] Those who had served the archduke for many years were sometimes able to secure themselves a carefree life with a pension.[104]

The court title was also not granted according to any comprehensible criteria,[105] and did not necessarily include a regular salary.[106] According to contemporary guild regulations, foreign artists had no opportunities to remain in Innsbruck apart from service at the court: this was surely the reason for the high number of Italian and Dutch court title-holders.

A particular privilege enjoyed by court artists, and above all the court musicians, was financial support for their education. The court chapel choirboys, after their

---

99  Egg 1972, p. 56: Alexander Colin, sculptor, and Roman Fleschauer, painter.

100  Gerhard Marauschek, 'Leben und Zeit', in *Der Innerösterreichische Hofkünstler Giovanni Pietro de Pomis 1569–1633*, ed. by Kurt Woisetschläger (Graz, Vienna and Cologne, 1974), p. 14: Alexander Colin was the godfather of Pietro de Pomis' oldest son.

101  Granichstaedten-Czerva 1962, p. 38: Clockmaker Andreas Illmair wedded the daughter of the goldsmith Pfaundler, while his own daughter was married to Nikolaus Yenpacher, the court tinsmith. Ludwig Schönach, *Beiträge zur Geschlechterkunde tirolischer Künstler aus dem 16.–19. Jahrhundert* (Innsbruck, 1905), p. 6: Hans Anshalm, painter, married the daughter of the painter Hans Maisfelder. Also Schönach 1905, p. 35: Jeremias Scalabrin, painter, wedded the daughter of the painter Paul Trabl; Schönach 1905, p. 8: Pietro de Pomis married the daughter of the court tapestrier Benedikt Dermoyen.

102  Egg 1972, p. 61: The painter Georg Fellengiebel married the widow of the painter Christoph Perkhammer.

103  KS III 20.62: Lienhard Waldburger, form-cutter; Schönherr 1896, pp. XLI–XLII, reg. 14446 (25th September 1597): The present court goldsmith, Anton Ort, received 100 *Gulden* as severance in 1597.

104  TLA, G.v.H. 1578, fol. 999/999v (10 November 1578): the court master-builder Giovanni Lucchese received approval for a lifetime pension of 78 *Gulden* (annually), in case he should no longer be able to work because of the effects of old-age; TLA, KS I 723 (6 February 1572), Georg von Werdt (court carpenter) should receive 40 *Kreuzer* weekly (not even 35 *Gulden* per year) for a lifetime pension.

105  TLA, Missiven an Hof 1572, fol. 364v/365 (9 July 1572) and Schönherr 1893, p. CXLI, reg. 10399 (9 Juli 1572): The sculptor Alexander Colin, for example, was never granted membership to the court, even though he received a regular retainer.

106  TLA, KS III, 21.59/3: Antoni Ort describes how he served the court for 35 years, but received neither payment for his work, nor any charitable donations.

voices broke and they were therefore removed from the choir, usually received a scholarship: they did however need to produce convincing documents from their intended school or university.[107] Archduke Ferdinand II supported some artists with rent-assistance,[108] and sometimes he also facilitated the buying of a dwelling or made an apartment available. This was not always to the artist's liking: The caster Hans Lendenstreich from Munich was permitted to live in the *Bilderhaus* at Mühlau (a building comprising a storage gallery for artworks with dwelling space in the upper floors), but this was clearly not an elegant space to live and work in. Lendenstreich complained that the dwelling had neither doors nor windows, and that apart from the oven, there was nothing suitable in the apartment. He had therefore had to run back and forth to Innsbruck in order to retain the necessary workmen.[109]

The consistent housing rights granted to court artists as described by Martin Warnke were non-existent at the court of Innsbruck.[110] Quite the opposite, in fact: Archduke Ferdinand II wanted, for example, to tax both of the court painter Giovanni Battista Fontana's houses in the *Silbergasse* ('Silver lane')[111] at the ordinary rate. He clearly did not want to privilege the court artists in this particular matter.[112]

The provision of meals at court is mentioned in numerous documents,[113] but in a 1595 register of the court tables[114] not a single court artist appears. Various invoices prove however, that artisans were given this kind of support.[115] Sigmund Waldhueter worked, for example, with several painters, and they received four to five meals per working day, besides at least two servings of "good wine" and a snack.[116]

The social elevation of court artists was a good motivation for people to seek out a position at court. Archduke Ferdinand II was above all generous in cases of illness: he

---

107  TLA, G. v. H. 1572, fol.191. Also Senn 1954, p. 94.

108  Schönherr 1893, p. CLXIII, reg. 10637 (13 June 1567): Alexander Colin, sculptor, received 26 *Gulden*; p. CLXXX, reg. 10823 (30 April 1580): the Dutch painter Roman Fleschauer received 6 *Gulden* in interest; p. CCV, reg. 11112 (1584): Albrecht Lucchese received 15 *Gulden*.

109  Lendenstraich was so frustrated with this situation, that he would prefer to "leave today, rather than tomorrow" ("heint als morgen hinwegziehe") (Schönherr 1893, p. CXXVI–CXXVII, reg. 10232, 23 Mai 1570).

110  Martin Warnke, *Hofkünstler. Zur Vorgeschichte des modernen Künstlers*, 2nd revised edition (Cologne, 1996), pp. 160, 169.

111  The current Universitätsstrasse.

112  Schönherr 1893, p. CXCVIII, reg. 11025 (2 January 1583).

113  Schönherr 1893, p. CXCVII, reg. 11011 (26 November 1582). Ludovico de Duca suggested various forms of payment: a yearly salary or payment for his work according to the estimation of an expert, or full board at the court for himself and his servants, as was previously arranged and an extra cash payment; TLA, KS III 20.34: In a letter, Antoni Boys also requested that the "ordinary meals at the court continue as before" ("ordinari Tafel fürohin inmassen, wie bißheer beschechen, fortzusetzen").

114  TLA, Codex 5328/5, "table" ("Tafl").

115  TLA, G.v.H. 1591, fol.1: The armourer's assistant Matheus Comissari received one *Taler* as a meal allowance every week; or TLA, KS III 43.71: "common provision of board" ("*gemaine Zerung*") for the artisans.

116  "guten Wein", TLA, KS I 721 (27 September 1567): "at snack-time, also bread, cheese, and wine, as is traditional" ("[...] zu der Marent-Zeit auch Prot, Käß und Wein, wie dann von alten gebreuchlichen ist"). Cost: 16 *Kreuzer* per painter per day.

granted extra funds[117] and paid for visits from his personal doctor,[118] or offered support in the form of a cure at the curative baths.[119] Orphans and widows were also regularly provided with extra funds, and often widows could hope for a *Gnadenjahr* ('charity year'). These requests were carefully reviewed, but not always approved.[120]

Great numbers of coats of arms were granted, and in this there was no special priority given to foreign artists. Other privileges took the form of travel expenses,[121] the use of a horse for carrying out service-related tasks,[122] court robes,[123] and various other *Erzgötzlichkeiten* ('favours of the archduke') in the form of extra payments that supplemented the often modest salaries or wages of those in court service.[124] All extra payments or services had to be requested, and the archduke would then decide – often after a review performed through the Upper Austrian Chamber or the court master-builder

---

117  TLA, KS I 908 (30 April 1580): The Dutch painter Roman Fleschauer received an extra payment (due to his impoverishment and illness).

118  Fischnaler 1934, p. 75: Roman Fleschauer was permitted to use the services of Archduke Ferdinand II's personal doctor, and was sent to the curative baths. Fischnaler 1934, p. 139: Konrad Leitgeb, likewise a painter, who injured himself at a traditional shooting tournament celebrating the christening of a child, received his medical expenses from the archduke.

119  TLA, G.v.H. 1587, fol. 264: Antonio Montano, an Italian glassmaker, was allowed a hot springs cure in October 1587. TLA, KS I 908 (13 September 1581): the painter Roman Fleschawer was also given 10 Gulden to enjoy this treatment.

120  Schönherr 1893, p. CLXXIV, reg. 10752 (3 September 1578): The pregnant widow of the painter Alexander Maisfelder, who was drowned at Inn, asked for a weekly donation; Schönherr 1893, p. CLXXVI, reg. 10767 (16 December 1578): This was granted for five years at a sum of 20 *Kreuzer* (!) per week; TLA, Gemeine Missiven 1584, fol.125 (27 January 1584) and Schönherr 1893, p.CCII, reg. 11078 (7 January 1584): In January 1584 the Upper Austrian Chamber withdrew its approval, however, on the grounds that the petitioner had found work, and her children were now grown.

121  Wendelin Boeheim, Urkunden und Regesten aus der k.k. Hofbibliothek, *JKSAK* 7 (1888), p. CXLII, reg. 5180 (10 April 1570): Alexander Colin, sculptor, received 40 *Gulden* in 1570 for his trip from Innsbruck to Prague, though he had estimated his costs as being far higher than this. Schönherr 1893, p. CLX, reg. 10600 (13 September 1575): The travel of the glass-painter Thomas Neidhart from Feldkirch to Innsbruck was compensated with 4 *Gulden*. Schönherr 1896, p. XXXVI, reg. 14400 (1595): Albrecht Lucchese received 30 *Gulden* for a working trip to Bozen.

122  TLA, G.v.H. 1575, fol. 320/320v' (4 June 1575): An order to the government and the Upper Austrian Chamber to provide the court master-builder Giovanni Lucchese with a better horse for his court duties.

123  Schönherr 1893, p. CII, reg. 10025 (13 February 1567): The organ-builder Georg Ebert, received court robes as recognition for his work; Schönherr 1896, p. VIII, reg. 14124 (11 September 1589): Albrecht Lucchese received 60 *Gulden* in 1589 for purchasing robes of honour. TLA, KS III 20.61: Upon the death of Archduke Ferdinand II, the Upper Austrian Chamber owed the form-cutter Leonhard Waldburger fourteen promised court robes.

124  TLA, G.v.H. 1591, fol.16v: Albrecht Lucchese, the court master-builder received a monthly "extra payment" ("Zuepuß") of 5 *Gulden* due to rising cost of living in the area, in addition to his wages; Schönherr 1893, p. CV, reg. 10053 (7th August 1567): Hans Christoph Löffler, caster, tried to gain a 'Zubussgeld', first in 1567 (he requested 200 *Gulden*). This was not granted at first. TLA, G.v.H. 1590, fol. 122v–123: In 1590 Archduke Ferdinand II finally granted him a donation of the unbelievable sum of 1000 *Gulden*, on the grounds that Löffler had for many years "rendered service without salary or ambitions" ("one Besöldung und Ergezlichkeit gehorsamlich gebrauchen lassen") and had furthermore produced a "delicately cast piece" ("zierlich gegossen Stück") for the archduke. TLA, G.v.H. 1591 fol. 52, 52v: However, Löffler had to exercise patience, since the archduke only gave instructions for the money to be paid in 1591.

– whether such a request would be approved or not. As was the case at other European courts,[125] this money would not necessarily be paid for services already rendered, but rather to support the readiness and capacity to serve. That being said, the matter was rarely so straightforward. Requests for these 'favours of the archduke' were often followed by a lively exchange of letters between the Upper Austrian Chamber and the archduke, until a payment was approved or, as was more often the case, denied.

The archduke gave gifts very freely, but very few court artists appear in the longs lists of recipients. Single silver cups were given at weddings, but these examples were of far lower value than the cups and goblets given to noble friends, or officials.[126]

None of the privileges and benefits named here were assumed, and they were also never consistently regulated or laid down as obligatory. The granting of these favours and the amount given was at the discretion of the archduke. The court artists usually had to request extra payments by making a supplication, and these were certainly not always granted. The archduke would also often compromise on the amount requested. It is true that these supplications were time-consuming and demoralising for the artists, and later for their widows,[127] especially since they usually only met with success after repeated attempts. Nonetheless, they still showed a kind of social benefit that could definitely not be taken for granted at that time, which provided something for widows and orphans, as well as for artists who were no longer able to work. This was a great financial advantage over artists not bound to the court.

The total number of artists recorded with commissions from Archduke Ferdinand II's period as ruler is considerable. A court appointment neither guaranteed a secure livelihood for the families of the court artists, nor did it necessarily make artists financially comfortable: it could not, in fact, even guarantee them protection against impoverishment. It was nonetheless a social elevation when compared to the civil artists and artisans not engaged by the court. The honour of holding such a title and securing such employment was probably also considered a worthy achievement. Various inventories[128] and the abundant primary material kept in the Tyrolean regional

---

125  Warnke 1996, pp. 172 and 175.

126  Cf. Schönherr 1893, p. CLXXXIII, reg. 10848 (1580), or p. CLXXXIV, reg. 10858 (1580), p. CLXXXV, reg. 10875 (11 February 1581), pp. CXC–CXCI, reg. 10941(1581): Register of silverware given as gifts, mostly valued between 50 and 115 *Gulden*. Antoni Ort, the court goldsmith, also appears as having received a gift worth 40 *Gulden*.

127  Schönherr 1893, p. CXXXVIII, reg. 10366 (12 February 1572): The sculptor Alexander Colin complained that he would rather get on with his work than have to make supplications for his pay.

128  For example: Boeheim 1888, pp. CXLI–CXLII, reg. 5170 (4 October 1569): "Infentari von irer gnaden klainoter" ("inventory of your Grace's jewels") etc.; pp. CLXIX–CLXXIX, reg. 5375 (15th September 1577, Ambras): "Inventari allerlai klainotter von gold mehrlai sort" ("inventory of sundry gold treasures of many sorts"); pp. CLXXXIX–CCXVIII, reg. 5440 (1583, Innsbruck): detailed descriptions of weapons, war machinery, trophies, objects and props for celebratory parades and masquerades, as well as tournament equipment from Schloss Ambras (incomplete inventory), pp. CCXXVI–CCCXIII, reg. 5556 (30th May 1596, Innsbruck): "Inventari weilend der fürstl. durchlaucht erzherzog Ferdinanden zu Österreich etc. lobseligister gedechtnus[...]" ("Estate inventory of the Archduke Ferdinand of Austria etc., of most praised memory") (incomplete transcription of the 1596 inventory).

archives provide a glimpse into the unbelievable level of artistic production commissioned by the archduke, of which only a fraction survives today. Fortunately, Archduke Ferdinand II remained immune to the innumerable calls of the Upper Austrian Chamber to spare money, and gave out commissions without concern for the problematic financial situation. The extant examples of work by Archduke Ferdinand II's court artists form a significant part of most precious cultural inheritance of the *Bundesland Tirol* (province of Tirol), the foundation of the Kunsthistorisches Museum in Vienna and Ambras.

# Humanism, Science, Library

Ivo Purš

# Scientific and literary activity linked with the influence of Archduke Ferdinand II (1529–1595) in the Bohemian Lands and in Tyrol

The wide extent of Archduke Ferdinand II's interests was projected, amongst other things, in the building of the library at Ambras Castle, which has recently been analysed on the basis of the 1596 estate inventory (version held in the Österreichische Nationalbibliothek sign. Cod. 8228, hereafter estate inventory ÖNB).[1] Although this library was conceived in the contemporary spirit of universal education, it also reflected the archduke's personality. It became an essential accessory to the famous *Kunstkammer*: both units served as a source of knowledge and fulfilled the ideal of a humanist-oriented court.[2]

The archduke's interest in natural sciences and medicine, which arose partly due to his own health problems, was also closely linked to the establishment of the collection of arts and curiosities.[3] A further important trait of Archduke Ferdinand II's activities reflected in the compilation of the library was support for historical research focussed on the history of his family and the history of Tyrol; this interest was closely associated, for instance, with the establishment of a collection of the armour and weaponry of famous heroes (the *Heldenrüstkammer*, or Heroes' Armoury). Nor did literature and poetry escape the archduke's attention, although he dedicated himself to this sphere to a lesser extent. The archduke's patronage as also connected with all these areas of interest, as well as the requests for support that he received from a number of publishing authors.

---

1   See *Knihovna arcivévody Ferdinanda II. Tyrolského*, ed. by Ivo Purš and Hedvika Kuchařová, 2 vols. (Prague, 2015). Although this extensive work was published in the Czech language, it contains over a hundred pages of résumé in German; the identification of books classified according to the inventory published in the second volume is internationally comprehensible. The authors worked mainly on the basis of the transcription of the estate inventory deposited in the Österreichiche Nationalbibliothek (hereafter quoted as ÖNB), Cod. 8228, see Wendelin Boeheim, 'Urkunden und Regesten aus der k.k. Hofbibliothek', *Jahrbuch der kunsthistorischen Sammlungen des Allerhöchsten Kaiserhauses* (hereafter as *JKSAK*) 7 (1888), pp. CCXXVI–CCCXIII , reg. 5556; Wendelin Boeheim, 'Urkunden und Regesten aus der k.k. Hofbibliothek', *JKSAK* 10 (1889), pp. I–X, reg. 5556, and also from the list of manuscripts brought to Vienna from Ambras in 1665 by the Imperial Librarian Peter Lambeck, see Petrus Lambeck, *Commentariorum Augustissima Bibliotheca Caesarea Vindobonensi Libri VIII* (Vienna, 1669).

2   Lenka Veselá, 'Závěr', in Purš / Kuchařová 2015, I, pp. 468–469; Jaroslava Kašparová, Ivo Purš and Alena Richterová, 'Základní kontury knihovny a její analýzy', in Purš / Kuchařová 2015, I, p. 56.

3   See Václav Bůžek, 'Ferdinand II. Tyrolský v souřadnicích politiky Habsburků a jeho sebeprezentace', in Purš / Kuchařová 2015, I, pp. 13–40 (15, 30); Katharina Seidl, '…how to assuage all outer and inner malady…': Medicine at the Court of Archduke Ferdinand II', in *Ferdinand II. 450 Years Sovereign Tuler of the Tyrol. Jubilee Exhibition*, ed. by Sabine Haag and Veronika Sandbichler, exh. cat. (Innsbruck and Vienna, 2017).

In this study we will deal with the scientific and literary activity that was linked to a varying extent with the influence of Archduke Ferdinand II in Bohemia and Tyrol. This is a theme that has received less scholarly attention than the archduke's interest in architecture or the organisation of festivities.[4] Here we will concentrate purely on providing an overview of this theme, without expanding on some of its aspects, which certainly deserve further attention (that being said, the relationship between the library and the *Kunstkammer* are partly covered in the article by Katharina Seidl in this volume). As far as concerns the language specification of the works we shall be dealing with, these were mainly Latin texts, as Latin was the language of science and also the language of humanist literature, but we shall also mention works in vernacular languages.

### Theology and Confessional Problems

The confessional situation in Bohemia during the time of Archduke Ferdinand II was characterised by the coexistence of several religions – alongside the dominant Utraquism and minority Catholicism, a highly significant role was played here by the Bohemian Brethren, who were gradually drawing closer to Calvinism. The Lutheran Reformation was also being promoted with increasing frequency in Bohemia. The archduke was a decisive supporter of Catholicism, as was his father King Ferdinand I, and he also fully agreed with the strategy promoted by his father, especially in the procedures against the Bohemian Brethren. Part of the re-Catholicisation effort was the invitation of the Jesuit Order to Prague in 1556, and the occupation of the long empty See of the Prague Archbishopric by Antonín Brus of Mohelnice in 1561. In the following year the Jesuit Philosophical and Theological Schools acquired university status.[5]

Under the given circumstances, it is logical that no circle of kindred theological thinkers formed around Archduke Ferdinand II in Prague; thinkers who might dedicate their publications to the archduke and become recipients of his support. For this reason, the period is characterised instead by individual examples of book patronage undertaken by both the archduke and other members of the Habsburg family. Such examples included the manuscript *De sacris temere neque violandis neque inuulgandis libri duo* (Vienna 1539), dedicated by its author, the Viennese Bishop Johannes Fabri, to Maximilian II.[6] Fabri's successor at the cathedral, Friedrich Nausea, dedicated his book entitled *De Domini nostri Iesu Christi et nouissima omnium mortuorum*

---

4   Regarding the architectural treatises in the archduke's library see Ivan P. Muchka, 'Literatura o architektuře', in Purš / Kuchařová 2015, I, pp. 279–285; festivities will be mentioned later in this article.
5   Hedvika Kuchařová, *Classis theologica*. Teologická literatura', in Purš / Kuchařová 2015, I, pp. 105–106.
6   Kuchařová 2015, pp. 117–118.

*resurrectione libri III* (Vienna 1551) directly to Archduke Ferdinand II.[7] One relatively exceptional little work was also dedicated to the archduke: the speech of the converted Jew and Professor of Hebrew, Paul Weidner, which he delivered in 1561 in the Prague Synagogue in an effort to convert the Jewish community to the Christian faith. This is a print with the title *Ein Sermon ... den Juden zu Prag Anno MDLXI ... in irer Synagoga geprediget* (Vienna 1562).[8]

The situation in Tyrol when Archduke Ferdinand II came to power in 1567 was very different. Here the archduke was surrounded by a considerably larger circle of Catholic theologians. In those days the University of Freiburg am Breisgau and its theological faculty was an important centre for theological studies. It was logical that its representatives should turn with their works to the ruler, who had an exceptionally well-prepared field in the Tyrol for the promotion of the Catholic faith. Tyrol was a predominantly Catholic country and the aim of the activities undertaken by the archduke and the theologians of the Freiburg University was the realisation or application of the outcomes from the Council of Trent, which had ended four years before Archduke Ferdinand II's move from Bohemia to Tyrol.[9]

The foremost figure at the Freiburg Theological Faculty was Professor Jodocus Lorichius, who dedicated his manuscript *Evangelium* to the archduke: the full title of this work was *Hoc est de vi, natura et scopo evangelii Iesv Christi, Domini ac Saluatoris nostri* (Ingolstadt 1580).[10] In the example preserved from Archduke Ferdinand II's library there is a printed dedication supplemented by the author's handwritten inscription. Lorichius, a Carthusian, did not address his dedications to the archduke alone, but also to other members of the Habsburg family, and to Archduke Ferdinand II's courtiers. An example of this is found in a bundle of Lorichius's manuscripts from the years 1577–1579, concerning in particular disputable questions concerning the teaching of the faith. This was preserved in the archduke's library in its original red velvet binding with a handwritten dedication to the archduke himself.[11] A significant Jesuit theologian and preacher of the time was Peter Canisius, who was already known to Archduke Ferdinand II from his period as the governor of Bohemia, and who the archduke had in fact requested as his court preacher in Innsbruck. In Innsbruck Canisius wrote and published the first part of his manuscript against the so-called

---

7   The donation example was preserved in the Universitäts- und Landesbibliothek Tirol (hereinafter ULB), sign. 219.930, in the original binding decorated with silver embossing and the inscription "AD ILLVSTRISPP.[imum] ARCHIDVCEM AVSTRIAE FERDINANDVM 1551 F.[ridericus] E. [piscopus] V.[ienensis] M.". See Purš / Kuchařová 2015, II: Katalog, p. 149 (here 1Theo 226). Nausea was also the author of sermons on the occasion of a number of events linked with the imperial family. Kuchařová 2015, p. 115.

8   Kuchařová 2015, p. 119; Lenka Veselá, 'Knihy dedikované Ferdinandovi II. Tyrolskému', in Purš / Kuchařová 2015, I, pp. 429–445 (435).

9   Josef Hirn, *Erzherzog Ferdinand II. von Tirol. Geschichte seiner Regierung und seiner Länder*, 2 vols. (Innsbruck, 1885–1588), I, pp. 339–343.

10  Veselá 2015, p. 440; Purš / Kuchařová 2015, II, here 1Theo 620; Hirn 1885, p. 339. Archduke Ferdinand II's library contained several of Lorichius's theological works.

11  Held in ULB, sign. 171 E 11; see Kuchařová 2015, p. 118; Purš / Kuchařová 2015, II, here 1Theo 143.

Magdeburg Centuries – *Commentariorum de verbi dei corruptelis Liber primum* (Dilingae 1571) with the financial support of the archduke. As is noted by Lenka Veselá, although the work was written at the request of Pope Pius V, it was finally dedicated to Archduke Ferdinand II.[12]

At the beginning of the 1570s Johann Nasus became active in Tyrol, and in 1573 he became Archduke Ferdinand II's court preacher. This fervent opponent of Protestantism wrote a large portion of his manuscripts in Tyrol and won himself a permanent place in the history of 16th century German literature. Amongst the other religious writers who dedicated their works to the archduke, we should also mention the Superior of the Dominican Monastery in Bolzano, Sebastiano Cattaneo, who dedicated his book on the sacraments to Archduke Ferdinand II.[13] In this context we cannot then omit Dr Johannes Pistorius, physician and theologian, nominated to Archduke Ferdinand II's council by the archduke himself in 1590, and to whom he promised special protection. Pistorius subsequently entered the services of the Bishop of Constance and Cardinal Andreas of Austria (1558–1600), the first-born son of the archduke. After the cardinal's death in 1600 Pistorius became confessor to Emperor Rudolf II.[14]

## Poetry and Historiography

If we compare the situation of religious and theological literature in Bohemia during the period of Archduke Ferdinand II's influence with the activity of the local humanist circle of writers,[15] we cannot but notice the great difference, for this second group was not subjected to such severe control. In the group centred around the court there were humanists from the poetry circle of Jan the Elder Hodějovský of Hodějov.[16] Seeking literary patronage and service at court, these men commented with poetic praise on the archduke and the whole ruling family. As shown by the four collections entitled *Farragines*, these authors demonstrated a rather positive attitude in their occasional poems dedicated to King Ferdinand I and his sons, even though many of them, in contrast to Hodějovský himself, rejected some of the steps taken by the Habsburgs, such as the suppression of the 1547 uprising.[17] The significant authors of this circle included Jan Horák of Milešovka, the former tutor of Archduke Ferdinand II in Innsbruck,[18] as

---

12  Veselá 2015, p. 439; Hirn 1885, p. 360.

13  Hirn 1885, pp. 252–256, 359.

14  Ivo Purš, 'The Intellectual World of Rudolf II and the Kabbalah', in *Path of Live. Rabbi Judah Loew Ben Bezalel, ca 1525–1609*, ed. by Alexandr Putík (Prague, 2009), pp. 204–206.

15  See Jaroslava Hausenblasová, 'Ferdinand I. a pražský humanistický okruh. Několik poznámek k problematice panovnického mecenátu kolem poloviny 16. století', *Acta Universitatis Carolinae: Historia Universitatis Carolinae Pragensis* 47: 1–2 (2007), pp. 89–97.

16  Lucie Storchová, „*Paupertate styloque connecti*". *Utváření humanistické učenecké komunity v českých zemích* (Prague, 2011), pp. 110–142.

17  Marta Vaculínová and Martin Bažil, 'Básnická díla', in Purš / Kuchařová 2015, I, pp. 287–327 (322).

18  Bůžek 2015, pp. 13–40 (15); *Rukověť humanistického básnictví v Čechách a na Moravě*, ed. by Josef Hejnic and Jan Martínek, 6 vols. (Prague, 1966–2011), II, pp. 332–336.

well as Jan Balbinus,[19] Kaspar Brusch,[20] Matouš Collinus of Chotěřina,[21] Georg Handsch,[22] Martin Hanno,[23] Martin Kuthen,[24] Tomáš Mitis[25] and Jan Serifaber.[26] A typical trait of dedications from the period of Archduke Ferdinand II's activity in Bohemia was the fact that they addressed several people simultaneously, especially, for example, Ferdinand I or the Archduke's siblings. This was logically connected to the fact that the archduke was only installed as governor.[27]

The oldest imprint dedicated to Archduke Ferdinand II in Bohemia was the manuscript of Martin Kuthen of Šprinsberk entitled *Catalogus ducum regumque bohoemorum...* (s. l. 1540).[28] This overview of the Bohemian rulers was not only dedicated to the archduke, but also to his brothers. Chronologically there followed several editions devoted to the ceremonial arrival of the newly elected Emperor Ferdinand I in Prague in 1558. Firstly, let us look at the small piece that Kuthen wrote together with Matouš Collinus of Chotěřina under the title *Brevis et succincta descriptio Pompa in honorem... Ferdinandi Primi* (Prague 1558).[29] This became the subject of a complaint on the part of the Jesuit Order, and was rewritten and published in a second, revised edition with the archduke's approbation.[30] Archduke Ferdinand II's physician Pietro Andrea Mattioli also published his own description of this ceremony, entitled *Le solenni pompe et gli splendidi spettacoli facti alla venuta dell'imperatore Ferdinando I.* (Prague 1559); he did not dedicate this article, however, to the archduke, but to Count Alfonso di Porcia.[31] Celebratory poems about the same event were also published by Jan Balbinus.[32] The glorious arrival of Ferdinand I in Prague, organised in 1558 by the archduke, was praised by Vít Traianus in the poem *De spectaculo, quod Ferdinandus*

19    Hejnic / Martínek 1966, I, pp. 126–130.
20    Hejnic / Martínek 1966, I, pp. 233–234.
21    Hejnic / Martínek 1966, I, pp. 416–451.
22    Hejnic / Martínek 1966, II, pp. 255–259; Josef Smolka and Marta Vaculínová, 'Renesanční lékař Georg Handsch (1529–1578)', *Dějiny vědy a techniky* 43 (2010), pp. 1–26.
23    Hejnic / Martínek 1966, II, pp. 261–263.
24    Hejnic / Martínek 1969, III, pp. 116–120.
25    Hejnic / Martínek 1969, III, pp. 339–361.
26    Hejnic / Martínek 1982, V, pp. 47–50.
27    Veselá 2015, pp. 432.
28    Anežka Baďurová, 'Úvod', *Bibliografie cizojazyčných bohemikálních tisků z let 1501–1800. I. Produkce tiskáren na dnešním území České republiky v 16. a 17. století*, CD-ROM, Prague 2003.
29    Purš / Kuchařová 2015, II, here 4Va 518; Václav Bůžek, *Ferdinand von Tirol zwischen Prag und Innsbruck. Der Adel aus den böhmischen Ländern auf dem Weg zu den Höfen der ersten Habsburger* (Vienna, Cologne and Weimar, 2009), pp. 142–159; Jan Bažant, 'Pompa in honorem Ferdinandi 1558', in *Druhý život antického mýtu*, ed. by Jana Nechutová (Brno, 2004), pp. 195–205, pp. 195–205; Olga Fejtová and Jiří Pešek, 'Varii variarum rerum, factorum, dictorum, multarumque aliarum historiarum scriptores. Dějepisná literatura', in Purš / Kuchařová 2015, I, pp. 181–208 (197).
30    Vaculínová / Bažil 2015, p. 326; Veselá 2015, p. 433.
31    Baďurová 2003, s.v. Mattioli, Pierandrea.
32    Jan Balbinus z Vorličné, *In trivmphalem adventvm Pragam... Ferdinandi... primi... carmen gratulatorium...* (Prague, 1558). See Vaculínová / Bažil 2015, p. 326. In 1566 he further dedicated the poem *Querela Iusticiae* to the archduke, in which he complains about the poor state of the law in the Kingdom of Bohemia following the death of the Emperor.

*archid[ux] exhibuit.*[33] A separate ode to Emperor Ferdinand I was published in 1558 by Matouš Collinus of Chotěřina,[34] who in the following year dedicated a poem about the tragic death of Hans Gregor of Herberstein to the archduke, *De Iohannis Gregorii libero baronis in Herberstain miserabili casu* (Vienna 1559).[35] We should also add Kaspar Brusch to this overview of the humanists from Archduke Ferdinand II's Bohemian circle who addressed him with dedications. Brusch briefly attended the archduke's court and dedicated a treatise to him entitled *Monasteriorum Germaniae praecipuorum ac maxime illustrium centuria prima...* (Ingolstadt 1551).[36] The poem by the physician and professor at the University of Vienna Wolfgang Lazius, *Exemplum orationis... ad excipiendum ... Archiducem...Ferdinandum secundum* (Vienna 1560), should also be noted in this context.[37] Martin Hanno wrote the *Idyllion de hastiludio a Ferdinando archiduce instituto*[38] describing the tournament games organised by Archduke Ferdinand II. The Silesian poet Jan Serifaber also glorified the archduke in the first book of the collection *Sylva encomiorum* from 1550,[39] which he dedicated to Ferdinand I.

Just as in the case of the theological and confessional problems, the Tyrolean situation was also very different from the Bohemian one in the case of works and support in the fields of poetry and historiography. The archduke's interest in history only developed to the full during his Tyrolean period, and we can only agree completely with the opinion of Josef Hirn, that "no kind of science was more cultivated during Ferdinand's rule in Tyrol than history".[40] The most significant work that came into being at the court of Archduke Ferdinand II was that of Gerard van Roo. This native of Oudewater in Holland came to the archduke's court when it was still in Prague in 1564, as the bass singer in his court choir. He subsequently moved with the archduke's court to Tyrol, where he taught the boys in the choir. In 1580 he began to look after the *Kunstkammer, Wunderkammer* and the library, and acquired residence in the castle.[41] All this enabled van Roo to make good use of the library's literature for the writing of his work entitled *Annales rerum belli domique ab austriacis Habsburgicae gentis principibus a Rudolpho primo usque ad Carolum V. gestarum* (Innsbruck, 1592). (Fig. 1) He did not however complete this work, which was divided into twelve parts, the first of which begins at the birth of the Austrian house and the last of which ends

---

33   Hejnic / Martínek 1982, V, p. 383; Vaculínová / Bažil 2015, p. 326.

34   Matouš Collinus z Chotěřiny, *Ad... Ferdinandum... ode gratulatoria* (Prague, 1558). See Baďurová 2003.

35   Baďurová 2003; Bůžek 2015, pp. 38–39.

36   Purš / Kuchařová 2015, II, here 4Va 706. Vaculínová / Bažil 2015, pp. 326–327.

37   Purš / Kuchařová 2015, II, here 5Co 1173. See Marta Vaculínová and Martin Bažil, 'Rétorika a filologie', in Purš / Kuchařová 2015, I, pp. 287–327 (359).

38   *Secunda Farrago*, 1548, fol. 250a – 251b. Hejnic / Martínek 1966, II, p. 262.

39   Hejnic / Martínek 1982, V, p. 48; Vaculínová / Bažil 2015, p. 326.

40   Hirn 1885, p. 344; Christian Gries, 'Erzherzog Ferdinand von Tirol. Konturen einer Sammlerpersönlichkeit', *Frühneuzeit-Info* 4:2 (1993), pp. 162–173 (168).

41   Hirn 1885, p. 345.

with the death of Maximilian I. When van Roo died in 1589 the editing and completion of this history was handled by Archduke Ferdinand II's secretary Konrad Dietz (Conrad Decius of Weidenberg). The latter also later made a German translation of the work (Augsburg 1621). During his lifetime van Roo also dedicated his poems to the archduke.[42]

A no less important member of the court from 1565 on was the archduke's secretary Jakob Schrenck of Notzing (circa 1530–1612), who together with several other colleagues was in charge of the *Rustkammer* (armoury) and *Kunstkammer*. Other members of his family also had numerous relations with the court, for instance his brothers shared a common interest in prospecting, or the seeking of precious metals, in the environs of Innsbruck.[43] In 1588 Schrenck was appointed Archduke Ferdinand II's counsellor, which was undoubtedly connected

Fig. 1. Gerard van Roo, Annales rerum belli domique ab Austriacis Habsburgicae gentis Principibus a Rudolpho usque ad Carolum V. rerum gestarum, Innsbruck 1592 (Innsbruck, Universitäts- und Landesbibliothek Tirol, sign. 21 C 7)

with the fact that, in the course of his career at court, he fulfilled especially those tasks that stemmed from the archduke's personal interests. Apart from the compiling of a *Tierbuch* (zoological album)[44] and copying other books, Schrenck was mainly occupied with the acquisition of items for the archduke's collections, and the two men conducted

---

42  *Sapientia Salomonis* (Innsbruck 1572), see Hirn 1885, pp. 346, note 1; *Ad illustrissimum principem ac dominum, D. Ferdinandum D. G. Archiducem Austriae* (Innsbruck 1583), Purš / Kuchařová 2015, II, here 5Co 1158.

43  Hirn 1885, p. 349.

44  Hirn 1885, p. 350.

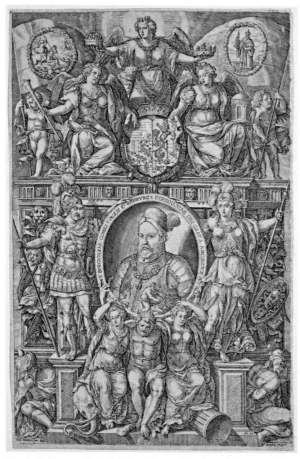

Fig. 2. Title page of Jacob Schrenck von Notzing, Armamentarium Heroicum, Innsbruck 1601 (National Gallery Prague, inv. no. DR 7005 232)

a very extensive correspondence on these acquisitions.

Schrenck dealt first and foremost with the armoury, and was tasked with compiling an extensive work along the lines of a detailed literary and pictorial catalogue to supplement this collection. This was, however, such demanding work that it was not published until six years after Archduke Ferdinand II's death. This work, richly illustrated with copperplates and entitled *Armamentarium Heroicum* (Innsbruck 1601),[45] contained the portraits and biographies of the men whose arms the archduke had acquired or attempted to acquire for his collection. (Fig. 2) According to the archduke's instructions, Schrenck was to compile the biographies of those still alive on the basis of the data he requested from them, whereas in the case of those already deceased he was to compile biographical sketches on the basis of "trustworthy authors". After the death of the archduke, his son and heir Karl of Burgau saw to the expansion of the biographical material contained in this book, and Emperor Rudolf II supported the publication of the work financially. The idea behind this opulent-looking edition was first and foremost to create a 'mirror' of the military virtues of the individual figures who were, in addition, materially, 'physically' present via their armour held in the archduke's collection. The work had no political subtext or ambition to glorify the Habsburg allies.[46]

---

45   See *Jakob Schrenck von Notzing. Die Helden Rüstkammer (Armamentarium Heroicum) Erzherzog Ferdinands II. auf Schloß Ambras bei Innsbruck*, ed. by Bruno Thomas (Osnabrück, 1981); Barbara Welzel, 'Die Ambraser Heldenrüstkammer und die Schlacht von Ostende', *Jahrbuch des Kunsthistorischen Museums Wien* 2 (2001), pp. 223–225; Alfred Auer, 'Vznik, rozvoj a rozptýlení knihovny arcivévody Ferdinanda II. Tyrolského', in Purš / Kuchařová 2015, I, pp. 41–54 (48).

46   Hirn 1885, pp. 351–352.

A further significant figure in Tyrolean historiography during the rule of Archduke Ferdinand II was the humanist Christoph Wilhelm Putsch. Unlike the two preceding authors, Putsch was not in the service of the archduke's court and carried out his historical research quite privately and at his own expense. The Putsch family was an important one in Tyrol. Christoph was born in Innsbruck in 1542 and in his youth had already shown intense interest in the topography and history of Germany, especially Tyrol. For this purpose he not only collected the appropriate literature, but also sought out documentary sources in archives, especially those held in monasteries.[47] He became renowned for this and Archduke Ferdinand II consulted him, for instance, with regard to the relationship of the county of Tyrol to the monastery in Trento, of which Putsch then wrote an historical account. When Putsch died at the age of only thirty in 1572, he left behind an extensive, but also very fragmentary body of work.[48] His manuscript legacy consisted mainly of rich excerpts. The archduke purchased a portion of the books from Putsch's estate, and also the manuscript *Collectanea*.[49] Putsch's collection of books, which was one of the most significant civic libraries of its time, consisted of 326 items[50] and its value was estimated in the course of the estate proceedings at 430 guilders. (Fig. 3) As was ascertained during the investigation of the archduke's own library, Putsch marked his books with inscriptions, such as "1536 M. M. M. [= Memento mortalis mori] Christophorus Gulielmus Putschius Aenipontanus Tyrolensis".[51] In the Universitäts- und Landesbibliothek Tirol a portion of his books have been preserved in their original, usually light-coloured wood and leather bindings, decorated with Renaissance embossing.[52]

Immediately after the death of van Roo in 1589, Dr Adolf Occo (III) was summoned from Augsburg to the court of Archduke Ferdinand II to organise a numismatic collection.[53] His grandfather and father of the same name were also physicians. Occo II was the adoptive son of Occo I and the author of an exceptionally important

---

47   Hirn 1885, p. 354.

48   In the library only one printed work was recorded, but this did not relate to historical research, being a work in verse entitled *Historia divi Iacobi Maioris apostoli* published in Innsbruck in 1565, see Purš / Kuchařová 2015, II, here 1Theo 781; cf. Vaculínová / Bažil 2015, p. 314.

49   Hirn 1888, p. 440. Purš / Kuchařová 2015, II, here 4Va 428. Today in Universitäts- und Landesbibliothek Tirol (hereinafter ULB), Cod. 825 and Cod. 826. See Stanislav Petr and Alena Richterová, 'Rukopisy v knihovně a v kunstkomoře', in Purš / Kuchařová 2015, I, pp. 75–104 (98); Vaculínová / Bažil 2015, p. 314.

50   Cf. Sieglinde Sepp, 'Die Bibliothek entsteht und wächst. Bemerkungen zur Entwicklung des Bestandes der Innsbrucker Universitätsbibliothek in den ersten hundert Jahren', in *Vom Codex zum Computer. 250 Jahre Universitätsbibliothek Innsbruck*, Tiroler Landesmuseum Ferdinandeum 8. 11. 1995 – 7. 1. 1996, ed. by Walter Neuhauser (Innsbruck, 1995), pp. 21–46 (30). On p. 44, note 22 there is a reference to the inventory of the Putsch Library, deposited in: TLA, inv. no. 43/1.

51   Purš / Kuchařová 2015, II, here 1Theo 199.

52   Petr Mašek and Ivo Purš, 'Identifikace tisků z knihovny', in Purš / Kuchařová 2015, I, pp. 61–74 (73–74).

53   Hirn 1885, p. 354, Hirn 1888, p. 442.

Fig. 3. List of books purchased by Archduke Ferdinand II
from Georg Wilhelm Putsch (Innsbruck, Tiroler Landes-
archiv, Inv. No E 43/1)

pharmaceutical manual, which was published many times over under the title *Pharmacopeia seu medicamentarium pro Republica Augustana* (first edition 1564).[54] His writing made a significant contribution to the formation of a common range of medicaments and the standardisation of their composition and preparation.[55] Occo III was also a physician, but became famous mainly as a numismatist, as documented by his work entitled *Imperatorum romanorum numismata a Pompejo magno ad Heraclium. Additae sunt inscriptiones veteres, arcus triomphales* (Antwerp 1579), a printed catalogue of ancient Roman coins. The probable example from the Ambras library, which was preserved in the Österreichische Nationalbibliothek,[56] is interleaved with multiple inscriptions in the text and even on bound-in blank pages. It can be assumed that these are notes which were made according to the actual numismatic collection of Archduke Ferdinand II.[57]

Of the other authors active in the archduke's court we should mention Georg Rösch of Geroldshausen, who elaborated the Habsburg genealogy and made a concept of five volumes of representative album *Imagines gentis Austriacae* (Innsbruck 1569–1571), illustrated by Francesco Terzio (Fig. 4), and chancellor Leomann Schiller, who was known as a pedagogical writer and also published two theological books and

---

54  In the archduke's library it was there in duplicate, see Purš / Kuchařová 2015, II, 3Me 28 and 3Me 160.

55  See Josef Smolka, 'Artis medicinalis libri. Lékařská literatura', in Purš / Kuchařová 2015, I, pp. 145–180 (176). Unfortunately, in this text the two Adolph Occos, father (II) and son (III), were taken to be the same person.

56  Purš / Kuchařová 2015, II, 4Va 110; ÖNB, sign. 44 G 70.

57  Mašek / Purš 2015, p. 73.

essays.[58] Archduke Ferdinand II's interest in military history was reflected in the dedication of the *Enchiridion strategematicon* (Tegernsee 1577) by the Tyrolean knight Anselm Stöckel,[59] who later became a member of the archduke's court. Apart from the influence of the book mentioned above, Stöckel's acceptance at court may also have been helped by his friendship with Gerard van Roo.[60]

A very important part of the archduke's cultural circle, however, also consisted of authors who were not directly in his service, but dedicated their works to him and occasionally visited him at Ambras. Alfonso Ulloa was one such author, a fruitful writer and translator who gave Archduke Ferdinand II his biography of Ferdinand I and received 100 *Thaler*.[61] A dedicated copy of this edition entitled *Vita del potentissimo imperatore Ferdinando Primo*, printed in Venice in 1565, has been preserved in the Universitäts- und Landesbibliothek Tirol. The printed dedication is devoted to Maximilian II, but before the title page is a pre-bound page with a personal dedication to Archduke Ferdinand II written in golden lettering within a decorative gold frame: "Al serenissimo principe Ferdinando Arcidvca D'Avstria etc. Alfo[n]so Vlloa dona di propria mano."[62]

Apart from these and similar historiographic and biographical works, Archduke Ferdinand II also received dedications of works from authors writing about tournaments and festivities: the archduke was an important and enthusiastic organiser of such events. In 1566 the *Thurnier Buch* was dedicated to Archduke Ferdinand II by its publisher Sigmund Feyerabend; this was an extended edition of the original anthology by Georg Rüxner from 1530 with descriptions of 36 tournaments and festivities organised in Germany during the years 938–1487.[63] When Archduke Ferdinand II's court painter Sigmund Elsässer published a description of tournament festivities that the archduke had organised in 1580 in Innsbruck on the occasion of the wedding of Jan of Kolowraty, he dedicated the work to the archduke – *Warhaffte beschreibung vnd Abcontrafectung... in Ynsprugg... Thurnierplatz... gehalten* (Innsbruck 1580). Elsässer naturally also created a pictorial record of Archduke Ferdinand II's own wedding, entitled *Hochzeitkodex Erzhertzog Ferdinands II.* (1582),[64] which, however, apart from inscriptions identifying the individual actors in the gala parade, does not

---

58   Hirn 1885, p. 353.

59   Purš / Kuchařová 2015, II, here 5Co 691.

60   Veselá 2015, p. 439.

61   Hirn 1885, p. 354; Jaroslava Kašparová, 'Chronologická, geografická a jazyková provenience tisků a rukopisů', in Purš / Kuchařová 2015, I, pp. 405–428 (414).

62   Purš / Kuchařová 2015, II, here 4Va 330; in the library of the ULB sign. 214.556.

63   *Thurnierbuch: von Anfang, Ursachen, Ursprung und Herkommen der Thurnier im heyligen Roemischen Reich Teutscher Nation* (Frankfurt am Main, 1566). See Veronika Sandbichler and Alena Richterová, 'Literatura k festivitám', in Purš / Kuchařová 2015, I, pp. 361–374 (363).

64   On the literary and pictorial records of both weddings see Sandbichler / Richterová 2015, pp. 369–370; *Wir sind Helden: habsburgische Feste in der Renaissance*, ed. by Alfred Auer, Margot Rauch and Wilfried Seipel, exh. cat. (Vienna, 2005); on the Kolowrat wedding Elisabeth Scheicher, 'Ein Fest am Hofe Erzherzog Ferdinands II', *Jahrbuch des Kunsthistorischen Museums Wien* 77 (1981), pp. 119–154; on Archduke Ferdinand II's wedding in particular Veronika Sandbichler, 'Der Hochzeitkodex Erzherzog Ferdinands II.', *Jahrbuch des Kunsthistorischen Museums Wien* 6/7 (2004/2005), pp. 47–90.

contain any text (as is the case for several other albums of drawings, kept in the *Kunstkammer* rather than the library).[65] A further opportunity for a literary and also artistic description of festivities was the conferring of the Order of the Golden Fleece in Prague and in Landshut in 1585: Archduke Ferdinand II was the presiding knight under the authorisation of the King of Spain as the sovereign of the Order. The task of publishing the description of these festivities fell to the archduke's secretary Paul Zehentner of Zehentgrub, who did this in the work entitled *Ordenliche Beschreibung* [...] *den Orden deß Guldin Flüß, in disem 85. Jahr zu Prag und Landshut empfangen und angenommen* (Dillingen 1587). The book did not contain a direct dedication to the Archduke, but in its introduction we can read the celebratory verses of the Plzeň Jesuit Mikuláš Salius on the procession of Archduke Ferdinand II and his wife through Plzeň and the journey to Landshut on 13th June 1585.[66] A different description of the same celebration was written by Jacobus Vivarius under the title *Descriptio aurei velleris ad... Rodolphum II. Caesarem Max. serenissimos, Carolvm, & Ernestvm Austriae Archiduces, Dominos Clementissimos...* (Prague 1585).[67]

A description of the history and symbolism of the Golden Fleece entitled *Velleris aurei hieroglyphica* (Brescia 1589)[68] was dedicated to the archduke by the physician Giovanni Francesco Olmo (Ulmus); this book arrived in the archduke's library together with Ulmus's medical manuscript *De iis quae in medicina agunt ex totius substantiae proprietate.*[69]

Although Archduke Ferdinand II continued to show great interest in the Lands of the Bohemian Crown and their representatives throughout his rule in Tyrol, and was considered, within the framework of the Habsburg family, as their greatest connoisseur, books produced in the Lands of the Bohemian Crown only seem to have reached his library in quite miniscule amounts. We may consider it even more of a curiosity that the treatise by Racek Dubravius of Doubrava entitled *Vlastae Bohemicae historia* (Prague 1574) was actually found in the archduke's library in three copies.[70] Similarly exceptional was the Czech edition dedicated to Archduke Ferdinand II by Blažej Domin Jičínský, *Carmina Cžeská: Na Gméno a Tytul... Ferdynanda... Arcyknjžete rakouského*, published in Prague in 1588.[71] This did not appear in the estate inventory of the library, but it must be pointed out that the officials who compiled it were unfamiliar with the Czech language and did not pay much attention to any Czech titles, but were often satisfied to make a note such as "Ain behamisch Puech", and so on.

---

65   For details see especially *Natur und Kunst. Handschriften und Alben aus der Ambraser Sammlung Erzherzog Ferdinands II. (1529–1595)*, ed. by Alfred Auer and Eva Irblich, exh. cat. (Innsbruck, 1995).

66   Veselá 2015, p. 438.

67   Purš / Kuchařová 2015, II, here 4Va 342 a 4Va 777; Fejtová / Pešek 2015, p. 198.

68   Purš / Kuchařová 2015, II, here 4Va 579; Veselá 2015, p. 438.

69   Smolka 2015, p. 174; Purš / Kuchařová 2015, II, here 3Me 22.

70   Purš / Kuchařová 2015, II, here 4Va 136, 4Va 735 and 4Va 790.

71   *Knihopis českých a slovenských tisků od doby nejstarší až do konce XVIII. století*, ed. by Zdeněk Tobolka and František Horák, 9 vols. (Prague, 1939–1967), II : 3, č. 3563.

Fig. 4. Gaspare Oselli after Francesco Terzio, Archduke Ferdinand II, from Imagines gentis Austriacae, Innsbruck 1569–1571 (National Gallery Prague, inv. no. R 190113)

As far as concerns Tyrolean poetry production during the rule of Archduke Ferdinand II, a part was naturally also played by the humanists concentrated around Freiburg University, but we have no documentation concerning their relationship to the court.[72] Indeed, their role in the conservation of the literary heritage which Ferdinand acquired in 1576 from Wilhelm of Zimmern (1549–1594) was of far more fundamental importance for German literature than their own literary production. Zimmern gave this body of works to the archduke, on the archduke's own request, from the legacy of his uncle Wilhelm Werner. It comprised 69 partly illuminated manuscripts of literary and artistic significance, as well as 293 printed works.[73] The most important manuscript from this group was the *Ambraser Heldenbuch*, a set of twenty-five compositions of courtly, heroic and short poetry of Austro-Bavarian origin dating from the end of the 12th century and the 13th century, which were copied for the Emperor Maximilian I during the years 1504–1516 by the scribe Hans Ried. This is a unique set of German medieval poetic compositions, fourteen of which have been preserved only in this manuscript.[74]

At Archduke Ferdinand II's instigation, his own secretary Jakob Schrenck of Notzing also arranged for a copy to be made of the manuscript *Ehrenspiegel des Hauses Österreich*, a two-volume work which was prepared in 1555 for Johann Jakob Fugger. And last but not least, the archduke also ordered a richly decorated missal from Joris Hoefnagel (1542–1600), which Hoefnagel compiled and illuminated between 1581–1590 in Innsbruck and in Munich. It was intended for Archduke Ferdinand II's eldest son, Cardinal Andreas of Austria.[75]

Not only did Archduke Ferdinand II support literary activity, he also devoted himself to it marginally, which was exceptional for a provincial ruler of this period. He was the author of a moralist drama entitled *Eine schöne Comödie: speculum vitae humanae, auf deutsch ein Spiegel des menschlichen Lebens genannt*, which was published by Johan Pawer in Innsbruck in 1584. This was one of the first prose dramas composed in the German language, and was performed in June 1584 in Innsbruck at the christening of the archduke's daughter Marie.[76] The work compared various ways of life, at court and during war, as well as while travelling and in marriage, concerning which a noble youth consulted his estate master, secretary, *Hausmeister* and a hermit. The content of

---

72  See overview in Hirn 1885, pp. 340–341.

73  See Brigitte Mersich, 'Cod. 12.595', in Exh. Cat. Innsbruck 1995, pp. 52–54; Auer 2015, p. 47; Fejtová / Pešek 2015, p. 191. See also Heinrich Modern, 'Die Zimmern'schen Handschriften der k.k. Hofbibliothek', *JKSAK* 20 (1899), pp. 113–180 (116–117).

74  See Eva Irblich, 'Cod. Ser. n. 2663', in Exh. Cat. Innsbruck 1995, pp. 122–125; Vaculínová / Bažil 2015, pp. 299–301.

75  This exceptional work was preserved in the ÖNB, Cod. 1784; Auer (note 45), pp. 48–49; Andreas Fingernagel, 'Cod. 1784', in Exh. Cat. Innsbruck 1995, pp. 105–107; Thea Vignau-Wilberg, *Joris and Jacob Hoefnagel: Art and Science around 1600* (Berlin, 2017).

76  Martin Bažil, 'Dramatická díla', in Purš / Kuchařová 2015, I, pp. 329–344 (329). See *Speculum vitae humanae – Ein Drama von Erzherzog Ferdinand von Tirol, 1584. Nebst einer Einleitung in das Drama des 16. Jahrhunderts*, ed. by Jacob Minor (Halle an der Saale, 1889), p. XXXV; Alena Jakubcová and Martin Vaňáč, 'Ferdinand Tyrolský', in *Starší divadlo v českých zemích do konce 18. století: Osobnosti a díla*, ed. by Alena Jakubcová et al. (Prague 2007), pp. 166–167.

the play unfortunately brings nothing new as regards the intellectual background and range of opinion of the author – on the question of the selection of a bride, for instance, the young man is presented with the following variations: a hump-backed lame countess, a rich but probably infertile widow, a beautiful but proud young lady or, finally, a girl who was "not particularly beautiful", but god-fearing and modest from a good, honourable and fertile family.[77] The writing of plays was not completely exceptional at Archduke Ferdinand II's court, as demonstrated by one of his retinue, Benedikt Edelbeck, who dedicated a play in rhyme entitled "Von der freudenreichen Geburt unsers ainigen Trost und Heiland Jesu Christi" to his lord in 1568, and Georgius Lucius, who dedicated "eine schöne Tragödie von sechs streitbaren kämpfern" to the archduke in 1579, the subject of which was the battle of the Horatii and the Curiatii.[78]

## Medicine and Chemistry

Archduke Ferdinand II's relationship to the natural sciences was conditioned by three factors: the scientific trends of the time, in which he showed an obvious interest, his other hobbies, and last but not least, the requirements arising from his state of health. During the archduke's stay in Bohemia his interest in natural science was focused mainly on medicine, a fact undoubtedly due to the persons active at his court. His most important physician was certainly Pietro Andrea Mattioli (1501–1578) who, at the invitation of his father Ferdinand I, entered court service in Prague in 1555.[79] (Fig. 5) The Czech edition of Mattioli's *Commentarii in libros sex Pedacii Dioscoridis Anazarbei de materia medica* reworked as *Herbář* was of fundamental importance for cultural and scientific life in the Bohemian Lands, and its translation into Czech was entrusted to a further scholar from the circle of Archduke Ferdinand II and the Imperial Court, the physician and astronomer Tadeáš Hájek of Hájek (1526–1600).[80] For details concerning Mattioli's botanical interests and financing of the herbal I refer to the chapter by Katharina Seidl in this volume. A year later the German edition was published, translated by Mattioli's colleague, the archduke's future physician Georg Handsch (1529–1578).[81]

A further significant work published by Mattioli during his time in Bohemia was his medical correspondence, the *Epistolarum medicinalium libri quinque*,[82] published by Melantrich in 1561. This book comprises 85 letters, 58 of which are from Mattioli.

---

77    Hirn 1885, pp. 366–367.

78    Hirn 1885, pp. 367–368.

79    Korenjak / Schaffenrath / Subaric / Töchterle, pp. 359–360; Mirjam Bohatcová, 'Čtení na pomezí botaniky, fauny a medicíny. České tištěné herbáře 16. století', *Sborník Národního Muzea v Praze, řada C – Literární historie* 38 (1993), pp. 1–65 (3–4).

80    Concerning Hájek's relationship to the court, in the court lists he was mentioned as a physician who was in charge of the servants. See Josef Smolka, 'Postavení Tadeáše Hájka jako lékaře na císařském dvoře', *Acta Universitatis Carolinae – Historia Universitatis Carolinae Pragensis* 48, 2 (2008), pp. 11–32 (25–27); Bohatcová 1993, p. 34.

81    Miroslava Hejnová, *Pietro Andrea Mattioli 1501–1578*, exh. cat. (Prague, 2001), pp. 14–17.

82    Purš / Kuchařová 2015, II, 3Me 142.

Fig. 5. Pietro Andrea Mattioli, Commentarii in Libros sex Pedacii Dioscorides, Venice 1554, from the Archduke's library at Ambras Castle (Vienna, Österreichische Nationalbibliothek, Department of Manuscripts and Rare Books, sign. 69.P.32)

In the dedication to Archduke Ferdinand II Mattioli expressly states that a number of these letters were written at the archduke's court and under his patronage.[83] Mattioli also took an active interest in iatrochemical medicine, as documented not only in the final chapters of his key work *Commentarii in libros sex ... de materia medica* (in which the information about these medicines is accompanied by woodcuts of the most varied types of distillation ovens), but also in the *Epistolarum*.[84]

Another important physician from the circle of the Habsburg court during Archduke Ferdinand II's governorship in Bohemia was Giulio Alessandrini (1506–1590) from Trento, who was appointed as the personal physician of Ferdinand I in 1556, and was subsequently also active in the service of the two following Emperors, Maximilian II and Rudolf II. We know of fifteen medical works by Alessandrini, texts dealing in particular with translations and elaboration of the works of Galen. Due to the fact that Alessandrini was an outstanding scholar of Greek, he is designated as one of the leading revivalists of Greek medicine.[85] He also dealt with philosophy and cooperated with Mattioli.[86] Andrea

---

83   Hejnová 2001, p. 30.

84   Although the publication appeared before the revival of interest in Paracelsus, Mattioli approved the application of some chemical medicaments and included a letter from a young physician from Prague, Andreas of Plauen, on different methods of preparing potable gold in his *Epistolae*. For detail see Lynn Thorndyke, *A History of Magic and Experimental Science*, 8 vols. (New York, 1923–1958), VI, p. 224.

85   Hirn 1885, p. 362. Korenjak / Schaffenrath / Subaric / Töchterle 2012, I, p. 363; Vittorino Fellin, 'La figura di Giulio Alessandrini', in *Giulio Alessandrini, personaggio illustre del Cinquecento tridentino, Atti del convegno, Civezzano 12 Settembre 1997* (Formace and Pergine, 2000), pp. 7–17.

86   See *Consilium medicum*, ÖNB, Cod. 11155, fol. 27r–35r. Cit. Korenjak / Schaffenrath / Subaric / Töchterle 2012, I, p. 362.

Gallo also came from Trento, and was the personal physician in Prague to both Ferdinand I and Archduke Ferdinand II. For several years he was assisted by Georg Handsch.[87] We might also mention Dr Francesco Partini from Roveredo, who was originally the personal physician to the Cardinal of Trento, Cristoforo Madruzzo.[88] We know of Archduke Ferdinand II's health problems during his governorship in Prague through the so-called *consilia*, physician's recommendations which were published in extensive compendia.[89] In the archduke's case, for instance, these *consilia* were written in 1549 by Franciscus Emericus, or by Renato Brassavola whose recommendations date from 1554.[90]

When Archduke Ferdinand II took power in Tyrol there developed, not only there but also in the other Austrian lands, a hitherto unprecedented interest in investigation of nature through expeditions into the mountains. This was connected with the increased interest in botany and also followed on from the traditional investigation of locations with a view to finding new mining opportunities. A significant moment, for instance, was the ascent of Ötscher by Reichard Strein of Schwarzenau with an entourage, which was documented in a written description, as well as through depictions. Archduke Ferdinand II's courtier, Sir Jakob Boymont of Payersberg, repeatedly ascended the Laugenspitz in South Tyrol with his family, and Doctor Ippolito Guarinoni also undertook a significant mountain tour in the vicinity of Innsbruck. The archduke himself made the ascent of an unnamed mountain peak close to Ambras twice, where he had his name and those of his guides cut into the peak.[91]

In Tyrol Mattioli continued in the medical service of the archduke, and at this time he published two further medical works, the *Opusculum de simplicium medicamentorum facultatibus* (Venice 1569) and the *Compendium de plantis omnibus* (Venice 1571). Another important figure was the aforementioned physician Georg Handsch,[92] who was active in Tyrol from 1568 to 1575, when he returned at his own request to his native Česká Lípa. He offered to sell Archduke Ferdinand II his library and manuscripts for the sum of 100 guilders, although they were allegedly worth twice as much:[93] thanks to this his manuscripts and printed works were preserved in the collections of the Österreichische Nationalbibliothek and the Universitäts- und Landesbibliothek

87    Smolka 2015, p. 160.

88    Hirn 1885, p. 362.

89    See Bohdana Buršíková, 'Sbírka konsilií císařského lékaře Christophora Guarinoniho', *Dějiny věd a techniky* 34:1 (2001), pp. 22–38; Bohdana Buršíková, 'Dobré rady pro zdraví'. Lékařská konsilia rudolfínské doby', *Dějiny a současnost* 23:1 (2004), pp. 15–18.

90    Korenjak / Schaffenrath / Subaric / Töchterle 2012, I, p. 362; rukopis Emericus ÖNB, Cod. 11207, fol. 38rv; Brassavola ÖNB, Cod. 11155, fol. 1v–24v.

91    Hirn 1885, p. 361.

92    Hejnic / Martínek 1966, II, pp. 255–259; Smolka / Vaculínová 2010, pp. 1–26; Vaculínová / Bažil 2015, p. 323; Leopold Senfelder, *Georg Handsch von Limus. Lebensbild eines Arztes aus dem XVI. Jahrhundert, Sonderabdruck aus Wiener klin. Rundschau* (Vienna, 1901), pp. 28–30.

93    Hirn 1885, p. 363; Hirn 1888, p. 440.

Fig. 6. Hieronymus Fracastorius, De sympathia et antipathia liber unus, Venetiis 1546 (Vienna, Österreichische Nationalbibliothek, Department of Manuscripts and Rare Books, sign. 69.E.16)

Fig. 7. Hieronymus Fracastorius, De sympathia et antipathia liber unus, Venetiis 1546, front pastedown of a book with a proprietary signature of Georg Handsch (Vienna, Österreichische Nationalbibliothek, Department of Manuscripts and Rare Books, sign. 69.E.16)

Tirol.[94] (Fig. 6, Fig. 7, Fig. 8) Handsch's manuscripts were noted by the imperial librarian Peter Lambeck on the occasion of the transport of the Ambras manuscripts and books to Vienna in 1665, when he registered twelve volumes as formerly belonging to Handsch.[95] In the analysis of the archduke's library we also find a record of the manuscript of Handsch's *Proverbs*,[96] but there is uncertainty concerning the identification of Handsch's extensive zoological manuscripts.[97]

The most important of all of these manuscripts, in which Handsch deals with the health and treatment of the archduke's family, is the *Diarium medicum de archiduce*

---

94  Of the editions owned by Handsch it was only possible to find two medical books with his inscription, see Purš / Kuchařová 2015, II, here 3Me 111 a 3Me 124. For an overview of all Handsch's manuscripts preserved in the ÖNB see Hejnic / Martínek 1966, II, p. 256.

95  Petrus Lambeck, *Commentariorum de Augustissima Bibliotheca Caesarea Vindobonensi*, libri II, Vindobonae (1665–1679), pp. 836—840 and 984.

96  Purš / Kuchařová 2015, II, 5Co 1011 – ÖNB, Cod. 9671.

97  Petr / Richterová 2015, pp. 102 –103; Purš / Kuchařová 2015, II, here 5Co 109 – ÖNB, perhaps Cod. 11130, Cod. 11140—11143, Cod. 11153. On these manuscripts see Madelon Simons, '"Unicornu in membrana elegantissime depictum": Some Thoughts about the Activities of Archduke Ferdinand II in Prague, 1547–1567', *Studia Rudolphina* 7 (2007), pp. 34–43.

Fig. 8. Hieronymus Fracastorius, De sympathia et antipathia liber unus, Venetiis 1546, fol. 66v-67r, doublepage with the inscriptions of Georg Handsch (Vienna, Österreichische Nationalbibliothek, Department of Manuscripts and Rare Books, sign. 69.E.16)

*Ferdinando Tirolensi eiusdem coniuge Philippina Welser et Andrea et Carolo filiis.*[98] Like some of Handsch's other writing, this manuscript contains not only medical information, but also many comments on court life during this period at Ambras.[99] Handsch's interest in court life was undoubtedly linked to the 'renaissance' scope of his interests: he had in fact been writing poetry from his student years onwards.[100] Handsch's poetry is discussed in detail in the article by Lucie Storchová in this volume.

Information concerning the archduke's state of health does not only appear in Handsch's writings, but also in the anonymous manuscript *De praeservatione a calculo et arenulis consilium medicum principi cuidam, ut videtur Austriae archiduci Tirolensi.*[101] A further exceptional example of such medical 'counsels' is the manuscript by Hieronymus Brissian (or Brescian), *Geraeologia ad Ferdinandum archiducem Austriae* (Trento 1585). Gereology was meant to discuss the health problems of the elderly, which corresponds to the fact that Archduke Ferdinand II was 56 years old when this work was published.[102]

---

98   Preserved in the ÖNB, Cod. 11204; Korenjak / Schaffenrath / Subaric / Töchterle 2012, I, p. 364.

99   Rudolf Wolkan, *Geschichte der deutschen Literatur in Böhmen und in den Sudetenländern* (Augsburg, 1925).

100  See Hejnic / Martínek 1966, II, pp. 256–257; Vaculínová / Bažil 2015, p. 324.

101  ÖNB, Cod. 11083, cf. Korenjak / Schaffenrath / Subaric / Töchterle 2012, p. 368.

102  Smolka 2015, 154–155; Purš / Kuchařová 2015, II, here 3Me 45.

In the account of medical interests associated with the archduke's court we must not omit the interest in spa treatment, which was very popular with both the archduke and his first wife Philippine Welser. Several prints and manuscripts on this theme were identified in the archduke's library, and Georg Handsch also mentions the use of spas in his medical diaries.[103] Indeed, in 1584 Antonio Maria Venusti published the small work *Balneorum Burmiensium descriptio, natura et virtus* directly in Innbruck, the subject of which was the well-known spa in *Bormi*o. The recipient of the dedication in this small volume was Adamus Gallus Popellius, chamberlain of Archduke Ferdinand II.[104]

Although the topic is usually passed over in older literature,[105] Archduke Ferdinand II was also interested in the medical trend outlined in the ground-breaking work of Theophrastus Paracelsus (1493–1541).[106] This was undoubtedly also connected to the fact that the archduke had both an intellectual and practical interest in alchemy.[107] He was in contact with important Paracelsians and was instrumental in the publication of the writings of Paracelsus: In 1563 the archduke was requested to ask the municipal council in Klagenfurt (Kärnten) about the fate of the *"Schrifften und Büechern"* (texts and books), which Paracelsus had allegedly left in that town. The copies of the original texts sent to the archduke (*Defensiones, Labyrinthus medicorum, Von dem tartarischen Krankheiten*) were passed on by him to the doctor Theodor Byrckmann, who published them in Cologne.[108]

In this connection it is logical that several distinguished Paracelsian editors and publishers turned to the archduke with dedications. In first place we should mention the alchemist, astrologist and Paracelsian physician Leonhard Thurneisser of Thurn,[109] who worked as a metallurgist in the archduke's service in Tyrol during the years 1563–1566.[110] It is highly probable that entering the service of the archduke was made easier

103  Smolka 2015, pp. 170–171.

104  Korenjak / Schaffenrath / Subaric / Töchterle 2012, p. 370.

105  An exception is Hirn, who recalls this activity of the archduke. See Hirn 1885, pp. 363–366.

106  The basic study on this theme is still Walter Pagel, *Paracelsus: an introduction to philosophical medicine in the era of the Renaissance* (Basel, Munich, Paris, London, New York, Tokyo and Sydney, 1982).

107  For details on this see Ivo Purš, 'Das Interesse Erzherzog Ferdinands II. an Alchemie und Bergbau und seine Widerspiegelung in seiner Bibliothek', *Studia Rudolphina* 7 (2007), pp. 75–109; Ivo Purš, 'The Habsburgs on the Bohemian Throne and Their Interest in Alchemy and the Occult Sciences', in *Alchemy and Rudolf II. Exploring the Secrets of Nature in Central Europe in the 16th and 17th centuries*, ed. by Ivo Purš and Vladimír Karpenko (Prague, 2016), pp. 106–128.

108  See Paracelsus, *Kärntner Schriften*, ed. Kurt Goldammer (Klagenfurt, 1955) p. 302. The copy of Archduke Ferdinand II's letter dated 20th August 1563 and the reply from the municipal council dated 22nd of October 1563 are to be found in the Tiroler Landesarchiv, Kunstsachen I, 786, fol. 1–3.

109  On the life of Thurneisser see Paul H. Boerlin, *Leonhard Thurneysser als Auftraggeber. Kunst im Dienste der Selbstdarstellung zwischen Humanismus und Barock* (Basel and Stuttgart, 1976), pp. 11–30.

110  Hugo Neugebauer, 'Alchymisten in Tirol', in *Volkskundliches aus Österreich und Südtirol: Hermann Wopfher zum 70. Geburtstag dargebracht*, ed. by Anton Dörrer and Leopold Schmidt (Vienna 1947), pp. 181–203 (182).

for Thurneisser by his previous contacts with Ferdinand I. Apart from work on the improvement of furnaces in the Tyrol, he made a number of journeys on the orders of the archduke during the years 1560–1565, which took him as far as the Orkneys, North Africa, and the Near East. In the course of his travels he collected findings from the fields of montanistics, alchemy and medicine, but it was Paracelsian medicine that interested him most. The turning-point in Thurneisser's career came in 1571, when he was appointed personal physician to the Brandenburg Elector Johann Georg (1525–1598).[111] In his work *Archidoxa, Darin der recht war Motus, Lauff und Gang, auch heimligkeit, Wirckung und Krafft, der Planeten...*, which Thurneisser first published in 1569 in Münster, he printed an extensive dedication to Archduke Ferdinand II. As he states here, he wrote this work during his travels.

A further work dedicated to Archduke Ferdinand II comprised a set of five Paracelsian medical treatises dealing with the medicinal properties of plants, metals and minerals, published by Michael Toxites under the title *Ettliche Tractatus Des hocherfarnen unnd berümbtesten Philippi Theophrasti, der waren Philosophi und Artzney Doctoris* in Strasbourg in 1570. In the dedication Toxites emphasises that the book is intended to benefit not only physicians, but also rulers, who also succumb to severe illnesses that the Galenist physicians often cannot treat effectively. The other reason behind the work's dedication to Archduke Ferdinand II is that Toxites was born in Tyrol and wanted to look for various medicinal substances in the Austrian lands, more precisely the medicinal clays known as *bolus armenus* and *terra sigillata*. At the close of the dedication he emphasised that the archduke not only took pleasure in medicine, but also supported it with great effort and expense as could be seen from the "*opera Mattioli*".

Two years later Archduke Ferdinand II was honoured by a dedication from the 'head of the Theophrastists', Adam of Bodenstein. The dedication was printed in the Paracelsian *Metamorphoses* published in Basle in 1572. This consisted of five treatises devoted to alchemy (*Von natürlichen Dingen, Manual von Stein der Weisen, Alchimia, Tinctura physica, Büchlin belangend lapidem*). In the dedication Bodenstein describes Paracelsus as Elias Artista, a specifically Paracelsian image, influenced by Chiliasm, of a prophet who will arrive shortly before the Last Judgment and reveal alchemical secrets. In the second part the dedication Bodenstein defends Paracelsian medicine against its opponents. It refers, for instance, to the preparation of the medicaments (arcana), in purely alchemical terminology – and also addresses the archduke as someone who understands even theoretical questions of Paracelsian alchemy.

The most extensive dedication of a Paracelsian work to Archduke Ferdinand II was written and published by one of the most significant Paracelsians of the time, Gerhard Dorn (1535 – after 1584), who became famous partly as the editor of Paracelsus, but primarily as his erudite translator into Latin. The dedication belongs to the book *Commentarium in Archidoxorum libros decem D. Theophrasti Paracelsi*, published in

---

111  Wolf-Dieter Müller-Jahncke, 'Thurneisser', in *Alchemie. Lexikon einer hermetischen Wissenschaft*, ed. by Claus Priesner and Karin Figala (Munich, 1998), pp. 360–361.

Frankfurt am Main in 1584. Dorn was, in addition, the author of an extensive work that takes up 400 pages in the first part of the collection of alchemical texts contained in Lazarus Zetzner's *Theatrum chemicum* (Strasbourg, 1603). Dorn was an early protagonist of mystical and theosophical oriented alchemy and prepared the way for such authors as Heinrich Khunrath and Jakob Böhme.[112] The *Commentarium* is a Latin translation of two of Paracelsus' writings: *Archidoxa* and *Philosophia Magna*, which Dorn provided with a commentary. The dedication to Archduke Ferdinand II is quite remarkable, as it does not solely comprise the obligatory praising of the virtues of the addressee, but is rather a specialised, theoretical and polemical introduction to the problems of the Paracelsian alchemy.

Dorn, apart from the obligatory request for support, attached an *Epistola censorial* to the dedication, intended for the archduke's physician Johann Willebroch. Here, Dorn promises that he will improve his book in its next edition according to Willebroch's suggestions.[113] We know only very little about Willebroch's medical treatments, but from the report on the procedure he used to treat burns caused by fireworks at the solstice celebration in Achenthal it appears that, as opposed to the traditional Galenist treatment by means of the opposite effect – *contraria contrariis curantur* – he preferred the principle *similia similibus*, in other words the treatment of similar with similar, which was a typical Paracelsian concept.[114]

There is one last figure interested in Paracelsus who was in close contact with Archduke Ferdinand II, as well as with Mattioli, Willebroch and Handsch: the humanist poet and physician Vavřinec Špán of Špánov (1531–1575), who dedicated a poetic description of the Star Summer Palace to the archduke in his youth.[115] There are more details about Špán in the text by Marta Vaculínová in this volume.

At the close of this overview of the scientific and literary activities linked to various extents with the influence of Archduke Ferdinand II in Bohemia and in Tyrol, we should also mention the astrological forecasts prepared for the archduke by two important astronomers and astrologists, the imperial mathematician and physician Paul Fabricius (1529–1588), and the no less significant contemporary astronomer Cyprianus Leovicius (1529–1574). Their works are included in a bundle of manuscripts deposited in the Innsbruck Ferdinandeum.[116] A calendar drawn up by Paul Fabricius is also preserved in the Österreichische Nationalbibliothek, as well as a

112  Didier Kahn, 'Dorn, Gerhard', in Priesner / Figala 1998, pp. 112–114.

113  The dedications to Ferdinand and Willebroch are analysed in *Corpus Paracelsisticum. Studien und Dokumente zur deutschen Literatur und Kultur im europäischen Kontext*, II: *Der Frühparacelsismus*, ed. by Wilhelm Kühlmann and Joachim Telle (Tübingen, 2004), pp. 916–947.

114  Senfelder 1901, p. 22.

115  ÖNB, Cod. 9902; on the summer palace and its description see Ivan P. Muchka, Ivo Purš, Sylva Dobalová and Jaroslava Hausenblasová, *The Star. Archduke Ferdinand II of Austria and His Summer Palace in Prague* (Prague, 2017); on Špan's Paracelsian tendencies see especially Kühlmann / Telle 2004, pp. 562–563.

116  Tiroler Landesmuseum Ferdinandeum, FB 32089, 1. [1]r–[14]v; 2. 16v– [51]r. Korenjak / Schaffenrath / Subaric / Töchterle 2012, I, p. 358; *Die Entdeckung der Natur. Naturalien in den Kunstkammern des 16. und 17. Jahrhunderts*, ed. by Wilfried Seipel, exh. cat. (Innsbruck, 2006), pp. 229–230.

prophecy for the year 1590 written by the hand of Daniel Meltzer.[117] These works were linked to the tradition of astrological forecasts, which were prepared on the orders of other members of the Habsburg family, including the archduke's father Ferdinand I.[118] This was therefore in no way an exceptional display of interest in this topic and as Josef Smolka stated in the analysis of the astronomical and astrological literature contained in Archduke Ferdinand II's library at Ambras Castle, it is impossible to determine whether the archduke was more deeply interested in this sphere from the contents of the library alone.[119]

---

117  ÖNB, Ser. Nova 2635, the manuscript was originally deposited in the Ambras *Kunstkammer/ Wunderkammer*. Eva Irblich, 'Cod. Ser. n. 2635', in Exh. Cat. Innsbruck 1995, pp. 113–115; see Petr / Richterová 2015, p. 104; Purš / Kuchařová 2015, II, here 6Kk 123.

118  Emperor Ferdinand I had Joseph Grünpeck calculate a horoscope for his first-born son, the future Maximilian II, see manuscript in the ÖNB, Cod. 8459. In connection with the conflict with the Turks he asked the astrologist Luca Gaurico (1475 –1558) in 1532 for a horoscope for the next three years. See Wilhelm Knappich, *Histoire de l'astrologie* (Paris, 1986), pp. 208–210; Rumen K. Kolev, *1532. Three Annual Horoscopes for Ferdinanda I, King of the Romans, Archduce of Austria, translated for the fisrt time from the Manuscript Codex Vindobonensis Palatinus 7433* (Varna, 2012).

119  Astronomical literature in the Ambras library was not arranged systematically and shows gaps; it lacks Copernican literature and more literature on the Nova of 1572; more literature on the calendar reform would also be expected, and nowhere do we find mention of quadrants or sextants. Of the greater figures, for instance, the works of Tycho Brahe are completely lacking, as are those of Kepler's teacher Michael Maestlin. See Josef Smolka, Cosmographici, Geographici, Geometrici, Mathematici, Philosophici, Astronomici, Astrologici, Militaris rei, Architecturae, Humanarum Literarum, alteriusque generis libri. Filosofie, matematika, fyzika, astronomie, astrologie, kosmografie, geografie, zemědělství, zoologie, botanika, in Purš / Kuchařová, 2015, I, pp. 217–278. Concerning literature on the Nova of 1572, in the library there was a single document on this by Bartholomeus Reisacher entitled *De mirabili Novae ac splendidis Stellae, Mense Novembri anni 1572, primum conspectae* (Vienna, 1573), which contains a printed dedication to Rudolf II. This example, which was preserved in the Innsbruck University Library (ULB 210.746) after its removal from the Ambras library also has a highly exceptional personal dedication to Archduke Ferdinand II, which is embossed in relief on white pigskin on the front board. Idem, pp. 255–256. See Purš / Kuchařová 2015, II, here 5Co 1153.

Lucie Storchová

# Humanist occasional poetry and strategies for acquiring patronage: The case of a court physician Georg Handsch

This article will deal with the ways in which Georg Handsch/Handschius (1529–1578), a court physician serving under Archduke Ferdinand II, communicated with his patrons and other intellectuals of his time.[1]

Handsch is mostly known to modern scholars for his translation of Pietro Andrea Mattioli's herbal into German, but he was also the author of numerous works in Latin which were largely influenced by his interest in medicine and natural philosophy. He produced fascinating books of remedies as well as medical journals in which he described his sensory experiences, observations, and the ways in which he treated the archduke's family and other patients.[2] In this article, I would like to discuss one of his seemingly less important intellectual activities, which has been almost completely overlooked in previous research – Handsch's occasional poetry, which has never been published in its entirety.

## Handsch's life and work

We are relatively well informed about Handsch's personal life and professional career, and this is also partly due to the information contained in his occasional poems. Born into a German speaking patrician family from Leipa (today Česká Lípa),[3] Handsch

---

1    The article is the outcome of a Czech Science Foundation project, grant no. 16-09064S: *Podoby humanismu v literatuře českých zemí (1469–1622)* [Forms of Humanism in the Literature of Bohemian Lands, 1469–1622], implemented at the Institute of Philosophy of the Czech Academy of Sciences.

2    For a general overview of his works see *Rukověť humanistického básnictví v Čechách a na Moravě*, ed. by Josef Hejnic and Jan Martínek, II (Prague, 1966), pp. 256–259. For a new concise study on his biography and work see *Companion to Central and Eastern European Humanism: The Czech Lands*, I, ed. by Lucie Storchová (Berlin and Boston, 2020), pp. 512–522. Handsch's medical manuscripts have been just recently brought into the focus of the history of medicine by Michael Stolberg and Lukas Oberrauch. Lukas Oberrauch, 'Medizin', in *Tyrolis Latina. Geschichte der lateinischen Literatur in Tirol, I: Von den Anfängen bis zur Gründung der Universität Innsbruck*, ed. by Martin Korenjak, Florian Schaffenrath, Lav Subaric and Karlheinz Töchterle (Vienna, Cologne and Weimar, 2012), pp. 364–367; Michael Stolberg, 'Empiricism in Sixteenth-Century Medical Practice: The notebooks of Georg Handsch', in *Early Science and Medicine* 18:6 (2013), pp. 487–516; Michael Stolberg, 'Kommunikative Praktiken. Ärztliche Wissensvermittlung am Krankenbett im 16. Jahrhundert', in *Praktiken der Frühen Neuzeit. Akteure – Handlungen – Artefakte,* ed. by Arndt Brendecke (Cologne, Weimar and Vienna, 2015), pp. 111–121; Michael Stolberg, 'Medical Note-Taking in the Sixteenth and Seventeenth Centuries', in *Forgetting Machines: Knowledge Management Evolution in Early Modern Europe*, ed by Alberto Cevolini (Leiden and Boston, 2016), pp. 243–264. Handsch held several notebooks which he used as an aid for writing new texts, both in Latin and Greek, see Lucie Storchová, „*Paupertate styloque connecti*". *Utváření humanistické učenecké komunity v českých zemích* (Prague, 2011), pp. 97–100.

3    Josef Smolka and Marta Vaculínová, 'Renesanční lékař Georg Handsch (1529–1578)', *Dějiny vědy a techniky* 43 (2010), pp. 1–26 (25–26).

studied at a gymnasium in Goldberg, which at that time was led by the famous humanist pedagogue Valentin Trotzendorf. In 1544 Handsch left for Prague, where he started taking private lessons with the university professor Jan Šentygar/Schentygarus. He became an auxiliary teacher in the private school of Matouš Collinus, who later introduced him to Jan Hodějovský the Elder of Hodějov, one of the period's most active Bohemian patrons.[4] Handsch decided to specialize in medicine, and began to work for the Prague physician Oldřich Lehner of Kouba. In 1549 he became an assistant to the court physician Andrea Gallo from Trento. Together, they treated well-off burghers and aristocratic families, sometimes also based outside of Prague (for example, Handsch stayed for a longer period of time with the Ungnad family in Hluboká).[5] In 1550, Handsch accompanied the young noble Karel of Dietrichstein to Italy. They visited Venice, Padua (where, besides medicine, Handsch also studied botany)[6], and Ferrara where he pursued his doctoral degree in medicine in 1553. After that they stayed for some time in Trento and returned to Prague in autumn 1553.

Upon his return, Handsch worked briefly as an assistant to Andrea Gallo, and once again as a teacher in Collinus's school. Between 1555 and 1558 he established new contacts by writing occasional poetry. He was above all in contact with Jan Hodějovský the Elder of Hodějov, who commissioned several encomiastic works from him. Hodějovský also helped him to get a title of nobility. Handsch travelled together with several other humanist poets (Matthaeus Collinus, Tomáš Mitis, and Prokop Lupáč/Lupacius) to Hodějovský's dominion in Řepice, southern Bohemia, in May 1557. Handsch even spent several months in Řepice editing four volumes of Latin occasional poetry by various authors (including a few works by Handsch himself) that had been sent to Hodějovský previously: these appeared as the *Farragines poematum* in 1561–62.[7]

Having opened his own medical practice in Prague in 1558, Handsch sought stronger ties to the archduke's court. He cooperated with Pietro Andrea Mattioli from spring 1561 onwards.[8] He assisted him in his medical practice and work on the German translation of his herbal, which appeared under the title *New Kreuterbuch mit den allerschönsten vnd artlichsten Figuren aller Gewechsz* in Prague 1563. Handsch became the court physician to Archduke Ferdinand II after Mattioli left the position. He settled down in Innsbruck in 1567 and commuted to Ambras Castle each day. Besides his treatment of the archduke's family, which he described in the aforementioned medical diaries, Handsch wrote the *Historia naturalis* in five volumes, supported by the archduke. He left the archduke's service and returned to his native town

---

4    For a basic overview on Hodějovský's literary circle and previous research concerning this topic, cf. Lucie Storchová, *Bohemian School Humanism and its Editorial Practices (ca. 1550–1610)* (Turnhout, 2014), 40–43.

5    Smolka / Vaculínová 2010, p. 7.

6    Smolka / Vaculínová 2010, pp. 7–8.

7    Storchová 2011, p. 149.

8    Handsch's letter from the 26th of April 1561, in which he asked for Mattioli's patronage, has recently been edited and translated into Czech (see Smolka / Vaculínová 2010, pp. 25–6)

of Leippa in 1575, but he very probably planned to return soon to Innsbruck.[9] During his stay in Leipa, however, Handsch fell ill and died in February 1578.

## Handsch and his Latin poetry

Neo-Latin occasional poems were the most frequent type of Neo-Latin literature in the Bohemian Lands from the 1550s onwards.[10] Writing poems was a widely shared literary practice there, necessary for everyday scholarly communication. Poetry was considered a learned and teachable practice – "a practical accomplishment rather than an inspired act", as Kristian Jensen put it.[11] The relatively stable system of minor poetic genres corresponded to particular social events like weddings or burrials, the birth of a child, attainment of particular burocratic functions and so on. Epicedia (dirges or elegies) and especially epithalamia (poetic celebrations of weddings) belonged to the most popular genres of poetry in the Bohemian Lands at that time. Humanist poets of Handsch's generation often employed figures likes anagrams using the letters of a person's name, acrostics and telestichs forming the name of a benefactor, or chronostichs forming dates. Occasional poetry functioned predominantly as a 'calculated' literary product, a means by which humanist poets demonstrated their mastery of style and expanded their scholarly networks. In this respect, the case of Georg Handsch provides us with unexpected potential for a comparative study of this kind of poetry.

Though he was certainly not one of the pre-eminent Neo-Latin poets of his time, Handsch wrote hundreds of occasional poems for his patrons and learned friends. This paper will concentrate on the works preserved in his huge manuscript volume entitled *ΡΑΠΣΩΔΗΑΙ SIVE EPIGRAMMATA* (or *Handschii Poemata et Miscellanea* as the cover reads). It contains more than 321 folios pages of occasional poems with many marginal comments,[12] cross references, and ammendments concerning metrics, style, and vocabulary. Handsch kept this notebook for most of his lifetime, and left it in Innsbruck together with another 28 manuscripts before he went back to Bohemia; it was considered as a precious collection and housed in the Ambras library until 1665, when it was transferred to the Imperial library in Vienna (it is currently held in the Österreichische Nationalbibliothek, Vienna, Cod. 9821). Only a very small number of the verses included in Handsch's volume appeared as reworked versions in the *Farragines poematum*.[13]

---

9   Jaroslav Panáček, 'Testament Georga Handsche z roku 1578', *Bezděz: vlastivědný sborník Českolipska* 22 (2013), pp. 367–384 (356).

10   For basic information on social functions of humanist occasional poetry in the Bohemian Lands, cf. Storchová 2014, pp. 35–40.

11   Kristian Jensen, 'The Humanist Reform of Latin and Latin Teaching', in *The Cambridge Companion to Renaissance Humanism*, ed. by Jill Kraye (Cambridge, 1996), p. 74.

12   According to Jan Martínek, it was Handsch's teacher Collinus who commented upon his poems in the margins of the manuscript, see Jan Martínek, 'Dvě díla M. Matouše Collina', *Listy filologické* 82:1 (1959), pp. 111–121 (115).

13   For their list see Hejnic / Martínek 1966, II, p. 256.

Fig. 1. Handschii Poemata et Miscellanea, title page (Vienna, Österreichische Nationalbibliothek, Department of Manuscripts and Rare Books, sign. Cod. 9821)

Handsch was able to write in various metrical units (beside hexametres and elegiac couplets, there were also Asclepiad verses, Sapphic stanzas etc.), and he also wrote epigrams, tautograms, chronostichs and even visual, so-called figure poems.[14] Previous Czech researchers have referred Handsch's poetry as trivial, "because of its low literary quality and a lack of significant topics".[15] Handsch himself would have been of the opposite opinion: he considered his occasional poems as "epistolae poeticae", that is, a part of his learned correpondence.[16] In other words, this poetry was a tool used to acquire patronage and establish scholarly contacts, both of which were crucial in promoting his career as a physician. The volume of occasional poetry can therefore give us a highly valuable insight into how Handsch expanded his scholarly networks over his lifetime. The main research question proposed here is whether or not Handsch used different styles for approaching different groups of patrons and scholars. If so, how did his style and

---

14   Josef Hejnic, Zu den Anfängen der humanistischen Figuralpoesie in Böhmen, *Listy filologické* 111:2 (1988), pp. 95–102; Julie Nováková also appreciated the quality of his versified cisioan, which appeared for the first time as a part of Collinus's textbook *Elementarius libellus in lingua Latina et Boiemica pro novellis scholasticis* in 1550; see Julie Nováková, Rytmické kalendárium Jiřího Handsche, *Listy filologické* 89 (1966), pp. 315–320 (319).

15   Hejnic / Martínek 1966, II, p. 257; Jan Martínek, *Jan Hodějovský a jeho literární okruh* (Prague, 2012), p. 315.

16   One of his manuscript volumes (ÖNB, Cod. 9650) contains a selection of Handsch's letters in prose dated from 1545 to 1562 that he probably also hoped to publish (see Michael Stolberg, *The Many Uses of Writing: A Polygraph Physician in Sixteenth-Century Prague,* forthcoming). I would like to thank Prof. Stolberg for sharing a draft of his forthcoming study. For the list of these letters and their abstracts see the database *Frühneuzeitliche Ärztebriefe des deutschsprachigen Raums (1500–1700),* http://www.aerztebriefe.de. Handsch sent some prose letters to the same addresses as his poetic ones, and they often dealt with similar topics.

rhetorical strategies change over time? Last but not least, did he fashion himself in different ways to achieve his aims?

## 1544–1550: School years and the first period in Prague

Handsch started writing occasional poetry during his studies at the town school in Goldberg, and during his early years in Prague. His poems from this period mostly display intertextual relationships with Virgil's work, and illustrate how poetry writing was taught at Lutheran town schools and universities. These poems were mostly school exercises, and often deal with Luther and confessional issues. Handsch most often

Fig. 2. Handschii Poemata et Miscellanea (Vienna, Österreichische Nationalbibliothek, Department of Manuscripts and Rare Books, sign. Cod. 9821, fol. 72v)

used topics from ancient mythology, and ancient fables with moralizing interpretations for these poems (for example, the *Fabula de Orpheo*, *Gygantomachia*, and the *De Circe* saga, as well as several of Aesop's fables and similar works). He learned how to write a poetic summary of the 18th book of the *Iliad*, as well as prayers, adaptations of the Psalms, and the Old and New Testamental stories. He probably wrote his first poem at the end of 1546, a piece about the nativity of Jesus (*Saphicum de natali Domini nostri*)[17] which belonged to the most common poetic topics among former students of Lutheran schools: such pieces were widely used as Christmas or New Year presents. Handsch also composed tetrastichs about the lives of the Evangelists.[18] Rather exceptionally, he also added notations to his religious poems, which illustrates that some of them might also have been sung.[19] Handsch often wrote multiple poems on the same

---

17  *Rhapsodeai sive epigrammata*, ÖNB, Cod. 9821, fol. 38v. All quotations from the manuscript will be transcribed as it reads in the original, I have not edited them according to any editorial guidelines, or corrected mistakes and errors which are – rather unsurprisingly in a manuscript notebook of this kind – quite numerous.

18  *Rhapsodeai sive epigrammata*, fols 103v–113r.

19  *Rhapsodeai sive epigrammata*, fol. 71r.

topic during his school years, in order to practice various metrical units.[20] Humanist occasional poetry was a learned literary practice that students needed to master during their school years. If we compare Handsch's early poems, it seems to be obvious that he had some favourite phrases and collocations which he used especially in the opening or concluding sections of his pieces (*'accipe fronte serena'*, for instance).

Handsch composed this sort of poetry from 1549 onwards, for almost fifteen years. He paid special attention to gratulatory poems, epithalamia and epitaphia: these were the genres that could be easily sent to patrons. Imitating the style of Lutheran instruction, his epithalamia were divided into chapters written in various metrical forms, in which Apollo and the Muses congratulate to the newly married couple.[21] Handsch also mastered chronostics and acrostics very early, and employed them in writing to patrons about their lives and more general events from the recent past.[22] He endeavoured to write more and more demanding pieces that might impress patrons, like laudatory tautograms or poems in Greek.[23] He made an especial effort to extend his poetic skills while writing laudatory poems about members of Habsburg family, whom he probably believed would be more impressed by these slightly experimental works. Most of these poems included chronostics to celebrate events like Habsburg coronations or weddings.

During his stay in Prague between 1544 and 1550, Handsch began to write poems aimed at Bohemian noblemen as possible patrons. Jiljí Berka of Dubá and Lipá, a member of the noble family that owned Handsch's native town was among the first Handsch contacted in this way. However, most of his poems were dedicated to Jan Hodějovský the Elder of Hodějov, and on rare occasions, he also wrote poems also to Karel of Žerotín and Jan the Elder of Lobkowicz.

In his early poems to patrons, Handsch fashioned himself in rather unsurprising way. Similarly to many humanist poets he employed many rhetorical figures, among other diminutive forms, in order to stress both his intellectual inferiority and subaltern position to patrons. Instead of claiming to write poems which would be worthy of the Muses, Handsch described his style as immature and childish (*carmina crassa, tenuissima scripta clientis* or *puerilia scripta*), saying his poems are nothing more than rubbish (*nugae*). In his first poem to Hodějovský, Handsch explained that he was just a beginner (*neotericus, tener Poeta*) sending his first poetic attempts (*primitiae tyronis*) and hoping that Hodějovský would not feel sick while reading them (*Quodque super nullis veniat tibi nausea scriptis*).[24] In his poems for former teachers, which he wrote in order to display his educational progress, Handsch admitted that he was still not experienced enough (*non ego sum talis certe mihi conscius artis*).[25] He asked them for benev-

---

20  *Rhapsodeai sive epigrammata*, fols 32r–37r.

21  *Rhapsodeai sive epigrammata*, fols 54r– 62r.

22  *Rhapsodeai sive epigrammata*, fols 72b–74r, 212r–216r.

23  *Rhapsodeai sive epigrammata*, fols 91r, 92r, 206v (examples of verses in Greek); 113v–114v, 205r–v, 227r–v (for tautograms).

24  *Rhapsodeai sive epigrammata*, fol. 121v.

25  *Rhapsodeai sive epigrammata*, fol. 11v.

olence or even to become his censors, and he apologised in advance for all possible mistakes made in a hurry.

Modern readers might be surprised how directly Handsch asked his patrons for a support. The very first poem to Hodějovský illustrates that a possible *cliens* ('servant') was expected to put his request in a direct way: "*Obtestor te per Musas et numen earum/ Ut mihi patronus, tutor et esse velis/ Ut me suscipias, foveas, tuteris amesque/ Ac ut sis studiis portus et aura meis*".[26] While approaching his new patron, Handsch developed laudatory motivs which were also common among other poets of his generation: they praised Hodějovský as the protector of suffering Muses, who – unlike other Bohemian noblemen – not only performed all of his professional duties, but also supported poetry instead of useless entertainments and who by doing so, excelled in true virtue (*propria virtus*).[27] Similarly to many other poets, Handsch described his poems as *chartacea dona*, presents made of paper which should be exchanged for other presents, including those made of gold. If Hodějovský accepts Handsch as his *cliens*, Handsch promises that he – following Virgil's example – would write as diligently as possible (he speaks about *sedulitas nova* in this context) and fulfill his duties to his patron (*Nil dubites de me, semper pro parte virili,/ Ingenui quae sunt cuncta clientis, agam*).[28] He further made a promise to celebrate his patron forever (*… me fidum, memorem, studiosum semper habebis,/ Te dum nostrorum vivet uterque, colam*).[29] Handsch also promised to carry out all his duties and to write about those topics that his patron commissioned. He also repeated this promise in his later poems (*Cuncta libens faciam semper, qaecumque iubebis/ Inque tuos iussus officiosus ero./ Tantum praestabo quantum mea robora possunt/ Haec tibi syncero pectore verba loquor.*)[30]

Handsch mostly wrote celebratory works for his patrons, but he still did not hesitate to write a fierce and personal invective against one of Hodějovský's neighbours, Kateřina of Pacov, the so-called *mala Catta*. This piece is based on a comparison between the patron's qualities and Kateřina's vices, in order to depict her as a bad wife, a tyrannical feudal ruler, and a shameless woman. She is said to be similar to Jezebel (*Jezabel par atque simillima*), and Handsch also compares her to wild animals (*Cruscula formicae gestat, pectusque cicadae,/ Ac os tam latum non Crocodylus habet./ Hac melius caneret culex Adriaticus, atque/ Garriret melius rana palustris ea./ Anseris aut anatis sunt huic Oropygia macra,/ Illud olet, caprae quod vir olere solet.*).[31] Handsch combined these images of animals with denigrating passages about her body; he mocked Kateřina as an old woman (*gerontica femina*) who had lost her beauty by describing her hair, skin, and breasts (*Vix habet in toto capitis sex vertice pillos/ Callosam sulcat plurima ruga cutem/ Pannosae tristi pendent de pectore mammae/ Tam*

---

26   *Rhapsodeai sive epigrammata*, fol. 122r.
27   Storchová 2011, pp. 126f.
28   *Rhapsodeai sive epigrammata*, fol. 34r.
29   *Rhapsodeai sive epigrammata*, fol.135v.
30   *Rhapsodeai sive epigrammata*, fol.176r.
31   *Rhapsodeai sive epigrammata*, fols 166v–170r, here 167r.

*cernit bene quam noctua mane videt).*[32] He even indicated that Kateřina was a witch. This polemic was probably too harsh to be published; Handsch did however refer to Kateřina of Pacov in his later published poems in which he congratulated Hodějovský on having defeated his neighbour in a court-case.[33]

When approaching other scholars, Handsch adopted a different strategy to the one he used with his patrons. He developed an idea of scholarly friendship, and employed emotional codes of mutual love among scholars; he also criticised those scholars who were not able to meet these expectations. This was already illustrated in his poems to the former teacher from Leipa, a certain Thomas. Handsch tried to give the impression of being on the same social level as his former teacher. He did not even hesitate to advise Thomas on how to best teach the children in the town school, including Handsch's own young brother. Handsch addressed his former teacher as *dulcis amicus* and employed more personal and friendly style. In addition to their "eternal friendship", he emphasised the fact that they were related through the bond of scholarly love (*firmus et auctus amor*). Handsch described love between scholars as radiating from one heart to another, remaining there forever (*Crede mihi radius, quae nos coniunxit amoris/ Firmiter in medio pectore fixa latet).*[34]

Some of Handsch's poems also show his growing self-confidence in communicating with other poets. He adopted a self-confident attitude in a polemic poem against the Silesian poet Jan Serifaber (whom he labelled as a mere *versificator* or *versifex non dico versuum fex,* and not a true *vates)*[35], and also against a certain Paulus who was a preceptor in the family of Count Ungnad and to whom Handsch had incautiously lent some books.[36] Although his attitude towards patrons was much more cautious, Handsch never lost his agency while communicating with them. When he was commissioned, for instance, to write an encomiastic topography of Hodějovský's properties in southern Bohemia, he asked his patron to let him come and stay for some time in his castle and travel in his dominions in order to get a better idea of their appearance (as he put it, *quae nuncquam vidi, non scribere possum).*[37] Handsch developed his agency in many other ways: in a poem addressed to Hodějovský from the end of 1548, he mentions his his new professional medical skills and the time consuming treatment of his patients for the first time.[38] He continued writing about medical topics and classical medical authors in the following months. As will be explained later, Handsch shifted the focus very strongly to his medical knowledge and professional status in the poems which he sent to his patrons after his return from studying in Italy.

---

32  *Rhapsodeai sive epigrammata,* fol. 167r.
33  *Rhapsodeai sive epigrammata,* fols 184b–187r. For a printed version see Hejnic / Martínek 1966, II, p. 256.
34  *Rhapsodeai sive epigrammata,* fol. 67r.
35  *Rhapsodeai sive epigrammata,* fols 76r–180r.
36  *Rhapsodeai sive epigrammata,* fols 189v–190v.
37  *Rhapsodeai sive epigrammata,* fols 146v; 275r–v.
38  *Rhapsodeai sive epigrammata,* fol. 188v.

Rather unsurprisingly, an interest in medical topics also prevails in Handsch's early poems for Andrea Gallo, in which Handsch not only celebrated Gallo as a physician and author of a treatise on the plague, but also expressed his ambition to become Gallo's assistant.[39] He once again described their relationship by using the rhetoric of scholarly love (*Te rogito caepto me complectaris amore/ Et servum dici me patiare tuum*) and, while promising to forever perform his duties as an obedient servant, he employed verses recycled verbatim from the poem he had send to Hodějovský just shortly before (*Sic mihi praecipuus patronus habebere semper/ Sic mihi cardineus, sic mihi primus eris/ Nil dubites de me, semper pro parte virili/ Ingenui, quae sunt, cuncta clientis agam*)[40]. While working for Gallo, Handsch still maintained contact with Hodějovský, and promised to write further laudatory poems dedicated to him.[41] He very probably started planning a journey to Italy in order to study at this time.

## 1551–1553: Study in Italy

There is an interesting discontinuity in the rhetorical strategies employed in Handsch's poems between those he wrote before and during his studies in Italy.[42] Handsch adopted a new style there, which was clearly connected to the different modes of communication within Italian universities. Instead of writing long occasional poems he started producing short pieces, mostly just one or two lines dealing with more general topics. These recall the style of *alba amicorum* entries. Handsch dedicated these short works to his professors, for instance those at the university in Padua, and to a librarian named Hieronymus from Trento. The doctoral degree that Handsch obtained in Ferrara (his *laurea* as he calls it), and his increasing professional skills became an important topic. Although his contacts with patrons were detached from his academic life, the completion of a doctorate would clearly give him the opportunity to play a new social role and fashion himself in a different way.[43] Handsch reflected more and more on his own professional situation and expressed the opinion that he wanted to be both a poet and a physician. He believed this was possible because Apollo, whom he invokes, invented both poetry and medicine (*Confero me patrocinii sub duplicis umbram/ et vati et medico tu mihi fautor eris/ Nam friget passim divina Poetica, quare/ Istud Paeonio supprimet igne gelu*).[44]

---

39  *Rhapsodeai sive epigrammata*, fols 209v–210r.

40  *Rhapsodeai sive epigrammata*, fols 210v–211r (for the last two phrase which Handsch recycled from his earlier poem to Hodějovský, fol. 134v).

41  *Rhapsodeai sive epigrammata*, fols 240r–v.

42  For the whole series of his poems from Italy, see *Rhapsodeai sive epigrammata*, fols 243r–246r.

43  For differences in literary fields related to universities and courts see Albert Schirrmeister, 'Die zwei Leben des Heinrich Glarean: Hof, Universität und die Identität eines Humanisten', in *Humanisten am Oberrhein. Neue Gelehrte im Dienst alter Herren*, ed. by Sven Lembke and Markus Müller (Leinfelden-Echterdingen, 2004), pp. 237–266.

44  *Rhapsodeai sive epigrammata*, fol. 243v.

## 1554 – the early 1560s: Prior to joining the archduke's court

Having come back from Italy, Handsch returned both to his previous contacts, and to his previous style of writing. He was, however, able to 'code-switch' if necessary. In the letter Handsch sent to the renowned religious poet Tomáš Mitis, his former student and friend, in July 1548, Handsch is in fact already complaining that Hodějovský makes him write too many epigrams instead of giving him more time for his studies in medicine and natural philosophy. This letter illustrates that even before his departure to the Italian universities, Handsch presented an image of himself as both a learned poet and a physician (*Dominus Hoddeovinus iampridem est mihi, Patronus et Mecaenas, qui iam plurima Epigrammata a me habet, pluraque in dies flagitat, sed ego conor onus hoc a me discutere, non cum Soli Poësi vacare volo, sed in Physicorum et Medicorum campis exspaciabor, praesertim cum hortatorem et ductorem habeam M. Ulricum. Volo igitur me conferre sub duplicem Apollinis umbram, cuius Poesis, et medicina inventium est.*).[45] He complained, however, about being forced to write occasional poetry in a poem written for a close friend. Only five years later, enriched by his experiences in the Italian universities, Handsch had also changed his attitude towards his patrons. We can illustrate this by examining one of the first poems Handsch wrote to re-establish contact with Hodějovský after his return to Prague. Already in the poem of January 1554 – which is in fact a wish to the New Year – Handsch presents his doctoral degree in quite a self-confident way (*Doctoralis laurea*), and discusses his next cooperation with Andrea Gallo and how they will work for courtiers of the Archduke Ferdinand II.[46] As he stresses in his poem *In privilegium mei doctoratus*, he feels like a true follower of Apollo, because he can both write poems and take care of people's health (*Ipse ego, qui studium sum complexatus utrumque/ Me sub Apollineum, dedo patrocinium*).[47] In the later hodoeporicon describing his journey from Prague to Venice Handsch emphasised that he – despite the fact that he had studied in Italy – still remained the same obedient *cliens* that he always was (*Semper tuus Handschius idem/ Sum, cum qualis antea fui./ Observans cultorque tui studiosus honoris/ Ut promereris optime*).[48] Needless to say, this was actually a means of emphasising exactly the opposite: Handsch had acquired a new social rank due to his studies abroad, with his new professional skills and the academic degree he had obtained in Ferrara. Handsch even dared to criticise his patron, saying that Hodějovský did not answer his poems quickly enough, and explains that he does not want to seem "impolite" by sending too many unanswered poems (*Crebrius ad te scripsissem, si quando dedisses/ Meis responsum litteris/ Scribere saepe, nihil scripti sperare vicissim/ Mihi videtur indecens*).[49]

Poems to his patrons from this period were getting shorter and include an increasing number of references to Handsch's new professional status. Instead of writing

---

45  Georgius Handschius, *Epistolae ad varios an. 1545–1562*, ÖNB , Cod. 9650, p. 19.
46  *Rhapsodeai sive epigrammata*, fols 247r–v.
47  *Rhapsodeai sive epigrammata*, fol. 279r.
48  *Rhapsodeai sive epigrammata*, fol. 289r.
49  *Rhapsodeai sive epigrammata*, fol. 273r.

tetrastichs about the New Testament, as he did during his school years, Handsch now started composing new types of poems entitled *"in transfiguratione medici"*. He also started making excuses for his writing on the basis of his medical practice, work on medical treatises, and his duty to patients *(mea cura medendi* as he calls it in his poem to Karel of Dietrichstein)[50]. In a poem addressed to Hodějovský from 1554, Handsch stresses that he was sending his patron just few verses *(paucula dimetra)*, because he had to study Galen's work *(Quamvis labores plurimi/ Galeniani dogmatis/ Nunc aggravant me quo minus.)*[51] In a later poem from 1556 Handsch explains that he is the only one who can help his new colleague and patron, Andrea Gallo from Trento, to prepare his book on plague for printing, because of his expert knowledge on medicine. This is, as Handsch put it quite directly and concisely, why he cannot concentrate on writing encomiastic and occasional poems as he used to do earlier, and why he will be back to "saturating" his patron's poetic needs in the more distant future *(Sed cur non alius potuit describere dices?/ Haec praeter medicum scribere nemo potest./ Nam medici numeros mensuras pondera, signis/ Depingunt propriis atque characteribus./ Ergo meae parcas Musae quandoque tacenti./ Dignatus curis aequior esse meis./ His cito finis erit scribam tibi post modo plura/ Et quid vis aliud? Te saturabo. Vale.)*[52]

Moreover, a set of new topics emerged around 1560 which were closely connected to Handsch's professional experience as a physician, together with fragments of medical and alchemical discourse. An increasing number of references to classical medical authorities such as Hippocrates, Galen or Dioscorides is also typical for his poetry from the late 1550s onwards. Handsch also began to mention the names of other physicians, including foreign ones – for instance Johannes Naevius, court physician to Augustus of Saxony, with whom he also maintained epistolary contact.

In addition to references to his new professional role and networks, Handsch paid attention to one more, slightly paradoxical, topic. Together with other two humanist poets, Jiří Vabruschius and Tomáš Mitis, Handsch gained a coat-of-arms and a predicate, 'z Limuz' (of Limuzy), in May 1556. On the one hand, it was once again Hodějovský who supported their request at court and in fact helped them to obtain the predicate,[53] but on the other hand the title of nobility gave Handsch and other humanists a more independent and somewhat more equal status when communicating with their patrons, including Hodějovský himself. The title of nobility also changed the ways in which Handsch approached humanist authors who were more experienced or renowned than himself. As the first poem to Simon Ennius shows, Handsch paid special attention to the predicates of other humanists ('a Phoenicio Campo' in this case) in order to draw attention to his own new predicate and thereby balance any possible inequality between him and his adresees, be it caused by an age difference or a

---

50   *Rhapsodeai sive epigrammata*, fol. 249v.
51   *Rhapsodeai sive epigrammata*, fol. 251r.
52   *Rhapsodeai sive epigrammata*, fols 271r–v.
53   *Rhapsodeai sive epigrammata*, fol. 284v (Ad D. H gratiarum actio pro insignibus a rege impetratis).

difference in intellectual reputation. He also wrote laudatory poems (*symbola*) on the coat-of-arms of enobled humanist scholars, for instance Šimon Proxenus.[54]

After 1555 Handsch concentrated more on his relationship to the Habsburg court. On the one hand, he still produced typical occasional and laudatory poems for Hodějovský, as well as Protestant hymns in various metrical units.[55] On the other hand, he also started writing short poems celebrating individual members of the Habsburg family and courtiers, poems that accompanied their small-scale printed portraits (the *in effigiem* type)[56]. Another series of poems dealt with the Habsburg festivities, such as the ceremonial arrival of Maximilian II into Prague, or the coronation ceremony of Ferdinand I, both of which Handsch described in colourful detail. In the case of a short elegiac couplet from 1558 commemorating the same event, Handsch made a remark on margin of the manuscript that it had already appeared in print and found favour.[57]

As a next step, Handsch started establishing stronger ties directly to the courtiers of Archduke Ferdinand II. He composed short poems celebrating the archduke and his support of humanist literary projects, like the edition of the *Historiae animalium* (which was another title for Handsch's *Historia naturalis*).[58] He wrote laudatory pieces on individual courtiers like Pietro Andrea Mattioli, or on musicians like Jacobus Losius. It is again striking to note how explicit Handsch was in negotiating with Bohemian noblemen who were related to the court. For example, he asked Václav Šeliha and above all Jan the Elder of Lobkowitz – who was a head of the royal council at that time – to gain funds from the archduke for Handsch's journey to Italy. He promised that after his return he would remain at the service of the court: "*Per te quaeso Ducis boni-tate/ Fidelis in omnem/ Eventum meritas grates promitto, nec ullum/ Strenuus omit-tam cultum, quem fida patrono/ Turba suo debet, si Princeps annuet aequus/ His caep-tis, Italasque mihi continget ad urbes/ Sumptus, ubi medicas absolvam sedulus artes/ Atque domos patrias quondam cum laude reversus/ Archiduci, patriaeque meae cum fruge rependam/ Hoc pietatis opus: quod, si Comes inclyte velles,/ Praesidio firmare tuo potes, atque benigno/ Persuadere animum Ferdnandi principis ore.*"[59] In addition to these quite explicit demands, Handsch sent Jan the Elder of Lobkowitz a sample laudatory poem on his coat-of-arms, and several more short occasional pieces.

### From 1567 onwards: Being a member the Ambras community

Handsch's rhetorical strategies changed markedly in the mid-1560s, when he became closely tied to the court of Archduke Ferdinand II. The first poems in this series date

54  *Rhapsodeai sive epigrammata*, fols 298v; 302v–303v.
55  *Rhapsodeai sive epigrammata*, fols 260v–262v.
56  *Rhapsodeai sive epigrammata*, fols 265r–264v, 311r.
57  *Rhapsodeai sive epigrammata*, fols 287v, 279v–282r.
58  *Rhapsodeai sive epigrammata*, fol. 310r.
59  *Rhapsodeai sive epigrammata*, fols 308b–309a. This poem is not exactly dated, but it appears in the volume following poems that Handsch wrote after his return from Italy.

to 1566. As personal physician to the archduke, Handsch very probably found other ways to acquire support and establish learned contacts outside of writing occasional poems. As we shall see, he no longer had to ask directly for anything.

Handsch continued to produce occasional poetry until the end of his life, even though he was in daily contact with Archduke Ferdinand II, Philippine Welser and her family. What, then, was typical in these late works? First and foremost, Handsch did not write more than two or three pieces a year, sometimes even less. His late poems usually did not exceed ten lines, which means they were significantly shorter than his earlier works. He stopped composing chronostic and acrostic poems, which had been a part of his earlier strategies for the acquisition of patronage (i.e. by commemorating certain dates and events from the patron's life).

In terms of content, Handsch's late poems describe everyday situations and social events at the court, which Handsch sometimes related to more general moral issues. Some of his late poems are like the more traditional epitaphia, and the very last piece in the volume is an epitaphium for the physician-poet himself. A small number of pieces exhibited a slight symbolism in his last years, a thing it is hardly possible to identify in his older texts (such symbolism includes, for example, a poem about the eagle of Emperor Ferdinand). Handsch now left New Testament and eschatological topics aside, though these were so typical for his early poetry, and were based on his instruction at Lutheran schools.[60] Handsch completely changed his strategies for acquiring patronage. His language became more implicit: he neither labelled his cor-repondents as patrons nor did he celebrate them or make any direct claims. He stopped presenting his public persona at all.

Given all of this, it seems obvious that Handsch's late poems played different social and communicative roles to the previous ones – he might have conceptualised them as small witty presents to other courtiers, often commemorating their relatives who had recently passed away (as in a case of Johann Georg Welser or the daughter of the coun-cillor Jiří of Lokšany).[61] Nevertheless, these short pieces also remained a part of his networking strategies. Handsch probably used short poems also as a tool for keeping particular events in his memory (this could for example be the case with the epitaphium for Hieronym Rösch of Geroldshausen, captain of Ambras castle). Some poems com-mented on news or even gossip from the court and have a slightly moralizing overtone. This seems to be true in the case of the Spanish nobleman Ferdinandus Mercadus, who was murderd in his sleep by his own servant in April 1566, something that Handsch interprets as *mala gratia mundi*.[62]

In conclusion, I would like to once again stress that Handsch was never a profes-sional poet. He always strived to specialise in medicine and he used occasional poetry

---

60  The last poem, which deals with a storm in Prague and interprets this from the Protestant point of view as a sign of God's wrath and punishment can be found in fols 311v–312r ("Esse quid hoc aliud dicam, nisi numinis iram?/ Quae nos prodigiis excitat, atque monet.")

61  *Rhapsodeai sive epigrammata*, fols 319v–321r.

62  *Rhapsodeai sive epigrammata*, fols 318v–319r.

as an auxiliary tool for promoting his medical career. Nevertheless, it is precisely his poetry that shows us how he was perfectly able to code-switch when approaching different patrons and scholars. To put it in a more general way, writing poems was not only a highly exclusive literary task, but also an everyday tool produced and used by many humanist scholars for social purposes. In further examining this specific case, it is clear that Handsch's occasional poetry can give us an alternative insight into what the members of Archduke Ferdinand II's court expected from 'their' authors, and also shows us how the exchange of literary texts worked in that environment. Neo-Latin poetry therefore also deserves to be analysed as a part of this cultural exchange.

Marta Vaculínová

# The poet and physician Laurentius Span and his place among the humanists in the circle of Archduke Ferdinand II

The court of Archduke Ferdinand II attracted not only artists, but also scholars of various disciplines, who tried to acquire a place in the service of the court. The best path to success was the recommendation of an influential figure and good personal contacts. A further way of attracting the attention of the archduke and winning his favour was through symbolical gifts in the form of occasional poems. An interesting example of this strategy can be found in the preserved manuscripts of works by the physician Laurentius Span of Spanow (Vavřinec Špán of Španov), who approached the archduke over a period of many years with a number of poetical compositions.[1]

The relationship of medicine and poetry underwent various transformations during the Renaissance and the result was their combination in the form of didactic medical poetry. This genre arrived in Central Europe during the 16th century from Italy, where it was made famous by Girolamo Fracastoro.[2] One of Fracastoro's friends, Giulio Alessandrini from Trent, was the personal physician to Ferdinand I, and Alessandrini also devoted time to didactic poetry. It was perhaps Alessandrini who influenced Laurentius Span, one of the few Czech physician-poets. Span is the most famous Czech representative of this genre in the period before the Battle of White Mountain.[3] While seeking a place in court service, Span tried to obtain a post in Prague at the court of Archduke Ferdinand II, and dedicated extensive poetic compositions to him. He did not, however, win the archduke's favour and the man who became the archduke's personal physician was Span's more successful fellow-countryman Georg Handsch, who was also a physician-poet. In this text I will try to answer the question of why Span's efforts were not successful, and what his place was among the authors dedicating works to the archduke.

Laurentius Span[4] was born in 1530 in Žatec and studied theology and medicine in Wittenberg. His final choice of medicine may have been influenced by the fate of his friend, the Žatec priest Jacobus Camenicenus, who was defrocked during the Utraquist

---

1    In this case the German term used is "Dichterarzt".

2    His didactic epic *Syphilis*, in which he presents the results of his research on this disease, was published in the year of Span's birth.

3    He summed up his relationship to medicine and poetry in the distich: "Noster amor CHRISTUS, studium Medicina, voluptas / Pieris: Ille animae, corporis ista decus" (My love is Christ, my profession medicine, my passion the Muse: the former adorns the soul, the latter the body).

4    Basic literature: *Rukověť humanistického básnictví v Čechách a na Moravě*, ed. by Josef Hejnic and Jan Martínek, 6 vols. (Prague, 1966–2011), V (1982), pp. 289–296 (with older bibliography); Hejnic / Martínek 2011, VI, pp. 290–291; Eduard Wondrák, 'Der Arzt und Dichter Laurentius Span (1530–1575)', *Medizinhistorisches Journal* 18: Part 3 (1983), pp. 238–249; Wilhelm Kühlmann, 'Span Laurentius', in *Killy Literaturlexikon*, 11 (Berlin, 2011), pp. 76–77.

*IN EFFIGIEM*
*Autoris.*

Noster amor *CHRISTVS, studium Medi-*
       *cina, voluptas*
*Pieris: Ille anima, corporis ista decus.*
*Nec moror ex lauru textam viridante coronam,*
       *De folijs Quercus det mihi serta suis.*
*Vna iuuare meos mihi stat sententia ciues,*
       *His ego si prosim: Gloria vana vale.*

Fig. 1. Portrait of Laurentius Span, from Laurentius Span, Aphorismorum, Wroclav 1570 (Prague, Collection the National Museum, National Museum Library, sign. 49 D 13)

Consistory and imprisoned for his inclination towards Lutheranism, after which he made a living in Prague and later in Moravia as a doctor. It was to be expected that Span, who had translated the explanations of the Gospels of Luther's former secretary Veit Dietrich into Latin, might have had similar problems. On completing his studies, Span returned to Bohemia, where he perhaps had a private practice in Kutná Hora and later in Prague. He was one of the poets supported by Jan Hodějovský the Elder. In 1558 he was ennobled with the epithet 'a Spanow' (of Španov), and two years later he acquired his doctorate in medicine.[5] In the existing literature there is some speculation about Span's possible appointment as a laureate,[6] although he never used the title *poeta laureatus*. In all his surviving portraits he does not wear a laurel wreath, but rather a wreath of oak, known as the *corona quercea*, awarded in ancient Rome for the saving of life and therefore perhaps a reference to Span's services in the field of medicine. (Fig. 1) At the end of the 1560s Span was working in Prague, where he came into contact with the court physicians, particularly Andrea Gallo, one of the physicians of

5    It is not known where he acquired his doctorate, but it could have been at the same time as his enno-
     blement. See Wondrák 1983, pp. 239.

6    John L. Flood, *Poets laureate in the Holy Roman Empire* (Berlin and New York, 2006), pp. 1967–
     1968 on the basis of information from the work of Caspar Cunradus *Prosopographiae mellicae
     millenarius*, 1615. Cunradus does, however, also give unreliable data for other poets.

Archduke Ferdinand II. He was also acquainted with Pietro Andrea Mattioli and, naturally, with Georg Handsch. His relationship with Handsch was probably not completely ideal, as we know from Handsch's letter in reply to Span's accusation that he had taken one of his patients in Collinus's Garden of Angels.[7] During his Prague period, which lasted from the end of the 1550s until 1562, when he moved to Olomouc, Span devoted himself intensively to both perfecting his medical knowledge, and seeking a suitable position in the court service. He attempted to win the favour of influential men of the kingdom through, among other things, his poetic works. He had been devoted to poetry from the time of his studies in Wittenberg and used it considerably to further his career – during the 1550s he won the favour of Christoph of Lobkowicz, who helped him with his ennoblement, through appropriate poetry. Later, when he was living in Moravia, he also won the favour of Jaroslav of Pernštejn. He concentrated his greatest efforts, of course, towards the members of the Habsburg family, specifically the Archduke Ferdinand II and his brother Maximilian II, who was the titular King of Bohemia from 1549, and later also Emperor. In addressing the Habsburgs, Span was not satisfied with small occasional compositions. Rather, he dedicated extensive descriptive and didactic poetic compositions to them, as is documented in a number of manuscripts stored in the Austrian National Library in Vienna.[8]

## Span's dedications to the members of the Habsburg family

The first work that Laurentius Span dedicated to the Archduke Ferdinand II was probably the well-known Ferdinandopyrgum,[9] written after 1555. (Fig. 2) This extensive poetic composition, focused directly on the person of the archduke, celebrated his construction of the Hvězda (Star) Summer Palace, which was almost completed at this time. Where did Span find the inspiration for such celebration of a work of architecture and a garden? Apart from Wittenberg, where he studied, he probably drew on the Bohemian environment. At this point he belonged to the poetry circle of Jan the Elder Hodějovský of Hodějov, the members of which have left us numerous descriptions of their patron's estates and gardens at Řepice, as well as praise for his native town of Hodějov.[10] Given the popularity of this theme with his benefactor Hodějovský,[11] Span

---

7   Letter from Handsch to Span dated 12. 4. 1559, Österreichische Nationalbibliothek (hereafter ÖNB), Cod. 9650, pp. 140–141.

8   At this point I would like to thank Dr Katharina Kaska and Dr Friedrich Simader from the Manuscript Department of the ÖNB in Vienna for their kind assistance.

9   The name itself is worthy of attention, created according to the example of the mixed names of German cities such as Palaeopyrgum (Altenburg in Saxony), Neopyrgum (Neuburg in Thuringen). Here we find, quite exceptionally, the original Greek word *pyrgos*, meaning tower, castle or fortification, in the neutral form *pyrgum*.

10  ÖNB, Cod. 9902. See Dana Martínková, *Literární druh veršovaných popisů měst v naší latinské humanistické literatuře* (Prague, 2012), p. 34; Jan Martínek, 'K latinským popisům renesančních a barokních zahrad', *Zprávy Jednoty klasických filologů* 10 (1968), pp. 151–152.

11  For Hodějovský, however, Span did not write a topographic poem. He offered to prepare a Czech Chronicle in verses, Hejnic / Martínek 1982, V, p. 296.

Fig. 2. Laurentius Span, Ferdinandopyrgum (Vienna,
Österreichische Nationalbibliothek, Department of Manuscripts
and Rare Books, sign. Cod. 9902, fol. 3)

evidently assumed that the same theme would receive a favourable response from Archduke Ferdinand II. The archduke, however, did not support the publication of the poem financially, which would have been expected in the case of an extensive composition of this type. He gave priority to supporting publications that corresponded more to the serious nature of his position, i.e. prose print editions focusing on medicine and history. It is possible that poetry in general was insufficiently representative from this viewpoint.[12] The Star Summer Palace was celebrated in poems as a notable construction commissioned by the Habsburgs even after Archduke Ferdinand II's death. In 1597 Julius Torzarrellianus dedicated a poetical description of the Star Summer Palace to Emperor Rudolf II, and in 1617 Jan Sixti dedicated a plagiarism of this composition to Emperor Ferdinand II on the occasion of his Bohemian coronation. Less well known is Sixti's further composition *Stella stellae* on the victory at the White Mountain, in which the summer palace also plays a symbolic role.[13]

It was perhaps his experience with the reception of the *Ferdinandopyrgum* that led Span to avoid relying on a single sponsor and to adapt the theme of his poetical works so that they could be dedicated to more than one person. Even before January 1558 (in other words, before his ennoblement) he dedicated his poem about the plague, *De Peste*, to the archduke's brother Maximilian II, the titular King of Bohemia. Today we know of four manuscript examples, which differ from one another in the dedication

---

12   For instance, Giulio Alessandrini dedicated his dialogue *De medicina et medicis* (1557) to Ferdinand I, but the didactic epic *Paedotrophia* (1559) he dedicated to one of Ferdinand I's courtiers, the Imperial Counsellor Hieronymus of Sprinzenstein.

13   Hejnic / Martínek 1982, V, p. 113.

poems and text, and even to the extent of variations in the actual composition. The poem originated during the time of the plague in 1554.[14] The older version of the poem, consisting of one book written before 1558, comes from the Ambras Collection and is, as mentioned above, introduced by a poem of dedication to Archduke Ferdinand II's brother Maximilian II.[15] It is possible that it was dedicated to the archduke himself, with the request that it be delivered to his brother. It would not be the first time that the archduke appeared as an intermediary for delivery of a work to another person; as an example, we could cite the *Sarmacia* by the Czech nobleman Jan Zajíc of Házmburk, dedicated to the archduke with the request that he deliver it to his father. The later version of *De Peste*,[16] which comprises two books, was written after 1558 with an extended and basically differently worded dedication poem: we can also demonstrate that this version was sent directly to the addressee. The latter behaved as expected and as early as 1561, during a further plague epidemic that afflicted the country between 1561–1562, the *De peste libri duo* were published in Olomouc by the Jan Günther press. The original manuscript dedication poem was replaced in this printed version by an extensive prose foreword dedicated to King Maximilian II. Span dedicated a manuscript with the same title and extended to three books with a dedication poem to the Elector of Saxony, Augustus.[17] Span's fourth composition on the plague, which showed considerable formal differences from the preceding versions, especially in the higher proportion of use of ancient mythology, was inspired by the plague epidemic of 1568. Its manuscript, bound in purple parchment with gilt edging, was dedicated to Richard Strein of Schwarzenau, President of the Court Chamber and the confidant of Maximilian II, who had already become Emperor by that time.[18] Span was also the author of a printed prose anti-plague regimen in German[19] – he dedicated this in 1564 to Fridrich of Žerotín.

How close was Laurentius Span to the court of the archduke at this time? We have already mentioned his contact with the court physicians Andrea Gallo from Trent, and Pietro Andrea Mattioli, both of whom represented real authorities in the field for the talented young apprentice of medicine, and Span also quoted both men in his poems.[20] For a certain time Span was probably Gallo's assistant, as was his more successful

---

14  Foreword to the printed issue of *De peste* in 1561, fol. AIIIa.

15  ÖNB, Cod. 11162.

16  ÖNB, Cod. 11202.

17  Sächsische Landesbibliothek – Staats- und Universitätsbibliothek Dresden (SLUB), manuscript C 343. The text of the dedication poem was reprinted by Johann Christian Götze, *Die Merckwürdigkeiten Der Königlichen Bibliotheck zu Dreßden*, 3 (Dresden, 1746), p. 417.

18  ÖNB, Cod. 10307.

19  This type of literature, already popular in the Middle Ages, was commonly published in Lands of Bohemian Crown in living languages; apart from Daniel Adam of Veleslavín, medical literature was most frequently published by the Olomouc printer Jan Günther.

20  For instance, in the print version of *Liber de peste* he gives several of their opinions of the treatment of plague with a note in margin. In Mattioli's correspondence one of Span's letters has been preserved, datable to the years 1558–1560 and including the reply, see *Epistolarum medicinalium libri quinque* (Prague, 1561), p. 247–249.

colleague Georg Handsch before him. In his poem on the plague Span quotes Gallo's opinions on the treatment of this disease, which only appeared in print four years later.[21] In his collection of elegies (Prague 1554) Span also dedicated one work to Gallo as the royal physician. When Gallo died in Prague six years later, Span published his *Epicedium* (Prague 1560). This was reprinted twice more in the posthumous editions of Gallo's medical writings.[22] According to Span's verses Gallo first spent six years as the physician of Ferdinand I at the court in Innsbruck (i.e. circa 1542–1548), and then twelve years in the same position in Prague.[23] A whole group of physicians and relatives mourned him: Iulius Alexander, the Emperor's personal physician Giulio Alessandrini, also a native of Trent; Pietro Andrea Mattioli, the physician of Archduke Ferdinand II; and also Gallo's brothers and sons. The author proudly includes himself, weeping for Gallo as his teacher and father.

Span's increased dedication activity around 1560 and this epicedium indicate that he had ambitions to take over Gallo's place in service to the court. Archduke Ferdinand II's chief physician at this time, however, was Mattioli and in 1561 Mattioli selected Georg Handsch as his assistant, so it was Handsch who later replaced him as the archduke's personal physician. After further unsuccessful attempts to gain a position in court service during the reign of Maximilian II, Span moved to Olomouc, where he evidently had a medical practice and later became personal physician to the Bishop of Olomouc and later to the Bishop of Wrocław.

Although Span was clearly unsuccessful with Archduke Ferdinand II, many years later he made a further attempt and dedicated his *Liber de homine* to the archduke, who was identified in this case as Count Tyrol.[24] Span's poetic dedication, in which he repeatedly asks to be accepted among the archduke's "clients" (*cliens,* in the sense of a servant), is very general in its content. This demonstrates perhaps only that his previous attempts had been unsuccessful. It is notable that the actual poem, which describes the seven stages of human life and includes elements of astrology, medicine and theology, had already appeared in print at this time.[25] Span clearly only wanted to repeat his attempt to attract the archduke's attention, without trying to acquire financial support for the publication of the work.

In the same way he tried to win the favour of Archduke Ferdinand II, Span also tried to win that of Maximilian II with the dedication of his *Aphorismorum*

---

21   *Fascis de peste, peripneumonia pestilentiali cum sputo sanguinis, febre pestilentiali ac de quibusdam symptomatibus* (Brescia, 1565).

22   *Fascis de peste, peripneumonia pestilentiali cum sputo sanguinis, febre pestilentiali ac de quibusdam symptomatibus* (Brescia, 1565), pp. 90–92; *Homo afflictus et iacens*, ed. Petrus Uffenbach (Frankfurt, 1608), pp. 616–622.

23   Josef Smolka and Marta Vaculínová, 'Renesanční lékař Georg Handsch (1529–1578)', *Dějiny věd a techniky* 43 (2010), pp. 1–26 (5).

24   ÖNB, Cod. 11213.

25   Firstly in 1560 in Prague with the dedication to Archbishop Antonín Brus of Mohelnice, secondly in altered form in Nisa in 1566, dedicated to Andreas, Abbot of the Cistercian Monastery in Jindřichov, Silesia (today Henryków).

*Hippocratis paraphrasis* (Aphorisms according to Hippocrates), published in Wrocław in 1570. This work was one of Span's most popular and widely read poetic efforts, which also inspired other authors. In the foreword Span mentions the support given by Maximilian II to his youthful works and hopes that this work, written at a mature age, will be given even greater support. The manuscript of the composition *Anabiosis de resurrectione mortuorum* was probably also dedicated to Maximilian II. This work is preserved in the Viennese National Library with an ex libris from the hand of the librarian Hugo Blotius.[26] The work was not, however, published with the emperor's support: it did not come out in print until 1574 and is dedicated to the Bishop of Wrocław, Span's employer at that time.

It is possible to perceive a certain development in Span's dedications to members of the Habsburg family and also in the themes of the manuscripts devoted to them. Following the unsuccessful dedication of the *Ferdinandopyrgum*, which was aimed specifically and exclusively at its addressee, the author moved on to themes that could be used for several different persons at once, and took pleasure in using the strategy of multiple dedications. The plague was the most frequently repeated theme of his didactic poems preserved in manuscript form. Instructive writings on the plague in various forms, and also in various languages were often dedicated during of epidemics or shortly afterwards to rulers or high provincial officials, who supported such works financially in the cause of raising public awareness. In Span's manuscripts and printed dedications, the Muses gradually gave way to Hippocrates as the representative of the medical profession. Whereas Span emphasised the importance of support for poetry on the part of the rulers of the land in his earlier dedications, he now gradually moved towards stressing the importance of medicine and especially the usefulness of didactic poetry for the education of budding physicians or even the lay public. Personally, he was very active in popularising such works and also wrote a health regimen in prose, the *Hypomnemata ad conservandam bonam valetudinem* (Nisa, circa 1565).

## Manuscripts dedicated to Archduke Ferdinand and their authors

What was Span's position among those who dedicated their works to Archduke Ferdinand II? In what way did he resemble the other people dedicating works to the archduke, and in what ways did he differ from them? Let us first take a look at the composition of this group of people. To simplify matters we could divide these 'dedicators' into two groups: those who were successful, that is the authors of those printed books that were dedicated to the archduke and often directly supported by him financially; and the others, meaning the authors of manuscripts dedicated to him. If we

---

26   ÖNB, Cod. 9948. This manuscript does not contain any dedication, just like the (probably older) version kept in the Library of the National Museum in Prague (KNM VI F 27). I would like to thank Mgr. Zdeněk Mužík for providing more detailed information on this.

compare the dedications of the printed works[27] with the dedications of manuscripts (for the most part preserved in the Austrian National Library, see also the list of such works attached as an appendix to this article), we arrive at several interesting findings. Practically no-one appears simultaneously on both lists.[28] No manuscript originals of the dedicated print copies have been preserved. Of the dedicated manuscripts not a single one was published in print with the support of the archduke, though several were published with the support of other patrons, including both of Span's works. The number of dedicated prints and manuscripts does not differ greatly (40:50), and the proportions are more or less preserved between dedications from the pre-Tyrolean period (circa 13:15) and the Tyrolean period (roughly 27:31).[29] In language composition Latin prevails in both groups (30:29), but in the manuscripts (especially in certain genres) this gives way to living languages – German (8:16), Italian (1:3) and Czech (1:2). Seven of the eight German manuscripts are poetical works.

In the comparison of thematic fields several differences can be observed. Specialist medical prose works and editions of older medical works, which formed the core of the dedicated printed editions, do not appear in manuscript form at all. The ratio of printed and manuscript medical works is in itself worthy of note – 10:3. Of the three manuscript works two are Span's poems *De homine* and *De peste*, whereas the third is a scroll of medical counsels, which is dedicated to Archduke Ferdinand II, but it can be assumed that this worked was actually ordered by the archduke. In the sphere of alchemy and natural sciences we can see a certain difference (4:9), which would be further intensified if we added the manuscripts that originated from a direct commission from the archduke himself (e. g. Handsch's natural science work or depictions of marine fauna). The proportion of historical works and militaria is equal (8:8), as are the proportions of theology and spiritual poetry (5:6), and architecture (1:1). In the sphere of architecture we might be surprised by the fact that only one printed and one manuscript work were dedicated to benefactors like the archduke, who had definite artistic leanings. This can however be explained, among other things, by the fact that the number of works published in this field at the time was relatively low in comparison to the fields previously mentioned. There is a further striking difference in the field

---

27  Lenka Veselá, 'Knihy dedikované Ferdinandovi II. Tyrolskému', in *Knihovna arcivévody Ferdinanda II. Tyrolského*, I: *Texty*, ed. by Ivo Purš and Hedvika Kuchařová (Prague, 2015), 429–445. With regard to the list of printed works it is possible to add some titles, e. g. the printed epicedium of Georg Roner to Philippine Welser (*Verzeichnis der im deutschen Sprachbereich erschienenen Drucke des 16. Jahrhunderts* [VD16]: ZV 28391) and the music publications of Michael des Buissons and Alexander Utendal, see Franz Gratl, 'Music at the Court of Archduke Ferdinand II within the Network of Dynastic Relationships', in *Ferdinand II. 450 Years Sovereign Ruler of Tyrol. Jubilee Exhibition*, ed. by Sabine Haag and Veronika Sandbichler, exh. cat. (Innsbruck and Vienna, 2017), pp. 61–71 (63) and 322–323. With the manuscripts there will doubtless be even more additions and specifications in the future.

28  In one manuscript the name of Pietro Andrea Mattioli does appear, but only as a member of the wider medical council.

29  Four manuscripts could not be placed with regard to date.

of drama – we know of five manuscripts of theatrical plays dedicated to the archduke, but no printed editions whatsoever.

It may be generally said that the authors of manuscripts dedicated to Archduke Ferdinand II were less well known than the authors of the dedicated printed works: in some cases we were able to find almost no information about these manuscript authors. Apart from a few exceptions (the singer Zindecker or master of ceremonies Benedikt Edelbeck[30]), they did not come from the immediate surroundings of the archduke.[31] We find dedications to the archduke from Czech officials, nobles and writers during the period of his residence in the Bohemian Lands and his later trips to Prague: apart from Span there were Jan Zajíc of Házmburk, Vilém of Hradešín, Matouš Collinus or Matyáš Hutský. However, there were also dedications from foreigners active in Bohemia, such as the Lutheran priest Michael Winkler or the poet laureate Christoph Nenning. During both the Bohemian and Tyrolean periods authors addressed the archduke from nearby Bavaria, which he sometimes visited because his sister had married into that region and settled there. Most often these were descriptions of celebrations and occasional dramas.[32] There are strikingly fewer manuscripts from Italian authors, even though another of the archduke's sisters had married into Italy. There was small circle of people linked to the Viennese court (the mathematician Paul Fabricius, the future imperial counsellor Johann Ziegel and so on) and a further group of authors belonged to the highest literary circles in Tyrol. A considerable number of the authors were persons with no relationship to Archduke Ferdinand II's court or the courts of his relatives, coming from various ends of Europe, especially the German-speaking areas such as Silesia, Prussia, Alsace and so on. The only more distant country represented was Belgium, by an author under the name of van der Muelen.

In the case of the dedicated printed works, Archduke Ferdinand II was often only one of the recipients of the dedication, which was usually aimed first and foremost at his father Ferdinand I, and his brother Maximilian II. In manuscripts this method was less frequent (there are only two cases where a manuscript was dedicated to both Maximilian II and Archduke Ferdinand II, in one manuscript by Locarno, and another by Span). This does not mean, however, that authors did not also simultaneously turn to other members of the Habsburg family. It was often the practice that the work was copied out several times and each copy bound, and then each addressee received his own copy with an appropriate dedication poem or enclosed sheet. However, I will deal with the widespread practice of multiple dedication manuscripts, for which there is

---

30  Michael Forcher, *Erzherzog Ferdinand II. Landesfürst von Tirol: sein Leben, seine Herrschaft, sein Land* (Innsbruck and Vienna, 2017), pp. 256–7: In 1568 Benedikt Edelbeck, a court official of Archduke Ferdinand II, composed the play *Comedie von der freundesreichn geburt unseres Ainigen Trost und Hailandt Jesu Christ*, which is one of the earliest German dramas.

31  We could, perhaps, also include here the epithalamium ordered by Archduke Ferdinand II's secretary Zehentner, from the priest Johann Leucht, see Veselá 2015, p. 438.

32  Thomas Winter dedicated a theatrical play to Archduke Ferdinand II that was intended for his nephews, Wolfgang Liginger dedicated descriptions of monks' processions, etc.

rich material for the investigation provided by the manuscript collection of Archduke Ferdinand II, on some other occasion.

What genres did authors choose in attempting to win the archduke's favour? The creators of prognostics came forward with relative confidence. In their forewords, which are expertly formulated, without excessive flattery, they turned to the archduke as an expert on the problem examined in their text. They emphasise the demands made on their time by their work and offer him further services. Although some of these works aspire in their very arrangement to be printed, and we know of similar printed works by their authors (for example, works by Renßberger and Caesareus), the printing of the manuscript only occurred in the case of the edition of one older book of prophecies by Flock, but in this case the printed dedication was devoted to a different person. Some of these works, although they have a brief dedication, probably originated as commissions from the archduke (for example, the horoscopes by Fabricius and Leovicius).

A further striking group are the rhyming works written in German, focussed on celebrations, militaria or history, as well as stage dramas mentioned above. Some of the authors of these descriptions of festivities and contests even published their works in print. It is worth mentioning the famous Lienhart Flexel and his rhyming descriptions in German of shooting contests, which in some cases were even published in print in small numbers, supplemented with coloured illustrations and provided with a decorative binding.[33] However, manuscripts from some of the other authors were never printed.[34] amongst the works of this type dedicated to Archduke Ferdinand II we do not know of any printed version of a manuscript, nor does it emerge from the forewords that the authors were asking for support for the publication of the work (with the exception of Aegidius Holy, but even his play about the Judgement of Solomon did not get printed).

The authors of occasional poetry in Latin appeal to the addressee in their forewords (often also written in verse), asking for his support for art and literature, with the frequent topos "a poetical work makes man immortal". In the same way, the astrologists often offered to create some extensive and more demanding work for the archduke. Elsewhere such authors simply appeal to his generosity. Among the works with a religious theme (these are without exception poems) compositions about the Nativity dominate: poems in this genre represented a traditional symbolic gift for the New Year. The authors of a number of these poems were Lutherans. Manuscript epis-

---

33    Archduke Ferdinand II had the coloured example of a printed work published by Flexel on the occasion of a shooting festival organised in Innsbruck in 1569 in his library (ÖNB, Cod. 9023). A further example of this edition, which was the model for the edition of August Edelmann of 1885, is kept in the Bayerische Staatsbibliothek Munich (BSB, Cod. germ. 945). For further similar manuscripts see Veronika Sandbichler and Alena Richterová, 'Literatura k festivitám', in *Knihovna arcivévody Ferdinanda II. Tyrolského*, ed. by Ivo Purš and Hedvika Kuchařová , 2 vols. (Prague, 2015), I, p. 367.

34    Wolfgang Liginger and his numerous descriptions of Munich processions and other compositions, preserved in the manuscripts of the ÖNB and BSB.

tolary handbooks were more for internal use, with no ambitions regarding publication.

In the vast majority of cases the form of the dedicated manuscripts was also important. These manuscripts were usually written by a professional scribe on quality paper or parchment and some (especially those from more affluent donors) contained illustrations. A manuscript intended as a gift was provided with a representative binding – the most typical was brown leather with a raised inscription and gilding, in more modest volumes it was light parchment. Gilt edging was more or less obligatory.

What were the intentions of authors in dedicating their manuscripts to Archduke Ferdinand II? Most usually this was an effort to draw attention to themselves and offer further services. This was a common factor for both poets and the authors of prophesies, who presented themselves with works closely focussed on the person addressed, whether these were *carmina laudatoria* or horoscopes, or something more generally useful (prognostics, religious poems and so on).[35] Only in a few cases did the authors directly request support for the publication of their work.[36] There are some cases where the request does not appear in the dedication, but the manuscript itself is in the form of a printed work and it can be supposed that it was also intended for print.[37] Sometimes the publication of a manuscript was not even desirable – for example, in cases where the work was a plagiarism of some less well-known publication.[38] In such cases the manuscript really only fulfilled the function of a gift, and was simply used to attract attention. In the case of authors' manuscripts, on the other hand, it sometimes happened that the text was later published in print by another author.[39] Some authors quite openly requested a financial reward (Locarno), whereas others merely indicated this.[40] In the case of the above-mentioned Zindecker, an author from the archduke's court circles, his dedication was an expression of gratitude for the provision of employment, and also an indication of willingness to accept further work.

What, then, is the position of Laurentius Span among the authors of manuscript dedications? We can state that he did not attempt, with regard to his financial situation, to represent himself through costly bindings. In his manuscripts there is, however, a

---

35   A larger work was promised to the archduke by, for instance, the mathematician Nikolaus Caesareus and the poet Michael Winkler.

36   Aegidius Holy, who dedicated the publication of his play to the archduke, also prepared the text for printing, including the accompanying poems.

37   For example, Renßberger's prognostics from the year 1570, which was prepared for printing, but no publication is documented.

38   Johann Ziegelius gave Archduke Ferdinand II an elegy, which he had had published with the same title three years earlier by the printer Nicolaus Curtius, *De infinitis ecclesiae catholicae malis de qve eorvm cavssis et remediis duae epistolae*, VD16 ZV 20498. Similarly, Petrus Silvius from Vienna, the translator of Löwenklau's chronicles into German, gave the archduke the manuscript of a poem entitled *Historia natalitii Messiae ac salvatoris totius generis humani Iesu Christi ex evangelistarum enarratione versibus conscripta*. A printed edition with the same title was published in 1579 in Leipzig by Georg Vögelin, VD16 V 2032.

39   Georg Miller actually published Faber's poem, without mention of his name, in several editions with differing dedications (VD16 M 6497 and others).

40   Thomas Winter, who in the foreword addresses the archduke as "vestra Munificentia".

clear shift – at the beginning he wrote everything himself, later he restricted himself to writing the dedication poem in his own hand and had the remainder copied by a professional scribe. Whereas other poets tried to win favour with shorter celebratory poems, often with decorative devices (e. g. the *carmina figurata* of Leonard Zindecker), Span stubbornly presented the archduke with longer epic compositions comprising several books: in this way he is exceptional among the authors of dedicated manuscripts. He did however share the strategy of multiple dedications with some of these other authors, especially with Christoph Nenning, who of all the other authors provides us with perhaps the best comparison to Span.

Laurentius Span did not find employment in the court of the archduke and other members of the Habsburg family as a physician, because he was prevented from so doing by the competition of better educated and more experienced persons, who also published in this field. He did not publish an original medical work in prose, unless we count the more popularly focussed health regimen and plague regimen. He restricted himself to the transferral of pre-existing material into poetic form without any striking specialist contribution of his own. As a poet, he was able to handle even the difficult form of didactic poetry in such a way that his compositions remain readable and natural. Such works, however, required a sufficiently educated public and it is not therefore surprising that in the later period of his life he acquired patrons from the ranks of high spiritual dignitaries who were able to appreciate the qualities of his poetry. His didactic compositions, initially aimed at the theme of medicine, increasingly acquired a theological dimension, which might also be explained as an effort to comply with the wishes of his new patrons. Among the authors dedicating the manuscripts of their compositions to the archduke, Laurentius Span must indeed be considered as a successful author, even though he did not win the archduke's favour: he acquired the support of other patrons with his work. The collective composition of the printed and manuscript works dedicated to Archduke Ferdinand II tells us more about which works he supported financially, and also what genres and languages he preferred. The dedicated works that remained in manuscript form show that he had little interest in certain literary genres: especially poetry, and even here he gave priority to rhymed German poetry over complicated Latin, even if it dealt with themes that he supported in prose form. The archduke's interest was not even engaged by Span's composition describing the Hvězda (Star) Summer Palace, which was quite unique in the context of the literature of the Habsburg states during this period, and would undoubtedly have impacted the literary development of Czech poetry and perhaps even prose if it had been published in print in its time.

## Appendix – List of manuscripts dedicated to Archduke Ferdinand II[41]

### Medicine, including didactic poetry:

1. Span, Laurentius: Liber de homine (Prague 1560), ÖNB, Cod. 11213.
2. Span, Laurentius: Carmen de peste, ÖNB, Cod. 11162 (dedicated to Maximilian II, provenance Ambras).
3. Ärztliche Gutachten und Ratschläge, ÖNB, Cod. 11155.

### Alchemy and natural sciences, mining and metallurgy:

4. Lohr, Johannes: Tabulae variae arithmeticae, 1569, ÖNB, Cod. 10687.
5. Fabricius, Paul: Schreib-Calender... und Prognosticon auf das Jahr 1590, 1589, ÖNB, Cod. Ser. n. 2635.
6. Descriptio germanica reditum fodinarum metall. Vallis Ioachimicae a. 1568–1578, 1579, ÖNB, Cod. 10998.
7. Caesareus, Nicolaus: Prognosticon ad. a. 1558; Opus astronomicum, quo ,Usus Annuli' demonstratur, ÖNB, Cod. 10538.
8. Caesareus, Nicolaus: Praedictiones astrologicae et astronomicae pro a. 1559–1565, 1558, ÖNB, Cod. 10545.
9. Renßberger, Nicolaus: Practica auf das Jahr 1570, ÖNB, Cod. 10593.
10. Horoscope by Paul Fabricius and Cyprianus Leovicius for Archduke Ferdinand, Innsbruck, Tiroler Landesmusem Ferdinandeum, sign. FB 32098.
11. Flock, Erasmus: Prognostica Iohannis Viterbiensis de imperiis Christiano et Turcico, ÖNB, Cod. 10637.
12. Abhandlung über die Kunst der Giesserei, 1575, ÖNB, Cod. 11024.

### History and militaria

13. Schellenschmid, Achilles Scipio: Opus germanicum de arte et disciplina militari, 1557, ÖNB, Cod. 10764.
14. Hutský, Matyáš: Icones historici, 1585, ÖNB, Cod. Ser. n. 2633.
15. Vilém of Hradešín (ordering party): Sammelhandschrift, 1562, ÖNB, Cod. 3464.
16. Holzhammer, Johann: Poema germanicum de occupatione regni Lusitanici per Philippum II. regem Hispaniarum, ÖNB, Cod. 9865.

---

41  For reasons of insufficient space, we have only provided a simple list of manuscripts without references to modern catalogues, editions and secondary literature. Apart from the electronic catalogue of the ÖNB we have drawn in particular on the following basic works: *Knihovna arcivévody Ferdinanda II. Tyrolského*, ed. by Ivo Purš and Hedvika Kuchařová , 2 vols. (Prague, 2015); Franz Unterkircher, *Die datierten Handschriften der* Österreichischen *Nationalbibliothek von 1501 bis 1600* (Vienna, 1976); *Tyrolis Latina. Geschichte der lateinischen Literatur in Tirol, I: Von den Anfängen bis zur Gründung der Universität Innsbruck*, ed. by Martin Korenjak, Florian Schaffenrath, Lav Subaric and Karlheinz Töchterle (Vienna, Cologne and Weimar, 2012); and numerous exhibition catalogues from Ambras Castle.

17. Neuner, Ieremias: Tractatus germanicus de nova methodo castra carribus muniendi a. 1587, ÖNB, Cod. 10778.
18. van der Muelen, Johannes Baptista: Descriptio quinque profectionum, ÖNB, Cod. 8932.
19. Idem: Collecta ad speculum orbis terrarum Gerardi de Iode, ÖNB, Cod. 8936.
20. Zajíc of Házmburk, Jan: Vom Schauspiel des Türkenkrieges zu Budin (*Sarmacia*), ÖNB, Cod. 8091.

## Descriptions of celebrations and occasional poetry

21. Flexel, Lienhart: Descriptio exercitii sclopetariorum publici, Freischiessen dicti, Prague 17. 9. 1565, ÖNB, Cod. 7880.
22. Flexel, Lienhart and Valentin: Beschreibung des Büchsenschießens in Innsbruck vom Jahr 1569, ÖNB, Cod. 9023.
23. Rosenfels, Philipp: Paraphrasis psalmi, ÖNB, Cod. 10075, fol. 1r–7v.
24. Petrus Hombergius Mendensis: Historia vocationis et conversionis divi Pauli, ÖNB, Cod. 10075, fol. 26r–30v.
25. Zindecker, Leonard: Carmina elegiaca pro fausti novi anni auspicio ad Ferdinandum archiducem Teriolensem, ÖNB, Cod. 10075, fol. 20r–25r.
26. Leucht, Johann: Epithalamium heroicum in nuptias ... Ferdinandi archiducis Austriae ... ducentis in uxorem ... Annam Catharinam ..., 1582, ÖNB, Cod. Ser. n. 2666.
27. Locarno, Giacom'Antonio: Poemata italica ad Maximilianum II. imperatorem et ad imperatricem, 1568, ÖNB, Cod. 10029.
28. Prudeker, Michael: Oraculum...Carmen elegiacum, quo archiduci Ferdinando Tirolensi de adventu gratulatur a. 1585, ÖNB, Cod. 9886.
29. Parsimonius, Johannes: Carmen elegiacum dubiis in rebus, ÖNB, Cod. 10139.
30. Cervoni da Colle, Giovanni: Poemata varia italica in laudem Iohannae Austriae archiducissae et Francisci Medices Etruriae ducis coniugis a. 1578, ÖNB, Cod. 10252.
31. Liginger, Wolfgang: Descriptio processionis Monachi 1584 rhytmis germanicis, ÖNB, Cod. 9862.
32. Liginger, Wolfgang: Descriptio processionis Monachi 1581 rhytmis germanicis, ÖNB, Cod. 9825.
33. Liginger, Wolfgang, Descriptio processionis Monachi 1586, ÖNB, Cod. 9828.
34. Collinus's unpreserved manuscript on the accident of Hans Gregor of Herberstein (draft for printing, see L. Veselá, Knihy dedikované, p. 433).

## Theology, spiritual poetry and Judaica:

35. Hierodinus, Hieronymus: Hymnus de conservatione ecclesiae Ferdinando Tirolensi dicatus, ÖNB, Cod. 9919, fol. 68a–70a.
36. Ziegelius, Johann: De infinitis ecclesiae catholicae malis, ÖNB, Cod. 11682.

37. Nenning, Christoph: Ad Ferdinandum archiducem Austriae comitem Tirolis de duplici nobilitate, ÖNB, Cod. 10105.
38. Winkler, Michael: Poemata religiosa archiduci Ferdinando dicata a. 1565, ÖNB, Cod. 9831.
39. Silvius, Petrus Antonius: Historia natalitii Iesu Christi versibus conscripta, ÖNB, Cod. 9897.
40. Bisterfeldius, Henricus: Carmen elegiacum in natalem DNI Christi archid. Ferdinando dicatum, 1563?, ÖNB, Cod. 9837.
41. Faber, Iacobus: Epigrammata de passione et resurrectione Christi carmine elegiaco conscripta a. 1578, ÖNB, Cod. 9903.

## Architecture and art:

42. Span, Laurentius: Ferdinandopyrgum, ÖNB, Cod. 9902.

## Theatrical plays:

43. Tragoedia de S. Catharina, ÖNB, Cod. 13232.
44. Holy, Aegidius: Salomonis iudicium, ÖNB, Cod. 9868.
45. Edelbeck, Benedikt: Weihnachtsspiel, 1588, ÖNB, Cod. 10180.
46. Lucius Georgius of Dünkelspühl: Tragoedia de Horatiis et Curiatiis, rhythmis germanicis a. 1579, ÖNB, Cod. 9832.
47. Winter, Thomas: Proedria Alexandri Magni, Hannibalis et Scipionis Africani Maioris... in iusti spectaculi forma redacta, ÖNB, Cod. 10083.

## Philology, didactic poetry:

48. Labia, Raimund: Libro, nel quale si contengono tute le sorti di lettere, che s'usano in Italia, kol. 1580, ÖNB, Cod. Ser. n. 2605.
49. Formulae inscriptionum epistolarum germanicarum, ÖNB, Cod. 8995.
50. Faber, Georgius: Poema de litterarum origine rhythmis germanicis a. 1578, ÖNB, Cod. 9833.

Katharina Seidl

# Potato flowers and lemon trees: Botanical highlights at the court of Archduke Ferdinand II

## Kunstkammer

Plants, above all those from distant lands, played a special role in the collections of Archduke Ferdinand II. Alternating between the poles of art and nature, he presented objects partly made from exotic plants and likewise actual parts of such plants, alongside sumptuous, valuable, and finely crafted collectors' items in his *Kunst- und Wunderkammer*. A few items can be named here, for example the bottle gourd.[1] (Fig. 1) In the 1596 inventory of Archduke Ferdinand II's estate (inventory held in Vienna, Kunsthistorisches Museum, Kunstkammer, inv. no. KK 6652, hereafter estate inventory KHM) the item is mentioned as follows: "A pumpkin, wider at the bottom and narrower at the top, with a long spout, engraved with a ship and other things."[2] The engravings, overdrawn in black ink, show amongst other things a fortress tower, probably that of Belim at the mouth of the Tagus River in Lisbon. Depicted on the sea in the background are a galley with reefed sails, a galleon, and a carrack with all of its sails set. At the end of the 16th century these types of ships sailed along the Indian coast, and were developed and built in Goa and Cochin. A marine map such as that created by João de Castro could have been the iconographical exemplar for these motifs, as mid-sixteenth century copies of that map do exist. The hard, watertight, and nevertheless very light shell made the calabash (gourd) highly suitable as a drink- or storage vessel. The gourd (*Lagenaria siceraria*) or calabash was the only type of pumpkin cultivated in middle Europe before the discovery of the Americas. Probably originating from Africa, it became widespread in all tropical and sub-tropical regions as a cultivated plant. The first archaeological evidence for this appears in Africa, Peru (12th – 6th millennium BCE), and Thailand (8th millennium BCE).

The estate inventory KHM describes a fan made from a palm leaf: "An Indian fan made from a whole palm leaf, decorated on both sides with leaf-ornaments three

---

1   Schloss Ambras Innsbruck, inv. no. PA 758; Annemarie Jordan Gschwend, 'As Maravilhas do Oriente: colecções de curiosidades renascentistas em Portugal / The marvels of the east: Renaissance curiosity collections in Portugal', in *A herança de Rauluchantim - The heritage of Rauluchantim*, ed. by Nuno Vassallo e. Silva, exh. cat. (Lisbon, 1996), pp. 82–127; Katharina Seidl, 'Bottle Gourd', in *Ferdinand II. 450 Years Sovereign Ruler of Tyrol. Jubilee Exhibition*, ed. by Sabine Haag and Veronika Sandbichler, exh. cat. (Innsbruck and Vienna, 2017), pp. 258–259, cat. no. 6.4.8.
2   "Mer ain Kirbiß, unnden weit unnd/oben enng, mit ainem lanngen schnabl,/darauf sein grosse schiff unnd anndere/sachen gestochen", In *Inventarj Weyland der Frh: Drt: Erzherzog Ferdinannden Zu Ossterreich etc. lobseeligister gedechtnuß Varnussen Unnd mobilien [...]*, Innsbruck 1596, Vienna, Kunsthistorisches Museum, inv. no. KK 6652, fol. 535r.

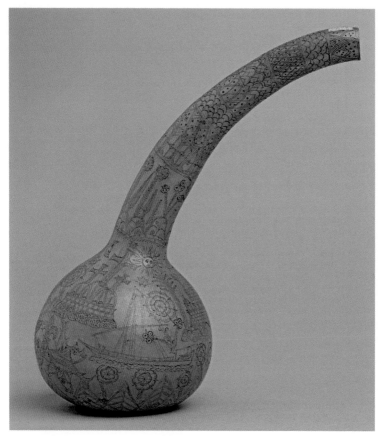

Fig. 1. Bottle guard (Schloss Ambras Innsbruck, inv. no. A 758)

fingers wide, the grip is crooked and painted red."³ (Fig. 2) The fan was probably made in Malacca on the west coast of Malaysia, an area which had been under Portuguese control since the conquest of Alfonso de Albuquerque in 1511. From there, the fan came to Europe as a gift of honour. Malacca was originally founded by the Chinese as a trading post for spices from the nearby Maluku islands. It quickly developed into a business centre, where the Chinese, Arabs, and Indians traded their goods. The almost completely round, unperforated leaves of the parasol palm (a type of fan palm found all over south-east Asia) were particularly favoured for the making of fans.

---

3    "Ain indianischer windmacher von aim ganzen plat von aim pämb, ist zu baiden seiten drei
     zwerchfinger brait von allerlai laubwerch gemacht, der still daran ist khrump und rot angestrichen",
     estate inventory KHM, fol. 533r. It could be associated with the palm leaf fan, deposited in Schloss
     Ambras Innsbruck, inv. no. PA 512; *Exotica. Portugals Entdeckungen im Spiegel fürstlicher Kunst-
     und Wunderkammern der Renaissance*, ed. by Wilfried Seipel, exh. cat. (Vienna, 2000), p. 253,
     cat. no. 163; *Frauen. Kunst und Macht. Drei Frauen aus dem Hause Habsburg*, ed. by Sabine Haag,
     exh. cat. (Vienna, 2018), p. 161, cat. no. 4.23.

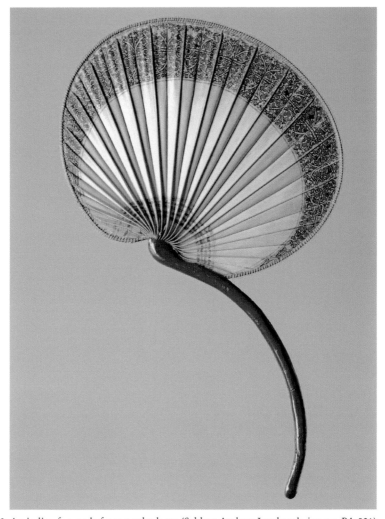

Fig. 2. An indian fan made from a palm leave (Schloss Ambras Innsbruck, inv. no. PA 521)

In the 15th showcase of Archduke Ferdinand II's *Kunstkammer* 'two mandrake roots laid on blue fabric in a drawer"[4] are described. Mandrakes are the roots of the *Mandragora officinarum*, a poisonous Mediterranean member of the nightshade family. Mandrake roots contain analgesic and hallucinogenic alkaloids, for which reason they have been used for both medicinal and magical purposes since Antiquity. The archduke's personal doctors, including Renato Brassavola (1529–1576) and Pietro Andrea Mattioli (1500–1577)[5], saw the mandrake's anthropomorphic form as a clear

---

4    "in ainem Lad auf aim Plawen daffet Zween Alraun", estate inventory KHM, fol. 511v.
5    *Ärztliche Gutachten und Ratschläge über Erzherzog Ferdinand II.*, Innsbruck, 1554, 1567/68, manuscript, Österreichische Nationalbibliothek, Cod. 11.155.

sign that it was a medicinal substance capable of affecting the whole body. In this, they were following the Doctrine of Signatures. The mandrake in the form of a crucifix[6] currently displayed in Ambras Castle had its head dotted with grass-seeds. These, when brought to sprout, served as 'hair.' A comparable mandrake was kept by Emperor Rudolf II in his own *Kunstkammer*, which also contained a pair of costumed mandrakes.

A further example of exotic fruits in Archduke Ferdinand II's *Kunstkammer* is the coconut-goblet.[7] The fruit of the coconut palm *(Cocos nucifera L.)* was often referred to as a *Meernuss* (lit. sea-nut, but not to be confused with the coco de mer, which is referred to as a *Seychellennuss* in German) during the medieval period, since it was observed that although it appeared to originate from the sea, the nut was still capable of sprouting and taking root on land. The terms '*Muskat*' and '*Muskatnuss*' (nutmeg) only appear in the inventory KHM in reference to coconuts and coco de mer, which can be attributed to the inventory scribes' lack of knowledge: "A raw nutmeg" [8], or "A whole Indian nutmeg with a mouthpiece."[9]

Carolus Clusius (1526–1609) took the Portuguese term 'cocos' for the fruit (which, botanically, is not a nut but a stone-fruit). This term derived from the fruit's similarity to the face of a meerkat *(macaco* in Portuguese). While coconut shells had always been used as cheap vessels in their tropical regions of origin, they served as rare tableware in medieval Europe. The art of making coconut goblets reached its height during the 16th century. The case was similar for the coco de mer goblet currently on display in the Vienna *Kunstkammer*.[10] (Fig. 3) This pseudo-nut is in fact the fruit of the coco de mer palm.[11] Inside the double-chambered shell there is a hard stone, wrapped in a thick hull of flesh and pith fibres. The coco de mer can reach up to 50 centimetres in diameter and up to twenty kilogrammes in weight, and is therefore the largest tree-borne fruit on earth.

These giant nuts were first brought to Europe during the 16th century by Portuguese on the sea route from India. They were first thought to have originated in the Maldives, and were therefore referred to as 'cocos of the Maldives'. For more than two

---

6   Schloss Ambras Innsbruck, inv. no. PA 687; Katharina Seidl, 'Alraune in Form eines Kruzifixes', in *Die Entdeckung der Natur. Naturalien in den Kunstkammern des 16. und 17. Jahrhunderts*, ed. by Wilfried Seipel, exh. cat. (Vienna, 2006), p. 61–62, cat. no. 2.10.

7   Kunsthistorisches Museum Wien, Kunstkammer, *Kokosnusspokal*, inv. no. KK 917; Elisabeth Scheicher, Kurt Wegerer, Ortwin Gamber and Alfred Auer, *Die Kunstkammer. Kunsthistorisches Museum, Sammlungen Schloß Ambras*, Führer durch das Kunsthistorische Museum, 24 (Innsbruck, 1977), p. 30, cat. no. 13.

8   "Ain rauche Muscetnuß, In der driten Stell", estate inventory KHM, fol. 542r.

9   "Ain halber Indianische Muscet Nuß, [...] Ain gannze Indianische Muscet Nuß. mit aim Mundt-stuckh", estate inventory KHM, fol. 304v.

10   Vienna, Kunsthistorisches Museum, Kunstkammer, inv. no. KK 6849; Katharina Seidl, 'Ewer made from half a coco de mer', in Exh. Cat. Innsbruck 2017, p. 242, cat. no. 6.3.4; Marnie P. Stark, 'Mounted Bezoar Stones, Seychelles Nuts and Rhinoceros Horns: Decorative Objects as Antidotes in Early Modern Europe', *Studies in the Decorative Arts* 11: 1 (2003/2004), pp. 69–94.

11   Robert Lee Riffle et al., *An Encyclopedia of Cultivated Palms* (Portland, 2007), p. 381.

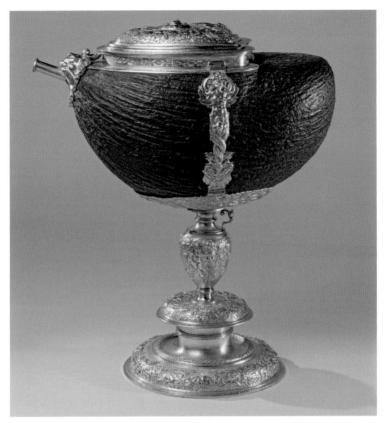

Fig. 3. Coco de mer goblet (Vienna, Kunsthistorisches Museum, Kunstkammer, KK 6849)

hundred years the origin of these nuts remained a subject of speculation, and it was during the 18th century that European first learned the nuts were in fact the fruit of trees, or more accurately palms, growing in the Seychelles. Like all rare and exotic natural specimens, coco de mer specimens were highly valued by European collectors, and very expensive. These fruits were also ascribed healing powers: they were supposed to neutralise poison, and were therefore ideal for the making of drinking vessels or pitchers. In order to produce a luxurious vessel from a coco de mer, half of the exotic nut was used, the shape of which was of course ideal for this. For the item in question, the natural specimen was set on a high, stepped foot, and secured by two flanges. The silver, gilded and richly worked setting increases the effect of the unusual natural material. The setting reflects the imagined origin of the coco de mer in the Indian Ocean with imagery of tritons, nereids, mussels, fish, and many other sea creatures.

The coco de mer goblet possessed by Archduke Ferdinand II was stored in the second showcase, the so-called *Silberkasten* (silver showcase) of his *Kunstkammer*. The 1596 estate inventory KHM described it as: "A sea-nut set on a high foot, complete

with a lid, with a crowned swan on top, silver and gilded, weighing 8 *Mark,* 10 *Lot*"[12]
(that is, just barely 2.5 kilogrammes). The crowned swan, since lost, was last confirmed
in an inventory from 1821. Vessels made from coco de mer shells were rarities much
sought after by collectors. In 1564/65, Carolus Clusius reported having seen numer-
ous coco de mer shells worked into magnificent vessels at the royal Portuguese court
in Lisbon. Today, some ten examples of such pitchers survive, three of which were part
of the Habsburg collections: apart from the example from Archduke Ferdinand II's
*Kunstkammer* given here, there were two coco de mer shell pitchers owned by the
archduke's nephew, Emperor Rudolf II.

As a final example of exotic fruits found in the *Kunstkammer* at Ambras, we can
take the rosary made from nutmegs.[13] At the beginning of the 16th century the Portu-
guese captain Alfonso de Albuquerque (who also delivered the elephant 'Hanno', and
the rhinoceros immortalised by Dürer into the menagerie of Manuel I) opened up the
route to the Maluku islands, the so-called 'spice islands'. From 1502 the Portuguese
introduced nutmeg as a commodity from the Banda islands into Europe. The first lit-
erary mention of nutmeg is found in the Portuguese doctor Garcia da Orta's 1563
work *Colóquios dos Simples e Drogas e Cousas Medicinais da* Índia. This book quickly
established itself in Europe, and became the standard reference for early European
tropical medicine. In Archduke Ferdinand II's estate inventory KHM, the chain is
probably that described here: "scented old Frankish prayer beads."[14]

## Library

The library of Archduke Ferdinand II offers a special glimpse into this thirst for
knowledge concerning everything new. The library was stocked with the most impor-
tant botanical works of the time, including books by Otto Brunfels, Pietro Andrea
Mattioli, Hieronymus Bock, Carolus Clusius, and Leonhart Fuchs.

The archduke owned the *Lexicon Medicinae simplicas Otthonis Brunfelsy,* and the
1537 Strasbourg German-language edition of the *Kreutter Peuch,*[15] both by the Mainz-
born theologian, physician and botanist Otto Brunfels (1488–1534). Brunfels did
appropriate older texts into his works, he was however the first to dedicate himself to
the precise observation and depiction of plants, a practice which remains crucial to
botany today.

In 1544 Pietro Andrea Mattioli[16] published an Italian translation of the *Materia
medica* with an extensive commentary, although it lacked illustrations. The *Materia*

---

12   "Ain grosse Mörnussen auf aim hochen fuesz sambt dem luckh, darauf ain schwan, mit aim
     drinckhrörl, silbern und vergult, wigt 8 markh 10 lot", estate inventory KHM, fol. 422r.
13   Schloss Ambras Innsbruck, inv. no. PA 709; Scheicher 1977, p. 121, cat. no. 314.
14   "Ain schmeckhete lannge Alt frennckhischer Peten", estate inventory KHM, fol. 548v.
15   Estate inventory KHM, fol. 616v.
16   Eva Ramminger, 'Pier Andrea Mattioli', in *Vom Codex zum Computer,* ed. by Gerd Ammann, exh.
     cat. (Innsbruck, 1996), p. 116, cat. no. 2.34; Veronika Sandbichler, 'Pier Andrea Mattioli', in *Herrlich
     Wild. Höfische Jagd in Tirol,* ed. by Wilfried Seipel, exh. cat. (Innsbruck, 2004), p. 183, cat. no. 6.21.

*medica,* a pharmaceutical text produced by Dioscorides in the 1st century CE, counted among the most important medical texts of Antiquity and copies were disseminated throughout the middle ages. In five books, the work describes healing substances derived from botanical, animal, and mineral sources, and their usages. During the Renaissance new commentated editions proliferated.

A second edition, extended to include a sixth book on antidotes, appeared in 1548, followed by a third and further extended edition in 1550/51. In Venice in 1554 Mattioli published a fully revised Latin version of his commentary under the title *Commentarii in sex libros Pedacci Dioscoridis,* completed with 563 woodcuts based on illustrations by various artists, including Giorgio Liberale.

In 1555, Mattioli had been called to Prague by Emperor Ferdinand I to act as court doctor to his son, Archduke Ferdinand II, in 1555. One reason for Mattioli's move may have been a promise on the part of the Habsburgs to finance the publication of his herbal, originally part of the text of the *Commentari.* It should be emphasised that the *Herbář* was financed not only by the Habsburgs and the finances released by the *Böhmischer Landtag* (Bohemian Diet), but was also supported by representatives of the domestic nobility and townspeople.[17] The Bohemian Diet asked the emperor on two separate occasions to release funds from taxes for the publishing of the herbal (Diet assembly in 1558, 250 *kop großen* (kop = amount of "sixty"); 1561, 300 *kop*). The dedication of the Czech herbal also mentions fourteen high-ranking Czech aristocrats and fourteen Czech knights; their coats of arms are depicted in the book. The only burgher mentioned was the *Rat* of the Prague Old Town.[18] The text was translated from Latin into Czech by Tadeáš Hájek of Hájek, who also expanded the herbarium considerably, adding many botanical species known in Bohemia (for more details concerning Hájek, see the article by Ivo Purš in this volume). The book *Herbář, jinak bylinář* was printed in 1562 in Prague and was accompanied by full-page woodcuts by several artists including Liberale, who arrived in Prague to work with Mattioli. Some of these woodcuts were taken from the *Commentarii.* After his return to Italy, Giorgio Liberale was still in the contact with the archduke, and finally entered his service in Innsbruck in 1576/77. Here he continued work on large scaled zoological drawings. After the Czech publication, a year later a German translation came out translated by Georg Handsch (1529–1578), future physician to Archduke Ferdinand II (*Neuw Kreütterbuch,* 1563).[19]

Because of the level of demand, Joachim Camerarius (d. 1586) edited a new version of Handsch's translation, complemented by illustrations from the estate of Conrad Gessner. This edition included, among other things, new curiosities like the *Goldapfel* (lit. gold apple), better known today as the tomato. (Fig. 4) Mattioli was not particu-

17    Mirjam Bohatcová, 'Čtení na pomezí botaniky, fauny a mediciny. České tištěné herbáře 16. století', *Sborník Národního Muzea v Praze, řada C – Literární historie* 38 (1993), pp. 1–65 (34).

18    Miroslava Hejnová, *Pietro Andrea Mattioli 1501–1578. U příležitosti 500. výročí narození / in ocassione de V centenario della nascita* (Prague, 2001), pp. 14–16.

19    Hejnová 2001, p. 32.

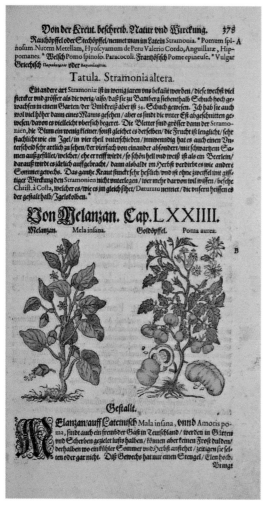

Fig. 4. Poma aurea (tomato), in Pietro Andrea Mattioli, Kreutterbuch, Frankfurt 1586 (Herzog August Bibliothek Wolfenbüttel)

larly impressed by this then primarily decorative plant: "In some places it is also called *Amoris poma*, they have become common in all gardens and therefore need little description." He describes the effects of the plant thus: "In *Welschland* [Italy] it is normal to eat them cooked with pepper, oil and vinegar, but it is an unhealthy food, that can give very little nourishment."[20]

Mattioli's text is simultaneously the first documentation in the history of the horse chestnut's immigration into the Habsburg empire: "It is yet another foreign species of the chestnut, which I have had illustrated for the sake of its beautiful appearance. This branch, complete with the fruit, was sent to me from Constantinople by the very famous Augerius, the Christian Emperor's own legate." A description of the fruit is followed by it usages: "They taste almost the same as our own, but are sweeter and not so fleshy to eat. The Turks call them horsechestnuts, because they are helpful for short-winded horses."[21] (the chestnut can be found already in 1562 and 1563 edition, Fig. 5) The 1596 inventory KHM of Archduke

---

20   "Man nennt diese an ein theil orten auch Amoris poma, sindt in allen Gärten gemein worden/darumb es nicht viel beschreibens bedarff.... In Welschland pflegen diese Frucht etliche zu essen mit Pfeffer/ öl und Essig gekocht/ aber es ist ein ungesunde speiß/ und die ganz wenig nahrung geben kann." *Kreutterbuch Deß Hochgelehrten und weitberühmten Herrn D. Petri Andreae Matthioli: Sampt dreyen wolgeordneten nützlichen Registern, der Kreutter Lateinische vnd Deutsche Namen, und dann die Artzneyen, darzu dieselbigen zu gebrauchen, jnnhaltend. Jetzt widerumb mit vielen schönen neuwen Figuren, auch nützlichen Artzneyen ... auß sonderm fleiß gemehret, und verfertigt / Durch Ioachimum Camerarium, der löblichen Reichsstatt Nürmberg Medicum,* ed. by Joachim Camerarius (Frankfurt, 1586), p. 378 (hereafter Mattioli 1586).

21   "Sie schmecken fast wie die unsern/ sind doch süsser/ und nicht so lieblich zu essen. Die Türken nennens Roßcastanien/ darumb daß sie den keichenden Rossen sehr behülfflich sind." Mattioli 1586, p. 67.

Ferdinand II's estate also names further books by Mattioli: *Epitome de plantis, Appologia Petri Andreae Mattheolj, Epistolae medicinales*,[22] *Compendium plantarum*,[23] *de medica materia, Kreütterpuech*,[24] *Il Dioscoride*,[25] as well as four works without title details.[26]

Carolus Clusius[27] (Charles de l'Ecluse, 1526–1609) studied law in Löwen and Marburg, and medicine in Wittenberg. In 1550 he continued his studies in Montpellier under the naturalist and doctor Guillaume Rondelet. There, in the face of the region's rich flora, his interest in the world of plants grew. This interest prompted his first botanical work, a French translation of the newly published *Kräuterbuchs* by Rembertus Dodonaeus.[28] From 1560 Clusius travelled to Paris and through the Netherlands, and in 1564 he began a two-year scientific expedition through Spain and Portugal. In England, in 1571, he was introduced to Nicolas Monardes' *Flora der Neuen Welt*.[29]

Fig. 5. Castanea equina (chesnut tree), in Pietro Andrea Mattioli, Neuw Kreütterbuch, 1563 (Prague, National Library of the Czech Republic, sign. 16 A 50)

22  Estate inventory KHM, fol. 614v.

23  Estate inventory KHM, fol. 615r.

24  Estate inventory KHM, fol. 615v.

25  Estate inventory KHM, fol. 616r.

26  Eleven books by Mattioli concerning botany and also medicine are mentioned in estate inventory from Österreichische Nationalbibliothek in Vienna, *Inventarium germanicum rerum mobilium archiducis Ferdinandi Oenipontati verfasser. Karl von Wolkenstein*, 1596, sign. Codex 8228, published by Wendelin Boeheim, 'Urkunden und Regesten aus der k.k. Hofbibliothek', *JKSAK* 7 (1888), pp. XCI–CCCXIII, see Olga Fejtová and Jiří Pešek, 'Varii variarum rerum, factorum, dictorum, multarumque aliarum historiarum scriptores. Dějepisná literatura', in *Knihovna arcivévody Ferdinanda II. Tyrolského*, ed. by Ivo Purš and Hedvika Kuchařová , 2 vols. (Prague, 2015), I, pp. 181–208 (p. 198); for a discussion see also a chapter by Smolka in this volume, pp. 276–278.

27  Katharina Seidl, 'Rariorum aliquot Stirpium per Pannoniam, Austriam et vicinas provincias observatatum historia, quatuor libris expressa', in Seipl 2006, pp. 62–64, cat. no. 2.11.

28  *Aus dem Kräuterbuch des Dodonaeus*, ed. by Hildegard Guembel (Brüssel, 1943).

29  Nicolas Monardes, *Historia medicinal de las cosas que se traen de nuestras Indias Occidentales* (Sevilla, 1565).

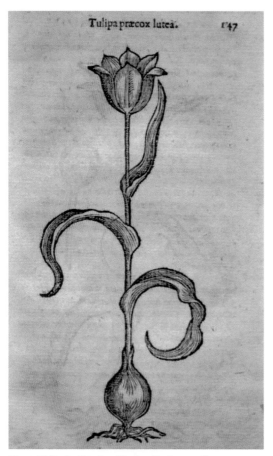

Tulipa præcox lutea.        147

Fig. 6. Tulip, in Carolus Clusius, Rariorum aliquot Stirpium per Pannoniam, Austriam [...], Antwerpen 1583 (St. Louis, Missouri Botanical Garden, Peter H. Raven Library)

A decisive factor in his scientific progress was the task appointed to him by Emperor Maximilian II in 1573, to found and cultivate a *Hortus medicus*, an apothecary garden, in Vienna.[30] Clusius stayed in the Emperor's service for fourteen years. During this time he travelled the whole of Austria and Hungary, to research the native middle-European flora. Through botanical excursions on the Ötscher and the Schneeberg Clusius became the first to develop a knowledge of Austrian alpine vegetation.

Clusius compiled the results of these expeditions in his 1583 scientific work *Rariorum aliquot Stirpium per Pannoniam, Austriam et vicinas provincias observatarum historia*, which was published by Christoph Plantin in Antwerp. On pages 154–55 we see a depiction of a tulip: "Tulip praecox R. v." (Fig. 6) Clusius saw a tulip for the first time in Vienna, which was one of the few sixteenth century ports to Turkey and the Muslim Orient. Turkmen nomads had already brought the wild variety of tulips to Anatolia in the 13th century. By the 16th century the tulip had established itself there as a symbol of the spring and fertility, and therefore also as the favourite flower of the sultan. The Fleming Ogier Ghiselin de Busbecq (1522–1592), a friend of Clusius, was Emperor Ferdinand I's envoy at the court of Sultan Suleiman I. The sultan was a passionate enthusiast and collector of tulips. In 1554 Busbecq sent tulip seeds and bulbs to Clusius at the court in Vienna, and here Clusius had his first experience with these exotic bulbous flowers. Clusius was also responsible for bringing tulips to the Netherlands, when he travelled to Leiden as court botanist. During the 17th century the tulip became a favourite item of fiscal speculation; this went so far as to cause a 'tulipmania', whereby single bulbs of certain varieties reached prices of up to 13,000 guilder.

---

30   For details see Jochen Martz, 'Die Gärten an der Wiener Hofburg im 16. und 17. Jahrhundert und die Entwicklung der Zitruskultur', *Studia Rudolphina* 10 (2010), pp. 68–88.

Leonhard Fuchs[31] (1501–1566), along with Otto Brunfels and Hieronymus Bock, is considered one of the fathers of German botany. Following foundational studies at the faculty of arts in Erfurt, Fuchs studied at Ingold under Professor Reuchlin from 1519 until 1524, when he graduated to doctor of medicine. Following two years working as a doctor in Munich and a professorship at the catholic university in Ingolstadt, Fuchs, having converted to Protestantism, moved to the position of personal doctor to the *Markengraf* (margrave) Georg von Brandenburg, in Ansbach. In 1535 he was called to Tübingen through the mediation of Phillip Melanchton, where he developed his botanical work through field studies undertaken with his students. Fuchs first published the discoveries he made during this period in 1542 as a Latin work entitled *De Historia stirpium*.[32] In the following year the German edition appeared under the title *New Kreüterbuch*, in which more than 400 European and 100 exotic plants were described. Here the text was illustrated for the first time with woodcut prints, which were not only artistically pleasing, but also botanically highly informative. Three artists were involved in the production of these botanical depictions: the painter Albrecht Meyer delivered the templates, which had been painted from life, Heinrich Füllmaurer transferred these to the wooden printing block, and the form cutter was Veyt Rudolf Speckle. The illustrations are remarkable not only for the accurate detail in the depiction of each plant, but also for the exact portrayal of the various stages of growth from bud to fruit.

In terms of contents this early herbal already signalled the emancipation of botany from its role as a discipline solely devoted to assisting medicine. Fuchs records plants in his work that he clearly does not credit with any medicinal uses.

The page to which the book is opened shows, after the manner of Pliny's *Natural History*, a large pumpkin and a small pumpkin. The subjects here are those varieties of pumpkin which first arrived in Europe during the 16th century, where previously only the gourd (originally of African origin) had been known. Archduke Ferdinand II's library also contained the *Institutiones Medicina Leonardi Fuchsy*[33], *Leonhardus Fuckhius de componendorum medicamentorum ratione*,[34] *Leonardus Fuckhsius de curandi ratione*,[35] and *Leonardus Fucchsius de curandi ratione*.[36]

31  Georg Kugler, 'New Kreüterbuch, Leonhard Fuchs', in *Kaiser Ferdinand I. 1503–1564. Das Werden der Habsburgermonarchie*, ed. by Wilfried Seipel, exh. cat. (Vienna, 2003), p. 501, cat. no. VIII.19; Werner Dressendörfer, *Blüten, Kräuter und Essenzen. Heilkunst alter Kräuterbücher* (Darmstatt, 2003), pp. 39–42.

32  Frederick G. Meyer, Emily Emmart Trueblood and John L. Heller, *The Great Herbal of Leonhart Fuchs. De historia stirpium commentarii insignes, 1542*, 2 vols. (Stanford, CA 1991).

33  Estate inventory KHM, fol. 613v.

34  Estate inventory KHM, fol. 612r.

35  Estate inventory KHM, fol. 612v.

36  Estate inventory KHM, fol. 614v.

## Park and apothecary garden

Archduke Ferdinand II did of course also take living plants into his collection: in the park at Ambras he had southern trees (pomegranate, fig, quince, peach, orange and lemon), as well as exotic Damascus and Muscat roses planted.[37] Citrus plants, planted in large tubs, only spent the warmer seasons outside. In turn, the descriptions given by Pietro Andrea Mattioli in his herbal played an important role in choosing plants for the garden. For example, Mattioli names the so-called *Adamsäpfel* (Adam's apple), a variety of lemon: "The juice has all the same properties as those credited to the juice of the lemon, but it is not so strong. It is particularly helpful against blemishes of the skin and mange / when you chop an apple / and sprinkle it with crumbled sulphur / roast it a little under warm ashes / and use this to coat the sickly areas of skin."[38] With the pomegranate, Mattioli distinguished sweet and sour types, stating that the sour is more effective: "The sour is astringent and clotting, cool and refresh the mouth, slake thirst, are good for a heated stomach, repress the gall/ encourage urination."[39]

The fig is singled out by Mattioli as "the least harmful of all fruits / since they do not tarry for long in the stomach/ by which they would be destroyed, but rather go and bring forth."[40] The quince "is much-needed in the apothecary / since people make a juice/syrup/puree/oil/ from it also the seed and twigs are used and the flowers and all such serve to clot fluids throughout the body."[41]

Peaches were to eaten in quantity before the meal, "so that they do not stay long in the stomach but rather pass through quickly and so soften/prepare the stomach." Dried boiled peaches are healthier, in that they calm "the fluids of the stomach and the belly," or "the blood," when prepared as a puree against worms in children.[42]

All other citrus fruits, whether lemons, bitter oranges, or limes, were particularly highly valued, since their distillations were also used in beauty treatments: "The females also need such water, to make their faces clear, it is also good against other blemishes on the body." [43]

---

37    Josef Hirn, *Erzherzog Ferdinand II. von Tirol. Geschichte seiner Regierung und seiner Länder*, I (Innsbruck, 1885), p. 357.

38    "Der Saft aus diesen Öpfeln vermag alle wirckung welche den Limonien zugeschrieben worden ist/ doch nicht gar so krefftig. Insonderheit aber dienet er trefflich wol wider den Grindt/ und reude/ so man einen Apfel mitten entzey schneidet/ gestossen Schwefel darauff strewet/ ein wenig unter warmer Aschen bratet/ und damit die schebichte Haut bestreicht." Mattioli 1586, p. 80.

39    "Die sauren ziehen zusammen und stopfen/ kühlen und erfrischen den Mund/ leschen den durst/ sind gut dem hitzigen Magen/ unterdrücken die Gall/ fürdern den Harn." Mattioli 1586, p. 77.

40    "unter allem obst das unschädlichste/ denn sie seumen nicht lange in dem magen/ damit sie möchten zerstöret werden, sondern gehen und bringen fort." Mattioli 1586, p. 101.

41    "braucht man viel in den Apotecken/ denn man macht darauß einen Safft/Sirup/Latwergen/Oele/ auch nützt man die Kern/Laub/ und Blumen/ unnd solchs alles dient zur stopfung allerley Flüsse deß ganzen Leibs." Mattioli 1586, p. 82.

42    "damit sie nicht lang im Magen liegen/ sondern schnell durchgehn/ also erweychen sie den Bauch ... die Flüsse des Magens und deß Bauchs ... der Blüt." Mattioli 1586, p. 84.

43    "Die Weiber brauchen auch solch Wasser, das Angesicht darmit klar zumachen/ es ist auch gut wider andere Flecken am Leibe." Mattioli 1586, p. 80. For a trade with citrus fruits in Central Europe and

Archduke Ferdinand II's personal doctor Georg Handsch, together with the apothecary Gorin Guaranta, developed numerous new medicines from tried and trusted herbs and spices, but also from those originating in Africa, India and New World.[44] Empirical experiments were used to determine the effects of the medicinal herbs. In his notes Handsch describes how Mattioli first gave a prisoner sentenced to death a mixture of blossoms, leaves and seeds of the highly poisonous aconite (commonly known as monkshood or wolfsbane) brought from Siberia and then (in this case without success) attempted to allay the poison's effects using a mixture of medicinal herbs named the 'Archduke's powder' after Archduke Ferdinand II. The same antidote had helped a prisoner poisoned with arsenic.[45]

The pharmacopoeia produced by Anna Welser (mother of Philippine Welser) clearly reflects the pragmatic connection between traditional knowledge and awareness of contemporary conventional medicine. Alongside Anna Welser's personal recipes we find entries reliant on the reports of other women knowledgeable in the healing arts, such as the "old Heidenreichin" (Anna Maria Heidenreichin, a court lady to Philippine Welser), but are also based on the work of doctors such as Johann Willebroch (later the personal physician to Archduke Ferdinand II).[46] A progressive and marked difference from other pharmacopoeias of the period is the emphasis on hygiene and the instruction to use clean materials and to prepare the patients by bathing them before various procedures.

## Kitchen

While Anna Welser's pharmacopoeia develops from initial recipes for the making rose-syrup into an unmistakeably medical work, another manuscript owned by Philippine Welser is clearly a collection of recipes commissioned for her marriageable daughter. With the stereotypical opening for the recipes: "if you want to make / bake / boil [...]"[47] and recipes that only seem to be what their name implies (for example, 'game' made from eggs or beef), Philippine's cookbook sits firmly in the tradition of late medieval recipe collections. However, the book's inclusion of dishes from other lands, above all those from the Romanic regions, does anticipate a feature of Baroque cookbooks.

terminology of Mattioli see Sylva Dobalová and Jaroslava Hausenblasová, 'Die Zitruskultur am Hofe Ferdinands I. und Anna Jagiellos: Import und Anbau von Südfrüchten in Prag 1526–1564', *Studia Rudolphina* 15 (2015), pp. 9–36.

44  Hirn 1885, p. 362, 363.

45  Michael Stolberg, 'Empiricism in Sixteenth-Century Medical Practice: The Notebooks of Georg Handsch', *Early Science and Medicine* 18:6 (2013), pp. 487–516.

46  Josef Hirn, *Erzherzog Ferdinand II. von Tirol. Geschichte seiner Regierung und seiner Länder*, 2 (Innsbruck, 1888), p. 327.

47  "wilt du [...] machen/bachen/syeden." Kochbuch der Philippine Welser, Schloss Ambras Innsbruck, inv. no. PA 1473.

Philippine's handwritten addenda show above all her interest in the healing crafts, so that we find for example a group of recipes with the heading, "these are good to eat for all people when they are weak."[48]

In Archduke Ferdinand II's court kitchen, it was not only the *Gardaseefrüchte* (fruit of Lake Garda) such as lemons, oranges, pomegranates, and peaches that were put to use. Corn, tomatoes or runner beans were also prepared as exquisite dishes spiced with pepper, nutmeg, cinnamon, and cloves. Marx Rumpolt, who served for a little while as personal cook to Archduke Ferdinand II's mother, Anna of Bohemia and Hungary, as well as to the archduke himself, was possibly the first to include the potato (long used as a purely decorative plant) in his *New Kochbuch*.

Little more is known about the Hungarian-born Rumpolt, who served as personal cook to the *Kurfürst* (Prince Elector) Daniel Brendel, than what he wrote in the prologue to his cookbook. He gives a brief account of his erratic, itinerant life, but without omitting to mention that one of his own recipes had become a favourite dish of Anna of Bohemia and Hungary – the mother of Archduke Ferdinand II – while he was serving at her court. The fact that he purloined kitchen utensils and provisions for his own guests while he was serving as personal chef at Ambras Castle remains unmentioned: this was the reason for the termination of his employment.[49]

*Ein New Kochbuch*[50] appeared in Frankfurt am Main in the year 1581. Rumpolt emphasised the uniqueness of his textbook in the prologue, but he actually took many ideas from other works. Given the 2000 recipes included in his book, which were also "prepared according to Czech, Hungarian, Hispanic, Italian and French wisdom/knowledge,"[51] this is hardly surprising.

In the chapter entitled "Concerning diverse vegetables," we read on page 144: "*Erdepffel* (earth-apples). Peel and slice them small / soak them in water / and press it out well in a hair-towel / chop them small / and roast them in bacon-fat / that has been finely chopped / add a little milk / and let it boil / so it will be good and delicious."[52]

The first mention of the potato appears in the 1552 work *Historia general de las Indias*, composed by Francisco López de Gómara, secretary to Hernán Cortés. The tuber found its way to Europe as a decorative plant through the auspices of Carmelite monks. In 1588 Carolus Clusius received two tubers and one fruit from the Belgian

48  "die seind guet allen Leuten zu essen wan sy schwach sind". Kochbuch der Philippine Welser, Schloss Ambras Innsbruck, inv. no. PA 1473, fol. 125 v.

49  Katharina Seidl, 'Ein New Kochbuch', in *Fürstlich Tafeln*, ed. by Sabine Haag, exh. cat. (Vienna, 2015), p. 44–45, cat. no. 7; see also my essay in this catalogue: idem, '"Ohne allen zweiffel aber ist vnter gedachten Künsten nit die geringste Kochen oder Küchenmeisterey". Kleine Kostproben des Küchenhandwerks in der Renaissance', in ibidem, pp. 13–20.

50  Marx Rumpolt, *Ein New Kochbuch* (Frankfurt am Main, 1581); Innsbruck, Universitäts- und Landesbibliothek Tirol, sign. 100572.

51  "auff Teutsche, Vngerische, Hispanische, Italianische vnd Frantzösische weiß." See Rumpolt 1851, Preface, pp. 1–7.

52  "Erdepffel. Schel und schneidt sie klein / quell sie in Wasser / unnd druck es wol auß durch ein Härin Tuch / hack sie klein / und rößt sie in Speck / der klein geschnitten ist / nim ein wenig Milch darunter / und laß damit sieden / so wirt es gut und wolgeschmack." See Rumpolt 1581, p. 144.

Phillipe de Sivry. Sivry had been given these by a papal envoy under the name 'Tara-touffli'.

Whether the *Erdepffel* mentioned by Rumpolt were actually potatoes, or rather some other root vegetable, and whether Archduke Ferdinand II owned any potatoes or indeed had ever eaten one himself, remains in any case impossible to prove beyond all doubt.

Kunstkammer, Collections,
Cultural Transfers

Veronika Sandbichler

# The reconstruction of the *Kunst-* and *Wunderkammer* of Archduke Ferdinand II: 'Facts 'n' Figures', an interim report

In 1565 the first work to touch upon the contents and organisation of a *Kunst-* and *Wunderkammer* appeared: Samuel Quiccheberg's *Inscriptiones vel tituli theatri amplissimi [...]*, written in connection with the *Kunstkammer* of the Bavarian duke Albrecht V.[1] In this work the art theoretician, who was a native of Antwerp, described the ideal *Kunstkammer*. He also described the *Kunstkammer*'s assembly as 'preparation' of knowledge, in terms of a categorisation of art objects and natural specimens that had been specially designed for the collection. Firstly, he defined the terms *Kunstkammer* and *Wunderkammer*, using the collection of the counts of Zimmern (*Grafen von Zimmern*) as his concrete example, "whose repository cannot be called a *Kunstkammer*, which is a room filled with artful objects, but rather must be called a *Wunderkammer*, since it is a repository of wondrous things"[2].

In the context of this discussion, it is most significant that Quiccheberg's treatise lists exemplary collectors, including Emperor Maximilian II and his brothers, the archdukes Karl II and Ferdinand II (1529–1595). This paper concerns itself specifically with the *Kunst-* and *Wunderkammer* of Archduke Ferdinand II at Ambras Castle.[3] Quiccheberg writes that "these repositories deserve to be described in individual books, and thus preserved for posterity"[4]. This leads us to conclude that the collection of Archduke Ferdinand II must have already existed in some form by this point time.

The term *Kunstkammer* has however also been found in a document from 1554, in connection with the acquisition of objects for the "Kunsst Camer" of Ferdinand I, father of Archduke Ferdinand II, as well as in a report from 1558 concerning the "building of a *Kunstkammer*" within the Vienna Hofburg.[5] Both of these references

1   Harriet Roth, *Der Anfang der Museumslehre in Deutschland. Das Traktat „Inscriptiones vel Tituli Theatri Amplissimi" von Samuel Quiccheberg*, Latin-German edition (Berlin, 2000).

2   "[...] cuius equidem promptuarium [...] non iam Kunstkamer, quod est artificiosarum rerum conclave, sed solum Wunderkamer, id est miraculosarum rerum promptuarium undique rerum vocant [...]", quoted from Roth 2000, p. 194.

3   Roth 2000, p. 169.

4   "quorum etiam promptuaria digna forent, ut singulis libris describerentur et posteritati commentarentur", quoted from Roth 2000, p. 169.

5   "erpauung einer khunstkhamer", Alphons Lhotsky, *Festschrift des Kunsthistorischen Museums zur Feier des fünfzigjährigen Bestandes. Zweiter Teil: Die Geschichte der Sammlungen. Erste Hälfte: Von den Anfängen bis zum Tode Kaiser Karls VI. 1740* (Vienna, 1941–1945), pp. 144–145; Franz Kirchweger, 'Die Schätze des Hauses Habsburg und die Kunstkammer. Ihre Geschichte und ihre Bestände', in *Die Kunstkammer. Die Schätze der Habsburger*, ed. by Sabine Haag and Franz Kirchweger (Vienna, 2012), pp. 12–49 (17); Franz Kirchweger, 'Die Kunstkammern der österreichischen Habsburgerinnen und Habsburger: Ein kurz gefasster Überblick', *Frühneuzeit-Info* 25 (2014), 45–66.

predate Quiccheberg's 1565 tract. The terms "Kunst- und Wunderkammer" were first used in relation to Ambras Castle and the collection of Archduke Ferdinand II in a 1588 letter from Archduke Ferdinand to Baron (*Freiherr*) Sigmund Khevenhüller. This letter discussed the purchasing of "[...] antiquities, a good number of which have already been brought together in our *Kunst-* and *Wunderkammer*, so that they may especially delight us and be experienced by us.[6] Finally, in 1594 the "*Kunst* or *Wunderkammer*: likewise the armoury (*Rüst- und Harnischkammer*)" were all named in the codicil of Ferdinand's last will and testament.[7]

### The collection of Archduke Ferdinand II

A pen and ink sketch by Joris Hoefnagel, completed in the 1580s after a template by Alexander Colin, shows a view of Innsbruck and Ambras Castle (Fig. 1). The inscription above the palace reads: "Castrum Ameras a sereniss[imo]: Archiduce Ferdinando Austriaco extructum, in quo et eius bibliotheca et Musaeum"[8]. Here we find the first instance of the term 'museum' being applied to Ambras. It is not only the museum which is mentioned here, rather we find mention of both the museum and the library in the same breath: "bibliotheca et Musaeum". This in turn leads us back to Samuel Quiccheberg, who in his *Inscriptiones vel Tituli Theatri Amplissimi* described the ideal collection as one paired with a library of relevant and straightforward encyclopaedias of all conceivable knowledge.[9] The fact that the library at Ambras Castle was located very near to the collection is made clear by Matthäus Merian's 1649 copperplate engraving *Das Fürstliche Schloss Ambras.*[10] Despite the late appearance of this work (approximately 60 years after the death of Archduke Ferdinand II) there were no significant alterations to the building in the intervening period, so this representation still reflects the conditions as they were during Ferdinand's lifetime (Fig. 2).[11]

In the left picture field (geographically the southern side of the view represented) we recognise an irregular complex that is clearly comprised of multiple buildings, with four main wings and open on one side. Here we find the building erected in approxi-

---

6   "[...] antiquiteten [...], deren auch albereit ain guete anzal in unser kunst- und wunderkamer unzther zusamenbracht und uns darmit sonderlich delectiren und erlieben [...]", David von Schönherr (ed.), 'Urkunden und Regesten aus dem k.k. Statthalterei-Archiv in Innsbruck', *Jahrbuch der kunsthistorischen Sammlungen des Allerhöchsten Kaiserhauses* (hereafter as *JKSAK*) 17 (1896), pp. I–CVIII, reg. 14035 on p. I; cf. Kirchweger 2014, p. 49.

7   "Auch der khunst: oder wunder: dißgleichen Rüst: und Harnisch Cämera", codicil to the last will and testament of Archduke Ferdinand of Tyrol, from 30th March 1570 (18 June 1594), pages unnumbered. Vienna, Haus,- Hof- und Staatsarchiv, Habsburg-Lothringisches Familienarchiv, Familienurkunden, no. 1463; cf. auch Alois Primisser, *Die k.k. Ambraser-Sammlung* (Vienna, 1819), p. 3.

8   Vienna, Kunsthistorisches Museum, Kunstkammer, inv. no. KK 5351.

9   Roth 2000, p. 79.

10  Copperplate engraving on paper from: Matthäus Merian, *Topographia Provinciarum Austriacarum [...]* (Frankfurt am Main, 1649).

11  On the history of the building, cf. Elisabeth Scheicher, 'Schloss Ambras', in *Die Kunstdenkmäler der Stadt Innsbruck. Die Hofbauten*, ed. by Johanna Felmayer, Österreichische Kunsttopographie, 47 (Vienna, 1986), pp. 509–623.

Fig. 1. Joris Hoefnagel after Alexander Colin, View of Innsbruck and Ambras Castle (Vienna, Kunsthistorisches Museum, Kunstkammer, inv. no. KK 5351)

Fig. 2. Matthäus Merian, Ambras Castle, from Tophographia Provinciarum Austriacarum, 1649 (Schloss Ambras Innsbruck, inv. no. PA 1505)

mately 1572 as the "Kornschütte". The ground floor of this building was used as the archducal stables ("Klepperstall"), and the upper floor as the library ("Bibliothec").[12] The arrangement of stables in the lower floor and collections in the upper floor of the same building is found in comparable princely *Kunstkammern*: for example, in the ducal stables in Munich and the "Neue Stall" (new stables) built by the Prince Elector (*Kurfürst*) Christian I in Dresden between 1586 and 1590.[13] In Ambras, this same arrangement is used for the placement of the library. On the narrow north-western side, the *Kunstkammer* and armoury are connected to one another at an obtuse angle. In 1589 the heroic armoury (*Heldenrüstkammer*) was finally built onto the western tract of the existing armoury. The collections were connected to the library in the "Kornschütte" by an additional two-levelled arcade. This is not the only conformance to Quiccheberg's recommendations: according to his treatise the collection should be housed in a building comprised of multiple wings, and independent from the main residence. This is the case at Ambras, where we can recognise the clear spatial distinction between the "Kornschütte" and the residential and prestige buildings lying to the northeast of the estate (the *Hochschloss* [lit. 'upper castle'], "Grosser Saal" [lit. 'great hall'], *Ballspielhaus* [hall for ball-games], and garden terraces).

### The estate inventory of 1596

The only extant written records detailing the contents of Ferdinand's "Musaeum" at the time of its foundation are for the armoury.[14] There is no specific inventory for the *Kunst-* and *Wunderkammer* from this period. One of the earliest sources on this topic are the travel journals of Hans Ernstinger, who travelled to Innsbruck in 1579, 1583, 1595 and 1605, and later summarised all of his experiences there, along with all he saw, into a single report.[15] He reports about Ambras Castle and the *Kunst-* and *Wunderkammer* of Archduke Ferdinand II as follows:

---

12   For an introduction to the library, see: Alfred Auer, 'Das Inventarium der Ambraser Sammlungen aus dem Jahre 1621. II. Teil: Bibliothek', *Jahrbuch des Kunsthistorischen Museums Wien* 2 (2001), pp. 281–345.

13   Lorenz Seelig, 'Die Münchner Kunstkammer', in *Die Münchner Kunstkammer*, III: *Aufsätze und Anhänge*, ed. by Willibald Sauerländer and Dorothea Diemer (Munich, 2008), pp. 1–114 (12–14); Dirk Syndram, '"Diese Dinge sind warlich wohl wirdig das sie in derselben lustkammer kommen." Kurfürst August, die Kunstkammer und das Entstehen der Dresdner Sammlungen', in *Dresden & Ambras. Kunstkammerschätze der Renaissance*, ed. by Sabine Haag, exh. cat. (Vienna, 2012), pp. 17–29 (24).

14   *Designatio germanica armamentarii arcis Ambrasianae prope Oenipontum Innsbruck*, after 1583. Ink on paper, Vienna, Österreichische Nationalbibliothek, Department of manuscripts and rare books, sign. Cod. 7954; cf. Wendelin Boeheim, 'Urkunden und Regesten aus der k.k. Hofbibliothek', *JKSAK* 7 (1888), pp. XCI–CCCXXII, reg. 5440 on pp. CLXXXIX–CCXVIII.

15   *Hans Georg Ernstingers Raisbuch*, ed. by Philipp Alexander Ferdinand Walther, Bibliothek des Literarischen Vereins in Stuttgart, 135 (Tübingen, 1877).

> Not even a half-hour's walk from Innsbruck, on a rise, there lies Schloss
> Ambras, built by the Archduke Ferdinand of most praised memory,
> and in that place there are many beautiful things to see, firstly the
> *kunstcammer* filled with all manner of strange, artful and precious
> things, kept in the unusual cabinets, which are not shown without the
> special permission of his noble grace the Margrave [*marggrafen*,
> modern: *Markgraf*] Karl of Burgau (since the castle and the lordship
> now belong to him).[16]

It is clear, then, that Ernstinger visited Ambras after Ferdinand's death in 1595, since the protocol for visiting was under the authority of Ferdinand's heir, Karl of Burgau. Apart from this subjective travel report, the first comprehensive overview of the *Kunst-* and *Wunderkammer* is provided by the 1596 inventory of Ferdinand's estate.[17] This records all of the objects collected there, as well as their organisation and positioning within the room.

The inventory was created as a legal record of the stocktake of Archduke Ferdinand II's estate after his death in 1595. The authors were administrative officials, and therefore not experts equipped with specialised knowledge. This explains the high frequency of inept descriptions and recording of items, a factor which makes identifying the extant objects today more difficult. Only in the case of the goldsmiths' works do we find exact details of weight and material composition, as this was necessary for evaluating the material worth of the items. The inventory of 1596 is nonetheless the most significant source of information concerning the contents and arrangement of Archduke Ferdinand II's *Kunst-* and *Wunderkammer* at Ambras.

The inventory scribe began: "In the large *Kunstkammer* there are the following eighteen various high cabinets", he described his path, "in from the nearby armoury described above, near the door on the left side"[18], and counted all 18 cabinets in turn,

---

16  "Nit gar ain halbe stund fuessweg von Innsprugg ligt auf ainer höhe das schloss Ombras, welches erzherzog Ferdinand hochlöblichster gedechtnus aufbauen lassen, alda viel schöner sach zu sehen, als erstlich die kunstcammer von mancherlay selzamen, künstlichen und cöstlichen sachen, welche in etlichen absonderlichen casten verwart werden, und ohne irer fürstl. gn. Carl marggrafen zu Burgau (als dem solch schloss und herrschafft jetziger zeit zugehört) special bevelh nit gezaiget werden", Walther 1877, p. 10.

17  *Inventarj weylandt Fst. Dht. Erzherzog Ferdinnanden zu Österreich etc. lobseligister gedechtnuß Varnussen unnd mobilien.* The manuscript is housed in Vienna, in the Kunsthistorisches Museum, Kunstkammer, inv. no. KK 6652 (hereafter as estate inventory KHM). A divergent manuscript is kept in the Österreichische Nationalbibliothek in Vienna, Cod. 8228 (hereafter as estate inventory ÖNB). This was edited by Boeheim 1888, pp. CCXXVI–CCCXIII, reg. 5556, and Wendelin Boeheim, 'Urkunden und Regesten aus der k.k. Hofbibliothek', *JKSAK* 10 (1889), pp. I–X (Fortsetzung: Bibliothek). Concerning the 1596 estate inventory, see also Thomas Kuster's contribution to this volume.

18  "In der grossen Kunst Camer darynnen volgende Achzehen hohe unndterschidenliche Cässten stehen"….. "von nechst ob beschribner Rüstcamer hinein neben der Thür auf der linggen Seiten", see estate inventory KHM, fol. 410v.

and in some cases also noting their colour. In addition, two "Zwerch Cassten" [19] (cabinets turned sideways) were noted, giving a total of 20 cabinets:

1. First cabinet. Painted blue. Containing sundry crystal, set in gold, and gilded tableware.
2. Second cabinet: in the next cabinet, painted green, silverware.
3. Third cabinet, painted red, containing *Handsteine.*
4. Fourth cabinet, painted white, containing [musical] organs.
5. Fifth cabinet, painted in skin-colour, containing clocks.
6. Sixth cabinet, painted in ash-colour, containing sundry stone sculptures.
7. Seventh cabinet, containing sundry ironwork.
8. Eighth cabinet, containing sundry books.
9. Ninth cabinet, containing items made from feathers.
   [without number] sideways-facing cabinet near the door: containing sundry items turned and carved from ivory.
   [without number] In the sideways-facing cabinet, near the rise.
10. Tenth cabinet, containing alabaster items.
11. Eleventh cabinet, painted black, containing glassware items.
12. Twelfth cabinet, containing sundry items made from coral.
13. Thirteenth cabinet, containing sundry metal sculptures.
14. Fourteenth cabinet, containing porcelain tableware.
15. Fifteenth cabinet, containing small cabinets and sundry gold and silver coins.
16. Sixteenth cabinet, containing sundry rifles and guns.
17. Seventeenth cabinet, called the *värio* [miscellany] *Casten,* painted in skin-colour.
18. Eighteenth cabinet, containing sundry wooden items.[20]

---

19   Estate inventory KHM, fols. 473r, 477v.
20   "1. Erst Cassten, Plaw angestrichen. Darynnen allerlaj Cristallene, mit golt eingefaste Unnd auch gannz guldine gschirr sein. / 2. Annderer Cassten In dem negsten Casten daran so grien angestrichen darynnen Silbergschirr / 3. Driter Cassten Rot angestrichen Darynnen […] Hanndtstain / 4. Vierter Cassten weisz angestrichen Darynnen […] Orgl / 5. Fünfft Casten, Leibfarb angestrichen Darynnen […] Uhren / 6. Sechste Casten Äscherfarb angestrichen, Darynnen von Stain allerlaj Bilder / 7. Sibennt Cassten Darynnen allerlay Eisenwerch / 8. Achtet Casten Darynnen allerlaj Büecher / 9. Neinte Casten Darynnen sachen von Federn / [without number] Cassten bej der Thür Darynnen allerlaj Painwerch gedräete und geschnizlete sachen verhanden / [without number] In dem undern Zwerchcassten. bej der Stiegen. / 10. Zehende Cassten Darynnen sachen von Allebasster / 11. Aindlefft Casten, schwarz angestrichen, Darynnen sachen von glaswerch / 12. Zwelffte Casten, Darynnen allerlaj Corrallenwerch / 13. Dreizehennt Casten Darynnen allerlaj Metallene Pilder / 14. Vierzehendt Casten, Darynnen das Gschirr von parzelana / 15. Fünfzehendt Casten Darynnen Schreibtisch unnd allerlaj sortn von golt und Silber Minzen / 16. Sechzehendt Casten Darynnen allerlaj Pichsen und Wöhrn / 17. Sibenzehendt Casten der värio Casten genannt Leibfarb angestrichen / 18. Achtzehendt Casten Darynnen allerlaj Holzwerch."

## The *Kunst-* and *Wunderkammer*

The 1596 estate inventory, along with the extant objects from that estate, have served generations of researchers as the basis for a possible reconstruction of the original collection.[21] Finally, in 1974 a first historicising reconstruction of Archduke Ferdinand II's *Kunst-* and *Wunderkammer* was produced under the guidance of Elisabeth Scheicher, the *Neuaufstellung der Kunstkammer in ihrer ursprünglichen Gestalt* (new installation of the *Kunstkammer* in its original form).[22] New showcases with glass fronts (some painted), were produced based on the original pine cabinets of the armoury[23] and filled with available objects: a necessary concession to the contemporary requirements of the museum and the expectations of the visitors. Two cabinets were, on the contrary, integrated into the current installation as originals and complete

Fig. 3. View of the former library of Archduke Ferdinand with original cabinets, so called 'Zwerchkasten', Ambras Castle, Granary

21   Julius von Schlosser, *Die Kunst und Wunderkammern der Spätrenaissance. Ein Beitrag zur Geschichte des Sammelwesens* (Leipzig, 1908), p. 46; Lhotsky 1941–1945, p. 200; Elisabeth Scheicher et al., *Die Kunstkammer* (Innsbruck, 1977), p. 14; Veronika Sandbichler , '"souil schönen, kostlichen und verwunderlichen zeügs, das ainer vil monat zu schaffen hette, alles recht zu besichtigen vnd zu contemplieren": die Kunst- und Wunderkammer Erzherzog Ferdinands II. auf Schloss Ambras', in *Das Haus Habsburg und die Welt der fürstlichen Kunstkammern im 16. und 17. Jahrhundert*, Schriften des Kunsthistorischen Museums 15 (Vienna, 2015), pp. 167–193 (p. 175).
22   Friederike Klauner, 'Vorwort', in Scheicher 1977, p. 8.
23   Currently displayed in the first armoury.

Fig. 4. Kunst- and Wunderkammer of Archduke Ferdinand II, reconstruction of the former appearance of cabinets in the original room at the exhibition Archduke Ferdinand 2017, Ambras Castle

the row of cabinets as the 'Zwerchkasten'.[24] This installation is currently still on permanent display in the rooms of the former library in the "Kornschütte" (Fig. 3).

The idea of reconstructing Archduke Ferdinand II's original *Kunst-* and *Wunderkammer* using the help of visual media emerged during the extensive anniversary exhibition *Ferdinand II. 450 Jahre Tiroler Landesfürst*, shown during 2017 at Ambras Castle. The idea was to reconstruct the collection in its entirety, using the original location in the current third armoury room.[25] By following the details provided by the inventories completed in 1596 and 1621, and using photographs of extant objects and graphic placeholders for unidentified items, the most complete and accurate possible impression could be made upon the viewers.[26] We can deduce from the description in the inventory, and the present layout of the rooms, that the cabinets stood back-to-back in the large, eight-axis space, making a full circuit possible. The room was illuminated

24   They bear the inscriptions "Artificiosa ex plumis" and "Imagines ex aere".

25   'Ferdinand II. – 450 Jahre Tiroler Landesfürst. Jubiläumsausstellung'; Cf. *Ferdinand II. 450 Jahre Tiroler Landesfürst. Jubiläumsausstellung*, ed. by Sabine Haag and Veronika Sandbichler, exh. cat. (Innsbruck and Vienna, 2017), English version: *Ferdinand II. 450 Years Sovereign Ruler of Tyrol. Jubilee Exhibition*, ed. by Sabine Haag and Veronika Sandbichler, exh. cat. (Innsbruck and Vienna, 2017); Veronika Sandbichler, '"Innata omnium pulcherrimarum rerum inquisitio": Archduke Ferdinand II as Collector', in ibidem, pp. 77–87 (79).

26   Concept: Paulus Rainer and Veronika Sandbichler, in cooperation with Thomas Kuster. Design: Gerhard Veigel, graphic design: Sanela Antic, Tom Ritter, Michaela Noll, and Clemens Wihlidal.

by windows on each of its long sides, a fact confirmed by later travel journals like that of Hainhofer from 1628.[27] (Fig. 4)

For this virtual reconstruction, a historicising presentation was consciously avoided, and for this reason, only a simple system of steel-tubing marks the place of the original cabinets. Their contents – comprising the objects named in the 1596 inventory – is visualised through large format photographs, which also display individual shelves. All identified objects are pictured, and the unidentified objects are, alternatively, given as silhouettes. The employment of paints, still used by Scheicher, has also been avoided, on the grounds that even though they are mentioned in the inventory, their precise placement is not explained. Scheicher and successive authors have interpreted the entry in the inventory to indicate that these colours were used on the inner surfaces of the cabinets for presentational-aesthetic purposes.[28] Thus Scheicher discusses an "optical connection between the contents and the colour", and how in this way "the optimal effect was achieved [for the objects] and the colour choices formed the foundation for a differentiated aesthetical discernment".[29] In this respect, though, such an interpretation is confusing, since colour details are only given for 8 of the 20 cabinets, and the term "angestrichen" (painted) does not necessarily apply to the inside of the cabinets. Also, if we recall that the objects were originally quite densely displayed, and not always on shelves (as indicated by "stellen", or 'stood'), but partially also in coffers, sheaths and boxes ("tadten, truchen, fuetteral"), and sometimes even fastened to the inner side of the double-wing doors[30], a differentiated colour-awareness seems implausible. As much as there has only been a little research into the actual practices used in handling the pieces in the collection, we must surely assume that the collection was organised from the outset with the intention that individual objects could be chosen, taken from their places and studied more closely at the *Repositorien* (tables for viewing objects) provided for that purpose.

In the first cabinet we find items of the highest artistic and material value, including the *Saliera* created by Cellini, the *Michaelspokal*, the *Onyx Jug* and the *Burgundian Court Goblet* (*Hofbecher*)[31], all of which were given to Archduke Ferdinand II by King Charles IX of France (Fig. 5). The objects worked from mountain crystal in the

27    "Von diser rüstkammer sein wir veber den gang in die kunstkammer gangen, sogar ain langes gemach, auf baiden seitten fenster hat, vnd in der mitten, durchab, 20 kästen, von der Erden an biß an die Dillen, vmb die man herumbgehen kan, vnd gegen den fensteren [oder liechteren] eröffnet warden", quoted from Oscar Doering, *Des Augsburger Patriciers Philipp Hainhofer Reisen nach Innsbruck und Dresden*, Quellenschriften für Kunstgeschichte und Kunsttechnik des Mittelalters und der Neuzeit, N. F. 10 (Vienna, 1901), p. 83; Paulus Rainer, 'Über Kunst und Wunder im außermoralischen Sinne', in Exh. Cat. Innsbruck 2017, pp. 89–97 (90).

28    Kirchweger 2012, p. 22, based on Elisabeth Scheicher, *Die Kunst- und Wunderkammern der Habsburger* (Vienna, Munich and Zürich, 1979), p. 81.

29    "optisch Verbindung von Inhalt und Farbe […und dass damit den Gegenständen…] das Optimum an Wirkungsmöglichkeiten verschafft wurde und der Farbwahl ein differenziertes ästhetisches Urteilsvermögen zugrunde lag", Scheicher 1979, p. 81.

30    "was auf baiden luckhen in disem casten hangt", estate inventory KHM, fol. 478r.

31    Vienna, Kunsthistorisches Museum, Kunstkammer, inv. nos. KK 881, KK 1120, KK 1096, KK 27.

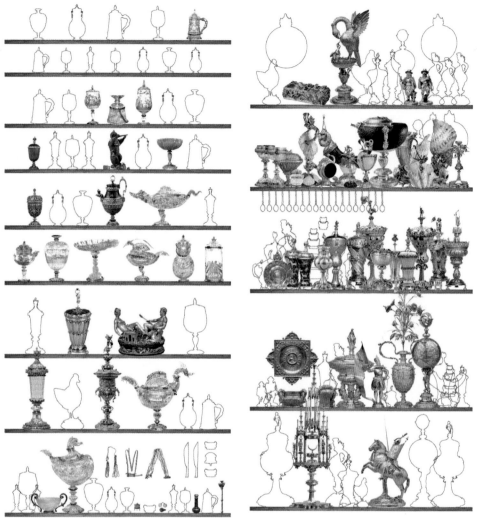

Fig. 5. Kunst- and Wunderkammer of Archduke Ferdinand II, a reconstruction of the "Gold and Crystal Cabinet", Ambras Castle

Fig. 6. Kunst- and Wunderkammer of Archduke Ferdinand II, a reconstruction of the "Silver Cabinet", Ambras Castle

famous Milanese workshops of Saracchi, Miseroni, and Fontana were also stored in this cabinet.[32] The 72 items in this first cabinet are still arranged to provide some kind of overview, whereas the second one contains twice as many objects all in silver, including the silverware inherited from Emperor Friedrich III and Emperor Maximilian I. Interestingly, we also find objects worked from exotic natural specimens here, such as nautilus shell, rhinoceros horn, tortoise shell, and mother of pearl. These were placed

---

32  Grundlegend: Rudolf Distelberger, *Die Kunst des Steinschnitts. Prunkgefäße und Commessi aus der Kunstkammer* (Vienna, 2002).

Fig. 7. Kunst- and Wunderkammer of Archduke Ferdinand II, reconstruction of the former appearance of the cabinets in the original room at the exhibition Archduke Ferdinand 2017, Ambras Castle

in the 'silver cabinet' on the basis of their gilded silver settings and fastenings (Fig. 6).[33] Further examples of exotica are found in the seventeenth cabinet, containing an unbelievable total of 233 items. In the 1596 inventory items are frequently described as 'Indian', simply in order to document their origin in a distant land. For example, there is "an Indian vessel just like a pumpkin, long and with a narrow spout"[34], or "a large Indian fan made from a leaf, with square gilded dots", and "furthermore an Indian straw-quilt"[35].

Objects specific to the Ambras collection, such as glasswork, corals (Fig. 7), and *Handsteine* (unusual and beautiful pieces of mineral aggregate, with small scenes or figures worked into their natural form) were each stored in a dedicated cabinet. The "Thirteenth cabinet, containing sundry metal images"[36] appears to have almost overflowed with the 850 small bronze objects it is cited to have held, some of which (the plaques and medallions) were kept in "88 narrow built-in drawers...[...]"[37]. This exam-

---

33  Vienna, Kunsthistorisches Museum, Kunstkammer, inv. no. KK 3732.

34  "ain Indianisch Fläschl gleichwie ain Kürbis, ist lannggelet mit aim khrumben schnabl", estate inventory KHM, fol. 535r.

35  "Mer ain Indianische stroene deckhen", estate inventory KHM, fol. 537r.

36  "Dreizehennt Casten Darynnen allerlaj Metallene Pilder", estate inventory KHM, fol. 492r.

37  "88 eingemachte schmale schubladen...[..]", estate inventory KHM, fol. 499r.

ples suffice to convey an impression of the original arrangement and sheer quantity of objects in the collection. The homogeneity of materials demonstrated for certain sections in the inventory gives us an indication of the possible method of categorisation and ordering of objects within the cabinets. This system was nonetheless inconsistent in certain cases, and in at least six cabinets we find a purely thematic categorisation (musical instruments, clocks/measuring devices, books, miscellany and weaponry).

The presentation definitely communicates a programme: "An apparently endless number of items, each one of which holding within itself a whole world of knowledge and potential discovery, are to be found in one place, arranged and laid out according to a system which is both material and academic, and by this juxtaposition manages to represent a coherent whole. Such a place contains the knowledge of the world, and can be both an encyclopaedia that one can actually enter, as well as a laboratory for the study of nature"[38] – just as it is described in Quiccheberg's treatise. In its composition the *Kunstkammer* at Ambras Castle reflected the ideas of its time: it comprised every known category of nature, art and science.

Furthermore, Archduke Ferdinand II's *Kunst-* and *Wunderkammer* was also furnished with taxidermied animals, the extracted and dried jaws of fish and bones from giants (unusually large humans), all hanging from the ceiling. The 1596 inventory noted, alongside numerous small examples, "a large crocodile",[39] "A large elephant's tooth",[40] "Two rhinoceros horns",[41] "a large mouth from a sea fish",[42] "A hare's head with an antler",[43] "A shinbone from a giant",[44] and further similar examples.

Paintings are only summarily mentioned in the 1596 inventory: "This *Kunstkammer* is hung on all four walls, with very artistic seeming portraits and paintings".[45] The paintings were listed comprehensively for the first time in the inventory of 1621, and this allows for some retrospective conclusions concerning the original collection:[46] "Following are the portraits and other artworks that hang upon the walls of this *Kunst-*

---

38   "Eine unendlich erscheinende Anzahl an Gegenständen, von denen jeder einzelne für sich eine ganze Welt an Wissens- und Erkenntnismöglichkeiten bereithält, findet sich an einem Ort, geordnet und aufgereiht in einem materiellen wie gelehrten System, das in seinem Nebeneinander ein Ganzes und Zusammenhängendes repräsentiert. Ein solcher Ort enthielt das Wissen der Welt, konnte eine begehbare Enzyklopädie sein und ein Labor zur Erforschung der Natur", Anke te Heesen, *Theorien des Museums* (Hamburg, 2012), p. 36.

39   "ain grosser Crocodill", estate inventory KHM, fol. 561v.

40   "Ain grosser Helephannten Zan", estate inventory KHM, fol. 561v.

41   "Zwaj Renocero Horn", estate inventory KHM, fol. 561v.

42   "Ain groß Mör Fischmaul", estate inventory KHM, fol. 562v.

43   "Ain Hasen Kopf mit ainem khirn", estate inventory KHM, fol. 562v.

44   "Ain Schinpain Von aim Rysen", estate inventory KHM, fol. 563r.

45   "Dise Kunstcamer ist umbhenngt an allen vier ennden, mit gar khunstlichen schenen Contrafect unnd gemäl", estate inventory KHM, fol. 561v.

46   *Haubt Inventary Ober das Fürstlich Schloß Ombras sambt der Kunst: Auch Rüsst camer und Bibliodeca. ec.* [31st March 1621], Vienna, Kunsthistorisches Museum, Kunstkammer, inv. no. KK 6654, fol. 357r–363r (unpublished).

Fig. 8. Kunst- and Wunderkammer of Archduke Ferdinand II, reconstruction the original hanging of paintings, Ambras Castle

*kammer*. [Listed] upwards from the stairs on the right hand side"[47]. The inventory scribes of 1621 named both the paintings and also their placement, "zwischen den Fenstern" (between the windows) and "zu obrist/darunter/daneben/zu undrist" (uppermost/underneath/next to/lowest). In this way it is also possible to reconstruct the original hanging. (Fig. 8) According to the 1621 inventory there were historical paintings, landscape scenes, portraits of historical figures, giants, dwarves and other people and animals presented as "Wunder der Natur" (wonders of nature), as well as paintings with biblical or mythological themes.

The reconstitution of these paintings for the anniversary exhibition was handled in the same way as the virtual reconstruction of the *Kunstkammer*'s cabinets: identified works were represented by a photograph, and the unidentified works represented by their description from the inventory in a fictitious frame printed on the wall. Of the 152 paintings named in the inventory, 39 can be positively identified after the exclusion of works possibly acquired after Ferdinand's lifetime, and those stored in the lower cabinets. These include *Vlad Tzepesch* ("a vaivode of Walachia")[48], the *Haarmenschen* (lit. the hair-people) ("the hairy man from Munich and next to him, off to the side, his two children, a boy and a girl")[49], *Bartlmä Bon with the court dwarf Thommele* ("Furthermore a painting of a large man in a red robe and black coat, and by him the dwarf figure Thomele")[50] and the *Ambraser Schwein* (the pig of Ambras) "A huge domestic pig, that is supposed to have weighed at least eight *Centen* (painted

---

47  "Volgen die Conterfet unnd Andere Stückh so in diser Khünst Camer an den Wenden herümb hangen. Von der Stiegen hinab aüf der rechten Handt." *Haubt Inventary* 1621, Vienna, Kunsthistorisches Museum, Kunstkammer, inv. no. KK 6654, fol. 357r.

48  "Ain Weiboda, auß der Wallachej", *Haubt Inventary* 1621, Vienna, Kunsthistorisches Museum, Kunstkammer, inv. no. KK 6654, fol. 361r; Vienna, Kunsthistorisches Museum, Picture Gallery, inv. no. GG 8285.

49  "Der Rauch man zu Münichen Darneben Auf der Seiten hinab, vorgedachts Rauchen Mann Zway Kinder. Ain Biebl, und Ain Mädl", *Haubt Inventary* 1621, Vienna, Kunsthistorisches Museum, Kunstkammer, inv. no. KK 6654, fol. 358v; Vienna, Kunsthistorisches Museum, Picture Gallery, inv. nos. GG 8332 8331, 8330, 8329.

50  "Mer Ain Pildnus ainer grossen Mannß=Person in Ainem Rothen Klaid, und schwar:zen Mantl, darbey das Thomele Zwergen Figur", *Haubt Inventary* 1621, Vienna, Kunsthistorisches Museum, Kunstkammer, inv. no. KK 6654, fol. 357v, 358r, 366r; Vienna, Kunsthistorisches Museum, Picture Gallery, inv. nos. 8299, 3839.

on linen)"[51]. There is, however, no discernible content-based concept in the hanging; it must have been pragmatically orientated on the available wall-space. It is possible that research in conjunction with the as yet unexamined works on wood, canvas, parchment and paper found in the "Unterschränken"[52] (low cabinets) could lead to new insights.

## Comparisons

Two collections are comparable to Archduke Ferdinand's *Kunst-* and *Wunderkammer* at Ambras in terms of content, and period: The *Kunstkammer* of August, Prince Elector (*Kurfürst*) of Saxony and Christian of Saxony in Dresden, and the Munich *Kunstkammer* of the Bavarian Dukes Albrecht V and Wilhelm V. Both of these, like the collection at Ambras, are documented via inventories.[53]

The closest resemblances are found with the Munich *Kunstkammer*, established around 1565. This collection is identifiably referred to in many parts of the *Inscriptiones* by Samuel Quiccheberg mentioned in the introduction, and the similarities are most notable in the collections of corals, *Handsteine*, woodturning work ("Berchtesgadener Arbeiten") and alabaster items.[54] An important factor underlying the similar priorities of the two collections was naturally the familial relationship of the two collectors themselves: Albrecht was the brother-in-law of Archduke Ferdinand II. Ferdinand's nephew, Wilhelm V of Bavaria, owned almost the same number of coral specimens, which suggests that both collectors obtained these objects from the same merchants.[55]

We also find similarities between the two collections in terms of the books held as part of the *Kunstkammer*. In connection with this Peter Diemer makes reference to a kind of competitiveness, when he speaks of the "friendly rivalry with Archduke Ferdinand II of Tyrol's efforts to enlarge his *Kunstkammer* at Ambras Castle [...]".[56]

Archduke Ferdinand II and the Prince Elector (*Kurfürst*) Augustus of Saxony enjoyed notably friendly relations. Nonetheless, the very well-developed collection of scientific equipment and instruments at Dresden, which formed the core of the

51  "Ain grosses haimisch schwein, so acht Centen wienisch gewicht, soll gewogen haben (auf Tuech gemalen)", *Haubt Inventary* 1621, Vienna, Kunsthistorisches Museum, Kunstkammer, inv. no. KK 6654, fol. 362v, Vienna, Kunsthistorisches Museum, Picture Gallery, inv. no. GG 8304.

52  *Haubt Inventary* 1621, Vienna, Kunsthistorisches Museum, Kunstkammer, inv. no. KK 6654, fol. 364r–370r.

53  *Johann Baptist Fickler. Das Inventar der Münchner herzoglichen Kunstkammer von 1598, Transcription of the inventory manuscript cgm 2133*, ed. by Peter Diemer, Bayerische Akademie der Wissenschaften, philosophisch-historische Klasse, Abhandlungen Neue Folge, 125 (Munich, 2004); *Die Inventare der kurfürstlich-sächsischen Kunstkammer in Dresden: Inventarbände 1587, 1619, 1640, 1741*, ed. by Dirk Syndram and Martina Minning (Dresden, 2010).

54  Cf. Seelig 2008, pp. 75–78.

55  Seelig 2008.

56  "freundschaftlicher Wetteifer mit den Anstrengungen Erzherzog Ferdinands II. von Tirol, seine Kunstkammer auf Schloß Ambras zu vermehren [..]", Diemer 2004, p. 6.

"Reißgemach" (the chamber for drawing and measuring instruments) as early as 1560, represents an area of the collections that is far less distinctive and noticeable at Ambras. The comparably small number of clocks and automata documented in the fifth cabinet, as well as the actual scientific instruments such as compasses, pairs of compasses and astrolabes, seems to indicate a representative collection, rather than one designed for practical use.

On the other hand, it is possible to recognise clear parallels with Augustus of Saxony's extensive collection of *Handsteine*: like Archduke Ferdinand, he had direct access to the mineral resources of his territory, and possibly for this reason also had a particular liking for these pieces, artfully worked from mineral samples.[57] As an aside, when it came to *Handsteine*, the collectors of Munich could not 'keep up'. The Bavarian dukes made a concerted effort to acquire *Handsteine* for the Munich *Kunstkammer*, turning to other, friendly rulers. In this way a large *Handstein* made its way into the Munich *Kunstkammer*, as a gift from Augustus of Saxony.[58] Here we can observe another of Quiccheberg's recommendations being put into practice: that collectors ought to mutually support one another, an easy thing to do, especially for kings and princes.[59]

Parts of the Dresden *Kunstkammer* have been preserved, while a large portion of the Munich *Kunstkammer* was despoiled in 1632, during the Thirty Years' War. Concerning the collections of Archduke Ferdinand's brothers, which as mentioned in the introduction, were considered exemplary by Quiccheberg, the following can be noted: the collection of Maximilian II was bequeathed to his son Rudolf II, and was transported to Prague. Due to a lack of documentary or material sources, this collection is difficult to reconstruct today.[60] Similarly, only a few extant objects can be positively identified as coming from the collection of Archduke Karl today.[61] By contrast, a part of the collection of Archduke Ferdinand II has been housed right up to the present day in its original, dedicated building within Ambras Castle. In this way, Ambras Castle has itself become an 'exhibit' in our present time, with very good reason.

---

57   Ulrike Weinhold, 'Handstein mit Christus am Ölberg', in Haag 2012, p. 165, cat. no. 2.47.

58   Seelig 2008, p. 40.

59   After Roth 2000, pp. 120–122.

60   *Inventar des Nachlasses Kaiser Maximilians II.* (six-part pamphlet), 10/4 to 19/6 of 1578, in Hans von Voltelini, 'Urkunden und Regesten aus dem k. und k. Haus-, Hof- und Staats-Archiv in Wien', *JKSAK* 13 (1892), pp. XXVI–CLXXIV, reg. 9093 on pp. XCI–CIV; Karl Rudolf, 'Die Kunstbestrebungen Kaiser Maximilians II. im Spannungsfeld zwischen Madrid und Wien, *Jahrbuch der kunsthistorischen Sammlungen in Wien* 91 (1995), pp. 165–256, here see an attachment 'Das Kammerinventar Kaiser Maximilians II. 1568) und Der Nachlass Kaiser Ferdinands I. (1568)', on pp. 231–253.

61   'Inventar des Nachlasses Erzherzog Karls II. von Innerösterreich vom 1. November 1590', published in: Heinrich Zimerman, 'Urkunden, Acten und Regesten aus dem Archiv des k.k. Ministeriums des Innern', *JKSAK* 7 (1888), pp. XV–LXXXIV, reg. 4597 on p. XVII–XXXIII; Susanne König-Lein, 'mit vielen Seltenheiten gefüllet: Die Kunstkammer in Graz unter Erzherzog Karl II. von Innerösterreich und Maria von Bayern', *Das Haus Habsburg und die Welt der fürstlichen Kunstkammern*, ed. by Sabine Haag, Franz Kirchweger and Paulus Rainer (Vienna, 2015), pp. 195–227.

## Prospects

We can examine the *Kunst-* and *Wunderkammer* of Archduke Ferdinand II from an endless number of perspectives. In order to prevent the 'spirit' of this collection from declining and becoming merely part of a lost, illusory world, it is necessary to cast an ever more inquisitive, critical and careful gaze upon the sources. Without the 'facts 'n' figures' gained from such an exercise, we will never be able to sharpen our perspective upon the collection. Apart from providing a clear and didactically informative visualisation for the museum public of the 21st century, the reconstruction of the Ambras *Kunst-* and *Wunderkammer* also represents a contribution to the overall history of *Kunstkammern* in the 16th century, and simultaneously gives us a clear illustration of the current state of research.

Archduke Ferdinand's *Kunst-* and *Wunderkammer* at Ambras Castle is, and remains, an extremely exciting topic of research. The 'reconstruction' introduced here is a work in progress, one that will be continued within a collective research project focused on the 1596 estate inventory. This project naturally involves all of Ferdinand's collections, including the *Kunstkammer*.[62] Considering the significance of Archduke Ferdinand II's Ambras collections, it is astonishing that this inventory has not yet been definitively edited, nor systematically analysed. Nor has there been any attempt at a full reconstruction of the original collection. In 1888 and 1889 the custodian of the Ambras collections, Wendelin Boeheim, published a transcription of the fair copy of the inventory in *Regestenform* (a summary of the document's contents), found in the Österreichische Nationalbibliothek (Austrian National Library) in the *Jahrbuch der Kunsthistorischen Sammlungen des Allerhöchsten Kaiserhauses in Wien*.[63] This has long been the only basis for research on the topic. However, this work is deeply deficient, in that it is in fact only an incomplete transcription of the text, lacking any identification of the objects. Since Boeheim's publication, the academic staff of the Kunsthistoriches Museum have consistently identified new objects, initially in connection with the *Kunstkammer* at Ambras Castle (during its reorganisation in 1974, for example) and up to the present day in connection with various individual projects and special exhibitions.[64] It is a desideratum that the 1596 inventory should be made available to the international scholarly community, both digitally and in print, in a form adequate to support further academic study. Comparable projects, such as the edition of the 1598 "Fickler" inventory of the Munich *Kunstkammer*, as well as that of the Dresden *Kunstkammer* (from 1587 on), were completed in 2008 and 2010.[65] Furthermore, with the assistance of the data currently in the museum database it is possible to not only create an academic reconstruction, but also a virtual exhibition of the original Ambras collections.

---

62 Title: *Das Inventar Erzherzog Ferdinands II. aus dem Jahr 1596. Datenbankbasierte Edition der Inventarshandschrift Inv.-Nr. KK 6652 des Kunsthistorischen Museums Wien*.

63 Boeheim 1888.

64 Final exhibition of 2017.

65 Seelig 2008, pp. 75–78.

Thomas Kuster

# From treasure chests and linen trunks: The 1596 inventory of Archduke Ferdinand II's estate

Upon the death of the Tyrolean prince Archduke Ferdinand II on the 24th of January 1595, the familiar and time-honoured wheels of administration began to turn in the *Ratstube* (private council chamber) and chancellory of the capital of Innsbruck (Fig. 1). On one hand, Archduke Ferdinand II's death signalled the end of an era, but on the other hand it brought fresh opportunities for a new start in government, after the motto 'The king is dead, long live the king'. The priority now was to bury the deceased, execute his testament, provide for his descendants, and organise the succession.[1]

## Background

On the 6th of February 1595, an order arrived in Innsbruck from the new ruler, Emperor Rudolf II, commanding that the rooms of the chancellory, secretariat and scriptorium (in other words, the rooms containing all of the governmental departments) should be closed and locked with immediate effect.[2] This precaution was intended to prevent unauthorised persons from misappropriating any objects. Since the Emperor could only delegate business in Tyrol from his own residence in Prague, he appointed Konrad Dietz as a suitable imperial agent in Innsbruck. Dietz was the private court secretary and had already been in Archduke Ferdinand II's service for fifteen years.[3] His knowledge of German, Italian, and Latin made him the ideal proxy. Together with Sigmund Freiherr of Welsberg, the *Oberstkämmerer* (high chamberlain) of the deceased prince, all of the official papers were examined, archived as necessary, and any detrimental or damaging documents destroyed. Three weeks had been allocated to this task. However, since the volume of documents was far greater than expected it became necessary to employ two further scribes (rather than a single copyist) just one week after the work began.[4]

The imperial command that "everything should be locked away, so that nothing gets moved or changed"[5] also applied to all areas of Archduke Ferdinand II's personal residences, including Ruhelust Palace, the Hofburg, Ambras Castle, both of the

---

1    The author is project coordinator, significantly involved in the production of a critical, academic edition of the inventory of Archduke Ferdinand II's estate. This edition follows the inventory currently held in the *Kunstkammer* of the Kunsthistorisches Museum in Vienna, under the inv. no. KK 6652 (hereafter inventory KHM).

2    Tiroler Landesarchiv Innsbruck (hereafter TLA), Geschäft von Hof, 1595, fol. 6r.

3    TLA, Empieten und Bevelch, 1595, fol. 131v, 132r.

4    Idem, fol. 135r, v.

5    'allerlai soll versperrt sein […] daran nichts verruckt und verändert werden'. Quoted from: TLA, Von der Kayserlichen Majestät, 1595, fol. 8v.

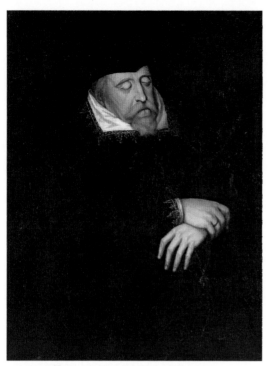

Fig. 1. Giovanni Pietro de Pomis (attributed to),
Archduke Ferdinand II, 1595 (Vienna, Kunsthistorisches
Museum, Picture Gallery, inv. no. GG 8992)

hunting lodges in the Tyrolean lowlands, Thurnegg Castle, and the Fürstenhaus near the Achensee.

The reading of the testament followed on the 15th of July 1595, in the presence of the widowed Archduchess Anna Caterina (Fig. 2), both of Archduke Ferdinand II's sons from his first marriage, Cardinal Andreas of Austria, and Karl of Burgau. Archduke Matthias was present as the Emperor's proxy, and also to represent the interests of Maria of Inner Austria, the deceased's sister-in-law, and her son, the future Emperor Ferdinand II, who was then still in his minority.[6]

It would now be clear which family members had been remembered by the former prince. Emperor Rudolf II was particularly eager, after his uncle's death, to acquire the two inalienable artworks of the Habsburg family treasury, the so-called *Achatschale* and the so-called *Einkürn*, a narwhale tusk.[7] According to family agreements, Archduke Ferdinand II had acquired the two items in 1576, after the death of Emperor Maximilian II.[8] To facilitate the next step, the actual execution of the testament, a thorough inventory of the estate was needed.

This meant a stocktake of the entire goods and properties belonging to the testator (the deceased) up to the time of his death. The sense and purpose of this exercise was to catalogue all items belonging to the estate as precisely and clearly as possible, in

---

6   David von Schönherr, 'Urkunden und Regesten aus dem k.k. Statthalterei-Archiv in Innsbruck', *Jahrbuch der kunsthistorischen Sammlungen des Allerhöchsten Kaiserhauses* (hereafter JKSAK) 17 (1896), pp. I–CVIII, reg. 14382 on p. XXXIV; concerning the will & codicil see: Vienna, Haus,- Hof- und Staatsarchiv (hereafter HHStA), Habsburg-Lothringisches Familienarchiv, Familienurkunden, no. 1463.

7   Schönherr 1896, p. XXXIV, reg. 14387, reg. 14388, reg. 14389. These treasures were not, as has been incorrectly claimed in recent works on the theme, kept in the Ambras collection. Ferdinand kept the *Achatschale* and the *Einkürn* in the *Schatzgewölbe* (treasure vault) at the Hofburg.

8   HHStA, Habsburg-Lothringisches Familienarchiv, Familienurkunden, no. 1350/1.

Fig. 2. Johann Michael Strickner (follower of), Anna Caterina Gonzaga,
after 1757 (Schloss Ambras Innsbruck, permanent loan from the
Landesgedächtnisstiftung Tirol, inv. no. AM FI 103)

order to make them more easily identifiable for the heirs.[9] In the case of the Tyrolean prince it was necessary to attend to those private or personal items which would arouse the interest of the supposed heirs, in order to avoid embarrassing conflicts in this highest of families. There was also the need to eliminate every object considered 'immovable' from the court, and therefore an asset of the general court household and untouchable. The department of the *Hofstelle* (court administration) appointed for this task was the Upper Austrian Chamber, and was itself an object evaluated as 'dysfunctional' or 'no longer serviceable',[10] to be alienated from the royal court with its

9     In general, see: Carola Fey, 'Inventare', in *Höfe und Residenz im spätmittelalterlichen Reich*, ed. by Werner Paravicini et al., Residenzforschung 15.III (Ostfildern, 2007), pp. 473–483; further: Lorenz Seelig, 'Historische Inventare-Geschichte, Formen, Funktionen, in Sammlungsdokumentation. Geschichte.Wege. Beispiele', *Museumsbausteine* 6 (2001), pp. 21–35.

10    "nicht für thunlich". Quoted from: TLA, Empieten und Bevelch, 1595, fol. 300r.

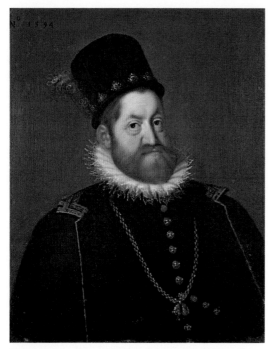

Fig. 3. Joseph Heinz the Elder, Emperor Rudolf II, circa
1592 (Vienna, Kunsthistorisches Museum, Picture
Gallery, inv. no. GG 1124)

contents sold off. This kind of evaluation was also relevant, among other cases, for the workshops in the area surrounding Ruhelust Palace, where tools and raw materials were sold to the armoury and various Innsbruck craftsmen for cash.[11]

Nonetheless, it took until January 1596 for the actual inventorying to begin. What did this mean for the court at Innsbruck? In this period, the collective court mourning Archduke Ferdinand II meant there was a reduced court household, but the closing of most areas of the residence and the administration from mid-January 1595 on still caused significant complications in the daily life of the court. Karl of Burgau expressed discontent with the restrictions many times in his letters to his imperial cousin Rudolf II (Fig. 3). He constantly requested right of access to the Ambras Castle, to which he was heir. Karl referred to monies he knew to be held in the palace coffers, but which he could not access due to the *versecretieren* (sealing off) of the building.[12]

### The stocktake

There is no extant information concerning the actual inventorying process. This is hardly surprising, as this was an administrative process managed mostly via verbal communication, and followed a traditional pattern. This was also the case for stocktakes of other royal collections, for example that of the *Kunstkammer* of the Bavarian dukes in Munich and the princely *Kunstkammer* in Dresden.[13]

---

11    TLA, Empieten und Bevelch, 1595, fol. 300v. One beneficiary was the Innsbruck *Püxen- und Glockenmeister* (master of canons and bells), Heinrich Reinhardt.

12    TLA, Geschäft von Hof, 1596, fol. 138r.

13    *Die Münchner Kunstkammer*, III: *Aufsätze und Anhänge*, ed. by Willibald Sauerländer (Munich, 2008); *Die kurfürstlich-sächsische Kunstkammer in Dresden. Das Inventar von 1587*, ed. by Dirk Syndram and Martina Minning (Dresden, 2010); *Die kurfürstlich-sächsische Kunstkammer in Dresden. Das Inventar von 1619*, ed. by Dirk Syndram and Martina Minning (Dresden, 2010); *Die kurfürstlich-sächsische Kunstkammer in Dresden. Das Inventar von 1640*, ed. by Dirk Syndram and Martina Minning (Dresden, 2010); *Die kurfürstlich-sächsische Kunstkammer in Dresden. Das Inventar von 1741*, ed. by Dirk Syndram and Martina Minning (Dresden, 2010).

The inventory of the court at Innsbruck began on the 28th of January 1596. Taking the 17th century examination of the Ambras collection as a model, we can sketch out how the 1596 stocktake progressed as follows: the offices of the *Kammerkanzlei* (chancellory of the Upper Austrian Chamber) appointed scribes and clerks, who undertook the process of examining all property on location. Evidence of a greater amount of written work than intended is found in the entries of the Upper Austrian Chamber's ledgers from the second half of 1595 onwards. Here we find large orders of paper, ink, quills and string.[14]

The scribes did not, however, visit their appointed buildings alone, but rather together with supervisors responsible for each building. The *Hofburgpfleger* (guardian of the Hofburg), Phillip Lang,[15] was responsible for the Hofburg, and the housemaster Sebastian Günzinger was responsible for Ruhelust Palace. Ambras Castle and its collections were visited under the supervision of Jakob Schrenck of Notzing,[16] the private secretary of the deceased archduke. Commissioners were appointed by the Emperor to represent the interests of the heirs, and also to act as expert advisors. These men were charged with observing the stocktake very closely. Karl Freiherr of Wolckenstein, senior official of the *Oberösterreichischer Regierungsrat* (Upper Austrian government),[17] and Karl Schurff of Schönwarth, *Obersthofmarschall* (chief steward) to Archduke Ferdinand II and executor of his last will and testament,[18] acted as proxies for the Emperor. Cyriak Haidenreich zu Pidenegg, *Oberösterreichischer Kammerpräsident* (president of the Upper Austrian chamber),[19] and Christof Vintler[20] were

---

14   TLA, Raitbuch, 1595, fol. 200v. Among other things, one hundred *Schreib Pirmentheüt* ("writing parchments") were bought through the Augsburg merchants Christof and Hans Wolf.

15   Lang (before 1560–1609/1610) was a chorist in the Innsbruck court chapel, took service in the retinue of the young Cardinal Andreas of Austria, was a valet to the Tyrolean prince from 1580, and from 1592 caretaker of the archducal court. Lang was at the court of Emperor Rudolf II from 1601, where he became one of the most influential and powerful courtiers. See: *Allgemeine Deutsche Biographie*, 17 (1883), pp. 617–618.

16   Schrenck (1539–1614) was a relation of Philippine Welser, the first wife of Archduke Ferdinand II. In his capacity as secretary to the prince, Schrenck was one of the most important people involved in assembling the Ambras collection. He was also responsible for the monumental printed work *Armamentarium Heroicum*, a literary realisation of the 'heroic' armoury at Ambras. See: Constantin von Wurzbach, *Biographisches Lexikon des Kaiserthums Oesterreich*, 31 (Vienna, 1876), p. 300.

17   Wolkenstein (1557–1618) was born into the house of Wolkenstein-Rodenegg, and was *Vizestatthalter* (Vice-governor) of the county of Tyrol from 1588. From 1591 to 1602 he served as *Präsident der Regierung* (president of the government). See: Margret Überbacher, *Beamtenschematismus der drei Oberösterreichischen Wesen in den Jahren 1586 bis 1602* (unpublished doctoral thesis Innsbruck 1972), pp. 94–96.

18   Schurff (also Schurf; 1548–1618), was *Erblandjägermeister* (master of hunting for the patrimonial lands), *Kämmerer* (chamberlain), as well as *Pfandinhaber* and *Zollmeister* (pledge-holder and customs master) for the Kufstein rulers. From 1583 he was the administrator of the *Stallmeisteramtes* (office of stablemaster), and from 1594 *Obersthofmarschall* (chief steward). See: Überbacher 1972, pp. 43–44.

19   Haidenreich (d. 1608), like his brothers Erasmus and Georg, had been in the service of the Tyrolean prince since the 1560s. In 1578 he was named as *oberösterreichischen Kammerpräsidenten* (president of the Upper Austria chamber). In 1596 Haidenreich was appointed *Obersthofmeister* (chief controller of the household) of the abdicated Duke Wilhelm V of Bavaria. See: Überbacher 1972, pp. 163–164.

20   Vintler (1540–1614), was the *oberösterreichischen Kammerpräsidenten* (president of the Upper Austria chamber) from 1596–1602. See: Überbacher 1972, pp. 96, 113, 117–118.

authorised to represent Archduke Matthias and the dowager Archduchess Maria of Inner Austria. Representing the interests of the dowager Archduchess Anna Caterina were her *Oberhofmeister* (chief controller of the household), Dario di Nomi, and Andreas Unterberger. Andreas of Völs, Hans Reichert, Veit Schemberger and Friedrich Schrenck of Notzing,[21] brother of Jakob Schrenck, acted as proxies for Andreas of Austria and Karl of Burgau.[22]

It must be noted that the taking of the inventory was not carried out in a consistent manner. The buildings were not inspected according to a centralised and systematic plan, orientated on doors, windows or any regular direction of movement from left to right. Each room was recorded in its own way. Significant objects served as points of reference for orientation, for example large chests, particularly magnificent coffers, or writing desks. The buildings were also inspected in varying orders, not consistently from top to bottom or vice versa. In Ruhelust Palace, Archduke Ferdinand II's study was the starting point; in the Hofburg work began on the ground floor; and in Ambras the stocktake began on the third floor of the *Hochschloss*.[23] Since the inventory was already completed just a few weeks later, on the 28th of February 1596, despite the massive quantity of material that needed to be recorded, we must assume that a pragmatic approach was taken. The scribes roved in small groups, accompanied by the supervising representatives. Work must have begun before daybreak, and continued until darkness began to fall. Here we presume that the work was carried out by candlelight. This additional expenditure on wax, tallow and wicks is recorded as an additional expense by the Upper Austrian Chamber.[24]

The swift execution of the work was aided by the availability of highly varied partial inventories of Archduke Ferdinand II's possessions, completed during the prince's lifetime. The clerks and scribes performing the stocktake could refer to lists of the contents of the saddlery and armoury of Innsbruck castle, the treasury of Saint Leopold's chapel in Ruhelust Palace, the full complement of silverware held in the Hofburg, and the coin collection at Ambras, as well as records of the deceased archduke's wardrobe held in the castle and Ruhelust Palace.[25]

---

21    Friedrich Schrenck (1555–1618) was the *Oberstrentmeister* (chief master of finances) for Karl of Burgau, and *Amtsmann* (bailiff) for the ruling houses of Bregenz and Hohenegg. See: *Neue Deutsche Biographie*, 23 (Berlin, 2007), pp. 542–544.

22    The commissioners are listed at the beginning of the estate inventory KHM. Their signatures, appended to the end of the inventory, confirmed its legal status. cf. KK 6652, fol. 1, 736r.

23    Cf. estate inventory KHM, sign. KK 6652, fol. 3r, 154r, 298r.

24    TLA, Raitbuch, 1596, fol. 178r,v.

25    Among others, see: TLA, A 1/12 (*Kleidung* [clothing] of Ferdinand II, 1583), A 1/13 (*Kleidung* [clothing] of Ferdinand II 1586), A 7/1 (Schloss Ruhelust), A 15/3 (*Sattel-und Rüstkammer* [saddlery and armoury], old castle), A 40/4 (Ambras Bibliothek 1581).

## Method of working

We must assume that the scribes creating the inventory were neither experts, nor knowledgeable about art in the way craftsmen, goldsmiths, silversmiths or printers may have been. Rather they were officials of the scribal guild. Their lack of expertise is partly recognisable in the descriptions, assessment of materials, naming of techniques and attributions given to all they found. This is particularly relevant with regards to the artworks in the collections at Ambras. This situation creates difficulties today when attempting to use these written descriptions to positively identify an object from amongst the extant items.

However, the imprecisions mentioned here were probably also the result of the obstructive working conditions in cold rooms. The work was of course carried out in January and February, and this meant that natural light was limited. Among other things, this had a negative effect on the recording of the collections. In the case of the drawers beneath the cases in the Ambras *Kunstkammer*, for example, the contents of the collections were not individually recorded. In the Ambras library there were also drawers simply recorded as having been found "in the aforementioned library, under the benches by the windows."[26] The paintings, drawings and prints examined there are only summarily recorded, without any further specification of the images. It is highly probable that Giorgio Liberale's depictions of ocean flora and fauna, animal studies and portraits of Archduke Ferdinand II's dogs were kept there.[27] Likewise, it is probable that the genealogical masterpiece of the Augsburg humanist Clemens Jäger, the so-called *Habsburger Peacock*, was also kept here (Fig. 4).[28]

To give the inventory of the estate a high level of authenticity, the Innsbruck goldsmith Hans Pfaundler the Younger was engaged as a well-known expert to assess the weight and material composition of all goldwork and silverware.[29] His precise statements are given for each item in greatly varied weight units, from pounds to *Marks*, *Lots* or *Cronen*. On the next-to-last (eighth) shelf of the first coffer of the Ambras *Kunstkammer* (where "sundry crystals, set in gold, and gilded cutlery" were stored)[30] there stood the so-called *Michaelspokal*, a gift from King Charles IX of France to Archduke Ferdinand II (Fig. 5). Pfaundler gave the weight of the circa 50 centimetre high trophy cup as eight *Marks* and two *Quintel*,[31] which corresponds to approxi-

---

26   "in bemelter Bibliotheca unnder den Penckhen bei den Fennstern." Quoted from: estate inventory KHM, KK 6652, fol. 689v.

27   Currently held in the Österreichische Nationalbibliothek Vienna, Department of manuscripts and rare books, sign. Cod.ser.n. 2648 *Meerestiere* (ocean fauna), Cod.ser.n. 2668 *Tierstudien* (animal studies), Cod.ser.n. 2669 *Hunde* (dogs).

28   This item is currently held in the Kunstkammer at Ambras Castle, inv. no. KK 4975.

29   Quoted from: TLA, Raitbuch, 1597, fol. 141v. Pfaundler was paid 2 *Gulden* und 24 *Kreuzer* for his work.

30   "Allerlaj Cristallene, mit golt eingefaste [...] guldine gschirr". Quoted from: estate inventory KHM, sign. KK 6652, fol. 410v.

31   One *Mark* equalled 180 grammes, one *Quintel* equalled 4 grammes.

Fig. 4. Clemens Jäger, The Habsburg Peacock, dated 26th of December 1550
(Vienna, Kunsthistorisches Museum, Kunstkammer, inv. no. KK 4975)

mately one kilogramme and 44 decagrams.[32] In the second coffer of the *Kunstkammer*
"painted green, and containing silverware",[33] stood the so-called *Narrenkopfpokal*,
marked as weighing 1 *Mark* and 10 *Lot*, which is less than half a kilogramme.[34]

---

32  "Further, a tall gold cup decorated with raised silver chasing showing figures; the cup has a tall lid, on
    which stands the Angel Michael with a sword in his hand. The cup is set all over with diamonds,
    rubies, emeralds and pearly, and came from the King of France; weighs: 8 *Marks* – 2 *Quintel*".
    "Mer ain guldiner Hoher Pecher, mit erhebter getribner Arbait von Fügurn sambt seim hohen
    Deckhl, oben Darauf der Enngl Michael mit aim schwert, in der Hanndt, mit grossen Diemant, Robin
    (?) schmaragt unnd Perl, überal versezt khombt auch Vom Kinig auß Frannckhreich wigt – 8mk.–
    2 quintel". Quoted from: estate inventory KHM, sign. KK 6652, fol. 416v.

33  "so grien angestrichen darynnen Silbergeschirr." Quoted from: estate inventory KHM, sign.
    KK 6652, fol. 420r.

34  "An Indian nut (coconut) in the form of a fool's cap with silver fastening – weighs 1 *Mark* and
    10 *Lot*." "Ain Inndiannische Nuß wie ain Narren khappen in Silber gefast wigt, - 1mk. 10 lot."
    Quoted from: estate inventory KHM, sign. KK 6652, fol. 422r.

We can cite the precise listing of textiles, fabric and furs as proof of the extreme exactitude of the stock-take. *Zwilch* (rough linen), damask, taffeta, trimming, English canvas (a kind of tweed), satin, camlet, and the pelts of deer, lynx, mink and sable are all recorded. The noting of precise colours is particularly humorous, with canary green, scarlet red, ash colour, *feil* brown (light brown), and 'body' colour (skin colour). Because the table linen from the Hofburg and Ruhelust Palace was an outward symbol of refined court behaviour and dining culture, it was granted a great deal of attention. Many hundreds of tablecloths, tray napery, chair covers, napkins and similar items were recorded. In principle, every item was taken in the hand and minutely studied. If a piece of the decoration (for example a jewel), or a bowl, lid, or binding was missing, this was recorded with the comment "was lacking", or "lacking".[35] The enormous quantity of coins and medallions were also taken out of the coin cabinets, counted, and in the majority of cases, identified and authenticated. However, containers such as chests, boxes, and coffers were not always unlocked, and the necessary key was also not always at hand (Fig. 6).

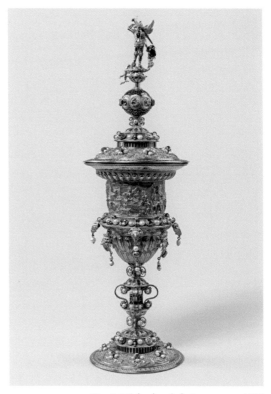

Fig. 5. Michaelspokal, Antwerpen, 1532 (Vienna, Kunsthistorisches Museum, Kunstkammer, inv. no. KK 1120)

The necessity of breaking a lock is recorded a number of times in the inventory. In some cases it was simply impossible to open the container, and these cases were clearly reported.[36] The inventory entries also sketch out the condition in which items were found, for example if something was damaged or incomplete: damage through mice infestation was also noted. The state of an item was often entered with a comment of *guet* or *bes*, the former indicating a good, usable condition, the latter a poor condition.[37]

---

35    "hat gemangelt"... "manglt". Quoted from: estate inventory KHM, sign. KK 6652, i.a. fol. 5r, 354r, 425r, 474v.

36    See estate inventory KHM, KK 6652, esp. fol. 218r, 303r, 418v, 716r.

37    See estate inventory KHM, KK 6652, esp. fol. 45v, 51v, 124r, 218r, 230r, 282v.

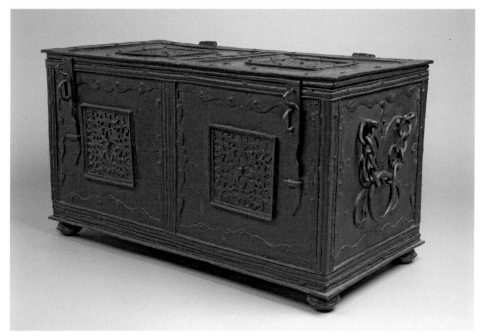

Fig. 6. Southern German, Iron trunk, second half of the 16th century (Schloss Ambras Innsbruck, inv. no. PA 485)

After all the buildings had been inspected, and all objects had been examined and recorded, the inventory was officially closed and the entire documentation given to a *Kanzleischreiber* (chancellory scribe) on the 25th of February 1596. The task of this scribe was to produce a complete and unified fair copy. To date, no extant notes from the 1596 inventory have been found, however, comparable written records from the stocktake of the Ambras collection for the year 1617/1621 are available.[38] The task of producing a fair, readable, and functional working copy of the 1596 inventory was given to the *Expeditor der Kammerkanzlei* (dispatcher of the chancellory of the Upper Austrian Chamber), Matthias Ferre.[39]

**The inventory book**

The estate inventory focussed on in this contribution (the academic and critical edition of which will be subsequently produced) is currently held in the *Kunstkammer* of the Kunsthistorisches Museum in Vienna under the inventory number KK 6652 (Fig. 7,

38   TLA, A40/13, fol. 27–42r; Verzeichnis der Gemälde der Ambraser Kunstkammer (records of the paintings of the Ambras Collection), dated 13th of September, 1617.

39   TLA, Raitbuch, 1597, fol. 141v. Matthias Ferre had served as *Kanzleischreiber* (chancellory scribe) in the *Hofkanzlei* (court chancellory) since 1584. In 1599 Ferre moved to Prague, where he served as a *Reichshofkanzleischreiber* (high court chancellory scribe). See: Überbacher 1972, pp. 82–83, 209–210.

Fig. 7. Matthias Ferre, Title page of the estate inventory, 1596 (Vienna, Kunsthistorisches Museum, Kunstkammer, inv. no. KK 6652)

Fig. 8. Detail of the estate inventory (Vienna, Kunsthistorisches Museum, Kunstkammer, inv. no. KK 6652)

hereafter referred to as inventory KHM).[40] This copy of the inventory is certainly the working copy, as the margin notes concerning the distribution of goods to Archduke Ferdinand II's heirs attest. These notes read, for example, 'both sons'[41], 'Cardinal', 'High Count', 'Archduchess', 'dowager Archduchess, or 'Archduke Mathias' (Fig. 8). The inventory KHM was therefore clearly used for the practical execution of the will and the division of the estate, a process which stretched into years, and was overshadowed by conflict between the heirs.[42] The identification of this copy as the working version is also supported by the judicial additions made to certain entries, which take the form of notes secured into the inventory KHM with red sealing wax. These additions provide details of the final division of the archduke's estate. A second fair copy

---

40  According to a supplementary inventory of the Ambras collection produced in the second quarter of the 19th century, the estate inventory KHM, KK 6652 was moved to the imperial collection in Vienna in 1817. See: Vienna, Kunsthistorisches Museum, Kunstkammer, Supplement-Inventarium der k.k. Ambraser Sammlung, fol. 67.

41  This refers to Cardinal Andreas of Austria and Karl of Burgau, Ferdinand II's sons from his first marriage to Philippine Welser.

42  Concerning this, see: Hans von Voltelini, 'Urkunden und Regesten aus dem K.u.K. Haus-, Hof und Staatsarchiv in Wien', *JKSAK* 15 (1894), pp. XLIX–CLXXIX, reg. 12325, p. CXLVI, reg. 12328, reg. 12329, reg. 12331, 12332, p. CXLVII, reg. 12335, p. CXLVIII, reg. 12410, p. XLVII; see also: Schönherr 1896, reg. 14398 on p. XXXVI, reg. 14414, p. XXVII, reg. 14572, p. LIII, reg. 14577, p. LIV.

was made, and was immediately moved for documentary reasons to the Upper Austrian Chamber. This version was then moved to the Ambras library at a later date.[43]

This second version was moved again during the 1665 relocation of significant, valuable codexes and books from the Ambras library in Innsbruck to the imperial court library Vienna, where it is kept today in the Österreichische Nationalbibliothek (sign. Cod. 8228, hereafter estate inventory ÖNB).[44] The inventory ÖNB in the national library was already published in 1888 by the historian Wendelin Boeheim. This edition, used in academic circles, can nonetheless be considered outdated. Boeheim's work was of course useful, but it was selective in that the author summarily abridged passages not relevant to his own work, and so omitted a great amount of interesting cultural-historical information. For this reason it is academically absolutely justifiable to address this gap in the research with a complete edition of estate inventory KHM. Further contemporary copies of the 1596 estate inventory were completed for the court of Graz, as well as for the imperial court in Prague.[45]

## Codicological key data for estate inventory KHM

The inventory KHM is an imposing and impressive book, which also serves to make its legal character visually clear (Fig. 9). It measures 35 centimetres in height and 24 centimetres in width. The body text comprises 736 pages, penned, with very few exceptions, on both the recto and verso sides. Paper is used as the base medium, with brown ink (no doubt originally black) used as the writing medium. The appendix comprises a table showing contents and site list. The original brown binding is made of leather over card. The front cover is stamped in the centre with Archduke Ferdinand II's large coat of arms in gold, framed by the livery collar of the Order of the Golden Fleece, and crowned with the Austrian archducal hat. The four corners of the cover's central field are decorated with floral bands and Renaissance style ornamentation in blind tooling. The two original metal fasteners also remain. On the outside of the front cover the following text appears handwritten in ink: *N273 a. Supplem. Invent p. 67. 1596* also appears in pencil, and label with the recent catalogue number from the

---

43   Franz Unterkircher et al., *Die datierten Handschriften der Österreichischen Nationalbibliothek von 1501 bis 1600. 1. Teil: Text. 2. Teil Tafeln* (Vienna, 1976), pp. 71–72.

44   Österreichische Nationalbibliothek Vienna, Department of manuscripts and rare books, sign. Cod. 8228 (*Inventarium germanicum rerum mobilium archiducis Ferdinandi Oenipontani*), on the 1665 transfer between libraries, see: Eva Irblich, 'Die Ambraser Handschriften in Wien. Wege in den Jahren 1665, 1806 und 1936', in *Natur und Kunst. Handschriften und Alben aus der Ambraser Sammlung Erzherzog Ferdinands II. (1529–1595)*, ed. by Alfred Auer and Eva Irblich, exh. cat. (Vienna, 1995), pp. 20–32.

45   The existence of the lost Grazer version is proven by an entry in: TLA, Geschäft von Hof 1596, fol. 120v, 121r (I am grateful to Ute Bergner, University of Graz for this reference). Luchner, in his work on the Ambras armoury, states that the Prague version of the inventory was in the Prague "Städtische Bücherei Prag" (National Library of the Czech Republic), but the current location is unknown. See: Laurin Luchner, *Denkmal eines Renaissancefürsten. Versuch einer Rekonstruktion des Ambraser Museums von 1583* (Vienna, 1958), p. 137.

*Kunstkammer* of the Kunsthistorisches Museum in Vienna: *6652*. In the centre of the label, handwritten in blue pencil, the year *1596* appears, along with the struck-out stamp of the *Bibliothek der kunsthistorischen Sammlung des ALLH. KAISER-HAUSES*. On the reverse back side there are handwritten notes in pencil from the 19th century: *Bibliothek.*, and a kind of contents table with folio details, as well as the current catalogue number of the item, *6652*. The foliation appears to be contemporary, marked in ink in the upper right corner of each recto leaf, beginning with the first page.

### Cultural-historical elements

Looking at the estate inventory KHM from the cultural-historical perspective reveals unexpected glimpses into the residence of Archduke Ferdinand II at the end of the 16th century, a residence still largely unknown because of the lack of extant depictions of the rooms (see also an essay by Ivan P. Muchka in this volume). In this way the inventory KHM delivers important information concerning the appearance and furnishings of Ruhelust Palace, the Hofburg before the baroque renovations begun after 1770, and of course the various buildings of Ambras Castle. In the case of Ruhelust Palace, which according to Archduke Ferdinand II's will was the official dowager residence for his second wife, Anna Caterina, it is prominently noted that the clerks and scribes also wanted to inspect the apartments of the former princess and take stock of the items therein. However, they could only begin this task once the widowed archduchess gave them permission to enter the building.[46]

The stocktake reveals the division of spaces, and the concrete usage of the rooms. Inside, they found fixed wall panelling and built-in benches along the window bays. The actual furniture, such as tables, chairs, beds and so on, was stored disassembled in corridors or storerooms near the official apartments, or in dedicated furniture depots. This furniture could only be requested and then reassembled on location when necessity arose. In the inner apartments, the archduke's private rooms, fabric wall coverings are noted over and over again. These were made of coloured silk, wool, or stamped leather. In the case of the archduke's bedroom in Ruhelust, the wall-coverings were of scarlet canvas shot through with silver thread.[47] It was explicitly stated that the original wall-coverings of gold-silver leather were still visible.[48] It is consistently noted that all the rooms inspected were hung with black mourning garb (so-called *Klagtuch*, literally a 'lamentation canvas'), to signal the court's collective mourning of the deceased archduke.

Amongst the most valuable furnishings to be found in a royal court of the early modern era were the wall-hangings, tapestries that were brought out as decoration for

---

46   See estate inventory KHM, sign. KK 6652, fol. 55v.

47   See estate inventory KHM, sign. KK 6652, 36v, 37r.

48   Johanna Felmayer, 'Ruhelust', in *Österreichische Kunsttopographie*, XLVII: *Die Kunstdenkmäler der Stadt Innsbruck. Die Hofbauten*, edited by Johanna Felmayer, Karl and Riccarda Oettinger, Elisabeth Scheicher et al. (Vienna, 1986), pp. 626–644 (626).

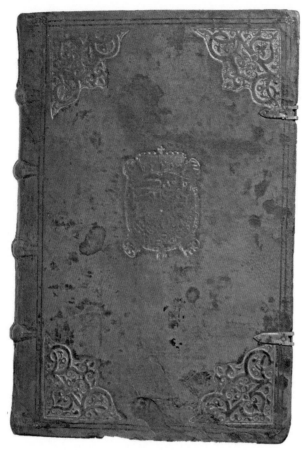

Fig. 9. Binding of the estate inventory, 1596
(Vienna, Kunsthistorisches Museum, Kunstkammer,
inv. no. KK 6652)

certain events and celebrations. At the court of Innsbruck, the extensive collection of tapestries was kept in the so-called *Tapessier Gwelb* on the first floor of the Hofburg's south-west wing.[49] The consistent layout of the rooms in Archduke Ferdinand II's most intimate quarters is also relevant here. The layout always followed the same order of rooms, namely from drawing room, to study, to dining room, and bedchamber. In terms of usage this translates to rooms for living, working, eating and sleeping, in that order. The estate inventory KHM also affords a glimpse behind the scenes at court. We discover, for example, that the court ladies and noblemen were housed in bedchamber-like rooms according to their rank (upper or lower), either four or six persons to a room.[50]

Since no depictions of the interior decoration of Archduke Ferdinand II's residence have survived, we can only look to contemporary comparisons to develop an approximate picture of these living spaces. Only a very few appropriate examples in the Gothic and Renaissance styles can be referred to for this purpose.[51] These include, among other spaces, the Hohensalz-

---

49   See estate inventory KHM, sign. KK 6652, fol. 194r–201r. Along with fabric wall-coverings, leather
      wall-coverings (so-called Turkish rugs), wall-hangings of satin, linen, and silk, and throne canopies
      were all stored there.

50   For example, the *Hochschloss* at Ambras Castle: see state inventory KHM, sign. KK 6652,
      fol. 321r–322v.

51   Concerning the culture of the home in the Renaissance, see: Helmut Hundsbichler, 'Zur Wohnkultur
      des Adels (1500–1700)', in *Adel im Wandel. Politik. Kultur. Konfession. 1500–1700*, exh. cat. (Rosen-
      burg, 1990), pp. 226–267 (228).

burg fort, as well as the *Fuggerstube* (a parlour) and *Königinnenzimmer* (queens' room) in Tratzberg Castle near Schwaz.

The general disorder in the archduke's rooms is striking, for example, the findings in the study at Ruhelust Palace. In the desk and cabinets there, all kinds of sundry unrelated items were found. The drawers were full of written papers, hunting paraphernalia, textiles (gloves, bags, and silks), natural specimens (bezoars, horns, and corals), antique and contemporary coins, gaming equipment, valuables, and jewellery of all kinds. This colourful mixture of items gives evidence of the conditions found by the clerks and scribes: although these rooms had been locked for a year, it was almost as if the Prince was still living and working there.

Another circumstance that is also certainly of cultural-historical interest is the fact that Archduke Ferdinand II not only worshipped the wine-god Bacchus with a drinking ceremony[52] in the so-called *Bacchus grotto*, but also called regular gatherings of a brotherhood of drinkers in his hunting lodge Thurnegg. The estate inventory KHM names a dedicated room, the *Willkomm-Saal*, as well as the so-called *Willkomm*, a silver drinking vessel, and a peculiar textile head covering resembling a fool's hat with bells. This cap would be worn by chosen guests during the drinking, as comic entertainment. Likewise, along with a written *Willkomm-Ordnung* (the regulations of the brotherhood), the inventory KHM lists a red-bound book, where those taking part in the drinking had to enter their names by hand, just like a guestbook. This shows a clear parallel to the well-known so-called *Ambraser Trinkbücher* still extant today.[53]

## Conclusion

Historical estate inventories are an important source for cultural history, since they allow us, among other things, to reconstruct historical living and working spaces, as well as their usage, furnishing and decoration. Fortunately in the case of the 1596 inventory KHM of Archduke Ferdinand II's estate, items were not simply mechanically listed, but fairly thoroughly described. These entries unlock the archduke's residences - Ruhelust Palace, the Hofburg, and Ambras Castle, as well as the hunting lodge at Thurnegg and the Fürstenhaus near Achensee – and provide unexpected glimpses into the world of the Innsbruck court at the end of the 16th century. Through these descriptions of the spaces, together with all their furnishings and the personal and everyday objects kept in them, the unapproachable and majestic personage of the Tyrolean prince Archduke Ferdinand II becomes a living presence. Finally, but very importantly, the estate inventory KHM of the Tyrolean prince is a significant cultural-historical source for the understanding of the extensive Ambras collections: the armouries, and the *Kunstkammer*, as well as the library and portrait collection.

---

52    Generally, see: Ludwig Igálffy von Igály and Karin Zeleny, *Die Ambraser Trinkbücher Erzherzog Ferdinands II. von Tirol. Erster Band (1567–1577). Transkription und Dokumentation*, ed. by Sabine Haag, Schriften des Kunsthistorischen Museums, 12 (Vienna, 2010).

53    Vienna, Kunsthistorisches Museum, Kunstkammer, inv. nos. KK 5251, KK 5262, KK 5328. Concerning this, see: *Trinkfest! Bacchus lädt ein*, ed. by Sabine Haag, exh. cat. (Innsbruck, 2011).

Annemarie Jordan Gschwend

# Treasures for Archduke Ferdinand II of Tyrol: Italy, Portugal, Spain and the Ambras Castle *Kunstkammer*

## Ferdinand II's cultural networking:
## Agency, strategies and transfers between Innsbruck, Italy and Iberia

Research in recent years has begun to take a closer look at the channels through which Archduke Ferdinand II acquired the exclusive exotica, luxury goods and wild animals he sourced from Portugal, Spain, and their overseas empires. When the archduke took up the governorship of Tyrol in 1567, he systemically began collecting rarities and curiosities for the *Kunstkammer* and extensive portrait gallery he created at Ambras Castle; many of these art works and objects also entered his collection at specific junctures of his rule. A number of Archduke Ferdinand II's remarkable *objets d'art* have survived, forming the core displays in the *Kunstkammer* at the Kunsthistorisches Museum in Vienna and the recreation of his original *Kunstkammer* displayed today at Ambras Castle.[1] During the course of the nineteenth century, against Archduke Ferdinand II's stipulations that his collection remain intact at Ambras,[2] it was dispersed amongst various Viennese museums: the Naturhistorisches Museum, the Weltmuseum, the Hofjagd- und Rüstkammer and the aforementioned Kunsthistorisches Museum.[3] Scholarship during the 1970s and 1980s was largely undertaken by two former directors of Ambras Castle, the late Elisabeth Scheicher and Alfred Auer, focusing primarily on the cataloguing of the archduke's Ambras collection and *Rüstkammer* (armoury). Recent investigation of archival sources in Spain (Archivo General de Simancas, Valladolid) and Innsbruck (Tiroler Landesarchiv), as well as private family archives, have revealed dates, names, locations and the variety of objects targeted for

---

1    Most recently, Veronika Sandbichler, '"souil schonen, köstlichen und verwunderlichen zeugs, das ainer vil monat zu schaffen hette, alles recht zu besichtigen vnd zu contemplieren". Die Kunst und Wunderkammer Erzherzog Ferdinands II auf Schloss Ambras', in *Das Haus Habsburg und die Welt der fürstlichen Kunstkammern im 16. und 17. Jahrhundert*, Schriften des Kunsthistorischen Museums 15, ed. by Sabine Haag, Franz Kirchweger and Paulus Rainer (Vienna, 2015), pp. 167–193. Consult also Josef Hirn, *Erzherzog Ferdinand II. von Tirol. Geschichte seiner Regierung und seiner Länder*, 1–2 (Innsbruck, 1885–1888) and *Ferdinand II. 450 Years Sovereign Ruler of Tyrol. Jubilee exhibition*, ed. by Sabine Haag and Veronika Sandbichler, exh. cat. (Innsbruck and Vienna, 2017).

2    Archduke Ferdinand II stipulated in his testament his collection should remain at Ambras Castle 'for all time': "für alle Zeiten unverteilt in Schloss Ambras zu verbleiben". Cf. Walter Senn, 'Innsbrucker Hofmusik', *Österreichische Musikzeitschrift* 11 (1970), pp. 659–671 (661).

3    Elisabeth Scheicher, *Die Kunstkammer. Kunsthistorisches Museum, Sammlungen von Ambras* (Innsbruck, 1977); Elisabeth Scheicher, *Die Kunst- und Wunderkammern der Habsburger* (Vienna, Munich and Zürich 1979); Elisabeth Scheicher and Alfred Auer, *Das Museum Erzherzog Ferdinands II. in Schloss Ambras* (Reid im Innkreis, 1981); Elisabeth Scheicher, *Schloss Ambras und seine Sammlungen: Innsbruck, Tirol* (Munich, 1981); Elisabeth Scheicher, Ortwin Gamber and Alfred Auer, *Die Rüstkammern auf Schloß Ambras* (Vienna, 1981).

the archduke's collection, housed during his lifetime not only at Ambras Castle, but also at his now destroyed castle, Ruhelust. Ruhelust Castle was built between 1562 and 1582, but later lost in two separate fires in 1675 and 1728.[4] Names of imperial agents, courtiers and intermediaries have emerged from these primary sources and documents in connection with Archduke Ferdinand II, who charged them with undertaking "shopping trips" on his behalf, primarily in Madrid and Lisbon. The archduke was connected to a well-organised network which stretched from his Innsbruck court to northern Italy, and further west to Spain and Portugal. Archduke Ferdinand II's family connections, particularly his close ties with his cousin Philip II, King of Spain, provided him with "insider information" about the sale and movement of goods in Iberia. Archduke Ferdinand II's privileged connections secured him exclusive access to commodities, medicinal drugs, and exotica from China, Japan, India, West Africa and the New World.

The archduke's strategy involved deploying trustworthy servants from his entourage or recruiting courtiers at the Viennese court in the service of his brother Emperor Maximilian II. He even enlisted the aid of imperial ambassadors stationed abroad in key European capitals, and all of these intermediaries facilitated his quest for art works, portraits, rarities and more. Adriana Concin has recently spotlighted the activities of Hans Albrecht of Sprinzenstein (1543–1598), who served Archduke Ferdinand II for over twenty years as his advisor (military and otherwise), and who also acted as his diplomatic envoy.[5] Sprinzenstein's long-term residency at the Medici court opened up opportunities for Archduke Ferdinand II, and through Sprinzenstein's contacts, the archduke was able to buy up artworks and sculptures made by the best Florentine goldsmiths, painters, sculptors and other élite artisans. As Concin has proven, Sprinzenstein acted as the archduke's agent, brokering many artistic commissions and acquisitions on his behalf in Florence. Unpublished correspondence in the Tiroler Landesarchiv in Innsbruck reveals how Archduke Ferdinand II systematically approached his acquisitions and commissions, with several instances presented below. These letters map out the tactics that the archduke assiduously availed himself of when buying and shopping, from 1567 when he moved to Tyrol, until his death in 1596.

Before he became a permanent ambassador to the Spanish court in 1574, Emperor Maximilian II's chamberlain, Hans Khevenhüller, acted as Archduke Ferdinand II's

---

4    For Archduke Ferdinand II's inventory of Ruhelust Castle drawn up in 1592, see Hans von Voltelini, 'Urkunden und Regesten: aus dem K. u. K. Haus-, Hof- und Staats-Archiv in Wien', *Jahrbuch der kunsthistorischen Sammlungen des Allerhöchsten Kaiserhauses* (hereafter *JKSAK*) 20 (1899), pp. CXXIV–CLXXXIX, here p. LI, reg. 17404, no. 88: "Fürstlich durchlaucht erzherzogen Ferdinanden zue Oesterreich inventarium zum Ruhelust anno 1592 manuscript, in folio, no. 82". For his 1596 estate inventory see Wendelin Boeheim, 'Inventar des Nachlasses von Erzherzog Ferdinand II. in Ruhelust, Innsbruck und Ambras vom 30. Mai 1596', *JKSAK* 7 (1888), pp. CCXXVI–CCCXIII, reg. 5556; 10 (1889), pp. I–X, reg. 5556.

5    Adriana Concin, 'Hans Albrecht von Sprinzenstein: An Austrian Art Agent in the Service of Archduke Ferdinand II of Tyrol', in *Art Markets, Agents and Collectors: Collecting Strategies in Europe and the United States: 1550–1950*, eds. Adriana Turpin and Susan Bracken, forthcoming 2021. I am grateful to Adriana Concin for allowing me to read her essay before publication.

informant, *gehorsamer diener* (obedient servant) and spy, reporting regularly from the Viennese court. In one letter filled with gossip and news, he informed the archduke about the recent arrival of two portraits of Philip II of Spain and his wife Isabel of Valois, sent from Madrid as personal gifts for Ferdinand.[6] Through correspondence and networking, Archduke Ferdinand II made certain he was always best informed about the circulation and movement of art works and diplomatic gifts both within and outside of the Habsburg territories.

Veit of Dornberg (1529–1591), another imperial diplomat and orator based in Venice from 1567 until 1587, sent Archduke Ferdinand II a letter written in early 1587, informing him of several portraits of Venetian ladies by an unnamed painter (some perhaps by Tintoretto?), which were intended to be sent to Innsbruck. This shipment comprised not only portraits earmarked for the archduke's expanding portrait gallery at Ambras Castle, but also portraits of aristocratic women under scrutiny as prospective brides for his eldest son, Karl, Margrave of Burgau (1560–1618).[7] Earlier in 1577, Archduke Ferdinand II had looked further south to Florence, soliciting replicas of full-length Medici portraits, with precise measurements provided as to width and height,[8] and an identical letter with the same request was simultaneously posted to the Duke of Ferrara.

Archduke Ferdinand II targeted those portraits he was best informed about, hanging in galleries dispersed amongst the Spanish royal residences: the Alcázar palace and the private gallery of Princess Juana of Austria in the Descalzas Reales Convent in Madrid, and the king's portrait hall (*Sala de Retratos*) at the hunting lodge of El Pardo. In 1565 through the imperial ambassador in Madrid, Adam of Dietrichstein (1527–1590), the archduke ordered copies of well-known portraits of Spanish kings and queens for the purpose of creating dynastic galleries of illustrious members of the House of Habsburg for his Innsbruck palaces at Ambras and Ruhelust.[9] Four years later this ambitious commission had yet to be fulfilled. Dietrichstein duly informed his patron he was doing his best to order the desired portraits, but the court painter in question, Alonso Sánchez Coello, "was so overloaded with work that he had entirely

---

6    Innsbruck, Tiroler Landesarchiv (hereafter TLA), Ferdinandea, Selekt 34, cart. 35, fol. 610, Vienna, 20 April 1567. For these portraits still extant in Vienna, see Kunsthistorisches Museum, Gemälde-galerie, inv. no. GG 3182 (Isabel of Valois) and inv. no. GG 3395 (Philip II; dated 1566).

7    TLA, Ferdinandea, Selekt 34, cart. 35, fols 596–597, Triest, 2 February 1587 (excerpt): "lasciandosi intendere di haver auttorità di trattar con la Illustrissima Signoria di maritaggio per l'Illustrissimo et Eccelentissimo Marchese di quella dilettissima figliuolo, con alcuna Bellissima Nobile Venetiana, chidendo ritratti di diverse per mandarle a Vostro Altezza, et à sua Excellenza da vedere [...]". These were gifted to Ferdinand by the Venetian courtier Gian Giacomo Cornaro but could not be identified in his 1596 *postmortem* inventory.

8    TLA, Kunstsachen III, 20/29: "[...] contrafactur, und allem ganz gemalt [...]". Cf. David von Schönherr, 'Urkunden und Regesten aus dem k.k. Statthalterei-Archiv in Innsbruck', *JKSAK* 14 (1893), pp. LXXI–CCXIII, here p. CLXVIII, reg. 10680.

9    Schönherr 1893, p. LXXIII, reg. 9718 (28 January 1565): "[...] allerei conterfet von unsers hochlöblichen haus Oesterreich und dersselben nahent verwandten und befreudten personen zu handen bringen".

lost perspective of his many assignments".[10] In the end, these full-length portraits were never executed during Dietrichstein's tenure; his successor Hans Khevenhüller later took over the supervision of the archduke's commission. Years later, only two portraits by Sánchez Coello managed to reach Ambras Castle.[11] This ambitious project was later laid to rest.

Knowledgeable about art collections in northern Italian cities and palazzi, Archduke Ferdinand II rallied aristocrats to help him procure portrayals of particular subjects that were close to his heart. Brandolino Brandolini, count of Valmareno (1520–1601) generously complied, dispatching the portraits of two female dwarfs to Innsbruck in April 1587.[12] The missive does not say who these ladies were, nor to which court they belonged. The count did not fail to point out to the archduke the "difficulties involved with properly portraying persons of small stature, precisely to their correct size and measurements".[13] Realistic portrayals of animals, dogs and birds were another favourite avidly collected by Archduke Ferdinand II for his library at Ambras Castle, either in the form of miniatures, loose folios or images bound in books. The little-known Cremonese painter and miniaturist Fabrizio Martinengo was sought out by Archduke Ferdinand II, who wanted Martinengo to collaborate with his court painter, Giulio Fontana (active 1562–1578) and his valet, Jakob Schrenck of Notzing (1539–1621),[14] on what Martinengo described in a missive to Innsbruck as *Libri di*

---

10   TLA, Ferdinandea, Selekt 34, cart. 35, fol. 745–746, Madrid, 4 March 1569 (excerpt): "die abconterfehungen so euer Furst Durchlaut haben wollen, will ich mit allen fleis bestellen und sollizitieren gleich wol hat es nit mer alls ainem maler hie der hat der arbait so vill das er nit volgen khan [...]".

11   Schönherr 1893, p. CLXX, reg. 10698 (27 September 1577). For more on these Sánchez Coello portraits see Almudena Pérez de Tudela and Annemarie Jordan Gschwend, 'Luxury goods for royal collectors: exotica, princely gifts and rare animals exchanged between the Iberian courts and Central Europe in the Renaissance (1560–1612)', *Jahrbuch des Kunsthistorischen Museums Wien* 3 (2001), pp. 1–128 (18–20).

12   This letter was consulted independently of Adriana Concin, who discusses it at length in Concin, forthcoming 2021. She determined these two portrayals were of female dwarfs: one full-length portrait cited in Archduke Ferdinand II's published 1596 estate inventory, and two listed in the unpublished Ambras Castle inventory dated 1621. Cf. Boeheim 1888, p. CCXXXII, reg. 5556: 'Ain Welschen zwergin ganze pildnus'. These portraits have not survived today in the Gemäldegalerie of the Kunsthistorisches Museum. I am grateful to Adriana Concin for sharing her findings with me.

13   Brandolini did not  mention who painted these portraits. See TLA, Ferdinandea, Selekt 34, cart. 35, fol. 608: "Seremissimo Principe. Già molti giorni sonno che Il Co[nte]: Giulio Camillo mio figlio et tanto sua Cordissimo servitor mi scrisse come vostro Altezza volontieri haveria veduto li retratti di due Nanne Italiana, et ch'io procurasi di inviar glie li con ogni maggior deligenza, cosi io hò attezo di ridurli in statto della giusti misure, et proportione delle persone loro come meglio sendo occorso l'intervallo di tempo per la passata dificultà di far retrare l'inferiore, quali poi assunatoli insieme per l'apportare delle gente che sara il sasso umilissimo servizio suo, et sudito mio glie le invio riverentemente rimanendo paratissimo di obbedire in tal negotio et in ogn'altra attione di commandato suo quanto per mesi potra maggiormente racommandando mi nelle Serenissima gratia. Di Padova il di 26 di Aprile 1587. Cordialissimi Brandolino Brandelini".

14   Born in Verona in 1543, Giulio was a painter, draughtsman, and illustrator. Brother of Giovanni Battista Fontana (1524–1587), who was Archduke Ferdinand II's court painter from 1575, they collaborated earlier in 1573 on the painted decorations of the *Silberne Kapelle* (Silver Chapel), Archduke Ferdinand II's funerary chapel in the Innsbruck Hofkirche. Between 1583 and 1584, Giovanni

*animali* (books filled with animal portraits).[15] Elsewhere, this tome was cited as *das gross Tierbuch* (the big animal book), and Martinengo's drawings may have been commissioned by the archduke for a projected publication which was never realized. Sometime in the late 1570s, to demonstrate his talents, Martinengo sent the archduke two miniatures of dogs, "one rapidly executed in three days", *alquanti disegni* (some of his drawings), and *uno quadreto di una vergine maria* (a small oil painting of the Virgin Mary).[16]

The patronage of outstanding musicians and the sourcing of contemporary religious and secular music played vital roles in Archduke Ferdinand II's ceremonial and daily life at Ambras Castle,[17] as did the collecting of extraordinary and rare instruments for his *Kunstkammer*, many of which have survived in the Sammlung alter Musikinstrumente in Vienna.[18] Count Guido della Torre, nephew of Michele della Torre, Bishop of Ceneda,[19] acted in July 1580 as the intermediary between the archduke and two leading composers in Venice and Treviso. A letter from Guido della Torre to Archduke Ferdinand II confirms he had secured musical scores (madrigals) for the archduke;[20] these were musical souvenirs of his momentous visit to Venice and

---

painted the wooden ceiling of the archduke's *Kunstkammer* with an *Allegory of the Zodiac, the Elements and Planets*, still extant at Ambras Castle. Giovanni is also documented as having executed portraits for Archduke Ferdinand II.

15  It has not been possible to identify the book or books with animal representations that Martinengo was expected to work on. For the surviving "animal books" once held at Ambras Castle, some of which are attributed to Giorgio Liberale, see Veronika Sandbichler, 'The 'natural copy and form'. The eye of the animal painter', *Echt tierisch! Die Menagerie des Fürsten*, ed. by Sabine Haag, pp. 69–75, pp. 69–75 and pp. 212–213, cat. 4.17. Also Boeheim 1888, p. CCXVLI, reg. 5556 (Ruhelust): "Ain grosz pergementes buech mit gemalten vöglen". This 2015 Ambras Castle exhibition on Habsburg menageries, pets, and exotic animals was guest curated by the author. Fabrizio Martinengo is later documented as working for Emperor Rudolf II in Prague: he was appointed to the post of imperial miniaturist in 1582 with a salary of 20 guilders per month and died in Prague in June 1585. His *oeuvre* for his Habsburg patrons has yet to be identified. Cf. Thomas DaCosta Kaufmann, *The School of Prague: Painting at the Court of Rudolf II* (Chicago, 1988), p. xiiii and p. 220, cat. 15.

16  TLA, Kunstsachen III, 20/44.

17  Walter Senn, *Musik und Theater am Hof zu Innsbruck. Geschichte der Hofkapelle vom 15. Jahrhundert bis zu deren Auflösung im Jahre 1748* (Innsbruck, 1954). More recently, Franz Gratl, 'Music at the Court of Archduke Ferdinand II within the Network of Dynastic Relationships', in Exh. Cat. Innsbruck 2017, pp. 61–71 (64).

18  Senn 1970, pp. 659–671.

19  Present day Vittorio Veneto, a province in Treviso.

20  Cited but not transcribed by Senn 1954, p. 157. See TLA, Ferdinandea, Selekt 34, cart. 35, fols 161–162 (30 July 1580): "Serenissimo Principe. Essendo l'Altezza Vostro Serenissimo l'anno passato in Venetia, Mons Andrea Gabrieli, uno de principale musici di quella Citta, et già mio Maestro, vedendo et mirando la Real presenza di Vostra Altezza Serenissima fermo nel suo pensiero de dedicarle alcuni Madrigalli che pur all'hora egli cominciava à comporré; et di pigliar me per sua guida et interpreti, à presentarli all'alto suo conspetto, sapendo esser io, suo fidelissimo et sui servatissimo servitor; et à lui anco molto amico: pero lavendogli gia finite et gli giorni passata fatti stampare, et poi inviatingli ni la pregato ch'io voglia favorer il voto suo, et presentarli à Vostro Serenissimo Altezza et insieme insieme [*sic*] farle fede dell'affetto sua ardentissimo, servirla et osservarla, et raccomodarlo alla sua begnissima gratia: ond'io non potendo mancar gli, per essergli huomo de bene, virtuossimi, et à me [illegible] la vio a Vostro Altezza Serenissimo queste virtuosi et nobile: sue fatiche, gia dedicatele sin da principio,

participation in the 1579 Venetian carnival.[21] One book of madrigals for six voices (*Il secondo libro de madrigali a sei voci*, Venice: Angelo Gardano, 1580) intended for use in the Ambras Castle chapel, had been expressly composed for Archduke Ferdinand II by the prolific and versatile Andrea Gabrieli (1533–1585), organist at San Marco since 1566; the composer dedicated this book to the archduke.[22] Gabrieli was a renowned member of the Venetian school of music and spread his grand, ceremonial style to Central Europe during his travels to Germany where he had befriended Orlando di Lasso. Guido della Torre also sent the archduke six books of madrigals by Michele Comis, which had been dedicated to della Torre himself. Comis, a composer from Vicenza, knew Andrea Gabrieli and had worked at San Marco in Venice. He was later employed by Guido della Torre's aforementioned uncle, Bishop Michele della Torre, from 1578 to 1581 as his *Kapellmeister*.[23] By sending Comis's books to the archduke, della Torre was bargaining for his own benefit, the gift of these invaluable musical scores intended to secure him greater opportunities at the archduke's court. Guido calculated that he would ingratiate himself with Archduke Ferdinand II by giving him the best Venetian music of the time.

Exchanges with Innsbruck were not always one-way, as gift-giving and reciprocity was equally expected from the archduke himself. Archduke Ferdinand II's allies at the Vatican, such as Tolomeo Gallio (1527–1607), Cardinal of Como and the Pope's Secretary of State, corresponded with the archduke on matters reaching beyond state politics or papal court gossip. The reputation of Philippine Welser, the morganatic wife of Archduke Ferdinand II,[24] and reports of her apothecary garden planted with medicinal plants at Ambras Castle, along with her expertise as a healer, did not fail to gain attention in Rome. News of her manuscript of medicinal recipes inherited from her mother

---

et insieme le raccordo esso Mons Andrea, loro Authore, confiandomi nella sua benignità de accetarà con quell'allegro et benissime animo et volto, che ella suole sempre l'opera de virtuosi et i degni huomini para suoi; poi che cosi facendo ella fa accrescer l'animo loro di maggiormente affaticersi nelle attioni virtuosi et honoraté et di continuamente pregar N. S. Dio per la conversazione del felicissimo stato de Vostro Altezza Serenissimo oltra di ciò con questi sarano anco altri sei libri, initolati à me de Mos Michele Comis musico, nostro di Capella di Monsignor Vescovo mi zio, di quali io ne faccio dono a Vostro Serenissimo Altezza stando ogni hora vigilantissimo aspettando ogni suo benigissimo comandamento alquale saro sempre prontissimo et obedientissimo et con questo fine humilmente inchiandomi et baciandole le invittissimo mani, insieme gli Illustrissimi et Eccelentissimi Signori Figliuoli me le raccone in buon gratia. Di Ceneda il 30 de luglio de 1580. Fidelissimo et devotissimo servidore, Guido della Torre, Consiglieri".

21  M. A. Katrizky, 'German Patrons of Venetian Carnival Art: Archduke Ferdinand II of Tyrol's Ambras Collections and the 1579 Travel Journal of Prince Ferdinand of Bavaria', in *Von kurzer Dauer? Fallbeispiele zu temporären Kunstzentren der Vormoderne*, ed. by Birgit Ulrike Münch, Andreas Tacke, Markwart Herzog and Sylvia Heudecker, Kunsthistorisches Forum Irsee 3 (Petersberg, 2016), pp. 126–142.

22  Senn 1954, pp. 157, 195 and 346.

23  Senn 1954, p. 157, who posits this may have been the *Primo libro di Madrigali a 6 voci* listed in the 1665 Schloss Ambras inventory. For more on Comis, consult the exhibition catalogue, *Gentilhomeni, artieri et merchatanti. Cultura materiale e vita quotidiana nel Friuli occidentale al tempo dell'Amalteo (1505–1588)*, exh. cat. (Pordenone, 2005), p. 403.

24  Philippine's dates: 1527–1580.

Anna Welser, her well-stocked pharmacy, and the medicines she made together with the court pharmacist, Gorin Guaranta, was reported at many Italian courts, particularly Florence and Ferrara.[25] A few months after Philippine's death in April 1580,[26] Cardinal Como wrote to Archduke Ferdinand II begging him to send him a powder which protected against poison, asking that specific instructions be included.[27] Gifts of all natures and all levels of importance thus produced bonds between various courts and individuals.

### Agents on the move in Spain and Portugal

Archduke Ferdinand II frequently sent his own courtiers and high-ranking soldiers to Spain on specific missions – diplomatic, military or otherwise - to visit and consult with King Philip II of Spain on a variety of matters, as well as to attend to his desired acquisitions and "shopping lists". These men were: the Augsburg entrepreneur and Fugger agent, Anthonio Meyting (1524–1591),[28] Christoph Tanner of Tann zu Mos, *Hauptmann* (captain) in Ferdinand II's Innsbruck guard,[29] and his *Kämmerer* (chamberlain), Adam Hochreiter.[30]

Archduke Ferdinand II simultaneously secured the services of the imperial ambassador, Hans Khevenhüller (1538–1606), resident in Spain since 1574, to officially rep-

25    Alisha Rankin, *Panaceia's Daughters: Noblewomen as Healers in Early Modern Germany* (Chicago, 2013), pp. 163–165. More recently, Katharina Seidl, '"… how to assuage all outer and inner malady …": Medicine at the court of Archduke Ferdinand II', in Exh. Cat. Innsbruck 2017, pp. 67–71.

26    Karl Beer, 'Philippine Welser als Freundin der Heilkunst', *Swiss Journal of the History of Medicine and Sciences* 7 : 1–2 (1950), pp. 80–86.

27    TLA, Ferdinandea, Selekt 34, cart. 35, fols 267–268, 10 September 1580 (excerpt): "Serenissimo Principe Signore mio Clementio. Se bene questa Corte é sempre sterile di avisi particolare fori del ordinario hora che la Santità di Nostro Signore [Pope Gregory XIII] si retrova alla villa molto meno tengo cosa di scrivere, l'IIlustrissmo Cardinale di Como il quale semore si ha demonstrato affirmissimo servitor di Vostro Serenissimo Altezza desidera infinitamente che Vostra Altezza *li faci gratia di un poco di quella polvera di Vostra Altezza contra venenum, con farli gratia di cometter chi li sia scritto tutte le proprieta che tiene detta polvere, et come si ha á usare, et la quantita che si debbe pigliare*, et se detta polvere conserva et ha la istessa virtù et proprieta o leve un'anno: et per quanta tempo é bona: che ricevera il tutto per singolarissimo gratia de Vostra Signore Altezza […]" [author's italics].

28    Annemarie Jordan Gschwend, 'Exotica for the Munich Kunstkammer. Anthonio Meyting: Fugger agent, Art dealer and Ducal Ambassador in Spain', in *Exotica*, ed. by Georg Laue (Munich, 2010), pp. 8–28; Mark Häberlein and Magdalena Bayreuther, *Agent und Ambassador. Der Kaufmann Anton Meuting als Vermittler zwischen Bayern und Spanien im Zeitalters Philipps II.* (Augsburg, 2013); Annemarie Jordan Gschwend, 'Anthonio Meyting: Artistic Agent, Cultural Intermediary and Diplomat (1538–1591)', in *Renaissance Craftsmen and Humanistic Scholars. Circulation of Knowledge between Portugal and Germany*, ed. by Thomas Horst, Marília dos Santos Lopes and Henrique Leitão (Franfurt am Main, 2017), pp. 187–201.

29    For Tanner in Spain, see Pérez de Tudela / Jordan Gschwend 2010, p. 61.

30    Annemarie Jordan Gschwend, 'Indisches Nashorn', in *Elfenbeine aus Ceylon. Luxusgüter für Katharina von Habsburg (1507–1578)*, ed. by Annemarie Jordan Gschwend and Johannes Beltz (Zurich, 2010), pp. 150–151, cat. 63; Thomas Kuster, 'Hern Adam Hochreitters Schiffart unnd Rayss […]', in *Echt tierisch! Die Menagerie des Fürsten*, ed. by Sabine Haag, exh. cat. (Vienna, 2015), pp. 132–133, cat. no. 2.2.

resent him at the Spanish court. In Madrid, Khevenhüller diligently administered the archduke's political agenda, while at the same time acting as his agent and intermediary for the acquisition of exotica, luxury goods, wild animals, and Andalusian horses. Archduke Ferdinand II's trust in Khevenhüller was implicit and often expressed by the archduke in their surviving correspondence.[31] Khevenhüller intervened in diverse political issues arising between Innsbruck and Madrid. Both before and after 1580, it was imperative for Archduke Ferdinand II to secure money and court positions within the empire for his morganatic sons, Andreas of Austria and Karl. The archduke addressed his requests in this matter directly to King Philip II, and expected Khevenhüller to support him.[32]

### Captain Christoph Tanner of Tann: Soldier and courtier

Additional family matters arose in 1584, when Archduke Ferdinand II sent Christoph Tanner of Tann to Spain to pay a courtesy visit to King Philip II. The archduke wanted the monarch to be godfather of his new child by his second wife, Anna Caterina Gonzaga. Through the construction of familial obligations, Archduke Ferdinand II strove to bind Madrid and Innsbruck together at tightly as possible.[33] Despite it being a state visit, Tanner was equally tasked with fulfilling the archduke's latest shopping lists on this occasion, taking luxury goods (rich textiles, silks, and portrait medals) back to Innsbruck in May of 1584: these were recorded in an official customs list.[34] Tanner served several important functions at the Innsbruck court, and had enlisted some years earlier as an officer in the military campaign of 1580–1581, when King Philip II conquered Portugal and took over the crown with an army led by Fernando Álvarez de Toledo, Duke of Alba (1507–1582). Tanner left for Portugal with the "German" regiment that Archduke Ferdinand II had generously ceded to King Philip II, under the

---

31  Valladolid, Archivo General de Simancas (hereafter AGS), Estado 692, fol. 118 (14 November 1586), for a letter Ferdinand II sent Khevenhüller, expressing his utmost confidence in the diplomat whom he considered a true friend: "[…] y la confiança que siempre he hecho de vuestra persona […]".

32  Valladolid, AGS, Estado 692, fol. 16 (Innsbruck, 20 February 1584), Ferdinand's letter to Philip II, asking for a post for Karl (excerpt): "Vostro Maestà riccorderà qualmente per il passato l'ho presentato et totalmente dedicato per servitore mio figliuolo secondgenito il Marchese Carolo [Karl], pregandola volesse accertarlo por tale et promover lo à qualche ispeditione di guerra, à dar principio alla servitù sua che desidera di far alla Vostro Maestà […]". For grants of money given Andreas and Karl see AGS, Estado 692, fol. 16, fol. 113 (29 August 1586) (excerpt): "[…] del Serenissimo Archiduque Ferdinando tiene por bien de dar al Cardenal [Andreas] su hijo tres mil ducados de pension aca en Spania y creo seran sobre el Arcobispado de Sevilla […]".

33  AGS, Estado 692, fol. 20 (Aranjuez, 29 April 1584) (minute of Philip's letter): "Al Archiduque Fernando +. Ala carta de Vuestra Alteza que me truxo el capitan Tanner, embiando me a ser padrino del hijo /o hija que me presto espera que le nasçera respondo mas largamente por via del Duque de Terranova, mas no he querido que el Tanner se vaya sin estos renglones, y por que de su relacion entendera Vuestra Alteza la voluntad y contento, con que he aceptado este officio y la orden que he darle para ello, no havra para que dizer mas, de que Vuestra Alteza crea que holgara yo de hazer lo en presençia / si el estar tan lexos no lestorbara / N. S. guarda V. A. como puede […]".

34  See note 29 above.

leadership of the professional army commander, Count Hieronymus Lodron.[35] Tanner's previous experiences in Iberia, having resided in Madrid and Lisbon for longer periods of time,[36] coupled with his excellent family connections to the Fugger merchant-banking family in Augsburg,[37] served Archduke Ferdinand II well. Tanner, both well-educated and talented, was able to adroitly manoeuver and negotiate for his Habsburg patron on many levels: cultural, diplomatic and military.

### Adam Hochreiter: Tourist and spy

Adam Hochreiter (1550–1595) assumed similar roles to those fulfilled by Christoph Tanner at Archduke Ferdinand II's court. Little is known of his early life (he was born in Wasserburg near Passau), and even less is known of his formative years. By 1585 he had been appointed the archduke's valet and later became his chamberlain (*Kämmerer*). In February of the same year, Hochreiter helped organise the "Bacchus Gesellschaft" in Innsbruck with the archduke's drinking society: a theatrical performance of *Bacchus and Ceres*, in which Archduke Ferdinand II and his entire court participated dressed in costume, while Hochreiter played the lute.[38] A better understanding of Hochreiter can be extracted from his diary, compiled between 1578 and 1595. Folios 100–122 of his *Tagebuch* detail a trip to Spain taken between 1583–1584, the objective of which may not have been travel and tourism. More likely, he was sent as Archduke Ferdinand II's spy to gather information at King Philip II's court. While in Madrid, he pasted a unique watercolour of an Indian rhinoceros he had seen into his diary; the archduke had coveted this animal for his Innsbruck menagerie.[39] The colourful Spanish silk thread and the crucifix in a casket, both from Portuguese Asia (India), which Hochreiter listed on fol. 127 may have been luxury goods earmarked for the archduke.

---

35  Lodron's involvement in the 1580–1581 Portuguese campaign discussed at length by Markus Neuwirth, 'Lissabon Rekonsturiert. Architektur und Kunstkammerstücke des ersterns Wetlhandels', *Mitteilungen der Carl Justi-Vereinigung* 27–28 (2015/2016), pp. 133–154 (140–146). Also see Vienna, Austrian National Library (ÖNB), Cod. 9865: *Beschreibung des Portugalesischen Kreigs*, which manuscript formerly belonged to Archduke Ferdinand II at Ambras Castle, and Vatican City, Biblioteca Apostolica Vaticana (hereafter BAV), Urb. Lat. 825/1, fol. 108v: "[…] assoldo anco il Conte Hieronimo de Ladrone con un regimento de 1000 fanti [infantry] Tedeschi […]".

36  Rafael Valladares, *La conquista de Lisboa. Violencia militar y comunidad politica en Portugal, 1578–1583* (Madrid, 2008); *The Global City. On the streets of Renaissance Lisbon*, ed. by Annemarie Jordan Gschwend and K. J. P. Lowe (London, 2015).

37  For Tanner and his Fugger relatives, see Oswald Bauer, *Zeitungen vor der Zeitung. Die Fuggerzeitungen (1568–1605) und das frühmoderne Nachrichtensystem* (Berlin, 2011), pp. 93–95.

38  Regarding this performance, see 'Aus dem Tagebuch des Abraham Kern von Wasserburg', in Lorenz Westenrieder, *Beyträge zu vaterländischen Historie, Geographie, Statistik und Landwirtschaft […]*, I (Munich, 1788), pp. 150–152.

39  Innsbruck, Universitäts- und Landesbibliothek Tirol, sign. MS I b 42: "Den 29 january anno 1584 hab jch alhie zu Madrid […] ain andern gross ungeheür thier, genant rinoceros, auff spänisch La Abada, gesehen, dessen abriss hieneben, der in meinem beysein ist gemalt worden".

## Anthonio Meyting: Agent, diplomat and merchant-dealer

Anthonio Meyting was a patrician from Augsburg, who played a leading role as financier, intermediary, art dealer, and, at various stages in his career, as courtier and diplomat for the Bavarian ducal court in the late sixteenth century. Meyting was influential in the formation of the Munich *Kunstkammer* created by his principal patron, Duke Albrecht V (1528–1579), while simultaneously serving as agent and artistic consultant for King Philip II of Spain and Archduke Ferdinand II. Correspondence and other documents map out Meyting's international career. Many outstanding artworks, exotica and luxury goods that once resided in the Renaissance *Kunstkammern* of Madrid, Munich, Vienna, Prague and Innsbruck entered these former collections under his sharp eye and personal directives.

Best described as an early modern acquisitions agent, Meyting embarked on a successful career as an entrepreneur and cultural mediator. He became a merchant-dealer and art broker, who redefined the commercial and artistic networks linking Iberia with Central Europe. His language skills and social mobility gained him access to the highest spheres. Meyting was extremely astute in understanding the needs of his royal and aristocratic clientele, and in satisfying their demands. He assumed multiple roles as dealer, royal agent and diplomat.[40]

In Spain Meyting functioned as an agent, while at the same time mediating for the Fuggers in an official capacity. His responsibilities mirrored those of the imperial ambassador, Hans Khevenhüller. He cultivated close ties with Archduke Ferdinand II, whom he had known since 1559 when the archduke placed his first order for "two pounds of the best Spanish silk Meyting could find in Madrid".[41] Years later, in 1590, the archduke invited Meyting to enter his service permanently, but this never came to pass, as Meyting died in 1591. During the years when Meyting collaborated with the archduke, he frequented Ambras Castle on his way to and from Munich.

In early 1591, Meyting acted as intermediary between Archduke Ferdinand II and the famous Spanish musician, Tomás Luis de Victoria (1548–1611), who was serving as chaplain at the court of the Dowager Empress Maria of Austria. Her court was in residence at the Descalzas Reales Convent in Madrid at that time. Victoria had sent the archduke *un libro grande de missas* (a printed book of music) from Rome for use in the Ambras chapel, a gift which had never been properly acknowledged. Two unpublished autograph letters located today in Innsbruck express Victoria's anger, complaining of

---

40   Manfred Tietz, 'The Long Journey from 'Deceiver and Conman' to 'Honorable Merchant.' The Image of the Merchant in Spanish Literature and its Contexts from the Sixteenth to the End of the Eighteenth Century', in *The Honorable Merchant – Between Modesty and Risk-Taking: Intercultural and Literary Aspects*, ed. by Christoph Lütge and Christoph Strosetzki (Cham, 2019), pp. 95–117 (100–102).

41   Order sent by the Archduke during his Prague residency in December 1559. Cf. TLA, Hofregister AB, fasc. 16 (1559): "[…] aus Hispania vonn allerlay schöner sort Spanischen Seiden werckh […]".

the archduke's silence and the lack of proper compensation for his book.[42] Victoria was desperate to settle matters in his favour, and begged Meyting to intervene. Whether the archduke ever compensated Victoria after Meyting's death in September is not known.

### The versatile Hans Khevenhüller

As the imperial ambassador to Spain from 1574 to 1606, Hans Khevenhüller was the official representative of the Austrian Habsburg court. On a private level, Khevenhüller redefined himself as dealer and intermediary, playing a major role in the development of various *Kunstkammern*, menageries and gardens in Vienna, Prague, Graz, Innsbruck and Munich. His long residency at the Spanish court influenced the evolution of Habsburg collecting in the late sixteenth century. Without Khevenhüller's engagement as an art agent and advisor, it would not have been possible for Emperor Maximilian II, his son Rudolf II, Archduke Ferdinand II, or the Bavarian dukes Albrecht V and Wilhelm V in Munich to form such outstanding collections; surviving objects from these collections are held today in the Kunsthistorisches Museum in Vienna, at Ambras Castle, and in the *Schatzkammer* of the Munich *Residenz*.

Fig. 1. Composite emerald cluster, Columbia, 1570s, mount late 16th century (Vienna, Naturhistorisches Museum, inv. no. C 3281)

---

42   TLA, Ferdinandea, Selekt 34, cart. 35, fol. 742: "Serenissimo Señor. Desde Roma invié a Vuestra Alteza por manos del obispo de San Francisco, avra algunos dias un libro grande de misas para serviçio de la capilla de Vuestra Alteza, y no e tenido jamas Respuesta, suplico a Vuestra Alteza ques pues las demas principes y yglesias me han hecho merçed / que la Rescivayo de Vuestra Alteza que la reconoçeré toda mi vida y que daré perpetuamente por criado de Vuestra Alteza cuya Serenissima persona nuestro Señor quarde mucho años, de Madrid y henero 28 de [15]91. Serenissimo señor a Vuestra Alteza beso los manos, su menor criado, Thome de Victoria capellan de la emperatriz', and fol. 744: 'Serenissimo principe. Por orden de Antonio Maytin [Meyting] suplique a Vuestra Alteza sea cordase he hacer merçed, atento lo mucho que yo gasté en imprimir el libro grande de misas que invié a Vuestra Alteza desde de Roma, con el obispo de San Francisco, criado de V. Alteza y pues delas demas ygelesias y principes e Resçibido merçed, suplico a Vuestra Alteza de la que fuere servida de haçer me, sea por orden del dicho Antonio Maytin residente en esta corte, y por ser negocio de tan poca importancia no é pedido al enbajador de la Magestad Cesarea [Hans Khevenhüller], lo pido a Vuestra Alteza aquien nuestro Señor guarde mucho años, de Madrid y hebrero 27 de [15]91. Serenissimo principe a Vuestra Alteza beso las manos, su menor criado, Thome de Victoria capellan de la emperatriz".

The imperial ambassador's network of merchants based in Lisbon, Seville and Goa proved invaluable. Khevenhüller cultivated reliable informants in Iberia, the Americas and Portuguese Asia, taking advantage of the Fugger's agents, such as Konrad Rott in Lisbon and Ferdinand Cron in Cochin and Goa. Cron was a significant link between India, the Far East, Lisbon, and Madrid, and certainly assisted Khevenhüller. Private merchants stationed at specific trading posts in Cochin, Cannanore, Calicut, and Quilon played decisive roles in the global trade network that Khevenhüller had gained access to. Nathanial Jung, the Fugger merchant-dealer and jeweller from Augsburg, resided for years in Lisbon and assisted Khevenhüller in acquiring bezoar stones, diamonds, and other precious stones from India.

It is clear from Khevenhüller's correspondence that the Peruvian minerals called *piedras de mina* or *handstein* in Spanish and German respectively were especially sought after by his Habsburg patrons. One such composite emerald cluster, a "fake" comprising of two different sorts of Columbian emeralds pasted together, entered Archduke Ferdinand II's *Kunstkammer*, and was later listed in his 1596 estate inventory (the inventory held in Vienna, Kunsthistorisches Museum, Kunstkammer, inv. no. KK 6652, hereafter estate inventory KHM) (Fig. 1). This object reached Innsbruck through Khevenhüller's intervention, as his published letters and Spanish customs lists confirm.[43]

## Conclusion
### 1580–1581: War, booty and the Queen of Portugal's *Kunstkammer*

King Philip II's conquest of Portugal, with the help of Archduke Ferdinand II's infantry, firearms, and mercenary soldiers under the command of Count Hieronymus Lodron, afforded the archduke and his expanding *Kunstkammer* unexpected advantages. King Philip II entered Portugal in 1580, two years after the death of the Habsburg queen, Catherine of Austria (1507–1578), who was also aunt to both Philip II and Archduke Ferdinand II (Fig. 2). Philip II's triumphant victory and succession to the Portuguese throne was eased by the chaos that had ensued after the death of King Sebastian, Catherine of Austria's grandson and the last Avis king, in North Africa in 1578. King Philip II entered Lisbon in June 1581, taking possession of the royal residences and their treasuries. He moved into the Lisbon royal palace, the *Paço da Ribeira*, which he immediately began to renovate and rebuild (Fig. 3). After Catherine's death, her outstanding collection of carved Ceylonese ivory fans and caskets (Fig. 4),[44] lacquer

---

43  Schönherr 1893, p. CLXIV, reg. 10641 (21 July 1576) and p. CLXVII, reg. 10672 (2 February 1577); Pérez de Tudela / Jordan Gschwend 2010, pp. 34–35. Vienna, Naturhistorishes Musuem, inv. no. C 3281, from the collection of Ferdinand II of Tyrol.

44  *Sinhalese ivory casket*, Vienna, Kunsthistorisches Museum, Kunstkammer, inv. no. KK 4743, from the collection of Ferdinand II of Tyrol, Schloss Ambras, after 1580.

Fig. 2. Nicolò Nelli, Portrait of Catherine of Austria
(1507–1578), Venice 1568 (private collection)

furniture exported from South China or the Ryukyu,[45] Chinese Ming and *kinrande* porcelain (Fig. 5),[46] carved Chinese nautilus shells, and other luxury goods from Portuguese Asia remained in her wardrobe in the Lisbon palace. No estate inventory of her *Kunstkammer* had been redacted in 1578 and it is recorded by eyewitnesses that when King Philip II became king of Portugal, he quickly absorbed the former Portuguese royal collections as his own.[47]

This Portuguese campaign was a costly, expensive enterprise, and Philip II lacked the funds necessary to pay Archduke Ferdinand II's "German" troops based in Lisbon for three or more years. The archduke complained bitterly to the king in subsequent letters dated 1586, requesting the monies owed him.[48] To appease the archduke's anger, the king gave him objects and treasures from the Portuguese royal wardrobe, one of which had belonged to King Manuel I (r. 1496–1521) and other objects, not all as yet identified, formerly belonging to Catherine of Austria. Those discovered at Ambras were recorded in her inventories dated before 1578.[49] In gratitude for Archduke Ferdinand II's military aid, King Philip II offered him a rare, late fifteenth-century West African Calabar ivory horn, still extant, which I have traced to the

45  *Black lacquer table*, South China or Ryukyu Islands, mid-16th century, (before 1596), black and gold lacquer, teak, brass hinges, L 121 cm, W 96.4 cm, Vienna, MAK – Austrian Museum for Applied Arts / Contemporary Art, inv. no. LA 280; collection of Catherine of Austria, before 1578 , and the collection of Ferdinand II of Tyrol, Ambras Castle, after 1580, for a depiction see p. 469 in this volume (article Bukovinská).

46  Here I illustrate the *Kinrande bowl with dragon,* Vienna, Kunsthistorisches Museum, inv. no. KK 2673, collection of Ferdinand II of Tyrol, Ambras Castle, after 1580.

47  Annemarie Jordan, 'Portuguese Royal Collections: A Bibliographic and Documentary Survey' (unpublished M.A. thesis, George Washington University, Washington, D.C., 1985); Annemarie Jordan Gschwend and K. J. P. Lowe, 'Renaissance Lisbon's Global Sites', in *A Cidade Global. Lisboa no Renascimento / The Global City. Lisbon in the Renaissance*, ed. by Annemarie Jordan Gschwend and K. J. P. Lowe (Lisbon, 2017), pp. 32–59.

48  Valladolid, AGS, Estado 692, fol. 118 (14 November 1586).

49  Jordan Gschwend / Lowe 2017, pp. 45–49.

Fig. 3. Anonymous, possibly a Portuguese artist, View of the Lisbon Royal Palace, Palace Square and tower, 18th century (private collection)

archduke's *Kunstkammer* (Fig. 6).[50] This oliphant was recorded in the 1596 estate inventory KHM from Ambras Castle, as "an ivory horn with two silver rings, three silver chains, and three bands upon which the empresa of Portugal and Terceira [Manuel I's coat of arms] were engraved".[51] Other treasures less easy to locate in the 1596 estate inventory left Lisbon in 1583 destined for Innsbruck: select pieces of Ming and *kinrande* porcelain, Ryukyu lacquers, painted Chinese scrolls, a West African raffia mat, and Catherine of Austria's Ceylonese ivories.[52]

As king, Philip II legally incorporated the Portuguese royal treasury into his own patrimony. Exotica, portraits, Flemish tapestries, manuscripts, and books were taken to Spain, and the king exhibited his Lisbon booty in the Alcázar palace in Madrid.

---

50   *West African horn*, Calabar (today Nigeria), Vienna, Kunsthistorisches Museum, Collection of Historical Music Instruments, inv. no. SAM 273, collection of Manuel I of Portugal, before 1495; and collection of Ferdinand II of Tyrol, Ambras Castle, after 1580.

51   Jordan 1985, p. 172.

52   Annemarie Jordan Gschwend, 'A Forgotten Infanta: Catherine of Austria, Queen of Portugal (1507–1578)', in *Women. The Art of Power. Three Women from the House of Habsburg*, ed. by Sabine Haag, Dagmar Eichberger and Annemarie Jordan Gschwend (Innsbruck and Vienna, 2018), pp. 50–63 (59).

Fig. 4. Sinhalese ivory casket, Ceylon (Sri Lanka), Sitavaka, 1546–1547, lock and lion's paws, sothern German, late 16ᵗʰ century (Vienna, Kunsthistorisches Museum, Kunstkammer, inv. no. KK 4743)

Fig. 5. Kinrande bowl with dragon, China, Ming Dynasty, second half of the 16ᵗʰ century (Vienna, Kunsthistorisches Museum, inv. no. KK 2673)

Fig. 6. West African horn, Calabar (today Nigeria), late 15th century (Vienna, Kunsthistorisches Museum, Collection of Historical Music Instruments, inv. no. SAM 273)

King Philip II knew of Archduke Ferdinand II's collection and his tastes, having been well informed by the imperial ambassador in Spain, Hans Khevenhüller, who sourced horses, animals, exotica (such as the abovementioned Peruvian emerald clusters), portraits, and luxury goods for Ambras Castle. These treasures from Archduke Ferdinand II's former collection, many of which have survived, exemplify his cultural transfers not only with Spain and Portugal in the later period of his life, but also the cultural exchanges he had cultivated earlier with various Italian courts.

Eva Lenhart

## Glasswork at the court of Archduke Ferdinand II: Glass jewellery from the lampworked glass collection in the *Kunstkammer*

Archduke Ferdinand II was one of the most significant and influential collectors of the late Renaissance. The curiosities gathered together in his *Kunstkammer* also included artworks made from glass. Among these, we find a collection of glass worked in the lampworking technique. This collection is currently held in the Kunsthistorisches Museum in Vienna, and in Ambras Castle in Innsbruck.[1] The collection comprises extensive holdings of glass jewellery, glass pictures, and other artworks in glass. All of these objects are however unified by the technique used to manufacture them. This technique, so-called *Lampenarbeit* (lampworking), involved forming and melting glass tubes and glass rods using the flame of an oil-lamp. This article concerns itself with selected glass artworks from the collection's holdings. Taking glass jewellery as the starting point, we will examine the function of the glass collection in connection with court festivities, and the general significance of lampworking at the court of Innsbruck.

### The lampworked glass collection

Archduke Ferdinand II was recognised by his contemporaries as a collector of choice pieces of glassware. Although he had indeed already ordered glass pieces made to a custom template in a Bohemian glassworks in 1561,[2] the majority of his collection originated during his reign as prince of Tyrol. He favoured Venetian glass. This preference was partially based on the skilled craftsmanship of the Venetian glassmakers, and also on the unequalled quality of the glass itself. *Cristallo* [Crystal glass][3] was produced

1    Eva Putzgruber, *Die vor der Lampe gearbeitete Glassammlung Erzherzog Ferdinands II. von Tirol. Untersuchungen zur Geschichte der Sammlung und zur Entwicklung der Lampenarbeit im 16. Jahrhundert* (unpublished doctoral thesis, Institute of Conservation, University of Applied Arts Vienna, 2016). Cf. Eva Putzgruber, 'Glasschmuck des 16. Jahrhunderts. Die Glasschmucksammlung Erzherzog Ferdinands II. in der Kunstkammer des Kunsthistorischen Museums Wien', in *Konservierungswissenschaften und Restaurierung heute. Von Objekten, Gemälden, Textilien und Steinen*, ed. by Gabriela Krist and Martina Griesser-Stermscheg, Konservierungswissenschaft – Restaurierung – Technologie 7 (Vienna, Cologne and Weimar 2010), pp. 333–343; Eva Putzgruber, Marco Verità, Katharina Uhlir, Bernadette Frühmann, Martina Griesser and Gabriela Krist, 'Scientific investigation and study of the sixteenth-century glass jewellery collection of Archduke Ferdinand II at the Kunsthistorisches Museum, Vienna', in *The decorative: conservation and the applied arts*, ed. by Sharon Cather et al. (London, 2012), pp. 217–226; Gabriela Krist, Johanna Wilk, Eva Putzgruber and Roberta Renz-Zink, 'Konservierungswissenschaftliche Dissertationen an der Universität für angewandte Kunst Wien', *Zeitschrift für Kunsttechnologie und Konservierung* 2 (2015), pp. 305–328.

2    Erich Egg, *Die Glashütten zu Hall und Innsbruck im 16. Jahrhundert*, Tiroler Wirtschaftsstudien, Schriftenreihe der Jubiläumsstiftung der Kammer der gewerblichen Wirtschaft für Tirol (Innsbruck, 1962), p. 43.

3    Marco Verità, 'L' invenzione del cristallo muranese: una verifica analitica delle fonti storiche', *Rivista della Stazione Sperimentale del Vetro* 15 (1985), pp. 17–29 (17).

in Venice, a colourless glass whose transparency and uniformity was comparable to rock crystal. A special feature of Venetian glass was its array of brilliant colours, which seem to have been handled in a very playful manner. When ordering such work, the archduke engaged the services of Veit of Dornberg, the imperial envoy in Venice. Most of these orders followed a given template, which would be enclosed with the letters.[4] The archduke's written instructions specified both the form and quality of the glass-work. For example, in 1568 he ordered gilded drinking vessels and various kinds of sheet glass. For the latter, he was especially concerned with its transparency and smoothness.[5] Sometimes we also find instructions that specify the desired colours: in one case, Archduke Ferdinand II ordered luxuriously coloured hanging lamps made from "red, yellow[..] green and blue colours".[6]

The core of the archduke's collection comprises those pieces kept in the *Kunst-kammer* at Ambras Castle. An important source of information concerning these pieces is the 1596 inventory of Archduke Ferdinand II's estate (inventory held in the Kunsthistorisches Museum Wien, Kunstkammer, hereafter estate inventory KHM),[7] as it is the first complete description of the contents of this room. The *Kunstkammer* was outfitted with windows along both sides, and wooden cabinets placed back to back. Two cabinets were placed sideways on the narrow sides. Within these cabinets the collection was ordered by material.[8] In the eleventh cabinet[9] there were: "items made from glass",[10] with drinking glasses stored in the lowest section of the cabinet, and glass curiosities in the upper sections. The middle section of the 'glass' cabinet was largely reserved for the lampworked glass collection. Here we find "beautiful glass necklaces and rosaries",[11] and also "flowers, cords and other such things"[12] stored and presented on red and blue silk cushions. Glass pictures are also mentioned, a glass mountain with a hunting scene, a glass chess board, and two lidded vessels with cruci-fixion groups. The glasswares were also mentioned in later inventories of the *Kunst-kammer*.[13]

---

4   Tiroler Landesarchiv (Tyrolean Regional Archives, hereafter: TLA), Kunstsachen (hereafter: KS) III/46, series III, 24 October 1568, Archduke Ferdinand II, writing to the imperial envoy Veit of Dornberg; TLA, KS III/46, series III, 9 March 1578, Archduke Ferdinand II, writing to the imperial envoy Veit of Dornberg.
5   TLA, KS III/46, series III, 4 March 1568, Archduke Ferdinand II, writing to the imperial envoy Veit von Dornberg; TLA, KS III/46, series III, 18 September 1568, Archduke Ferdinand II, writing to the imperial envoy Veit of Dornberg.
6   "roten gelben [...] gruenen vnd plawen farben", TLA, KS III/46, series III, 9 March 1578, Archduke Ferdinand II, writing to the imperial envoy Veit of Dornberg.
7   Vienna, Kunsthistorisches Museum (hereafter: KHM), Kunstkammer (hereafter: KK), Inventarj Weyland der Frh: Drt: Erzherzog Ferdinannden Zu Ossterreich etc. lobseeligister gedechtnuß Varnussen Unnd mobilien [...], Innsbruck 1596, inv. no. KK 6652.
8   Elisabeth Scheicher, *Die Kunst- und Wunderkammern der Habsburger* (Vienna, 1979), p. 108.
9   Estate inventory KHM, inv. no. 6652, fol. 483v–485r.
10  "sachen von glaswerch", estate inventory KHM, fol. 483v.
11  "schene gleserne ketten und paternoster", estate inventory KHM, fol. 484v.
12  "pluemen, schnier und dergleichen", estate inventory KHM, fol. 484r.
13  Putzgruber 2016, pp. 16–21.

## The glass jewellery pieces

The glass jewellery from Archduke Ferdinand II's collection comprises a great variety of holdings, with a total of 308 individual objects. These include glass necklaces, rosaries, glass buttons, earrings, floral bouquets and glass figurines. In terms of form, these pieces of glass jewellery are orientated on contemporary goldsmithery. Benvenuto Cellini[14] described the forms and materials he used for his goldsmithery in 1568. These works were produced with great precision from gold or silver, and decorated with precious stones, pearls, enamel[15] und filigree.[16] *Körperemail* (émail sur ronde bosse),[17] enjoyed particular popularity. This type of enamel covered the whole silver or gold surface, and contributed a magnificently colourful appearance to the goldsmith's work. Glass jewellery imitated these sumptuous materials by the use of ornate gilding, coloured glass stones, overlays in twisted glass thread, and richly coloured glasses. A unique feature of glass jewellery from this period were the glass figurines, which were crafted with a great deal of animation.

During the Renaissance, figurative jewellery often took on antique and mythological themes. The latter were influenced above all by Ovid's *Metamorphosis,* which decribes the transformation of human beings into animals or plants in connection with various heroic and divine sagas.[18] The Prince of Tyrol's appreciation for Antiquity is reflected in his collection of glass jewellery. The glass figurine of a dragon, a creature mostly associated with the element of water in Antiquity, is especially fascinating.[19] The dragon of the glass collection[20] exhibits a fishlike body made from turquoise-blue glass. His horned head is made from white glass, and the wide-open maul shows his fangs (Fig. 1). A glass loop serves to hang the piece on a chain. Triton is another sea-dwelling creature, and combines a human upper body with a fish's tail. His attribute is a horn, the sound of which rules all the world's waters.[21] The glass figure of this sea god[22] has only survived in a fragmented state, but still shows that it was hung on a chain of silver-plated brass. Precious pieces such as this one were mostly worn on a ribbon about the neck.[23]

---

14   Erhard Brepohl, *Benvenuto Cellini. Traktate über die Goldschmiedekunst und die Bildhauerei. I trattati dell'oreficeria della scultura di Benvenuto Cellini* (Cologne, 2005).

15   This term is applied to numerous techniques used to melt coloured glass on a metal surface, coating it. Erhard Brepohl, *Kunsthandwerkliches Emaillieren* (Leipzig, 1979), p. 12.

16   Brepohl 2005, pp. 41–139.

17   This type of enamel involved working the enamel in high relief over a metal core. Brepohl 1979, p. 163.

18   *Publius Ovidius Naso, Metamorphosen, Epos in 15 Büchern,* ed. by Herman Breitenbach (Stuttgart, 2011), pp. 10–19.

19   Thomas Honegger, 'Der Drache: Herausforderer von Heiligen und Helden', in *Animali. Tiere und Fabelwesen von der Antike bis zur Neuzeit,* ed. by Luca Tori and Aline Steinbrecher, exh. cat. (Geneva and Milan, 2012), pp. 193–203 (194–195).

20   KHM, Kunstkammer, inv. no. KK 2792.

21   Gerhard Fink, *Who's Who in der antiken Mythologie* (Munich, 1993), p. 303.

22   KHM, Kunstkammer, inv. no. KK 2789.

23   Yvonne Hackenbroch, *Renaissance Jewellery* (London, 1979), p. 102.

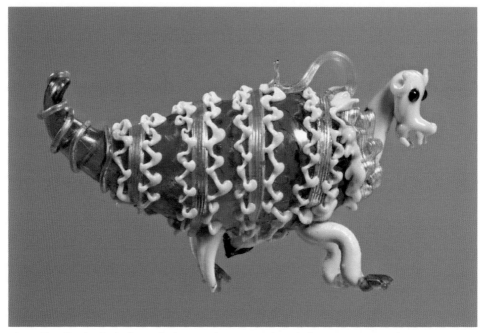

Fig. 1. Glass figurine in the form of a dragon (Vienna, Kunsthistorisches Museum, Kunstkammer, inv. no. KK 2792)

## Glass jewellery at court festivities

The loops and chains attached or worked onto the glass figurines show that they may well have also been worn as jewellery. An opportunity for wearing such jewellery was provided by court festivities, which not only served as amusement for the nobles, but also as a demonstration of the archduke's power. One of the most important celebrations during Archduke Ferdinand II's reign was the wedding of his chamberlain, Johann Libšteinský of Kolowraty, with Catherine of Payersberg in February 1580.[24] A *Festkodex* (a record of the event in the form of an ornate manuscript) was also produced for this festive occasion.[25] This documents the festive processions organised for the event, which were modelled on the triumphs of Antiquity. The festive company would participate in these and take to the tiltyard in costumes and masks. The affection for such tournaments was based on the desire to revive knightly chivalry and bring the legends of the knights to life.[26] During the Reniassance, the antique and

---

24    Veronika Sandbichler, 'Festkultur am Hof Erzherzog Ferdinands II.', in *Der Innsbrucker Hof. Residenz und höfische Gesellschaft in Tirol vom 15. bis 19. Jahrhundert,* ed. by Heinz Noflatscher and Jan Paul Niederkorn, Archiv für österreichische Geschichte, 138 (Vienna, 2005), pp. 159–174 (168).

25    KHM, Kunstkammer, inv. no. KK 5269.

26    Roy Strong, *Feste der Renaissance. 1450–1650. Kunst als Instrument der Macht* (Würzburg, 1984), pp. 78–80.

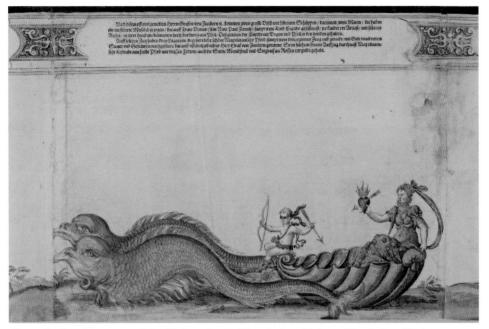

Fig. 2. Chariot with Venus and Cupid, from the Wedding Codex of Johann Libšteinský of Kolowraty (Vienna, Kunsthistorisches Museum, Kunstkammer, inv. no. KK 5269)

mythological tradition of the procession was often bound with the Christian tradition of the knights' tournaments. This connection was displayed at the Kolowrat wedding, an event which the Prince of Tyrol raised to a court festival, despite its low political importance.[27]

Archduke Ferdinand II participated in the organisation of the programme and had his court artists produce the necessary embellishments.[28] For the third and the fifth procession around the *Ringelrennen* (the *carrousel* or circular course of the tiltyard, where various games and jousts could be played), the festive company entered the tiltyard dressed as Antique gods and heroes, riding in triumphal chariots. These were sumptuously decorated, and pulled by various 'animals'. The 'animals' were actually elaborate set pieces, moved by the men hidden inside of them. One of the chariots took the form of a *Venusmuschel* (a round clamshell), pulled by dolphins. Venus and Cupid were seated on the giant shell.[29] The goddess held a flaming heart struck through by an arrow in her hand. The hair and clothing of the goddess of love were luxuriously decorated. Her skirt was fitted with cloth buttons crowned with pearls (Fig. 2).[30] Cos-

---

27 Sandbichler 2005, p. 168.
28 Elisabeth Scheicher, 'Ein Fest am Hof Erzherzog Ferdinands II.', *Jahrbuch der Kunsthistorischen Sammlungen in Wien* 77 (1981), pp. 119–153, p. 121.
29 Scheicher 1981, pp. 136–138.
30 Scheicher 1981, p. 139, Fig. 137.

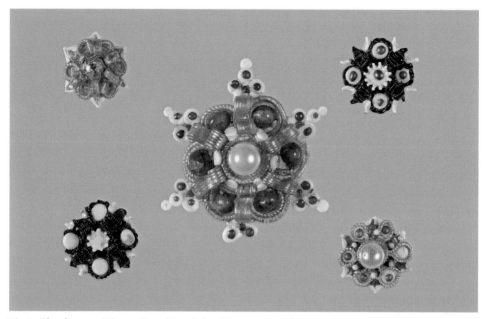

Fig. 3. Glass buttons (Vienna, Kunsthistorisches Museum, Kunstkammer, inv. nos. KK_2901, KK_2925, KK_2961, KK_2987, and KK_2784)

tumes used in the court festivities were usually made from affordable materials such as linen or satin, with accessories made from wood, metal or papiermaché.[31]

Glass jewellery pieces were less valuable[32] than their luxurious counterparts and were also used in costumes for court festivities during the Renaissance.[33] In fact, the buttons on Venus's skirt resemble certain buttons[34] in the lampworked glass collection (Fig. 3). These exhibit a basic star shape, decorated with turquoise-blue glass. Gilded glassthreads fasten a gilded glass pearl in the centre of the button. On the reverse side of the buttons there are iron eyelets used to sew the buttons onto clothing. Individual groups of buttons belonged to particular garments. The buttons could also be removed from garments and re-used.[35] The quantity of these buttons was very significant in terms of their visual effect. There is a large quantity of glass buttons, kept in groups,

31    Monika Kurzel-Runtscheiner, *Glanzvolles Elend. Die Inventare der Herzogin Jacobe von Jülich-Kleve-Berg (1558–1597) und die Bedeutung von Luxusgütern für die höfische Frau des 16. Jahrhunderts* (Vienna, 1993), pp. 238–240.

32    A pair of glass earrings were worth less than 10 *Reichstaler,* whereas a pair of similar earrings made from gold were worth 24 *Reichstaler.* Kurzel-Runtscheiner 1993, p. 194 and p. 196.

33    Claudia Rousseau, 'The pageant of the muses at the Medici wedding of 1539 and the decoration of the Salone dei Cinquecento', in *"All the world's a stage…": art and pageantry in the Renaissance and Baroque. Theatrical spectacle and spectacular theatre,* ed. by Barbara Wisch and Susan Scott Munshower, Papers in art history from the Pennsylvania State University, 6:2 (University Park, PA, 1990), pp. 416–457 (419).

34    KHM, Kunstkammer, inv. no. KK 2914 to KK 2953.

35    Kurzel-Runtscheiner 1993, pp. 95–97.

and this indicates that their usage in costumes and so on was most probable. If a glass button broke, it could be quickly reproduced using the lampworking technique. All of this suggests that these buttons were made for use with costumes for the court festivities. Moreover, certain of the glass figurines refer to the context of a wedding, in that they represent the ancient gods of love.

One of the glass figurines[36] from the collection of Archduke Ferdinand II shows Cupid as a winged boy-child holding his bow and arrow. Ovid describes how Cupid's golden arrows bind lovers together, whereas his lead arrows drive them apart.[37] Another glass figurine[38] shows the naked Cupid standing on a gilded glass pearl. He no longer holds his bow and arrow, instead he wears a blindfold. Cupid is pictured blind, whereby the aim of his arrows becomes even more a matter of fate. In the late Renaissance, the image of the blind Cupid was recognised as an indication of sensual, carnal love.[39] A print by Pietro Bertelli shows a sumptuously dressed Venetian lady. The front part of her gown could be lifted, allowing the observer to see her undergarments,[40] and she wears her hair in two little horns above her forehead. In this way, closer examination reveals this lady to be a courtesan. Above her, the god of love hovers, blindfolded and with his bowstring tensed and ready. Cupid was viewed ambivalently during the Renaissance, since sexuality was only legitimised within wedlock.

Another female figurine, also standing on a gilded glass pearl, is significant in this context. Her hair, made from overlaid gilded glass strands, is also gathered into two little horns above her forehead, and falls loose over her neck at the back. (Fig. 4). This hairstyle is documented from as early as 1578, and was recognised as a typical Venetian fashion.[41] In his famous book on costumes, Cesare Vecellio remarks that this hairstyle was favoured by Venetian brides.[42] As shown by the Pietro Bertelli's print, it was also worn by courtesans, whose luxurious dress often made it difficult to discern between them, and respectable Venetian wives. The uncertainty over a woman's virtue produced by this similiarity in dress was fascinating, and inspired numerous depictions in glasswork.[43] The capacity of this Venetian hairstyle to bind love and sexuality is also shown in the collection of glass jewellery, where the hairstyle seems to be reserved for naked female figures.[44] In the piece mentioned above, the figure appears to be a depic-

36   KHM, Kunstkammer, inv. no. KK 2875.
37   Naso (Breitenbach 2011), I, V. 460–470.
38   KHM, Kunstkammer, inv. no. KK 2803.
39   Erwin Panofsky, *Studien zur Ikonologie. Humanistische Themen in der Kunst der Renaissance* (Cologne, 1980), p. 170; Bodo Guthmüller, '„Pro! Quanta potentia regni / Est, Venus alma, tui!". Venus in der Mythologie der italienischen Renaissance', in *Faszination Venus. Bilder einer Göttin von Cranach bis Cabanel*, ed. by Ekkehard Mai, exh. cat. (Cologne 2001), pp. 49–55 (53).
40   Jonathan Bate and Dora Thornton, *Shakespeare staging the world* (London, 2012), pp. 155–156 and p. 155, no. 14.
41   Bate / Thornton 2012, p. 151, fig. 6.
42   Margaret Rosenthal and Ann Rosalind Jones, *Cesare Vecellio's habiti antichi et moderni, The clothing of the Renaissance world, Europe, Asia, Africa, The Americas* (London, 2008), p. 179.
43   Bate / Thornton 2012, pp. 151–153 and p. 152, fig. 9.
44   Cf. KHM, Kunstkammer, inv. no. KK 2771 and KK 2799.

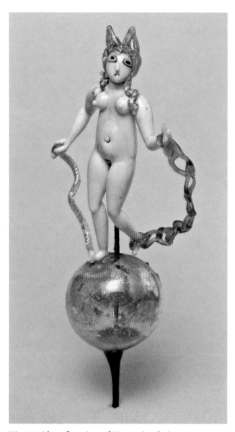

Fig. 4. Glass figurine of Venus in chains
(Vienna, Kunsthistorisches Museum,
Kunstkammer, inv. no. KK 2799)

tion of the love-goddess Venus,[45] whose right hand and right leg are chained. This visual device indicates wedlock, since the chained Venus represents a woman's faithfulness to her husband.[46]

The glass figurines of Venus and of Cupid could certainly have been accessories for festive costumes, and may well have been produced for the Kolowrat wedding in 1580. The costumes and accessories used for such festivities were usually stored close to the art collections. At the court of Innsbruck, they were stored in the armoury.[47] Glass jewellery was not listed in the inventory of the armoury, but the armoury and the *Kunstkammer* were in fact directly connected with one another.[48] It is therefore quite plausible that the glass jewellery was stored in the cabinet of the *Kunstkammer* dedicated to glassware. Furthermore, these pieces of glass jewellery were presented on silk cushions, just like their more expensive templates. This method of storage would not only have served the purpose of good presentation, but also rendered the glass jewellery easily accessible. Moreover, the storage of these items in the *Kunstkammer* also displays Archduke Ferdinand II's desire to be remembered by posterity. His various *Festkodizes*, which were completed for all of the festivities held at the court of Innsbruck, were also kept in the *Kunstkammer*.[49] The

---

45  KHM, Kunstkammer, inv. no. KK 2799.

46  Guthmüller 2001, p. 54.

47  Wendelin Boeheim, 'Urkunden und Regesten aus der k.k. Hofbibliothek', *Jahrbuch der kunsthistorischen Sammlungen des allerhöchsten Kaiserhauses* (hereafter as *JKSAK*) 7 (1888), pp. XCI–CCCXIII, reg. 5440 on pp. CCXVI–CCXVIII.

48  Veronika Sandbichler, '„AMBRAS […] worinnen eine wunderwürdig, ohnschäzbare Rüst=Kunst und Raritaeten Kammer anzutreffen". Erzherzog Ferdinand II. und die Sammlungen auf Schloss Ambras', in *Dresden & Ambras, Kunstkammerschätze der Renaissance*, ed. by Sabine Haag, exh. cat. (Vienna, 2012), pp. 31–41 (33).

49  Veronika Sandbichler, 'Der Hochzeitskodex Erzherzog Ferdinands II.: eine Bildreportage', in *Die Hochzeit Erzherzog Ferdinands II. Eine Bildreportage des 16. Jahrhunderts*, ed. by Sabine Haag, exh. cat. (Innsbruck, 2010), pp. 31–89 (32).

glass jewellery may have served as a kind of testament to the court festivities, and as evidence of the magnificent displays of splendour which took place during Archduke Ferdinand II's reign as Prince of Tyrol.

## Glass jewellery in court collections

Glass jewellery was also collected at other European courts during the Reniassance, including the court of Munich under the dukes Albrecht V and Wilhelm V of Bavaria. The *Kunstkammer* of these two dukes was considered one of the most significant collections of art to exist north of the Alps. Aside from other glass pieces produced using the lampworking technique, an inventory of the *Kunstkammer* from 1598 also mentions a "paternoster made from blue glasswork",[50] which was found in a credenza along with other rosaries. Archduke Ferdinand II's glass collection also included rosaries made with varicoloured glass. They are mostly comprised of blown glass beads, richly and ornately decorated. Originally, the glass collection did include rosaries in blue glass, the descriptions of which appears very similar to the rosary held in the Munich *Kunstkammer*.[51] The remaining extant rosaries are made of glass beads, which imitate beads made of silver or coral. Others are sumptuously designed, decorated with gilded overlays of glass thread and coloured glass dots.

Glass jewellery was also produced at the Florentine court of Grand Duke Ferdinando I de' Medici, and Grand Duke Cosimo II de' Medici. Niccolò di Vincenzo Landi was the leading lampworker, and in 1591 and 1592 he produced animal figurines from glass, amongst other things.[52] These included, for example, two "scorpions"[53] like the one from Archduke Ferdinand II's collection. The scorpion is made from black glass[54] and consists of a flat anterior body, with the head distinguished by a narrow neck formed using pressure from tongs or pliers. Two pincers flank the closed chelicerae, which serve to allow the scorpion to be hung on a chain (Fig. 5). Landi appears to have specialised in the production of glass animals. It is evident that he, among other things, made crickets, flies, spiders, locusts and butterflies from glass for the Grand Duchess and her daughters. Such jewellery was also given as gifts. A wealth of documentation shows that Ferdinando I de' Medici presented Landi's works as gifts to

---

50 "paternoster von blawem glaßwerckh", *Johann Baptist Fickler. Das Inventar der Münchner herzoglichen Kunstkammer von 1598, Editionsband, Edition der Inventarhandschrift cgm 2133*, ed. by Peter Diemer (Munich, 2004), p. 127.

51 KHM, Kunstkammer, Johann Baptist Primisser, *Vollständiges Verzeichnis Aller in dem k.k. Schloß Ambras vorfindigen Waffen, Rüstungen, Naturalien, Alterthümer, Kunstwerke, Kostbarkeiten, Seltenheiten, und Gerätschaften, wie sie sich im Jahre 1788 daselbst befanden*, II, *Die Schatzkammer* (Innsbruck, 1788), inv. no. KK 6661, p. 228 and p. 226.

52 Detlef Heikamp, 'Studien zur mediceischen Glaskunst. Archivalien, Entwurfszeichnungen, Gläser und Scherben', *Mitteilungen des Kunsthistorischen Institutes in Florenz* 30 (Florence, 1986), pp. 73–74.

53 "schorpioni", Heikamp 1986, p. 348.

54 KHM, Kunstkammer, inv. no. KK 2788.

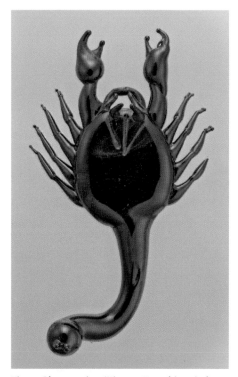

Fig. 5. Glas scorpion (Vienna, Kunsthistorisches Museum, Kunstkammer, inv. no. KK 2788)

noble houses all over Europe.[55] The scorpion from Archduke Ferdinand II's collection could also have been such a gift.

Glass jewellery was therefore collected as much as it was worn during the Renaissance. The fragile artworks can be viewed as both showpieces and practical objects. Even the actual production of these fragile glass works received particular attention. A drawing from 1610 shows a lampworker at his work table, transforming glass tubes and rods into miniatures.[56] A couple in court dress stand before his table in the company of two servants and observe the work with unconcealed wonderment. There is also evidence that Grand Duke Cosimo II de' Medici allowed Niccolò di Vincenzo Landi to set up his work table within the palace, so that he might watch Landi work glass with the lamp. In August and September 1620 Landi was employed within the chambers of the Grand Duke. This arrangement was repeated in October of the same year, when he also worked for a few days in the palace.[57] The artful working of the glass before the lamp's flame provided entertainment, and may also have been an attraction organised for court festivities.

## The lampworking technique

The lampworking technique for glassmaking was discovered during the Renaissance. The famous glassmaker Johannes Kunckel described the technique in 1689 by means of a copperplate engraving showing numerous lampworkers at their work.[58] An oil-lamp stands on a work table, and beneath it there is a bellows made from wood and leather. The uppermost wooden arm of the bellows is secured to the table, and the

55    Valentina Conticelli, Mattia Mercante and Laura Speranza, 'Un fragile capolavoro. Nuove ipotesi dal restauro di un reliquiario mediceo in vetro a lume', *Rivista dell' Opificio delle Pietre Dure e Laboratori di Restauro di Firenze* 28 (2016), pp. 40–70, p. 44 and p. 47.

56    Corning Museum of Glass, inv. no. 121962.

57    Heikamp 1986, pp. 93–95.

58    Johannes Kunckel, *Ars vitraria experimentalis oder Vollkommene Glasmacherkunst*, 2nd printing of the Frankfurt-Leipzig 1689 edition (Hildesheim, Zürich and New York, 1992), pp. 398–400 and p. 399, Fig. X.

lower arm is unsecured, allowing for the pumping of the bellows. A cord runs from the lower arm over a wheel, to a foot-pedal used by the seated lampworker. In this way, air was pumped from the nozzle of the bellows into a metal tube feeding upwards through a hole in the tabletop. This tube ended in a small nozzle with a narrow opening placed directly in front of the oil-lamp. The airflow produced a hot, directed flame, the temperature and form of which could be controlled via the foot-pedal (Fig. 6).[59] The lampworking technique was therefore highly compatible with the production of fine and delicate glass pieces, and very appropriate for the creation of glass jewellery.

Fig. 6. Lampworker at his work, copperplate engraving, in Johannes Kunckel, Ars vitraria experimentalis oder Vollkommene Glasmacherkunst, Frankfurt and Leipzig 1689 (Prague, National Library of the Czech Republic, sign. 65 D 002488)

Pre-made glass tubes and rods were necessary for the forming of glass pieces using the lampworking technique, and these had to be produced using a glass furnace. To make glass tubes, a glassmaker would use an iron rod to extract a portion of glass from the molten mass of glass in the crucible, and work it to a cylindrical form on a marble slab. When this was complete, the front end of the newly formed cylinder would be opened up using scissors, and this opening would later form the hollow within the finished tube. The glass would then be warmed again in the furnace, taking care that the new opening through the middle of the mass was maintained. Then a second iron rod would be attached to the back end of the glass form, and two further glassmakers would take the two rods and pull them in opposite directions.[60] Through the forming or twisting of the glass, vari-

---

59 Kunckel 1992, pp. 398–399.
60 Astone Gasparetto, *Il vetro di Murano dalle origini ad oggi* (Venice, 1958), pp. 179–180.

ous forms of glass tubes and rods could be made. These could then be worked into richly coloured pieces of jewellery using the lampworking technique.

## The court glasshouse at the court of Innsbruck

The glass tubes and rods used to make the glass jewellery in Archduke Ferdinand II's *Kunstkammer* could have been produced in the glassworks at the court of Innsbruck. As early as 1570, the archduke engaged the imperial envoy to Venice, saying he wanted "to take into his service a good glassmaker, who can make all manner of original and artful works in glass".[61] This artisan was not, however, to be constantly employed, but "should only be engaged to work according to our convenience and desires, to make glasswares".[62] He was to be given living quarters and a workshop in the court gardens, near the racing grounds, and his duties would include watching over the birds in the *Fasanengarten* (pheasant garden).[63] Since the glassmakers of Murano were not permitted to work outside of Venice, the negotiations with the Venetian government became difficult. Archduke Ferdinand II even sent his own glassmaker to Venice, so that the man might find some pretext in which to learn this specialised craft and return to Innsbruck well-equipped with glassmaking materials.[64] Even so, it does appear that the Prince of Tyrol was not satisfied with the glasswork produced at Innsbruck.

Only a few years later, the archduke once again made efforts to engage a skilled and experienced glassmaker.[65] Finally, in 1574, the glassmaker Salvatore Savonetti came to the court at Innsbruck with the permission of the Venetian government.[66] He ordered glass materials in the glasshouse of his father Sebastiano in Venice, which were transported to Innsbruck.[67] In the glassworks at the court of Innsbruck, the two glassmakers produced glasswares according to the wishes of the archduke. Following the fulfillment of these commisions, the two returned to Venice. In their own glassworks at Murano, they mostly produced highly prized glasswares made from *cristallo*. In the

61  "ain guetten glaßmacher, der allerlaj selzame vnnd kunstliche sortten vnnd arbait von glaßwerch machen khundte, in vnnsere diennst bestellen", TLA, KS III/46, series III, 23 July 1570, Archduke Ferdinand II, writing to the imperial envoy Veit of Dornberg.

62  "allain zu zeitten nach vnnser glegenhait vnd zu vnnserm Lusst mit dem glaßwerch arbaitten dürffen", TLA, KS III/46, series III, 23 July 1570, Archduke Ferdinand II, writing to the imperial envoy Veit of Dornberg.

63  Veronika Sandbichler, 'Letter from Archduke Ferdinand II to the imperial envoy Veit von Donberg in Venice', in *Ferdinand II. 450 Years Sovereign Ruler of Tyrol. Jubilee Exhibition*, ed. by Sabine Haag and Veronika Sandbichler, exh. cat. (Innsbruck and Vienna, 2017), cat. no. 5.14, p. 191.

64  TLA, KS III/46, series III, 09 February 1572, the imperial envoy Veit of Dornberg, writing to Archduke Ferdinand II.

65  TLA, KS III/46, series III, 11 December 1573, Archduke Ferdinand II, writing to the imperial envoy Veit of Dornberg.

66  TLA, KS III/46, series III, 30 March 1574, Archduke Ferdinand II, writing to the imperial envoy Veit of Dornberg.

67  TLA, KS III/46, series III, 20 January 1575, Archduke Ferdinand II, writing to Balthasar of Dornberg.

inventories we also find mention of gilded glass pieces, and glass sheets for windows.[68] This more or less summarises the type of work achieved by the two Venetians at the court of Innsbruck.[69] They were further supported by Andrea Tudin, another Venetian glassmaker. In a letter of safe conduct, Archduke Ferdinand II singled Tudin out as an artisan glassmaker, who was capable of producing particularly elegant pieces in glass.[70]

We do not know whether the glassmakers of the court at Innsbruck also produced the glass tubes and rods necessary for lampworking. They were, however, certainly familiar with this particular technique. Sebastiano Savonetti was related to glassworks owner Francesco Caner.[71] Caner owned a glassworks in Murano that specialised in the production of glass tubes and rods.[72] Apart from this, he also had connections to a lampworker in the centre of the city. In 1574 Caner accused a lampworker and his wife of theft. During the trial in the town hall of Murano, the wife stated that she had been buying glass tubes and rods for her husband from Francesco Caner for three years, which her husband formed into finished pieces using lampwork. These details were confirmed by the lampworker himself. The accusation is in fact the earliest evidence of lampworking in Venice, and only years later do we find mention of glass necklaces worked using the lampworking technique in the inventory of a Murano glassworks.[73]

### Lampworking at the court of Innsbruck

The fact that Archduke Ferdinand II was also familiar with this technique is demonstrated by a letter from 1578, in which the archduke requests that the imperial envoy in Venice, Veit of Dornberg, send "[…] Salvatore Savonetti […] and his father, and also the man who makes the gilded glass necklaces, who was previously […] here [in Innsbruck] to produce sundry glasswork […]"[74] to Innsbruck for two months. The glassmakers were also required to bring their equipment and materials for glassmaking. The lampworker was singled out in this letter as a glassmaker who could produce gilded glass necklaces. There were actually gilded glass necklaces in Archduke Ferdinand II's collection. These included a glass necklace,[75] made from gilded ornaments and decorated with small spots of white glass (Fig. 7). The content of this letter could also be

68   Luigi Zecchin, 'I Savonetti, vetrai a Murano fra il XVI ed il XVII secolo', in Luigi Zecchin, *Vetro e vetrai di Murano: Studi sulla storia del vetro*, III (Venice, 1990), pp. 101–106 (104).

69   Egg 1962, pp. 47–49.

70   TLA, KS III/46, series III, 29 July 1575, letter of safe conduct for the glassmaker Andreas Tudin, written in Latin.

71   Zecchin 1990, pp. 101–106 (102).

72   Paolo Zecchin, 'La nascita delle conterie veneziane', *Journal of Glass Studies* 47 (2005), pp. 77–92 (84).

73   Sandro Zecchin, 'La lavorazione a lume di oggettistica di vetro in Europa fino all'Ottocento', in *L'avventura del vetro: dal Rinascimento al Novecento tra Venezia e mondi lontani*, ed. by Aldo Bova, exh. cat. (Milan, 2010), pp. 51–55 (51–52).

74   "den Saluator Saluaneti […] auch seinen vattern vnnd dann den so die vergulten gläserne ketten macht wellich zuuor auch […] herauß gewest es vnerfertigung etlicher Glas arbeiten", TLA, KS III/46, series III, 11 May 1578, Archduke Ferdinand II, writing to the imperial envoy Veit of Dornberg.

75   KHM, Kunstkammer, inv. no. KK 3044.

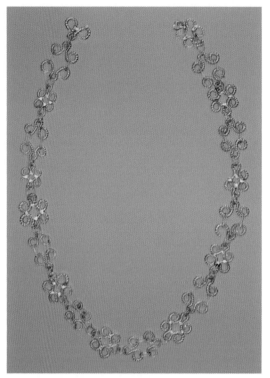

Fig. 7. Glass necklace with gilded links
(Vienna, Kunsthistorisches Museum, Kunstkammer,
inv. no. KK 3044)

taken as evidence of a connection between the Savonetti family and the lampworker. The Savonettis had been periodically employed at Innsbruck for many years. The fact that the lampworker in question had also been at Innsbruck before seems to indicate that he knew Sebastiano and Salvatore and was possibly recommended by them.

In the year 1579, the Savonettis ended their employment at the Innsbruck court glassworks.[76] Salvatore became more heavily involved in the management of his father's glassworks, and took over entirely when his father died.[77] The Savonetti family was nonetheless very significant for the glassworks at Innsbruck. The Venetian glassmakers developed the basis for a fully functional workshop during their employment there, and this was properly maintained after their departure. Archduke Ferdinand II produced a glass there with his own hands in 1581, which he wanted to finish with gold mounting and precious stones.[78] Furthermore, the archduke always returned to contacts he has made through the Venetian glassmakers. He called Andrea Tudin, amongst others, back into his service at Innsbruck and paid Tudin in 1583 for his work.[79] This is also the period of the Kolowrat wedding, which as a court festival may well have provided an opportunity for the manufacture of glass jewellery, and the setting up of a stage for lampworking demonstrations.

## Conclusion

A large part of glass jewellery produced using the lampworking technique in Archduke Ferdinand II's collection could have been made by the Venetian glassmakers and

76   Egg 1962, pp. 77–78.
77   Zecchin 1990, pp. 102–104.
78   David von Schönherr, 'Urkunden und Regesten aus dem k.k. Statthalterei-Archiv in Innsbruck',
     *JKSAK* 14 (1893), pp. LXXI–CCXIII, reg. 10897 on p. CLXXXVII.
79   Schönherr 1893, p. CC, reg. 11049.

lampworkers during their employment at the court of Innsbruck. This demonstrates that the archduke was well-informed about the newest developments and discoveries of Venetian glasswork. At the same time it is clear that lampwork came to hold a special place at the court of Innsbruck. Luxuriously coloured glass jewellery was produced for court festivities, and then displayed in the Kunskammer as proof of the court's festive culture. The fact that glass jewellery was not only worn, but also collected, is also evidenced by documentation from the Florentine and Munich courts. However, according to current research Innbruck was the first court of the late Renaissance to become a 'centre' of glassmaking, where the lampworking technique was practised and where a significant collection of extant objects has survived into the present day. The glass collection of Archduke Ferdinand II's *Kunstkammer* can therefore be considered as unique in the world.

Beket Bukovinská

## The *Kunstkammern* of Archduke Ferdinand II and Emperor Rudolf II: Past and present movements

The *Kunstkammer* of Archduke Ferdinand II and that of Rudolf II have much in common: the foundational work published by Julius von Schlosser compared and contrasted the two collections. Here, indeed, Archduke Ferdinand II's *Kunstkammer* was held up as an example of the earliest and most important *Kunstkammer* collections, while Rudolf's *Kunstkammer* was presented as an interesting collection, but one assembled without a specific, systematic approach.[1] The most significant exhibition project dedicated to the personage and collections of Archduke Ferdinand II, which took place in Ambras Castle in summer 2017 and later that year at the National Gallery Prague, also brought in new perspectives and research on his *Kunstkammer*. An essential contribution of the preparatory research was the careful reconstruction of the *Kunstkammer*, which was presented at the exhibition in Ambras. This reconstruction consistently followed the estate inventory from 1596 (see the article by Veronika Sandbichler in this volume).[2] In this unique way, the reconstruction communicated an idea of the original development of the collection, and clearly demonstrated the richness and significance of the remaining objects, their contexts, and the logic of this display, which we can no longer observe in its entirety today. (Fig. 1) This exhibition also provides a new impulse for comparison with Rudolf II's *Kunstkammer*, both in terms of the whole collection and its individual objects. A series of questions emerged in the course of surveying the Ambras collection, as well in connection with the development of the new exhibition of the Habsburg collections of arts and curiosities opened in 2013, and in the course of the current research projects. These questions demand further enquiry into the complex movements in both directions between Ambras and Vienna and, in this context, also the connections with the collections of Rudolf II.[3]

Archduke Ferdinand II died in January 1595, and we know that Emperor Rudolf II immediately gave an order to the *Schlosshauptmann* (keeper of the palace) to set and

---

1    Julius von Schlosser, *Die Kunst- und Wunderkammern der Spätrenaissance* (Leipzig, 1908), p. 80: "Übertreibend und doch nicht ganz mit Unrecht hat ein neuerer Schriftsteller von einem Barnumschen Museum gesprochen; so bunt zusammengewürfelt war die Sammlung, und so wenig ist in ihr irgend ein methodisches Bestreben, wie in den Kunstkammern von Ambras und München zu bemerken."

2    Veronika Sandbichler, "'Innata Omnium Pulcherrimarum Rerum Inquisitio": Archduke Ferdinand II as a Collector', in *Ferdinand II. 450 Years Sovereign Ruler of Tyrol. Jubilee Exhibition*, ed. by Sabine Haag and Veronika Sandbichler, exh. cat. (Innsbruck and Vienna, 2017), pp. 77–81.

3    *Die Kunstkammer: die Schätze der Habsburger*, ed. by Sabine Haag and Franz Kirchweger (Vienna, 2012).

Fig. 1. Kunst- and Wunderkammer of Archduke Ferdinand II, a reconstruction of the 17ᵗʰ cabinet, Ambras Castle

maintain a watch with the greatest possible discretion.[4] At the same time Rudolf II had his servant Kaspar Möller of Möllenstein remove the famous *Achatschale* (a large shallow agate dish) and the *Ainkhürn* (a narwhale tusk) as quickly as possible to the Prague *Kunstkammer,* since these two Habsburg treasures were always considered property of the oldest surviving male Habsburg, and were thus not part of Archduke Ferdinand's private collection. In connection within this, Alphons Lhotsky did nonetheless note that many hunting trophies, including those dating from the time of Maximilian I, were also removed.[5] In 1596 the estate inventory of the Ambras collection was completed. In January 1605, Rudolf II and Karl of Burgau – who had inherited Ambras and the collection – began negotiating Rudolf II's acquisition of the collection, and in February of that same year an agreement was reached. This agreement stated that "Margrave Karl, in honour of His Imperial Majesty, and in cousinly goodwill towards the other archdukes [wished to relinquish] the domain of Ambras".[6] In this way the domain, palace, and collection all became possessions of the House of Austria. The purchase price was set at 170,000 florins, with more than 100,000 florins reckoned for the *Kunstkammer* alone. At the same time, it was emphasised that following the wishes of the late Archduke Ferdinand II, "the library, armoury, *Kunstkammer,* and *Wunderkammer,* as they appeared in the inventory, should be kept entirely and per-

4   "in höchster geheim ein Guardi aufzustellen und erhalten". Alphons Lhotsky, 'Die Ambraser Sammlung: Umrisse der Geschichte einer Sammlung', in *Alphons Lhotsky Aufsätze und Vorträge* (Munich, 1974), p. 135, after Josef Hirn, *Erzherzog Ferdinand II. von Tirol, Geschichte seiner Regierung und seiner Länder,* II (Innsbruck, 1888), p. 448.

5   Lhotsky 1974, p. 136.

6   Lhotsky 1974, "Markgraf Karl der kaiserlichen Majestät zu Ehren und den anderen Erzherzogen zu vetterlichem Gefallen die Herrschaft Ambras [abtreten wolle] ...", p. 137.

manently together.[7] Here, Lhotsky pointed out that in this case there was actually no obligation on the part of the purchaser to leave the collection permanently at Ambras. On numerous occasions, the Emperor's possible intention to combine the two collections was discussed, as was his deliberation about leaving Prague and moving to Tyrol. We know that the Emperor had in fact already engaged a master builder to survey the old castle and present ideas for its renovation.[8] This plan was never realised, since the negotiations over the administration and governance of the collection were protracted until finally Archduke Maximilian III was named regent of Tyrol, and at the same time became responsible for the care for the collection.

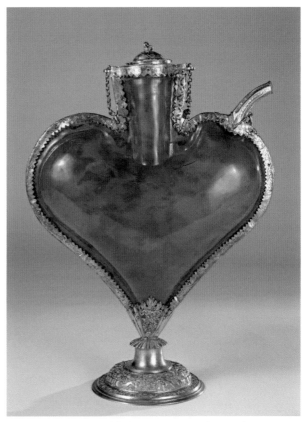

Fig. 2. Heart-shaped flask (Vienna, Kunsthistorisches Museum, Kunstkammer, inv. no. KK 4126)

Although Rudolf II visited Ambras when he was travelling back from Madrid in 1571, we do not know everything he would have been able to see in the *Kunstkammer* of Archduke Ferdinand II. There is no doubt, however, that the Emperor was very interested in his uncle's collection and that he was very well informed about what it contained.

Logically, he would also have possessed a copy of the estate inventory, given that he ordered it to be drawn up following his uncle's death.[9] We do not yet have any evidence of further objects that Rudolf may have coveted or had taken from the *Kunst-*

---

7    Lhotsky 1974, "die Liberey, Rüst- und Kunst- und Wunderkämmern laut des Inventarii ganz und unveruckt beysammen [...] gelassen werden solle."

8    Lhotsky 1974, p. 138.

9    In this context it is very interesting that an example of the estate inventory from 1596 should still be mentioned in 1958 in Prague. See Laurin Luchner, *Denkmal eines Renaissancefürsten: Versuch einer Rekonstruktion des Ambraser Museums von 1583* (Vienna, 1958), p. 137 – Inventare der Ambrase Sammlung.

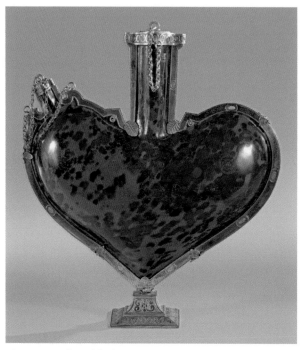

Fig. 3. Heart-shaped flask (Vienna, Kunsthistorisches Museum, Kunstkammer, inv. no. KK 4100)

*kammer* at Ambras, in the period up to his death.

At this juncture, we can make mention of a well-known example, which at first glance would seem to indicate a possible transfer from the Ambras collection to Prague. In the 1976 edition of the inventory of Rudolf II's *Kunstkammer*, the identified objects include two heart-shaped flasks associated here for the first time with entry number 424: "Two beautiful, gilded cases, with two flasks also made from tortoiseshell, studded with silver, formed like a heart and transparent yellow".[10] (Fig. 2, Fig. 3) These objects were also presented as a part of the Rudolfine *Kunstkammer* in the 1988 catalogue of the exhibition *Prag um 1600*.[11] Their next presentation took place during the 1997 exhibition *Rudolf II and Prague*, which took place in Prague Castle. Here, one of the two flasks was definitely shown in the context of an exhibition of Rudolf II's *Kunstkammer*, but in the catalogue Helmut Trnek had newly associated both objects with an entry from the 1596 estate inventory of Archduke Ferdinand II.[12] In the estate inventory of the Ambras collection, we can read on folio 457r: "Furthermore, an Indian flask, formed like a heart, completely yellow, and the flask is divided inside, so that two different drinks may be put into it, studded all over with silver, and stands on a silver base". Immediately following we read that: "The second flask like a heart, made from moulded glass or "erd", black and yellow, with many silver rings and

10    "2 vergulte schöne futral, darin 2 flachen auch von *tartaruga*, mit silber beschlagen, sein formiert wie ein hertz und gar durchsichtig gelb." See *Das Kunstkammerinventar Rudolfs II. 1607–1611*, ed. by Rotraud Bauer and Herbert Haupt, *Jahrbuch der Kunsthistorischen Museums Wien* 72 (1976), no. 424.

11    *Prag um 1600: Kunst und Kultur am Hofe Rudolfs II.*, exh. cat. (Freren, 1988), pp. 525–526, cat. no. 403, 404.

12    *Rudolf II and Prague. The Court and the City*, ed. by Eliška Fučíková et al., exh. cat. (Prague, London and Milan, 1997), p. 497, cat. no. II/124 (Helmut Trnek); Helmut Trnek also focuses on both of these objects in the exhibition catalogue for *Exotica: Portugals Entdeckungen im Spiegel fürstlicher Kunst- und Wunderkammern der Renaissance*, exh. cat. (Vienna, 2000), p. 174, cat. nos. 85, 86.

chains all around it, and studded with silver."[13] It is of course possible to establish dif-
ferences between the descriptions in the two inventories, for example in the statements
regarding materials used – in the Prague inventory the material is correctly identified
as tortoiseshell, and both objects are recorded in the section with other tortoiseshell
objects, whereas the scribe of the Ambras inventory described the material as "glasz
oder erd". Nonetheless, both are so accurately characterised that the identification in
both cases seems extremely convincing. However, at the same time Helmut Trnek
mentions that both flasks appear in later inventories of the Ambras collection and this
negates the possibility that these two vessels found their way, at some point in time,
from Ambras to Prague. This case, where the inventories describe two objects that
appear almost identical, and yet most likely reflect two entirely separate pieces, shows
clearly just how difficult and deceptive it can be to accurately assess the information
given in the inventories.[14]

While I was preparing the concept for the Prague exhibition in 1997 – an exhibition
where Rudolf II's *Kunstkammer* was to appear for the first time in its entirety – I used
the 1607–1611 inventory for that *Kunstkammer*.[15] Here, objects were recorded in
smaller or larger units according to material, provenance, or their functional context,
and could also be presented in this way for the exhibition. For a project conceived of
in this way, it was also important to research those areas that had received less atten-
tion during that period – above all the *exotica*. I examined the catalogue cards – still
used at that time – in the Sammlung für Plastik und Kunstgewerbe in the Kunsthis-
torisches Museum Wien seeking out those objects I believed could be matched to
entries in the inventory. In doing so I found a relatively large, shallow basin made from
tortoiseshell, which had up to that point been kept in storage. I tried to connect this
object with the following inventory entry. "A fairly large, flat, Indian tortoiseshell
dish"[16] (Fig. 4). This basin was then publicly presented for the first time in the Prague
*Kunstkammer* exhibition. However Helmut Trnek, who had dealt with this object in
the Prague catalogue, identified it with the following entry in the estate inventory of

---

13   "Mer ain Indianische flaschen, geformiert wie ain herz, ist durchaus gelb, inwendig ist die flaschen
     zertheilt, also dass man zwaierlei drankh thuen khan, rund herumb mit silber beschlagen, steet auf
     aim silbern fuez".
     "Die zweite flasche wie ain herz, von gegossenen glasz oder erd, schwarz und gelb, rund herumb
     sambt etlichen silbern ringen, ketlen mit silber beschlagen", see the estate inventory of Archduke
     Ferdinand II from 1596 (version from ÖNB) published by Wendelin Boeheim, 'Urkunden und
     Regesten aus der k.k. Hofbibliothek', *JKSAK* 7 (1888), p. CCXXVI–CCCXIII, here f. 457,
     p. CCCVI; see also second part of inventory in ibidem, *JKSAK* 10/2 (1889), pp. I–X.

14   Furthermore, a similar description of the heart-shaped flask still in the *Kunstkammer* in Graz: see
     research by Susanne König-Lein about this *Kunstkammer*, for example Susanne König-Lein, '"mit
     vielen Seltenheiten gefüllt": Die Kunstkammer in Graz unter Erzherzog Karl II. von Innerösterreich
     und Maria von Bayern', in *Das Haus Habsburg und die Welt der fürstlichen Kunstkammern im
     16. und 17. Jahrhundert*, Schriften des Kunsthistorischen Museums, ed. by Sabine Haag, Franz
     Kirchweger and Paulus Rainer (Vienna, 2016), pp. 195–227.

15   Bauer / Haupt 1976.

16   "Ein zimlich groß flach indianisch schiltkrottenschisselin". Estate inventory ÖNB, Boeheim 1888,
     no. 2393.

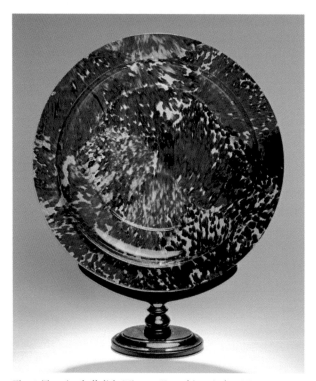

Fig. 4. Tortoiseshell dish (Vienna, Kunsthistorisches Museum, Kunstkammer, inv. no. KK 4131)

Archduke Ferdinand II "Furthermore a moulded Indian dish made from yellow and black material, with a kind of round form".[17] In this case it is not easy to decide which of the two descriptions is more accurate and convincing.

Amongst the objects presented in the 2000 exhibition *Exotica*, there was a foldable lacquered and gilded table-top, labelled as the *Tischplatte des Kardinals Albrecht* (table-top of the Cardinal Albrecht) and identified with the following entry in the estate inventory of the Ambras collection: "An Indian table-top from the cardinal". Apart from this, there is the following note: "in 1583, the table probably stood in the entrance".[18]

(Fig. 5) Julius von Schlosser mentioned this table-top as a "remarkable proof for the earlier imitation of east Asian decorative forms [...]".[19] In connection with this, I drew attention to the following entries in the Rudolfine inventory: "In chest no. 60, three Indian table-tops, lacquered in black and painted with gold pigment, which are foldable, and all of them are large...." and further, "In chest/coffer no. 61, three other Indian table-tops, lacquered in black and painted with gold, with attached feet, so they can be combined [into one large table]".[20] Since there are a total of six foldable, black-

17  "Mer ein indianisch gegossenes schissele von gelb und schwarzer materiii, ist in ain weis runden gestätele"; see Exh. Cat. Prague 1997, p. 497, cat. no. II. 125; see also Exh. Cat. Vienna 2000, p. 174, cat. no. 87, and Beket Bukovinská, 'Zum Exotica-Bestand der Kunstkammer Rudolfs II.', *Jahrbuch der Kunsthistorischen Museums Wien* 3 (2001), pp. 205–220.

18  "Ain indianisch tischbladt vom cardinal" .... "der Tisch hat vermutlich 1583 in Ambras Eingang gefunden". Exh. Cat. Vienna 2000, p. 211, cat. no. 118.

19  "Ein merkwüdiges Zeugnis früher Nachamung der ostasiatischen Dekorationsweise [...]". Schlosser 1908, p. 64.

20  "In der Truhe Nr. 60 3 indianisch schwartz gelackte mit gemalem gold gemalte tischblat, die man zusamen legen kan, sein alle 3 grösste..."; "In der truhe Nr. 61 3 andere indianische schwartzgelackte, mit goldt gemalte tischblat mit ihren dabey angehefften füssen, so zusamen können gelegt warden"; see Bauer / Haupt 1976, no. 462 und 464; Bukovinská 2001, p. 217.

Fig. 5. Black lacquer table, mid-16th century (Vienna, Museum of Applied Arts, inv. no. LA 280)

lacquered and gold-painted table-tops, it is obviously very tempting to identify the surviving foldable table-top as one of the remarkable wealth of these objects found in the *Kunstkammer* of Rudolf II. But what is the reality?

Transfers in the opposite direction may also be of interest – that is, the question of what made its way from Rudolf II's *Kunstkammer* into the Ambras *Kunstkammer* via the collection in Vienna, and how this occurred. Here, a much later time period comes into question, when part of the Rudolfine collection was moved to Vienna following the death of Rudolf II. This probably only happened after the Ambras collection was transported to Vienna in 1806, in response to the threat of war. This transportation process was extremely complicated and it also took some time before a suitable location in Vienna was found for the Ambras collection. The first independent and public exhibition of the collection took place in the Lower Belvedere Palace during 1819. Alois Primisser published the first description of this collection in 1819, entitled *Die kaiserlich-königliche Ambraser Sammlung*.[21] The collections were kept together during the following period and their return to Ambras was considered many times. This

---

21    Alois Primisser, *Die kaiserlich-königliche Ambraser-Sammlung* (Vienna, 1819).

Fig. 6. Emperor Charles V (Schloss Ambras Innsbruck, inv. no. P 3055)

actually occurred in 1855, when Emperor Franz Joseph I gave the order for all of the collections – with the exception of the paintings, numismatic collection, and library – to be recorded in preparation for the transfer. At this time, Eduard von Sacken published his text, *K. K. Ambraser-Sammlung*.[22] The titles of both publications therefore emphasised that these were works from the Ambras collection.

Surprisingly, on page 183, chapter *D. Mosaik* of Alois Primisser's 1819 publication, we read that "in terms of Roman mosaics, the collection only includes three small oval pictures, 5 *Zoll* high, with well-executed portraits: Emperor Karl V, no. 43, Emperor Ferdinand I, no. 42, and King Philip II, no. 41.[23] In the later publication from Eduard von Sacken, we also find the chapter *D. Mosaik*, and on page 103 a more detailed description of the three objects: "Three small bust-portraits, 5 *Zoll* high, of Emperor Karl V (43), Emperor Ferdinand I (42), and Philip II (41), in Roman mosaic, made from small pieces of stone set in cement, well and accurately made".[24] It is tempting to identify these three mosaic portraits with the objects still displayed today in the Ambras *Kunstkammer* exhibition – in reality the three people portrayed are Emperors Karl V (Fig. 6), Ferdinand I, and Maximilian II (not Philip II). This identification supports the formulation *eirund* ("oval") that appears in the 1819 text. Elisabeth

---

22   Eduard von Sacken, *Die Ambraser-Sammlung* (Vienna, 1855).

23   "Von römischer Mozaik besitzt die Sammlung nur drei eirunde, 5 Zoll hohe Bildchen, mit den wohl getroffenen Porträten: Kaiser Karl V. Nr. 43, Kaiser Ferdinand I. Nr. 42, und König Philipps II. Nr. 41". Primisser 1819, p. 183.

24   "Drei kleine, 5 Zoll hohe Brustbilder Kaiser Carls V. (43), Kaiser Ferdinands I. (42) und Philipps II. (41) sind von römischer Mosaik, aus kleinen Steinstückchen in Kitt eingesetzt, trefflich gearbeitet und wohl getroffen." Sacken 1855, p. 103.

Scheicher, who worked on the entry for this object in the catalogue of the Ambras collection, stated that the portraits of Karl V and Ferdinand I were the work of Valerio und Vincenzo Zuccherini and confirmed that all three mosaics originated from *Kunstkammer* of Rudolf II.[25] Here we are dealing with remarkable and unique works of high quality, which do not belong to the old holdings of the Ambras collections, but rather originated in the *Kunstkammer* of Rudolf II. They are not to be found in the 1607–1611 inventory of Rudolf II's *Kunstkammer*, just as Scheicher indicates, but rather in the list taken by the Bohemian estate in 1619, known to us as the *Ständeinventar*, and in Austria as the *Rebelleninventar*: "Three images of Emperor Carolus Quintus, Emperor Ferdinandus and Emperor Maximilianus, all three made from mosaic and valued at 150 florins."[26]

Unfortunately, my research has not yet enabled me to say precisely when and how these objects made their way from Vienna to Ambras. However, it was important to know that during this time, when the Ambras collection was held in Vienna, it was (at least in 1819 and 1855) still understood and presented as a whole collection. There were however already some objects that had originated from the Prague *Kunstkammer* of Rudolf II but, being held in Vienna, had found their place amongst the intricate and extensive Ambras collection.

There is another example which is more difficult to provide firm proof for. Lacquered pieces take an important place in the context of the extensive group of objects referred to as 'Indian' within the Rudolfine *Kunstkammer*.[27] Helmut Trnek emphasises that "in terms of the material similarity, the actual criterion used is not the primary materials such as wood or wickerwork, but rather the decorative materials – lacquer!".[28] The quantity and variety of this collection of lacquered objects – it numbers more than one hundred pieces – outstrips the holdings of every other middle European *Kunstkammer* from this period. Its significance in the context of the inventories of Rudolf II's *Kunstkammer* can be clearly observed in the care and precision

25  *Die Kunstkammer. Kunsthistorisches Museum, Sammlungen Schloß Ambras*, ed. by Elisabeth Scheicher, Kurt Wegerer, Ortwin Gamber and Alfred Auer, Führer durch das Kunsthistorische Museum, 24 (Innsbruck, 1977), pp. 131–132, cat. no. 342, 343, 344 (here the third mosaic is correctly identified as a portreit of Maximilian II). The author accepts that the frames were created in 1600 in Prague. Scheicher does not mention the statements of Alois Primisser and Eduard von Sacken in the literature.

26  "Drei Contrafeit kaiser Caroli Quinti, kaiser Ferdinandi und kaiser Maximiliani, von mosaico alle drei geschäczt per 150 fl." Jan Morávek, 'Nově objevený inventář rudolfínských sbírek na Pražském hradě', *Památky archeologické a místopisné*, 2–3 (1932–1935 [Separat 1937]), p. 11, fol. 31a with the inscription „Gemäl von mosaico". See: Beket Bukovinská, 'Drei contrafeit kaiser Caroli Quinti, kaiser Ferdinandi und kaiser Maximiliani, von mosaico', in *Haně Seifertové k 75 narozeninám*, ed. by Anja Ševčik (Prague, 2009), pp. 23–28.

27  Bauer / Haupt 1976, f. 40'– 45.

28  "Was die Materialgleichheit anlangt so liegt das eigentliche Kriterium eben nicht in den primären Werkstoffen wie Holz und Flechtwerk, sondern in dem Stoff, mit dem der Dekor gestaltet wurde: im Lack!" Helmut Trnek, 'Kaiser Rudolf II. (1552–1602) und seine Kunstkammer auf der Prager Burg', in *Exotica: Portugals Entdeckungen im Spiegel fürstlicher Kunst- und Wunderkammern der Renaissance*, exh. cat. (Vienna, 2000), pp. 36–42 (38).

Fig. 7. Lacquered bowl, China, middle of 16th century (Schloss Ambras Innsbruck, inv. no. PA 540/1)

with which each lacquer-work piece was recorded. Here, the individual groups of works are precisely categorised not only by their form, but also by the colour of the lacquered decoration and the gold embellishment. Lacquered bowls with *reisswerch* – woven bamboo – form one of the largest sub-groups of lacquered objects in the collection. In the 1997 Prague exhibition, I was able to present one such lacquered bowl, which I had found during my research in the storage of the Vienna collection.[29] However, in this context it is the small lacquered bowls, held today as part of the exhibition of the Ambras *Kunstkammer*, which are interesting. (Fig. 7) I have not been able to find any entries that could refer to these pieces in the whole of the 1596 estate inventory from ÖNB. Elisabeth Scheicher and Helmut Trnek have also established that there is barely any mention of lacquerwork pieces in the inventories of the Ambras Castle collections.[30] Could these pieces possibly be left over from the extensive and remarkable collection of lacquerwork belonging to Rudolf II's *Kunstkammer*?

As a last example, I would like to mention the so-called scroll-paintings – Chinese paintings on silk. (Fig. 8) Julius von Schlosser and Elisabeth Scheicher have both written on three such paintings, which appear in the estate inventory of Archduke Ferdinand II: "An Indian cloth, on which is painted a large bird like a swan, together with other birds, and is otherwise painted with various garlands". Further: "An Indian cloth, painted with Indian houses, in the house the Indians sit next to each other and one writes, wearing a red robe". Finally, the third entry: "Further, an Indian cloth, painted with a fair number of Indian houses, inside of these women, playing stringed instruments."[31] At the same time, however, Scheicher mentions that in the current

29   Exh. Cat. Prague 1997, p. 498, cat. no. II/127.

30   Scheicher / Wegerer / Gamber / Auer 1977; Trnek 2000, p. 40.

31   Estate inventory ÖNB (Boeheim, 1888), fol. 459v: "Ain Indianisch tuech, darauf ist gemaltain grosser vogl gleichwie ain swann sambt anderen vögelen, sonst von allerlai laubwerch gemalt"; "Ain Indinisch tuech, daraf Indianische heuser gemalt, in dem Haus siczen die Indianer bei einander und einer schreibt in ain roten rockh"; "Mer ain Indianisch tuech, darauf etliche Indianische heuser gemalt, darinnen weiber, so auf saitenspiel schlagen".

Ambras collection there are actually four of these paintings: "It is not possible to explain why there are only three paintings named in the inventory – even though the last description could actually apply to either of two paintings – when four paintings survive".[32] The 1607–1611 inventory of Rudolf II's *Kunstkammer* could offer an explanation, if we look to the following entry from the chapter *INDIANISCH GEMEL VON WASSER-FARBEN UFF PAPIER* (Indian watercolour paintings on paper): "Four large pictures, rolled together [perhaps into one roll], painted in watercolour on cloth, two of which show figural scenes, the other two of which show birds and floral motifs". Further: "Six large Indian paintings painted in watercolour on delicate cloth, rolled onto round wooden rods, [bought] from H. Letor".[33] Even though these

Fig. 8. Swans and other birds, 16th century (Vienna, Kunsthistorisches Museum, Kunstkammer, deposited in Schloss Ambras Innsbruck, inv. no. 8912)

scroll paintings are not precisely described, it is perhaps not inconceivable that in this case, one artwork made its way from this collection to Ambras.

---

32  "Der Umstand, dass im Inventar nur drei Bilder genannt, vier aber erhalten sind, wobei die letzte Beschreibung auf zwei anwendbar ist, läßt sich nicht erklären". Schlosser 1908, p. 67, fig. 61. It is interesting that the author states that these are held in the Naturhistorische Museum. Elisabeth Scheicher, 'Die Kunstkammer in Schloß Ambras', in *Europa und die Kaiser von China. Berliner Festspiele 1240–1816*, exh. cat. (Frankfurt am Main, 1985), pp. 58–61 (60). These objects have been presented in many exhibitions.

33  "4 grosse zusamengerolte indianische mit wasserfarben uff tuch gemalte gemehl, die 2 von bildern, die andere 2 von vögel und blumenwerkh"... "6 grosse uff rund holz gerollte indianische gemeld von wasserbarben uff zart tuch, von H. Letor." Bauer / Haupt 1976, no. 584 und 586.

The current intensive archival research being carried out in both Ambras and Vienna is uncovering much new information, also in terms of the connections between the *Kunstkammer* in Ambras and the one in Prague. It is probably already possible for us to confirm that hardly any objects made their way from the Ambras collection into the Prague *Kunstkammer* of Rudolf II. However, it does show that in contrast to this, many objects from the Rudolfine collections found a permanent place in Ambras over the course of time. The similarities in the descriptions included in both inventories prove how important and enriching such research into these connections is, and how new results provided by research into one collection can simultaneously throw light on the other.

# Conclusion

# Conclusion

Any researcher who studies the life and indeed the portraits of Archduke Ferdinand II must sooner or later conclude that his personality deviated significantly from the Habsburg family both in terms of physique and character. The archduke was of a small stature by the standards of his house, and his face lacked the typical narrow shape and highly characteristic 'Habsburg chin': a forward-jutting lower jaw. Instead, he had fuller features. His blonde hair with a rusty tone, fair skin and blue eyes were all inherited from his mother Anna Jagiellon, rather than from his father Ferdinand I. Likewise, Archduke Ferdinand II seems to have enjoyed a more relaxed lifestyle, in contrast to his father's strict adherence to formalities. Looking at the archduke's personal life decisions we can see the influence of a contradiction that is probably best described as a dichotomy between his responsibilities as a son, male heir and male ruler, and his personal tastes, desires, and pleasures. The archduke's political life took place on a trajectory between Prague and Innsbruck, that is between the Bohemian lands and the region of Tyrol. However, in the course of our research, spanning several years, these generally well-known features of the life of Archduke Ferdinand II have manifested themselves much more concretely, and our understanding of them has deepened. It is clear that his was a personal space filled with ambitions, and above all with people.

At the beginning of this inquiry into the life of this exceptional figure, we were faced with a young archduke, the second-born prince of Ferdinand I's house, who would spend twenty years as the governor in the Lands of the Bohemian Crown. Yet apart from the scholarly attention given to the archduke's construction of the Hvězda (Star Summer Palace) and his extensive social relations with the Czech aristocracy, there was little research specifically devoted to his political, economic and cultural activities in Bohemia. There were also regional inconsistencies in the existing scholarship: for example, the importance of his Tyrolean period remained almost unstudied within the Czech research environment. On the other hand, the significance of his work in Prague remained almost unnoticed on some part of foreign scholarship. This is significant, as the archduke really brought the skills and knowledge gained in Bohemia with him when he first became the independent ruler of Tyrol, and began developing the extensive collections of art and objects that are held and displayed today at Ambras Castle and at the Kunsthistorisches Museum in Vienna.

Thus from the point of view of research, it has long seemed as if the life of Archduke Ferdinand II was in fact two stories, with two separate fates being lived out by two different men. The exhibition project *Ferdinand II. 450 Jahre Tiroler Landesfürst / Ferdinand II. 450 Years Sovereign Ruler of Tyrol* (2017–2018) was undertaken in collaboration with the Ambras Castle in Innsbruck, the National Gallery in Prague, and the Institute of Art History of the Czech Academy of Sciences and presented selected works of art with the potential to map his entire life journey via an integrated view of its most important moments. The project was an explicit attempt to bridge this disconcerting 'double track' in the research and bring the 'two lives' of Archduke

Ferdinand II back together in a single narrative, using both artefacts and new research.
A wide variety of artefacts undoubtedly forms an important part of the legacy of any
historical figure, however academic historical research has the advantage that it is nat-
urally not limited by the size of the exhibits, their physical condition, or the success of
the diplomatic negotiations between the institutions involved. Such research may and
should also cover the less obvious, extinct or purely theoretical concepts that charac-
terise the selected person and his/her activities, as well as tangible objects.

Here, in conclusion, I could simply follow the individual chapters of this book and
summarise the new findings achieved by each author. Instead, I would like to offer a
cross-sectional summary of the most important features of Archduke Ferdinand II's
patronage, which was however also an integral part of his political and economic activ-
ities. The points presented here do not qualify as an exhaustive evaluation of the
research results, but several of these points aim to follow certain cross-sections that cut
across the different articles presented here. These represent the moments that most
surprised our team in the course of the project.

## Between Prague and Innsbruck

At the forefront of our interest was the comparison of the two main 'narratives' of the
archduke's life. The first of these took place between 1547 and 1567, when he managed
the lands of the Czech Crown as the representative of his father Ferdinand I. This was
followed by a second period, when the archduke became the sovereign ruler in Tyrol,
as well as several other countries, a position he held until his death in 1595.

The first period is usually characterised as preparatory, that is the period during
which the views and attitudes of the archduke were formed. These would later be devel-
oped when he ruled in Tyrol. This timeline undoubtedly applies to his development and
growth as a politician and statesman. Communicating with the Bohemian Estates was an
excellent school for the archduke, teaching him to deal not only with loyal subjects, but
also with discontented or antagonistic social groups within his realm. The archduke used
this experience many times in dealing with the Tyrolean states, from whom he demanded
the approval of ever-increasing taxes (an issue he also had to deal with in Bohemia).

In seeking a model that allows us to compare the two periods of the archduke's life,
we can for example follow the formation and development of his court, which not
only provided the archduke with an important base and all the necessary services, but
was also a platform for his patronage activities and representation. According to Jaro-
slava Hausenblasová, the archduke's court evolved continuously from his childhood
on. Importantly, during the Prague period the final structure of this court was defined
through collaboration between Ferdinand I and his son, and capable and reliable peo-
ple were chosen for its most essential offices functions. Many of these courtiers left
Prague in 1567 and went to Innsbruck with Archduke Ferdinand II, so in this way the
court of the new Tyrolean sovereign was a continuation of the 'preparatory' Prague
period, and the only major changes occurred in those offices which concerned the state
administration in Tyrol.

It is far more difficult to compare the two periods of the archduke's life in terms of his patronage, construction projects and collecting. Could Prague (and the other ruler's residences) in the Lands of the Bohemian Crown, now fallen from the zenith of its former Luxembourg glory, provide the archduke with the resources he needed: skilled artisans and artists, and a varied cultural life? Our research has shown that the Habsburgs enriched and renewed the cultural life of the Czech Republic with many new ideas, using the inspiration gained during their travels in Europe. Archduke Ferdinand II also travelled a great deal within the empire, especially to the cultured high courts in the Netherlands and Italy.

The development of the archduke's artistic priorities can be best monitored by examining his architectural commissions. The importance of Renaissance architecture, which is still evident in the towns in which we live, is unquestionable. In the period examined here, scholars must deal with an enormous number of archival sources. Importantly, we can note that the archival sources show that the local master builder – the *Baumeister* – held a similarly privileged position at both the Bohemian and later the Tyrolean courts. In Tyrol, the court master-builder gathered even more powers into his hands than his Prague counterpart, because many large financial transactions were in fact handled by his office, as Elisabeth Reitter pointed in her text.

While in Bohemia, the archduke acted as supervisor of all royal construction activities, accountable only to his father, though he was naturally his own master in Tyrol. This period of works carried out at Prague Castle is characterised by conflicts between 'German' and 'Italian' builders and their supporting schools of architectural thought, as well as unclear objectives, limited financial resources, and the poor state of the residence after the devastating 1541 fire. Art-historical literature dealing with this region has developed a trend wherein the scholarship monitors the increasing use of the new Italian building mode (*welsch*), which the Habsburgs preferred in the case of the Royal Summer Palace, to the detriment of the 'German' (*Deutsch*) Late Gothic style – especially the ribbed vault – which had a strong local tradition. However, our research has now shown that in particular cases it was financing and not architectural style that played a major role in the rulers' design decisions. Often during the internal competitions between architects, the design with the lower budget would be successful, regardless of its more progressive or more domestic and traditional aesthetical values. However, the arguments of at least one *Baumeister*, the German master-builder Bonifaz Wolmut, also played a role. Wolmut is considered to be the most important central European architect of the 16th century, and his work is noted as being exceptionally original in that he managed to combine both the new Renaissance and existing Gothic styles into a specific, elegant synthesis. Nonetheless, Petr Uličný suggests in his article that a key work attributed to Wolmut – the tribune in the Diet Hall – probably originated with Italian designers and Wolmut was only responsible for its construction.

Sarah Lynch's article focuses on the nature of the relationship between Wolmut and the archduke. Although researchers have already explored the documented history of the construction and numerous renovations of Prague Castle, analysis of the same

archival sources with regard to this relationship reveals a surprising intellectual exchange between these men, including a discussion of architectural preferences in theory and praxis, in the context of an exchange of letters and comparable material in their personal libraries. Close examination of this material upsets the traditional interpretation, that the archduke's preference for the Italian style came to conflict with Wolmut's more traditional ideas.

The much-researched rivalry of the artists and artisans certainly existed at the archduke's Bohemian court, just as it did later at his court in Tyrol, but we want to emphasise that the material results of his patronage were really born of cooperation. It might well happen that Italian artisans were ordered to design a unique piece, which would then be constructed by a German master-builder who was also responsible for the whole building and its proportions. The nature of the building process in this period (from planning to the awarding of commissions and financing, as well as shifts and changes in the course of the work) is illustrated in an almost humorous form by Hans Tirol, a builder of Augsburg origin, whose life is presented here by Eliška Fučíková. With all of his deliberations and complaints, Tirol fulfilled the agenda of the Royal Bohemian Chamber for almost 25 years. However, he failed to satisfy Ferdinand I, and especially Archduke Ferdinand II, and was forced to completely change his professional interests.

On the contrary, the insight into the communication between the Archduke and Wolmut (whose professional life also crossed paths with Tirol's) shows the unexpectedly strong authority Wolmut enjoyed in his exchanges with his employers. There were also clearly changes in standards and opinions: in Tyrol the archduke dismissed a master who had in fact already served the Habsburgs, namely Paul Uschall. Despite coming into conflict with the Upper Austrian Chamber over the matter, the archduke pushed for Uschall's replacement, promoting the less experienced Giovanni Lucchese, who had worked for him in the Czech Lands.

In Prague, Archduke Ferdinand II initiated and oversaw the design and construction of the Star Summer Palace. This building was his lifetime's crowning architectural achievement, and his flagship contribution to Prague Castle. The Star Summer Palace has already been studied in great detail by a variety of researchers, and for this reason it does not play a key role in this volume. Importantly, it seems that it was such an exceptional structure that it did not actually have a major influence on the other buildings commissioned and renovated by the archduke. A more influential role was played by its mythologically-themed ornamentation, and by the stucco artist responsible for these decorative elements, Antonio Brocco. The archduke does not seem to have built any other such flagship building in Tyrol, however here it is important to acknowledge that there is virtually nothing left of his main residence, Ruhelust Palace in the garden of Hofburg Castle in Innsbruck. This was clearly the main focus of his building and renovation efforts in Tyrol, but our information and capacity to reconstruct this building are completely inadequate. We do know that the exterior appearance of Ruhelust does not seem to have been remodelled after the latest trends, and it is in any case doubtful whether its architect, Lucchese from Ticino, really had the skills to achieve

such a remodelling. However its interior decoration, outfitting and equipment, as it appears in written evidence (especially the archduke's estate inventory) must have been splendid: we know for example, that there was a large spa area and a picture gallery. The unusual layout of Ruhelust Palace and the adjacent building, the Witwensitz or 'widow's residence' is analysed in this volume by Ivan P. Muchka on the basis of the estate inventory of Archduke Ferdinand II.

It appears there was no shortage of original projects in Tyrol (apart from Ruhelust Palace, let us also point out the buildings intended to house the archduke's collections on the outskirts of Ambras Castle). Above all, however, the Habsburgs developed a typical passion for building summer houses and hunting lodges, and Archduke Ferdinand II was no exception, establishing many such buildings in places suitable for hunting, fishing and similar activities. Most of the archduke's summer houses are typical of the 'castellum' type, emphasising corner turrets that demonstrate the influence of fortress architecture, as Muchka points out. It is this quality that connects them with the Star Summer Palace, a building whose character of the fortress almost excludes it from the category of leisure architecture. Many of the striking architectural elements of these summer houses seem to be linked to the Archduke's passion for military pursuits, which culminated in a focus on the armour collection, especially the armour gathered in the so-called *Heldenrüstkammer* (Heroes' Armoury) at Ambras Castle.

The archduke had spent much of his childhood in Innsbruck, so he did not move to a completely new and unknown location, and moreover, he actually organised some of the modifications to his Tyrolean residence to be completed in advance of his arrival from Prague. Naturally, he did not leave Prague alone and without company after twenty years. Along with his nascent collections and other personal property, he brought a fair number of the people with him from his Prague court. In addition to the artists and artisans who travelled with him, there were also some of his courtiers. In Innsbruck, some significant figures related to the archduke's middle-class wife, Philippine Welser, also gained new positions and status. This situation was of course unusual compared to similar cases of morganatic relationships (which did not end in marriage, unlike the very exceptional case of the archduke, cf. the illegitimate relationships and affairs of Charles V).

In Tyrol, Archduke Ferdinand II was also able to develop his talent for designing ceremonial processions more freely; in one such procession in Innsbruck, he even appeared personally in the role of Jupiter, a symbolic role previously reserved exclusively for his father. However, Innsbruck remained a provincial capital compared with Vienna and Prague, and the archduke had to satisfy his talents in the context of lesser events, rather than royal weddings or coronations. His own wedding to his second wife, his niece Anna Caterina Gonzaga, provided him with an opportunity to organise and enjoy festivities on a scale that had been denied to him on the occasion of his first (and necessarily secret) morganatic marriage. Our research has enriched the topic of festivities and ceremonies by throwing the focus onto an important sensory element of such events, namely the presence of music. According to Jan Baťa, although there are no explicit sources that would allow us to reconstruct the music used on such occa-

sions, we can begin to form an idea of it on the basis of comparisons and references in the written sources, because they indicate the use of existing pieces well-known by contemporary musicians and choirs. In this way, it is also possible to distinguish cases where a completely new musical accompaniment was needed.

While tournaments and festivities lasted only a few days a year, hunts and banquets occupied a substantial part of the archduke's annual calendar. In his article, Václav Bůžek points out that during the Prague period, the archduke spent a cumulative 3–5 months per year on hunts, as and there is no reason to believe that he behaved any differently different in Tyrol, at least for as long as he remained healthy and active. It is clear that the archduke took care to display the proper chivalrous virtues of a successful hunter and excellent marksman while out on the hunt, and it was also an ideal platform for developing personal relationships; mutually beneficial ties with nobles arose, for example, in the procurement of hunting dogs or birds of prey. As in other areas, there is evidence that the archduke liked to oversee many of the details personally: for example, in one source, the archduke reminisces about the "comfort in carrying live pheasants".

## Collecting

A task that could not be neglected in our research for this project was a revision of the individual areas of collecting undertaken by Archduke Ferdinand II. His collections are based on three important 'pillars', namely the *Kunstkammer*, the armouries, and the library. Looking closely at the archduke's collecting in its peak period during his rule as sovereign of Tyrol, we understand why a painter Joris Hoefnagel has labelled the buildings Ferdinand had built or renovated for his collections as real examples of "Musaeum" (museum) buildings, that is temple of the muses, constructed in the grounds of Ambras Castle.

The *Kunstkammer* was presented in its original location and rooms within Ambras for the first time in 2017 during above mentioned jubilee exhibition, by a team of Austrian researchers led by Veronika Sandbichler. The virtual and physical reconstruction potently evoked the sheer size of the original collection and showed important details of its display, such as the height and proportions of the original cabinets. However, it also revealed the ratio of identified and unidentified artworks still extant today. Prior to this new installation, visitors could only visit the historicising evocation of the *Kunstkammer* first opened to the public in 1974. Although appropriate period sources, furnishings and selected objects were used in forming this reconstruction, it nonetheless gave rise to some inaccurate clichés, which were identified by a closer re-examination of the written sources (for example, the traditional colours of the interior of the individual cabinets). Thanks to the new virtual reconstruction initiated by Sandbichler, it was also possible to draw attention to Archduke Ferdinand II's collection of paintings, some of which decorated the walls of the *Kunstkammer*.

The great surprise that occurred already during the preparation of the exhibition project was the release of a previously unstudied version of the inventory, which had

been preserved in the collections of Kunsthistorisches Museum in Vienna. Thomas Kuster gives an evaluation of this alternative version of the inventory in his article in this volume. In general, also other texts presented here draw attention to the fact that the *Kunstkammer* and its collections still constitute a living organism and it is clear now that further refinement of our knowledge of Archduke Ferdinand II's *Kunstkammer* must also influence a research of comparable collections, namely the Dresden *Kunstkammer* of Augustus, Prince Elector of Saxony and Christian of Saxony and the Munich *Kunstkammer* of the Bavarian Dukes Albrecht V and Wilhelm V.

It has long been suggested that the archduke started his acquisition activities not during his stay in Prague, but later in Innsbruck. As a keen collector he is mentioned in Quiccheberg's treatise on collecting (1565). However, her article, Blanka Kubíková highlights documents that show the archduke had already had portraits delivered to Prague and compiled the Habsburg family portrait gallery of his significant relations and their wives there; Sylva Dobalová also pointed out that the archduke had ordered various small carvings with mythological themes during his governorship in Prague. The assumption that Archduke Ferdinand II's personal armoury already existed in Prague has already been confirmed by Petr Uličný; it was probably deposited at the Prague Castle in the White Tower, which was adjacent to the archduke's palace. However, the question of whether or not the archduke had a court armourers' workshop in Prague had thus far remained open. Up to this point, we have had information concerning the armour that Archduke Ferdinand II brought with him to Prague, but his passion for tournaments must have necessitated frequent repairs to his armour, as Stanislav Hrbatý points out in his text. It is also clear that the production of new pieces according to the archduke's highly specific and refined ideas required abilities that could almost certainly not be satisfied by the Prague armourers' guild. That said, the archduke also required flexibility and speed which the German workshops were unable to fulfil, given their own popularity and the problem of communication and transport over longer distances. The archduke therefore naturally sought to establish a workshop directly at the Prague Castle. In addition to a permanent master, it seemed that masters were hired for shorter periods of time to complete particular contracts. However, due to the lack of equipment (especially the so-called pulp mill), the workshop had to hire equipment from the city guild. New information has also been found concerning the transfer of the archduke's personal and court armouries from Prague to Innsbruck when he and his court moved to Tyrol.

Although this volume devotes specific attention to the phenomenon of collecting, there is little direct attention paid here to the archduke's library. This is because the library, like the Star Summer Palace was the subject of a separate work published in 2016 by a group of authors led by Ivo Purš and Hedvika Kuchařová. This volume is rather focused on the literary and scientific activities of individual persons connected in some way with Archduke Ferdinand II through patronage, support or interest. Here again, the breadth of the Archduke's professional interests is evident, but it is clear that certain subjects such as medicine, history, military, and studies of natural phenomena and also alchemy were prioritised by the archduke. Naturally, he also

supported authors or the publication of theological writings that helped to promote the Catholic faith. On the other hand, panegyrics or Latin poetry stood at the very edge of the archduke's interest, and this had to be taken into account by the authors who wanted to ensure their position at the court. It may seem paradoxical to us that he did not financially support the publication of Laurentius Špán's poem "Ferdinandopyrgum" celebrating the Star Summer Palace. However, Marta Vaculínová explains that the archduke gave priority to supporting publications on subjects perceived as being more pragmatic and scientific, and therefore more reflective of a serious, mature ruler: this included, for example, prose print editions focusing on medicine and history. It is possible that poetry in general was simply insufficiently representative from this viewpoint.

Studying texts by Ivo Purš and Katarina Seidl in this volume, we also realise how often scientific interests were in fact closely linked to the archduke's artistic commissions - for example, writings on the history of the Habsburgs and the lists of Tyrol's rulers served as a basis for the paintings in the Spanish Hall at Ambras; scientific drawings and medical writings were commissioned following the trips to the mountains and musings on botany. The impetus to discover natural wealth was motivated by the desire to find and exploit deposits of metal ores, the processing of which was intended to provide financial resources to the exhausted treasury and, moreover, to be a source of interesting objects for the *Kunstkammer* (for example, *Handsteine*).

References to books, the use of manuscripts, and collections of drawings intersect with other articles in this volume; this is relevant, for example, to the topic of sculptural orders as discussed by Sylva Dobalová. The study of Archduke Ferdinand II's humanist circle has shown the need for interdisciplinary cooperation, as any view limited to one particular discipline - such as the history of art, for example – obviously cannot hope to capture the complexity of any historical figure's pursuits and personality, especially not a figure as multifaceted as the archduke.

In articles relating to the archduke's patronage and other related topics, questions relating to the employment of the artists and the management of the court came to the fore. On the one hand, the archduke supported only a few court artists; they were almost always artisans who were masters in multiple areas, such as Francesco Terzio (painter and 'designer'), or Pietro de Pomis (painter, architect and medal-caster). On the other hand, an immense number of artists and craftsmen were hired exclusively for short-term contracts and commissions by the archduke. In her article, Elisabeth Reitter calculates that there were about a hundred such 'contracted' artists and artisans who worked for the Innsbruck court during the reign of Ferdinand II. We do not have such detailed information from Prague; the results of our research are limited here by the fact that the lists of court members from 1547–1567 have not been preserved. Terzio, who was referred to as the 'archduke's painter', is certainly very visible in the historical record but he was paid by the archduke's father, Ferdinand I. An important role in Prague was played by Pietro Andrea Mattioli, not only as a doctor, but also as an *arbiter elegantiarum*. Already in Prague, the artists attended the archduke's court to fulfill specific orders, albeit on a much more modest scale then in Innsbruck.

## Finances

Lack of finances meant that the archduke was unable to carry out many of his planned projects during his stay in Bohemia (he did not even complete some planned details of the Star Summer Palace: the entrance portal, for example, remained incomplete). According to Jaroslava Hausenblasová, the archduke was reliant on several sources to fund his court, supply his family's needs, and maintain appropriate representation as Ferdinand I's second son. But amongst his various sources of income, only the so-called *deputat* (appanage) paid by his father were regular. Some of the archduke's personal needs, as well as the salaries of craftsmen working for the archduke were also financed by the Royal Bohemian Chamber (these funds were taken from the King's income), and by the Bohemian Estates in the form of the occasional taxes. Likewise, some of the archduke's commissions were paid via the Upper Austrian Chamber. Archduke Ferdinand II also used the yields of his estates in Chomutov and Křivoklát to generate income.

The most financially demanding period of his governorship in the Lands of the Bohemian Crown seems to have been the turn of the 1550s and beginning of the 1560s: at this time, the archduke began building the Star Summer Palace and simultaneously appeared to have increased expenses in terms of his social life and need for appropriate representation. This seems to have been the result of significant political successes amongst the members of the Habsburg family. These included, first of all, the coronation of Ferdinand I as Holy Roman Emperor in Frankfurt in 1558, and his subsequent spectacular ceremonial entrance into Prague, whose organisation lay entirely on the shoulders of the Archduke. The second important event was the coronation of Maximilian II, the archduke's elder brother, as King of Bohemia in 1562. The Archduke himself attended the ceremonial entrance of Maximilian into Prague and his subsequent coronation, and in 1563 he participated in his brother's Hungarian coronation in Pressburg (Bratislava). Not surprisingly, many of the loans the archduke used to solve his financial problems during this busy and expensive period remained unpaid.

As the sovereign ruler of Tyrol, the archduke had a number of his own financial resources, which were mainly managed by the Upper Austrian Chamber. However, it seems that even this increased income was insufficient to meet the archduke's needs. It should be noted that generally, rulers with a passion for collecting are rarely good financial managers. The applications for more taxes from the Tyrolean states and the problems surrounding the financing of the court's needs were usually blamed on excessive bureaucracy during both the Czech and the Tyrolean periods of the archduke's life.

## Networker

The Vienna – Prague – Innsbruck axis was the basis for forming extensive economic, political and socio-cultural networks. This important axis began to form in 1526, when Ferdinand I as the new King of Bohemia began to form a state under his rule – the

Danube monarchy. Not only did the monarch and his court frequently travel on this axis, but so did all of the required craftsmen, builders, writers, artists, and postal messengers, as well as frequent shipments of goods destined for the court. The activity at the Prague 'hub' were very intensive just at the time when the archduke resided there, and he used the established communication network to have both goods from Tyrol (e. g., southern fruits and armour) and also information concerning the Viennese court delivered to him in Prague. After relocating to Innsbruck, the archduke continued to use his connections to Prague: he acquired fish, wine and livestock for hunting from the Bohemian Lands, negotiating either in person on his frequent return visits, or through agents. In Prague he often also found the experts he needed to carry out his projects in Tyrol.

Despite the undoubted importance of Vienna, Innsbruck and Prague, our research has substantially expanded this axis. Markéta Ježková paid particular attention to the as yet somewhat underrated journeys of the archduke to the Netherlands. According to Ježková, the purpose of these trips was not, as is sometimes thought, in order to take part in any conflict on the battlefield, but rather to take part in peaceful and politically significant festivities, especially the triumphant entrance of Queen Eleanor, wife of King Francis I of France, to Brussels in the autumn of 1544. The high cultural standard of the Dutch environment undoubtedly had a great influence on the importance the archduke would later attach to festivities and ceremonies.

Archduke Ferdinand II also established many personal relationships, which were generally an important part of the family community and marriage politics of the Habsburgs. However, while the archduke quite naturally regularly found himself in rivalry with his male relations and peers, his contacts with the female representatives of the family developed in a remarkable way. Joseph Patrouch points out in his article that it was thanks to the archduke's female relatives that his connections reached far across the continent, from Lithuania in the northeast, to Cleves in the northwest, the neighbouring Bavaria, and south down the Italian peninsula as far as Tuscany. With regard to collecting, his aunts Mary of Hungary and Catherine of Austria, the Queen of Portugal, were of enormous importance – with their passion for exotic objects (and their rich financial resources) few courts could compete with them in terms of exotica and art. Patrouch also discusses the fact that although the involvement of female members of the Habsburg family between 1555 and 1618 was generally very influential in the social and political relations in Europe (and was generally more successful than that of the Jagiellonian women, for example), Archduke Ferdinand II's relationships with these important women were far more developed. The reason for this might well be his secret marriage to the middle-class burgher's daughter Philippine Welser, which made his political position peculiar, and also the interests of Philippine herself.

Forming and maintaining family relationships was not only politically important, but also ensured different sources of information and contacts relevant to the acquisition of new collectible artefacts. The archduke, however, did not rely solely on his kinship ties, but also created a network of agents that he sent to various other Habsburg and European courts. As Annemarie Jordan Gschwend pointed out, he used the

services of Hans Khevenhüller, the official ambassador in Spain, for such purposes. Archduke Ferdinand II also addressed requests for works by contemporary elite artists to Tuscany, northern Italy, and in particular to Spain, which allowed him to purchase highly valuable and rare exotica and luxury goods. His collections at Ambras Castle were eventually enriched with new treasures that he inherited from his aunt, Catherine of Austria. His enthusiasm and wide network of contacts meant that the archduke's personal preferences were quite well known, even in distant lands.

## Motivation

In the title of the book, we chose to highlight the phenomenon of the second-born son. The destiny of the second-born male child in the royal families of this period was an uncertain one, usually entailing a career path aimed at a high position within the church, the role of a military commander, or as the holder of some important secular office. Within the Habsburg family, the principle that the second-born was intended to become governor of lands he would then rule in his father's or elder brother's name was nothing unusual: on the contrary, it was a successful model that ensured the family's rule over most of Europe. For example, the regency in the Netherlands was kept permanently in the hands of the second-born Habsburgs (see the example of Margaret of Austria [1480–1530] in her role as governess). In order to be able to look more closely at this phenomenon, it would be necessary to analyse the title of 'governor' in general, its full implications, development, and the level of autonomous political authority it entailed, and also the various limits that it imposed upon its bearers.

Archduke Ferdinand II was not very satisfied with the position of the second-born child and the uncertain role of the governor that it implied for him. It appears that in many areas the archduke made genuine and concerted efforts to equal the accomplishments of his firstborn brother Maximilian and, above all, to gain an equal position not only in the Habsburg family, but in the wider European political arena. Although these efforts are not yet sufficiently mapped, we know that right up until the end of Archduke Ferdinand II's life, he could not reconcile himself to the title of archduke and sought the status of royalty: in short, he strongly desired to acquire a crown for himself. We find an important element of his competitiveness with his elder brother in the effort he devoted to his representation (all of the commissions and patronage, his famous *Kunstkammer*, and so on). We could also propose the cautious thesis that the strategies he developed during his life helped him to achieve a real sense of equality with Maximilian II - at least from our point of view today.

Apart from his status as the second-born son, another factor undoubtedly influenced the archduke's conduct, and this was his strict education. In the end, it seems that the strict discipline and rigorous education imposed on both Ferdinand and his brother Maximilian by their father caused them to resist this authority in different ways during their respective adulthoods – Archduke Ferdinand II contracted a politically unsuitable marriage without the permission of his father, and Maximilian II showed strong leanings towards Protestantism. However, the further we examine the archduke's

patronage activities, the more we see how deeply they are tied to the trends set by his father Ferdinand I and great-grandfather Maximilian I. This influence shows in how the archduke developed his collections, completing projects on a long-term plan while he was also naturally interested in objects and books from a Habsburg inheritance. This capacity to preserve memories and develop the legacy of its predecessors, that is, the typical emphasis on continuity, is of course a large part of what makes any aristocracy aristocratic. As we have seen, the period of the archduke's rule in Tyrol was relatively peaceful, and the archduke was therefore not overly involved in international conflicts. Taking care of the heritage of his ancestors and filling the gaps in the family history had undoubtedly become an important element of his rule, the basis on which he supported his dynastic authority as the sovereign ruler of Tyrol. However, he surely wanted to surpass his ancestors in his own individual way, and this was through the wealth of his collections, which, moreover, were to remain indivisible and immovable after his death, increasing the emphasis on continuity and heritage even more.

In the biographical introduction, the question was posed as to whether the battle scenes that Archduke Ferdinand II had portrayed in the reliefs on his tombstone and the deeds they depict truly represented his contributions to European cultural and political history. What do we value and hold in esteem about his person today? His legacy certainly deviates greatly from the standardised iconography of reliefs decorating his tombstone, which moreover shows the influence of Maximilian I's cenotaph, located in the same church.

We appreciate the archduke, above all, as a man who clearly had the courage to stand up to the conventions of that time and live his personal life according to his own decisions, as evidenced by his morganatic marriage to Philippine Welser. We value him as a true 'Renaissance man', who attempted to acquire a wide range of social, cultural, physical, scientific and intellectual knowledge: he was undoubtedly a well-educated individual and an intellectual who sought universal knowledge, but it is clear that he also had a practical view of the world and was deeply involved in all his activities, intellectual but also artistic. He was ambitious, but also extremely creative. And, of course, we appreciate the extraordinary cultural wealth offered by his preserved collections.

In a way, the archduke was indeed, as is sometimes claimed, a prototype for the renowned collector of Emperor Rudolf II, although the character of his patronage was different. Archduke Ferdinand II did not establish any court academy of art, nor did his patronage drive any transformation of artistic styles; he was interested in alchemy, but especially as a medical aid (as Ivo Purš discusses in his article). What the archduke did achieve was to make Innsbruck, with all its history and natural wealth, an indispensable centre on Europe's contemporary cultural map. He fulfilled the needs of his epoch, an epoch characterised by a certain need for the 'privatisation of art', with marked success, clearing the way for Rudolf II to establish Prague one of the centres of European cultural life. Rudolf II had a special relationship to Ambras Castle and was interested in its collections, of course, but apparently very few objects were taken from there, as Beket Bukovinská showed in her article – she suggests that Rudolf II could have had certain personal intentions for Ambras Castle.

In any case, this reflection can be concluded by saying that Archduke Ferdinand II undoubtedly achieved his main goal in life, which was indicated by his personal motto – to gain glory despite hardship. The interest of the surprisingly large and international group of scholars whom we met while composing this volume, is certainly proof of both the extent and longevity of the archduke's 'glory'. I would like to thank all of the colleagues who contributed to this project, whether in the form of written articles or scholarly support and advice, and I hope that this volume will encourage a deeper understanding of Central European cultural heritage and a role of the Archduke Ferdinand II in its formation.

<div align="right">Sylva Dobalová</div>

# Appendix

## Abbreviations

| | |
|---|---|
| AGS | Archivo General de Simancas (Valladolid) |
| APH | Archiv Pražského hradu (Prague) |
| b. | born |
| BAV | Biblioteca Apostolica Vaticana (Vatican) |
| BNF | Bibliothèque Nationale de France (Paris) |
| BSB | Bayerische Staatsbibliothek (Munich) |
| c. | circa |
| cart. | carton (= archive box) |
| cat. no. | catalogue number |
| cf. | confer/conferatur (compare) |
| Cod. | Codex |
| ČDKM | České oddělení dvorské komory (Národní archiv, Prague) |
| col. | column |
| d. | Pfennig |
| d. | died |
| DK | Dvorská komora (Archiv Pražského hradu, Prague) |
| ed. | edited by |
| e.g. | exempli gratia (for example) |
| esp. | especially |
| exh. cat. | exhibition catalogue |
| Fasc. | fascicle |
| FHKA | Finanz- und Hofkammerarchiv (Vienna) |
| Fig. | figure |
| Fl. | florin, gulden |
| fol., fols | folio, folios |
| G.v.H. | Geschäfts von Hof (Tiroler Landesarchiv, Innsbruck) |
| gld. | Gulden |
| HHStA | Haus-, Hof und Staatsarchiv (Vienna) |
| HZAB | Hofzahlamtsbücher (Finanz- und Hofkammerarchiv, Vienna) |
| inv. no. | inventory number |
| JKSAK | Jahrbuch der kunsthistorischen Sammlungen des Allerhöchsten Kaiserhauses |
| JKSW | Jahrbuch des Kunsthistorischen Museums Wien |
| KHM | Kunsthistorisches Museum Wien |
| KK | Kunstkammer (Kunsthistorisches Museum Wien) |
| KNM | Knihovna Národního muzea (Prague) |
| Kr. | Kreuzer, krejcar |
| KS | Kunstsachen (Tiroler Landesarchiv, Innsbruck) |
| M.a.H. | Missiven an Hof (Tiroler Landesarchiv, Innsbruck) |
| ML | Staré militare (Národní archiv, Prague) |
| NA | Národní archiv (Prague) |
| O.Ö. Raitbuch | Oberösterreichisches Raitbuch (Tiroler Landesarchiv, Innsbruck) |
| OMeA SR | Obersthofmeisteramt Sonderreihe (Haus-, Hof und Staatsarchiv, Vienna) |

| | |
|---|---|
| ÖNB | Österreichische Nationalbibliothek (Vienna) |
| p., pp. | page, pages |
| reg. | regest, regesta |
| RevZ | Reverzy k zemi (Národní archiv, Prague) |
| sign. | signature (in an archive or library) |
| SLUB | Sächsische Landesbibliothek – Staats- und Universitätsbibliothek Dresden |
| SM | Stará manipulace (Národní archiv, Prague) |
| SOA | Státní oblastní archiv (Czech Republic) |
| TLA | Tiroler Landesarchiv (Innsbruck) |
| vol./vols. | volume, volumes |

# Bibliography

**Alazard / Mellet 2013**
Florence Alazard and Paul-Alexis Mellet, 'De la propagande à l'obéissance, du dialogue à la domination: les enjeux de pouvoir dans les entrées solennelles', in *Entrées épiscopales, royales et princières dans les villes du Centre-Ouest de la France (xiv<sup>e</sup>–xvi<sup>e</sup> siècles)*, ed. by David Rivaud (Geneva, 2013), pp. 9–22.

**Alberti 1485**
Leon Battista Alberti, *De re aedificatoria* (Florence, 1485).

**Alscher 1984**
Ludger Alscher et al, *Lexikon der Kunst, Architektur, Bildende Kunst, Angewandte Kunst, Industriegestaltung, Kunsttheorie*, I (Berlin, 1984).

**Aram 2005**
Bethany Aram, *Juana the Mad: Sovereignty and Dynasty in Renaissance Europe* (Baltimore, 2005).

**Atwood 2006**
Margaret Atwood, *Moral Disorder* (Toronto, 2006), pp. 50–76.

**Auer 1984a**
Alfred Auer, 'Das Inventarium der Ambraser Sammlungen aus dem Jahre 1621, I. Teil: Die Rüstkammern', *JKSW* 80 (1984), pp. I–CXXI.

**Auer 1984b**
Alfred Auer, 'Das Kaiserzimmer auf Schoss Ambras. Versuch einer Chronologie der Ausgestaltung', *Österreichische Zeitschrift für Kunst und Denkmalpflege* 38 (1984), pp. 15–25.

**Auer 2001**
Alfred Auer, 'Das Inventarium der Ambraser Sammlungen aus dem Jahre 1621, II. Teil: Bibliothek', *JKSW* 2 (2001), pp. 282–346.

**Auer 2003**
Alfred Auer, 'Die Sammeltätigkeit Erzherzog Ferdinands II.', in *Kaiser Ferdinand I. 1503–1564. Das Werden der Habsburgermonarchie*, ed. by Wilfried Seipel, exh. cat. (Vienna, 2003), pp. 296–303.

**Auer 2015**
Alfred Auer, 'Vznik, rozvoj a rozptýlení knihovny arcivévody Ferdinanda II. Tyrolského', in *Knihovna arcivévody Ferdinanda II. Tyrolského*, I: *Texty*, ed. by Ivo Purš and Hedvika Kuchařová (Prague, 2015), pp. 41–54.

**Baďurová 2003**
Anežka Baďurová, 'Úvod', *Bibliografie cizojazyčných bohemikálních tisků z let 1501–1800. I. Produkce tiskáren na dnešním území České republiky v 16. a 17. století*, CD-ROM (Prague 2003).

**Bahnmüller 2004**
Wilfried Bahnmüller, *Burgen und Schlösser in Tirol, Südtirol und Vorarlberg* (St. Pölten, 2004).

**Bakay 2016**
Gunter Bakay, *Philippine Welser. Eine geheimnisvole Frau und ihre Zeit* (Innsbruck and Vienna, 2016).

**Balbinus z Vorličné 1558**
Jan Balbinus z Vorličné, *In trivmphalem adventvm Pragam... Ferdinandi... primi... carmen gratulatorium...* (Prague, 1558).

**Ballon / Friedman 2007**
Hilary Ballon and David Friedman, 'Portraying the City in Early Modern Europe: Measurement, Representation, and Planning', in *The History of Cartography, Volume Three (Part 1), Cartography in the European Renaissance*, ed. by David Woodward (Chicago and London, 2007), pp. 680–704.

**Bartlová 2011**
Milena Bartlová, 'Renaissance and Reformation in Czech Art History: Issues of Period and Interpretation', *Umění/Art* 59 (2011), pp. 2–19.

**Baťa 1585**
Jan Baťa, 'Remarks on the Festivities of the Order of the Golden Fleece in Prague (1585)', *Musicologica Brunensia* 51 (2016), pp. 25–35.

**Bate / Thornton 2012**
Jonathan Bate and Dora Thornton, *Shakespeare staging the world* (London, 2012).

**Bauer 2011**
Oswald Bauer, *Zeitungen vor der Zeitung. Die Fuggerzeitungen (1568–1605) und das frühmoderne Nachrichtensystem* (Berlin, 2011).

**Bauer / Haupt 1976**
*Das Kunstkammerinventar Rudolfs II. 1607–1611*, ed. by Rotraud Bauer and Herbert Haupt, *JKSW* 72 (1976).

**Bažant 2003a**
Jan Bažant, 'The Prague Belveder, Emperor Ferdinand I and Jupiter', *Umění/Art* 51 (2003), pp. 262–277.

**Bažant 2003b**
Jan Bažant, 'Emperor Ferdinand I, Boniface Wolmut and the Prague Belvedere', *Listy filologické* 126 (2003), pp. 32–52.

**Bažant 2004**
Jan Bažant, 'Pompa in honorem Ferdinandi 1558', in *Druhý život antického mýtu*, ed. by Jana Nechutová (Brno, 2004), pp. 195–205.

**Bažant 2006**
Jan Bažant, *Pražský Belvedér a severská renesance* (Prague, 2006).

**Bažant 2008**
Jan Bažant, 'Villa Star in Prague', *Ars* 41 : 1 (2008), pp. 55–72.

**Bažant 2011**
Jan Bažant, *The Prague Belvedere (1537–1563)*, Kindle Edition (Prague, 2011).

**Bažil 2015**
Martin Bažil, 'Dramatická díla', in *Knihovna arcivévody Ferdinanda II. Tyrolského*, I: *Texty*, ed. by Ivo Purš and Hedvika Kuchařová (Prague, 2015), pp. 329–334.

**Beaufort-Spontin / Pfaffenbichler 2005**
Christian Beaufort-Spontin and Matthias Pfaffenbichler, *Meisterwerke der Hofjagd- und Rüstkammer. Kurzführer durch das Kunsthistorische Museum Wien*, III (Vienna, 2005).

**Beer 1950**
Karl Beer, 'Philippine Welser als Freundin der Heilkunst', *Swiss Journal of the History of Medicine and Sciences* 7:1–2 (1950), pp. 80–86.

**Bercusson 2015**
Sarah Bercusson, 'Giovanna d'Austria and the Art of Appearances: Textiles and Dress at the Florentine Court,' *Renaissance Studies* 29:5 (2015), pp. 683–700.

**Besseler 1959**
Heinrich Besseler, 'Umgangsmusik und Darbietungsmusik im 16. Jahrhundert', *Archiv für Musikwissenschaft* 16 (1959), pp. 21–43.

**Białostocki 2004**
Jan Białostocki, *The Art of the Renaissance in Eastern Europe: Hungary, Bohemia, Poland* (Ithaca, NY, 1976).

**Bibl 1929**
Victor Bibl, *Maximilian II. Der rätselhafte Kaiser. Ein Zeitbild* (Hellerau bei Dresden, 1929).

**Biegel 2007**
Richard Biegel, 'Le dialogue entre gothique et Renaissance en Bohême au XVIe siècle' in *Le gothique de la Renaissance: Actes des quatrième Rencontres d'architecture européenne, Paris 12–16 juin 2007*, ed. by Monique Chatenet et al. (Paris, 2007), pp. 89–102.

**Biegel 2013**
Richard Biegel, 'Bonifác Wolmut a dialog renesance s gotikou v české architektuře 16. století', in *Tvary, formy, ideje. Studie a eseje k dějinám a teorii architektury*, ed. by Taťána Petrasová and Marie Platovská (Prague, 2013), pp. 17–29.

**Blockmans 2002**
Wim Blockmans, *Emperor Charles V* (London, 2002).

**Bodart 2011**
Diane Bodart, *Pouvoirs du portrait sous les Habsbourg d'Espagne* (Paris, 2011).

**Boeheim 1888**
Wendelin Boeheim, 'Urkunden und Regesten aus der k.k. Hofbibliothek', *JKSAK* 7 (1888), pp. XCI–CCCXIII.

**Boeheim 1889**
Wendelin Boeheim, 'Urkunden und Regesten aus der k.k. Hofbibliothek', *JKSAK* 10 (1889), pp. I–IX.

**Boeheim 1897**

Wendelin Boeheim, 'Der Hofplattner des Erzherzogs Ferdinand von Tirol Jakob Topf und seine Werke', *JKSAK* 18 (1897), pp. 262–276.

**Boerlin 1976**

Paul H. Boerlin, *Leonhard Thurneysser als Auftraggeber. Kunst im Dienste der Selbstdarstellung zwischen Humanismus und Barock* (Basel and Stuttgart, 1976).

**Bohatcová 1993**

Mirjam Bohatcová, 'Čtení na pomezí botaniky, fauny a mediciny. České tištěné herbáře 16. století', *Sborník Národního Muzea v Praze, řada C – Literární historie* 38 (1993), pp. 1–65.

**Bols 2015**

Nils Bock, *Die Herolde im römisch-deutschen Reich. Studie zur adligen Kommunikation im späten Mittelalter* (Ostfildern, 2015).

**Boom 2003**

Ghislaine De Boom, *Eléonore d'Autriche* (Brussels, 2003).

**Borový 1868**

*Jednání a dopisy konsistoře katolické i utrakvistické*, ed. by Klement Borový, I (Prague, 1868).

**Botta 1814**

Carlo Botta, *Storia d'Italia di Carlo Botta, in Storia d'Italia di Carlo Denina, Tomo 1* (Pavia, 1814).

**Bous 1965**

František Bous, *Karel z Žerotína, bojovník proti islámu* (Prague, 1965).

**Braun / Keller / Schnettger 2016**

*Nur die Frau des Kaisers? Kaiserinnen in der Frühen Neuzeit*, ed. by Bettina Braun, Katrin Keller and Matthias Schnettger (Vienna, 2016).

**Brepohl 2005**

Erhard Brepohl, *Benvenuto Cellini. Traktate über die Goldschmiedekunst und die Bildhauerei. I trattati dell'oreficeria della scultura di Benvenuto Cellini* (Cologne, 2005).

**Briesemaister 1995**

Dietrich Briesemaister, 'Vives in deutschen Übersetzungen (16. – 18. Jahrhundert)', in *Juan Luis Vives. Sein Werk und seine Bedeutung für Spanien und Deutschland*, ed. by Christoph Strosetzki (Frankfurt am Main 1995), pp. 231–246.

**Brown 1965**

Howard Meyer Brown, *Instrumental Music Printed Before 1600. A Bibliography* (Cambridge, Mass., 1965).

**Brown 2005**

Cynthia Jane Brown, 'Introduction', in Pierre Gringore, *Oeuvres*, II: *Les Entrées royales à Paris de Marie d'Angleterre (1514) et Claude de France (1514)*, ed. by Cynthia Jane Brown (Geneva, 2005), pp. 1–30.

**Büchner 2005**

Rober Büchner, 'Soziale Dimensionen einer Alpenstraße im 16. Jahrhundert. Die Arlbergsäumer auf ihrem Weg durch das Stanzertal', *Annali dell'Istituto storico italo-germanico in Trento* 31 (2005), pp. 31–85.

**Bucholz 1968**

Bernard von Bucholz, *Geschichte der Regierung Ferdinand des Ersten*, VI (Graz, 1968).

**Bücking 1972**

Jürgen Bücking, *Frühabsolutismus und Kirchenreform in Tirol (1565–1665). Ein Beitrag zum Ringen zwischen ‚Staat' und ‚Kirche' in der frühen Neuzeit* (Wiesbaden 1972).

**Buissons 1573**

Charles Des Buissons, *Cantiones aliquot musicae, quae vulgo muteta vocant, quatuor, quinque, et sex vocum* (Munich, 1573).

**Bukolská 1968**

Eva Bukolská, 'Renesanční portrét v Čechách a na Moravě' (unpublished doctoral thesis, Czechoslovak Academy of Sciences, Prague, 1968).

**Bukovinská 2001**

Beket Bukovinská, 'Zum Exotica-Bestand der Kunstkammer Rudolfs II.', *JKSW* 3 (2001), pp. 205–220.

**Bukovinská 2009**

Beket Bukovinská, 'Drei contrafeit kaiser Caroli Quinti, kaiser Ferdinandi und kaiser Maximiliani, von mosaico', in *Haně Seifertové k 75. narozeninám*, ed. by Anja Ševčik (Prague, 2009), pp. 23–28.

**Bukovinská 2018**

Beket Bukovinská, Kunstkammer Ferdinands I.: viele Fragen, wenige Antworten, *Dresden – Prag um 1600*, Studia Rudolphina Sonderheft, 2 (2018), pp. 69–86.

**Bullard 2002**

Mellisa Merriam Bullard, 'Heroes and their workshops: Medici Patronage and the Problem of Shared Agency', in *The Italian Renaissance: The Essential Readings. Blackwell Essential Readings in History*, ed. Paula Findlen (Malden, 2002), pp. 299–316.

**Buršíková 2001**

Bohdana Buršíková, 'Sbírka konsilií císařského lékaře Christophora Guarinoniho', *Dějiny věd a techniky* 34:1 (2001), pp. 22–38.

**Buršíková 2004**

Bohdana Buršíková, 'Dobré rady pro zdraví. Lékařská konsilia rudolfínské doby', *Dějiny a současnost* 23:1 (2004), pp. 15–18.

**Bůžek 2000**

Václav Bůžek, 'Ferdinand II. Tyrolský a česká šlechta (K otázce integračních procesů v habsburské monarchii)', *Český časopis historický* 98 (2000), pp. 261–291.

**Bůžek 2006a**
Václav Bůžek, 'Symboly rituálu. Slavnostní vjezd Ferdinanda I. do Prahy 8. listopadu 1558', in *Ve znamení zemí Koruny české. Sborník k šedesátým narozeninám prof. PhDr. Lenky Bobkové*, ed. by Luděk Březina, Jana Konvičná and Jan Zdichynec (Prague, 2006), pp. 112–128.

**Bůžek 2006b**
Václav Bůžek, *Ferdinand Tyrolský mezi Prahou a Innsbruckem* (České Budějovice 2006).

**Bůžek 2009**
Václav Bůžek, *Ferdinand von Tirol zwischen Prag und Innsbruck. Der Adel aus den böhmischen Ländern auf dem Weg zu den Höfen der ersten Habsburger* (Vienna, Cologne and Weimar, 2009).

**Bůžek 2012**
Václav Bůžek, Ideály křesťanského rytířství v chování urozeného muže předbělohorské doby, in Radmila Švaříčková Slabáková et al., *Konstrukce maskulinní identity v minulosti a současnosti. Koncepty, metody, perspektivy* (Prague, 2012), pp. 47–60, 416–421.

**Bůžek 2014**
Václav Bůžek, 'Ferdinand I. ve svědectvích o jeho nemocech, smrti a posledních rozloučeních', *Český časopis historický* 112 (2014), pp. 402–431.

**Bůžek 2015**
Václav Bůžek, 'Ferdinand II. Tyrolský v souřadnicích politiky Habsburků a jeho sebeprezentace', in *Knihovna arcivévody Ferdinanda II. Tyrolského*, I: *Texty*, ed. by Ivo Purš and Hedvika Kuchařová (Prague, 2015), pp. 13–40.

**Bůžek / Koreš / Mareš / Žitný 2016**
Václav Bůžek, František Koreš, Petr Mareš and Miroslav Žitný, *Rytíři renesančních Čech ve válkách* (Prague, 2016).

**Čabart 1958**
Jan Čabart, *Vývoj české myslivosti* (Prague, 1958), pp. 80–81.

**Campbell 1990**
Lorne Campbell, *Renaissance Portraits, European Portrait-Painting in the 14th, 15th and 16th Centuries* (New Haven and London, 1990).

**Capucci 1990**
Roberto Capucci, *Roben wie Rüstungen. Mode in Stahl einst und heute*, exh. cat. (Vienna, 1990).

**Carrai 2007**
Guido Carrai, 'Pietro Andrea Mattioli: architettura ed effimero alla corte imperiale alla fine del XVI secolo', in *Humanitas latina in Bohemis*, ed. by Giorgio Cadorini and Jiří Spička (Kolín and Treviso, 2007), pp. 169–194.

**Cartwright 1913**
Julia Cartwright, *Christina of Denmark* (New York, 1913).

**Čehovský 2016**
Petr Čehovský, 'Early Renaissance Architectural Sculpture in Lower Austria', *Umění/Art* 64 (2016), pp. 102–112.

**Čejka 2018**

*Historie pravdivá Jana Augusty a Jakuba Bílka*, ed. by Mirek Čejka (Středokluky, 2018).

**Černý 1968**

*Dějiny českého divadla I: Od počátků do sklonku osmnáctého století*, ed. by František Černý (Prague, 1968).

**Charruadas / Guri / Meganck 2014**

Paulo Charruadas, Shipé Guri and Marc Meganck, Évolution et développement du quartier de la cour, in *Le palais du Coudenberg à Bruxelles*, ed. by Laetitia Cnockaert, Vincent Heymans and Frédérique Honoré (Brussels, 2014), pp. 218–253.

**Checa / Falomir / Portús 2000**

Fernando Checa Cremades, Miguel Falomir Faus and Javier Portús Pérez, *Retratos de familia* (Madrid, 2000).

**Checa Cremades 1987**

Francesco Checa Cremades, *Carlos V y la imagen del héroe ed el renacimiento* (Madrid, 1987).

**Chisholm 2005**

M. A. Chisholm, 'A Question of Power: Count, Aristocracy and Bishop of Trent – The Progress of Archduke Ferdinand II into the Tyrol in 1567', in *Der Innsbrucker Hof. Residenz und höfische Gesellschaft in Tirol vom 15. bis 19. Jh*, ed. by Heinz Noflatscher (Vienna, 2005), pp. 398–400.

**Chlíbec 2011**

Jan Chlíbec, *Italští sochaři v českých zemích v období renesance* (Prague, 2011).

**Chlíbec 2015**

Jan Chlíbec, 'Bronzová sepulkrální plastika v Čechách od středověku do konce vlády Ferdinanda I.', *Epigraphica & Sepulcralia* 6 (2015), pp. 91–104.

**Chotěbor 2016**

Petr Chotěbor, 'K jagellonské přestavbě Starého královského paláce na Pražském hradě', *Castellologica Bohemica* 13 (2016), pp. 119–152.

**Christian 2016**

*Patronage and Italian Renaissance Sculpture*, ed. by Kathleen Christian (New York, 2016).

**Chytil 1906**

Karel Chytil, *Malířstvo pražské XV. a XVI. věku a jeho cechovní kniha staroměstská z let 1490–1582* (Prague, 1906).

**Cole 2011**

Michael Cole, *Ambitious Form. Giambologna, Ammanati, and Danti in Florence* (Princeton, 2011).

**Collinus / Cuthaneus 1558**

M. Collinus and M. Cuthaneus, *Brevis et svccincta pompae in honorem [...] imperatoris Ferdinandi primi [...]* (Prague, 1558).

**Collinus z Chotěřiny 1558**

Matouš Collinus z Chotěřiny, *Ad... Ferdinandum... ode gratulatoria* (Prague, 1558).

**Combet 2008**
Michel Combet, *Éléonore d'Autriche* (Paris, 2008).

**Concin 2021**
Adriana Concin, 'Hans Albrecht von Sprinzenstein: An Austrian Art Agent in the Service of Archduke Ferdinand II of Tyrol', in *Art Markets, Agents and Collectors: Collecting Strategies in Europe and the United States: 1550–1950*, ed by. Adriana Turpin and Susan Bracken, forthcoming.

**Conticelli / Mercante / Speranza 2016**
Valentina Conticelli, Mattia Mercante and Laura Speranza, 'Un fragile capolavoro. Nuove ipotesi dal restauro di un reliquiario mediceo in vetro a lume', *Rivista dell' Opificio delle Pietre Dure e Laboratori di Restauro di Firenze* 28 (2016), pp. 40–70.

**Cosandey 2007**
Fanny Cosandey, 'Entrer dans le rang', in *Les jeux de l'échange: entrées solennelles et divertissements du XVe au XVIIe siècle*, ed. by Marie-France Wagner, Louise Frappier and Claire Latraverse (Paris, 2007), pp. 17–46.

**Cruz 2009**
Anne J. Cruz, 'Juana of Austria. Patron of the Arts and Regent of Spain, 1554–59', in *The Rule of Women in Early Modern Europe*, ed. by Anne J. Cruz and Mihoko Suzuki (Chicago, 2009), pp. 103–122.

**Cupperi 2010**
Walter Cupperi, 'Giving away the moulds will cause no damage to his Majesty's casts – New Documents on the Vienna Jügling and the Sixteenth-Century Dissemination of Casts after the Antique in the Holy Roman Empire', in *Plaster Casts. Making, Collecting and Displaying from Clasiccal Antiquity to the Present*, ed. by Rune Frederiksen and Eckart Marchand (Berlin and New York, 2010), pp. 81–98.

**Czyżewski 2018**
Krzysztof J. Czyżewski, Kultura artystyczna Krakowa w pierwszej połowie XVI wieku / Die künstlerische Kultur Krakaus in der ersten Hälfte des 16. Jahrhunderts, in *Der Meister und Katharina. Hans von Kulmbach und seine Werke für Krakau / Mistrz i Katarzyna. Hans von Kulmbach i jego dzieła dla Krakowa*, ed. by Mirosław P. Kruk, Aleksandra Hola and Marek Walczak (Krakow, 2018), pp. 83–105.

**Daněk 2000**
Petr Daněk, 'Svatba, hudba a hudebníci v období vrcholné renesance. Na příkladu svatby Jana Krakovského z Kolovrat v Innsbrucku roku 1580', in *Slavnosti a zábavy na dvorech a v rezidenčních městech raného novověku*, ed. by Pavel Král and Václav Bůžek (České Budějovice, 2000), pp. 207–264.

**Delicati / Armellina 1884**
*Il diario di Leone X di Paride de'Grassi*, ed. by Pio Delicati and Mariano Armellina (Rome, 1884).

**Détshy 1987**
Mihály Détshy, 'Adalékok Perényi Péter Sárospataki várépítkezésének és mestereinek kérdéséhez', *Ars Hungarica* 15:2 (1987), pp. 123–132.

**Détshy 2002**
Mihály Détshy, *Sárospatak vára* (Sárospatak, 2002).

**Deutsche Reichstagsakten 2003**
*Deutsche Reichstagsakten. Jüngere Reihe. Deutsche Reichstagsakten unter Kaiser Karl V.*, XVI: *Der Reichstag zu Worms 1545*, 2 vols., ed. by Rosemarie Aulinger (Munich, 2003).

**Deutsche Reichstagsakten 2005**
*Deutsche Reichstagsakten. Jüngere Reihe. Deutsche Reichstagsakten unter Kaiser Karl V.*, XVII: *Der Reichstag zu Worms 1545*, ed. by Rosemarie Aulinger (Munich, 2005).

**Deutsche Reichstagsakten 2009**
*Deutsche Reichstagsakten. Jüngere Reihe. Deutsche Reichstagsakten unter Kaiser Karl V.*, XX: *Der Reichstag zu Augsburg 1555*, 4 vols., ed. by Rosemarie Aulinger, Erwein H. Eltz and Ursula Machoczek (Munich, 2009).

**Deutsche Reichstagsakten 2011**
*Deutsche Reichstagsakten. Jüngere Reihe. Deutsche Reichstagsakten unter Kaiser Karl V.*, XV: *Der Speyrer Reichstag von 1544*, 4 vols., ed. by Erwein Eltz (Göttingen, 2001).

**Diemer 1984**
Peter Diemer, 'Vergnügungsfahrt mit Hindernissen: Erzherzog Ferdinands Reise nach Venedig, Ferrara und Mantua im Frühjahr 1579', *Archiv für Kulturgeschichte* 66 (1984), pp. 249–314.

**Diemer 1995**
Dorothea Diemer, 'Antonio Brocco und der 'Singende Brunnen' in Prag', *JKSW* 31 (1995), pp. 18–36.

**Diemer 2004**
*Johann Baptist Fickler. Das Inventar der Münchner herzoglichen Kunstkammer von 1598, Transcription of the inventory manuscript cgm 2133*, ed. by Peter Diemer, Bayerische Akademie der Wissenschaften, philosophisch-historische Klasse, Abhandlungen N. F., 125 (Munich, 2004).

**Dietl 2000**
Walter Dietl, *Die Elogien der Ambraser Fürstenbildnisse* (Innsbruck, 2000).

**Distelberger 2002**
Rudolf Distelberger, *Die Kunst des Steinschnitts. Prunkgefäße und Commessi aus der Kunstkammer* (Vienna, 2002).

**Dmitrieva 2008**
Marina Dmitrieva, *Italien in Sarmatien: Studien zum Kulturtransfer im östlichen Europa in der Zeit der Renaissance* (Stuttgart, 2008).

**Dobalová 2008**
Sylva Dobalová, 'Erzherzog Ferdinand II. von Habsburg, das Lusthaus Belvedere und die Fischbehälter im Königlichen Garten der Prager Burg', *Die Gartenkunst* 20:2 Beilage (2008), pp. 11–18.

**Dobalová 2009**
Sylva Dobalová, *Zahrady Rudolfa II. Jejich vznik a vývoj* (Prague, 2009).

**Dobalová 2015**

Sylva Dobalová, 'The Royal Summer Palace, Ferdinand I and Anne', *Historie — Otázky — Problémy* 7:2 (2015), pp. 163–175.

**Dobalová 2017**

Sylva Dobalová, "La Barco' of the Star Summer Palace in Prague: A Unique Example of Renaissance Landscape Design', in *Looking for Leisure. Court Residences and their Satellites 1400–1700*, Palatium e-Publication 4, ed. by Ivan P. Muchka and Sylva Dobalová (Prague 2017), pp. 257–273.

**Dobalová 2018**

Sylva Dobalová, '*Temples & Logis domestiques* by Jacques Androuet du Cerceau and the Star Summer Palace in Prague', *Studia Rudolphina* 17–18 (2018), pp. 9–21.

**Dobalová / Hausenblasová 2015**

Sylva Dobalová and Jaroslava Hausenblasová, Die Zitruskultur am Hofe Ferdinands I. und Anna Jagiellos: Import und Anbau von Südfrüchten in Prag 1526–1564, *Studia Rudolphina* 15 (2015), pp. 9–36.

**Dobalová / Muchka 2014**

Sylva Dobalová and Ivan Muchka, 'A Bibliography of the Star (Hvězda) Summer Palace in Prague', *Studia Rudolphina* 14 (2014), pp. 139–143.

**Dobalová / Muchka 2017**

Sylva Dobalová and Ivan P. Muchka, 'Archduke Ferdinand II as Architectural Patron in Prague and Innsbruck', in Exh. Cat. Innsbruck 2017, pp. 38–45.

**Dobalová / Muchka 2017**

Sylva Dobalová and Ivan Prokop Muchka, Stavební projekty arcivévody Ferdinanda / Erzherzog Ferdinand II. als Bauherr in Prag und Innsbruck, in Exh. Cat. Prague 2017, pp. 32–37 / pp. 23 –26.

**Doering 1901**

Oscar Doering, *Des Augsburger Patriciers Philipp Hainhofer Reisen nach Innsbruck und Dresden*, Quellenschriften für Kunstgeschichte und Kunsttechnik des Mittelalters und der Neuzeit, N.F. 10 (Vienna, 1901).

**Dressendörfer 2003**

Werner Dressendörfer, *Blüten, Kräuter und Essenzen. Heilkunst alter Kräuterbücher* (Darmstatt, 2003)

**Dressler 1973**

Helga Dressler, *Alexander Colin* (unpublished doctoral theses, Karlsruhe, 1973).

**Duindam / Artan / Kunt 2011**

*Royal Courts in Dynastic States and Empires. A Global Perspective*, ed. by Jeroen Duindam, Tülay Artan and Metin Kunt (Leiden, 2011).

**Dunning 1970**

Albert Dunning, *Die Staatsmotette 1480–1555* (Utrecht, 1970).

**Dunning 1974**

*Novi thesauri musici a Petro Ioannello collecti. Volumen V*, ed. by Albert Dunning, Corpus mensurabilis musicae 64 (s.l., 1974).

**Edelmayer 1990**

*Die Krönungen Maximilians II. zum König von Böhmen, Römischen König und König von Ungarn (1562/63) nach der Beschreibung des Hans Habersack, ediert nach CVP 7890*, ed. by Friedrich Edelmayer et al., Fontes rerum austriacarum, I/13 (Vienna 1990).

**Edelmayer / Kohler 1992**

*Kaiser Maximilian II.: Kultur, und Politik im 16. Jahrhundert*, ed. by Friedrich Edelmayer and Alfred Kohler (Vienna, 1992).

**Egg 1962**

Erich Egg, *Die Glashütten zu Hall und Innsbruck im 16. Jahrhundert*, Tiroler Wirtschaftsstudien, Schriftenreihe der Jubiläumsstiftung der Kammer der gewerblichen Wirtschaft für Tirol (Innsbruck, 1962).

**Egg 1972**

Erich Egg, 'Die Innsbrucker Malerei des 16. Jahrhunderts', in *Festschrift für Karl Schadelbauer*, Veröffentlichungen des Innsbrucker Stadtarchivs, NF 3 (1972), pp. 39–53.

**Egg 1974**

Erich Egg, *Die Hofkirche in Innsbruck. Das Grabdenkmal Kaiser Maximilians I. und die Silberne Kapelle* (Innsbruck, Vienna and Munich, 1974).

**Eichberger 2005**

*Women of Distinction: Margaret of York, Margaret of Austria*, ed. by Dagmar Eichberger (Davidsfonds, 2005).

**Eisen Cislo 2008**

Amy Eisen Cislo, 'Paracelsus's Conception of Seede: Rethinking Paracelsus's Ideas of Body and Matter', *Ambix* 55 (2008), p. 274–282.

**Emmendörfer / Zäh 2011**

*Bürgermacht & Bücherpracht: Katalogband zur Ausstellung im Maximilianmuseum Augsburg vom 18. Märtz bis 19. Juni 2011*, ed. by Christoph Emmendörfer and Helmut Zäh (Augsburg, 2011).

**Erasmus 1995**

Erasmus von Rotterdam, *Institutio principis Christiani*, ed. and transl. by Gertraud Christian, Erasmus von Rotterdam Ausgewählte Schriften, 5 (Darmstadt, 1995).

**Evans 1973**

Robert J. W. Evans, *Rudolf II and His World. A Study Intellectual History 1576–1612* (Oxford, 1973).

**Exh. Cat. Munich 1985**

*Wenzel Jamnitzer und die Nürnberger Goldschmiedekunst 1500–1700: Goldschmiedearbeiten-Entwürfe, Modelle, Medaillen, Ornamentstiche, Schmuck, Porträts*, ed. by Gerhard Bott, exh. cat. (Munich, 1985).

**Exh. Cat. Cleve 1985**

*Land im Mittelpunkt der Mächte: die Herzogtümer Jülich, Kleve, Berg*, 3rd edition, exh. cat. (Cleve, 1985).

**Exh. Cat. Essen 1988**

*Prag um 1600: Kunst und Kultur am Hofe Rudolfs II.*, exh. cat. (Freren, 1988).

**Exh. Cat. Gent 1999**

*Carolus. Charles Quint 1500–1558*, ed. by Hugo Soly and Johan Van de Wiele, exh. cat. (Gent, 1999).

**Exh. Cat. Innsbruck 1995**

*Natur und Kunst. Handschriften und Alben aus der Ambraser Sammlung Erzherzog Ferdinands II. (1529–1595)*, ed. by Alfred Auer and Eva Irblich, exh. cat. (Innsbruck, 1995).

**Exh. Cat. Innsbruck 1996**

*Vom Codex zum Computer*, ed. by Gerd Ammann, exh. cat. (Innsbruck, 1996).

**Exh. Cat. Innsbruck 1998**

*Philippine Welser & Anna Catharina Gonzaga. Die Gemahlinnen Erzherzog Ferdinands II.*, ed. by Alfred Auer, exh. cat. (Innsbruck, 1998).

**Exh. Cat. Innsbruck 2001**

*Alle Wunder dieser Welt. Die kostbarsten Kunstschätze aus der Sammlung Erzherzog Ferdinands II. (1529–1595)*, ed. by Wilfried Seipel (Innsbruck, 2001).

**Exh. Cat. Innsbruck 2002**

*Werke für die Ewigkeit. Kaiser Maxmilian I. und Erzherzog Ferdinand II.*, ed. by Wilfried Seipel, exh. cat. (Innsbruck, 2002).

**Exh. Cat. Innsbruck 2004**

*Herrlich Wild. Höfische Jagd in Tirol*, ed. by Wilfried Seipel, exh. cat. (Innsbruck, 2004).

**Exh. Cat. Innsbruck 2005**

*Wir sind Helden. Habsburgische Feste in der Renaissance*, ed. by Wilfried Seipl, exh. cat. (Vienna, 2005).

**Exh. Cat. Innsbruck 2006**

*Die Entdeckung der Natur. Naturalien in den Kunstkammern des 16. und 17. Jahrhunderts*, ed. by Wilfried Seipel, exh. cat. (Innsbruck, 2006).

**Exh. Cat. Innsbruck 2010**

Sabine Haag and Veronika Sandbichler, *Die Hochzeit Erzherzog Ferdinands II. Eine Bildreportage des 16. Jahrhunderts*, exh. cat. (Innsbruck, 2010).

**Exh. cat. Innsbruck 2011**

*All Antica. Götter & Helden auf Schloss Ambras*, ed. by Sabine Haag, exh. cat. (Vienna, 2011).

**Exh. Cat. Innsbruck 2015**

*Fürstlich Tafeln*, ed. by Sabine Haag, exh. cat. (Vienna, 2015).

**Exh. Cat. Innsbruck 2017**
*Ferdinand II. 450 Years Sovereign Ruler of Tyrol. Jubilee Exhibition*, ed. by Sabine Haag and Veronika Sandbichler, exh. cat. (Innsbruck and Vienna, 2017).

**Exh. Cat. Innsbruck 2018**
*Frauen. Kunst und Macht. Drei Frauen aus dem Hause Habsburg*, ed. by Sabine Haag, exh. cat. (Vienna, 2018)

**Exh. Cat. Madrid 1998**
*Un príncipe del renacimiento: Felipe II, un monarca y su* época, ed. by Fernando Checa Cremades, exh. cat. (Madrid, 1998).

**Exh. Cat. Pordenone 2005**
*Gentilhomeni, artieri et merchatanti. Cultura materiale e vita quotidiana nel Friuli occidentale al tempo dell'Amalteo (1505–1588)*, exh. cat. (Pordenone, 2005).

**Exh. Cat. Prague 1997a**
*Magister Theodoricus, dvorní malíř císaře Karla IV.*, ed. by Jiří Fajt, exh. cat. (Prague, 1997).

**Exh. Cat. Prague 1997b**
*Rudolf II and Prague. The Court and the City*, ed. by Eliška Fučíková et al., exh. cat. (Prague, London and Milan, 1997).

**Exh. Cat. Prague 2006**
*Karel IV., Císař z boží milosti. Kultura a umění za vlády Lucemburků 1310–1437*, ed. by Jiří Fajt and Barbara D. Boehm, exh. cat. (Prague 2006).

**Exh. Cat. Prague 2007**
*Básník a král: Bohuslav Hasištejnský z Lobkovic v zrcadle jagellonské doby*, ed. by Ivana Kyzourová, exh. cat. (Prague, 2007).

**Exh. Cat. Prague 2011**
*Rožmberkové. Rod českých velmožů a jeho cesta dějinami*, ed. by Jaroslav Pánek, exh. cat. (České Budějovice, 2011).

**Exh. Cat. Prague 2017**
*Arcivévoda Ferdinand II. Habsburský. Renesanční vladař a mecenáš mezi Prahou a Innsbruckem / Ferdinand II. Erzherzog von Österreich aus dem Hause Habsburg. Renaissace-Herrscher und Mäzen zwischen Prag und Innsbruck*, ed. by Blanka Kubíková, Jaroslava Hausenblasová and Sylva Dobalová (Prague, 2017).

**Exh. Cat. Vienna 1979**
*Wien 1529. Die ersten Türkenbelagerung. Textband 62. Sonderaustellung des Historischen Museums der Stadt Wien*, exh. cat. (Vienna, 1979).

**Exh. Cat. Vienna 2000**
*Exotica. Portugals Entdeckungen im Spiegel fürstlicher Kunst- und Wunderkammern der Renaissance*, ed. by Wilfried Seipel, exh. cat. (Vienna, 2000)

**Exh. Cat. Vienna 2003**
*Kaiser Ferdinand I. 1503–1564. Das Werden der Habsburgermonarchie*, ed. by Wilfried Seipel (Vienna, 2003).

**Exh. Cat. Vienna 2004**
*Herrlich Wild. Höfische Jagd in Tirol*, ed. by Wilfried Seipel, exh. cat. (Vienna, 2004).

**Exh. Cat. Vienna 2006**
*Die Entdeckung der Natur. Naturalien in den Kunstkammern des 16. und 17. Jahrhunderts*, ed. by Wilfried Seipel, exh. cat. (Vienna, 2006).

**Exh. Cat. Vienna 2012a**
*Ambras & Dresden. Kunskammerschätze der Renaissance*, ed. by Sabine Haag, exh. cat. (Vienna, 2012).

**Exh. Cat. Vienna 2012b**
*Emperor Maxmilian I and the Age of Dürer*, ed. by Eva Michel and Maria Luise Sternath, exh. cat. (Vienna, 2012).

**Exh. Cat. Vienna 2016**
*Feste Feiern*, ed. Sabine Haag and Gudrun Swoboda, exh. cat. (Vienna, 2016).

**Exh. Cat. Yokohama 1998**
*Der Glanz des europäischen Rittertums. Prunkvolle Rüstungen für Mann und Pferd vom Spätmittelalter bis ins 16. Jahrhundert / The Splendour of European Knights*, exh. cat. (Yokohama, 1998).

**Fairholt 1858**
Frederick William Fairholt, *Miscellanea Graphica: Representations of Ancient, Medieval, and Renaissance Remains* (London, 1858).

**Falkenau 1999**
Karsten Falkenau, *Die "Concordantz Alt und News Testament" von 1550: ein Hauptwerk biblischer Typologie des 16. Jahrhunderts illustriert von Augustin Hirschvogel* (Regensburg, 1999).

**Fantazzi 1982**
Charles Fantazzi, 'Vives, More and Erasmus', in *Juan Luis Vives*, ed. by August Buck, Wolfenbütteler Abhandlungen zur Renaissanceforschung, 3 (Hamburg, 1982), pp. 165–176.

**Farbaky / Pócs / Scudieri 2013**
*Mattia Corvino e Firenze: arte e umanesimo alla corte del re di Ungheria*, ed. by Péter Farbaky, Dániel Pócs and Magnolia Scudieri (Florence, 2013).

**Farbaky / Waldman 2011**
*Italy and Hungary: Humanism and Art in the Early Renaissance*, ed. by Péter Farbaky and Louis A. Waldman (Florence, 2011).

**Fejtová / Pešek 2015**
Olga Fejtová and Jiří Pešek, 'Varii variarum rerum, factorum, dictorum, multarumque aliarum historiarum scriptores. Dějepisná literatura', in *Knihovna arcivévody Ferdinanda II. Tyrolského*, I: *Texty*, ed. by Ivo Purš and Hedvika Kuchařová (Prague, 2015), pp. 181–208.

**Fellin 2000**
Vittorino Fellin, 'La figura di Giulio Alessandrini', in *Giulio Alessandrini, personaggio illustre del Cinquecento tridentino, Atti del convegno, Civezzano 12 Settembre 1997* (Formace and Pergine, 2000), pp. 7–17.

**Felmayer 1986**
*Die Kunstdenkmäler der Stadt Innsbruck, Die Hofbauten*, ed. by Johanna Felmayer, Österreichische Kunsttopographie, 47 (Vienna, 1986).

**Fenlon 1980**
Iain Fenlon, *Music and Patronage in Sixteenth-Century Mantua*, I (Cambridge, 1980).

**Fey 2007**
Carola Fey, 'Inventare', in *Höfe und Residenz im spätmittelalterlichen Reich*, ed. by Werner Paravicini et al., Residenzforschung 15.III (Ostfildern, 2007), pp. 473–483.

**Fidler 1989**
Petr Fidler, 'Spanische Säle - Architekturtypologie oder -semiotik?', in *Spanien und Österreich in der Renaissance*, ed. by Wofgang Krömer (Innsbruck, 1989), pp. 157–173.

**Fidler 2007**
Peter Fidler, 'Renaissancearchitektur', in *Kunst in Tirol*, I, *Von den Anfängen bis zur Renaissance*, ed. by Paul Naredi-Rainer and Lucas Madersbacher (Innsbruck, 2007), pp. 571–588.

**Fink 1993**
Gerhard Fink, *Who's Who in der antiken Mythologie* (Munich, 1993).

**Fischer 1999**
Karl Fischer, 'Augustin Hirschvogels Stadtplan von Wien, 1547/1549 und seine Quadranten', *Cartographica Helvetica* 20 (1999), pp. 3–12.

**Fischnaler 1930**
Konrad Fischnaler, *Innsbrucker Chronik*, II (Innsbruck, 1930).

**Fischnaler 1934**
Konrad Fischnaler, *Innsbrucker Chronik*, V (Innsbruck, 1934).

**Flood 2006**
John L. Flood, *Poets laureate in the Holy Roman Empire* (Berlin and New York, 2006).

**Forcher 2017**
Michael Forcher, *Erzherzog Ferdinand II. Landesfürst von Tirol: sein Leben, seine Herrschaft, sein Land* (Innsbruck and Vienna, 2017).

**Fourny 2014**
Michel Fourny, 'Les vestiges archéologiques de la période bourguignonne', in *Le palais du Coudenberg à Bruxelles*, ed. by Laetitia Cnockaert, Vincent Heymans and Frédérique Honoré (Brussels, 2014), pp. 71–91.

**Frank 1967–1974**
Karl Friedrich von Frank, *Standeserhebungen und Gnadenakte für das Deutsche Reich [...], 1823–1918* (Schloss Senftenegg, 1967–1974)

**Frejková 1941**
Olga Frejková, *Palladianismus v české renesanci* (Prague, 1941).

**Frenzel 1978**

Monika Frenzel, *Historische Gartenanlagen und Gartenpavillons in Tirol* (unpublished doctoral thesis, Innsbruck, 1978)

**Fučíková 1989**

*Tři francouzští kavalíři v renesanční Praze*, ed. by Eliška Fučíková (Prague, 1989).

**Fučíková 1997**

Eliška Fučíková, 'Prague Castle under Rudolf II, His Predecessors and Successors', in *Rudolf II and Prague: The Imperial Court and Residential City as the Cultural and Spiritual Heart of Central Europe*, ed. by Eliška Fučíková, exh. cat. (Prague, London and Milan, 1997), pp. 2–71.

**Fučíková 2015**

Eliška Fučíková, 'Kaiser Ferdinand I. und das Schicksal des Herrscherzyklus' im Alten Königspalast der Prager Burg', *Historie – Otázky – Problémy* 7:2 (2015), pp. 135–141.

**Fučíková 2017a**

Eliška Fučíková, 'Prague Castle under Archduke Ferdinand II: Rebuilding and Decoration', in Exh. Cat. Innsbruck 2017, pp. 46–53.

**Fučíková 2017b**

Eliška Fučíková, 'Pražský hrad a jeho výzdoba za arcivévody Ferdinanda II. / Die Prager Burg unter Erzherzog Ferdinand II.: Umbau und künsterische Gestaltung', in Exh. Cat. Prague 2017, pp. 38–43.

**Fučíková 2018**

Eliška Fučíková, 'Ein Zyklus von Zeichnungen Habsburger Herrscher im Nationalarchiv in Prag', *Umění/Art* 66 (2018), pp. 60–71.

**Gachard 1854–1855**

Louis Prosper Gachard, *L'abdication de Charles-Quint* (Brussels, 1854–1855).

**Gachard 1874**

*Collection des voyages des souverains des Pays-Bas, Tome deuxième. Itinéraire de Charles-Quint de 1506 a 1531. Journal des voyages de Charles-Quint, de 1514–1551*, ed. by Louis-Prosper Gachard, II (Brussels, 1874).

**Gahtan 2014**

*Giorgio Vasari and the Birth of the Museum*, ed. by Maia Wellington Gahtan (Farnham, 2014).

**Gamber 1972**

Ortwin Gamber,'Die Kriegrüstungen Erherzog Ferdinands II. aus der Prager Hofplattnerei', *JKSW* 68, N. F. 32 (1972), pp. 109–152.

**Gamber / Beaufort-Spontin 1990**

Ortwin Gamber and Christian Beaufort-Spontin, *Katalog der Leibrüstkammer*, II (Vienna, 1990).

**Gasparetto 1985**

Astone Gasparetto, *Il vetro di Murano dalle origini ad oggi* (Venice, 1958).

**Gayangos 1899**

*Calendar of letters, despatches and State papers relating to the negotiations between England and Spain, preserved in the archives at Simancas, Vienna, Brussels and elsewhere, Vol. 7, Henry VIII, 1544*, ed. by Pascual de Gayangos (London, 1899).

**Gianoncelli 1977**

Matteo Gianoncelli, *L'antico museo di Paolo Giovio in Borgovico* (Como, 1977).

**Gluth 1876–1877**

Oskar Gluth, 'Die Wahl Ferdinands I. zum König von Böhmen 1526', *Mittheilungen des Vereins für die Geschichte der Deutschen in Böhmen* 15 (1876–1877), pp. 198–302.

**Goldammer 1955**

*Paracelsus, Kärntner Schriften*, ed. Kurt Goldammer (Klagenfurt, 1955).

**Gombrich 1996**

Ernst H. Gombrich, 'The Early Medici as Patrons of Art', in idem, *Norm and Form: Studies in the Art of Renaissance* (London, 1996), pp. 35–57.

**Götze 1746**

Johann Christian Götze, *Die Merckwürdigkeiten Der Königlichen Bibliotheck zu Dreßden*, 3 (Dresden, 1746).

**Graduale 1979**

*Graduale triplex seu Graduale Romanum Pauli pp. VI, cura recognitum & rhythmicis signis a Solesmensibus monachis ornatum neumis laudunensibus (cod. 239) et sangallensibus (codicum San Gallensis 359 et Einsidlensis 121) nunc auctum* (Solesmis, 1979).

**Graf-Stuhlhofer 1996**

Franz Graf-Stuhlhofer, *Humanismus zwischen Hof und Universität. Georg Tannstetter (Collimitius) und sein wissenschaftliches Umfeld im Wien des frühen 16. Jahrhunderts*, Schriftenreihe des Universitätsarchivs, Universität Wien, 8 (Vienna, 1996).

**Granichstaedten-Czerva 1962**

Rudolf Granichstaedten-Czerva, *Alt- Innsbrucker Stadthäuser und ihre Besitzer*, I (Innsbruck, 1962).

**Grapheus / Aelst 1550**

Cornelius Scribonius Grapheus and Pieter Coecke van Aelst, *De seer wonderlijcke, schoone, triumphelijcke incompst, van den hooghmogenden Prince Philips, Prince van Spaignen, Caroli des vijfden, Keysers sone: inde stadt van Antwerpen, anno M.CCCCC.XLIX* (Antwerpen, 1550).

**Gratl 2017**

Franz Gratl, 'Music at the Court of Archduke Ferdinand II within the Network of Dynastic Relationships', in Exh. Cat. Innsbruck 2017, pp. 61–71.

**Grieb 2007**

Manfred H. Grieb, *Nürnberger Künstlerlexikon* (Nuremberg, 2007).

**Gries 1993**

Christian Gries, 'Erzherzog Ferdinand von Tirol. Konturen einer Sammlerpersönlichkeit', *Frühneuzeit-Info* 4:2 (1993), pp. 162–173.

**Griessenbach 2014**

Roma Griessenbeck von Griessenbach, *Florian Griespek von Griespach in Geschichte und Gegenwart* (Regenstauf, 2014).

**Grohs 1988**

Brigitte Grohs, 'Italienische Hochzeiten. Die Vermählung der Erzherzoginnen Barbara und Johanna von Habsburg im Jahre 1565', *Mitteilungen des Instituts für österreichische Geschichtsforschung* 96 (1988) pp. 331–381.

**Groß 1994**

Bernhard Groß, *Gegenreformation und Geheimprotestantismus unter besonderer Berücksichtigung des Landes Tirol unter dem Einfluss der jesuitischen, franziskanischen und kapuzinischen Gegenreformation zur Zeit Erzherzog Ferdinand II.* (magister thesis, Universität Wien 1994).

**Größing 1998**

Sigrid-Maria Größing, *Die Heilkunst der Philippine Welser. Außenseiterin im Hause Habsburg* (Augsburg, 1998).

**Großmann / Grebe 2016**

Ulrich G. Großmann and Anja Grebe, *Burgen. Geschichte – Kultur – Alltagsleben* (Berlin, 2016).

**Grunwald 1936**

Max Grunwald, *History of Jews in Vienna* (Philadelphia, 1936).

**Guembel 1943**

*Aus dem Kräuterbuch des Dodonaeus*, ed. by Hildegard Guembel (Brussels, 1943).

**Gulyás 2019**

Borbála Gulyás, 'Triumphal arches in court festivals under the new Holy Roman Emperor, Habsburg Ferdinand I'., in *Occasions of State: Early Modern European Festivals and the Negotiation of Power*, ed. by J. R. Mulryne, Krista de Jonge, R. L. M. Morris and Pieter Martens (New York, 2019), pp. 65–68.

**Gurlitt 1889**

Cornelius Gurlitt, *Deutsche Turniere, Rüstungen und Plattner* (Dresden, 1889).

**Guthmüller 2001**

Bodo Guthmüller, '„Pro! Quanta potentia regni / Est, Venus alma, tui!". Venus in der Mythologie der italienischen Renaissance', in *Faszination Venus. Bilder einer Göttin von Cranach bis Cabanel*, ed. by Ekkehard Mai, exh. cat. (Cologne 2001), pp. 49–55.

**Haag / Kirchweger 2012**

*Die Kunstkammer: die Schätze der Habsburger*, ed. by Sabine Haag and Franz Kirchweger (Vienna, 2012).

**Häberlein / Bayreuther 2013**
Mark Häberlein and Magdalena Bayreuther, *Agent und Ambassador. Der Kaufmann Anton Meuting als Vermittler zwischen Bayern und Spanien im Zeitalters Philipps II.* (Augsburg, 2013).

**Hackenbroch 1979**
Yvonne Hackenbroch, *Renaissance Jewellery* (London, 1979).

**Haidacher 1984**
Christoph Haidacher, *Zur Bevölkerungsgeschichte von Innsbruck im Mittelalter und in der beginnenden Neuzeit*, Veröffentlichungen des Innsbrucker Stadtarchivs, Neue Folge, 15 (Innsbruck, 1984).

**Haidacher / Diemer 2004**
Christoph Haidacher and Dorothea Diemer, *Maximilian I. Der Kenotaph in der Hofkirche zu Innsbruck* (Innsbruck, 2004).

**Hájek 1541**
Václav Hájek of Libočany, *O nesstiastnee przihodie kteráž gse stala skrze ohen w Menssim Miestie Pražském, a na Hradie Swatého Waclawa, y na Hradčžanech etc.* Leta M.D.xxxj (Prague, 1541).

**Hamann 1988**
*Die Habsburger: Ein biographisches Lexikon*, ed. by Brigitte Hamann (Vienna, 1988).

**Haupt 2007**
Herbert Haupt, *Das Hof- und Hofbefreite Handwerk im barocken Wien, 1620 bis 1770* (Innsbruck, Vienna and Bozen, 2007).

**Hausenblasová 2002**
Jaroslava Hausenblasová, *Der Hof Kaiser Rudolfs II. Eine Edition der Hofstaatsverzeichnisse 1576–1612*, Fontes historiae artium, 9 (Prague, 2002).

**Hausenblasová 2007**
Jaroslava Hausenblasová, 'Ferdinand I. a pražský humanistický okruh. Několik poznámek k problematice panovnického mecenátu kolem poloviny 16. století', *Acta Universitatis Carolinae: Historia Universitatis Carolinae Pragensis* 47: 1–2 (2007), pp. 89–97.

**Hausenblasová 2010**
Jaroslava Hausenblasová, 'Ein modifiziertes Vorbild oder ein eigenes Modell? Der Aufbau des Hofes Ferdinands I. in Mitteleuropa in der ersten Hälfte des 16. Jahrhunderts', in *Vorbild, Austausch, Konkurrenz. Höfe und Residenzen in der gegenseitigen Wahrnehmung*, ed. by Werner Paravicini and Jörg Wettlaufer, Residenzenforschung, 23 (Ostfildern, 2010), pp. 363–390.

**Hausenblasová 2014**
Jaroslava Hausenblasová, 'Reflexe událostí První rakousko-turecké války v soukromé korespondenci Ferdinanda I., Anny Jagellonské a Marie Habsburské', *Historie – Otázky – Problémy* 6:2 (2014), pp. 125–137.

**Hausenblasová 2015**
Jaroslava Hausenblasová, 'Prag in der Regierungszeit Ferdinands I. Die Stellung der Stadt im System des höfischen Residenznetzwerks', *Historie – Otázky – Problémy* 7:2 (2015), pp. 9–28.

**Hausenblasová 2017a**

Jaroslava Hausenblasová, 'Arcivévoda Ferdinand II. Tyrolský – správce a místodržící zemí Koruny české / Erzherzog Ferdinand II.–Verweser und Statthalter der Länder der Böhmischen Krone', in Exh. Cat. Prague 2017, pp. 18–23 / 13–16.

**Hausenblasová 2017b**

Jaroslava Hausenblasová, 'A New Monarch and a New System of Residences: Ferdinand I Habsburg as the Founder of the Network of Main and Occasional Residences in the Habsburg Empire', in *Looking for Leisure. Court Residences and their Satellites 1400–1700*, ed. by Ivan P. Muchka and Sylva Dobalová, Palatium e-Publication 4 (Prague, 2017), pp. 46–61.

**Hausenblasová 2017c**

Jaroslava Hausenblasová, 'Building development of Hvězda – written sources and their interpretation', in Ivan P. Muchka, Ivo Purš, Sylva Dobalová and Jaroslava Hausenblasová, *The Star. Archduke Ferdinand II of Austria and his Summer Palace in Prague* (Prague, 2017), pp. 49–64.

**Hausenblasová 2019**

Jaroslava Hausenblasová, 'Dvůr habsburských arcivévodkyň a jeho reforma v roce 1563', *Paginae Historiae* 27 : 1 (2019), pp. 91–103.

**Hausenblasová 2021**

Jaroslava Hausenblasová: 'Die Krönung Maximilians II. zum böhmischen König 1562 in Prag und ihre langjährigen Vorbereitungen', in *Festvorbereitung. Die Planung höfischer Feste in Mitteleuropa 1500–1900*, ed. by Gerhard Ammerer, Ingonda Hannesschläger, Milan Hlavačka and Martin Holý, forthcoming.

**Hedicke 1904**

Robert Hedicke, *Jacques Dubroeucq von Mons. Ein niederländischer Meister aus der Frühzeit des italienischen Einflusses* (Strassburg, 1904).

**Heesen 2012**

Anke te Heesen, *Theorien des Museums* (Hamburg, 2012).

**Heikamp 1986**

Detlef Heikamp, 'Studien zur mediceischen Glaskunst. Archivalien, Entwurfszeichnungen, Gläser und Scherben', *Mitteilungen des Kunsthistorischen Institutes in Florenz* 30 (1986), pp. 73–74.

**Heinz 1963**

Günter Heinz, Studien zur Porträtmalerei an den Höfen der österreichischen Erblande, *JKSW* 59 (1963), pp. 99–224.

**Hejnic 1988**

Josef Hejnic, Zu den Anfängen der humanistischen Figuralpoesie in Böhmen, *Listy filologické* 111 : 2 (1988), pp. 95–102.

**Heintz / Schütz 1976**

Günther Heinz and Karl Schütz, *Porträtgalerie zur Geschichte Österreichs von 1400 bis 1800* (Vienna, 1976).

**Hejnic / Martínek 1966–2011**

*Rukověť humanistického básnictví v Čechách a na Moravě*, ed. by Josef Hejnic and Jan Martínek, 6 vols. (Prague, 1966–2011).

**Hejnová 2001**

Miroslava Hejnová, *Pietro Andrea Mattioli 1501–1578. U příležitosti 500. výročí narození / in ocassione de V centenario della nascita* (Prague, 2001).

**Herrmann 2007**

Cornelia Herrmann, *Die Kunstdenkmäler des Fürstentums Liechtenstein*, II, *Das Oberland*, Die Kunstdenkmäler der Schweiz, 112 (Bern, 2007).

**Hess / Hess 1555**

Bartholomäus Hess and Paulus Hess, *Ettlicher gutter Teutscher und Polnischer Tentz biß in die anderthalbhundert mit fünff und vier stimmen zugebrauchen auff allerley Instrument dienstlich* (Breslau, 1555).

**Hilbert 1909**

Kamil Hilbert, 'Hudební kruchta v chrámě sv. Víta na Hradě Pražském', *Časopis Společnosti přátel starožitností českých* 17 (1909), pp. 1–17, 41–51.

**Hilger 1969**

Wolfgang Hilger, *Ikonographie Kaiser Ferdinands I. (1503–1564)* (Vienna, 1969).

**Hilger 2003**

Wolfgang Hilger, '„Das Bild vom König und Kaiser". Ammerkungen zu Verbreitung und Wirkungsgeschichte von Herrscherdarstellungen am Beispiel Ferdinands I.', in *Kaiser Ferdinand I. 1503–1564. Das Werden der Habsburgermonarchie*, ed. by Wilfried Seipel (Vienna, 2003), pp. 231–241.

**Hirn 1885–1888**

Josef Hirn, *Erzherzog Ferdinand II. von Tirol. Geschichte seiner Regierung und seiner Länder*, 2 vols. (Innsbruck, 1885–1888).

**Hochenegg 1963**

Hans Hochenegg, *Die Tiroler Kupferstecher, Graphische Kunst in Tirol vom 16. bis zur Mitte des 19. Jahrhunderts* (Innsbruck, 1963).

**Hodapp 2018**

Julia Hodapp, 'Die Stiftung des Königlichen Damenstiftes in Hall in Tirol, 1569', in Julia Hodapp, *Habsburgerinnen und Konfessionalisierung im späten 16. Jahrhundert* (Münster, 2018), pp. 27–81.

**Holtzmann 1903**

Robert Holtzmann, *Kaiser Maximilian II. bis zu seinen Thronsteigung (1527–1564). Ein Beitrag zur Geschichte des Überganges von den Reformation zur Gegenreformation* (Berlin, 1903).

**Holzschuh-Hofer 2010**

Renate Holzschuh-Hofer, 'Feuereisen im Dienst politischer Propaganda von Burgund bis Habsburg', *RIHA Journal* no. 0006 (2010).

**Holzschuh-Hofer 2014**
Renate Holzschuh-Hofer, 'Die Hofburg und ihre Ikonologie im 16. Jahrhundert', in *Die Wiener Hofburg 1521–1705: Baugeschichte, Funktion und Etablierung als Kaiserresidenz*, ed. by Herbert Karner (Vienna, 2014), pp. 530–549.

**Homolka 1997**
Jaromír Homolka, 'Malíři a dílny pracující na výzdobě kaple sv. Kříže vedle Mistra Theodorika,' in *Magister Theodoricus: dvorní malíř císaře Karla IV. Umělecká výzdoba posvátných prostor hradu Karlštejna*, ed. by Jiří Fajt, exh. cat. (Prague, 1997), pp. 351–361.

**Honegger 2012**
Thomas Honegger, 'Der Drache: Herausforderer von Heiligen und Helden', in *Animali. Tiere und Fabelwesen von der Antike bis zur Neuzeit*, ed. by Luca Tori and Aline Steinbrecher, exh. cat. (Geneva and Milan, 2012), pp. 193–203.

**Honisch 2011**
Erika Supria Honisch, 'Sacred Music in Prague, 1580–1612' (unpublished dissertation thesis, University of Chicago, 2011).

**Hoppe 1996**
Stefan Hoppe, *Die funktionale und räumliche Struktur des frühen Schloßbaus in Mitteldeutschland. Untersucht an Beispielen landesherrlichen Bauten der Zeit zwischen 1470–1570* (Cologne, 1996).

**Hoppe 2010**
Stephan Hoppe, 'Hofstube und Tafelstube. Funktionale Raumdifferenzierungen auf mitteleuropäischen Adelssitzen seit dem Hochmittelalter', in *Die Burg. Wissenschaftlicher Begleitband zu den Ausstellungen "Burg und Herrschaft" und "Mythos Burg"*, ed. by G. Ulrich Großmann and Hans Ottomeyer (Berlin, Nürnberg and Dresden, 2010), pp. 196–207.

**Horyna 2006**
Martin Horyna, 'Vícehlasá hudba v Čechách v 15. a 16. století a její interpreti', *Hudební věda* 43 (2006), pp. 117–134.

**Hrejsa 1912**
Ferdinand Hrejsa, *Česká konfese, její vznik, podstata a dějiny* (Prague, 1912).

**Hrubý 1937**
*Moravská korespondence a akta z let 1620–1636, II, 1625–1636 (Listy Karla st. ze Žerotína 1628–1636)*, ed. by František Hrubý (Brno, 1937).

**Huvenne 1999**
Paul Huvenne, 'La peinture dans les dix-sept provinces', in *Carolus. Charles Quint 1500–1558*, ed. by Hugo Soly and Johan Van de Wiele, exh. cat. (Gent, 1999), pp. 133–155.

**Ilg 1889**
Albert Ilg, 'Francesco Terzio, der Hofmaler Erzherzogs Ferdinand von Tirol', *JKSAK* 9 (1889), pp. 229–263.

**Ilg / Boeheim 1882**
Albert Ilg and Wendelin Boeheim, *Das k.k. Schloss Ambras in Tirol. Beschreibung des Gebäudes und der Sammlungen* (Vienna, 1882).

**In Adventu 1567**
*In Adventu [...] Imperatoris Maximilianii II. [...] Chorus Musarum* (Prague, 1567).

**Jacquot 1956**
Jean Jacquot, 'Joyeuse et triomphante entrée', in *Les fêtes de la renaissance*, ed. by Jean Jacquot (Paris, 1956), pp. 10–21.

**Jäger 1873**
Albert Jäger, 'Beiträge zur Geschichte der Verhandlungen über die erbfällig gewordene gefürstete Grafschaft Tirol nach dem Tode des Erzherzogs Ferdinand von 1595–1597', *Archiv für österreichische Geschichte* 50 (1873), pp. 103–212.

**Jakubcová / Vaňáč 2007**
Alena Jakubcová and Martin Vaňáč, 'Ferdinand Tyrolský', in *Starší divadlo v českých zemích do konce 18. století: Osobnosti a díla*, ed. by Alena Jakubcová et al. (Prague 2007), pp. 166–167.

**Janáček 1984**
Josef Janáček, *České dějiny. Doba předbělohorská 1526–1547*, I/2 (Prague, 1984).

**Jansen 2015**
Dirk Jacob Jansen, 'Emperor Ferdinand I and the Antique: the Antique as Innovation', *Historie – Otázky – Problémy* 7:2 (2015), pp. 202–218.

**Jansen 2019**
Dirk Jacob Jansen, *Jacopo Strada and Cultural Patronage at the Imperial Court. The Antique as Innovation,* 2 vols. (Leiden and Boston, 2019).

**Jordan 1985**
Annemarie Jordan, *Portuguese Royal Collections: A Bibliographic and Documentary Survey* (unpublished M.A. thesis, George Washington University, Washington, D.C., 1985).

**Jordan Gschwend 1996**
Annemarie Jordan Gschwend, 'As Maravilhas do Oriente: colecções de curiosidades renascentistas em Portugal / The marvels of the east: renaissance curiosity collections in Portugal', in *A herança de Rauluchantim / The heritage of Rauluchantim*, ed. by Nuno Vassallo e. Silva, exh. cat. (Lisbon, 1996), pp. 82–127.

**Jordan Gschwend 2007**
Annemarie Jordan Gschwend, 'Leonor of Austria. Queen of Portugal and France. Patronage, collecting and the arts at the Avis and Valois courts', in *Patronnes et mécènes en France à la Renaissance*, ed. by Kathleen Wilson-Chevalier and Eugénie Pascal (Saint-Étienne, 2007), pp. 341–380.

**Jordan Gschwend 2010a**
Annemarie Jordan Gschwend, 'Exotica for the Munich Kunstkammer. Anthonio Meyting: Fugger agent, Art dealer and Ducal Ambassador in Spain', in *Exotica*, ed. by Georg Laue (Munich, 2010), pp. 8–28.

**Jordan Gschwend 2010b**
Annemarie Jordan Gschwend, *The Story of Süleyman: Celebrity Elephants and other Exotica in Renaissance Portugal* (Zurich, 2010).

**Jordan Gschwend 2017**
Annemarie Jordan Gschwend, 'Anthonio Meyting: Artistic Agent, Cultural Intermediary and Diplomat (1538–1591)', in *Renaissance Craftsmen and Humanistic Scholars. Circulation of Knowledge between Portugal and Germany*, ed. by Thomas Horst, Marília dos Santos Lopes and Hernique Leitão (Franfurt am Main, 2017), pp. 187–201.

**Jordan Gschwend 2018**
Annemarie Jordan Gschwend, 'A Forgotten Infanta Catherine of Austria, Queen of Portugal (1507–1578)', in *Women. The Art of Power. Three Women from the House of Habsburg*, ed. by Sabine Haag, Dagmar Eichberger and Annemarie Jordan Gschwend (Innsbruck and Vienna, 2018), pp. 50–63.

**Jordan Gschwend / Lowe 2015**
*The Global City. On the streets of Renaissance Lisbon*, ed. by Jordan Gschwend and K. J. P. Lowe (London, 2015).

**Jordan Gschwend / Lowe 2017**
Annemarie Jordan Gschwend and K. J. P. Lowe, 'Renaissance Lisbon's Global Sites', in *A Cidade Global. Lisboa no Renascimento / The Global City. Lisbon in the Renaissance*, ed. by Annemarie Jordan Gschwend and K. J. P. Lowe (Lisbon, 2017), pp. 32–59.

**Kabelková 1984**
Markéta Kabelková, *Hudba a škola v období české renesance* (unpublished master thesis, Charles University in Prague, 1984).

**Kagan 2009**
Richard L. Kagan, *Clio and the Crown: The Politics of History in Medieval and Early Modern Spain* (Baltimore, 2009).

**Kalina 2009a**
Pavel Kalina, 'Tři tváře gotiky: Wohlmut, Santini, Mocker', in *Historismy: sborník příspěvků z 8. specializované konference stavebněhistorického průzkumu, uspořádané ve dnech 9.–12.6.2009 v Děčíně*, ed. by Olga Klapetková and Renata Kuperová (Prague, 2010), pp. 15–22.

**Kalina 2009b**
Pavel Kalina, *Benedikt Ried a počátky záalpské renesance* (Prague, 2009).

**Kalina 2011**
Pavel Kalina, *Praha 1437–1610. Kapitoly o pozdně gotické a renesanční architektuře* (Prague, 2011), pp. 65–73.

**Kameníček 1886a**
František Kameníček, 'Výprava arciknížete Ferdinanda na pomoc obleženému od Turků Sigetu roku 1556', *Sborník historický* 4 (1886), pp. 321–331.

**Kameníček 1886b**
František Kameníček, 'Účastenství Moravanů při válkách tureckých od r. 1526 do r. 1568', *Sborník historický* 3 (1885), pp. 15–29, 65–77, 157–175, 193–206, 271–284.

**Karajan 1881**
*Kaiser Maximilians I. geheimes Jagdbuch und von den Zeichen des Hirsches eine Abhandlung des vierzehnten Jahrhunderts*, ed. by Th. G. Karajan (Vienna, 1881²).

**Karner 2014**
*Die Wiener Hofburg 1521–1705. Baugeschichte, Funktion und Etablierung als Kaiserresidenz,* ed. by Herbert Karner (Vienna, 2014).

**Kašparová 2015**
Jaroslava Kašparová, 'Chronologická, geografická a jazyková provenience tisků a rukopisů', in *Knihovna arcivévody Ferdinanda II. Tyrolského, I: Texty,* ed. by Ivo Purš and Hedvika Kuchařová (Prague, 2015), pp. 405–428.

**Katalog der Sammlung für Plastik 1966**
*Katalog der Sammlung für Plastik und Kunstgewerbe, II. Teil – Renaissance* (Vienna, 1966).

**Katrizky 2016**
M. A. Katrizky, 'German Patrons of Venetian Carnival Art: Archduke Ferdinand II of Tyrol's Ambras Collections and the 1579 Travel Journal of Prince Ferdinand of Bavaria', in *Von kurzer Dauer? Fallbeispiele zu temporären Kunstzentren der Vormoderne,* ed. by Birgit Ulrike Münch, Andreas Tacke, Markwart Herzog and Sylvia Heudecker, Kunsthistorisches Forum Irsee 3 (Petersberg, 2016), pp. 126–142.

**Kaufmann 1978**
Thomas DaCosta Kaufmann, *Variations of the Imperial Theme in the Age of Maximilian II and Rudolf II* (New York, 1978).

**Kaufmann 1988**
Thomas DaCosta Kaufmann, *The School of Prague: Painting at the Court of Rudolf II* (Chicago, 1988).

**Kaufmann 1995a**
Thomas DaCosta Kaufmann, 'Italian Sculptors and Sculpture Outside of Italy (Chiefly in Central Europe): Problems of Approach, Posibilities of Reception', in *Reframing the Renaissance. Visual Culture in Europe and Latin America 1450–1650,* ed. by Claire Farago (New Haven, NJ and London, 1995), pp. 46–66.

**Kaufmann 1995b**
Thomas DaCosta Kaufmann, *Court, Cloister & City. The Art and Culture of Central Europe 1450–1800* (London, 1995).

**Kaufmann 2003**
Thomas DaCosta Kaufmann, *Art and Architecture in central Europe. An Annotaded Bibliography* (Marburg, 2003).

**Kaufmann 2004**
Thomas DaCosta Kaufmann, *Toward a Geography of Art* (Chicago, 2004).

**Kayser 2006**
Petra Kayser, 'Wenzel Jamnitzer and Bernard Palissy uncover the secrets of nature', *Australian and New Zealand Journal of Art* 7 : 2 (2006), pp. 45–61.

**Keller 2012**
Katrin Keller, *Erzherzogin Maria von Innerösterreich (1551–1608): Zwischen Habsburg und Wittelsbach* (Vienna, 2012).

**Keller 2016**

Katrin Keller, 'Frauen und dynastische Herrschaft. Eine Einführung,' in *Nur die Frau des Kaisers? Kaiserinnen in der Frühen Neuzeit*, ed. by Bettina Braun, Katrin Keller and Matthias Schnettger (Vienna, 2016), pp. 13–26.

**Kemp 2007**

William Kemp, 'Transformations in the Printing of Royal Entries during the Reign of François Ier: The Role of Geofroy Tory', in *French Ceremonial Entries in the Sixteenth Century: Event, Image, Text*, ed. by Nicholas Russell and Hélène Visentin (Toronto, 2007), pp. 111–132.

**Kenner 1893–1898**

Friedrich Kenner, 'Die Porträtsammlung des Erzherzogs Ferdinand von Tirol', *JKSAK* 14 (1893), pp. 37–186; *JKSAK* 15 (1893), pp. 147–259; *JKSAK* 17 (1896), pp. 101–274; *JKSAK* 18 (1897), pp. 135–261; *JKSAK* 19 (1898), pp. 6–146.

**Kerkhoff 2005**

Jacqueline Kerkhoff, 'The Court of Mary of Hungary, 1531–1558', in *Mary of Hungary: The Queen and her Court 1521–1531*, ed. by Orsolya Réthelyi et al., exh. cat. (Budapest, 2005), pp. 136–151.

**Kienberger 1953**

Georg Kienberger, 'Geschichte der Stadt Hall, 1564–1595', in *Haller Buch. Festschrift zur 650-Jahrfeier der Stadterhebung* (Innsbruck, 1953).

**Kirchweger 2012**

Franz Kirchweger, 'Die Schätze des Hauses Habsburg und die Kunstkammer. Ihre Geschichte und ihre Bestände', in *Die Kunstkammer. Die Schätze der Habsburger*, ed. by Sabine Haag and Franz Kirchweger (Vienna, 2012), pp. 12–49.

**Kirchweger 2014**

Franz Kirchweger, 'Die Kunstkammern der österreichischen Habsburgerinnen und Habsburger: Ein kurz gefasster Überblick', *Frühneuzeit-Info* 25 (2014), 45–66.

**Klebersberg 1940/1945**

Martha von Klebersberg, 'Stuckarbeiten des 16. und 17. Jahrhunderts in Nordtirol I.', *Veröffentlischungen des Museum Ferdinandeum* 20/25 (1940/1945), pp. 175–214.

**Knappich 1986**

Wilhelm Knappich, *Histoire de l'astrologie* (Paris, 1986).

**Knecht 2002**

R. J. Knecht, 'Charles V's Journey through France, 1539–1540', in *Court Festivals of the European Renaissance: Art, Politics and Performance*, ed. by J. R. Mulryne and Elizabeth Goldring (Aldershot, 2002), pp. 153–170.

**Knoz 2008**

Tomáš Knoz, *Karel starší ze Žerotína: Don Quijote v labyrintu světa* (Prague, 2008).

**Koepf / Binding 2005**

Hans Koepf and Günther Binding, *Bildwörterbuch der Architektur* (Stuttgart, 2005).

**Kohler 1992**
Alfred Kohler, 'Vom Habsburgischen Gesamtsystem Karls V. zu den Teilsystemen Philipps II. und Maximilians II.', in *Kaiser Maximilian II. Kultur und Politik im 16. Jahrhundert*, ed. by Friedrich Edelmayer and Alfred Kohler (Vienna, 1992), pp. 13–54.

**Kohler 2003**
Alfred Kohler, *Ferdinand I. Fürst, König und Kaiser* (Munich, 2003).

**Kolev 2012**
Rumen K. Kolev, *1532. Three Annual Horoscopes for Ferdinanda I, King of the Romans, Archduke of Austria, translated for the first time from the Manuscript Codex Vindobonensis Palatinus 7433* (Varna, 2012).

**Koller 2016**
Alexander Koller, 'Maria von Spanien, die katholische Kaiserin', in *Nur die Frau des Kaisers? Kaiserinnen in der Frühen Neuzeit*, ed. by Bettina Braun, Katrin Keller and Matthias Schnettger (Vienna, 2016), pp. 85–97.

**Konečný / Bukovinská / Muchka 1998**
*Rudolf II, Prague and the Word. Papers from the International Conference, 2–7 September 1997*, ed. by Lubomír Konečný, Beket Bukovinská and Ivan Muchka (Prague, 1998).

**Konečný 1989**
Lubomír Konečný, 'Charles Dorigny a obraz *Snímání s kříže* v kostele Všech svatých na Pražském hradě', *Umění* 37 (1989), pp. 163–166.

**Konečný 2014**
Lubomír Konečný, 'Considering *Rilievo, Hemisphaera* and *Paragone* in Rudolfine Art', *Studia Rudolphina* 14 (2014), pp. 114–118.

**König-Lein 2015**
Susanne König-Lein, '„mit vielen Seltenheiten gefüllet": Die Kunstkammer in Graz unter Erzherzog Karl II. von Innerösterreich und Maria von Bayern', *Das Haus Habsburg und die Welt der fürstlichen Kunstkammern*, ed. by Sabine Haag, Franz Kirchweger and Paulus Rainer (Vienna, 2015), pp. 195–227.

**Köpl 1889**
Karl Köpl, 'Urkunden, Acten, Regesten und Inventare aus dem k.k. Statthalterei-Archiv in Prag', *JKSAK* 10 (1889), pp. LXIII–CC.

**Köpl 1891**
Karl Köpl, 'Urkunden, Acten und Regesten aus dem k.k. Statthalterei-Archiv in Prag', *JKSAK* 12 (1891), pp. I–XC.

**Kořán 1960**
Ivo Kořán, 'Knihovna architekta Bonifáce Wolmuta', *Umění* 8 (1960), pp. 522–527.

**Korenjak / Schaffenrath / Subaric / Töchterle 2012**
*Tyrolis Latina. Geschichte der lateinischen Literatur in Tirol*, I: *Von den Anfängen bis zur Gründung der Universität Innsbruck*, ed. by Martin Korenjak, Florian Schaffenrath, Lav Subaric and Karlheinz Töchterle (Vienna, Cologne and Weimar, 2012).

**Kotrba 1969**
Viktor Kotrba, 'Die Bronzeskulptur des Hl. Georg auf der Burg zu Prag', *Anzeiger des Germanischen Nationalmuseums* (1969), pp. 9–28.

**Krahe 1996**
Friedrich Wilhelm Krahe, *Burgen des deutschen Mittelalters* (Augsburg, 1996).

**Krämer / Prockh 2009**
Helmut Krämer and Anton Prockh, *Die schönsten Tiroler Burgen & Schlösser* (Innsbruck, 2009).

**Kraye 1996**
Kristian Jensen, 'The Humanist Reform of Latin and Latin Teaching', in *The Cambridge Companion to Renaissance Humanism*, ed. by Jill Kraye (Cambridge, 1996).

**Krčálová 1994**
Jarmila Krčálová, 'Renesance', in *Katedrála sv. Víta v Praze: K 650. výročí založení*, ed. by Anežka Merhautová (Prague, 1994), pp. 133–170.

**Kreyczi 1887**
Franz Kreyczi, 'Urkunden und Regesten aus dem K. und K. Reichs-Finanz-Archiv', *JKSAK* 5 (1887), pp. XXV–CXIX.

**Krist / Wilk /Putzgruber / Renz-Zink 2015**
Gabriela Krist, Johanna Wilk, Eva Putzgruber and Roberta Renz-Zink, 'Konservierungswissenschaftliche Dissertationen an der Universität für angewandte Kunst Wien', *Zeitschrift für Kunsttechnologie und Konservierung* 2 (2015), pp. 305–328.

**Kubíková 2011**
Blanka Kubíková, 'Závěsné malířství v rezidencích posledních Rožmberků', in *Rožmberkové. Rod českých velmožů a jeho cesta dějinami*, ed. by Jaroslav Pánek (České Budějovice, 2011), pp. 482–489.

**Kubíková 2015**
Blanka Kubíková, 'Gemälde in den Residenzen der letzten Rosenberger', in *Die Rosenberger. Eine mitteleuropäische Magnatenfamilie*, ed. by Martin Gaži, Jaroslav Pánek and Pavel Pavelec (České Budějovice, 2015), pp. 436–455.

**Kubíková 2016**
Blanka Kubíková, *Portrét v renesančním malířství v českých zemích. Jeho ikonografie a funkce ve šlechtické reprezentaci* (Prague, 2016).

**Kubíková 2017**
Blanka Kubíková, 'The image of Archduke Ferdinand II in his portraits', in Exh. Cat. Innsbruck 2017, pp. 55–60.

**Kubíková 2019**
Blanka Kubíková, 'Charles of Žerotín, a Commander of Noble Moravian Descent, in the Heldenrüstkammer of Archduke Ferdinand II at Ambras Castle', *Studia Rudolphina* 19 (2019), pp. 8–17.

**Kuchařová 2015**

Hedvika Kuchařová, 'Classis theologica. Teologická literatura', in *Knihovna arcivévody Ferdinanda II. Tyrolského*, I: *Texty*, ed. by Ivo Purš and Hedvika Kuchařová (Prague, 2015), pp. 105–106.

**Kugler 2003**

Georg Kugler, 'Kunst und Geschichte im Leben Ferdinands I.', in Exh. Cat. Vienna 2003, pp. 200–213.

**Kühlmann / Telle 2004**

*Corpus Paracelsisticum. Studien und Dokumente zur deutschen Literatur und Kultur im europäischen Kontext*, II: *Der Frühparacelsismus*, ed. by Wilhelm Kühlmann and Joachim Telle (Tübingen, 2004), pp. 916–947.

**Kühne 2002**

Andreas Kühne, 'Augustin Hirschvogel und sein Beitrag zur praktischen Mathematik', in *Verfasser und Herausgeber mathematische Texte der frühen Neuzeit: Tagungsband zum wissenschaftlichen Kolloquium vom 19. – 21. April 2002 in Annaberg-Buchholz*, ed. by Rainer Gebhardt (Annaberg-Buchholz, 2002), pp. 237–251.

**Kühnel 1968**

Harry Kühnel, 'Beiträge zur Geschichte der Künstlerfamilie Spazio in Österreich', *Arte Lombarda* 13:2 (1968), pp. 85–102.

**Kunckel 1992**

Johannes Kunckel, *Ars vitraria experimentalis oder Vollkommene Glasmacherkunst*, 2nd printing of the Frankfurt-Leipzig 1689 edition (Hildesheim, Zürich and New York, 1992).

**Kupelwieser 1898**

Leopold Kupelwieser, *Die Kämpfe Österreichs mit den Osmanen 1526 bis 1537* (Vienna, 1898).

**Kurzel-Runtscheiner 1992**

Monika Kurzel-Runtscheiner, *Glanzvolles Elend. Die Inventare der Herzogin Jacobe von Jülich-Kleve-Berg (1558–1597) und die Bedeutung von Luxusgütern für die höfische Frau des 16. Jahrhunderts* (Vienna, 1993).

**Kuster 2011**

Thomas Kuster, 'Hallart Denis', in *Allgemeines Künstlerlexikon, Die Bildenden Künstler aller Zeiten und Völker*, 68 (Berlin and New York, 2011), p. 248.

**Kuster 2012**

Thomas Kuster, 'Eur Lieb gannz wiliger Brueder. Fürstliche freundschaft am politischen Parkett? Die Beziehung der Habsburger und der Wettiner in der frühen Neuzeit', in *Ambras & Dresden. Kunskammerschätze der Renaissance*, ed. by Sabine Haag, exh. cat. (Vienna, 2012), pp. 43–53.

**Kuster 2015**

Thomas Kuster, '"Zu der Pracht eines Herren gehören Pferde, Hunde [...], Vögel [...] und fremde Thiere"'. Die Tiergärten Erzherzog Ferdinands II. in Innsbruck, in *Echt tierisch! Die Menagerie des Fürsten*, ed. by Sabine Haag, exh. cat. (Vienna, 2015), pp. 49–54.

**Kuster 2017**

Thomas Kuster, 'dises heroische theatrum': The Heldenrüstkammer at Ambras Castle', in Exh. Cat. Innsbruck 2017, pp. 83–87.

**Kuster 2018**

Thomas Kuster, 'Die Plattnerei in Prag and in Innsbruck zur Zeit Erzherzog Ferdinands II. (1529–1595)', in *Turnier. 1000 Jahre Ritterspiele*, ed. by Matthias Pfaffenbichler and Stefan Krause (Vienna, 2018), pp. 217–221.

**Kuthan 2010**

Jiří Kuthan, *Královské dílo za Jiřího z Poděbrad a dynastie Jagellonců I: Král a šlechta* (Prague, 2010), pp. 57–103.

**Kuthan / Royt 2011**

Jiří Kuthan and Jan Royt, *Katedrála Sv. Víta, Václava a Vojtěcha, svatyně českých patronů a králů* (Prague, 2011).

**Kuthan / Šmied 2009**

*Korunovační řád českých králů*, ed. by Jiří Kuthan and Miroslav Šmied (Prague, 2009).

**Lacambra 2009–2010**

Pilar Bosqued Lacambra, 'Los paisajes de Carlos V: primer viaje a España', *Espacio, tiempo y forma, Serie VII. Historia del Arte*, 22–23 (2009–2010), pp. 103–140.

**Laferl 1997**

Christopher F. Laferl, *Die Kultur der Spanier in Österreich unter Ferdinand I. 1522–1564* (Vienna, Cologne and Weimar, 1997)

**Lambeck 1669**

Petrus Lambeck, *Commentariorum Augustissima Bibliotheca Caesarea Vindobonensi Libri VIII* (Vienna, 1669).

**Landau / Parshall 1994**

David Landau and Peter Parshall, *The Renaissance Print, 1470–1550* (New Haven and London, 1994).

**Lange 2011**

Heidrun M. Lange, Die Augsburger Prachtcodices in Eton und im Escorial, in *Bürgermacht & Bücherpracht: Katalogband zur Ausstellung im Maximilianmuseum Augsburg vom 18. Märtz bis 19. Juni 2011*, ed. by Christoph Emmendörfer and Helmut Zäh, exh. cat. (Augsburg, 2011).

**Lanz 1846**

Karl Lanz, *Correspondenz des Kaisers Karl V.*, III, *1550–1556* (Leipzig, 1846).

**Lautensack 1564**

Heinrich Lautensack, *Des Circkels vnnd Richtscheyts, auch der Perspectiua, vnd Porportion der Menschen vnd Rosse, kurtze, doch gründtliche vnderweisung, deß rechten gebrauchs* (Frankfurt am Main, 1564).

**Le Goff 1991**

Jacques Le Goff, *Kultura středověké Evropy* (Prague, 1991), pp. 143–145.

**Le littere 1544**
*Le littere de li honorati et superbi trionphi tra la Maesta Cesarea de l'Imperatore [et] el Christianissimo Re di Franza con el numero de li gran Signori Principi Duchi [et] Marchesi e Conti e Cauallieri...* (Venice, 1544).

**Leeb / Strohmeyer / Wagner 2007**
*Der Reichstag zu Regensburg 1567; und der Reichskreistag zu Erfurt 1567*, ed. by Josef Leeb, Arno Strohmeyer and Wolfgang Wagner (Munich, 2007).

**Leino 2013**
Marika Leino, *Fashion, Devotion and Contemplation. The Status and Function of Italian Renaissance Plaquettes* (Oxford and New York, 2013).

**Leithe-Jasper 1986**
Manfred Leithe-Jasper, *Renaissance Master Bronzes from the Collection of the Kunsthistorisches Museum Vienna* (Washington DC, 1986).

**Lembke / Müller 2004**
*Humanisten am Oberrhein. Neue Gelehrte im Dienst alter Herren*, ed. by Sven Lembke and Markus Müller (Leinfelden-Echterdingen, 2004).

**Leminger 1889**
Emanuel Leminger, 'Stavba hradu pražského za krále Vladislava II.', *Památky archaeologické a místopisné* 14 : 12 (1889), col. 626–630.

**Leminger 2009**
Otokar Leminger, *Práce o historii Kutné Hory* (Kutná Hora, 2009).

**Leydi 2003**
Silvio Leydi, 'Registre des documents en langue originale', in José-A. Godoy and Silvio Leydi, *Parures Triomphales. Le manierisme dans l'art de l'armure italienne*, exh. cat. (Milan, 2003), pp. 531–557.

**Lhotsky 1941–1945**
Alphons Lhotsky, *Festschrift des Kunsthistorischen Museums zur Feier des fünfzigjährigen Bestandes. Zweiter Teil: Die Geschichte der Sammlungen. Erste Hälfte: Von den Anfängen bis zum Tode Kaiser Karls VI. 1740* (Vienna, 1941–1945).

**Lhotsky 1971**
Alphons Lhotsky, *Das Zeitalter des Hauses Österreich. Die ersten Jahre der Regierung Ferdinands I. in Österreich (1520–1527)* (Vienna, 1971).

**Lhotsky 1974**
Alphons Lhotsky, 'Die Ambraser Sammlung: Umrisse der Geschichte einer Sammlung', in *Alphons Lhotsky Aufsätze und Vorträge* (Munich, 1974).

**Li gran trionphi**
A., V. M. V., *Li gran trionphi et fbste fatte alla corte de la Cesarea Maesta per la pace fatta tra sua Maesta [et] il Re Christianissimo. La solenne intrata in Burcelles de la Regina di Francia. Le giostre, [et] torniamenti fatti in carezzar detta regina, con le superbe liuree, e richi pregi donati ai vincitori di detti torniamenti* ([n. p.], [n. d.]).

**Líbal / Zahradník 1999**
Dobroslav Líbal and Pavel Zahradník, *Katedrála svatého Víta na Pražském Hradě* (Prague, 1999).

**Lietzmann 1996**
Hilda Lietzmann, Hans Reisingers Brunnen für den Garten der Herzogin in München, *Münchner Jahrbuch der bildenden Kunst*, series 3, 46 (1995 [1996]), pp. 117–142.

**Lippmann 2003**
Wolfgang Lippmann, 'Der Fürst als Architekt', *Georges-Bloch-Jahrbuch des Kunsthistorischen Institutes der Universität Zürich* 8 (2001) [2003], pp. 110–135.

**Löcher 1962**
Kurt Löcher, *Jakob Seisenegger. Hofmaler Kaiser Ferdinands I.* (Berlin, 1962).

**Löcher 1980**
Kurt Löcher, 'Die Malerei in Augsburg 1530–1550', in *Welt im Umbruch. Augsburg zwischen Renaissance und Barock*, II (Augsburg, 1980), pp. 29–30.

**Löcher 1999**
Kurt Löcher, *Barthel Beham: ein Maler aus dem Dürerkreis* (Munich, 1999).

**Löcher 2008**
*Kleinodienbuch der Herzogin Anna von Bayern*, 2 vols., ed. by Kurt Löcher (Berlin, 2008).

**Löcher 2012**
Kurt Löcher, 'Jakob Seisenegger. Hofmaler Kaiser Ferdinands I. – Neue Funde und Stand der Forschung', *Münchner Jahrbuch der bildenden Kunst* 58 (2012), pp. 103–146.

**Loffredo 2013**
Fernando Loffredo, 'Il monument Euffreducci in San Francesco a Fermo: Bartolomeo Bergamasco e Pietro Paolo Stella', *Arte Veneta* 70 (2013), pp. 69–81.

**Lombaerde 2014**
Piet Lombaerde, 'Le parc et les jardins', in *Le palais du Coudenberg à Bruxelles*, ed. by Laetitia Cnockaert, Vincent Heymans and Frédérique Honoré (Brussels, 2014), pp. 191–215.

**Luchner 1958**
Laurin Luchner, *Denkmal eines Renaissancefürsten: Versuch einer Rekonstruktion des Ambraser Museums von 1583* (Vienna, 1958).

**Luchner 1983**
Laurin Luchner, *Schlösser in Österreich*, II: *Residenzen und Landsitze in Oberösterreich, Steiermark, Kärnten, Salzburg, Tirol und Vorarlberg* (Munich, 1983).

**Lutz 1964**
Heinrich Lutz, *Christianitas afflicta. Europa, das Reich und die päpstliche Politik im Niedergang der Hegemonie Kaiser Karls V. (1522–1556)* (Göttingen, 1964).

**Lynch 2017**
Sarah Lynch, 'Architecture at the Prague Belvedere: Between Theory and Practice', in *Looking for Leisure. Court Residences and their Satellites 1400–1700*, ed. by Ivan P. Muchka and Sylva Dobalová, Palatium e-Publication, 4 (Prague, 2017), pp. 204–214.

**Mádl 1886**
Karel B. Mádl, 'Renaissance v Čechách', *Zprávy spolku architektů a inženýrů v Čechách* 20:2 (1886), pp. 52–56.

**Marchant 2014**
Eckard Marchant, 'Material Distinctions: Plaster, Terracotta, and Wax in the Renaissance Artist's Workshop', in *The Matter of Art: Materials, Practises, Cultural Logics, c. 1250–1750*, ed. by Christy Anderson et al. (Manchester, 2014), pp. 160–179.

**Markham-Schulz 1985**
Anne Markham-Schulz, 'Paolo Stella Milanese', *Mitteilungen des Kunsthistorischen Institutes in Florenz* 29:1 (1985), pp. 79–110.

**Markschies 2003**
Alexander Markschies, *Icons of Renaissance Architecture* (Munich, Berlin, London and New York, 2003).

**Martínek 1959**
Jan Martínek, Dvě díla M. Matouše Collina, *Listy filologické* 82:1 (1959), pp. 111–121.

**Martínek 1968**
Jan Martínek, 'K latinským popisům renesančních a barokních zahrad', *Zprávy Jednoty klasických filologů* 10 (1968), pp. 151–152.

**Martínek 2012**
Jan Martínek, *Jan Hodějovský a jeho literární okruh* (Prague, 2012).

**Martínková 2012**
Dana Martínková, *Literární druh veršovaných popisů měst v naší latinské humanistické literatuře* (Prague, 2012).

**Martz 2010**
Jochen Martz, 'Die Gärten an der Wiener Hofburg im 16. und 17. Jahrhundert und die Entwicklung der Zitruskultur', *Studia Rudolphina* 10 (2010), pp. 68–88.

**Mašek / Purš 2015**
Petr Mašek and Ivo Purš, 'Identifikace tisků z knihovny', in *Knihovna arcivévody Ferdinanda II. Tyrolského*, I: *Texty*, ed. by Ivo Purš and Hedvika Kuchařová (Prague, 2015), pp. 61–74.

**Matějček 1937**
Antonín Matějček, 'Podíl Čech na vzniku portrétu v 14. století', *Umění* 10 (1937), pp. 65–74.

**Mattioli 1559**
Pietro Andrea Mattioli, *Le solenni pompe, i superbi, et gloriosi apparati, i trionfi, i fuochi, et gli altri splendidi & dilettevoli spettacoli, fatti alla venuta dell'Invitissimo Imperadore Ferdinando primo [...]* (Prague, 1559).

**Mattioli 1586**
*Kreutterbuch Deß Hochgelehrten und weitberühmten Herrn D. Petri Andreae Matthioli [...] Durch Ioachimum Camerarium, der löblichen Reichsstatt Nürmberg Medicum. D.*, ed. by Joachim Camerarius (Frankfurt, 1586).

**Maur 1976**

Eduard Maur, 'Vznik a územní proměny majetkového komplexu českých panovníků ve středních Čechách v 16. a 17. století', *Středočeský sborník historický* 11 (1976), pp. 53–63.

**Mayr 1899**

Michael Mayr, 'Urkunden und Regesten: aus dem k.k. Statthalterei-Archiv in Innsbruck (1364–1490)', *JKSAK* 20 (1899), pp. CXXIV–CLXXXIX.

**Mayr 1901**

*Das Jagdbuch Kaiser Maximilians I.*, ed. by Michael Mayr (Innsbruck, 1901).

**Mencl 1978**

Václav Mencl, 'Architektura', in Jaromír Homolka et al., *Pozdně gotické umění (1471–1526)* (Prague, 1978), pp. 80–87 and 94–129.

**Merian 1649**

Matthäus Merian, *Topographia Provinciarum Austriacarum [...]* (Frankfurt am Main, 1649).

**Meyer / Trueblood / Heller 1991**

Frederick G. Meyer, Emily Emmart Trueblood and John L. Heller, *The Great Herbal of Leonhart Fuchs. De historia stirpium commentarii insignes, 1542*, 2 vols. (Stanford, CA 1991).

**Meyer 1897**

*Meyers Konversations Lexicon*, 5th Edition (Leipzig and Vienna, 1897).

**Minor 1889**

*Speculum vitae humanae – Ein Drama von Erzherzog Ferdinand von Tirol, 1584. Nebst einer Einleitung in das Drama des 16. Jahrhunderts*, ed. by Jacob Minor (Halle an der Saale, 1889).

**Mitchell 2003**

Bonner Mitchell, 'Notes for a History of the Printed Festival Book in Renaissance Italy', *Daphnis* 32 (2003), pp. 41–56.

**Modern 1899**

Heinrich Modern, 'Die Zimmern'schen Handschriften der k.k. Hofbibliothek', *JKSAK* 20 (1899), pp. 113–180.

**Monardes 1565**

Nicolas Monardes, *Historia medicinal de las cosas que se traen de nuestras Indias Occidentales* (Sevilla, 1565).

**Morávek 1937**

Jan Morávek, 'Nově objevený inventář rudolfínských sbírek na Pražském hradě', *Památky archeologické a místopisné*, 2–3 (1932–1935 [Separat 1937]).

**Morávek 1938**

Jan Morávek, 'Z počátků královské zahrady v Praze', *Umění* 11 (1938), pp. 530–536.

**Moser / Tursky 1977**

Heinz Moser and Heinz Tursky, *Die Münzstätte Hall in Tirol, 1477–1665* (Innsbruck, 1977).

**Muchka 2003**
Ivan P. Muchka, 'Die Bautätigkeit Kaiser Ferdinand I. in Prag', in *Kaiser Ferdinand I. 1503–1564. Das Werden der Habsburgermonarchie*, ed. by Wilfried Seipel, exh. cat. (Vienna, 2003), pp. 249–257.

**Muchka 2014**
Ivan P. Muchka, 'Architectura Ancilla musicae', in *The Habsburgs and Their Courts in Europe, 1400–1700: Between Cosmopolitism and Regionalism*, ed. by Herbert Karner, Ingrid Ciulisová and Bernardo J. García García, Palatium e-Publication 3 (2014), pp. 46–54.

**Muchka 2015**
Ivan P. Muchka, 'Literatura o architektuře', in *Knihovna arcivévody Ferdinanda II. Tyrolského*, I: *Texty*, ed. by Ivo Purš and Hedvika Kuchařová (Prague, 2015), pp. 279–285.

**Muchka / Purš / Dobalová / Hausenblasová 2014**
Ivan P. Muchka, Ivo Purš, Sylva Dobalová and Jaroslava Hausenblasová, *Hvězda. Arcivévoda Ferdinand Tyrolský a jeho letohrádek v evropském kontextu* (Prague, 2014).

**Muchka / Purš / Dobalová / Hausenblasová 2017**
Ivan P. Muchka, Ivo Purš, Sylva Dobalová and Jaroslava Hausenblasová, *The Star. Archduke Ferdinand II of Austria and His Summer Palace in Prague* (Prague, 2017).

**Muchka / Purš 2012**
Ivan P. Muchka and Ivo Purš, 'Das Lustschloss Stern in Prag und die Villa Lante in Rom', *Studia Rudolphina* 11 (2012), pp. 127–132.

**Mudra 1957**
Miroslav Mudra, 'Pražská zbrojnice v druhé polovici 16. a na počátku 17. století', *Historie a vojenství* 2 (1957), pp. 251–258.

**Müller 1895**
*Die Gefangenschaft des Johann Augusta, Bischofs der böhmischen Brüder 1548 bis 1564 und seines Diakonen Jakob Bilek von Bilek selbst beschrieben*, ed. by Joseph Theodor Müller (Leipzig, 1895).

**Müller 2009**
*Von Dürer bis Gober. 101 Meisterzeichnungen aus dem Kupferstichkabinett des Kunstmuseums Basel*, ed. by Christian Müller (Basel, 2009).

**Mulryne / Aliverti / Testaverde 2015**
*Ceremonial Entries in Early Modern Europe: The Iconography of Power*, ed. by J. R. Mulryne, Maria Ines Aliverti and Anna Maria Testaverde (Farnham, 2015).

**Muñoz / Vermeir / Raeymaekers 2014**
*A Constellation of Courts: The Courts and Households of Habsburg Europe 1555–1665*, ed. by José Eloy Hortal Muñoz, René Vermeir and Dries Raeymaekers (Leuven, 2014).

**Mürner 2007**
Christina Mürner, 'Wie nannte man behinderte Menschen im 16. Jahrhundert? Dokumentation am Beispiel einer von Erzherzog Ferdinand II, von Tirol verfassten Komödie', in *Das Bildnis eines behinderten Mannes. Bildkultur der Behinderung vom 16. bis ins 21. Jahrhundert*, ed. by Petra Flieger and Volker Schönwise (Neu-Ulm, 2007), pp. 168–170.

**Naredi-Rainer / Madersbacher 2007**
*Kunst in Tirol*, I: *Von der Anfangen bis zum Renaissance*, ed. by Paul Naredi-Rainer and Lukas Madersbacher (Innsbruck, 2007).

**Naso (Breitenbach) 2011**
*Publius Ovidius Naso, Metamorphosen, Epos in 15 Büchern*, ed. by Herman Breitenbach (Stuttgart, 2011).

**Nespěšná Hamsíková 2016**
Magdaléna Nespěšná Hamsíková, *Lucas Cranach a malířství v českých zemích (1500–1550)* (Prague, 2016).

**Neugebauer 1947**
Hugo Neugebauer, 'Alchymisten in Tirol', in *Volkskundliches aus Österreich und Südtirol: Hermann Wopfher zum 70. Geburtstag dargebracht*, ed. by A. Dörrer and L. Schmidt (Vienna 1947), pp. 181–203.

**Neuhaus 1982**
Helmut Neuhaus, *Reichsständische Repräsentationsformen im 16. Jahrhundert. Reichstag-Reichskreistag-Reichsdeputationstag* (Berlin, 1982).

**Neuwirth 1896**
Josef Neuwirth, *Mittelalterliche Wandgemälde und Tafelbilder der Burg Karlstein in Böhmen* (Prague, 1896).

**Neuwirth 2015/2016**
Markus Neuwirth, 'Lissabon Rekonsturiert. Architektur und Kunstkammerstücke des ersterns Wetlhandels', *Mitteilungen der Carl Justi-Vereinigung* 27–28, (2015/2016), pp. 133–154.

**Niedermann 2008**
Christoph Niedermann, 'Marie de Hongrie et la chasse', in *Marie de Hongrie. Politique et culture sous la Renaissance aux Pays-Bas. Actes du colloque tenu au Musée royal de Mariemont les 11 et 12 novembre 2005*, ed. by Bertrand Federinov and Gilles Docquier (Morlanwelz, 2008), pp. 115–123.

**Niemöller 1969**
Klaus Wolfgang Niemöller, *Untersuchungen zu Musikpflege und Musikuterricht an den deutschen Lateinschulen vom ausgehenden Mittelalter bis um 1600*, Kölner Beiträge zur Musikforschung 54 (Regensburg, 1969).

**Noflatscher 2017**
Heinz Noflatscher, 'Archduke Ferdinand II as Sovereign Ruler of Tyrol', in Exh. Cat. Innsbruck 2017, pp. 31–37.

**Noris 2011**
John A. Noris, Mining and Metalogenesis in Bohemia during the Sixteenth Century, in *Alchemy and Rudolf II: Exploring the Secrets of Nature in Central Europe in the 16th and 17th Centuries*, ed. by Ivo Purš and Vladimír Karpenko (Prague, 2011), pp. 657–670.

**Nováková 1966**
Julie Nováková, Rytmické kalendárium Jiřího Handsche, *Listy filologické* 89 (1966), pp. 315–320.

**Novus thesaurus 1568**
*Novus thesaurus musicus*, 5 vols. (Venice, 1568).

**Odložilík 1936**
Otakar Odložilík, *Karel starší ze Žerotína* (Prague, 1936).

**Oettinger / Oettinger 1986**
Ricarda Oettinger and Karl Oettinger, 'Hofburg', in *Die Kunstdenkmäler der Stadt Innsbruck, Die Hofbauten*, ed. by Johanna Felmayer, Österreichische Kunsttopographie 47 (Vienna, 1986), pp. 55–197.

**Opll 2015**
Ferdinand Opll, 'Vienna from the 15th to the Middle of the 16th Century: Topography and Townscape', *A World of Innovation: Cartography in the Time of Gerhard Mercator*, ed. by in Gerhard Holzer, Valerie Newby and Petra Svatek (Newcastle upon Tyne, 2015), pp. 27–39.

**Ottův slovník 1888–1909**
*Ottův slovník naučný*, 28 vols. (Prague, 1888–1909).

**Pacala 2019**
Frederik Pacala, 'Georgius Handschius and Music: Notes on the Role of Music in the Life of the Humanist Scholar', *Hudební věda* 2 (2019), pp. 293–317.

**Pagel 1982**
Walter Pagel, *Paracelsus: an introduction to philosophical medicine in the era of the Renaissance* (Basel, Munich, Paris, London, New York, Tokyo and Sydney, 1982).

**Pálffy 2009**
Géza Pálffy, *The Kingdom of Hungary and the Habsburg Monarchy in the Sixteenth Century* (Boulder and Wayne, 2009).

**Palme 1986**
Rudolf Palme, 'Frühe Neuzeit. 1490–1665', in *Geschichte des Landes Tirol*, II, *Die Zeit von 1490 bis 1848*, ed. by Josef Fontana et al. (Bozen, Innsbruck and Vienna, 1986), pp. 120–125.

**Panáček 2013**
Jaroslav Panáček, 'Testament Georga Handsche z roku 1578', *Bezděz: vlastivědný sborník Českolipska* 22 (2013), pp. 367–384.

**Panagl 2004**
Victoria Panagl, *Lateinische Huldigungsmotetten für Angehörige des Hauses Habsburg. Vertonte Gelegenheitsdichtung im Rahmen neulateinischer Herrscherpanegyrik*, Europäische Hochschulschriften, 15, Klassische Sprachen und Literaturen, 92 (Frankfurt am Main, 2004).

**Pánek 1982**
Jaroslav Pánek, *Stavovská opozice a její zápas s Habsburky 1547–1577 (K politické krizi feudální třídy v předbělohorském českém státě)* (Prague, 1982).

**Pánek 1985**
Václav Březan, *Životy posledních Rožmberků*, I, ed. by Jaroslav Pánek (Prague, 1985).

**Pánek 1993**

Jaroslav Pánek, 'Der Adel im Turnierbuch Erzherzog Ferdinands II. von Tirol (Ein Beitrag zur Geschichte des Hoflebens und der Hofkultur in der Zeit seiner Statthalterschaft in Böhmen)', *Folia Historica Bohemica* 16 (1993), pp. 77–96.

**Pánek 2000**

Jaroslav Pánek, 'Königswahl oder Königsaufnahme? Thronwechsel im Königreich Böhmen an der Schwelle zur Neuzeit', in *Der frühmoderne Staat in Ostzentraleuropa*, 2, ed. by Wolfgang E. J. Weber, Documenta Augustana 3 (Augsburg, 2000), pp. 37–52.

**Pánek 2009**

Jaroslav Pánek et al., *A History of the Czech Lands* (Prague, 2009).

**Panofsky 1980**

Erwin Panofsky, *Studien zur Ikonologie. Humanistische Themen in der Kunst der Renaissance* (Cologne, 1980).

**Paprocký 1602**

Bartoloměj Paprocký z Hlohol a Paprocké Vůle, *Diadochos id est successio jinák posloupnost knížat a králův českých, biskupův i arcibiskupův pražských a všech třech stavův slavného království českého, to jest panského rytířského a městského krátce sebraná a vydaná*, 4 vols. (Prague 1602).

**Paredes / Demeter 2013**

Cécilia Paredes and Stéphane Demeter, 'Quand la marche raconte la ville. Quelques itinéraires de la cour à Bruxelles (XVIe-XVIIe siècles)', *Clara* 1 (2013), pp. 81–101.

**Parshall 1982**

Peter W. Parshall, 'The print collection of Ferdinand, Archduke of Tyrol', *JKSW* 78 (1982), pp. 139–190.

**Parshall 2018**

Peter W. Parshall, 'Art and Theatre of Knowledge: The Origins of Print Collecting in Northern Europe', in *Print Collecting in Sixteenth and Eighteenth Century Europe*, Harvard University Art Museum Bulletin 2:3 (Cambridge, 1994/95), pp. 7–36.

**Patrouch 2010**

Joseph F. Patrouch, *Queen's Apprentice: Archduchess Elizabeth, Empress María, the Habsburgs, and the Holy Roman Empire, 1554–1569* (Leiden, 2010).

**Patrouch 2013**

Joseph F. Patrouch, '"Bella gerant alii." Laodamia's Sisters/Habsburg Brides: Leaving Home for the Sake of the House,' in *Early Modern Habsburg Women: Transnational Contexts, Cultural Conflicts, Dynastic Continuities*, ed. by Anne J. Cruz and Maria Galli Stampino (Farnham, 2013), pp. 25–38.

**Pavoni 1985**

Rosanna Pavoni, 'Paolo Giovio, et son musée de portraits: à propos d'une exposition', *Gazette des Beaux-Arts* 105 (1985), pp. 109–116.

**Payne 2014**
Alina Payne, 'The Sculpture-Architect Drawing and Exchanges between the arts', in *Donatello, Michelangelo, Cellini. Sculptor's Drawings from Renaisance Italy*, ed. By Michael Cole, exh. cat. (Boston, 2014), pp. 56–73.

**Pechstein 1969**
Klaus Pechstein, *Nürnberger Brunnenfiguren der Renaissance* (Nuremberg, 1969).

**Pechstein 1974**
Klaus Pechstein, 'Zu den Altarskulpturen und Kunstkammernstücken von Hans Peisser', *Anzeiger des Germanischen Nationalmuseums* (1974), pp. 38–47.

**Pejčochová 2019**
Michaela Pejčochová, '*Ain Indianisch tuech, darauf Indianische heuser gemalt*. Revisiting the Chinese Paintings in the Kunstkammer of Archduke Ferdinand II at Ambras Castle', *Studia Rudolphina* 19 (2019), pp. 34–49.

**Peltzer 1925**
Rudolf Arthur Peltzer, 'Tizian in Augsburg', *Das Schwäbische Museum* 1 (1925), pp. 31–45.

**Perényi / Hirschvogel / Nagy 2017**
*Concordantz des Alten und Neuen Testaments durch Pereny Petri und Augustin Hirschfogel gedruckt zu Wienn in Österreych durch Egidium Adler. 1550. = Egybersengés az ó- és újtestamentumban Perényi Péter és Augustin Hirschvogel szerzette Egidius Adler nyomtatta az ausztriai Bécsben 1550*, ed. and transl. by Péter Perényi, Augustin Hirschvogel and Imre Nagy (Páty, 2017).

**Pérez de Tudela / Jordan Gschwend 2001**
Almudena Pérez de Tudela and Annemarie Jordan Gschwend, 'Luxury goods for royal collectors: exotica, princely gifts and rare animals exchanged between the Iberian courts and Central Europe in the Renaissance (1560–1612)', *JKSW* 3 (2001), pp. 1–128.

**Pešák 1929**
Václav Pešák, 'Hospodářství a správa komorních panství v Čechách za Maxmiliána II.', *Časopis pro dějiny venkova* 16 (1929), pp. 50–58.

**Pešák 1930**
Václav Pešák, *Dějiny Královské české komory od roku 1527. Část I.: Začátky organizace české komory za Ferdinanda I.* (Prague, 1930).

**Petr / Richterová 2015**
Stanislav Petr and Alena Richterová, 'Rukopisy v knihovně a v kunstkomoře', in *Knihovna arcivévody Ferdinanda II. Tyrolského*, I: *Texty*, ed. by Ivo Purš and Hedvika Kuchařová (Prague, 2015), pp. 75–104.

**Petrarca**
Francesco Petrarca, *De Remediis utrisque formae*.

**Petrasová / Švácha 2017**
*Art in the Czech Lands 800–2000*, ed. by Taťjána Petrasová and Rostislav Švácha (Řevnice and Prague, 2017).

**Pfaff 1822–1823**

*Tetrabiblos*, 2 vols., ed. and transl. by J. W. von Pfaff, *Astrologisches Taschenbuch für das Jahr 1822* (Erlangen, 1822–1823).

**Pfaffenbichler 2016**

Matthias Pfaffenbichler, 'Das Turnierfest zwischen Reiterkampf und Oper', in *Feste Feiern*, ed. Sabine Haag and Gudrun Swoboda, exh. cat. (Vienna, 2016).

**Pfaffenbichler 2018**

Matthias Pfaffenbichler, 'Die Turniere an den Höfen der österreichischen Habsburger im 16. Jahrhundert', in *Turnier. 1000 Jahre Ritterspiele*, ed. by Matthias Pfaffenbichler and Stefan Krause (Vienna, 2018), pp. 155–169.

**Pfisterer 2003**

Ulrich Pfisterer (ed.), *Metzler Lexikon Kunstwissenschaft. Ideen, Methoden, Begriffe* (Ulm, 2003).

**Pfisterer / Wimböck 2011**

Ulrich Pfisterer and Gabriele Wimböck, *Novità: Neuheitskonzepte in den Bildkünsten um 1600* (Zürich, 2011).

**Pflauder 1999**

Eva Pflauder, 'Genealogische Untersuchungen zur Hohenemsischen Portraitgalerie im Zeitraum von 1530–1590', *Innsbrucker Historische Studien* 20/21 (1999).

**Pinto 1976**

John A. Pinto, 'Origins and Development of the Ichnographic City Plan', *Journal of the Society of Architectural Historians* 35:1 (1976), pp. 35–50.

**Pirrotta / Povoledo 1982**

Nino Pirrotta and Elena Povoledo, *Music and Theatre from Poliziano to Monteverdi* (Cambridge, 1982).

**Pistoi 1976**

Mila Pistoi, 'Francesco Terzi', in *I pittori bergamaschi dal XIII al XIX secolo*, III/2, *Il Cinquecento*, ed. by Pietro Zampetti and Gian Alberto Dell'Acqua (Bergamo, 1976), pp. 593–609.

**Podlaha 1919**

Antonín Podlaha, 'Rukopisy z majetku Bonifáce Wolmuta v knihovně metropolitní kapituly pražské', *Památky archaeologické* 31 (1919), pp. 97–98.

**Polívka 1986**

Miloslav Polívka, 'Vývoj zbrojních řemesel v Praze na konci 14. a v první polovině 15. století', *Documenta Pragensia* 6:1 (1986), pp. 47–74.

**Pollak 1910–1911**

Oscar Pollak, 'Studien zur Geschichte der Architektur Prags 1520–1600', *JKSAK* 29 (1910–1911), pp. 85–170.

**Polleross 1986**

Friedrich B. Polleross, 'Zur Repräsentation der Habsburger in der bildenden Kunst', in *Welt der Barock*, ed. by Ruprecht Feuchtmüller and Elisabeth Kovács, exh. cat. (Vienna, Freiburg and Basel, 1986), pp. 87–104.

**Polleross 2000**

Friedrich B. Polleross, 'Kaiser, König, Landesfürst: Habsburgische „Dreifaltigkeit" im Porträt', in *Bildnis, Fürst und Territorium*, ed. by Andreas Beyer, Ulrich Schütte and Lutz Unbehaun (Munich and Berlin, 2000), pp. 189–218.

**Polleross 2006**

Friedrich Polleross, 'Romanitas in der habsburgischen Repräsentation von Karl V. bis Maximilian II.', in *Kaiserhof – Papsthof 16.–18. Jahrhundert*, ed. by Rochard Bösel, Grete Klingenstein and Alexander Koller, Publikationen des Historischen Instituts beim Österreichischen Kulturfor in Rom (Vienna, 2006), pp. 207–223.

**Possevino 1594**

Antonio Possevino, *Vita et morte della serenissima Eleonora, arciduchessa di Austria et duchessa di Mantoua* (Mantua, 1594).

**Potter 2011**

David Linley Potter, *Henry VIII and Francis I: The Final Conflict* (Leiden and Boston, 2011).

**Preiss 1957**

Pavel Preiss, 'Cykly českých panovníků na státních zámcích. Příspěvek k ikonografii českých knížat a králů', *Zprávy památkové péče* 17 (1957), pp. 65–78.

**Preiss 1986**

Pavel Preiss, *Italští umělci v Praze: renesance, manýrismus, baroko* (Prague, 1986).

**Price Zimmermann 1995**

T. C. Price Zimmermann, *Paolo Giovio: the historian and the crisis of sixteenth-century Italy* (Princeton, 1995).

**Priesner / Figala 1998**

*Alchemie. Lexikon einer hermetischen Wissenschaft*, ed. by Claus Priesner and Karin Figala (Munich, 1998).

**Primisser 1788**

Johann Baptist Primisser, *Vollständiges Verzeichnis Aller in dem k.k. Schloß Ambras vorfindigen Waffen, Rüstungen, Naturalien, Alterthümer, Kunstwerke, Kostbarkeiten, Seltenheiten, und Gerätschaften, wie sie sich im Jahre 1788 daselbst befanden. II. Theil. Die Schatzkammer* (Innsbruck, 1788).

**Primisser 1819**

Alois Primisser, *Die kaiserlich-königliche Ambraser-Sammlung* (Vienna, 1819).

**Purš 2007**

Ivo Purš, 'Das Interesse Erzherzog Ferdinands II. an Alchemie und Bergbau und seine Widerspiegelung im Inhalt der erzherzoglichen Bibliothek', *Studia Rudolphina* 7 (2007), pp. 75–109.

**Purš 2009**

Ivo Purš, 'The Intellectual World of Rudolf II and the Kabbalah', in *Path of Live. Rabbi Judah Loew Ben Bezalel, ca 1525–1609*, ed. by Alexandr Putík (Prague, 2009), pp. 204–206.

**Purš 2016**

Ivo Purš, 'The Habsburgs on the Bohemian Throne and Their Interest in Alchemy and the Occult Sciences', in *Alchemy and Rudolf II. Exploring the Secrets of Nature in Central Europe in the 16th and 17th centuries*, ed. by Ivo Purš and Vladimír Karpenko (Prague, 2016), pp. 106–128.

**Purš 2017**

Ivo Purš, 'The Library of Archduke Ferdinand at Ambras Castle', in Exh. Cat. Innsbruck 2017, pp. 99–103.

**Purš / Kuchařová 2015**

*Knihovna arcivévody Ferdinanda II. Tyrolského*, 2 vols., ed. by Ivo Purš and Hedvika Kuchařová (Prague, 2015).

**Putzgruber 2010**

Eva Putzgruber, 'Glasschmuck des 16. Jahrhunderts. Die Glasschmucksammlung Erzherzog Ferdinands II. in der Kunstkammer des Kunsthistorischen Museums Vienna', in *Konservierungswissenschaften und Restaurierung heute. Von Objekten, Gemälden, Textilien und Steinen*, ed. by Gabriela Krist and Martina Griesser-Stermscheg, Konservierungswissenschaft – Restaurierung – Technologie, 7 (Vienna, Cologne and Weimar 2010), pp. 333–343.

**Putzgruber 2012**

Eva Putzgruber et al., 'Scientific investigation and study of the sixteenth-century glass jewellery collection of Archduke Ferdinand II at the at the Kunsthistorisches Museum, Vienna', in *The decorative: conservation and the applied arts*, ed. by Sharon Cather et al. (London, 2012), pp. 217–226.

**Putzgruber 2016**

Eva Putzgruber, '*Die vor der Lampe gearbeitete Glassammlung Erzherzog Ferdinands II. von Tirol. Untersuchungen zur Geschichte der Sammlung und zur Entwicklung der Lampenarbeit im 16. Jahrhundert*' (unpublished doctoral thesis, Institut für Restaurierung and Conservierung, Vienna 2016).

**Rainer 2017**

Paulus Rainer, 'On Art and Wonders in an Extra-Moral Sense', in Exh. Cat. Innsbruck 2017, pp. 88–97.

**Rankin 2013**

Alisha Rankin, *Panaceia's Daughters: Noblewomen as Healers in Early Modern Germany* (Chicago, 2013).

**Rauch 2004**

Margot Rauch, 'Trophäen und Mirabilien', in *Herrlich Wild. Höfische Jagd in Tirol*, ed. by Wilfried Seipel, exh. cat. (Vienna, 2004), pp. 49–51.

**Rauch 2005**
Margot Rauch, 'Bankett, Tanz und Feuerwerk', in *Wir sind Helden: habsburgische Feste in der Renaissance*, ed. by Alfred Auer, Margot Rauch and Wilfried Seipel, exh. cat. (Vienna, 2005), pp. 135–138.

**Rave 1961**
Paul Ortwin Rave, 'Das Museo Giovio zu Como', *Miscellanea Bibliothecae Hertzianae* 16 (1961), pp. 275–284.

**Reisacher 1573**
Bartholomeus Reisacher, *De mirabili Novae ac splendidis Stellae, Mense Novembri anni 1572, primum conspectae* (Vienna, 1573).

**Říčan 1975**
Rudolf Říčan, *Dějiny Jednoty bratrské* (Prague, 1957).

**Riedmann 1982**
Josef Riedmann, *Geschichte Tirols* (Vienna, 1982).

**Riffle 2007**
Robert Lee Riffle et al., *An Encyclopedia of Cultivated Palms* (Portland, 2007).

**Rinne 2010**
Katherine W. Rinne, 'Water, Currency of Cardinals in Late Renaissance Rome', in *La Civilta` delle Acque tra Medioevo e Rinascimento*, ed. by Arturo Calzona and Daniela Lamberini (Florence, 2010), pp. 367–87.

**Roobaert 2004**
Edmond Roobaert, 'De ontvangst van koningin Eleonora', *Archives et bibliothèques de Belgique (Kunst en kunstambachten in de 16de eeuw te Brussel)* 74 (2004), pp. 125–232.

**Rosenauer 2003**
*Geschichte der Bildenden Kunst in Österreich*, III: *Spätmittelalter und Renaissance*, ed. by Arthur Rosenauer (Vienna, 2003).

**Rosenthal / Jones 2008**
Margaret Rosenthal and Ann Rosalind Jones, *Cesare Vecellio's habiti antichi et moderni, The clothing of the Renaissance world, Europe, Asia, Africa, The Americas* (London, 2008).

**Roth 1959**
Cecil Roth, *The Jews in the Renaissance* (New York, 1959).

**Roth 2000**
Harriet Roth, *Der Anfang der Museumslehre in Deutschland. Das Traktat „Inscriptiones vel Tituli Theatri Amplissimi" von Samuel Quiccheberg*; Latin-German edition (Berlin, 2000).

**Roubík 1937**
František Roubík, *Regesta fondu militare archivu ministerstva vnitra RČS. v Praze*, I (Prague, 1937).

**Rousseau 1990**
Claudia Rousseau, 'The pageant of the muses at the Medici wedding of 1539 and the decoration of the Salone dei Cinquecento', in *"All the world's a stage…": art and pageantry in the Renais-*

*sance and Baroque. Theatrical spectacle and spectacular theatre*, ed. by Barbara Wisch and Susan Scott Munshower, Papers in art history from the Pennsylvania State University, 6:2 (University Park, PA, 1990), pp. 416–457.

**Rovelli 1928**
Luigi Rovelli, *L'opera storica ed artistica di Paolo Giovio, comasco, Vescovo di Nocera: [Paulus Jovius.] Il museo dei ritratti* (Como, 1928).

**Ruiz Gómez 2004**
Leticia Ruiz Gómez, 'Retratos de corte en la monarquía española (1530–1660)', in *El retrato español: del Greco a Picasso*, ed. by Javier Portús Pérez and José Alvarez Lopera (Madrid, 2004), pp. 92–119.

**Rumpolt 1581**
Marx Rumpolt, *Ein New Kochbuch* (Frankfurt am Main, 1581).

**Sachs 1965**
Curt Sachs, *World History of the Dance* (New York, 1965).

**Sacken 1855**
Eduard von Sacken, *Die Ambraser-Sammlung* (Vienna, 1855).

**Sacken 1859–1862**
*Vorzüglichsten Rüstungen und Waffen der k.k. Ambraser-Sammlung in original-photographien*, ed. by Eduard von Sacken (Vienna, 1859–1862).

**Sánchez 1998**
Magdalena S. Sánchez, *The Empress, the Queen, and the Nun. Women and Power at the Court of Philip III of Spain* (Baltimore, 1998).

**Sandbichler 2000**
Veronika Sandbichler, 'In nuptias Ferdinandi. Der Hochzeitskodex Erzherzog Ferdinands II.', in *Slavnosti a zábavy na dvorech a v rezidenčních městech raného novověku*, ed. by Pavel Král and Václav Bůžek (České Budějovice, 2000), pp. 281–292.

**Sandbichler 2004/2005**
Veronika Sandbichler, 'Der Hochzeitskodex Erzherzog Ferdinands II.', *Jahrbuch des Kunsthistorischen Museums Wien* 6/7 (2004/2005), pp. 47–90.

**Sandbichler 2005**
Veronika Sandbichler, 'Festkultur am Hof Erzherzog Ferdinands II.', in *Der Innsbrucker Hof. Residenz und höfische Gesellschaft in Tirol vom 15. bis 19. Jahrhundert*, ed. by Heinz Noflatscher and Jan Paul Niederkorn, Archiv für österreichische Geschichte, 138 (Vienna, 2005), pp. 159–174.

**Sandbichler 2009**
Veronika Sandbichler, 'Er hatte es zum Vergnügen Seiner Majestät veranstaltet': höfische Feste und Turniere Erzherzog Ferdinands II. in Böhmen', *Studia Rudolphina* 9 (2009), pp. 7–21.

**Sandbichler 2012**
Veronika Sandbichler, '„AMBRAS […] worinnen eine wunderwürdig, ohnschäzbare Rüst=Kunst und Raritaeten Kammer anzutreffen". Erzherzog Ferdinand II. und die Sammlun-

gen auf Schloss Ambras', in *Dresden & Ambras, Kunstkammerschätze der Renaissance*, ed. by Sabine Haag, exh. cat. (Vienna, 2012), pp. 31–41.

**Sandbichler 2015a**
Veronika Sandbichler, '"souil schönen, kostlichen und verwunderlichen zeügs, das ainer vil monat zu schaffen hette, alles recht zu besichtigen vnd zu contemplieren": die Kunst- und Wunderkammer Erzherzog Ferdinands II. auf Schloss Ambras', in *Das Haus Habsburg und die Welt der fürstlichen Kunstkammern im 16. und 17. Jahrhundert*, ed by Sabine Haag, Franz Kirchweger and Paulus Rainer, Schriften des Kunsthistorischen Museums 15 (Vienna, 2015), pp. 167–193.

**Sandbichler 2015b**
Veronika Sandbichler, 'Elements of Power in Court Festivals of Habsburg Emperors', in *Ceremonial Entries in Early Modern Europe: The Iconography of Power*, ed. by J. R. Mulryne, Maria Ines Aliverti and Anna Maria Testaverde (Farnham, 2015), pp. 167–187.

**Sandbichler 2015c**
Veronika Sandbichler, 'The 'natural copy and form'. The eye of the animal painter', in *Echt tierisch! Die Menagerie des Fürsten*, ed. by Sabine Haag, exh. cat. (Vienna, 2015), pp. 69–75.

**Sandbichler 2017**
Veronika Sandbichler, '"Innata Omnium Pulcherrimarum Rerum Inquisitio": Archduke Ferdinand II as a Collector', in Exh. Cat. Innsbruck 2017, pp. 77–81.

**Sandbichler 2018**
Veronika Sandbichler, '"Ain [...] puech darinnen ir fürstlich durchlaucht allerlei turnier" – die Turnierbücher Erzherzog Ferdinands II., in *Turnier. 1000 Jahre Ritterspiele*, ed. by Matthias Pfaffenbichler and Stefan Krause (Vienna, 2018), pp. 203–215.

**Sandbichler / Richterová 2015**
Veronika Sandbichler and Alena Richterová, 'Literatura k festivitám', in *Knihovna arcivévody Ferdinanda II. Tyrolského*, I: *Texty*, ed. by Ivo Purš and Hedvika Kuchařová (Prague, 2015), pp. 361–374.

**Sanger 2014**
Alice E. Sanger, *Art, Gender and Religious Devotion in Grand Ducal Tuscany* (Farnham, 2014).

**Sauerländer 2008**
*Die Münchner Kunstkammer*, III: *Aufsätze und Anhänge*, ed. by Willibald Sauerländer (Munich, 2008).

**Schattkowsky 2003**
*Witwenschaft in der frühen Neuzeit*, ed. by Martina Schattkowsky (Leipzig, 2003).

**Scheicher 1975**
Elisabeth Scheicher, 'Der Spanische Saal von Schloss Ambras', *JKSW* 71 (1975), pp. 39–94.

**Scheicher 1979**
Elisabeth Scheicher, *Die Kunst- und Wunderkammern der Habsburger* (Vienna, Munich and Zürich 1979).

**Scheicher 1981**

Elisabeth Scheicher, 'Ein Fest am Hofe Erzherzog Ferdinands II', *JKSW* 77 (1981), pp. 119–154.

**Scheicher 1983**

Elisabeth Scheicher, 'Die „Imagines gentis Austriacae" des Francesco Terzio', *JKSW* 79 (1983), pp. 43–92.

**Scheicher 1985a**

Elisabeth Scheicher, 'Die Kunstkammer in Schloß Ambras', in *Europa und die Kaiser von China. Berliner Festspiele 1240–1816*, exh. cat. (Frankfurt am Main, 1985), pp. 58–61.

**Scheicher 1985b**

Elisabeth Scheicher, 'The Collection of Archduke Ferdinand II at Ambras: its purpose, composition and evolution', in *Origins of museum: The cabinet of curiosities in sixteenth- and seventeenth-century Europe*, ed. by O. R. Impey and Arthur MacGregor (Oxford, 1985), pp. 29–38.

**Scheicher 1990**

Elisabeth Scheicher, 'Historiography and display. The „Heldenrüstkammer" of Archduke Ferdinand II in Schloss Ambras', *Journal of the History of Collections* 1 (1990), pp. 69–79.

**Scheicher 1993**

Elisabeth Scheicher, 'Eine Augsburger Handschrift als Geschenk für König Philipp II. von Spanien: Zum Œvre Jörg Breus der Jüngere', *Münchner Jahrbuch der Bildenden Kunst*, 3.F. 44 (1993), pp. 151–179.

**Scheicher / Gamber / Wegerer / Auer 1977**

Elisabeth Scheicher, Ortwin Gamber, Kurt Wegerer and Alfred Auer, *Die Kunstkammer*, Führer durch das Kunsthistorisches Museum, 24 (Innsbruck, 1977).

**Scheicher / Gamber / Auer 1981a**

Elisabeth Scheicher, Ortwin Gamber and Alfred Auer, *Die Kunstkammer*, Führer durch das Kunsthistorisches Museum, 30 (Vienna, 1981).

**Scheicher / Gamber / Auer 1981b**

Elisabeth Scheicher, Ortwin Gamber and Alfred Auer, *Die Rüstkammern auf Schloß Ambras* (Vienna, 1981).

**Scheicher / Gamber / Wegerer / Auer 1977**

Elisabeth Scheicher, Ortwin Gamber, Kurt Wegerer and Alfred Auer, *Die Kunstkammer*, Führer durch das Kunsthistorisches Museum 24 (Innsbruck 1977)

**Scherg 1903**

Theodor Joseph Scherg, *Ueber die Religiöse Entwicklung Kaiser Maximilians II. bis zu seiner Wahl zum römischen Könige (1527–1562)* (Würzburg, 1903).

**Schlager / Kirsch 1998**

Karl-Heinz Schlager and Winfried Kirsch, 'Te Deum, in Die Musik in Geschichte und Gegenwart', in *Allgemeine Enzyklopädie der Musik. Sachteil*, 9, ed. by Ludwig Finscher (Kassel, 1998), sl. 433.

**Schlosser 1908**
Julius von Schlosser, *Die Kunst- und Wunderkammern der Spätrenaissance. Ein Beitrag zur Geschichte des Sammelwesens* (Leipzig, 1908).

**Schmid 1971**
Manfred Schmid, *Behörden und Verwaltungsorganisation Tirols unter Erzherzog Ferdinand II. in den Jahren 1564–1585, Beamtenschematismus der drei oberösterreichischen Wesen* (unpublished doctoral theses, Innsbruck, 1971).

**Schönach 1905**
Ludwig Schönach, *Beiträge zur Geschlechterkunde tirolischer Künstler aus dem 16.–19. Jahrhundert* (Innsbruck, 1905).

**Schönherr 1867**
*F. Schweygers Chronik der Stadt Hall 1303–1572*, ed. by David von Schönherr (Innsbruck 1867)

**Schönherr 1876**
David von Schönherr, 'Ezherzog Ferdinand von Tirol als Architect', *Repertorium für Kunstwissenschaft* 1 (1876), pp. 28–44.

**Schönherr 1884**
David von Schönherr, 'Urkunden und Regesten aus dem k.k. Statthalterei-Archiv in Innsbruck', *JKSAK* 2 (1884), pp. I–CLXXII.

**Schönherr 1890**
David von Schönherr, 'Urkunden und Regesten aus dem k.k. Statthalterei-Archiv in Innsbruck', *JKSAK* 11 (1890), pp. LXXXIV–CCXLI.

**Schönherr 1893**
David von Schönherr, Urkunden und Regesten aus dem k.k. Statthalterei-Archiv in Innsbruck, *JKSAK* 14 (1893), pp. LXXI–CCXIII.

**Schönherr 1893b**
David von Schönherr, 'Ein fürstlichen Architekt und Bauherr', *Mitteilungen des Instituts für Österreichische Geschichtsforschung* 4 (1893), pp. 465–470.

**Schönherr 1896**
David von Schönherr, 'Urkunden und Regesten aus dem k.k. Statthalterei-Archiv in Innsbruck', *JKSAK* 17 (1896), pp. I–CVIII.

**Schrenck von Notzing 1601**
Jakob Schrenck von Notzing, *Armamentarium Heroicum* (Innsbruck [?], 1601).

**Schrenck von Notzing 1603**
Jakob Schrenck von Notzing, *Heldenrüstkammer* (Innsbruck, 1603)

**Schütz 2002**
Karl Schütz, 'Die Porträtsammlung Erzherzog Ferdinands II.', in *Werke für die Ewigkeit. Kaiser Maximilian I. und Erzherzog Ferdinand II.*, ed. by Wilfried Seipel, exh. cat. (Innsbruck, 2002), pp. 19–23.

**Schutz 2003**

Karl Schutz, 'Die bildende Kunst in Österreich während der Herrschaft Ferdinands I.', in Exh. Cat. Vienna 2003, pp. 190–199.

**Schweikhart 1997**

Günter Schweikhart, 'Tizian in Augsburg', in *Kunst und ihre Auftraggeber im 16. Jahrhundert: Venedig und Augsburg im Vergleich*, ed. by Klaus Bergolt and Jochen Brüning (Berlin, 1997), pp. 21–42.

**Sciré 1983**

Giovanna Nepi Sciré, 'Giovanni Contarini', in *Dizionario Biografico degli Italiani*, 28 (Rome, 1983).

**Sedláček 1993–1998**

August Sedláček, *Hrady, zámky a tvrze Království českého*,15 vols. (Prague, 1998).

**Seelig 2001**

Lorenz Seelig, 'Historische Inventare-Geschichte, Formen, Funktionen', in *Sammlungsdokumentation. Geschichte – Wege – Beispiele'*, Museums-Bausteine 6 (2001), pp. 21–35.

**Seelig 2008**

Lorenz Seelig, 'Die Münchner Kunstkammer', in *Die Münchner Kunstkammer*, III: *Aufsätze und Anhänge*, ed. by Willibald Sauerländer and Dorothea Diemer (Munich, 2008), pp. 1–114.

**Seidl 2015**

Katharina Seidl, '"Ohne allen zweiffel aber ist vnter gedachten Künsten nit die geringste Kochen oder Küchenmeisterey". Kleine Kostproben des Küchenhandwerks in der Renaissance', in *Fürstlich Tafeln*, ed. by Sabine Haag, exh. cat. (Vienna, 2015), p. 44–45.

**Seidl 2017**

Katharina Seidl, '"... how to assuage all outer and inner malady ...": Medicine at the court of Archduke Ferdinand II', in Exh. Cat. Innsbruck 2017, pp. 67–71.

**Seipel 2008**

*Meisterwerke der Sammlungen Schloss Ambras*, ed. by Wilfried Seipel (Vienna, 2008).

**Sendrey 1970**

Alfred Sendrey, *The Music of the Jews in the Diaspora (up to 1800). A Contribution to the Social and Cultural History of the Jews* (New York, 1970).

**Senfelder 1901**

Leopold Senfelder, *Georg Handsch von Limupp. Lebensbild eines Artzes aus dem XVI. Jahrhundert*, Sonderabdruck aus Wiener klin. Rundschau (Vienna, 1901).

**Senn 1954**

Walter Senn, *Musik und Theater am Hof zu Innsbruck. Geschichte der Hofkapelle vom 15. Jahrhundert bis zu deren Auflösung im Jahre 1748* (Innsbruck, 1954).

**Senn 1970**

Walter Senn, 'Innsbrucker Hofmusik', *Österreichische Musikzeitschrift* 11 (1970), pp. 659–671.

**Sepp 1996**
Sieglinde Sepp, 'Die Bibliothek entsteht und wächst. Bemerkungen zur Entwicklung des Bestandes der Innsbrucker Universitätsbibliothek in den ersten hundert Jahren', in *Vom Codex zum Computer. 250 Jahre Universitätsbibliothek Innsbruck, Tiroler Landesmuseum Ferdinandeum 8. 11. 1995 – 7. 1. 1996*, ed. by Walter Neuhauser (Innsbruck, 1995), pp. 21–46.

**Serlio 1584**
Sebastiano Serlio, *Tutte l' Opere de Architettura* (Venice 1584).

**Silies 2009**
Michael Silies, *Die Motetten des Philippe de Monte (1521–1603)* (Göttingen, 2009).

**Silver 1986**
Larry Silver, 'The State of Research in Nothern European Art of the Renaisance Era', *Art Bulletin* 68:4 (1986), pp. 518–535.

**Silver 2006**
Larry Silver, 'Arts and Minds? Scholarship on Early Modern Art History (Nothern Europe)', *Renaisance Quarterly* 59:22 (2006), pp. 351–373.

**Silver 2008**
Larry Silver, *Marketing Maximilian: The Visual Ideology of A Holy Roman Emperor* (Princeton, 2008).

**Simons 2014**
Madelon Simons 'Presentation, Representation and Invisibility: Emperor Ferdinand I and His Son Archduke Ferdinand II of Austria in Prague (1547–1567)', in *The Habsburgs and Their Courts in Europe, 1400–1700: Between Cosmopolitism and Regionalism*, ed. by Herbert Karner, Ingrid Ciulisová and Bernardo J. García García, Palatium e-Publication 3 (2014), pp. 132–137.

**Simons 2007**
Madelon Simons, '"Unicornu in membrana elegantissime depictum": Some Thoughts about the Activities of Archduke Ferdinand II in Prague, 1547–1567', *Studia Rudolphina* 7 (2007), pp. 34–43.

**Simons 2017**
Madelon Simons, 'Up at the Castle and Down Town Prague. The Position of the Baumeister at the Habsburg Courts in Prague and Vienna in the middle of the Sixteenth Century', in *The Artist between Court and City (1300–1600)*, ed. Dagmar Eichberger, Philippe Lorentz and Andreas Tacke (Paderborn, 2017), pp. 147–161.

**Simonsohn 1977**
Shlomo Simonsohn, *History of the Jews in the Duchy of Mantua* (Jerusalem, 1977).

**Siracuso 2018**
Luca Siracusano, *L'epistolario di Cristoforo Madruzzo come fonte per la storia dell'arte con un'appendice di documenti dal notarile di Roma*, Collana Studi e Ricerche 1 (Trento, 2018).

**Smith 1994**
Jeffrey Chipps Smith, *German Sculpture of the Later Renaissance c. 1520–1580* (Princeton, NJ, 1994).

**Smith 2014**

Pamela H. Smith, 'The Matter of Ideas in the Working of Metals in Early Modern Europe', in *The Matter of Art*, ed. by Pamela H. Smith (Manchester, 2014), pp. 42–67.

**Smolík 1973**

Jan Smolík, 'Jan Augusta na Křivoklátě', *Středočeský sborník historický* 8 (1973), pp. 167–180.

**Smolka 2008**

Josef Smolka, 'Postavení Tadeáše Hájka jako lékaře na císařském dvoře', *Acta Universitatis Carolinae – Historia Universitatis Carolinae Pragensis* 48, Fapp. 2 (2008), pp. 11–32.

**Smolka 2015**

Josef Smolka, Cosmographici, Geographici, Geometrici, Mathematici, Philosophici, Astronomici, Astrologici, Militaris rei, Architecturae, Humanarum Literarum, alteriusque generis libri. Filosofie, matematika, fyzika, astronomie, astrologie, kosmografie, geografie, zemědělství, zoologie, botanika, in *Knihovna arcivévody Ferdinanda II. Tyrolského*, I: *Texty*, ed. by Ivo Purš and Hedvika Kuchařová (Prague, 2015), pp. 217–278.

**Smolka 2015**

Josef Smolka, 'Artis medicinalis libri. Lékařská literatura', in *Knihovna arcivévody Ferdinanda II. Tyrolského*, I: *Texty*, ed. by Ivo Purš and Hedvika Kuchařová (Prague, 2015), pp. 145–180.

**Smolka / Vaculínová 2010**

Josef Smolka and Marta Vaculínová, 'Renesanční lékař Georg Handsch (1529–1578)', *Dějiny vědy a techniky* 43 (2010), pp. 1–26.

**Sněmy české 1886**

*Sněmy české od léta 1526 až po naši dobu, IV* (1574–1576) (Prague, 1886).

**Stanley / Tyrrell 2001**

*The New Grove Dictionary of Music and Musicians*. Second Edition, ed. by Stanley Sadie and John Tyrrell, Vol. 7 (Oxford, 2001).

**Stark 2003/2004**

Marnie P. Stark, 'Mounted Bezoar Stones, Seychelles Nuts and Rhinoceros Horns: Decorative Objects as Antidotes in Early Modern Europe', *Studies in the Decorative Arts* 11:1 (2003/2004), pp. 69–94.

**Steen 2013**

Charlie R. Steen, *Margaret of Parma: A Life* (Leiden, 2013).

**Stejskal 1984**

Karel Stejskal, 'Klášter Na Slovanech, pražská katedrála a dvorská malba doby Karlovy', in *Dějiny českého výtvarného umění*, I/2, ed. by Rudolf Chadraba and Josef Krása (Prague, 1984), pp. 329–354.

**Stenzler 1857**

Adolph Friedrich Stenzler, 'Chronique des seigneurs et comtes d'Egmont, par un anonyme', *Bulletin de la Commission royale d'Histoire* 9 (1857), pp. 13–70.

**Stierhof 1993**
Horst H. Stierhof, *Das biblisch gemäl. Die Kapelle im Ottheinrichsbau des Schlosses Neuburg an der Donau* (Munich, 1993).

**Stolberg 2013**
Michael Stolberg, 'Empiricism in Sixteenth-Century Medical Practice: The Notebooks of Georg Handsch', *Early Science and Medicine* 18:6 (2013), pp. 487–516.

**Stolberg 2015**
Michael Stolberg, 'Kommunikative Praktiken. Ärztliche Wissensvermittlung am Krankenbett im 16. Jahrhundert', in *Praktiken der Frühen Neuzeit. Akteure – Handlungen – Artefakte*, ed. by Arndt Brendecke (Cologne, Weimar and Vienna, 2015), pp. 111–121.

**Stolberg 2016**
Michael Stolberg, 'Medical Note-Taking in the Sixteenth and Seventeenth Centuries', in *Forgetting Machines: Knowledge Management Evolution in Early Modern Europe*, ed by Alberto Cevolini (Leiden and Boston, 2016), pp. 243–264.

**Storchová 2011**
Lucie Storchová, „*Paupertate styloque connecti*". *Utváření humanistické učenecké komunity v českých zemích* (Prague, 2011).

**Storchová 2014**
Lucie Storchová, *Bohemian School Humanism and its Editorial Practices (ca. 1550–1610)* (Turnhout, 2014).

**Storchová 2020**
*Companion to Central and East European Humanism, Czech Lands: Vol. 1*, ed. Lucie Storchová (Berlin etc., 2020).

**Stotz 1940–45**
Otto Stolz, 'Über die Bauart der Innsbrucker Bürgerhäuser im Mittelalter', *Veröffentlichungen des Museum Ferdinandeum* 20–25 (1940–45), pp. 17–26.

**Strong 1973**
Roy Strong, *Splendour at Court. Renaissance Spectacle and Illusion* (London, 1973).

**Strong 1984**
Roy Strong, *Feste der Renaissance. 1450–1650. Kunst als Instrument der Macht* (Würzburg, 1984).

**Stroobant 1670**
Jaecques Stroobant, *Brusselsche Eer-Triumphen* (Brussels, 1670).

**Suida 1938**
Wilhelm Suida, 'Terzio (Terzi, Terzo), Francesco (Giov. Fr.)', in *Thieme-Becker. Allgemeines Lexikon der bildenden Künstler von der Antike bis zur Gegenwart*, XXXII, ed. by Hans Vollmer (Leipzig, 1938), pp. 546–548.

**Suppan 1965**
Wolfgang Suppan, 'A Collection of European Dances Breslau 1555', *Studia Musicologica Academiae Scientiarum Hungaricae* 7 (1965), pp. 165–169.

**Sutter-Fichtner 2001**
Paula Sutter-Fichtner, *Emperor Maximilian II* (New Haven and London, 2001).

**Svoboda s. d.**
Jiří Svoboda, *Inventář fondu archivu Pražského hradu č. 5. (Česká) dvorská komora z let 1529–1621, sg. DK*, unpublished typescript (Archive of the Prague Castle, s.d.)

**Syndram 2012**
Dirk Syndram, '„Diese Dinge sind warlich wohl wirdig das sie in derselben lustkammer kommen." Kurfürst August, die Kunstkammer und das Entstehen der Dresdner Sammlungen', in *Dresden & Ambras. Kunstkammerschätze der Renaissance*, ed. by Sabine Haag, exh. cat. (Vienna, 2012), pp. 17–29 (24).

**Syndram / Minning 2010**
*Die Inventare der kurfürstlich-sächsischen Kunstkammer in Dresden: Inventarbände 1587,1619, 1640, 1741*, ed. by Dirk Syndram and Martina Minning (Dresden, 2010).

**Taddei 2017**
Elena Taddei, 'Hin- und herüber die Alpen. Die Reisen von Anna Caterina Gonzaga (1566–1621), Erzherzogin von Österreich', in *Prinzessinnen unterwegs. Reisen fürstlicher Frauen in der frühen Neuzeit*, ed. by Annette C. Cremer, Anette Baumann and Eva Bender (Giessen, 2017), pp. 57–76.

**Tanner 1993**
Marie Tanner, *The Last Descendant of Aeneas: The Hapsburgs and the Mythic Image of the Emperor* (London, 1993).

**Thomas 1981**
*Jakob Schrenck von Notzing. Die Helden Rüstkammer (Armamentarium Heroicum) Erzherzog Ferdinands II. auf Schloß Ambras bei Innsbruck*, ed. by Bruno Thomas (Osnabrück, 1981).

**Thomas / Gamber 1976**
Bruno Thomas and Ortwin Gamber, *Katalog der Leibrüstkammer*, I. (Vienna, 1976).

**Thomas 2010**
Andrew L. Thomas, *A House Divided: Wittelsbach Confessional Court Cultures in the Holy Roman Empire c. 1550–1650* (Leiden, 2010).

**Thorndyke 1958**
Lynn Thorndyke, *A History of Magic and Experimental Science* (New York 1923–1958).

**Tietz 2019**
Manfred Tietz, 'The Long Journey from 'Deceiver and Conman' to 'Honorable Merchant.' The Image of the Merchant in Spanish Literature and its Contexts from the Sixteenth to the End of the Eighteenth Century', in *The Honorable Merchant – Between Modesty and Risk-Taking: Intercultural and Literary Aspects*, ed. by Christoph Lütge and Christoph Strosetzki (Cham, 2019), pp. 95–117.

**Tobolka / Horák 1939—1967**
*Knihopis českých a slovenských tisků od doby nejstarší až do konce XVIII. století*, 9 vols., ed. by Zdeněk Tobolka and František Horák (Prague, 1939–1967).

**Trapp 1984**
Oswald Trapp, *Tiroler Burgenbuch*, IV: *Eisacktal* (Bozen, 1984).

**Trnek 2000**
Helmut Trnek, 'Kaiser Rudolf II. (1552–1602) und seine Kunstkammer auf der Prager Burg', in *Exotica: Portugals Entdeckungen im Spiegel fürstlicher Kunst- und Wunderkammern der Renaissance*, exh. cat. (Vienna, 2000), pp. 36–42.

**Truhlář 1966**
*Rukověť humanistického básnictví v Čechách a na Moravě*, II, ed. by Antonín Truhlář et al. (Prague, 1966).

**Tschenett 1998**
Karin Elke Tschenett, *Die Baumeisterfamilie Luchese in Tirol* (master thesis Leopold-Franzens-Universität Innsbruck, 1998).

**Tuttle 2015**
Richard J. Tuttle, *Neptun Fountain in Bologna. Bronze, Marble, and Water in the Making of the Papal City*, ed. by Nadja Aksamija and Francesco Ceccarelli (London, 2015).

**Uhlirz 1897**
Karl Uhlirz, 'Urkunden und Regesten aus dem Archiv der k.k. Reichshaupt- und Residenzstadt Wien', *JKSAK* 18 (1897), pp. I–CC.

**Ueding 2003**
*Historisches Wörterbuch der Rhetorik*, ed. Gert Ueding (Tübingen, 2003).

**Uličný 2015a**
Petr Uličný, 'The Choirs of St Vitus's Cathedral in Prague: A Marriage of Liturgy, Coronation, Royal Necropolis and Piety', *Journal of the British Archaeological Association* 168 (2015), pp. 186–233.

**Uličný 2015b**
Petr Uličný, 'The Palace of Queen Anne Jagiello and Archduke Ferdinand II of Tyrol by the White Tower in Prague Castle', *Historie – Otázky – Problémy* 7:2 (2015), pp. 142–161.

**Uličný 2017**
Petr Uličný, 'The Making of the Habsburg Residence in Prague Castle. History of the Journey of the Imperial Palace from the Centre to the Periphery', *Umění/Art* 65 (2017), pp. 377–395.

**Uličný 2018a**
Petr Uličný, 'Bella, & Rara armaria di sua Altezza. Zbrojnice Pražského hradu v době Ferdinanda Tyrolského', *Průzkumy památek* 25:1 (2018), pp. 25–46.

**Uličný 2018b**
Petr Uličný, 'Od císaře k oráči a zase zpět. Panovnické cykly ve Starém královském paláci na Pražském hradě', *Umění/Art* 66 (2018), pp. 466–488.

**Uličný 2018c**
Petr Uličný, 'Střešní architektura a renesanční make-up pražských měst za krále a císaře Ferdinanda I.', *Staletá Praha* 34:2 (2018), pp. 69–95.

**Uličný 2018d**
Petr Uličný, 'The Garden of Archduke Ferdinand II at Prague Castle', *Studia Rudolphina* 17/18 (2018), pp. 23–34.

**Uličný 2020**
Petr Uličný, 'A Difficult Mission: The Building of St. Vitus Cathedral in the time of Ferdinand I and Anna Jagiellon (1526–1547)', *Umění/Art* 68 (2020), pp. 47–66.

**Unterkircher 1976**
Franz Unterkircher, *Die datierten Handschriften der Österreichischen Nationalbibliothek von 1501 bis 1600* (Vienna, 1976).

**Vácha 2013**
Petr Vácha, *Zvony a hodinové cimbály Katedrály sv. Víta, Václava a Vojtěcha* (Hradec Králové, 2013).

**Vaculínová / Bažil 2015a**
Marta Vaculínová and Martin Bažil, 'Rétorika a filologie', in *Knihovna arcivévody Ferdinanda II. Tyrolského*, I: *Texty*, ed. by Ivo Purš and Hedvika Kuchařová (Prague, 2015), pp. 343–360.

**Vaculínová / Bažil 2015b**
Marta Vaculínová and Martin Bažil, 'Básnická díla', in *Knihovna arcivévody Ferdinanda II. Tyrolského*, I: *Texty*, ed. by Ivo Purš and Hedvika Kuchařová (Prague, 2015), pp. 287–327.

**Vaissiere 1897**
*Journal de Jean Barillon secrétaire du Chancelier Duprat*, ed. by Pierre de Vaissiere (Paris, 1897–1899).

**Valladares 2008**
Rafael Valladares, *La conquista de Lisboa. Violencia militar y comunidad politica en Portugal*, 1578–1583 (Madrid, 2008).

**Van de Put 1939–1940**
Albert Van de Put, 'Two Drawings of the Fêtes at Binche for Charles V and Philip (II) 1549', *Journal of the Warburg and Courtauld Institutes* 3 (1939–1940), pp. 49–55.

**Vávrová 1997**
Věra Vávrová, 'Voda pro Pražský hrad', in *Klenot města: historický vývoj pražského vodárenství*, ed. by Jaroslav Jásek (Prague, 1997), pp. 15–28.

**Veen 2006**
Henk Th. van Veen, *Cosimo I de' Medici and his Self-Representation in Florentine Art and Culture* (Groningen, 2006).

**Verità 1985**
Marco Verità, 'L' invenzione del cristallo muranese: una verifica analitica delle fonti storiche', *Rivista della Stazione Sperimentale del Vetro* 15 (1985), pp. 17–29.

**Veselá 2015**
Lenka Veselá, 'Knihy dedikované Ferdinandovi II. Tyrolskému', in *Knihovna arcivévody Ferdinanda II. Tyrolského*, I: *Texty*, ed. by Ivo Purš and Hedvika Kuchařová (Prague, 2015), pp. 429–445.

**Vignau-Wilberg 2017**
Thea Vignau-Wilberg, *Joris and Jacob Hoefnagel: Art and Science around 1600* (Berlin, 2017).

**Vilímková 1972**
Milada Vilímková, *Stavebně historický průzkum Pražského hradu: Pražský hrad. Jižní křídlo. Dějiny* (typescript of the Institute for the Reconstruction of Historical Towns and Buildings in Prague, 1972).

**Vilímková 1974**
Milada Vilímková, *Stavebně historický průzkum: Pražského hradu. Starý palác. Dějiny* (typescript of the Institute for the Reconstruction of Historical Towns and Buildings in Prague, 1974).

**Vlček 1996**
*Umělecké památky Prahy. Staré Město a Josefov*, ed. by Pavel Vlček (Prague, 1996).

**Vlček 2000**
*Umělecké památky Prahy. Pražský hrad a Hradčany*, ed. by Pavel Vlček (Prague, 2000).

**Vlček 2004**
*Encyklopedie architektů, stavitelů, zedníků a kameníků v Čechách*, ed. by Pavel Vlček (Prague, 2004), pp. 165–166, 377–378 and 719–720.

**Vocelka 1976**
Karl Vocelka, *Die Habsburgische Hochzeiten 1550–1600. Kulturgeschichtliche Studien zum manieristischen Repräsentationsfest*, Veröffentlichungen der Kommission für neuere Geschichte Österreichs 65 (Graz, 1976).

**Vocelka 1981**
Karl Vocelka, *Die politische Propaganda Kaiser Rudolfs II. (1576–1612)* (Vienna, 1981).

**Voltelini 1890**
Hans von Voltelini, 'Urkunden und Regesten aus dem K. und K. Haus-, Hof- und Staats-Archiv in Wien', *JKSAK* 11 (1890), pp. I–LXXXIII.

**Voltelini 1892**
Hans von Voltelini, 'Urkunden und Regesten aus dem k. und k. Haus-, Hof- und Staats-Archiv in Wien', *JKSAK* 13 (1892), pp. XXVI–CLXXIV.

**Vorel 1997**
*Česká a moravská aristokracie v polovině 16. století. Edice register listů bratří z Pernštejna z let 1550–1551*, ed. by Petr Vorel (Pardubice, 1997).

**Vorel 1999**
Petr Vorel, *Páni z Pernštejna. Vzestup a pádu rodu zubří hlavy v dějinách Čech a Moravy* (Prague, 1999).

**Vorel 2005**
Petr Vorel, 'Místodržitelský dvůr arciknížete Ferdinanda Habsburského v Praze roku 1551 ve světle účetní dokumentace', *Folia Historica Bohemica* 21 (2005), pp. 7–66.

**Vrkotová 2006**
Jana Vrkotová, 'Žerotínové na Kolínsku ve světle jejich korespondence s českou komorou' (unpublished bachelor's thesis, Masaryk University in Brno, 2006).

**Vybíral 2014**
*Paměti Pavla Korky z Korkyně. Zápisky křesťanského rytíře z počátku novověku*, ed. by Zdeněk Vybíral, Prameny k českým dějinám 16.–18. století, serie B, IV (České Budějovice, 2014).

**Walther 1877**
*Hans Georg Ernstingers Raisbuch*, ed. by Philipp Alexander Ferdinand Walther, Bibliothek des Literarischen Vereins in Stuttgart, 135 (Tübingen, 1877).

**Warhafftige beschreibung 1562**
*Warhafftige beschreibung vnd verzeichnuß welcher gestalt die K[oe]nigkliche Wirde Maximilian vnnd Freuwlin Maria geborne K[oe]nigin auß Hispanien dero Gemahl zů Behemischen K[oe]nig vnd K[oe] nigin in Prag den 20. Septembris dises 1562. jars gekr[oe]net sind worden* (Frankfurt am Main, 1562)

**Warnke 1996**
Martin Warnke, *Hofkünstler. Zur Vorgeschichte des modernen Künstlers*, 2nd revised edition (Cologne, 1996).

**Watanabe-O'Kelly / Simon 2000**
Helen Watanabe-O'Kelly and Anne Simon, *Festivals and Ceremonies: A Bibliography of Works Relating to Court, Civic, and Religious Festivals in Europe 1500–1800* (London and New York, 2000).

**Weiss 2004a**
Sabine Weiss, *Aufbruch nach Europa: fünf Jahrhunderte Wien-Brüssel* (Graz, 2004).

**Weiss 2004b**
Sabine Weiss, *Claudia de' Medici: eine italienische Prinzessin als Landesfürstin von Tirol (1604–1648)* (Innsbruck, 2004).

**Welzel 2001**
Barbara Welzel, 'Die Ambraser Heldenrüstkammer und die Schlacht von Ostende', *Jahrbuch des Kunsthistorischen Museums Wien* 2 (2001), pp. 223–225.

**Wiesflecker 1971–1985**
Hermann Wiesflecker, *Kaiser Maximilian I. Das Reich, Österreich und Europa an der Wende zur Neuzeit*, 1–5 (Vienna and Munich, 1971–1985).

**Wiesflecker 1992**
Hermann Wiesflecker, *Maximilian I. Die Fundamente des habsburgischen Weltreiches* (Vienna, 1992).

**Wiewelhove 2002**
Hildegard Wiewelhove, *Tischbrunnen. Forschungen zur europäischen Tischkultur* (Berlin, 2002).

**Winkelbauer 2003**
Thomas Winkelbauer, *Österreichische Geschichte 1522–1699. Ständefreiheit und Fürstenmacht. Länder und Untertanen des Hauses Habsburg im konfessionellen Zeitalter*, I (Vienna, 2003).

**Winter 1909**
Zikmund Winter, *Řemeslnictvo a živnosti XVI. věku v Čechách* (Prague, 1909).

**Wirth 1913**
Zdeněk Wirth, 'Inventář zámku litomyšlského z r. 1608', *Časopis Společnosti přátel starožitností českých* 21 (1913), pp. 123–125.

**Woisetschläger 1974**
*Der Innerösterreichische Hofkünstler Giovanni Pietro de Pomis 1569–1633*, ed. by Kurt Woisetschläger (Graz, Vienna and Cologne, 1974).

**Wolf 1933**
Miloslav Wolf, 'Boj o solný monopol v Čechách v XVI. a na počátku XVII. století', *Český časopis historický* 39 (1933), pp. 297–326, 505–536.

**Wolfsgruber 2007**
Karl Wolfsgruber, Barbara Schütz and Helmut Stamper, *Schloss Velthurns* (Bozen, 2007).

**Wolkan 1925**
Rudolf Wolkan, *Geschichte der deutschen Literatur in Böhmen und in den Sudetenländern* (Augsburg, 1925).

**Wondrák 1983**
Eduard Wondrák, 'Der Arzt und Dichter Laurentius Span (1530–1575)', *Medizinhistorisches Journal* 18: Part 3 (1983), pp. 238–249.

**Wood 2008**
Christopher Wood, *Forgery, Replica, Fiction: Temporalities of German Renaissance Art* (Chicago and London, 2008).

**Yates 1977**
Frances Amelia Yates, *Astraea. The Imperial Theme in the Sixteenth Century* (Harmondsworth, 1977).

**Zecchin L. 1990**
Luigi Zecchin, *Vetro e vetrai di Murano: Studi sulla storia del vetro*, III (Venice, 1990).

**Zecchin P. 2005**
Paolo Zecchin, 'La nascita delle conterie veneziane', *Journal of Glass Studies* 47 (2005), pp. 77–92.

**Zecchin S. 2010**
Sandro Zecchin, 'La lavorazione a lume di oggettistica di vetro in Europa fino all'Ottocento', in *L'avventura del vetro: dal Rinascimento al Novecento tra Venezia e mondi lontani*, ed. by Aldo Bova, exh. cat. (Milan, 2010), pp. 51–55.

**Zehendtner vom Zehendtgrub 1587**
Paul Zehendtner vom Zehendtgrub, *Ordentliche Beschereibung mit was stattlichen Ceremonien und Zierlichheiten, die Röm[ische] Kay[serliche] May[estät], unser aller gnedigster Herr, sampt etlich andern Ertzherzogen, Fürsten und Herrn den Ordens deß Guldin Flüß in di[e]sem 85. Jahr zu Prag und Landshut empfangen und angenommen [...]* (Dilingen, 1587).

**Zíbrt 1905**
Čeněk Zíbrt, *Bibliografie české historie III/2* (Prague, 1905).

**Zimerman 1887**

Heinrich Zimerman, 'Urkunden, Acten und Regesten aus dem Archiv des k.k. Ministeriums des Innern', *JKSAK* 5 (1887), pp. CXX–CLXXVI.

**Zimerman 1888**

Heinrich Zimerman, 'Urkunden, Acten und Regesten aus dem Archiv des k.k. Ministeriums des Innern', *JKSAK* 7 (1888), pp. XV–LXXXIV.

**Zmora 1997**

Hillay Zmora, *State and Nobility in Early Modern Germany: The Knightly Feud in Franconia, 1440–1567* (Cambridge, 1997), pp. 143–145.

**Zoller 1825**

Franz Carl Zoller, *Geschichte und Denkwürdigkeiten der Stadt Innsbruck und der umliegenden Gegend* (Innsbruck, 1825).

# Photographic credits

### Introduction

Kunsthistorisches Museum Wien © KHM-Museumsverband

### Jaroslava Hausenblasová (text 1)

1. Sylva Dobalová, 2010
2. Erlangen, © FAU Graphic Collection, AH 512
3. Kunsthistorisches Museum Wien © KHM-Museumsverband
4. The City of Prague Museum
5. Ivan P. Muchka, 2014
6. Ivan P. Muchka, 2020
7. Kunsthistorisches Museum Wien © KHM-Museumsverband
8. Kunsthistorisches Museum Wien © KHM-Museumsverband
9. Prague, National Library of the Czech Republic
10. Kunsthistorisches Museum Wien © KHM-Museumsverband

### Jaroslava Hausenblasová (text 2)

1. Prague, National Archives of the Czech Republic
2. Ivan P. Muchka, 2019
3. © The Lobkowicz Collections, Lobkowicz Palace, Prague Castle, Czech Republic
4. Prague, Institute of Art History, Czech Academy of Sciences, photo © Vlado Bohdan
5. Prague, National Library of the Czech Republic
6. Prague, National Library of the Czech Republic
7. Kunsthistorisches Museum Wien © KHM-Museumsverband

### Markéta Ježková

1. Kunsthistorisches Museum Wien © KHM-Museumsverband
2. Kunsthistorisches Museum Wien © KHM-Museumsverband
3. Kunsthistorisches Museum Wien © KHM-Museumsverband
4. London, British Library
5. Kunsthistorisches Museum Wien © KHM-Museumsverband

### Stanislav Hrbatý

1. Photo © National Gallery Prague, 2021
2. Kunsthistorisches Museum Wien © KHM-Museumsverband
3. The City of Prague Museum
4. Kunsthistorisches Museum Wien © KHM-Museumsverband
5. Kunsthistorisches Museum Wien © KHM-Museumsverband
6. Kunsthistorisches Museum Wien © KHM-Museumsverband

## Václav Bůžek

1. Kunsthistorisches Museum Wien © KHM-Museumsverband
2. Innsbruck, TLMF, Historische Sammlungen, Waffensammlung
3. © Österreichische Nationalbibliothek, Bildarchiv
4. Kunsthistorisches Museum Wien © KHM-Museumsverband

## Jan Baťa

1. Prague, National Library of the Czech Republic
2. Bayerische Staatsbibliothek München, [Shelfmark 4 Mus. pr. 46, adl. 4]
3. Kunsthistorisches Museum Wien © KHM-Museumsverband
4. Kunsthistorisches Museum Wien © KHM-Museumsverband
5. Prague, National Library of the Czech Republic

## Joseph F. Patrouch

1. Kunsthistorisches Museum Wien © KHM-Museumsverband
2. Kunsthistorisches Museum Wien © KHM-Museumsverband
3. Kunsthistorisches Museum Wien © KHM-Museumsverband
4. Kunsthistorisches Museum Wien © KHM-Museumsverband
5. Kunsthistorisches Museum Wien © KHM-Museumsverband
6. Oelsnitz/Vogtland, © Schloss Voigtsberg

## Petr Uličný

1. The Archives of the Prague Castle, Prague Castle Administration – Photography Collection, No. 2436
2. Florence, Gallerie degli Uffizi, Gabinetto dei disegni e delle stampe
3. Prague, The Archives of the Prague Castle, Old Plans Collection
4. Petr Chotěbor, 2018
5. Petr Uličný, 2019
6. The City of Prague Museum
7. The Archives of the Prague Castle, Old Plans Collection
8. Ivan P. Muchka, 2019
9. Ivan P. Muchka, 2018
10. Petr Uličný, 2019

## Sarah W. Lynch

1. The metropolitan chapter of St Vitus in Prague
2. The metropolitan chapter of St Vitus in Prague
3. Sarah W. Lynch
4. Martin Mádl
5. Ivan P. Muchka
6. Prague, National Archives of the Czech Republic
7. Prague, Institute of Art History, Czech Academy of Sciences, photo © Prokop Paul

## Ivan Prokop Muchka

1. Ivan P. Muchka, 2019
2. Ivan P. Muchka, 2019
3. Ivan P. Muchka, 2019
4. Ivan P. Muchka, 2019
5. Ivan P. Muchka, 2019
6. Innsbruck, Tiroler Landesarchiv
7. Ivan P. Muchka, 2019
8. Ivan P. Muchka, 2019
9. Ivan P. Muchka, 2019
10. Ivan P. Muchka, 2019

## Eliška Fučíková

1. Eton College Library, © reproduced by permission of the Provost and Fellows of Eton College
2. Prague, The Archives of the Prague Castle

## Sylva Dobalová

1. Ivan P. Muchka
2. Ivan P. Muchka
3. Prague, Institute of Art History, Czech Academy of Sciences, photo © Vlado Bohdan
4. Kunsthistorisches Museum Wien © KHM-Museumsverband
5. Ivan P. Muchka
6. Kunstsammlungen der Veste Coburg/Germany
7. Kunsthistorisches Museum Wien © KHM-Museumsverband
8. Kunsthistorisches Museum Wien © KHM-Museumsverband
9. Kunsthistorisches Museum Wien © KHM-Museumsverband

## Blanka Kubíková

1. Kunsthistorisches Museum Wien © KHM-Museumsverband
2. Kunsthistorisches Museum Wien © KHM-Museumsverband
3. Kunsthistorisches Museum Wien © KHM-Museumsverband
4. © National Gallery Prague 2021
5. Ivan Muchka
6. Kunsthistorisches Museum Wien © KHM-Museumsverband
7. Kunsthistorisches Museum Wien © KHM-Museumsverband

## Elisabeth Reitter

1. Kunsthistorisches Museum Wien © KHM-Museumsverband
2. Kunsthistorisches Museum Wien © KHM-Museumsverband
3. Kunsthistorisches Museum Wien © KHM-Museumsverband
4. Kunsthistorisches Museum Wien © KHM-Museumsverband

5. Ivan P. Muchka
6. © Tiroler Landesmuseen/Hofkirche, photo Watzek
7. Kunsthistorisches Museum Wien © KHM-Museumsverband
8. © Tiroler Landesmuseen/Hofkirche, photo Watzek

## Ivo Purš

1. Innsbruck, Universität- und Landesbibliothek Tirol
2. © National Gallery Prague 2021
3. Innsbruck, Tiroler Landesarchiv
4. © National Gallery Prague 2021
5. © Österreichische Nationalbibliothek, Bildarchiv
6. © Österreichische Nationalbibliothek, Bildarchiv
7. © Österreichische Nationalbibliothek, Bildarchiv
8. © Österreichische Nationalbibliothek, Bildarchiv

## Lucie Storchová

1. © Österreichische Nationalbibliothek, Bildarchiv
2. © Österreichische Nationalbibliothek, Bildarchiv

## Marta Vaculínová

1. Prague, Collection the National Museum, National Museum Library, Czech Republic
2. © Österreichische Nationalbibliothek, Bildarchiv

## Katharina Seidl

1. Kunsthistorisches Museum Wien © KHM-Museumsverband
2. Kunsthistorisches Museum Wien © KHM-Museumsverband
3. Kunsthistorisches Museum Wien © KHM-Museumsverband
4. © Herzog August Bibliothek Wolfenbüttel <http://diglib.hab.de/inkunabeln/14-astron/start.htm>
5. Prague, National Library of the Czech Republic
6. St. Louis, Missouri Botanical Garden, Peter H. Raven Library

## Veronika Sandbichler

1. Kunsthistorisches Museum Wien © KHM-Museumsverband
2. Kunsthistorisches Museum Wien © KHM-Museumsverband
3. Kunsthistorisches Museum Wien © KHM-Museumsverband
4. Kunsthistorisches Museum Wien © KHM-Museumsverband
5. Kunsthistorisches Museum Wien © KHM-Museumsverband
6. Kunsthistorisches Museum Wien © KHM-Museumsverband
7. Kunsthistorisches Museum Wien © KHM-Museumsverband
8. Schloss Ambras Innsbruck, photo © Gerhard Veigl

## Thomas Kuster

1. Kunsthistorisches Museum Wien © KHM-Museumsverband
2. Kunsthistorisches Museum Wien © KHM-Museumsverband
3. Kunsthistorisches Museum Wien © KHM-Museumsverband
4. Kunsthistorisches Museum Wien © KHM-Museumsverband
5. Kunsthistorisches Museum Wien © KHM-Museumsverband
6. Kunsthistorisches Museum Wien © KHM-Museumsverband
7. Kunsthistorisches Museum Wien © KHM-Museumsverband
8. Kunsthistorisches Museum Wien © KHM-Museumsverband

## Annemarie Jordan Gschwend

1. Naturhistorisches Museum Wien
2. Private collection
3. Private collection
4. Kunsthistorisches Museum Wien © KHM-Museumsverband
5. Kunsthistorisches Museum Wien © KHM-Museumsverband
6. Kunsthistorisches Museum Wien © KHM-Museumsverband

## Eva Lenhart

1. Kunsthistorisches Museum Wien © KHM-Museumsverband
2. Kunsthistorisches Museum Wien © KHM-Museumsverband
3. Kunsthistorisches Museum Wien © KHM-Museumsverband
4. Kunsthistorisches Museum Wien © KHM-Museumsverband
5. Kunsthistorisches Museum Wien © KHM-Museumsverband
6. Prague, National Library of the Czech Republic
7. Kunsthistorisches Museum Wien © KHM-Museumsverband

## Beket Bukovinská

1. Kunsthistorisches Museum Wien © KHM-Museumsverband
2. Kunsthistorisches Museum Wien © KHM-Museumsverband
3. Kunsthistorisches Museum Wien © KHM-Museumsverband
4. Kunsthistorisches Museum Wien © KHM-Museumsverband
5. Vienna, Museum für angewandte Kunst
6. Kunsthistorisches Museum Wien © KHM-Museumsverband
7. Kunsthistorisches Museum Wien © KHM-Museumsverband
8. Kunsthistorisches Museum Wien © KHM-Museumsverband

# Index of personal names

The index does not refer to the person of Archduke Ferdinand II, or to the text of the Introduction. Dates are given only in cases of two or more persons bearing the same name, in order to avoid confusion.

Margaret of Parma, Duchess of Florence and
   Parma, 152, 153
Margherita Farnese (1567–1643), 160
Margarete *see* Margaret of Habsburg, Archduchess
   of Austria
Maria of Austria (Habsburg), Empress, (María), 31,
   149, 150, 154, 154 (note 14), 164, 440
Maria of Habsburg, Archduchess of Austria,
   Duchess of Jülich-Cleves-Berg, 32, 53, 150,
   156, 158, 158 (Fig.), 159
Maria of Habsburg (Tyrol), Archduchess of
   Austria, 340
Maria of Hungary *see* Mary, Queen of Hungary
   and Bohemia
Maria of Portugal, Duchess of Viseu, 151 (note 7),
   153, 154
Maria of Spain *see* Maria of Austria, Empress
María *see* Maria of Austria, Empress
Maria de' Medici, Queen of France, 162
Maria (Anna) of Bavaria, Archduchess of Austria,
   420
Maria Anna of Bavaria, Archduchess of Inner
   Austria, 157
Maria Manuela of Portugal, Princess of Asturias,
   Duchess of Milan and Princess of Portugal, 290
Martínek, Jan, 353 (note 12)
Martinengo, Fabrizio, 434, 435, 435 (note 15)
Martinic *see* Clam-Martinic, Charles Philip of
Martinice, Jan Bořita of, 125 (note 48)
Mary, Queen of Hungary and Bohemia, Governor
   of the Netherlands, 28, 31, 32, 35, 77, 78, 78
   (note 20), 79, 81, 83, 84, 86, 87–89, 91, 151
   (note 7), 153, 155, 189, 260, 263, 486
Mary Tudor, Queen of England, 290
Mastaing, Philibert de, 92 (note 120)
Master IW, 263, 263 (note 21)
Matthias (II) of Habsburg, Holy Roman Emperor,
   43, 314, 416, 420, 425
Mattioli, Pietro Andrea, 63, 64, 64 (Fig.), 68, 100,
   171, 177, 331, 341, 342, 342 (Fig.), 343, 347,
   348, 351, 352, 352 (note 8), 362, 367, 369, 370,
   372 (note 28), 383, 386–388, 388 (Fig.), 389, 389
   (Fig.), 392, 393, 484
Maximilian I of Habsburg, Holy Roman Emperor,
   25, 26, 26 (note 3), 40, 121, 185, 224 (note 34),
   262, 272, 280, 280 (Fig.), 285, 285 (note 4), 286,
   311 (Fig.), 312, 313 (note 49), 333, 340, 408,
   464, 488
Maximilian II of Habsburg, Holy Roman Emperor,
   27, 28, 29 (Fig.), 30, 31, 33, 35–37, 39, 48–53,
   66, 68, 74 (Fig. 2), 76, 77, 83–87, 89, 117, 117
   (note 13), 128, 129, 137–139, 149, 154, 157, 161,
   163, 164, 181 (note 38), 191, 193, 211, 240, 252,
   253, 255, 263, 273, 274, 277, 277 (note 67), 314,
   328, 337, 342, 362, 367, 369, 369 (note 20), 370,

371, 373, 390, 399, 413, 416, 432, 441, 470, 471,
   471 (note 25), 485, 487
Maximilian (III) of Habsburg, Archduke of
   Austria, 465
Medici, *family*, 432
Melanchton, Phillip, 50, 296, 391
Melantrich of Aventino, Jiří, 293, 294 (note 37), 341
Meltzer, Daniel, 349
Mercadus, Ferdinandus, 363
Merian, Matthäus, 400, 401 (Fig.)
Meurl, Alexander, 311 (note 41)
Meyer, Albrecht, 391
Meyting, Anthonio, 437, 440, 441, 441 (note 42)
Mičan of Klinštejn, Fridrich, 123 (note 42)
Mielich, Hans, 157 (Fig.)
Miller, Georg, 375 (note 39)
Miřkovský of Tropčice, *family*, 57 (note 60)
Miseroni, *family*, 408
Mitis, Tomáš, 331, 352, 360, 361
Mittermayer, Gabriel, 113
Modrone, Caremolo, 110, 113 (Fig. 6)
Möller of Möllenstein, Kaspar, 464
Monardes, Nicolas, 389
Monluc, Blaise de, 296
Montano, Antonio, 322 (note 119)
Monte, Philippe de, 144, 146
Montigni, Seigneur of, 152
Montmorency, Floris de, 152
Muelen, Johannes Baptista van der, 373, 378
Müllner, Hans, 108
Münster, Sebastian, 197, 198 (Fig.), 199
Mužík, Zdeněk, 371

Naevius, Johannes, 361
Nasus, Johann, 330
Nausea, Friedrich, 328, 329 (note 7)
Navagero, Bernardo, 78, 78 (note 20), 191
Negroli, Giovanni Paolo, 101
Neidhart, Thomas, 322 (note 121)
Nelli, Niccolò, 443 (Fig.)
Nenning, Christoph, 373, 376, 378
Neufchatel, Nicolas, 301
Neuner, Ieremias, 378
Nomi, Dario di, 420
Nostic, Reinold of, 66 (note 98)
Nostitz *see* Nostic, Reinold of

Oberrauch, Lukas, 351 (note 2)
Occo I, Adolf, 335
Occo II, Adolf, 335, 336 (note 55)
Occo III, Adolf, 335, 336, 336 (note 55)
Oertl (I), Ulrich, 111
Olmo (Ulmus), Giovanni Francesco, 338
Ort, Anthoni (Anton, Antoni), 307, 307 (note 21),
   310, 313 (note 49), 314 (note 62), 314 (note 65),

# List of contributors

Jan Baťa, Prague, Institute of Art History, Czech Academy of Sciences / Institute of Musicology, Faculty of Arts, Charles University

Beket Bukovinská, Prague, Institute of Art History, Czech Academy of Sciences

Václav Bůžek, Institute of History, Faculty of Arts, University of South Bohemia in České Budějovice

Sylva Dobalová, Prague, Institute of Art History, Czech Academy of Sciences

Eliška Fučíková, Prague, Institute of Art History, Czech Academy of Sciences

Annemarie Jordan Gschwend, Prague, Institute of Art History, Czech Academy of Sciences / Universidade Nova de Lisboa – Centro de Humanidades (CHAM)

Jaroslava Hausenblasová, Prague, Institute of Art History, Czech Academy of Sciences / Institute of Czech History, Faculty of Arts, Charles University

Stanislav Hrbatý, Prague, Institute of Art History, Czech Academy of Sciences / Museum of Eastern Bohemia in Hradec Králové

Markéta Ježková, Prague, Institute of Art History, Czech Academy of Sciences

Blanka Kubíková, Prague, Institute of Art History, Czech Academy of Sciences / National Gallery Prague

Thomas Kuster, Schloss Ambras Innsbruck

Eva Lenhart, Institute of Conservation, University of Applied Arts, Vienna

Sarah W. Lynch, Dept. of Media Studies and Art History, Friedrich Alexander University of Erlangen-Nuremberg

Ivan Muchka, Prague, Institute of Art History, Czech Academy of Sciences

Joseph F. Patrouch, Wirth Institute, Faculty of Arts, History & Classics Dept., University of Alberta

Ivo Purš, Prague, Institute of Art History, Czech Academy of Sciences

Elisabeth Reitter, Faculty of Philosophy and History, Universität Innsbruck

Veronika Sandbichler, Schloss Ambras Innsbruck

Katharina Seidl, Schloss Ambras Innsbruck

Lucie Storchová, Prague, Institute of Philosophy, Czech Academy of Sciences

Petr Uličný, Prague, Institute of Art History, Czech Academy of Sciences

Marta Vaculínová, Prague, Institute of Art History, Czech Academy of Sciences / Institute of Philosophy, Czech Academy of Sciences